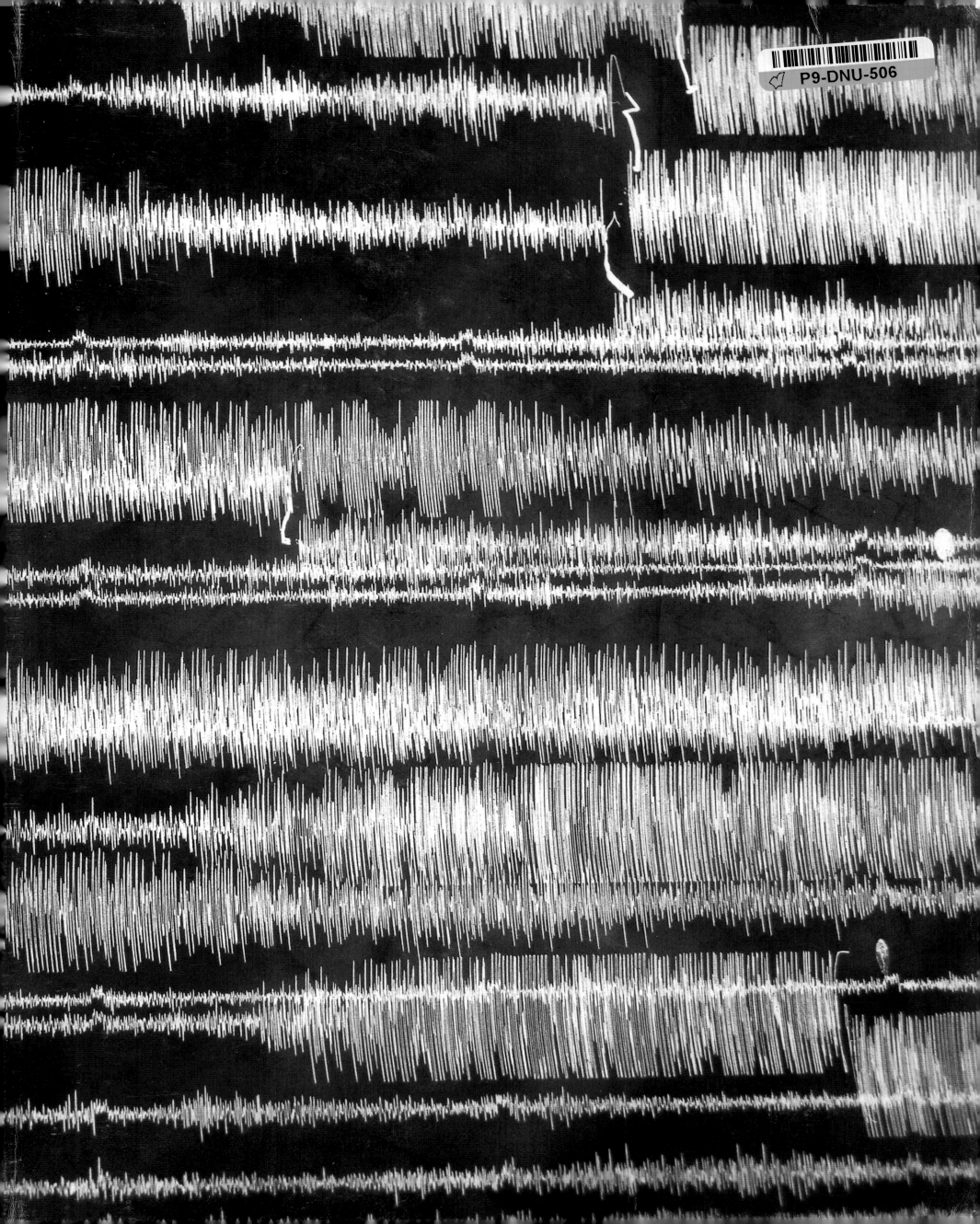

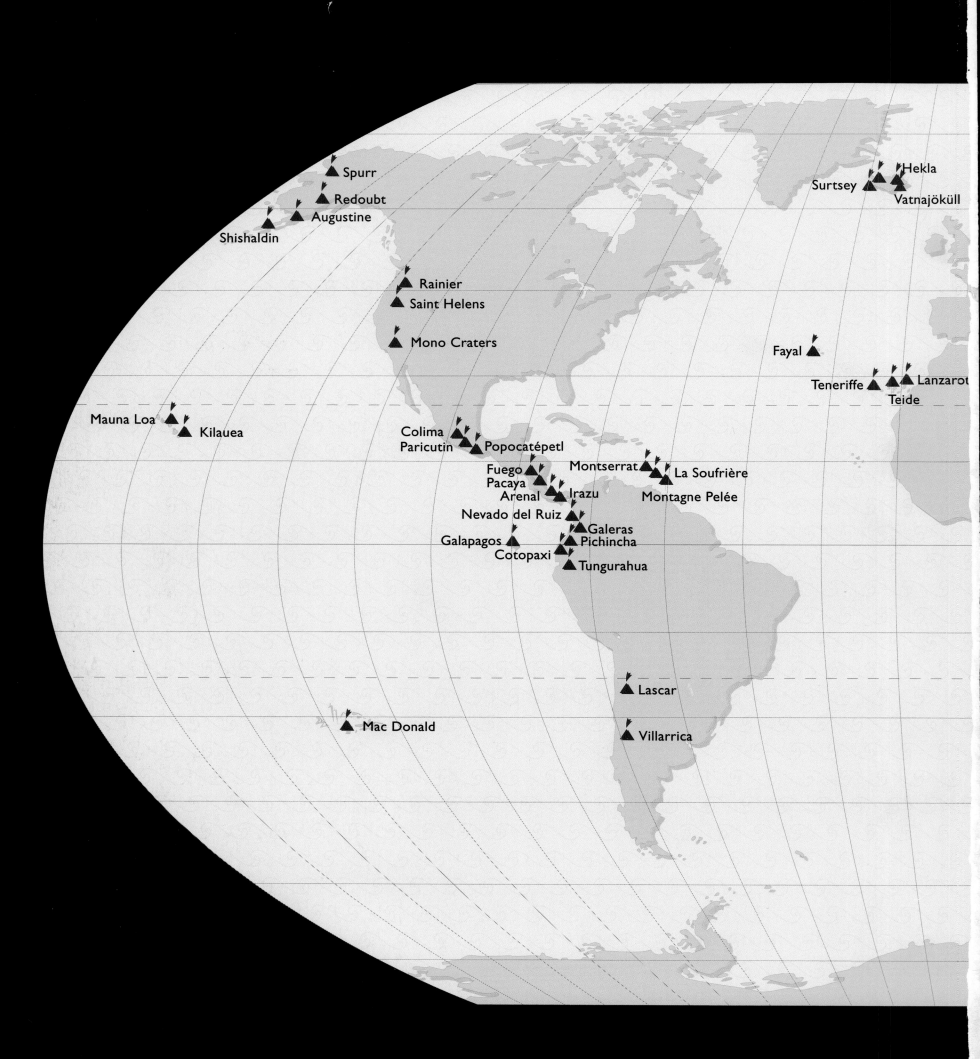

Spurr

Redoubt

Augustine

Shishaldin

Surtsey

Hekla

Vatnajökull

Rainier

Saint Helens

Mono Craters

Fayal

Teneriffe

Lanzarot

Teide

Mauna Loa

Kilauea

Colima

Paricutin

Popocatépetl

Fuego

Pacaya

Arenal

Irazu

Montserrat

La Soufrière

Montagne Pelée

Nevado del Ruiz

Galeras

Galapagos

Pichincha

Cotopaxi

Tungurahua

Lascar

Mac Donald

Villarrica

MAJOR VOLCANOES

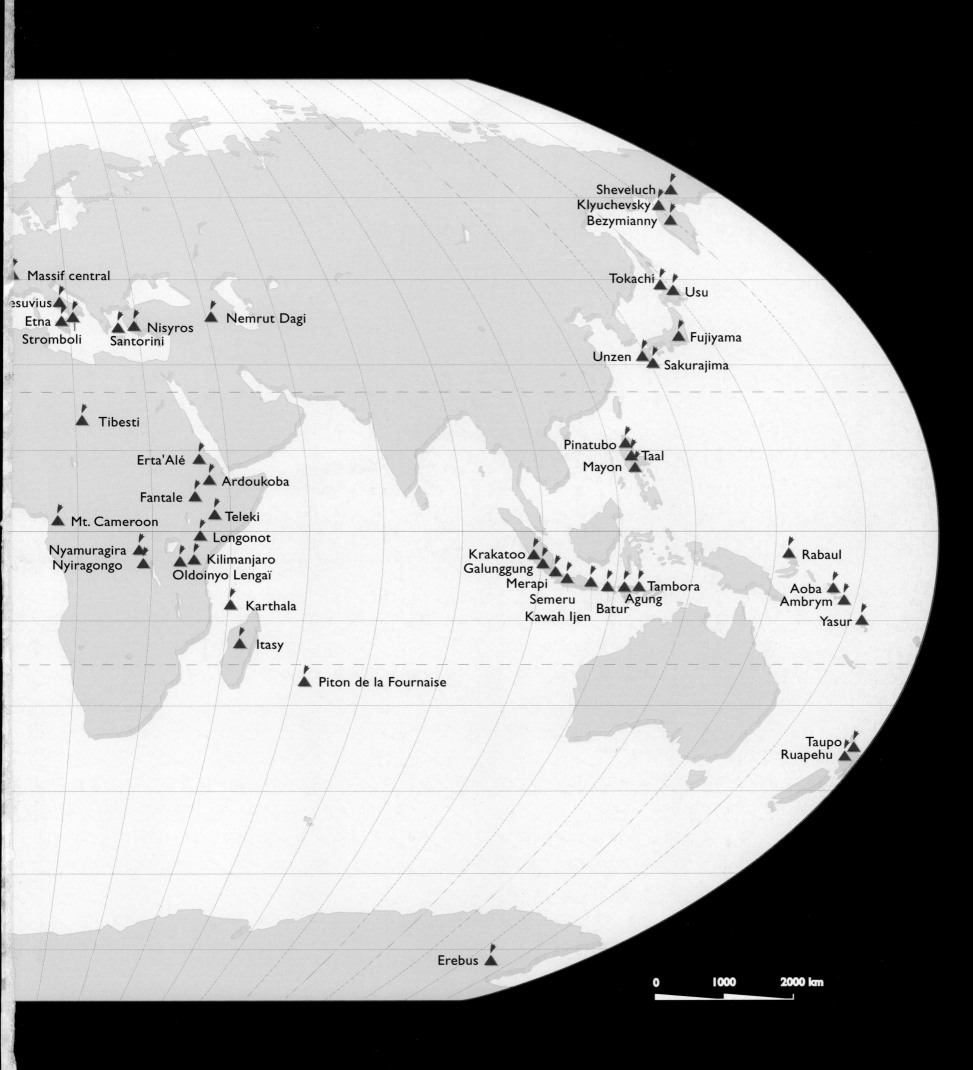

Sheveluch
Klyuchevsky
Bezymianny

Massif central

esuvius
Etna
Stromboli
Santorini
Nisyros
Nemrut Dagi

Tokachi
Usu

Fujiyama
Unzen
Sakurajima

Tibesti

Erta'Alé
Ardoukoba
Fantale
Mt. Cameroon
Teleki
Longonot
Nyamuragira
Nyiragongo
Kilimanjaro
Oldoinyo Lengaï

Pinatubo
Mayon
Taal

Karthala

Krakatoo
Galunggung
Merapi
Semeru
Kawah Ijen
Batur
Agung
Tambora

Rabaul

Aoba
Ambrym
Yasur

Itasy

Piton de la Fournaise

Taupo
Ruapehu

Erebus

0 1000 2000 km

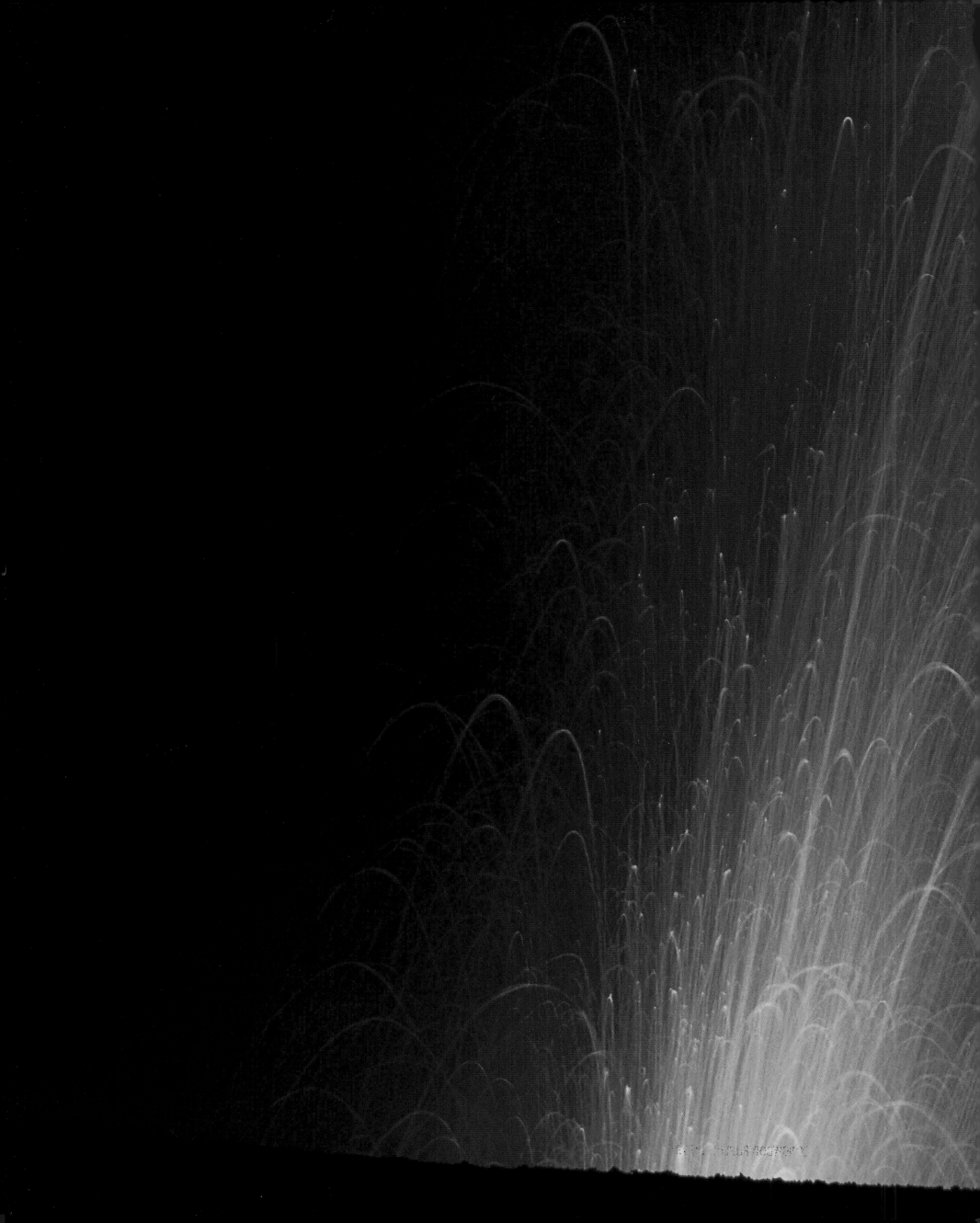

VOLCANOES

Philippe Bourseiller | Jacques Durieux

Harry N. Abrams, Inc., Publishers

Project manager, English-language edition: Ellen Nidy
Editor, English-language edition: Julia Gaviria
Translated from the French by David Baker

Library of Congress Control Number: 2002100975
ISBN: 0–8109–1699–1

Copyright © 2002 Éditions de La Martinière, Paris
English translation copyright © 2002 Harry N. Abrams, Inc.

Published in 2002 by Harry N. Abrams, Incorporated, New York

Printed and bound in France
10 9 8 7 6 5 4 3 2 1

Harry N. Abrams, Inc.
100 Fifth Avenue
New York, N.Y. 10011
www.abramsbooks.com

Abrams is a subsidiary of

To produce a work like *Volcanoes* requires authors who are not only knowledgeable but also inspired. Philippe Bourseiller and Jacques Durieux have been a team for some time, writing and producing works of reportage, particularly on volcanoes. Both are alpinists, one is a professional photographer (Bourseiller), the other (Durieux), as a volcanologist, serves as both photographer and filmmaker in his free time. Their knowledge and skill led to this remarkable volume, with its rich detailing of the myths and beliefs associated with volcanoes, volcanic eruptions, scientific knowledge, and volcanic risks—in other words, all about volcanoes and man's relationship with them.

A fine book also requires an excellent publisher—in this case Éditions de La Martinière, who produced the original French edition, and Harry N. Abrams, who provided the English-language edition of *Volcanoes*.

Bourseiller and Durieux have mounted numerous volcanic expeditions. One of these, part of the television series *Dans la Nature (In Nature) with Stephane Peyron*, concerned Erta' Alé volcano in Afar, in the Danakil depression located between the Ethiopian high plateaus and the Red Sea. It left an indelible impression on me for two reasons. First, it was my first visit to the region after twenty years' absence. In fact, from 1967 to 1974 I had taken part in a French-Italian team in the geological and volcanological exploration of this area under the direction of Haroun Taziett and Giorgio Marinelli. During these expeditions we discovered the two lava lakes of Erta' Alé: some of the rarest volcanic phenomena in the world. It was very moving to be able to share the discovery of such amazing land with friends. Second, this was a highly emotional mission. Just as we were about to leave a village by helicopter, near the salt plain where my friends had just spent a week on very cordial terms with the local liberation front, its commander rushed the helicopter, brandishing his revolver, and forced everyone to disembark. Negotiations were not easy. Eventually we learned that there had been a misunderstanding between the commander on board and the leader of the front about the number of guerrilla warriors who would be flying. After hours of tense discussion, we were granted four days in the Erta' Alé caldera. Such a dust-up as this one at Erta' Alé was extremely rare.

One of our aims was to bring back images of the behavior of the permanent lava lake—the other having disappeared—as well as samples of the lava and emitted gases. I could only admire my two friends' free and easy descent by rope down the 300-foot wall of the well, or "pit crater," with boiling lava below. As for me, lowered and then raised with the help of a hand winch on the end of a cable, my heart was in my throat. But that is what happens when you are dealing with real pros. Unfortunately, Erta' Alé gets only scant coverage in the book, which is no doubt appropriate, considering all the other volcanoes throughout the world, many of which make their dazzling appearance here.

In 1650 geologist Bernhard Varen reported just 27 recent or active volcanoes; in 1862 volcanologist George Poulett Scrope raised that number to 217; and by 1869 the famous explorer Alexander von Humboldt knew of 407. Today Tom Simkin and Lee Siebert, in *Volcanoes of the World* (Geoscience Press, 1994), put the figure at more than 1,500. Their inventory includes only visible volcanoes on the earth's surface, and thus it omits all submarine volcanoes except a few whose effects are visible on the sea or ocean surface. It is important to note that the axis of the ocean folds, at a depth of some 6,500 to 8,000 feet, extending for 40,000 miles along the separation of the tectonic plates, is really just one immense, continuous volcano in statistically permanent activity. It came to the attention of scientists thanks to submarine descents but remains unknown to the public. Only two zones of this fold have been sounded: Iceland and Afar, which happens to be the site of Erta' Alé. And what are we to make of the tens of thousands of submarine volcanoes carpeting the ocean floor, detected by satellite methods—volcanoes whose formation mechanisms are unknown except for those connected with hot spots?

Popularizing science is a difficult art. The authors set out here to explain and demonstrate what volcanoes are, to make them accessible to everyone fascinated by this natural phenomenon. They have managed to do just that—and brilliantly. But that is not all. Today, all over the world, 500 million people are exposed to volcanic risks. As we celebrate the hundredth anniversary of the eruption of Montagne Pelée, which claimed 29,000 victims in 1902, it behooves us to recall all the efforts undertaken to mitigate these dangers. Volcanology has made great strides, and thanks to the surveillance networks installed on volcanoes, I doubt that we could witness a similar catastrophe today at any of the monitored volcanoes. Although most of the dangerous volcanoes are now kept under surveillance, some standing right over populous cities still exist without any monitoring devices. Governments often seem unaware of the risk.

Reduction of volcanic risks is possible only if the public has been prepared and informed. The least we can expect is that civil authorities and scientists do their jobs; in addition, the public needs to be educated adequately of the danger that it faces. Without knowledge of volcanoes and their risks, no prevention is possible. In this sense, *Volcanoes* makes a valuable contribution.

Jean-Louis Cheminée
Research Director, CNRS
Director, Volcanological Observatories of
the Institut de Physique du Globe de Paris

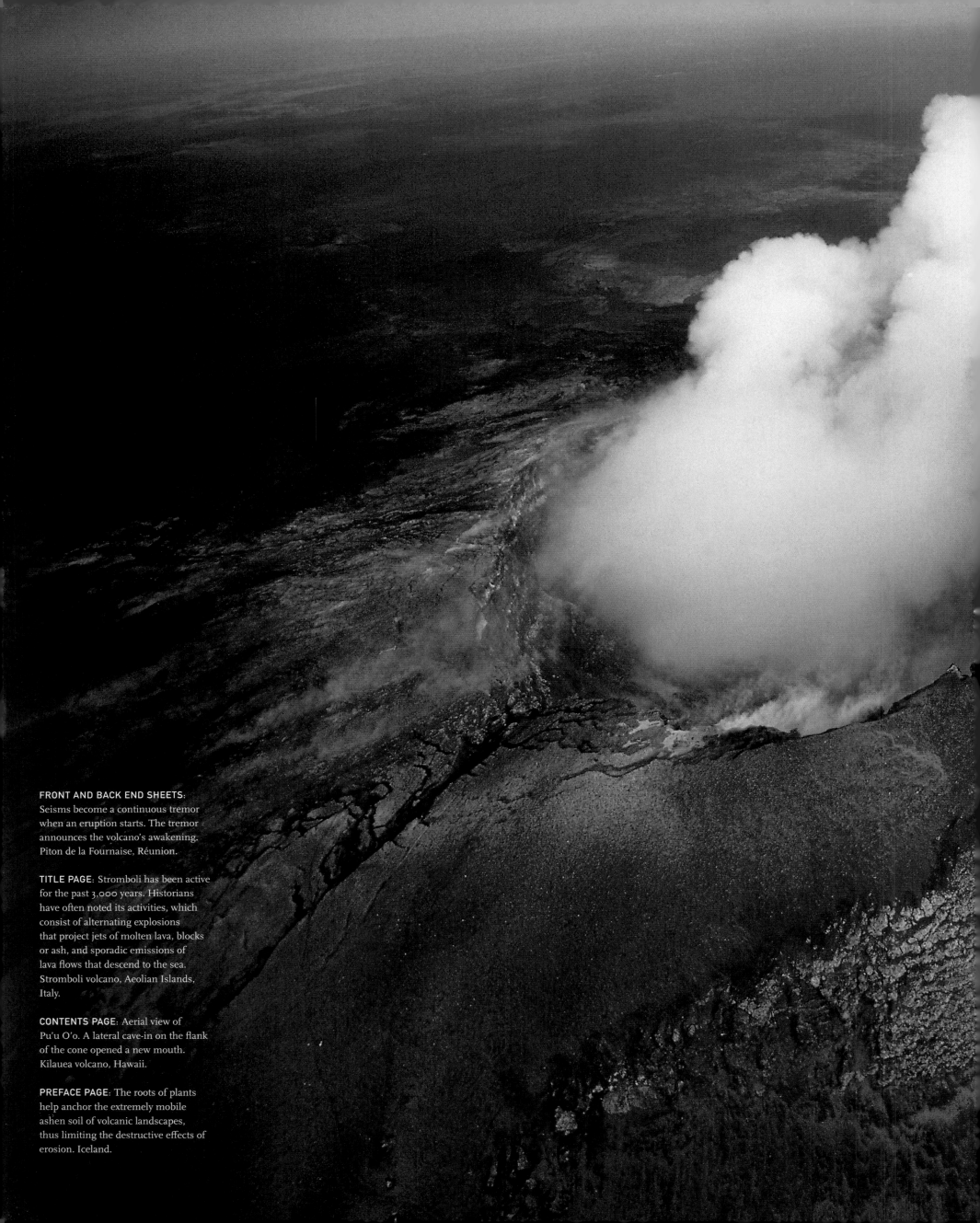

FRONT AND BACK END SHEETS:
Seisms become a continuous tremor
when an eruption starts. The tremor
announces the volcano's awakening.
Piton de la Fournaise, Réunion.

TITLE PAGE: Stromboli has been active
for the past 3,000 years. Historians
have often noted its activities, which
consist of alternating explosions
that project jets of molten lava, blocks
or ash, and sporadic emissions of
lava flows that descend to the sea.
Stromboli volcano, Aeolian Islands,
Italy.

CONTENTS PAGE: Aerial view of
Pu'u O'o. A lateral cave-in on the flank
of the cone opened a new mouth.
Kilauea volcano, Hawaii.

PREFACE PAGE: The roots of plants
help anchor the extremely mobile
ashen soil of volcanic landscapes,
thus limiting the destructive effects of
erosion. Iceland.

CONTENTS

PAGE 9. Oldoinyo Lengai is the only volcano on the planet that emits carbonatites, black lava that is fluid in molten state but becomes white as snow on cooling. This layer of white matter covers the bottom of the crater and is also crowned by several eruptive chimneys formed above the emitting fissures. Tanzania.

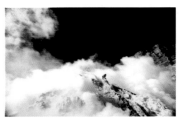

PAGES 10–11. A miner collects sulfur on the banks of the acid lake of Kawah Ijen volcano. Indonesia.

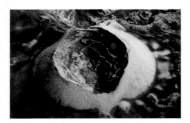

PAGES 12–13. The volcanic cone of Lakagigar, which is covered with moss and lichen, was formed in the eruption of Laki volcano in 1783. Iceland.

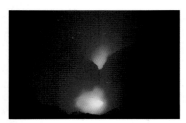

PAGES 14–15. A nocturnal view of the crater and the lava lake of Benbow crater on the island of Ambrym. Vanuatu.

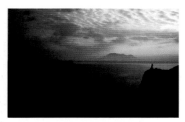

PAGES 16–17. At Cape Milazzo on the island of Panarea, residents of a Neolithic site exploited obsidian. Aeolian Islands, Italy.

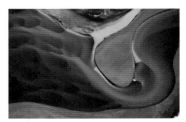

PAGES 18–19. An aerial view of a river whose waters derive their colors from the mineral salts originating in volcanoes. Iceland.

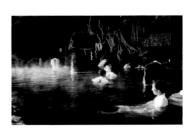

PAGES 20–21. Sakurajima volcano is the source of popular hot springs, which the Japanese visit for relaxation. Japan.

PAGES 22–23. A volcanologist begins a rappelled descent into the Benbow crater of Ambrym to investigate its lava lake. Vanuatu.

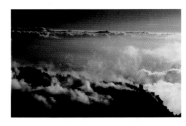

PAGES 24–25. Volcanologists are seen obtaining samples from the active dome of Merapi volcano. At regular intervals the dome topples and collapses, sometimes provoking *nuées ardentes* that destroy the fields and dwellings on the flanks of the volcano. Indonesia.

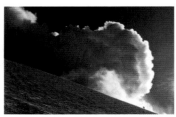

PAGES 26–27. A vapor cloud on the flanks of Etna, seen in winter. Sicily, Italy.

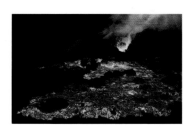

PAGES 28–29. At the beginning of an eruption, magma comes to the surface of the volcano. Magma builds one or more new cones and pours forth in lava flows. Piton de la Fournaise, Réunion.

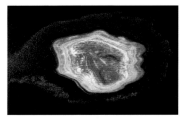

PAGES 30–31. Colonies of pink flamingoes settle on the shores of Lake Bogoria, inside a former volcanic crater. Kenya.

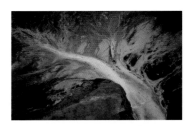

PAGES 32–33. A river, photographed from the air, shows the water colored by mineral salts from the volcanic structure. Iceland.

PAGES 34–35. A caustic soda spring on the shores of Lake Natron. Tanzania.

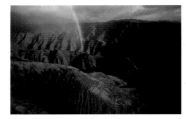

PAGES 36–37. Intense erosion of Waimea Canyon has revealed red cliffs beneath the ancient decomposed lava flows. Hawaii.

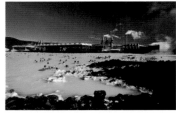

PAGES 38–39. Svartsengi is an example of Icelandic pragmatism. While this power station extracts subterranean water to heat the neighboring city, bathers enjoy all year long the delightful heat of the basin fed by harnessed spring water. Iceland

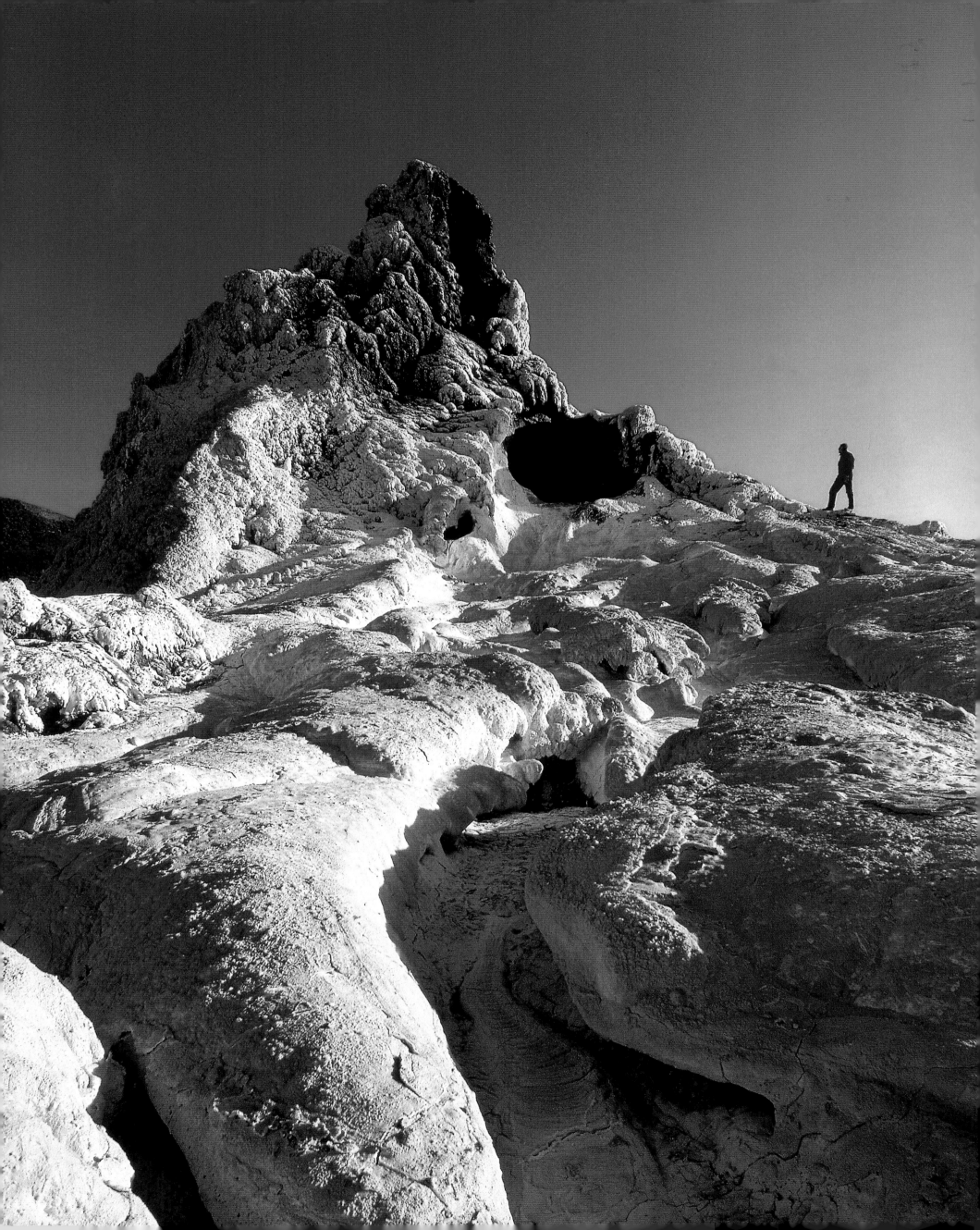

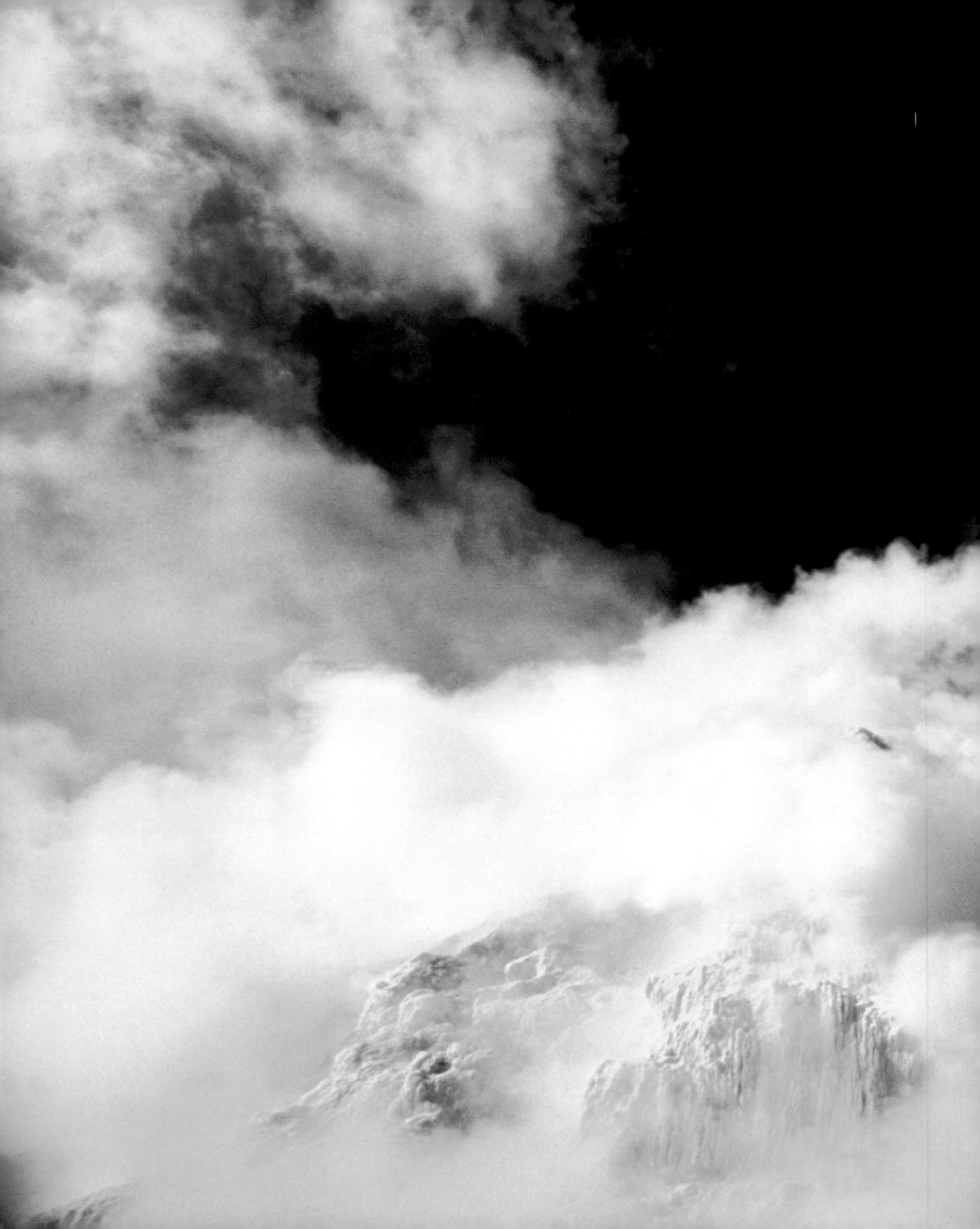

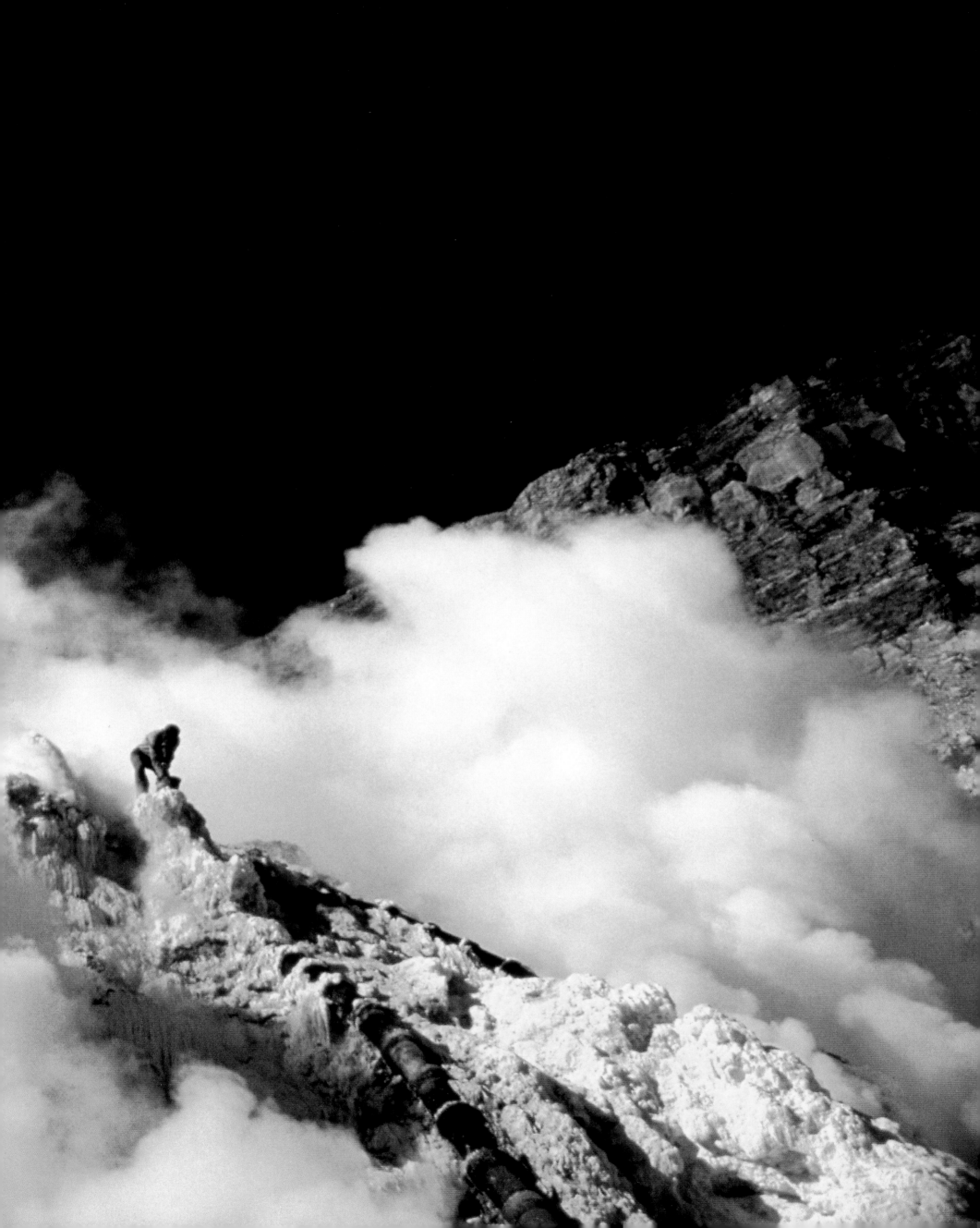

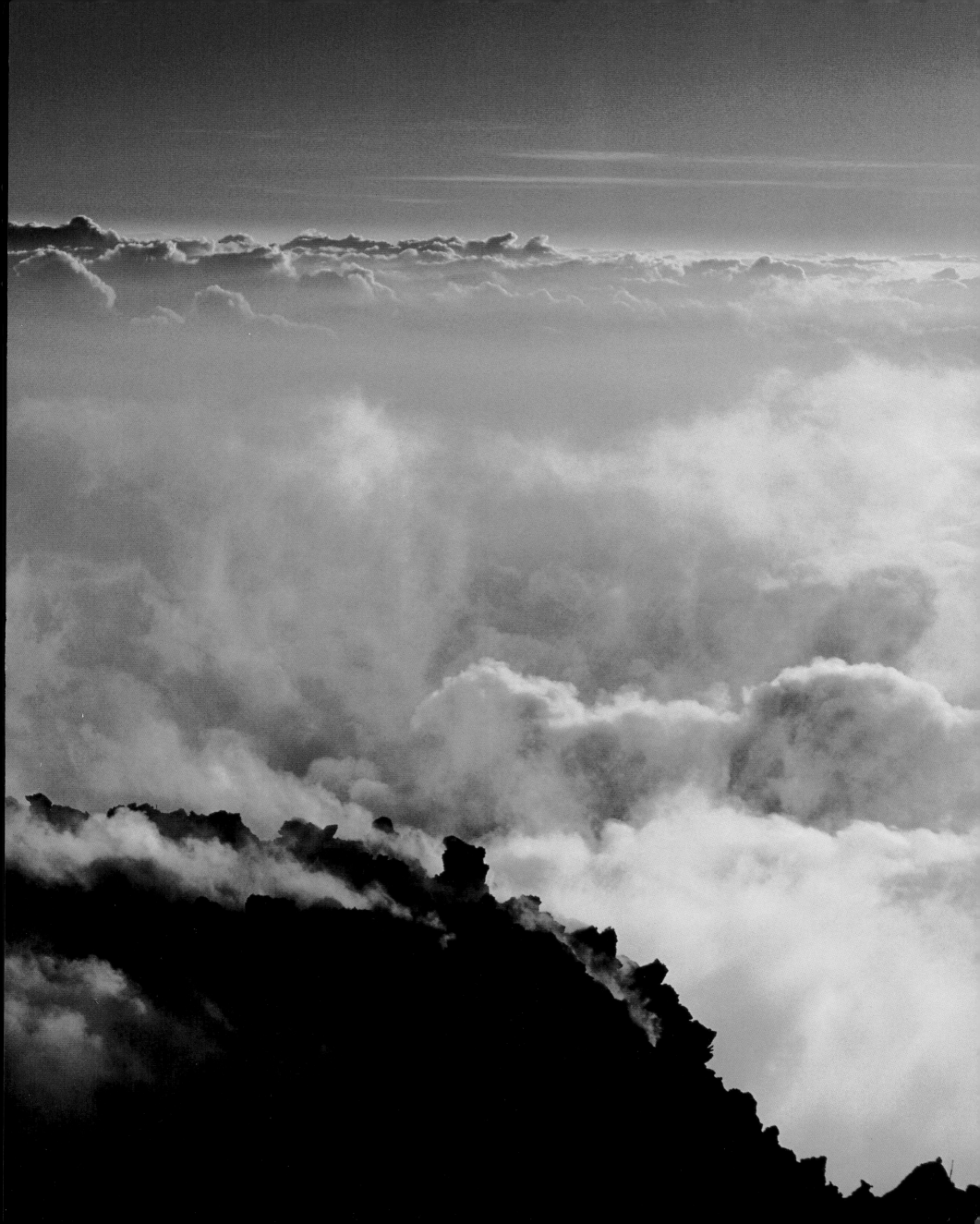

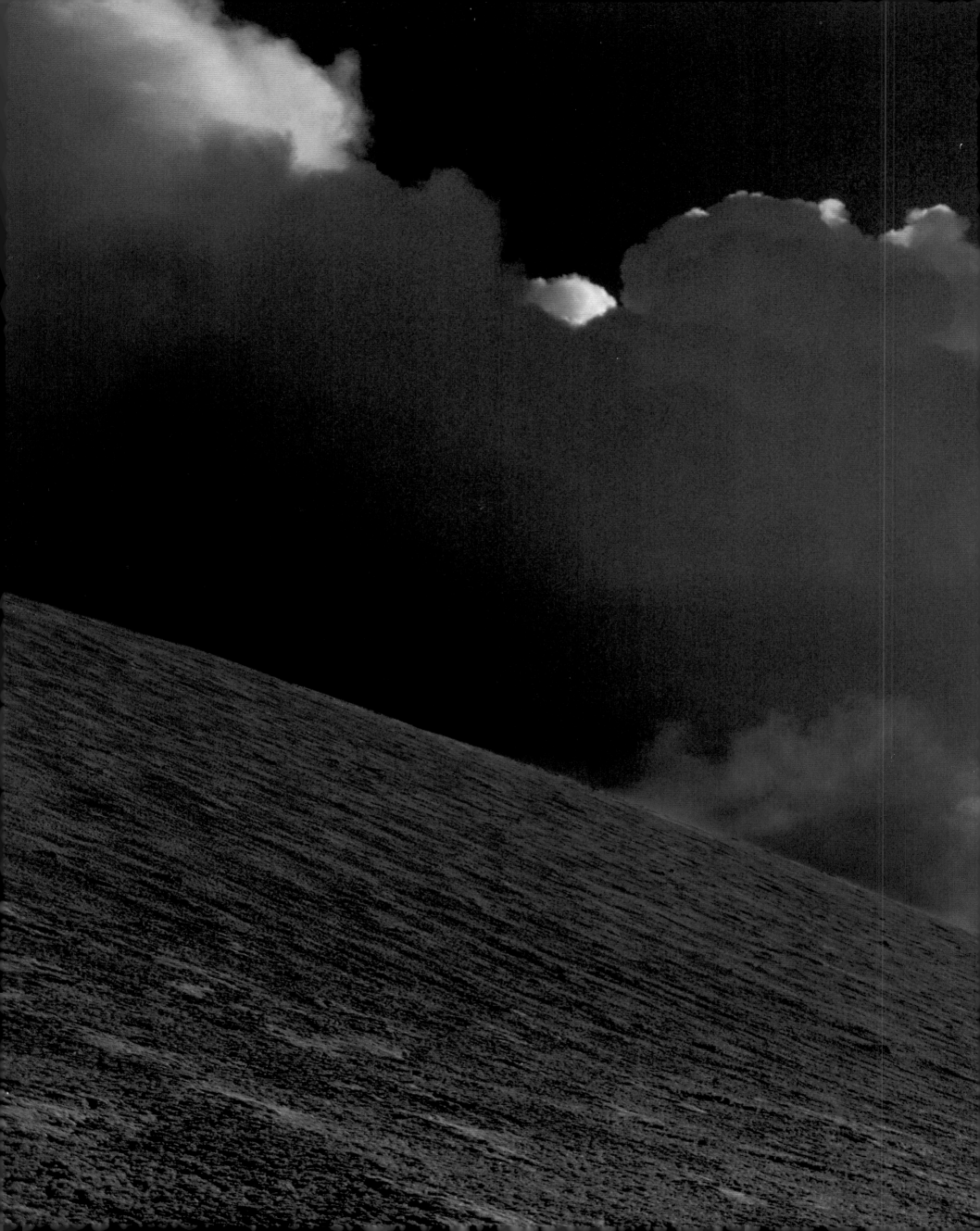

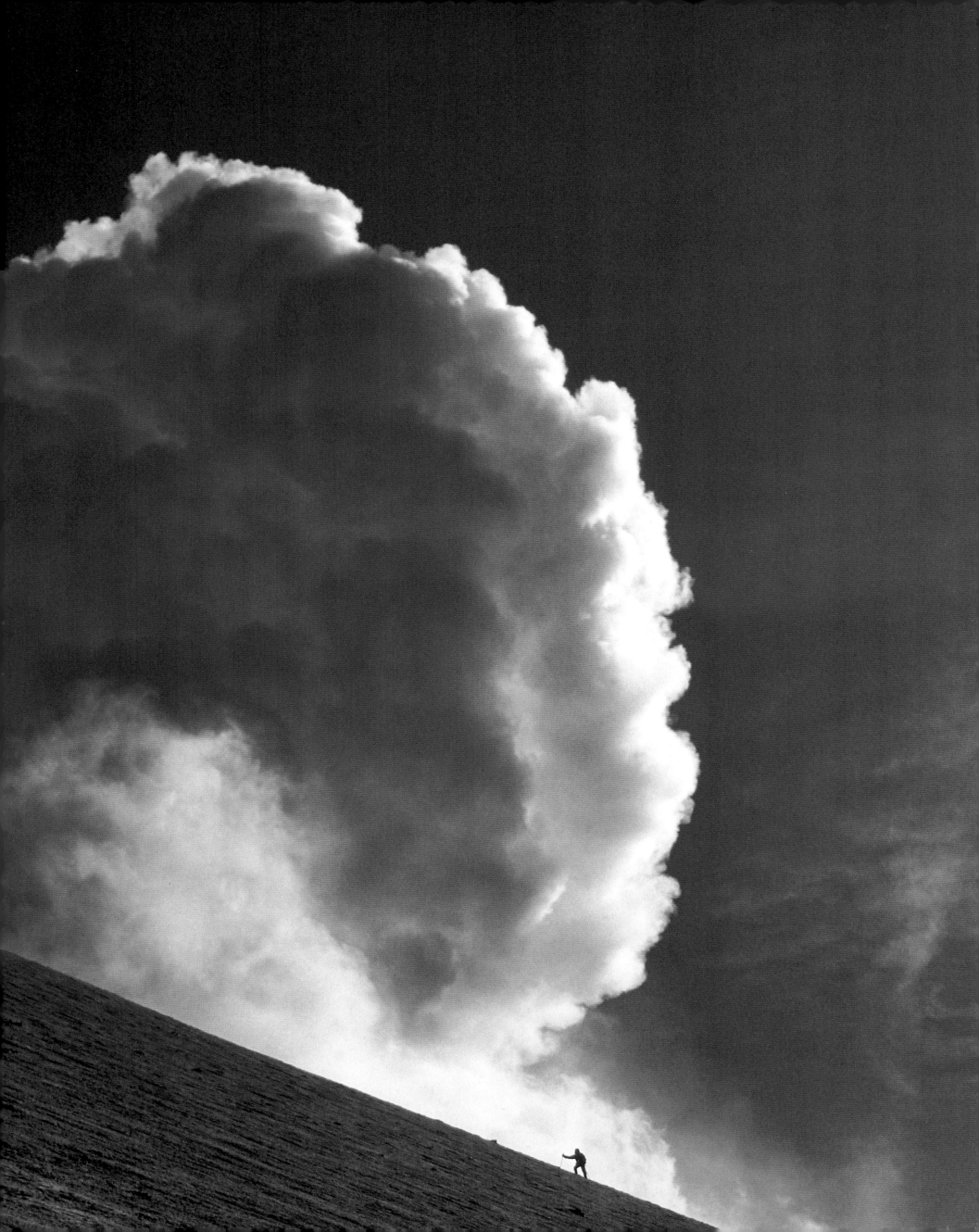

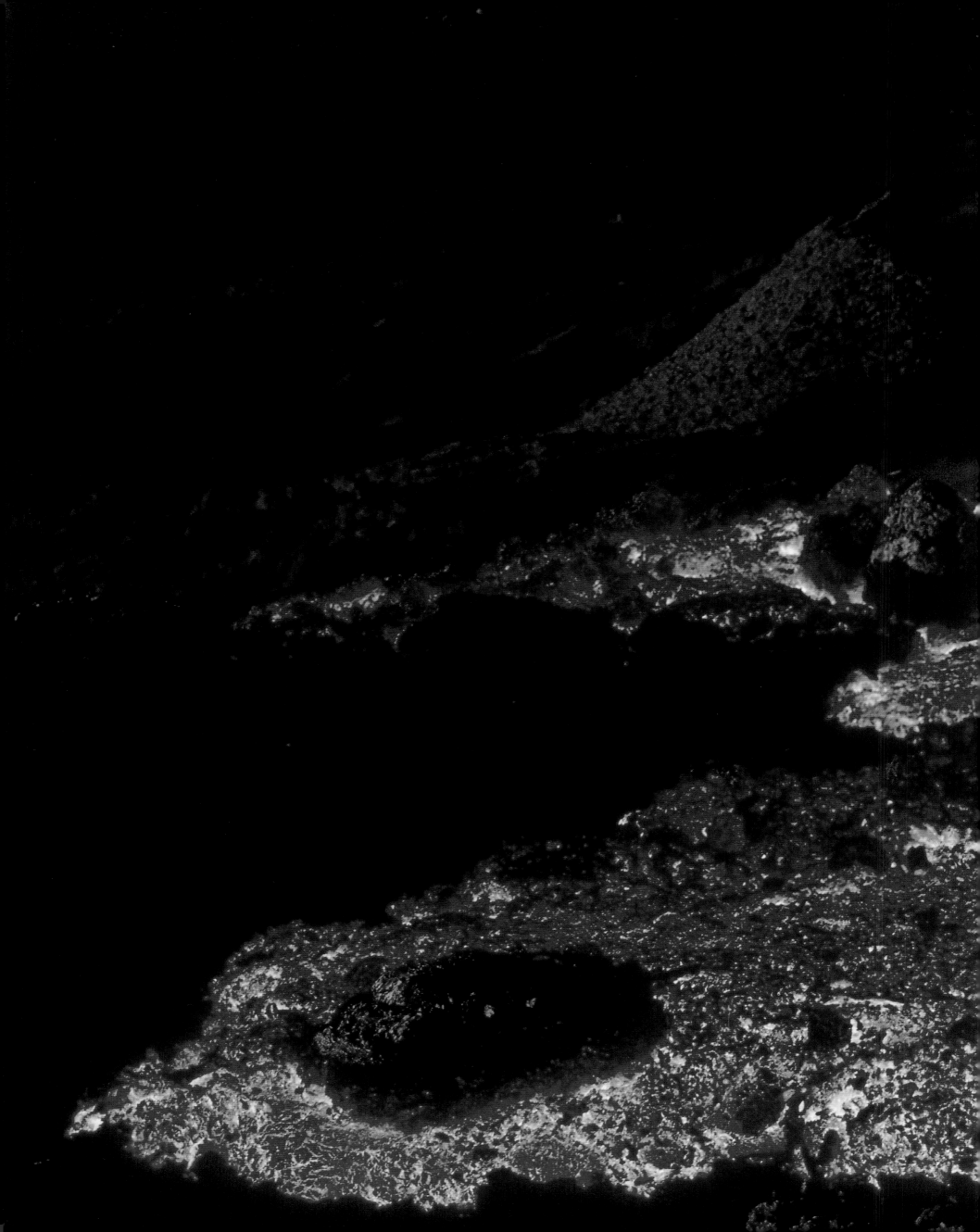

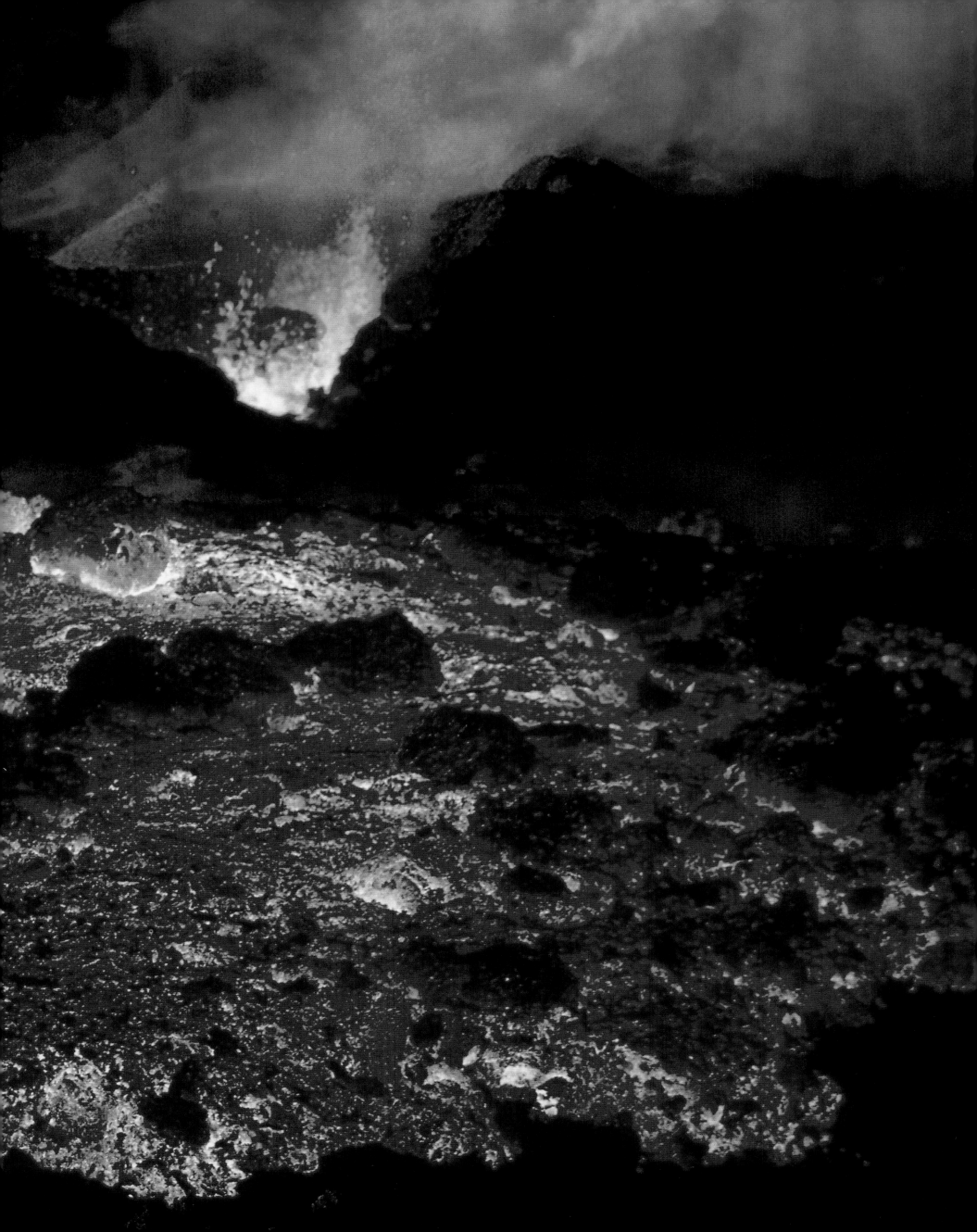

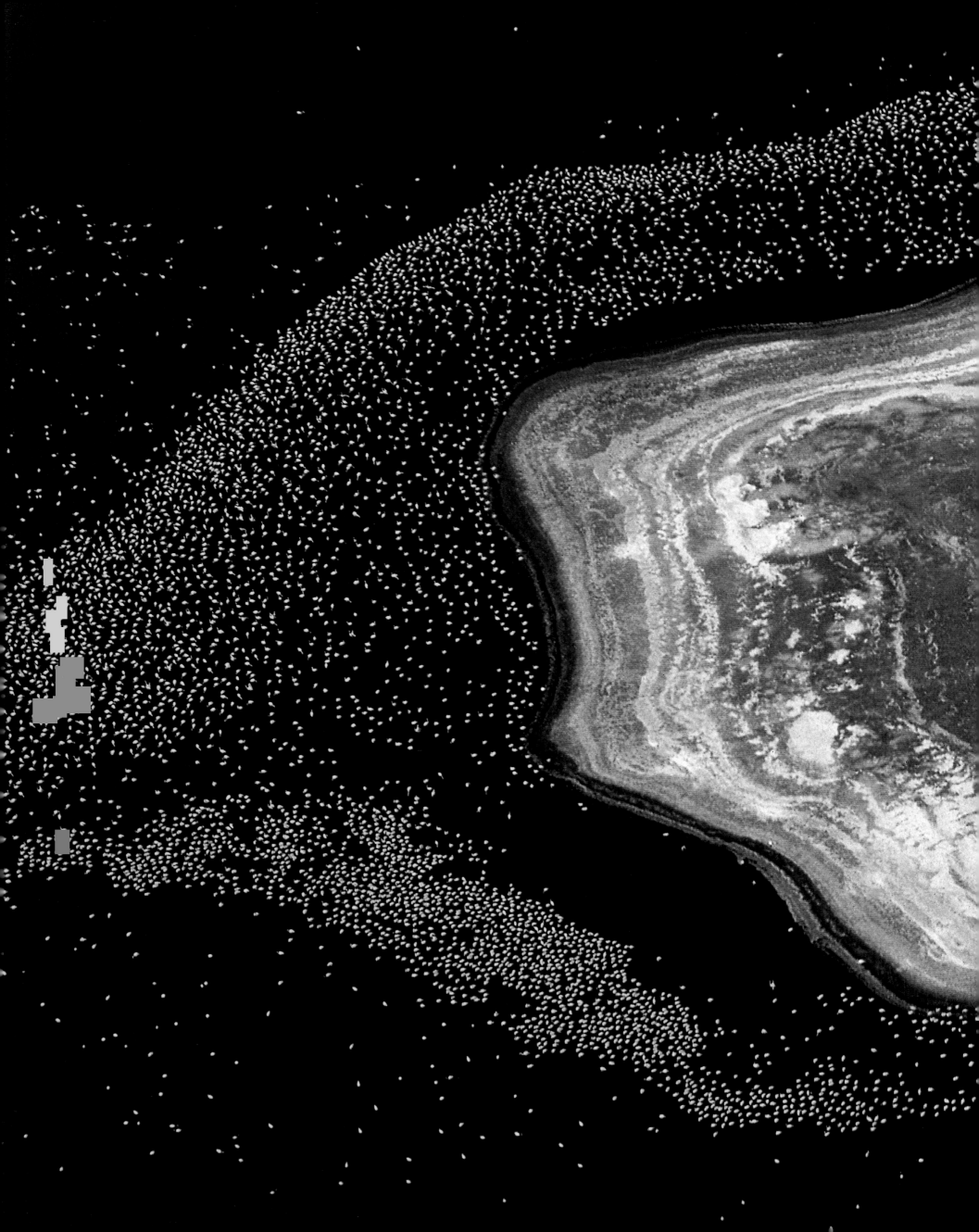

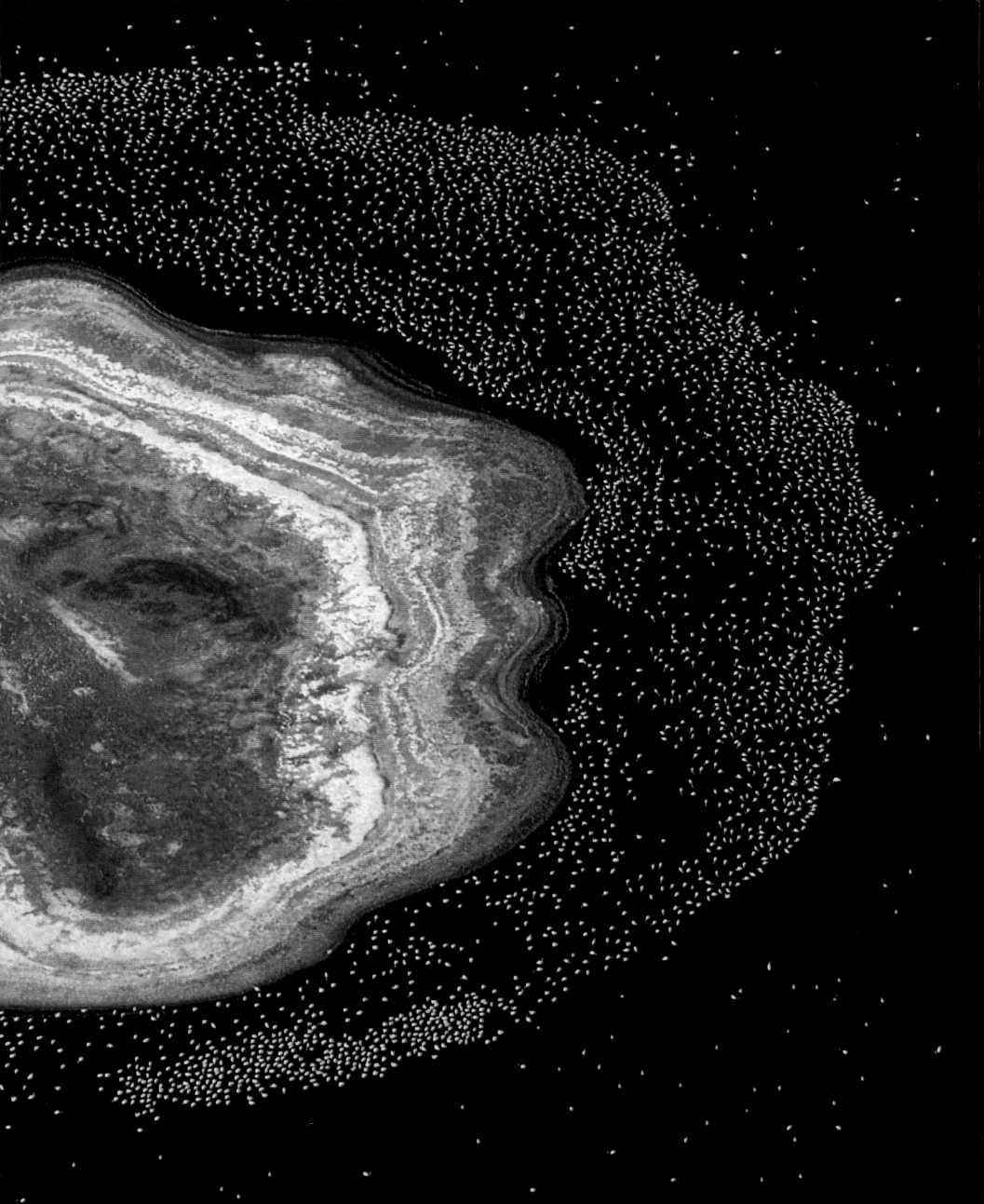

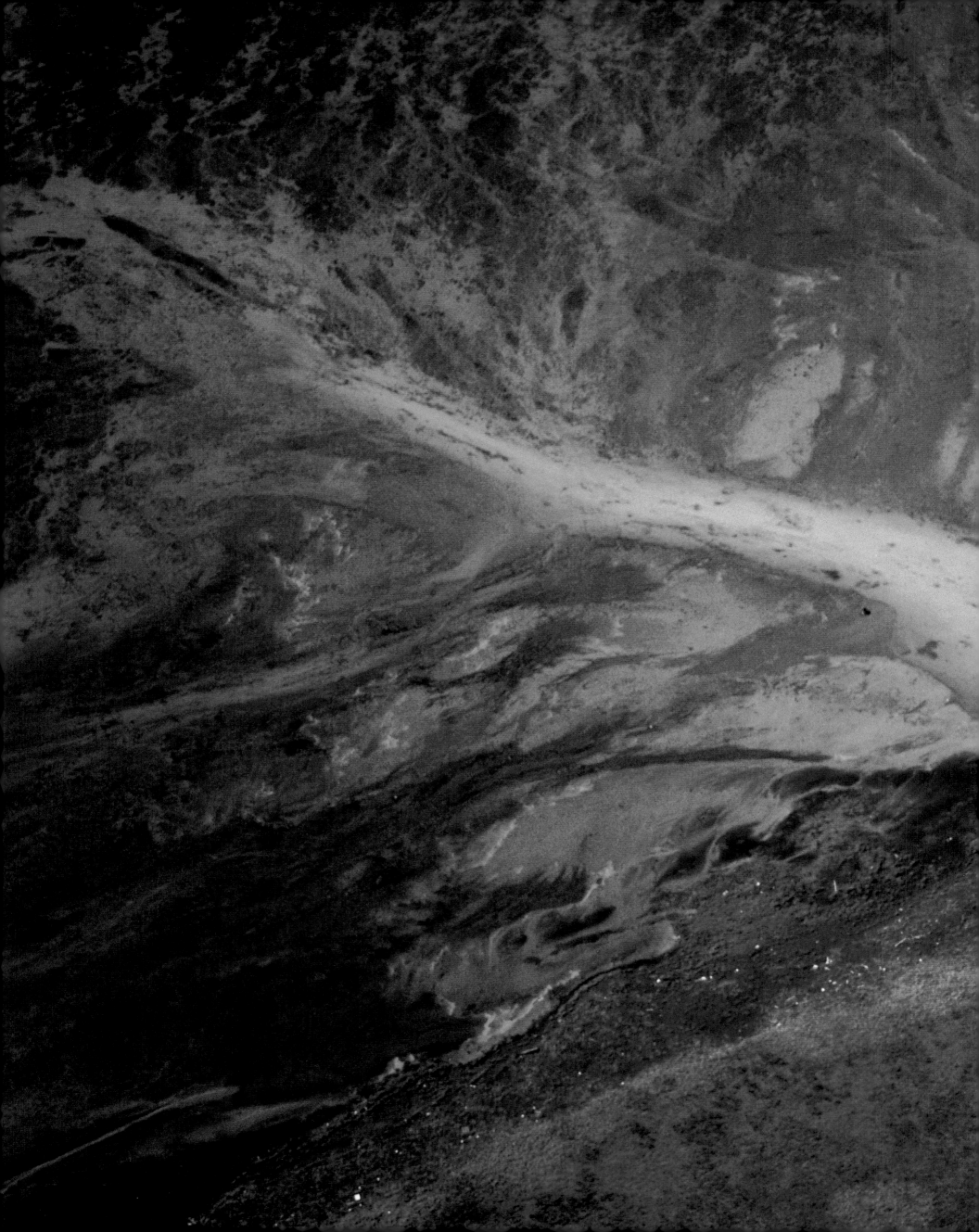

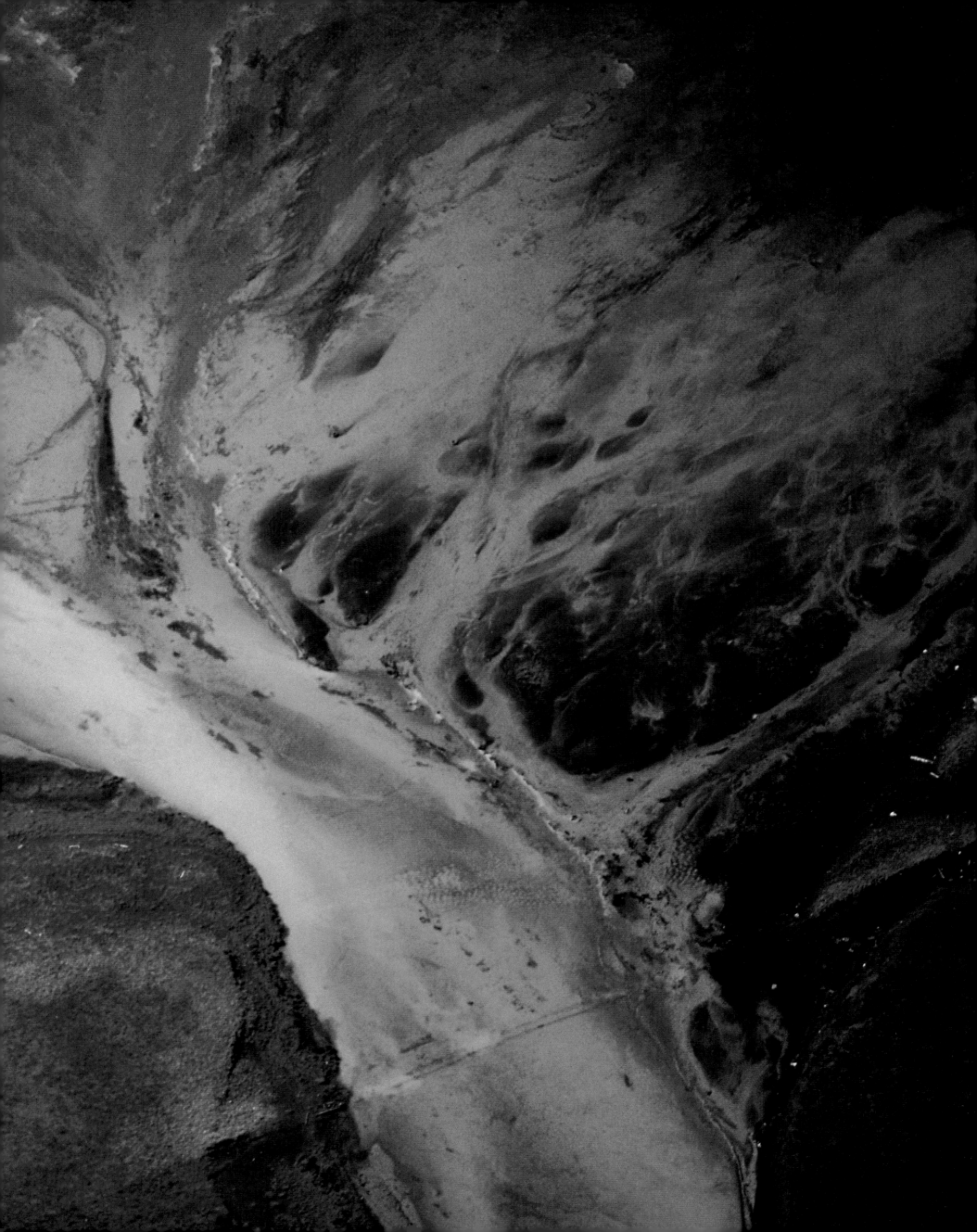

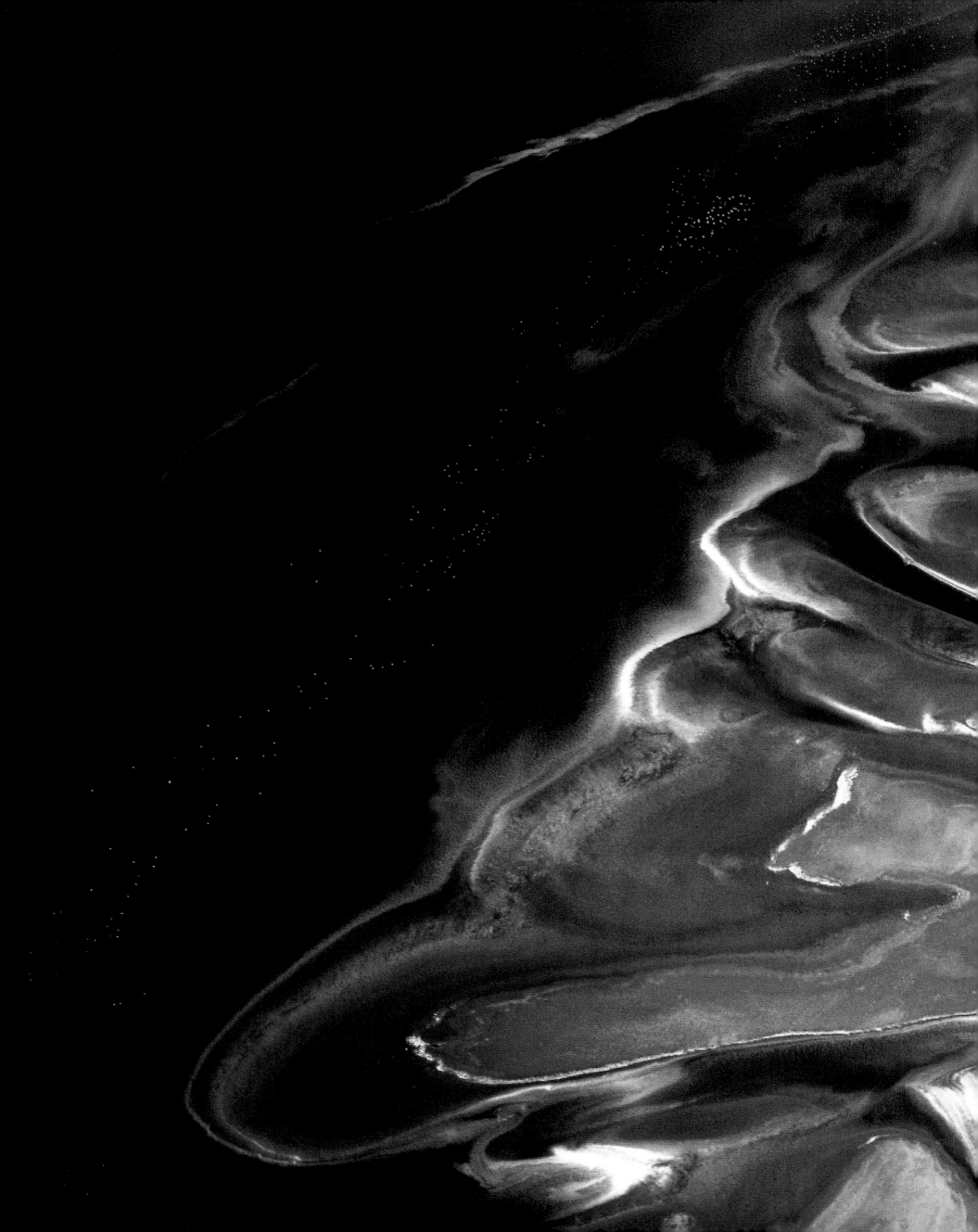

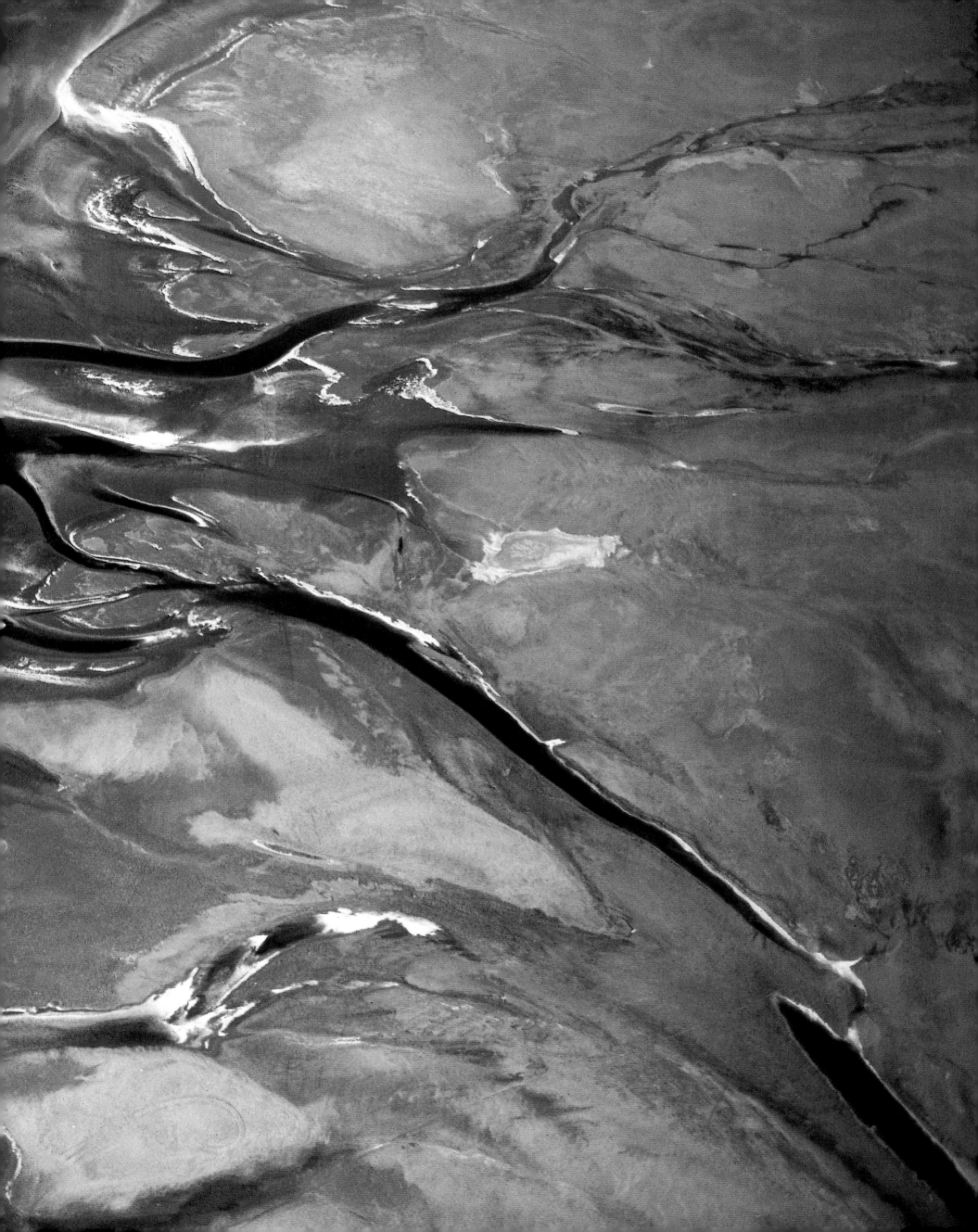

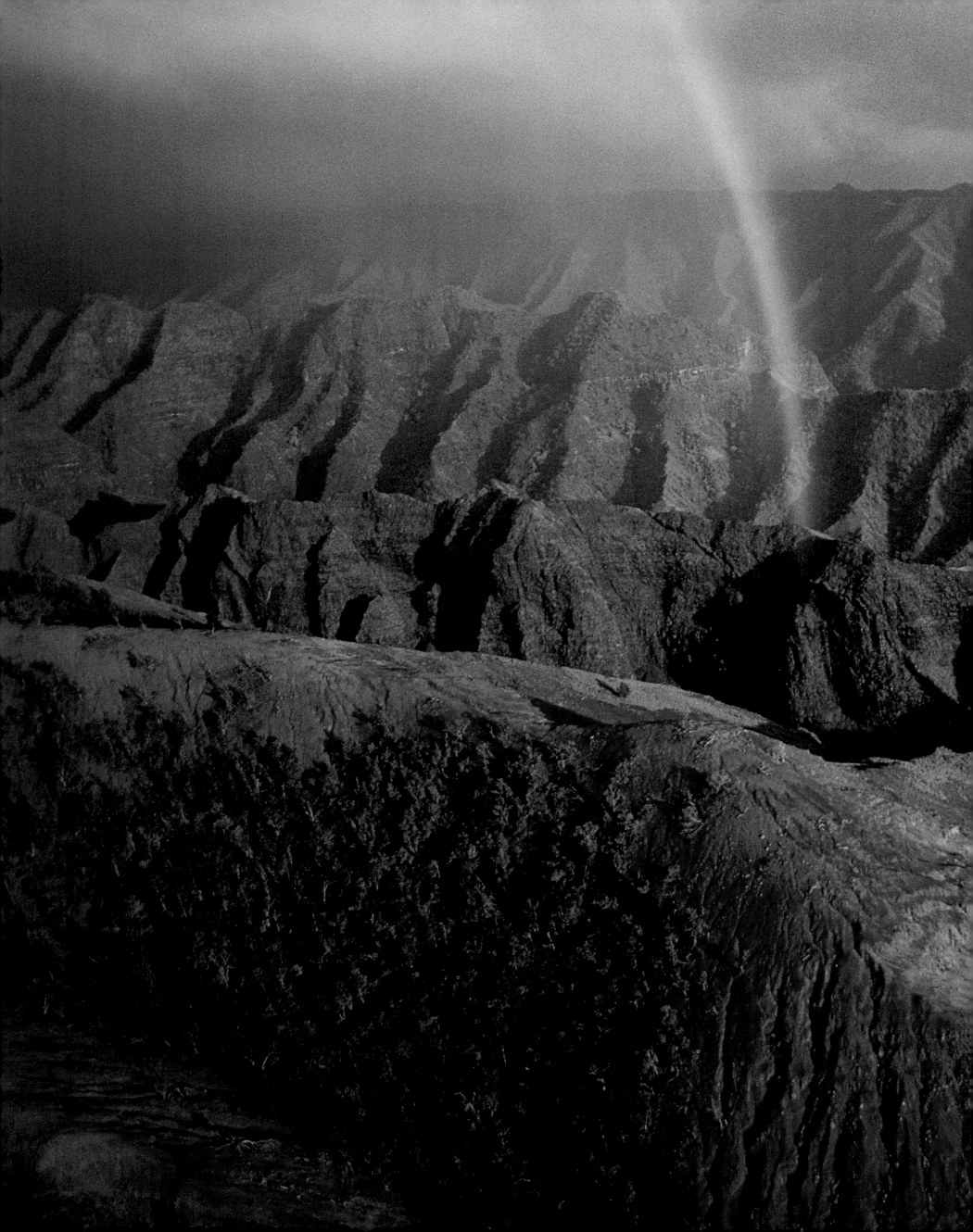

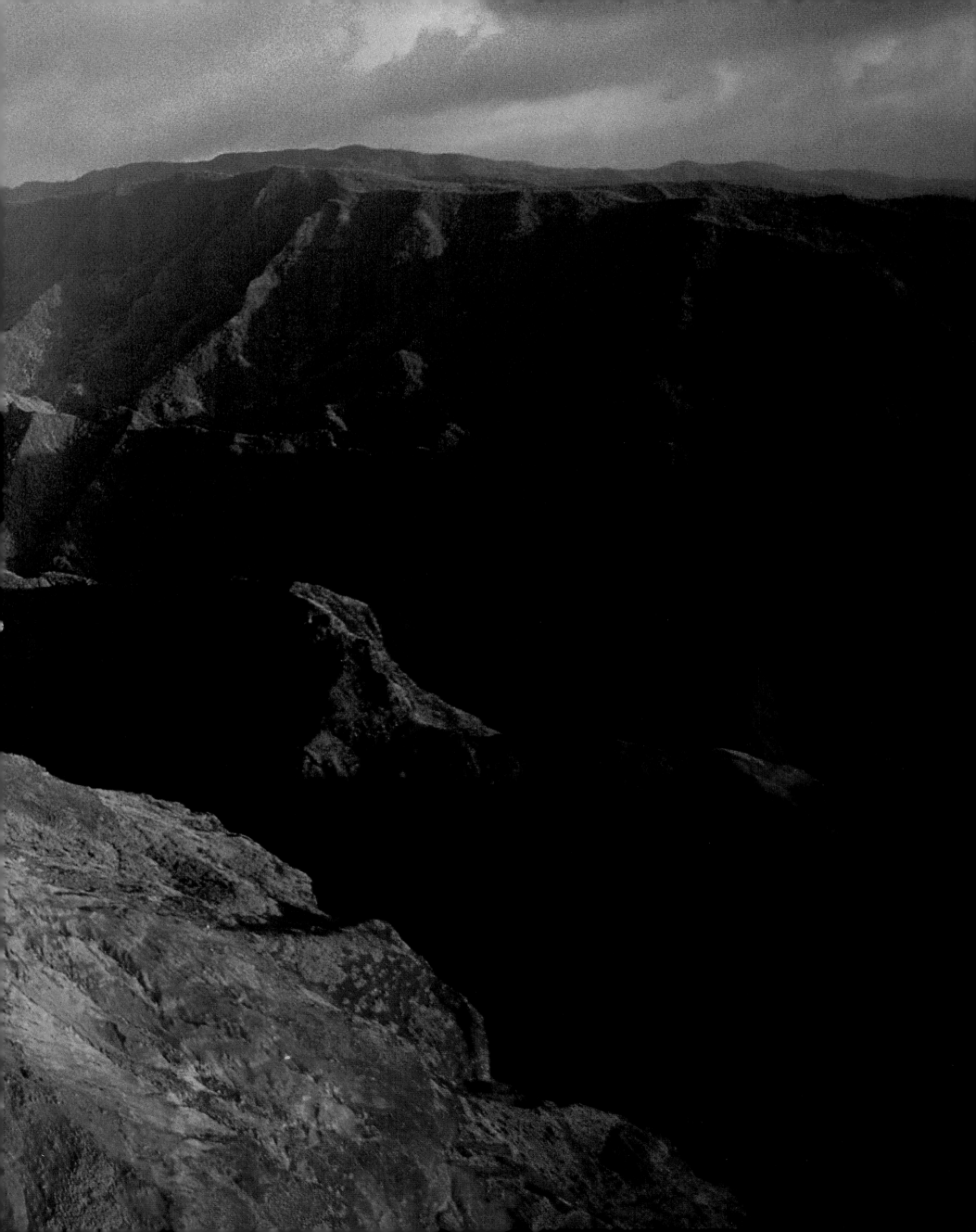

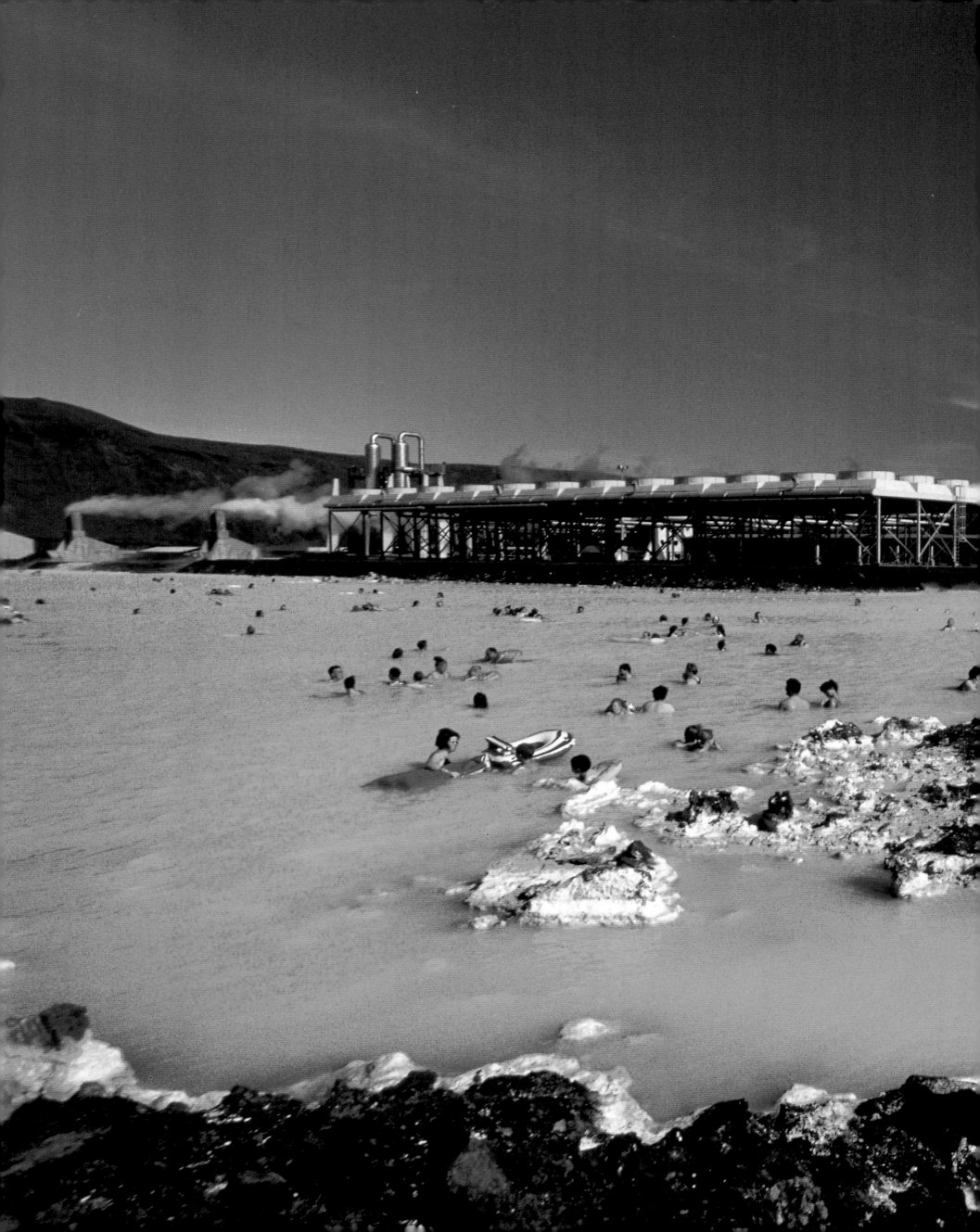

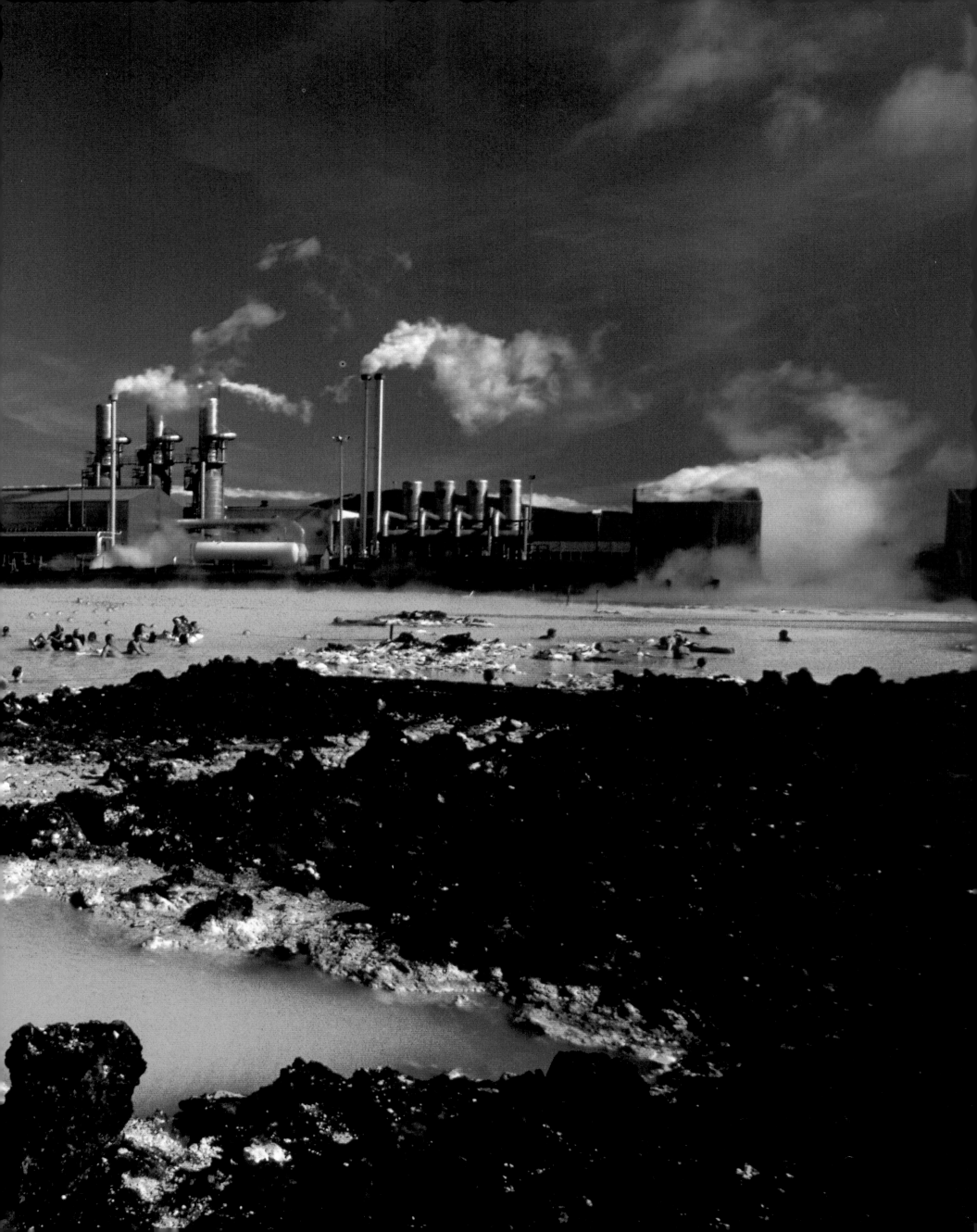

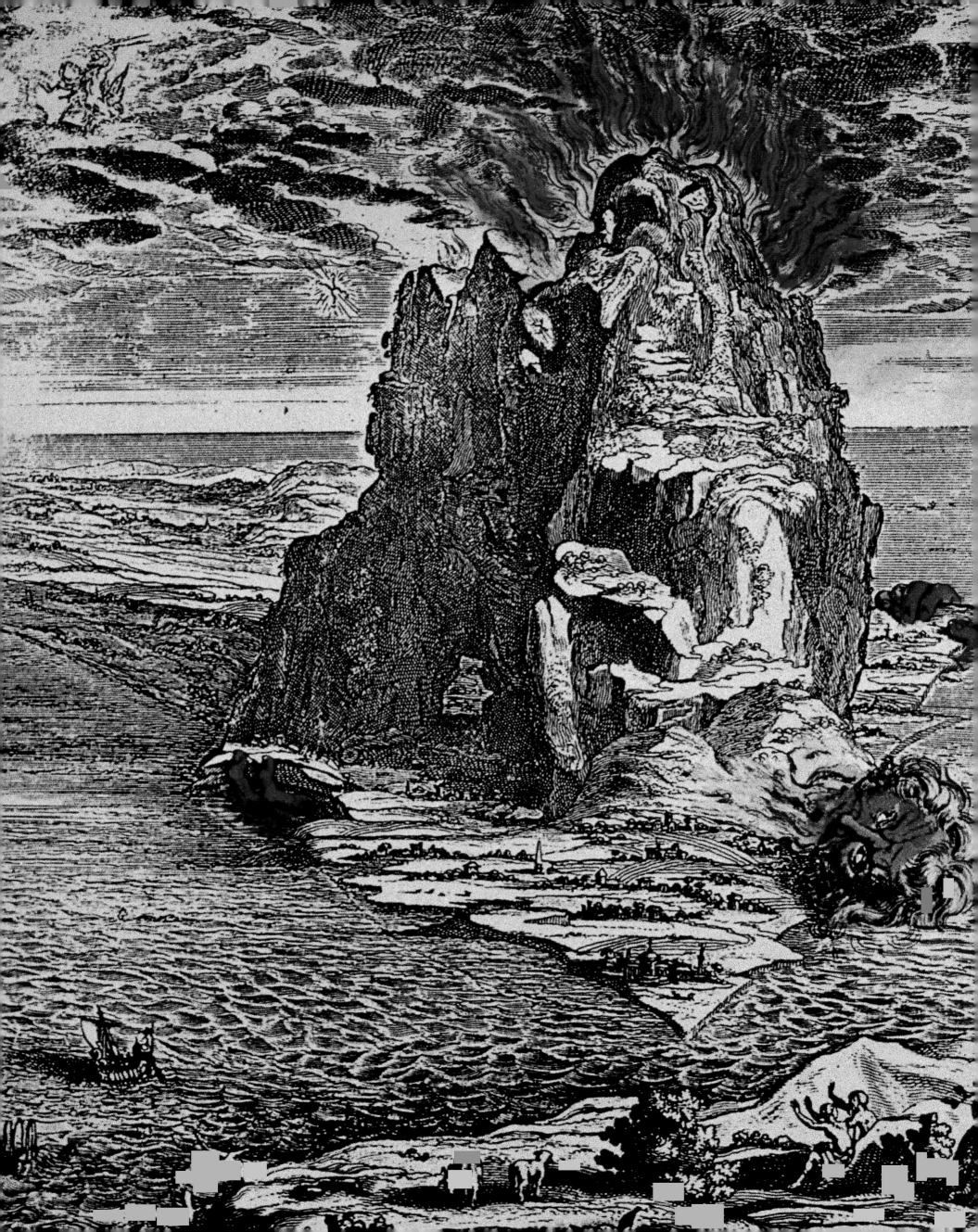

BELIEFS AND LEGENDS

OF GODS AND VOLCANOES

It is interesting how much reality lies behind the great myths and legends. In fact, actual experiences unite people in believing in the same "history." There is no doubt that such a basis in reality is indispensable for these beliefs to endure for centuries. Volcanic eruptions, especially sizeable ones, have had a deep impact on people's imagination. Every aspect is impressive—the trembling of the earth, the molten stone that is ejected, the explosion and projection of bombs and clouds of ash, the deafening noise. It is hardly surprising that natural phenomena of this kind should play a role in several of the great myths. The evocative power and great destructiveness of such eruptions immediately impress and affect people.

Fear often comes from the unknown. Legends give people a means of explaining the somewhat mysterious world around them. Humankind, therefore, always tried through legends to find an explanation for volcanic eruptions. At first, the cause was believed to be gods or demons who were shaking the volcanoes. Later, people took comfort in more rational explanations.

The Mediterranean basin and Near East formed the cradle of many volcanic eruptions, starting from early periods in the Caucasus, in Armenia, Syria, Iran, and Afghanistan, and, until very recently, in Greece and Italy. Witnesses to these eruptions were struck by the sight of "mountains of fire." The terror and the awe inspired by these explosions reappear in their pantheon and in their myths.

The active volcanoes of the Mediterranean region profoundly impacted the ancient world. How then did the Greeks explain these earthly rages? For them, volcanic eruptions were the work of the Titans. In the battles these giants waged with the gods of Mount Olympus, they shook the earth and sent flames shooting upward. The largest of the Titans, Typhon, son of Tartarus and Gaia (the Earth), was punished for his rebellion against the gods with imprisonment beneath Mount Etna. His efforts to break free set the mountain to trembling, and his fiery breath burst from the crater spitting molten rocks, while his violent shouts deafened everyone around.

Hephaestus, the guard for the imprisoned Titans, became the god of fire and of volcanoes. In his forge beneath the largest volcanoes of the Mediterranean, he worked metals with an artist's skill to make weapons for gods and heroes, including Zeus's lightning bolts and the arms and shield of Achilles. He was assisted in this work by the Cyclops, whose single eye is reminiscent of a volcanic crater. While their hammer blows reverberated in the depths of the mountain, the fire of their forges leapt from the crater.

The ancient Greek philosophers also offered various explanations for volcanic activity. These accounts, based on observation as well as deduction, were far more rational and quite visionary. All the Greeks lacked in order to raise their conclusions to the status of science were the means of verifying their hypotheses. Despite this "scientific" advance, numerous legends survive.

In the seventeenth century B.C., the power of Crete was at its zenith. For more than four centuries the Minoans ruled the entire Mediterranean. A maritime people, they controlled navigation, set up flourishing ports, and established prosperous trading centers on every coast. Their capital, Knossos, was a highly developed city, rich in palaces of great refinement.

But around 1650 B.C. a major eruption struck the island of Santorini (or Thera). It began in a series of phreatic explosions that deposited a layer of stones 14 feet high. The volcano calmed, but explosions resumed, leaving a deposit of ash three feet deep. The worst was still to come. A sudden and violent explosion destroyed the entire volcano; the plume of smoke reached a height of more than 20 miles, and the isle of Santorini was covered in a layer of stone nearly 2,000 feet thick.

What was left of the volcano collapsed into the sea to form a caldera, or crater, several miles in diameter. The resulting tidal wave reached heights of 650 feet and wiped out all the Cretan ports. This was the end of Minoan civilization. The sudden destruction, described by Plato in his *Critias*, was the basis of the

myth of Atlantis. After Plato, hundreds of other authors wove various hypotheses, some quite fanciful and some tenacious.

The Greek legends were quickly adopted by the Romans, who inhabited the same region with the same volcanoes. At first they merely changed the names of characters: Typhon became Encelade, Hephaestus became Vulcan—Roman god of fire and the source of the word "volcano."

A bit later there appeared another major work of mythology, the roots of which are found in the eastern Mediterranean: the Old Testament. A careful reading shows several references to volcanoes. Some believe that the plagues of Egypt are a reflection of the falling ash from Santorini, while the miraculous crossing of the Red Sea is inspired by the receding waters following the tidal wave from the same eruption. Above all, numerous appearances of God bear a close resemblance to the spectacle of a volcanic eruption. Most of these texts are concerned with Exodus, the delivery of the Jews out of Egypt.

"And the glory of the Lord abode upon Mount Sinai, and the cloud covered it six days. And the seventh day He called to Moses

ABOVE: An aerial view of the summit craters of Etna, engulfed in the fog and vapor clouds.

LEFT: Anonymous seventeenth-century engraving illustrating the legend of the Titan Typhon's revolt against the gods. Conquered, he was imprisoned beneath Etna, where he continues to struggle, making the earth tremble and breathing fire.

out of the midst of the cloud. And the sight of the glory of the Lord was like devouring fire on the top of the mountain in the eyes of the sons of Israel." (Exodus 24:16–17, King James edition)

And it happened on the third day, in the morning, that there were thunders and lightnings, and a thick cloud up on the mountain. And the voice of the trumpet was exceedingly loud, so that all the people in the camp trembled. And Moses brought the people out of the camp to meet with God. And they stood at the lower part of the mountain. And Mount Sinai was smoking, all of it, because the Lord came down upon it in fire. And the smoke of it went up like the smoke of a furnace, and the whole mountain quaked greatly. And when the voice of the trumpet sounded long, and became very strong, Moses spoke, and God answered him by voice. And the Lord came down upon Mount Sinai, on the top of the mountain. And the Lord called Moses to the top of the mountain, and Moses went up. And the Lord said to Moses, "Go down. Command the people, lest they break through the Lord to gaze, and many of them perish." (Exodus 19:16–21)

In addition to these few episodes, there are many descriptions of this often menacing God whose appearance can be identified easily with volcanoes. He is quick to anger, loud, thundering, with a rumbling voice. He is always introduced by a cloud, and sometimes is himself a cloud. He does not reside permanently on Mount Sinai, but goes from one mountain to another. His footstep shakes the earth, and each of his appearances occurs among flames and lightning, in rumbling thunder and terrifying quakes. We also read that smoke emerges from his nostrils and fire from his mouth. He can punish the infidel by raining down sulfur or fire on them. Could anything be more like the mouth of an erupting volcano?

Hell is a concept that developed later. Around the fourth century A.D., it is referred to as a ditch filled with fire. Later it is

associated with volcanoes and we encounter the legend of San Calogero, a hermit living on the isle of Lipari, in the Mediterranean, from A.D. 542 to 562, who drove the devil off the island while extinguishing volcanoes. And, in fact, the last eruption there occurred in the sixth century.

Thereafter, volcanoes became instruments that were used with great skill. In the twelfth century, to deal with various religious lapses, the Church tried to make an impression on heretics by threatening an afterlife in the torment of hellfire. There was still the problem of proving its existence, so the clergy turned to volcanoes. In 1104 a formidable eruption shook Hekla volcano in Iceland. News of it reached Europe by Irish monks and then by Cistercians. Herbert, abbot of Clervaux, used this information to identify two entranceways to hell: one into the volcano of Hekla, the eternal prison of Judas, and the other at the peak of Etna. There, hell was supposedly visible, and numerous witnesses confirmed what became of the souls of the damned.

Many other civilizations, at the four corners of the earth, also deified volcanoes. In Indonesia volcanoes were the dwelling places of the gods. In the province of Kizu, the souls of ancestors live on—and sometimes reveal themselves violently—through the intermediary of active volcanoes. In Central and South America the Mayas, Aztecs, and Incas felt obligated to make offerings, even human sacrifices, to appease their often turbulent volcanoes. The Spanish Conquest, with its goal of converting the conquered peoples to Catholicism, suppressed these beliefs, replacing them with others. Even today an annual mass is celebrated on the summit of El Misti, a volcano in Peru.

As for the Vikings of Norway, they saw hell as a dark, frozen wasteland. It includes, however, a burning region dominated by the giant Surtur, god of fire. In 1963, when a new volcanic island appeared south of Iceland, it was named Surtsey, island of Surtur. In Japan, a country marked by volcanoes, craters are occupied by Oui, the red, grimacing monster that thrashes about and throws

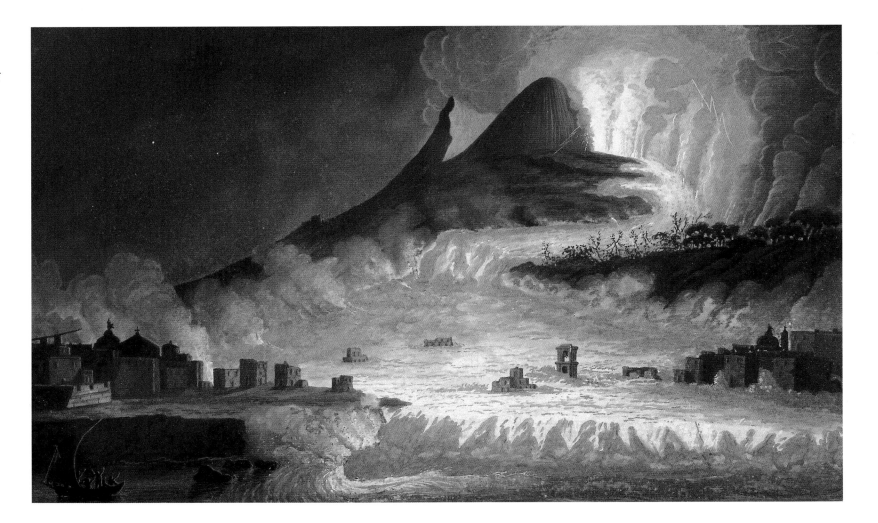

This painting of an eruption of Vesuvius shows lava flows that destroyed the village of Torre del Greco, in the Bay of Naples, Italy.

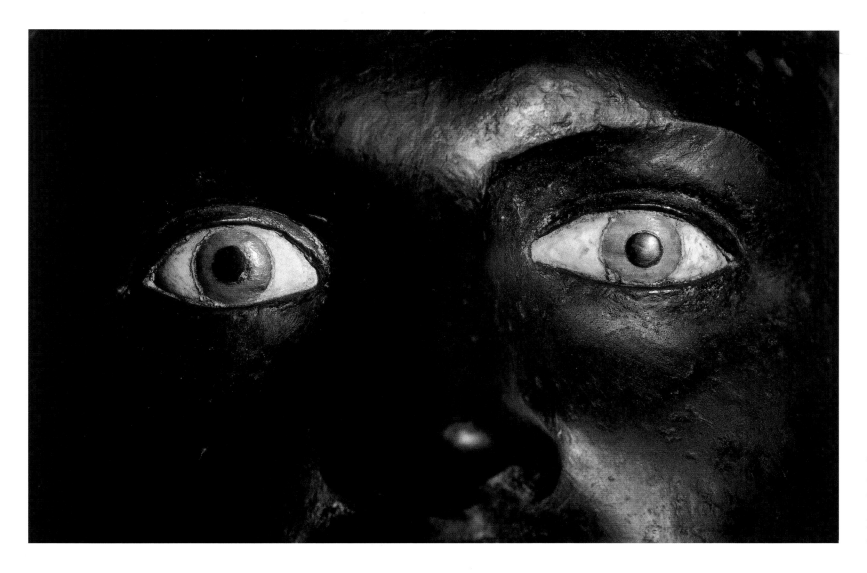

The eyes of this bronze statue of an athlete, excavated at Pompeii, seem to portray the horror of the city's destruction in A.D. 79.

stones during eruptions. Likenesses of the god are seen at the foot of all the volcanoes in Japan, even in shops that sell souvenirs. In Hawaii, Pelé, the Polynesian goddess of fire, is still worshipped. According to legend, following a violent fight with her sister, Pelé had to swim toward the southeast. Each time she emerged from the water, an island took shape. They became the Hawaiian Islands. Pelé eventually settled in the Halemaumau crater of the volcano of Kilauea, which remains her current dwelling place. When Pelé grew angry, she would strike the ground with her heel. The earth broke and lava emerged. The beliefs in Pelé remain alive: when an eruption starts, many people say that Pelé is waking and witnesses claim to have seen her dance on fountains of lava. Offerings are still made to Pelé on the rim of the volcano, and many public ceremonies mark her cult.

It may seem strange that a student of volcanoes would be so interested in the beliefs that exist in connection with these phenomena. The reason may be that volcanology, or the study of volcanoes, has changed markedly in recent years, and has undergone an awakening. Nearly as much attention is now paid to the populations victimized by these catastrophes as to what happens inside craters. The new, important viewpoint is an integral part of the work of volcanologists, or at least of their basic education. Legends often incorporate eyewitness accounts, sometimes transformed over time, of past phenomena. It is striking how a geological phenomenon marked the imaginative life of a whole population, how it was handed down within a civilization. Equally important is the need to know these traditions and these rites when it comes to the

practical work of setting up risk-reduction programs. In fact, in order to appeal effectively to people exposed to volcanic danger, one needs first of all to know what these people think of their volcanoes, how they view them. The main actors in these beliefs, living gods, priests, or religious communities, could also serve as media for the messages one hopes to convey.

The most acute risk-reduction problems arise in developing countries, which is also where the most active or most dangerous volcanoes are found, as well as where beliefs are most firmly rooted. In these countries, volcanology in the future will certainly consist of an intelligent alliance between highly developed science and respect for traditions.

ITALY: AT THE FOOT OF VESUVIUS

Unlike other active volcanoes of the Mediterranean world, Vesuvius does not seem to have inspired ancient myths and legends. Admittedly, the only eruptions were in 800 and 600 B.C. Not until much later, however, did Greek and Roman naturalists identify the mountain as a volcano. In the first century A.D., the Greek historian Diodorus climbed Vesuvius. Born at the foot of Mount Etna, he knew volcanoes and volcanic rocks. "The highest mountain, called Vesuvius," he wrote, "gives every indication of having emitted fire in ancient times." Soon after, the geographer Strabo climbed the same mountain and, while stressing the great fertility of the slopes of Vesuvius, added: "Much of the summit is flat and sterile, as if

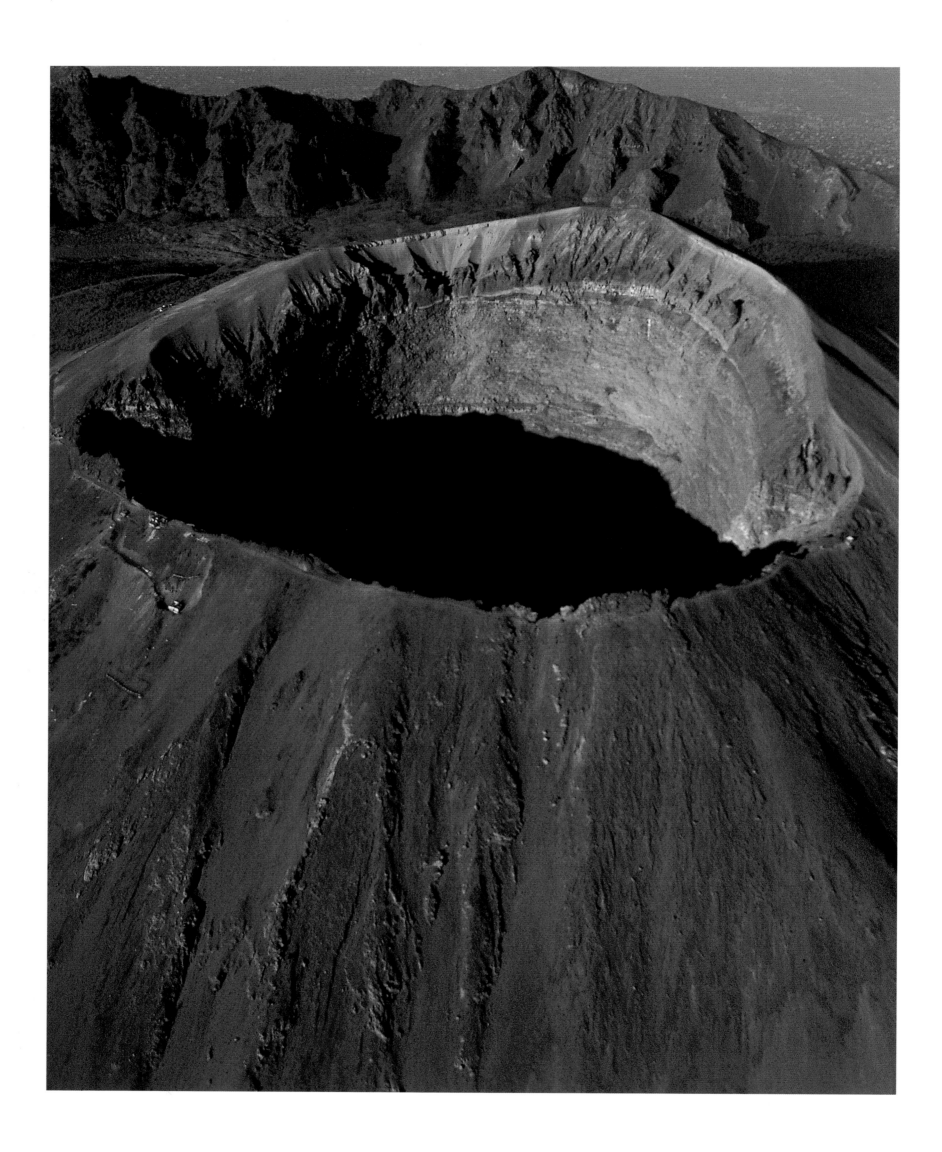

covered with ash. . . . The rocks are like soot, with pores and holes, and seem to have been consumed by fire. It is easy to believe, then, that this place was once on fire and that there were igneous craters there, which were extinguished only through the absence of fuel."

At the time, Vesuvius was covered with vegetation and wine grapes were grown up to its summit, the same summit that served as a shelter for Spartacus and rebellious slaves in the first century B.C. For the Romans of the first century A.D. who lived nearby, Vesuvius had lost completely its identity as a volcano, to become Monte Somma—the highest mountain. Its defining characteristic was the wine it produced. The only surviving artistic depiction shows it at this time as a backdrop, behind the god Bacchus covered with grapes and wine leaves. Pliny the Elder, author of *Natural History,* in attempting a survey of all volcanoes on earth, or at least of the world as known at that time, never mentions Vesuvius. Yet he lived quite close by, at Misenum. And that is where he was surprised, like so many others, by the eruption of A.D. 79, which destroyed Pompeii and Herculaneum and left its imprint on human consciousness for centuries to come. This eruption was described in detail by Pliny the Younger, who, in two letters to the historian Tacitus, told of the experiences and death of his uncle Pliny the Elder, at the foot of the volcano. Some of his sentences have a rare evocative power:

And now cinders, which grew thicker and hotter the nearer he [Pliny the Elder] approached, fell into the ships, then pumice-stones too, with stones blackened, scorched, and cracked by fire, then the sea ebbed suddenly from under them, while the shore was blocked up by landslips from the mountains. . . . In the meanwhile Mount Vesuvius was blazing in several places with spreading and towering flames, whose refulgent brightness the darkness of the night set in high relief. . . . the house now tottered under repeated and violent concussions, and seemed to rock to and fro as if torn from its foundations. In the open air . . . they dreaded the falling pumice-stones, light and porous though they were. . . . They tied pillows upon their heads with napkins; and this was their whole defence against the showers that fell around them. . . . The buildings around us already tottered, and though we stood upon open ground, yet as the place was narrow and confined, there was certain and formidable danger from their collapsing. . . . On the other side, a black and dreadful cloud bursting out in gusts of igneous serpentine vapour now and again yawned open to reveal long fantastic flames, resembling flashes of lightning but much larger. Ashes now fall upon us, though as yet in no great quantity. I looked behind me; gross darkness pressed upon our rear, and came rolling over the land after us like a torrent. You could hear the shrieks of women, the crying of children, and the shouts of men; some were seeking their children, others their parents, others their wives or husbands, and only distinguishing them by their voices; one lamenting his own fate, another that of his family; some praying to die, from the very fear of dying; many lifting their hands to the gods; but the greater part imagining that there were no gods left anywhere, and that the last and eternal night was come upon the world. (From *Pliny Letters,* trans. William Melmoth, 1915; 1961)

A few years later, other classical authors described the same eruption. Statius cited "the day when Jupiter raised to the heavens the mountain he himself had torn from the earth, then let it fall on mankind and its cities." The historian Dio Cassius even evoked distant consequences: "The clouds of ash fell on faraway countries; even black Africans were stricken by it. This ash rolled in whirlwinds over the ancient soil of Syria and Egypt."

This exceptionally violent volcanic eruption into the world of humans, and the total destruction of their cities, had a great impact on society for a whole era. The event was also certainly the source of the entire Western conception of volcanoes. Although Europe has not suffered excessively from volcanic eruptions, volcanoes have always been associated—as they still are—with the idea of destruction and death. In other civilizations, however, where devastating eruptions occur with some frequency, volcanoes are associated with the creative life forces.

It is very probable that Europeans still live the distant memory of the destruction of Pompeii, which possibly influenced their notion of divine retribution. The eruption of Vesuvius, since its own time,

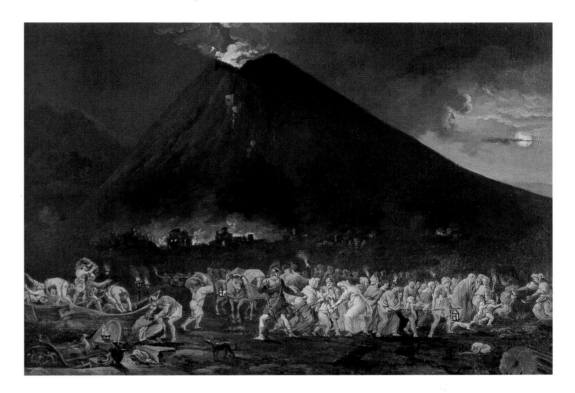

has been used by religion. The earliest Christian writings, Jewish in inspiration, speak of this catastrophe as of a divinely inspired punishment visited upon the emperor Titus, who had just come to power. One year before, he had sacked the Temple at Jerusalem. For the first time a volcano came to the aid of the Catholic religion.

The bond between Catholicism, so firmly implanted in central Italy, and Vesuvius has always remained strong. Even today, the Church honors San Gennaro, a saint believed to have protected Naples from the dangers of the volcano. This bishop of Naples fell victim to the "Great Persecution" of the year 302 proclaimed by the emperor Diocletian. His first miracle was to survive the stake erected for him at Nola, and his reputation was born in part from the fire's inability to touch him. He was transported to Pozzuoli, where the wild beasts in the arena refused to devour him. Finally the Romans succeeded in beheading him inside the crater of La Solfatara, another volcano. His head and body were retrieved by his followers, while his blood was recovered by a blind man and preserved in two crystal amphoras. His relics were kept intact until

ABOVE: Anonymous, oil on canvas, nineteenth century. Pompeii's destruction reflected a popular theme in artistic tradition: a city punished by God for its lust and other sins.

LEFT: Encased in the summit caldera, Vesuvius is considered by the international scientific community to be the world's most dangerous volcano. Rising over the Bay of Naples, it threatens its 800,000 residents.

the fifteenth century in the Chapel of San Gennaro within the Duomo of Naples, of which he became the patron saint. In a ceremony held twice a year, the holy relics are brought out in a procession throughout the city. The faithful then pray before the great amphoras set up near the bust portrait of the saint. If the prayers are of sufficient fervor, the blood liquefies. This miracle promises San Gennaro's protection of the city and its inhabitants. Each time Vesuvius erupts, the relics are also brought out and presented before the volcano. Sir William Hamilton (1730–1803), in his excellent book on Vesuvius and the Phlegraean fields, used the records of the processions of the relics to date past eruptions of the volcano. He also tells us that during the first phase of the great eruption of Vesuvius in October 1767, ash fell on the city of Naples for two days. The houses and even boats at sea were covered with scoria. People could barely walk the streets, and the whole population of the area turned out in a demonstration in front of the bishop's residence to demand that the saint's relics be brought out. As soon as these relics were carried to the mountain, the crater stopped spitting its fountain of lava. Alexandre Dumas (1803–1870), who lived for a long time in Naples and was fond of history and local traditions, wrote in *Le Corricolo*: "Suddenly, the marble statue of San Gennaro, which stood at the head of the bridge with hands joined, removed its right hand from the left and, with a proud, imperious gesture, stretched its marble arm toward the river of flame. At once the volcano closed again; at once the earth ceased trembling; at once the sea grew calm. Then the lava, having gone a few steps farther, feeling its nourishing source stilled, in turn stopped at once. Naples was saved."

Even today, the statue of San Gennaro stands vigil at the end of Naples's bridge of the Maddalena. Its hand is still raised toward the volcano. We can be sure that San Gennaro will step forth again at the first sign of another eruption. This belief in a miracle also allows the Neapolitans not to take too seriously the warnings of scientists about a future awakening of the volcano.

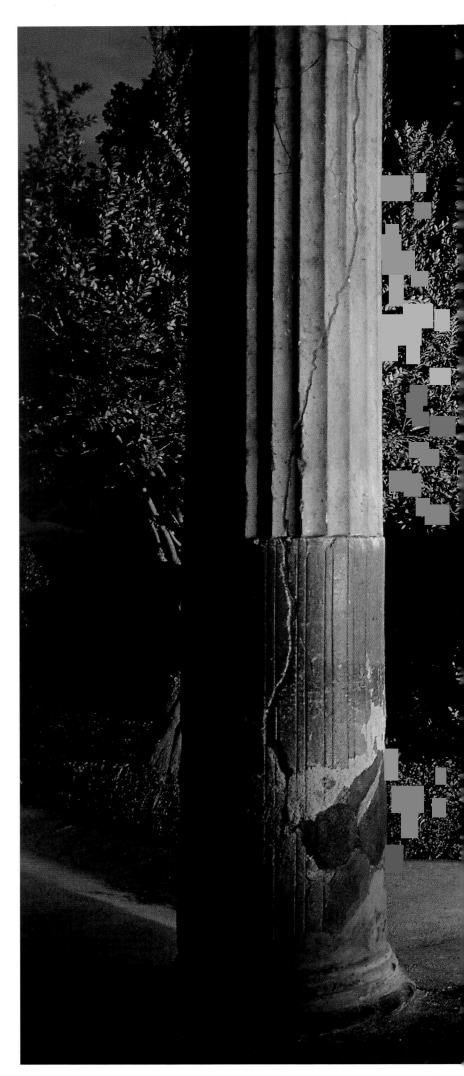

RIGHT: A Roman villa in Pompeii.

Anonymous, oil on canvas, seventeenth century. San Gennaro, the patron saint of Naples, borne aloft by angels, flies over Vesuvius, blessing it to calm its rage.

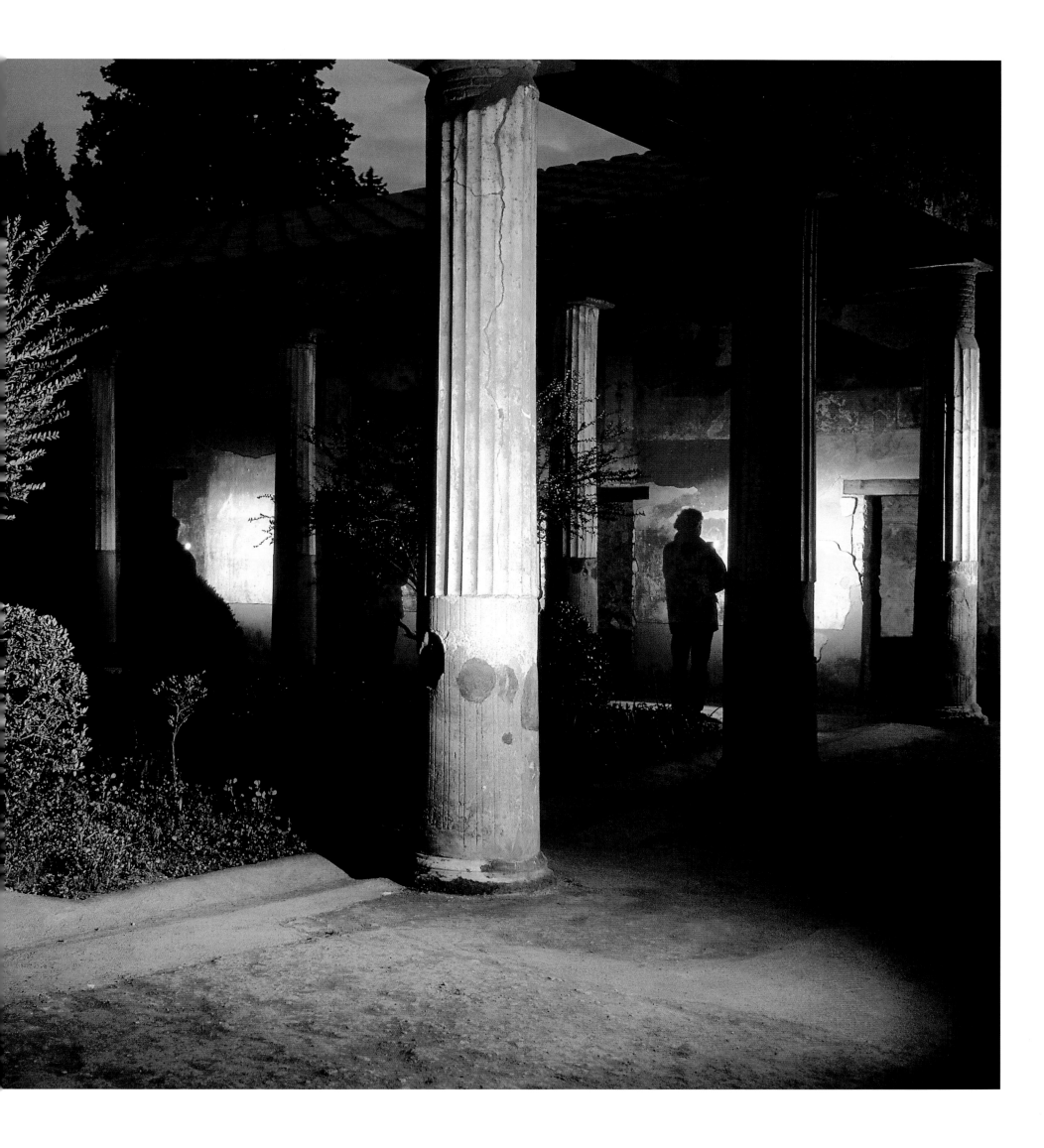

PAGE 49. Afar, on the Red Sea coast, is the site of extremely intense seismic activity. It is the only spot on earth where one can witness an event that normally occurs at the bottom of the sea—the separation of two continents. In a few million years, in fact, the earth will have succeeded in transforming this desert into a new ocean. Djibouti.

PAGES 50–51. The north crater of this volcano contains a lake of permanently molten lava. Erta' Alé is one of just three volcanoes in the world that possess such a lava lake. The lake stands nearly 330 feet below the rim of the crater. Afar, Ethiopia.

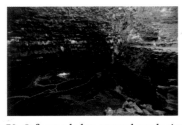

PAGES 52–53. Safe on a ledge, two volcanologists observe convection movements of the lava lake of the Erta' Alé volcano. Afar, Ethiopia.

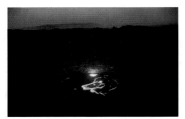

PAGES 54–55. View of the lava lake of the Erta' Alé volcano. Afar, Ethiopia.

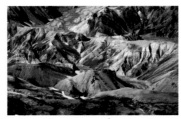

PAGES 56–57. In the mountains of Landmannalaugar, volcanic smoke and gas have corroded the rocks to the point of almost obliterating them. Exposed are the various minerals that make up the rocks. Iceland.

PAGES 58–59. Spirit Lake was swept by a wave nearly 1,000 feet high, caused by the wind blast from the eruption of Mount Saint Helens. All the trees on the banks were sucked into the center of the lake. Washington State.

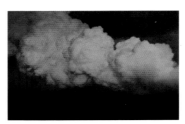

PAGES 60–61. Reflection of the sunset in the gaseous smoke plume from Kilauea volcano. Hawaii.

PAGES 62–63. Several important rivers have converged to erode this enormous gorge through sizeable layers of basalt lava. The site features the largest waterfall on the island of Réunion. Trou de Fer (Hellhole Falls), Réunion.

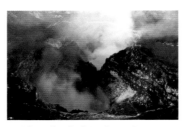

PAGES 64–65. The island of Ambrym is a great volcanic cone more than 7,300 feet above the ocean floor. The upper region of this cone collapsed to form a vast caldera 70 miles in diameter. Inside this caldera, two volcanic cones are active today: Marum and Benbow. Since 1774 many eruptions have been registered, originating in one of these two cones. These eruptions project bombs or lapilli and ash that fall back into the caldera as well as onto the northeastern slope of the island, depending on the prevailing winds. Benbow Crater, Vanuatu.

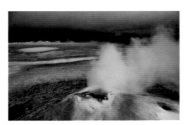

PAGES 66–67. Deposits of geyserite have formed a dome around the mouth of this volcano, ejecting water and steam. Geyserite is an accumulation of amorphous silica transported by warm water, which evaporates, leaving a deposit. This silica crystallizes into opal, and then slowly forms cristobalite and quartz. Hveravellir, Iceland.

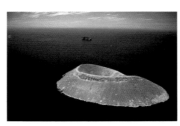

PAGES 68–69. The island of Daphne Mayor is a veritable sanctuary for sea birds. Galapagos Islands.

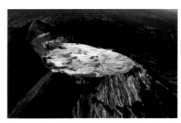

PAGES 70–71. Cone of Oldoinyo Lengai volcano (altitude 9,400 feet) located in the African rift. The lava from Lengai is very fluid. This is the only volcano in the world that produces the lava known as carbonatite, which turns white on cooling. Tanzania.

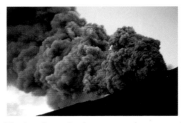

PAGES 72–73. A volcanologist approaches a smoke cloud from the explosive Krakatoa volcano. The dangers are considerable, since numerous explosions project bombs into the sky that can weigh several tons. Indonesia.

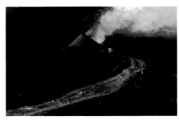

PAGES 74–75. Close to such a major lava river, wearing heat-resistant gear is obligatory to protect against lava at temperatures exceeding 2,012° F. Piton de la Fournaise, Réunion.

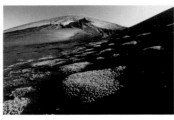

PAGES 76–77. Thirty years ago the island of Surtsey, Iceland, was born. Immediately after the end of the eruption that created it, access to the island was restricted to a few scientists who came to study the emergence of life. Here, beginning at the beaches, coastal plants set out to scale the slopes of the island. Iceland.

PAGES 78–79. Dromedary caravans descend into the depression from the high plateaus (average altitude 6,560 feet) in northeastern Ethiopia. The Danakil depression (also called the Afar Triangle) is an enormous break in the earth's crust stretching northward, which is the result of a tectonic phenomenon in the African rift. It is a wide, collapsing valley, which, even today, is continually widening from east to west. With its numerous fractures, this zone is the site of diverse volcanic activity. It is, in fact, a future ocean in the process of formation in the midst of the continent of Africa. Ethiopia.

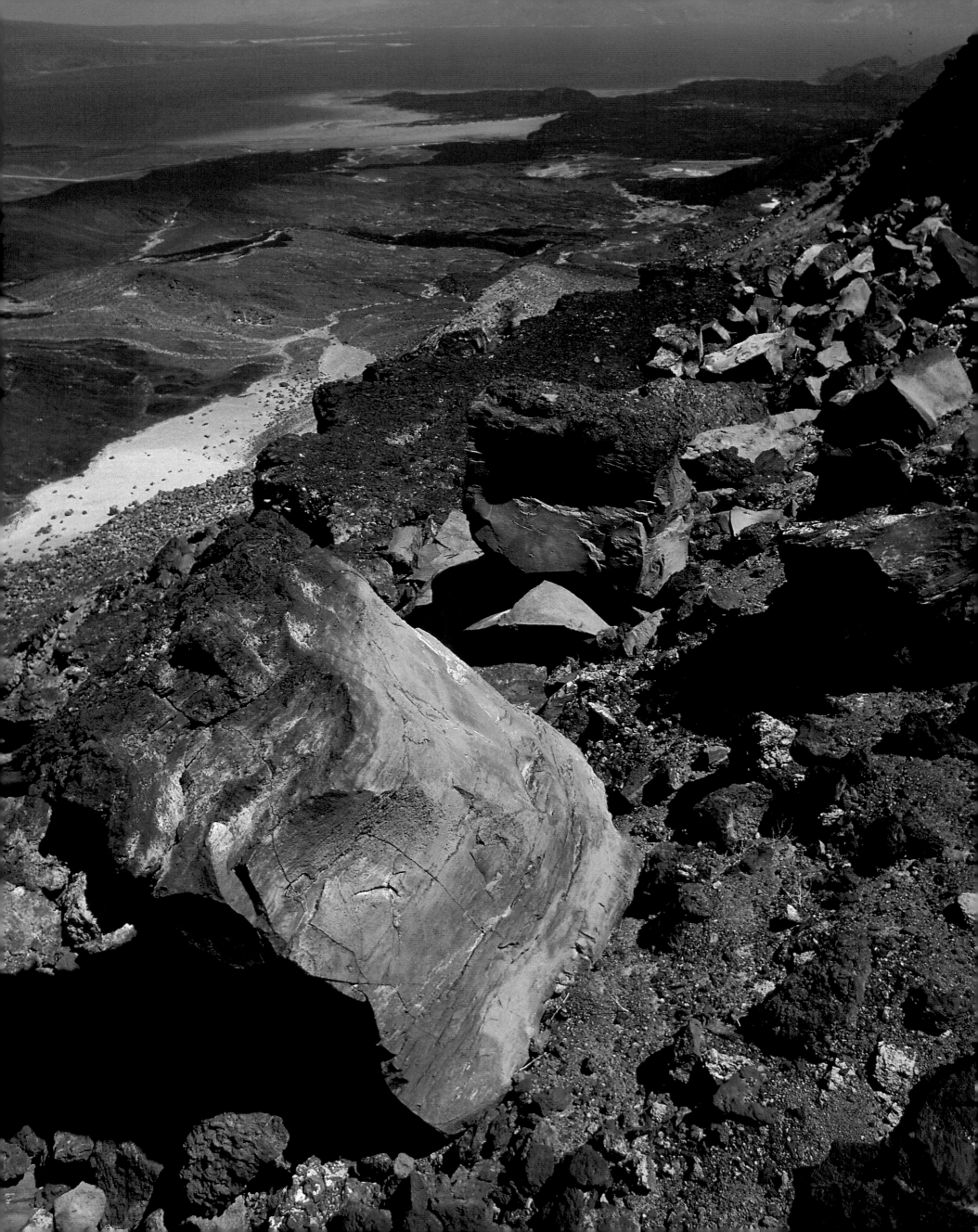

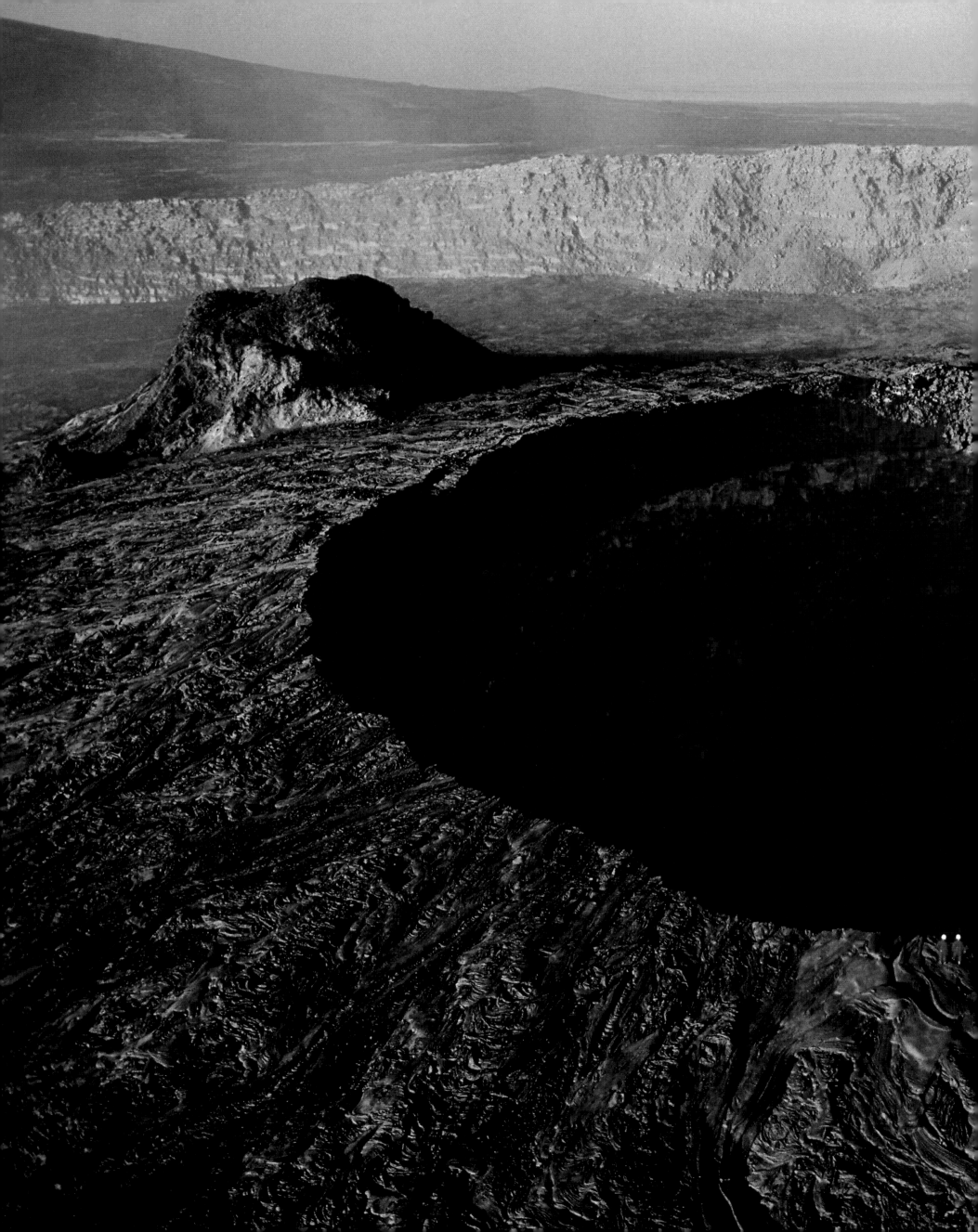

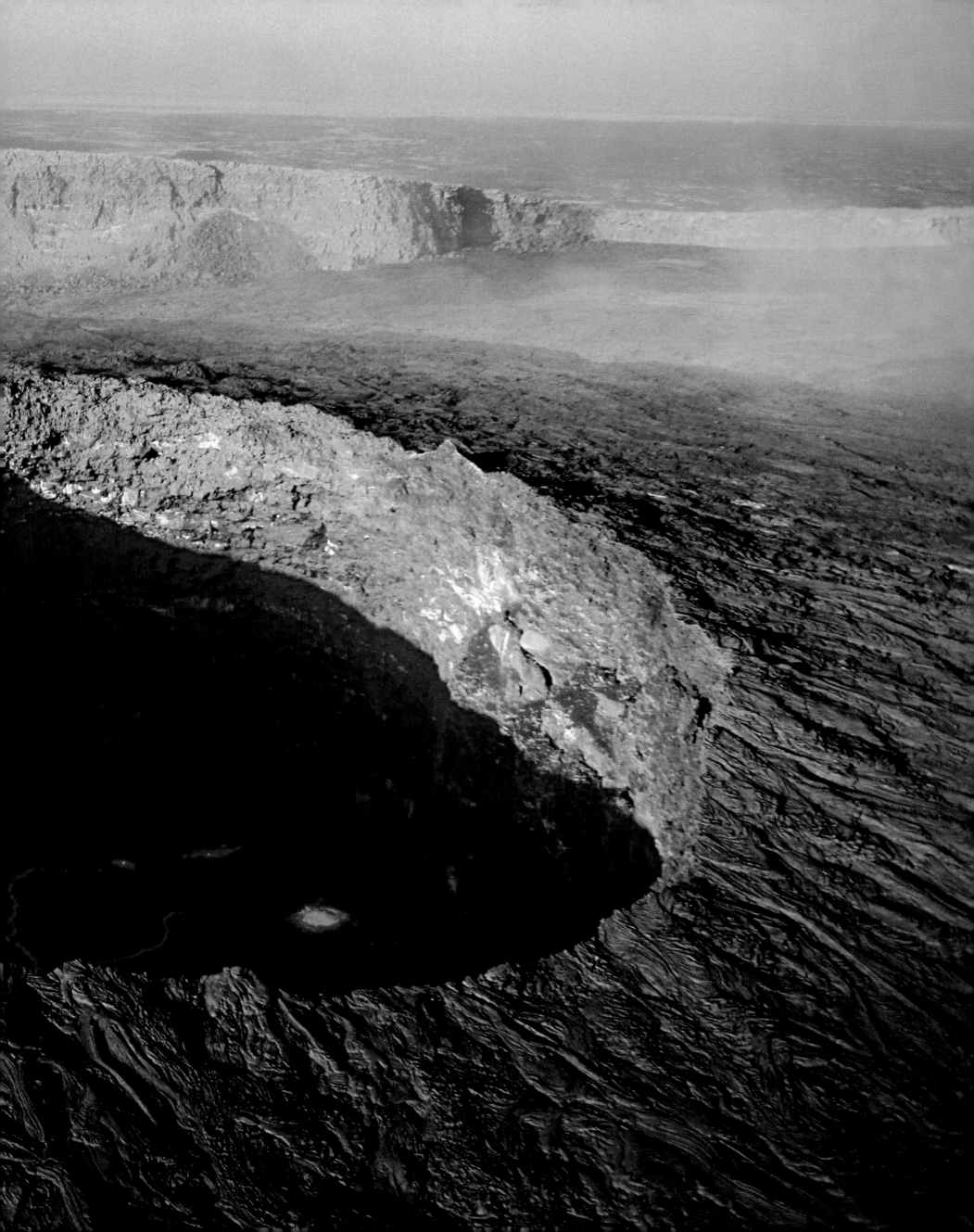

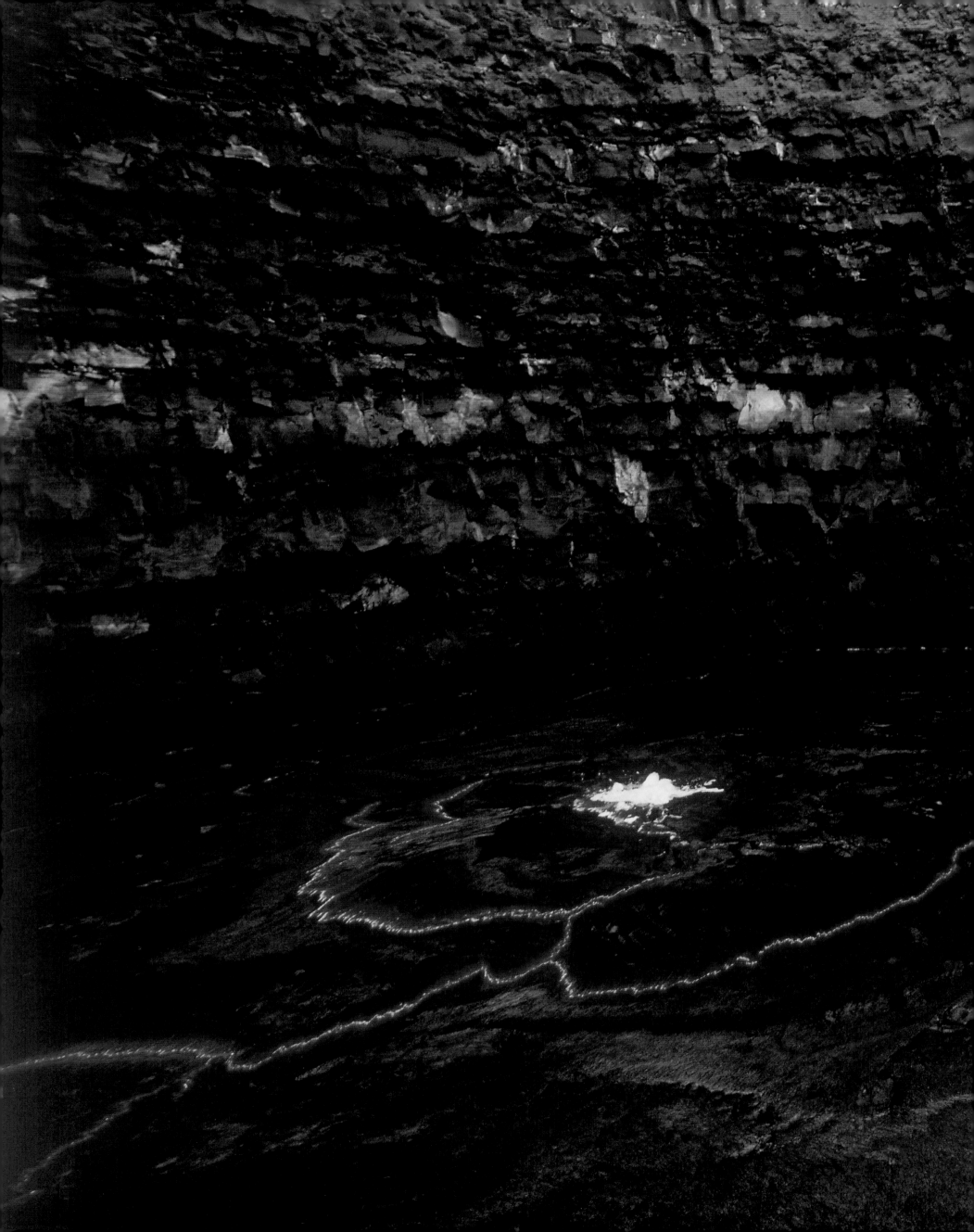

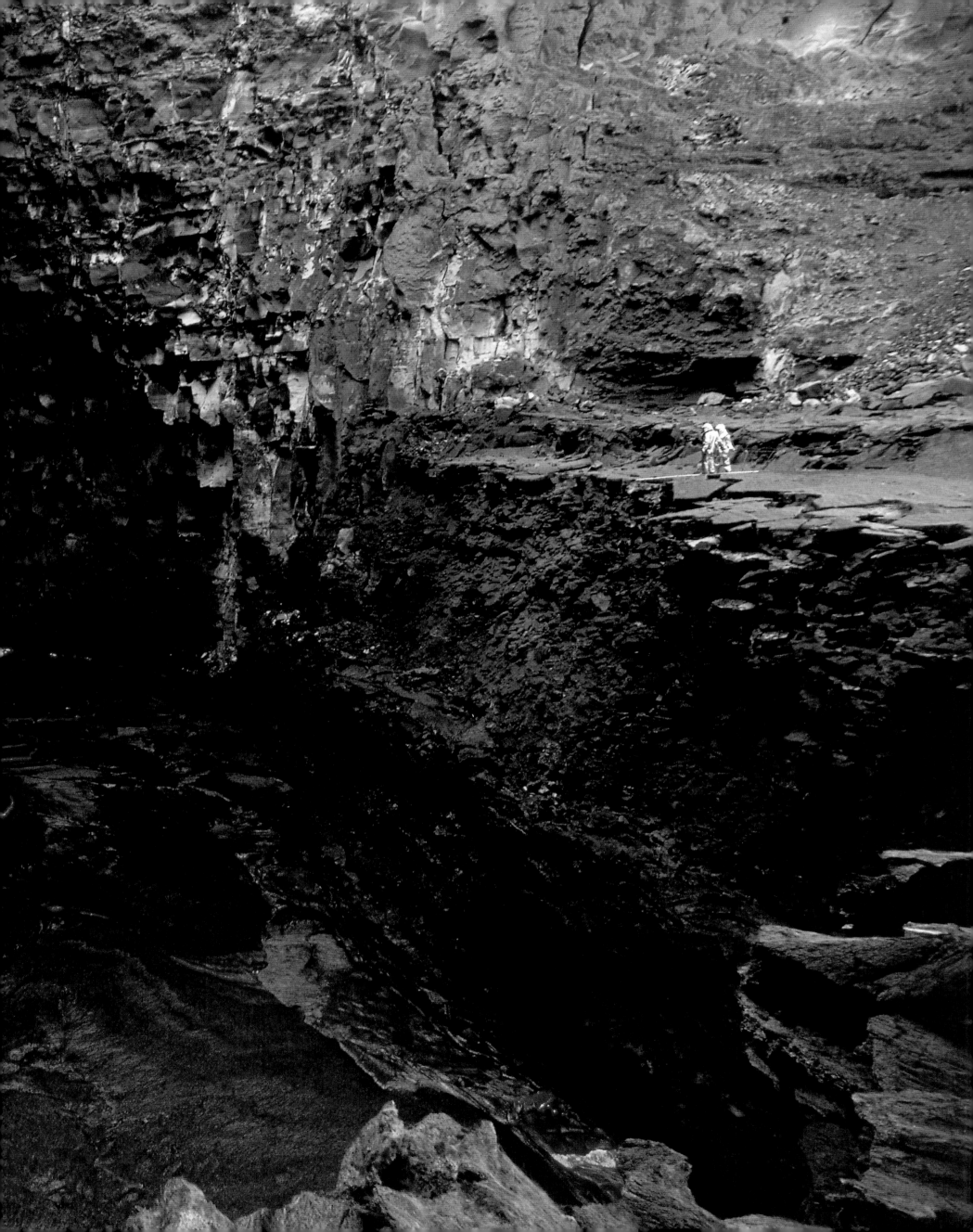

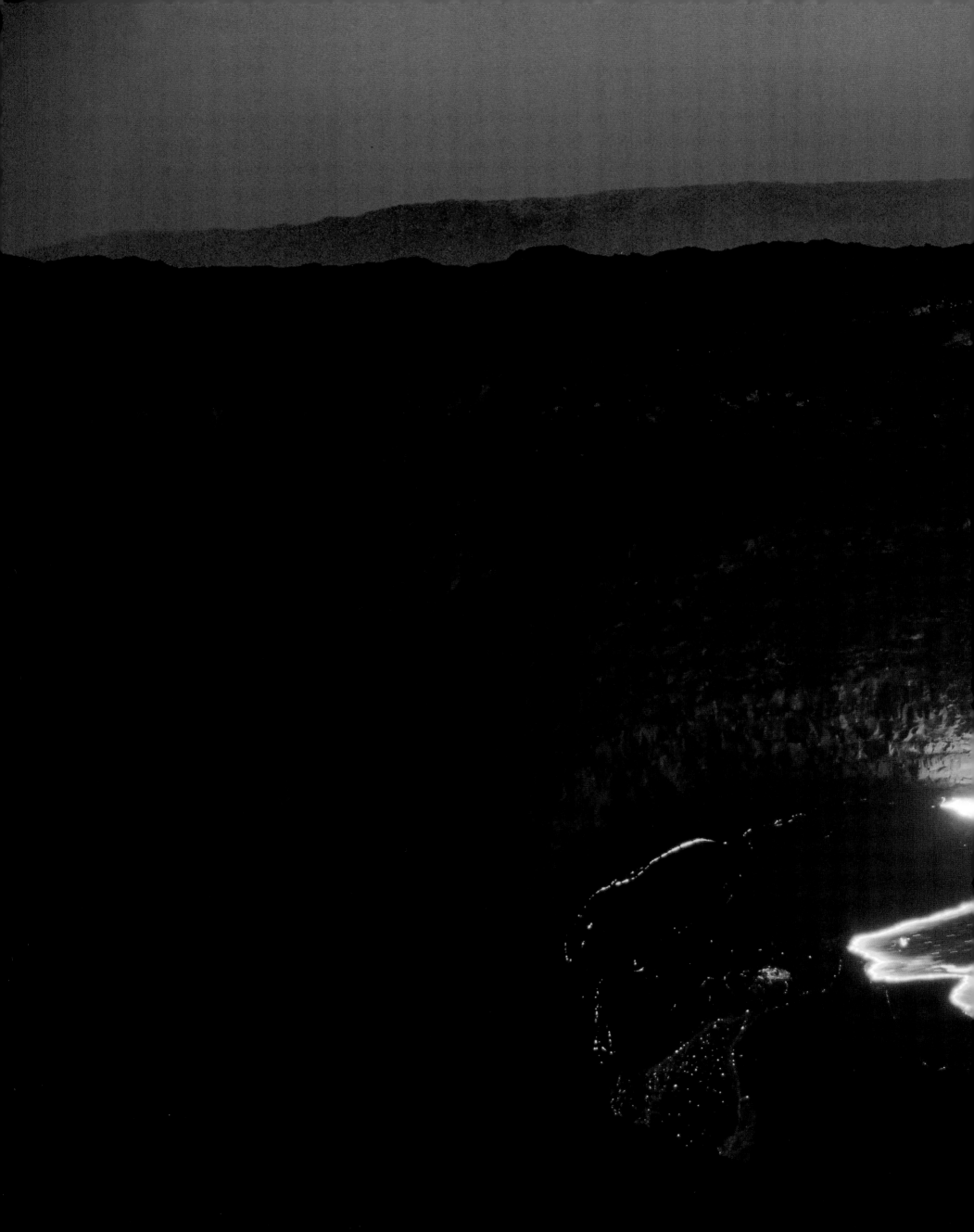

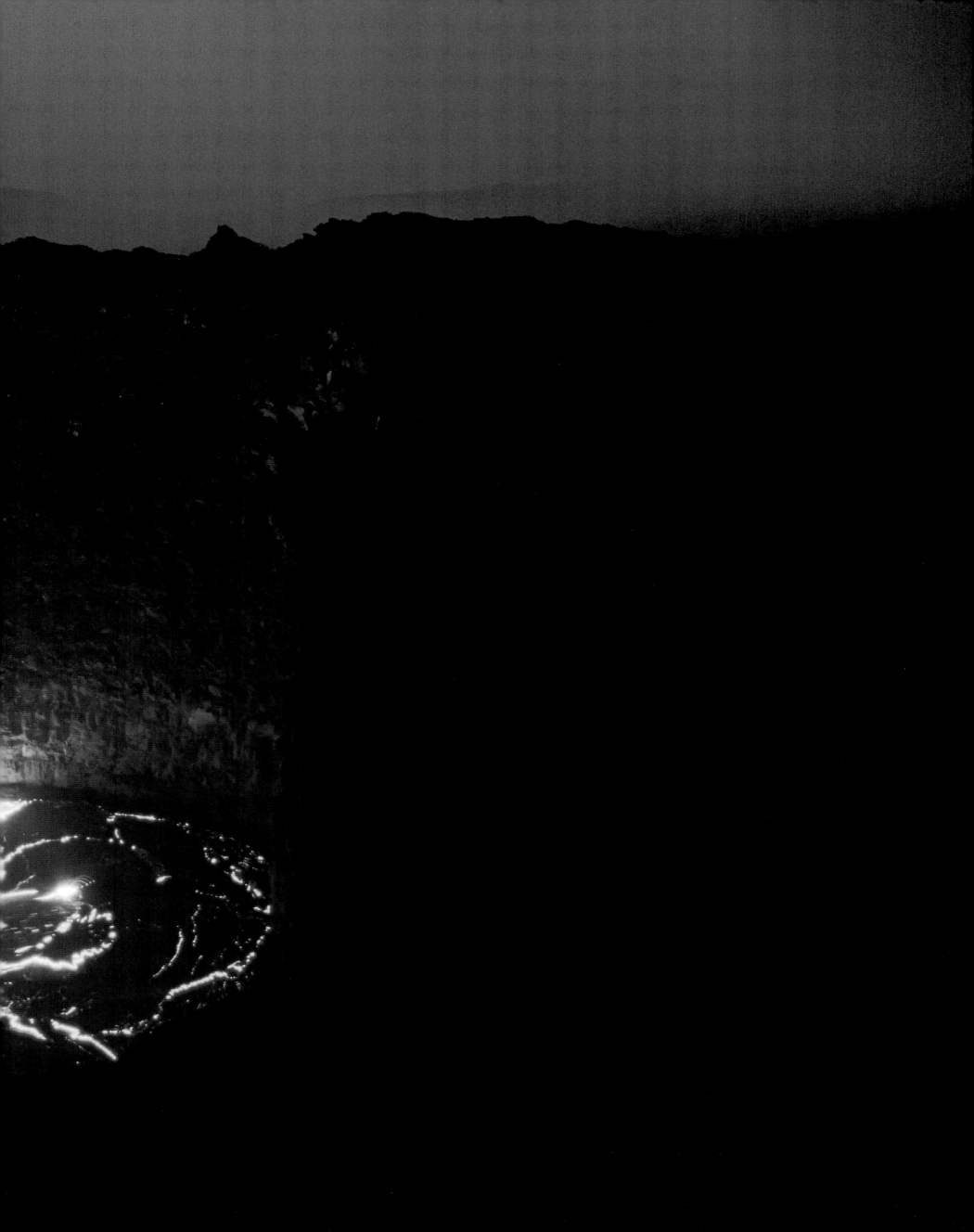

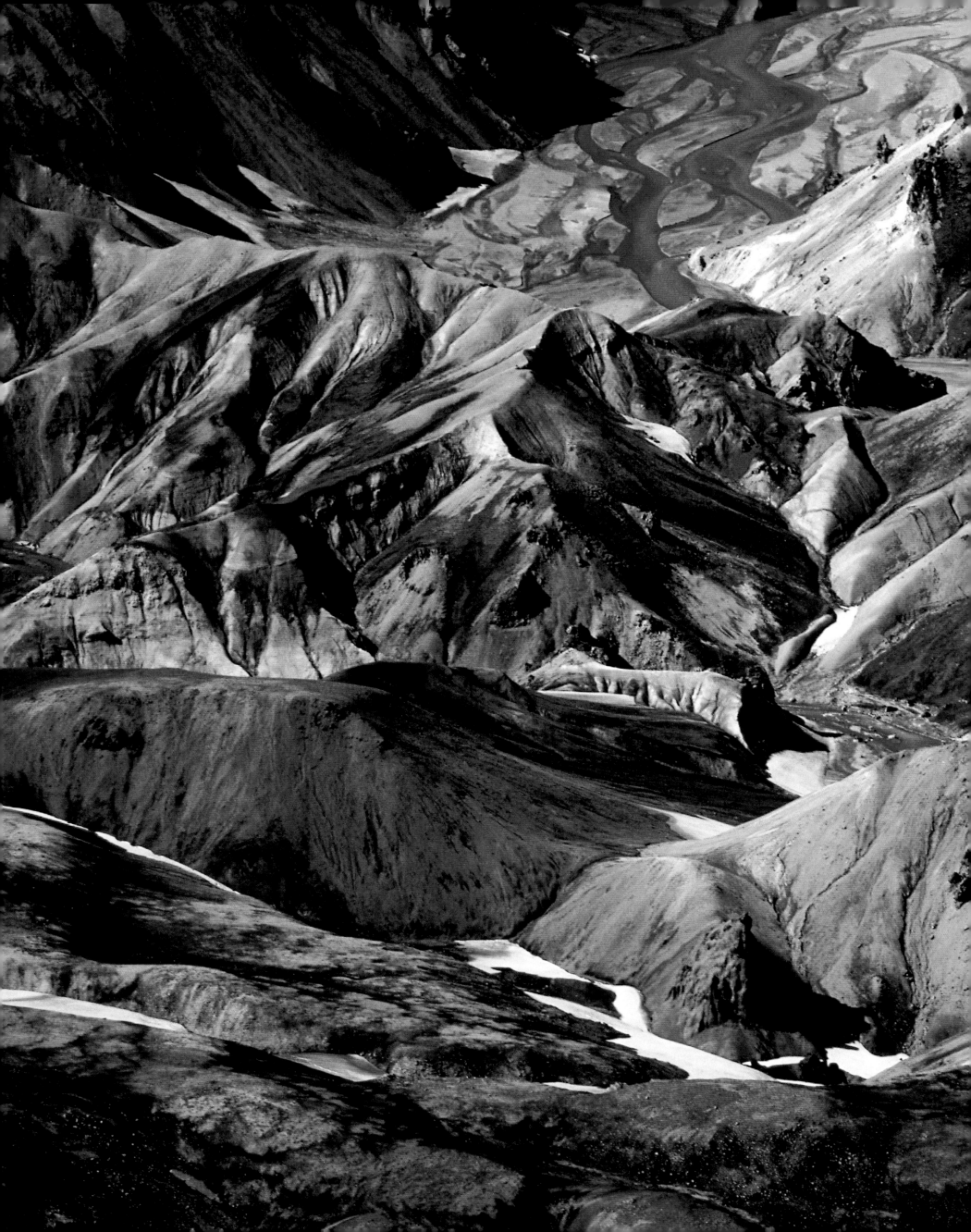

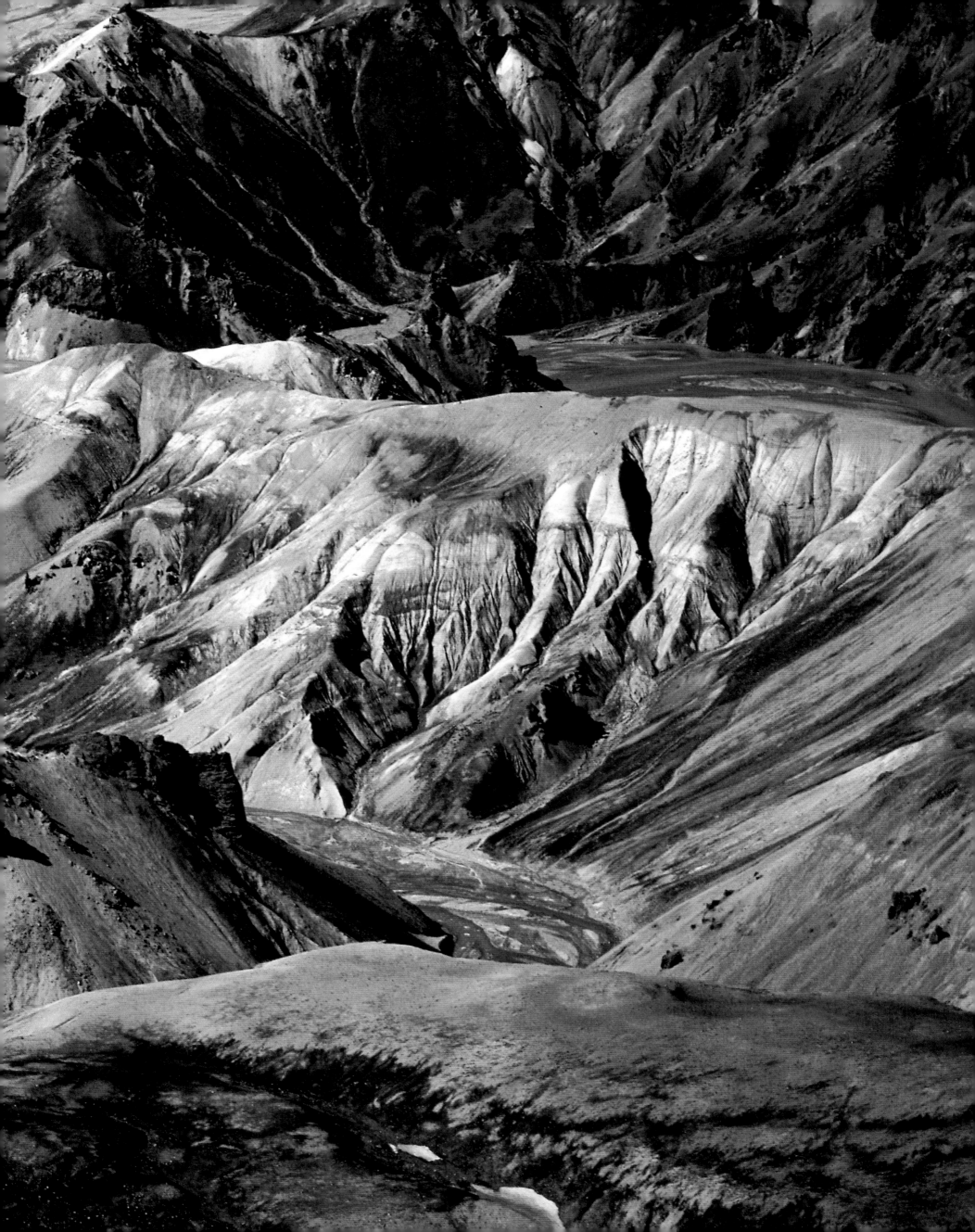

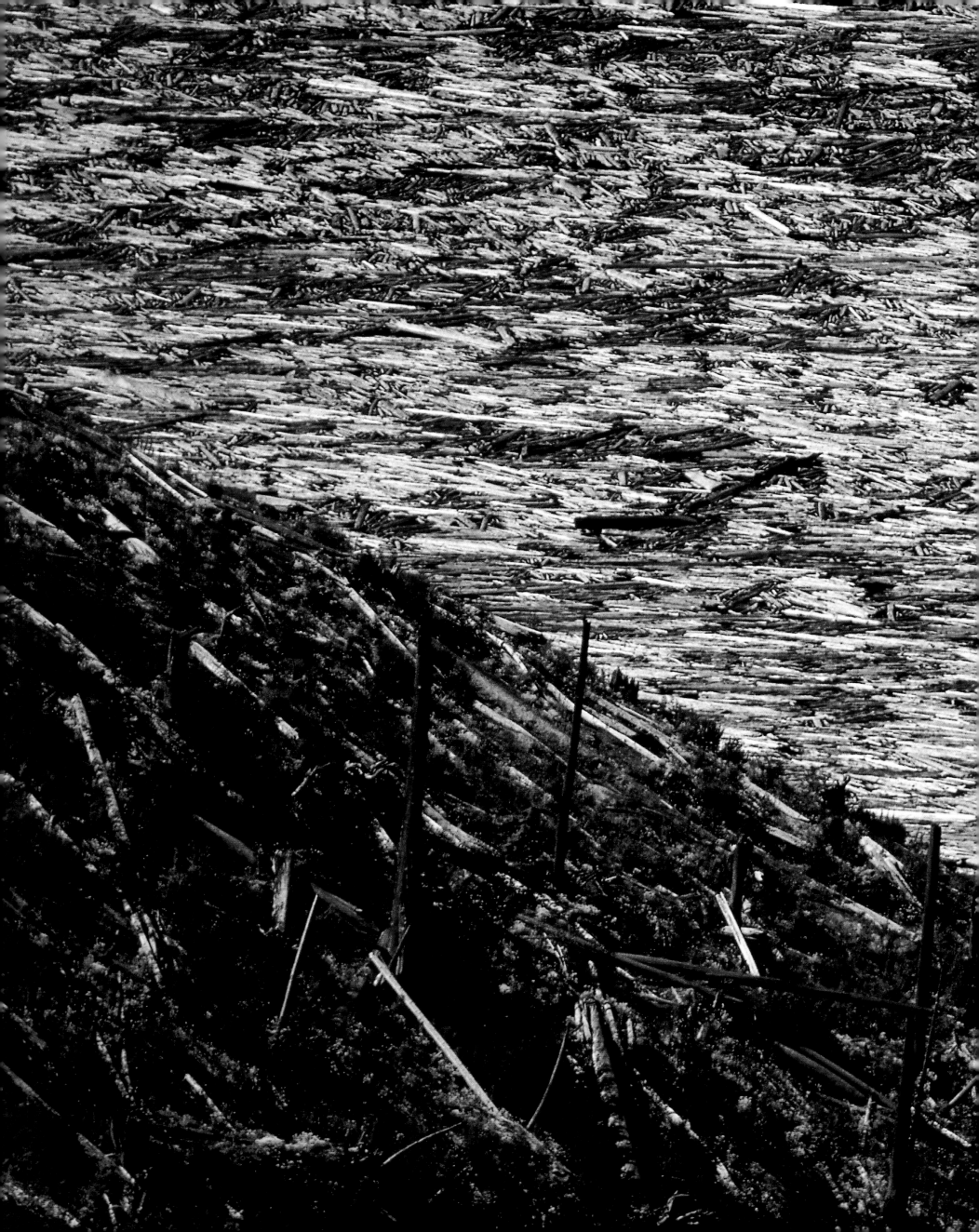

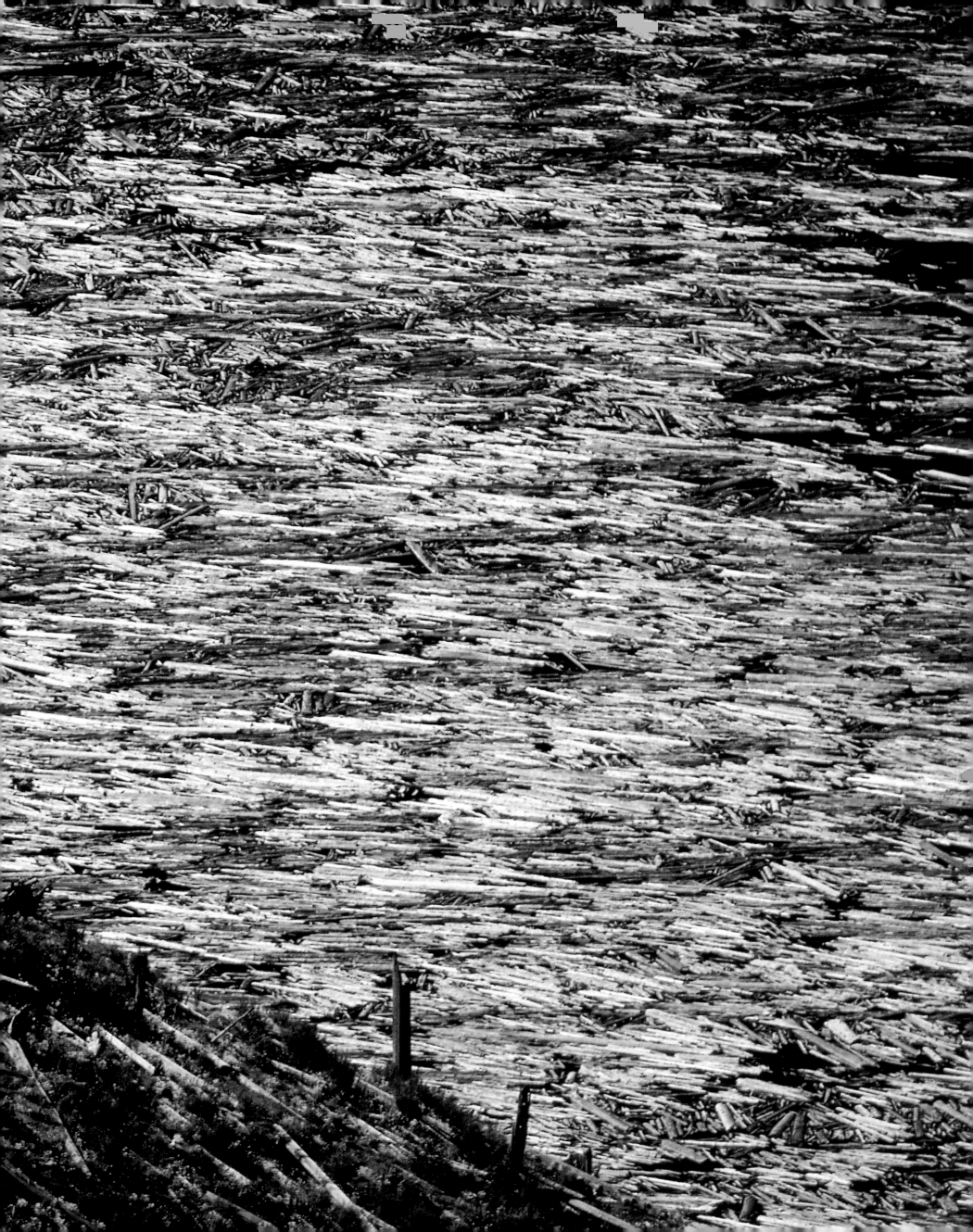

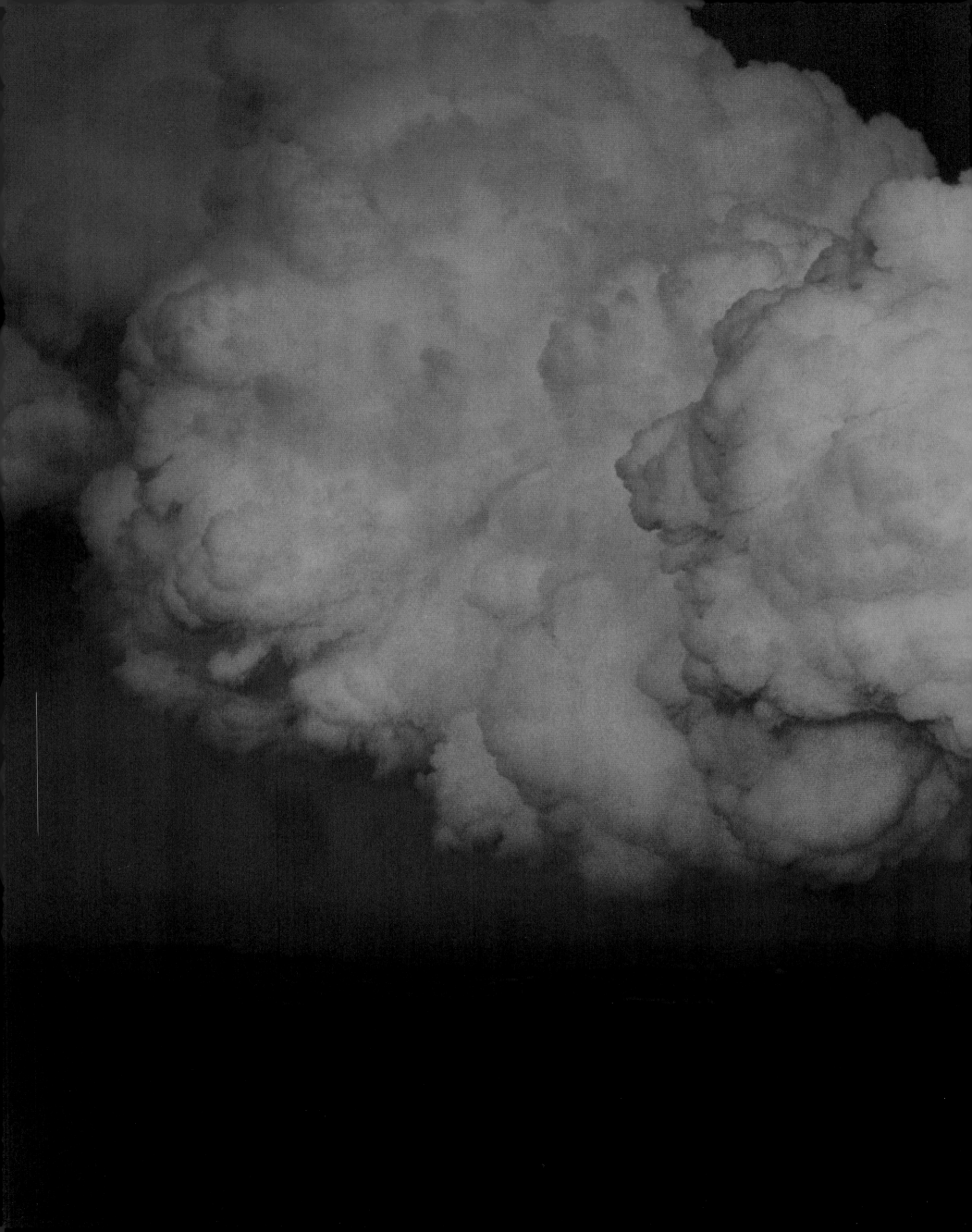

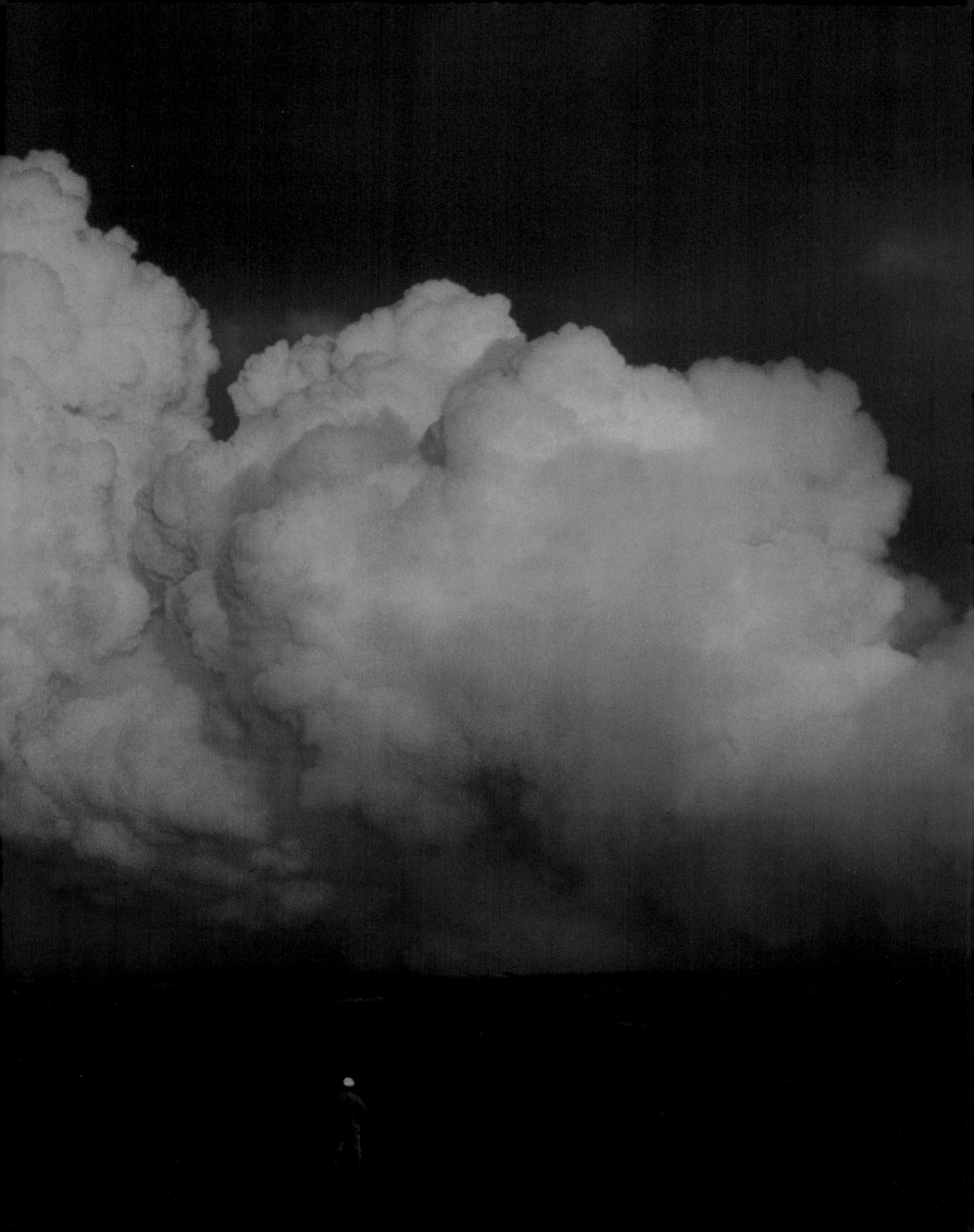

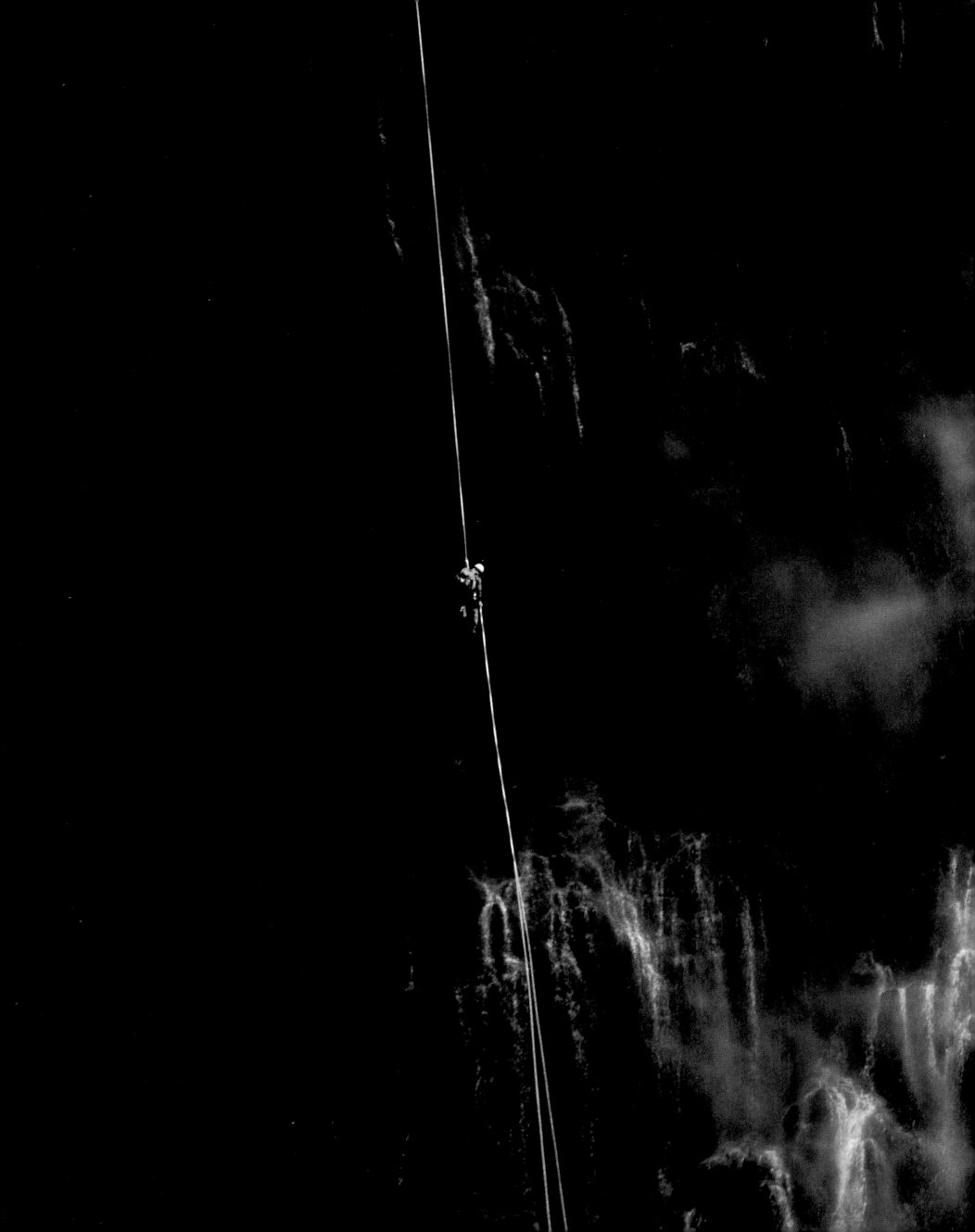

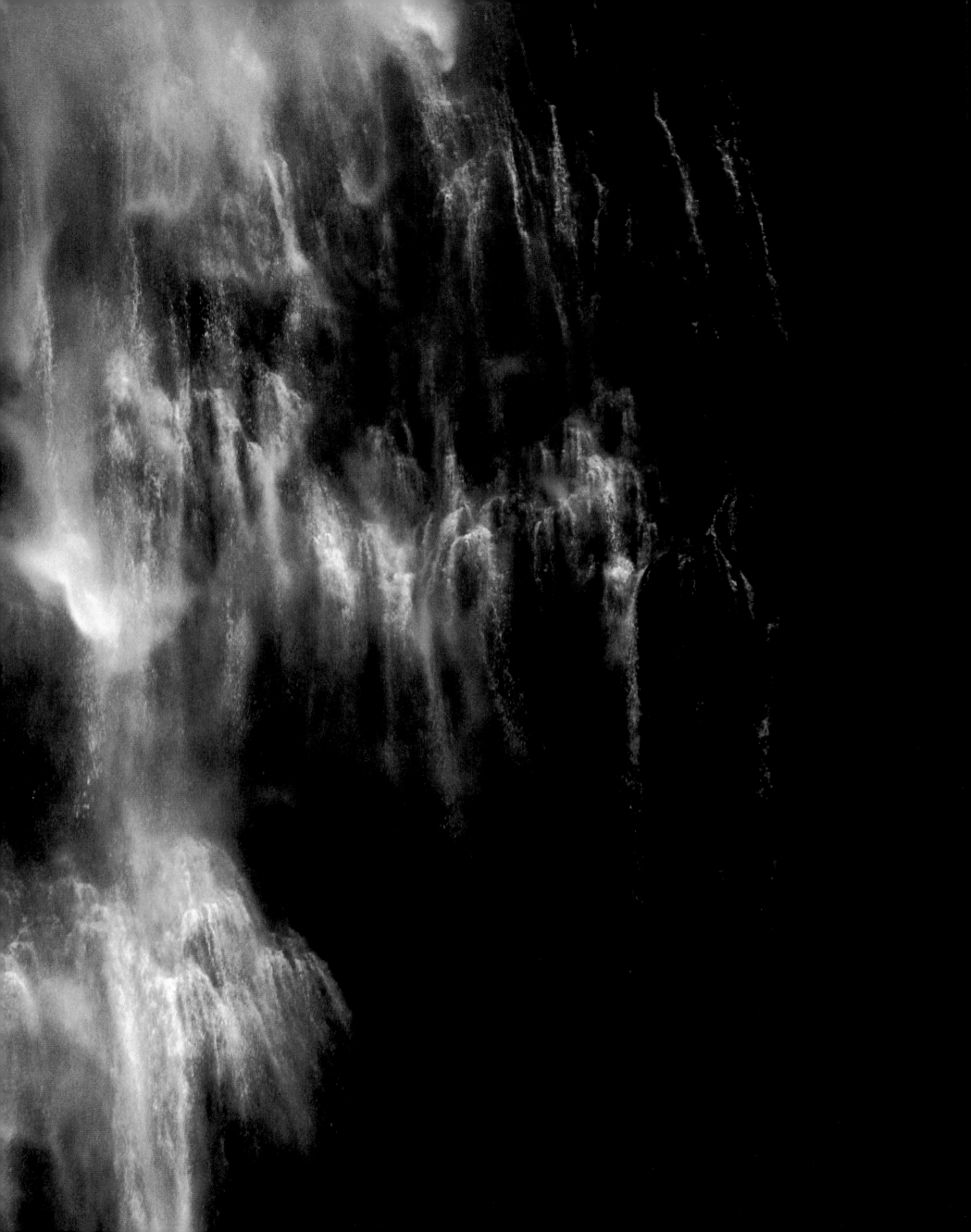

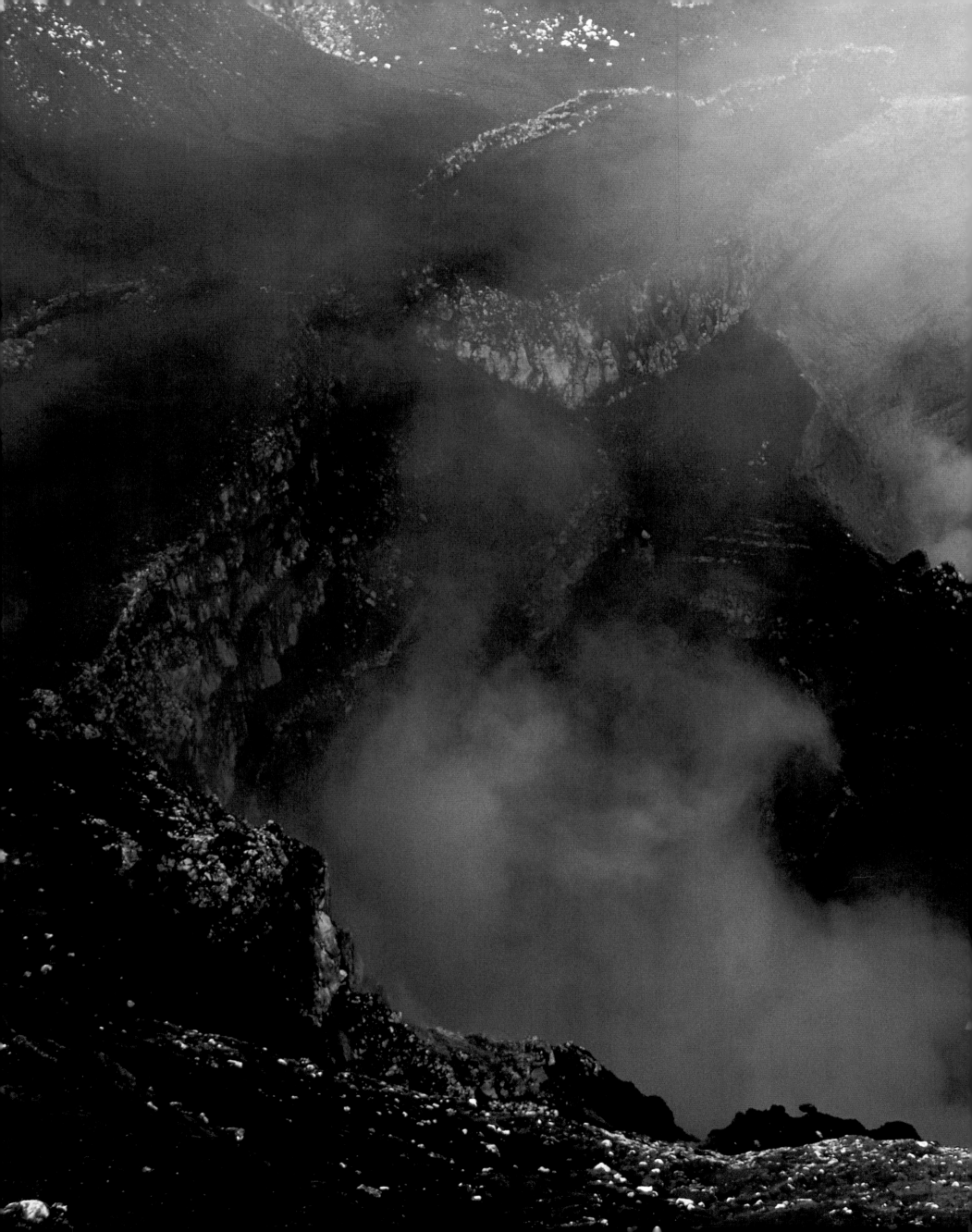

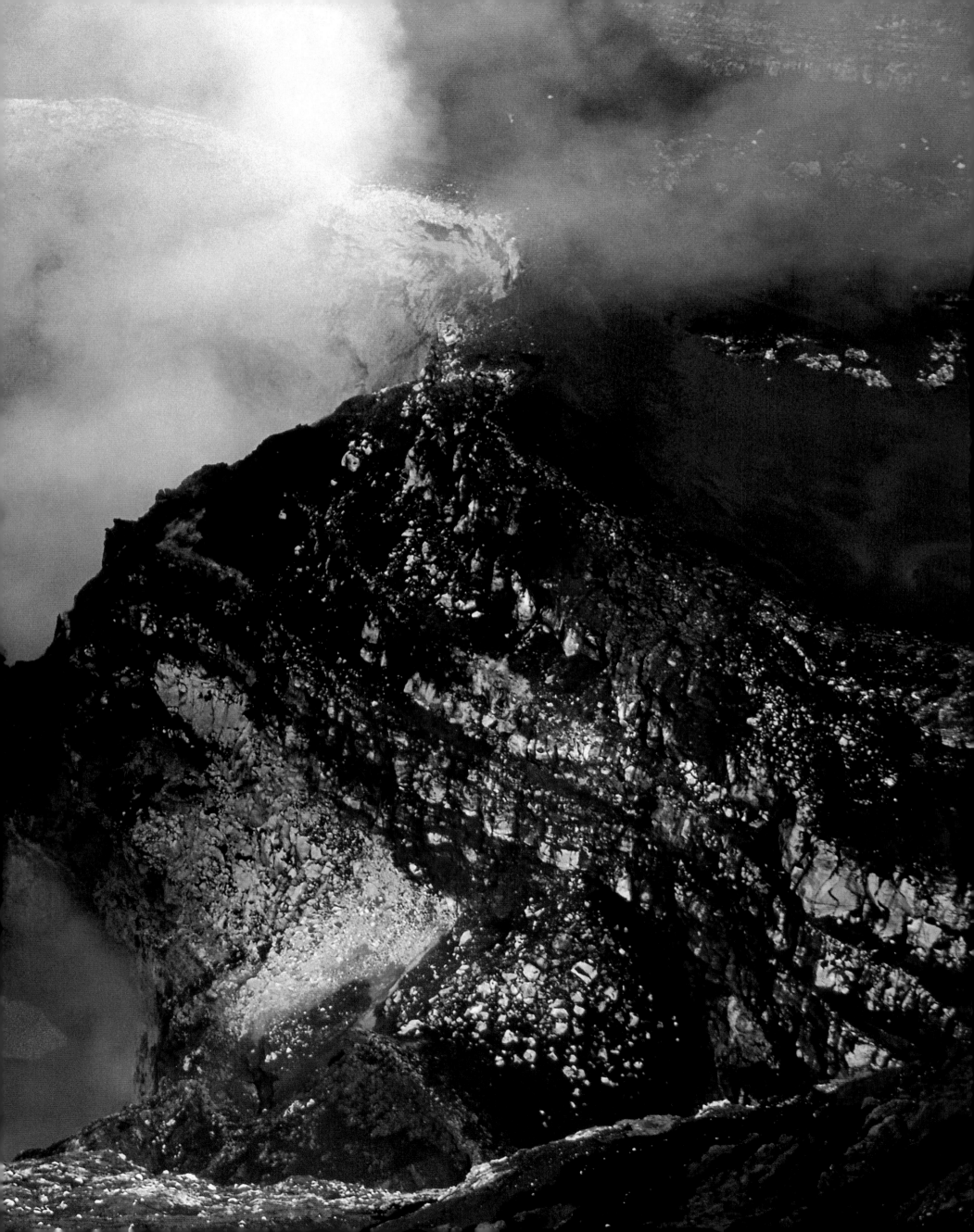

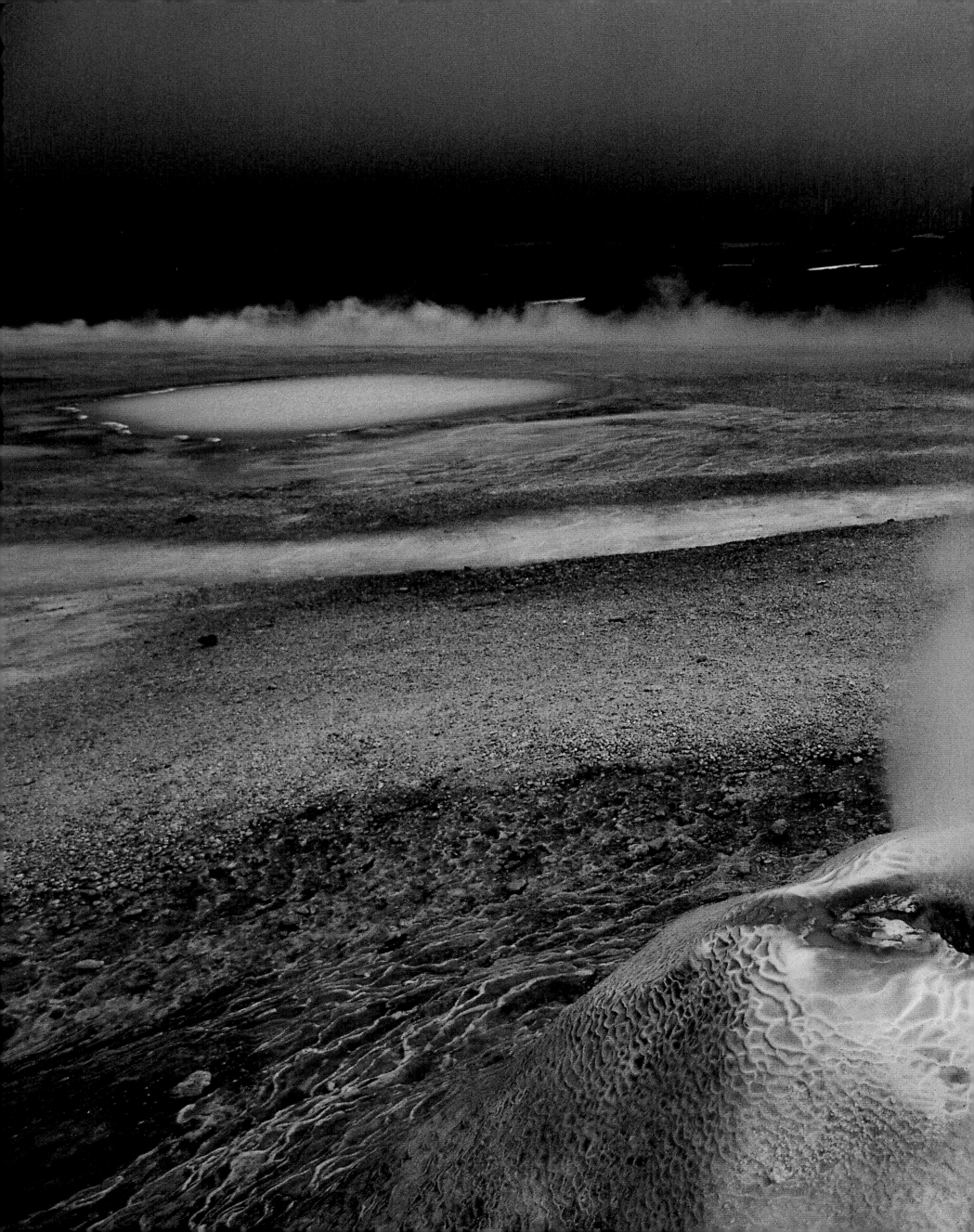

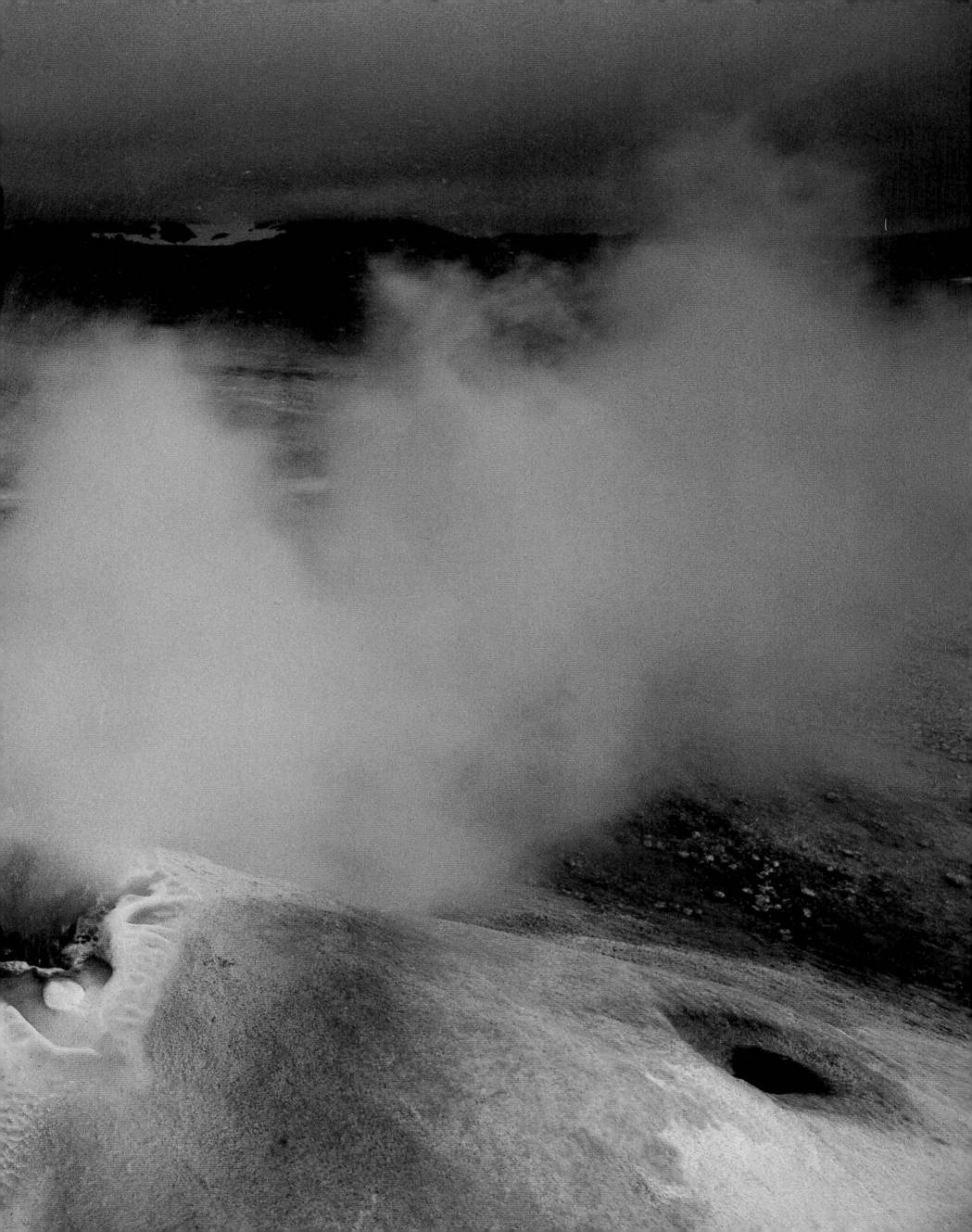

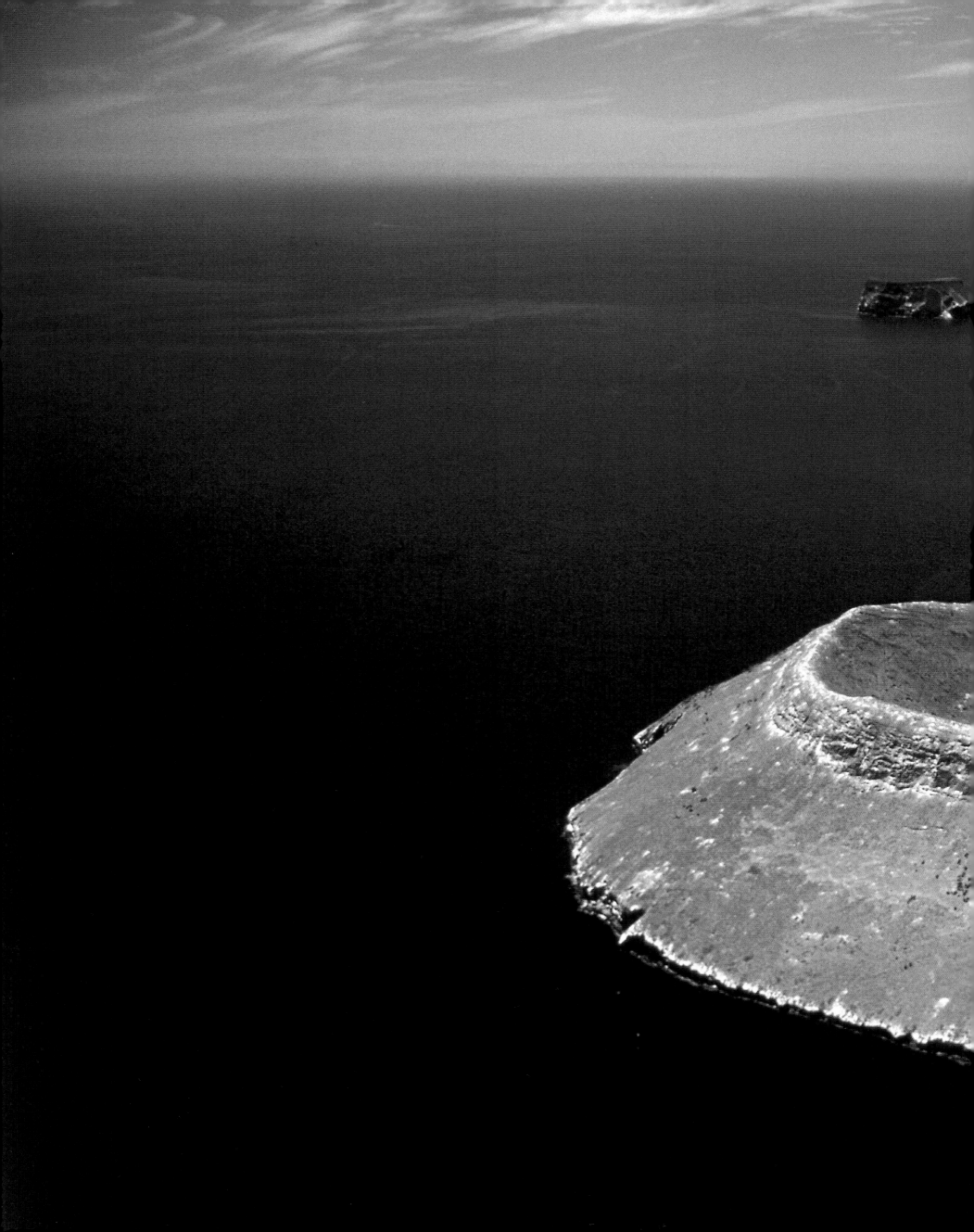

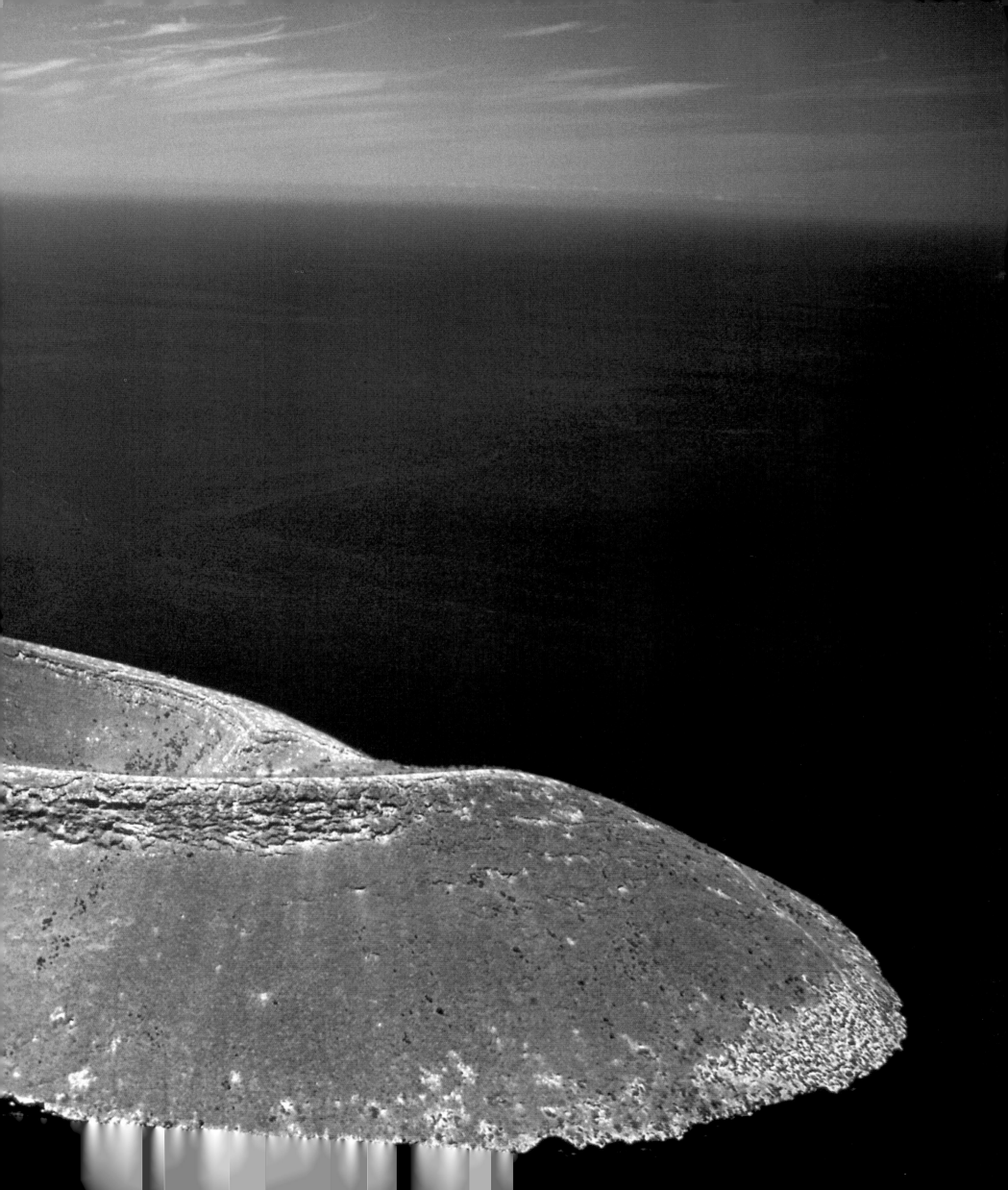

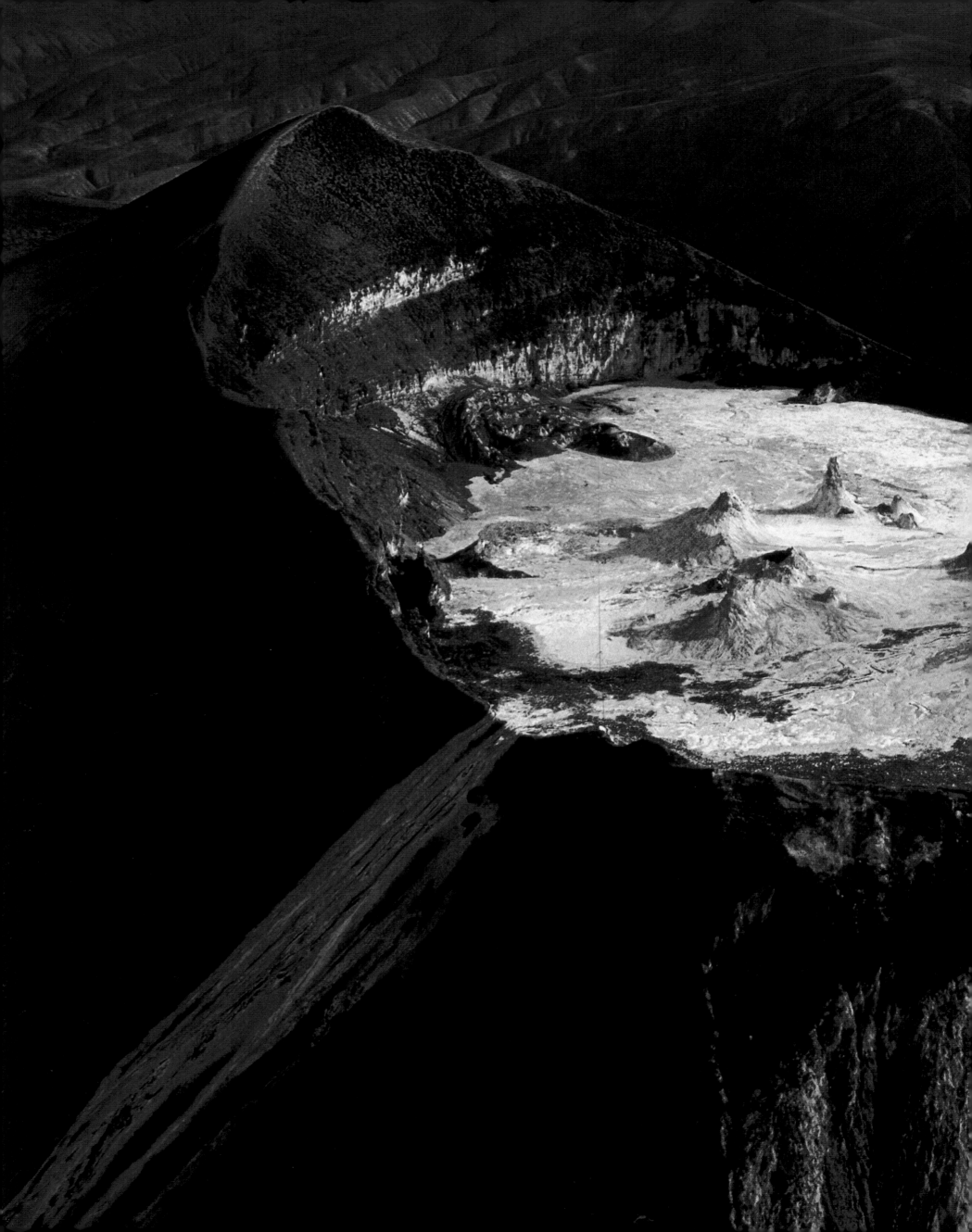

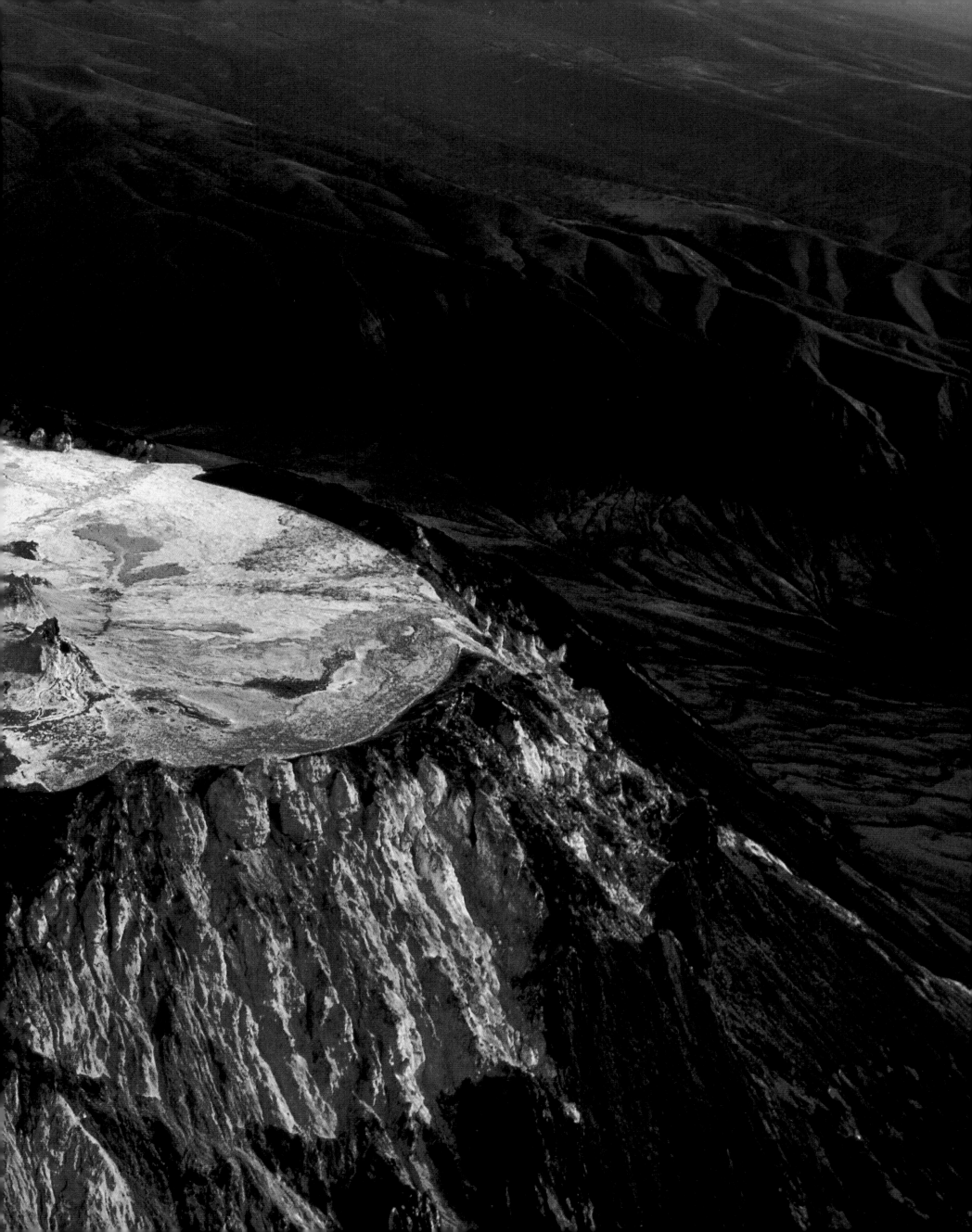

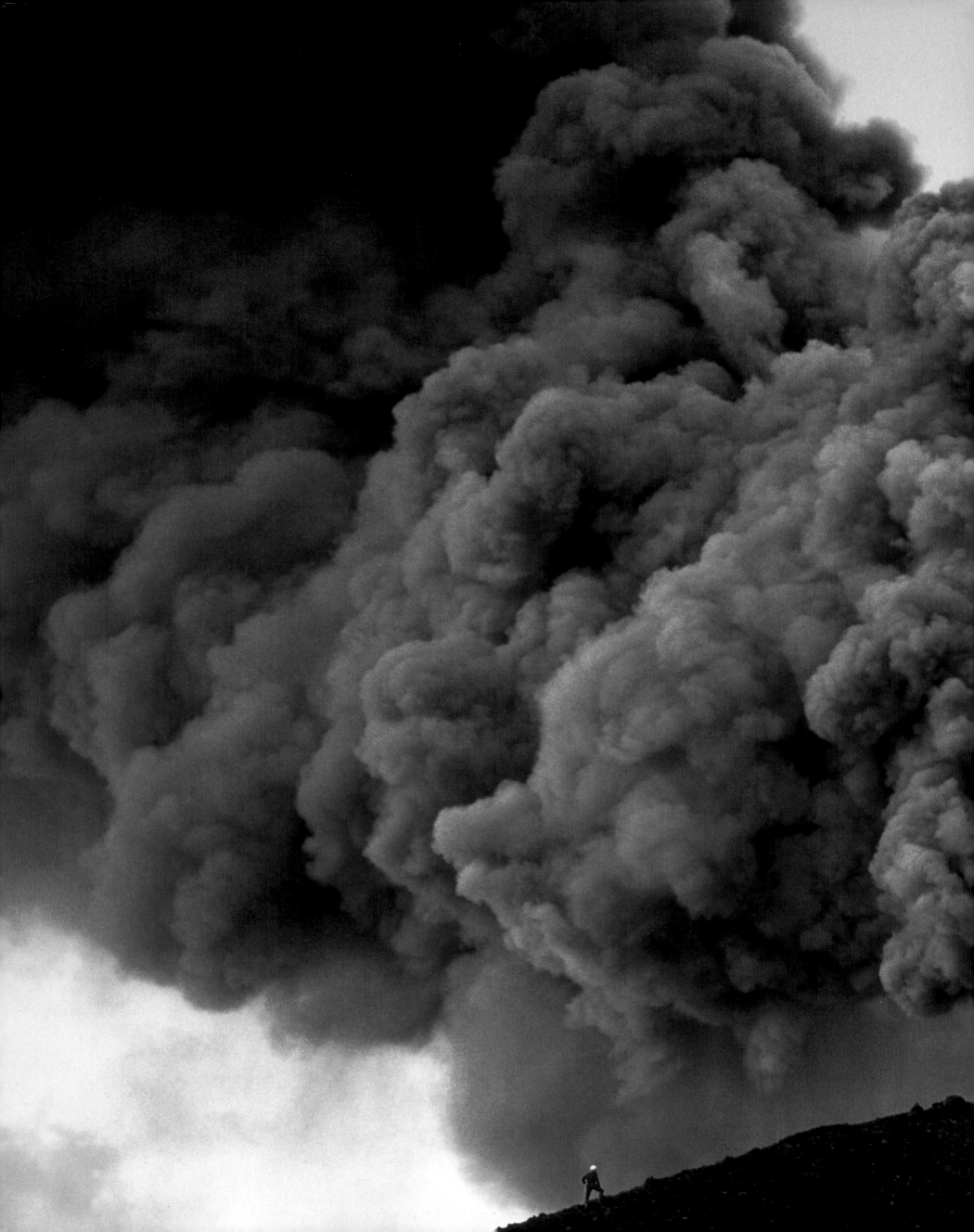

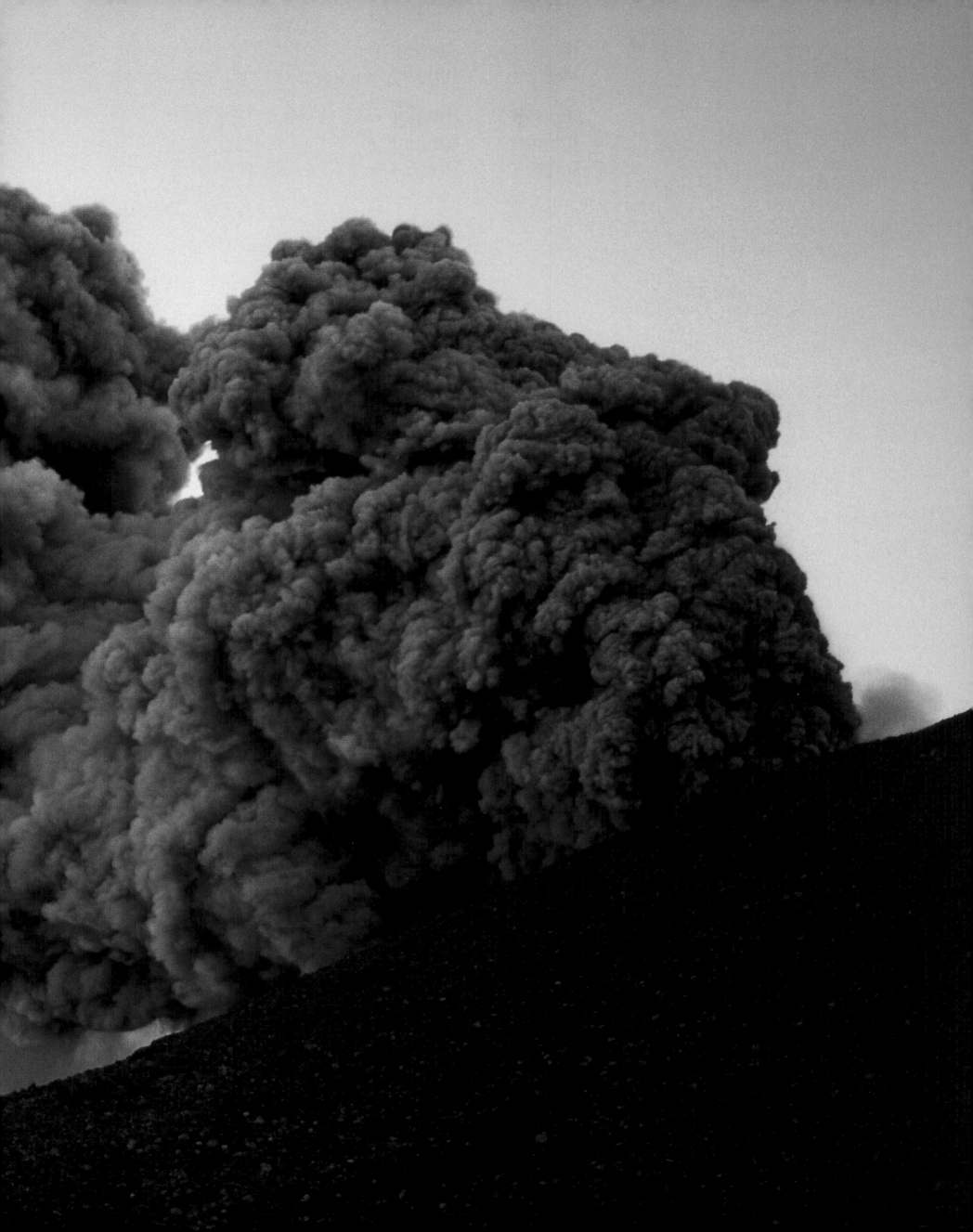

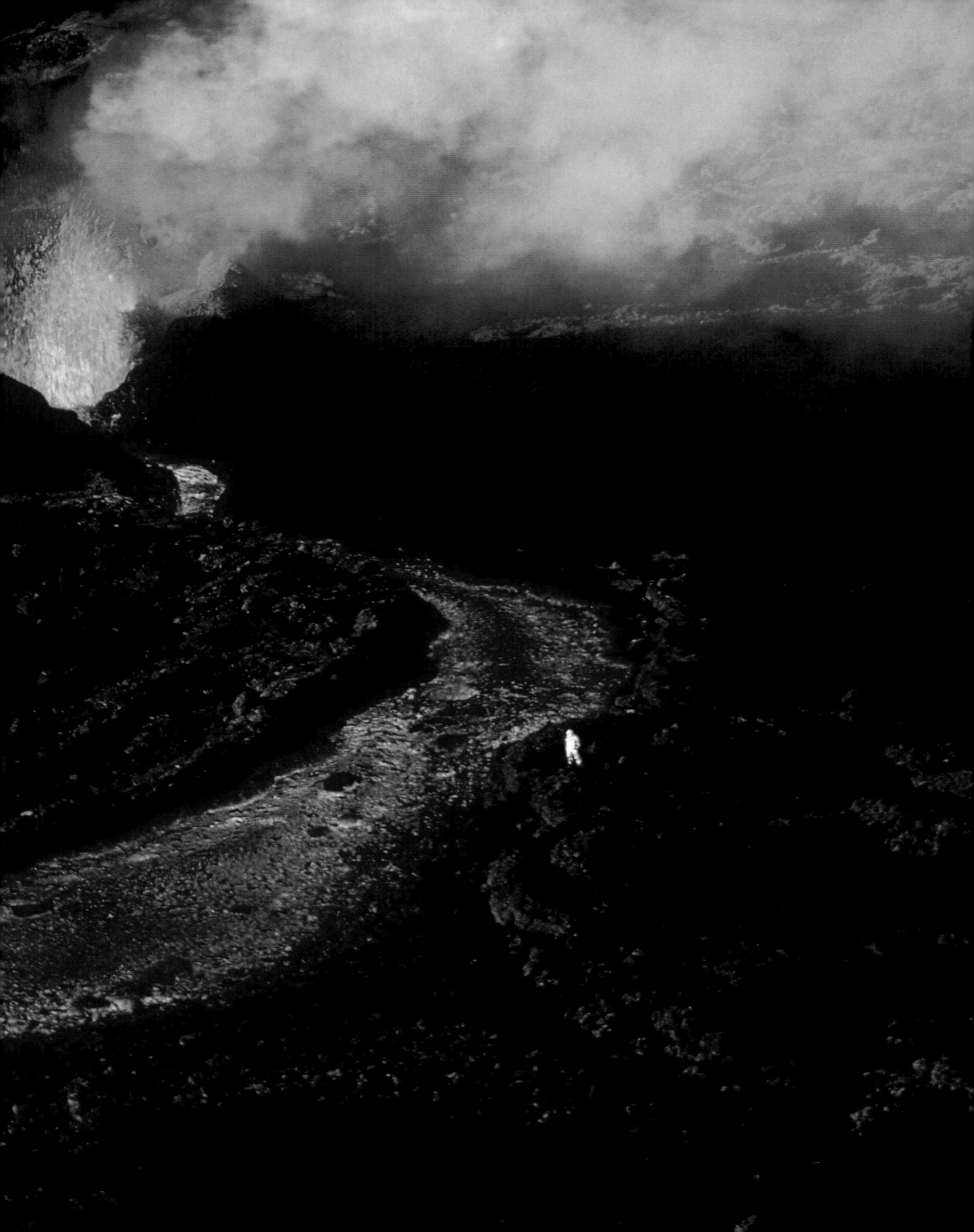

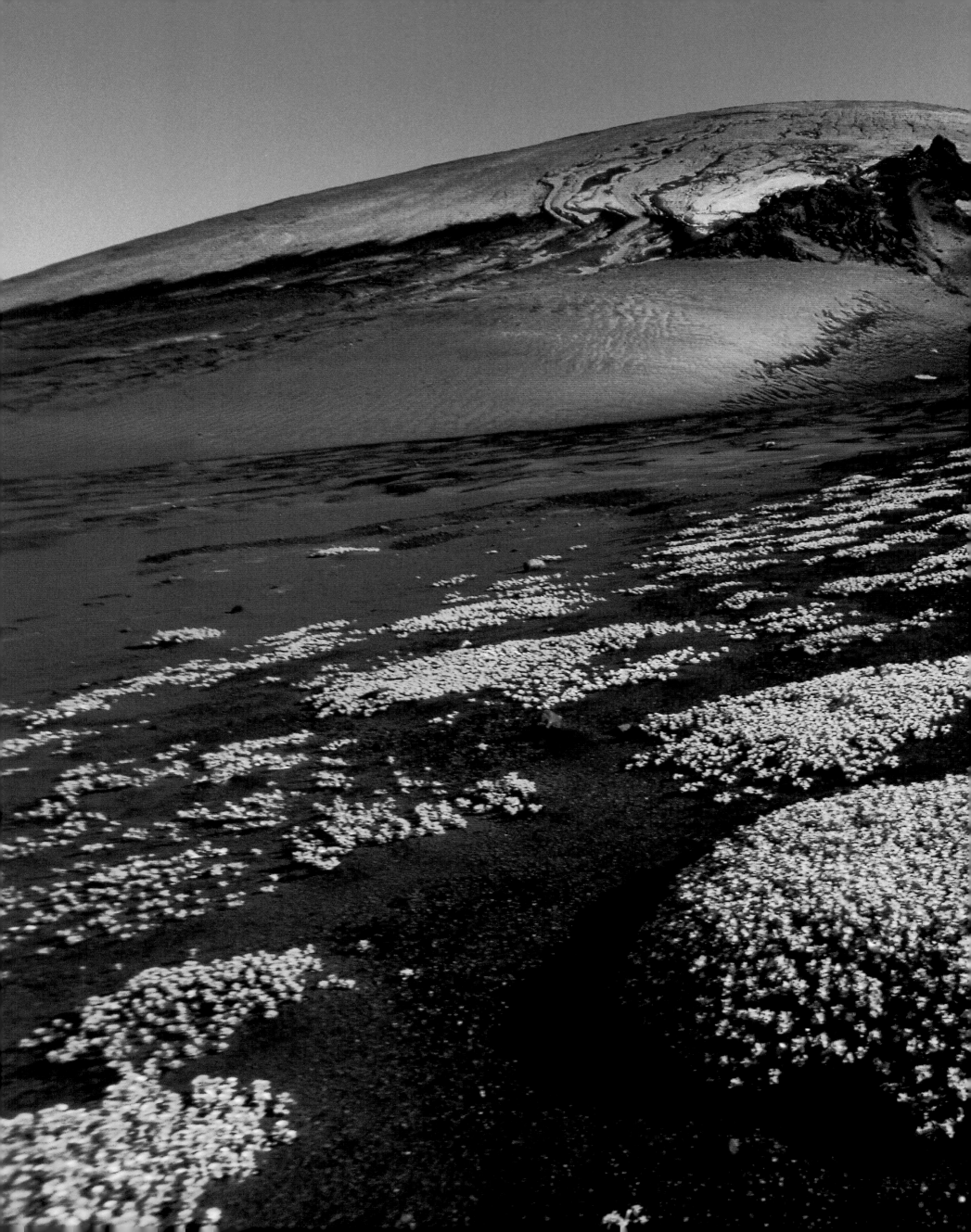

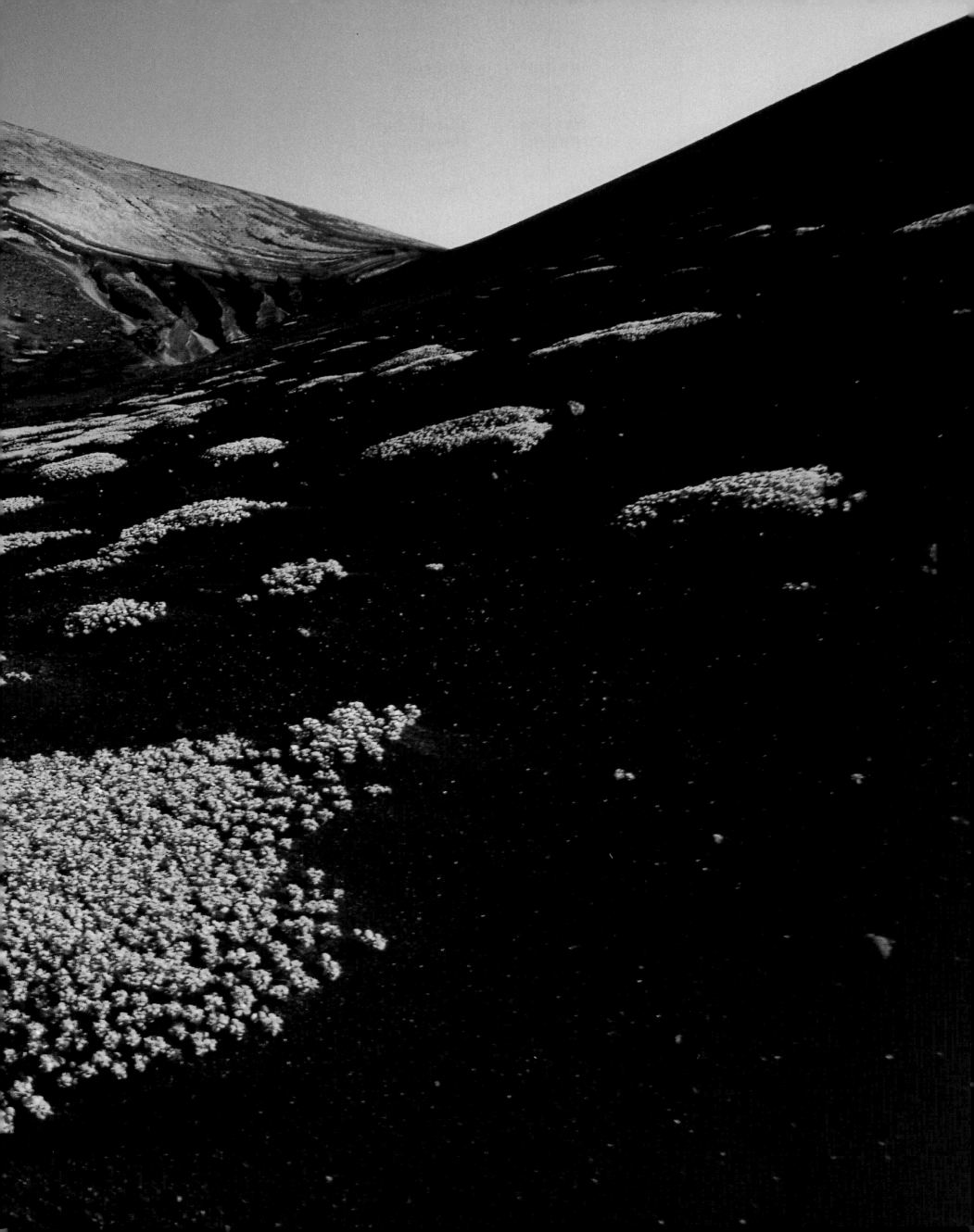

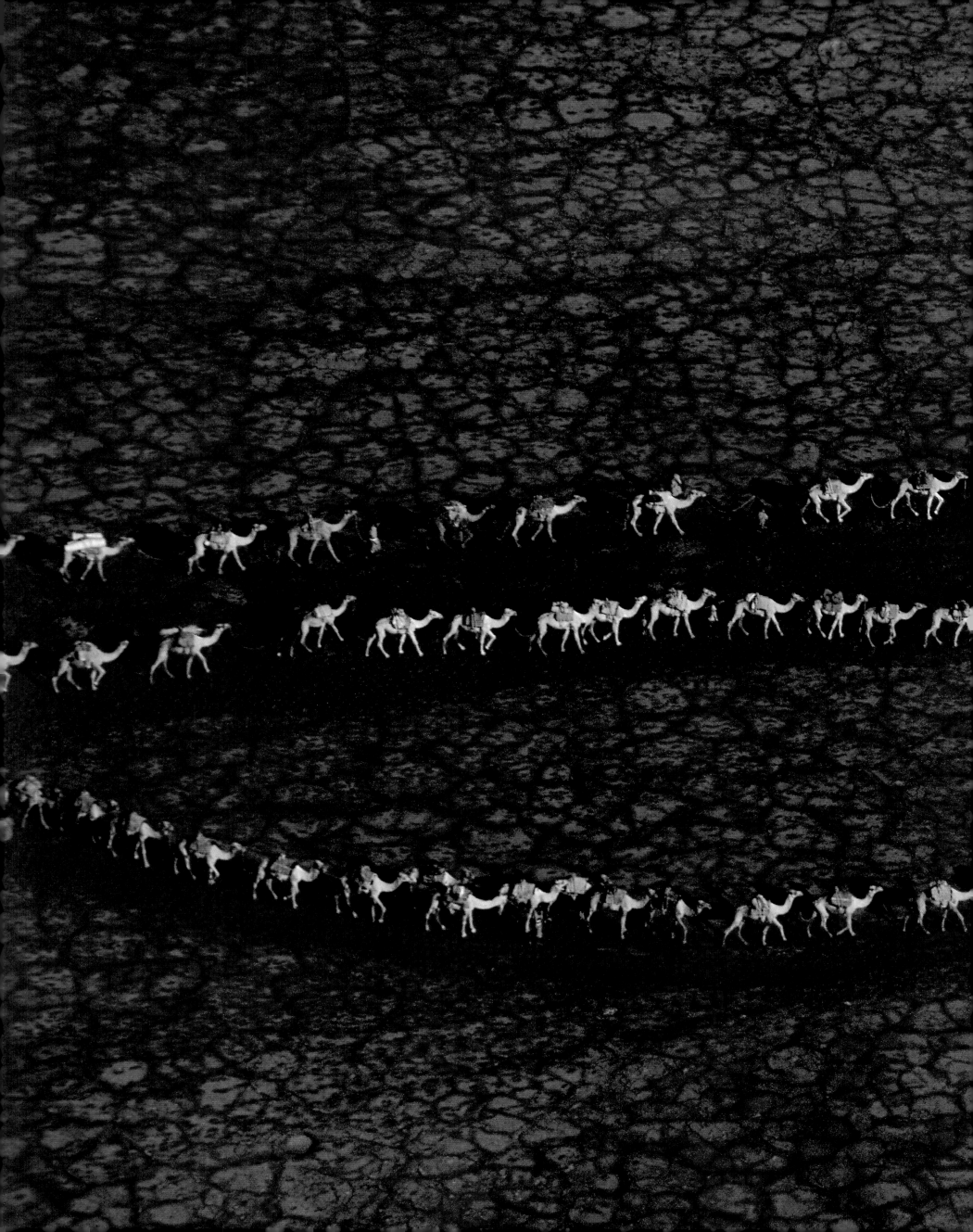

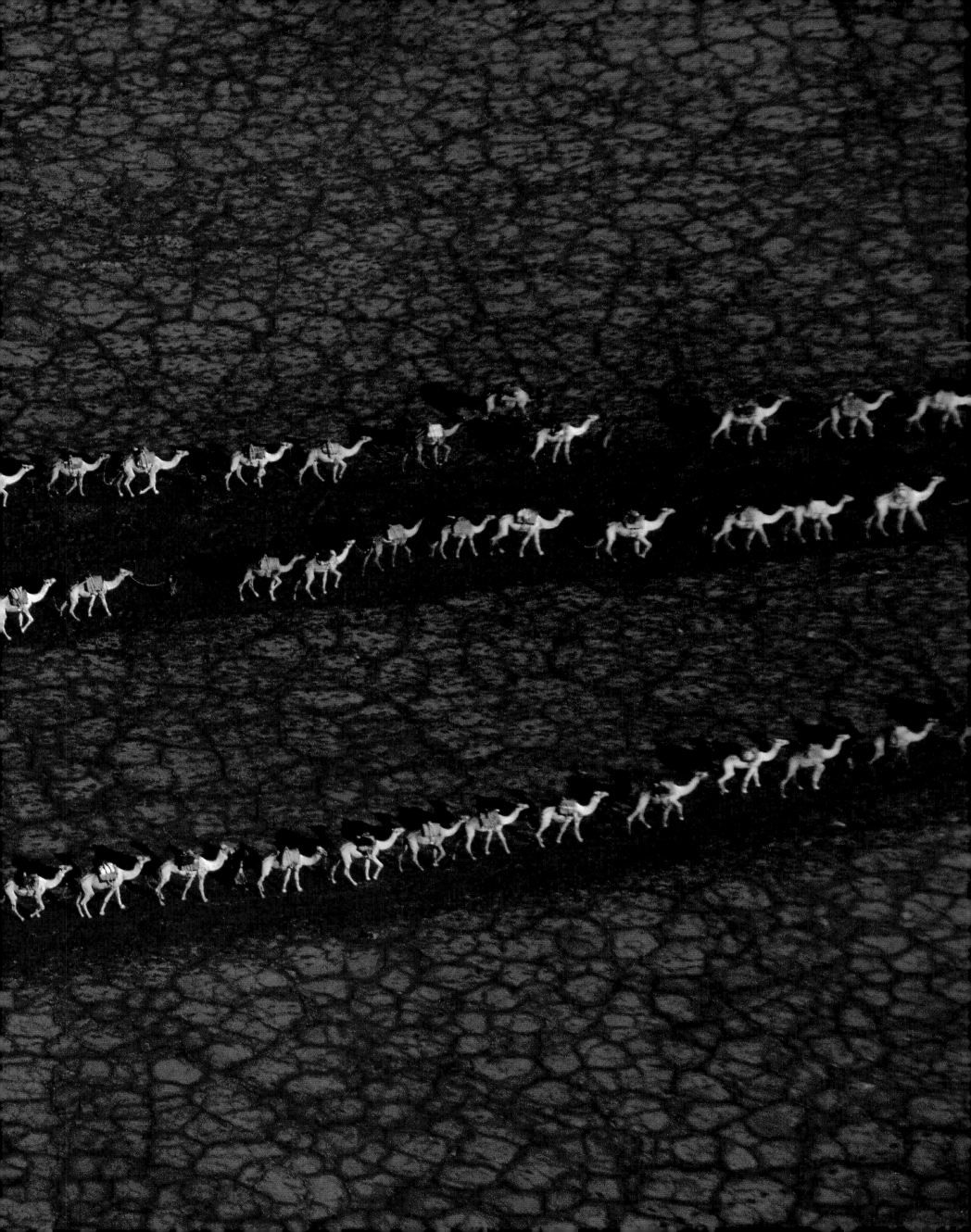

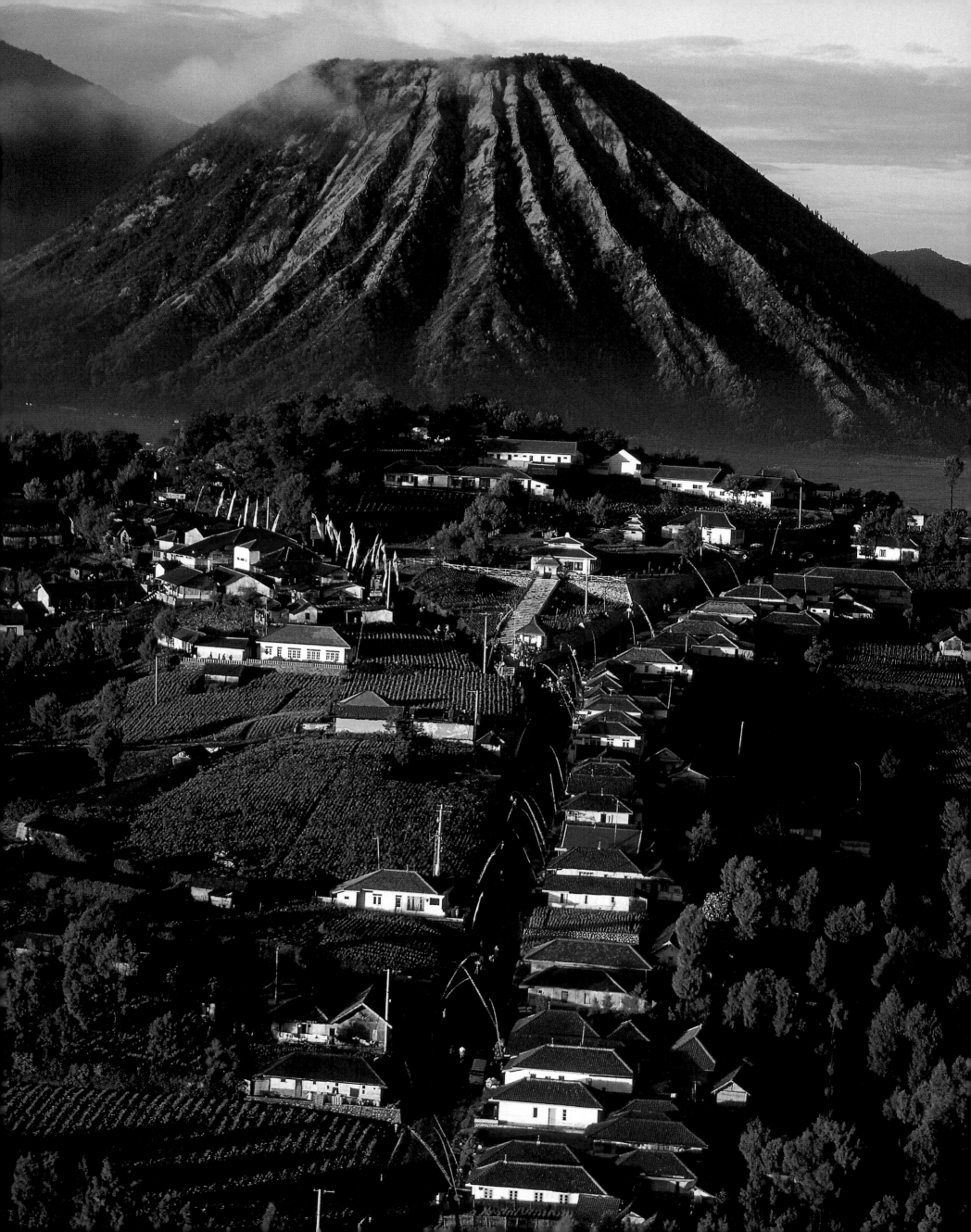

CEREMONIES

INDONESIA AND ITS VOLCANOES

As part of the Pacific fire belt, Indonesia has the world's greatest concentration of active volcanoes. The archipelago has a total of seventy-six that are potentially active. Statistics on volcanic eruptions have been kept only since 1600, but it is rapidly becoming clear that Indonesia is the country with the most frequent eruptions and the one that has had the most victims over the past four hundred years. We need only recall the eruption of Krakatoa in 1883, which left nearly 36,000 dead, or that of Tambora in 1815, which killed 92,000.

The eruptions are often violent, always explosive, and usually fatal for many. Despite this omnipresent danger, which has struck often in the past and will strike again in the future, people in Indonesia continue to live close to active volcanoes. The reasons for living in close proximity to volcanoes are many and diverse. Overpopulation and lack of space are increasingly pushing people to live in dangerous areas previously deserted. But, above all, these areas have the most fertile soils. Volcanic ash is rich in mineral salts that can be easily absorbed by vegetation. Each eruption throws out millions of cubic feet of this ash. For the farmers of Indonesia, it is a rich fertilizer that falls, free of charge, from heaven. It is a fertilizer that is easily soluble in the water that streams down the sides of the volcano. This water then floods the rice fields where it leaves a deposit of nutrients. The Indonesian farmer is thus able to obtain two or three rice harvests each year and to feed a population that is ever-growing.

For several generations, farmers living at the foot of volcanoes have well understood the risks they run, but they have integrated those dangers into their culture. Risk is part of life. They say themselves that fertile soil is a gift of the volcano, but that this wealth also comes at a price, even if the price is counted in human lives. In the end, for them, volcanoes always give more than they take.

The understanding between the farm people and the volcanoes is reflected in their religious beliefs. Although the ritual may vary, in a spiritual world of great richness, populated by gods, demons, and evil spirits, the fundamental idea is always the same. Volcanoes incarnate the forces of good, the forces of life, and they are also the origin of the world. The sea, by contrast, is the domain of the forces of evil, of ancestors, and of death. The whole of human life is an effort to live in harmony between these two worlds. Several diverse ceremonies, always linked to volcanoes, allow people to maintain or to restore a balance between the forces of good and of evil: to preserve the harmony of the world.

FESTIVAL OF KESODO, TENGGER, JAVA

Wednesday, 8 A.M.

A sea of sand, flat and empty, like a desert stretching to the horizon. The only notable difference is that here the sand is black and it occupies the bottom of a vast depression surrounded on every side by a high wall. At its summit, 650 feet above the bottom, one can see the sunlight that dances on the black sand. Here, too, there are mirages. Two small black points appear in the midst of this

mirage, two human silhouettes slowly advance. Subahir calls to me: "You see, they're coming from faraway. They're coming from the villages of Tengger, and tomorrow there will be more than 100,000 of us for the festival. We have to get started too, but first we need to prepare our offerings."

His fields are perched on the edge of the enormous depression. A dark soil, rich and moist, is cultivated in terraces that follow the curvature of the mountain slopes. Onion, cabbage, and potato are carefully aligned, not a single weed disturbs this fine garden. Quickly, Subahir fills a basket with vegetables. In the next field he selects a few ears of corn, then, taking the path toward the village, he assures me that he has rice, bananas, and chickens at home.

The village of Ngadisari is built on a wide ridge separating two deep valleys. All its houses are aligned on a steep slope. Neat foundations, fresh paint, a few flowers—the decor is typical of a mountainous landscape. Here, at a height of nearly 6,500 feet, we are far from the customary Indonesian habitat built beside a rice paddy.

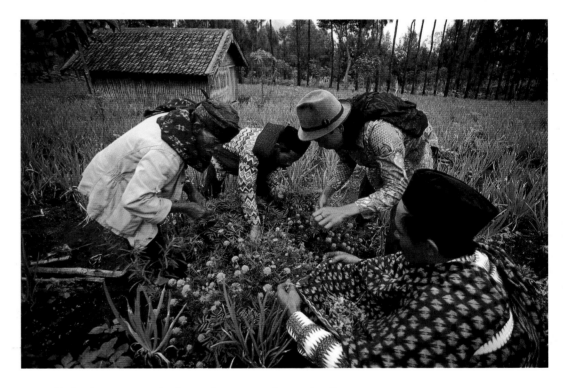

All the houses are built on the same plan. The front room is open to the outside through large windows, and there are tables and armchairs. This is typical of the hospitality of Tengger: The house welcomes anyone who cares to enter and the finest room is used for company. The kitchen is in the back of the house, and here the family lives, around the central stove where a wood fire is always crackling. Subahir's wife busies herself cooking a great pot of rice. It will later be placed in a mold and pressed hard. What emerges is called *tumpany,* a conical mountain of rice on a banana leaf in the center of a large tray. Subahir explains that this tumpany will be the centerpiece of the offerings. The cone shape recalls that of the mountain toward which the offerings will be carried, as well as a symbol of the principle of verticality, of ascension to the gods. Arranged around the tumpany are corn, bananas, vegetables cooked according to traditional recipes, chicken, and so on. People make offerings of all the produce or livestock of their home. On

ABOVE: Each year, during the festival of Kesodo, the priests' assistants (or *dukuns*) of the village of Ngadisari prepare collective offerings consisting of local agricultural products.

LEFT: The village of Ngadisari is located above the cliff overlooking Tengger caldera on the island of Java. In the background rises the profile of Batok, a volcano that is no longer active.

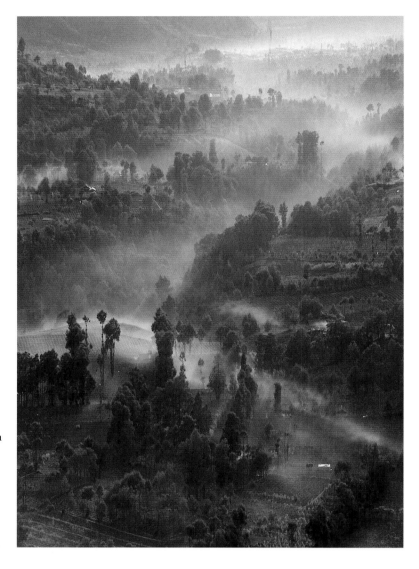

In the massif or mountain heights of Tengger a community of about 300,000 subsists today on agriculture. The population remains strongly attached to the ancient Hindu traditions.

other trays people prepare small piles of flower petals, charcoal, and a resin that is reminiscent of incense. Trays full of offerings are placed in the middle of the kitchen. There they will stay until the next day, the feast day.

Wednesday, 3 P.M.

At the bottom of the caldera, the uniformly black soil forms light clouds that alternately hide and expose those walking together near the central path. Ahead, a wide, low volcano sends up a great column of white smoke. This is Bromo, which will receive the pilgrims' offerings.

Pak Sujahi is the chief priest of Tengger, a sort of local pope. He has given us permission to follow most of the ceremonies of Kesodo alongside him and his priests and followers. At the foot of the slope of Bromo, a band of musicians is waiting, surrounded by their instruments. Nothing happens in Indonesia without music. These musicians come from Bali, where many people are Hindu. Often the Balinese come to join in the religious activities at Tengger.

The gamelan, an orchestra of gongs, cymbals, and drums, awaits the procession, which is to descend from the steep slopes. Above is a grotto in which a thin line of water drips. The water is considered sacred, and the priests will collect it for the blessing of the offerings. Soon a procession of men and women appears. All are wearing their ceremonial garb: dark brown or black sarong, black shirt or white jacket for some, black or yellow turban, sacred yellow sash. The ceremony in which we are participating is not public. It is normally open only to priests and their assistants and some of the men and women.

As soon as the procession of water bearers comes into sight, the musicians begin to play and the procession takes shape to the strains of music at the bottom of the caldera. There are still two miles to go across the sea of sand. The water that has been collected is carried in great bamboo stalks decorated with ribbons. In the procession the mood is both intense and good-natured. This is a religious ceremony, but it is also fun. Some people come from faraway villages and this afternoon provides the perfect occasion for exchanging news.

The temple, recently constructed, rises at the foot of the cone of Bromo volcano, in the center of the sea of sand. Protected by high ramparts, it contains the terraces used for prayers and the platforms intended for receiving offerings. Here the gods will descend to accept what is given to them. While the gamelan settles on a lateral terrace, the priests occupy the main terrace toward the volcano and the offering platforms. Facing the smoking volcano, about a hundred people are now concentrating. In the desert silence, a chanted prayer begins, which turns into a song softly accompanied by the gamelan. The service is led by a chief priest, invited by Sujahi, who is accompanied by a small boy six or seven years old. Dressed like the dignitaries, the boy takes full part in the ceremony. In fact, he is learning his profession, because he has been designated a future Tenggeri priest. But the ceremony is long for a small child, even one selected to lead it in the future.

Prayers and benedictions alternate, voices rise toward the volcano and the sky, while dusk slowly settles in the entire caldera.

Thursday, 6 A.M.

Subahir is waiting in front of his house with his whole family. Today they are going to present their offerings to the volcano. He wants to start early to avoid the crowds. He is accompanied by his elderly father, full Tenggeri on both sides, his mother, aunt, wife, and their two children. Once again we return by the path that crosses the whole village heading toward the caldera. Subahir explains that we are not to climb directly to the volcano crater, but instead we must stop before reaching it, at the "Watu Dukun," or priest's stone, a great volcanic projectile thrown long ago by an explosion of Bromo. Legend claims that here the god seized prince Raden Kusuma (see the story opposite).

The entire family stops in front of this rock. The women spread tablecloths on the ground while Subahir, near the rock, lights a few pieces of charcoal. Everyone sits in lotus positions around the elderly father, who will pray before Watu Dukun. First, he places a few pieces of resin on the small fire. This is a purification rite: the celebrant makes the gesture of washing his hands in the smoke and of capturing some of it to spread on his face. Duly cleansed, he is in a position to speak to the gods. A lengthy prayer is recited before the sacred rock, repeated by all members of the family. Then the tray of offerings is passed through the smoke from the resin and placed at the foot of the rock. A few flower petals, some rice, a cigarette, and money are all placed in a crevice in the lava. The ceremony ends as abruptly as it began, when everyone sits around the large plate of offerings—and eats them! The gods have descended during the prayer and taken what they wanted from the offerings. Their passage has sanctified the remainder of the food and, by eating it, people can partake of

MOUNT BROMO VOLCANO

Tengger massif is a large volcanic ensemble, crowned by a caldera, a depression eight miles in diameter formed by collapse. Five volcanoes stand in the center of the caldera. One, Bromo, is still active.

Bromo erupts with relative frequency. Most recently, there was an eruption in 1979, and another was under way in 2000 through the beginning of 2001. The eruptions all share the common trait of emitting only projectiles or ash, never lava. This ash inundated the bottom of the caldera. The deposit, more than 650 feet thick, forms a sea of sand, called *Laut Pasir*.

Outside the caldera, Semeru rises up over the entire Tengger. At 12,000 feet, it is the highest peak in Java. At regular ten-minute intervals, its crater is the site of violent explosions that emit vast clouds of ash. Occasionally, more violent eruptions with low-temperature pyroclastic flows endanger the villages at the foot of the cone. The whole volcanic massif of Tengger is marked by very steep slopes difficult to climb. Only one road provides access, leading to the village of Ngadisari and to the edge of the caldera.

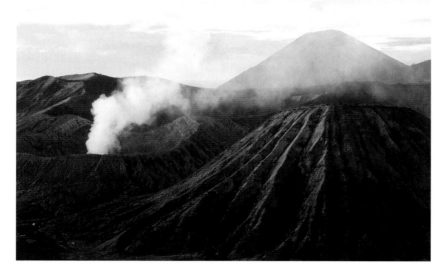

Caldera of Tengger, Bromo volcano, and in the background another volcano, Semeru. Java, Indonesia.

A LONG HISTORY

At one time all of Java was Hindu, and the religion was practiced by the ruling royal courts. When Islam appeared, although its conversion of the country was peaceful, many fled from the new beliefs. They included the members of the kingdom of Mojopahit. As Islam arrived from the west, they fled eastward.

In their exodus they encountered an enormous massif of mountains defended by steep ascents, and with rich soil favorable for agriculture. The farmers stopped here, while the nobles and artists continued on to Bali. In Tengger the farmers set up their villages and laid out their fields. They also continued to practice their traditions and their religion. Protected from the outside world, they preserved their way of life for

many years. Today Tengger massif is like an island emerging from Java. Above the low plains, where people of Muslim faith grow rice, there rises a compact mountain range inhabited by people who are considered "different." They do not speak the same language, but instead use old Javanese, and they worship Hindu gods. People below eat rice; here they cultivate green vegetables and eat pork. And everywhere there are dogs.

On arriving in the mountains, this small Mojopahit people was led by Prince Joko Senger and Princess Roro Ariteng. Abbreviations of their two names, "Teng" and "Ger," were contracted to form the name of the country. The couple loved each other but sadly had no offspring. One day, when they took refuge in a grotto of Mount Panenjakan, the founding god Hyang Widi ("Brahma" in classical Hinduism) appeared to them. He promised them twenty-five children if they would give up the firstborn to him, to live in his service. Of course they accepted and began having children. Happiness reigned in their family and in the whole region, the children grew, and the eldest, Raden Kusuma, was clearly their favorite. As time passed they forgot their promise and could not resign themselves to sacrifice their firstborn son.

The god grew impatient, and soon a series of misfortunes befell the kingdom. The crops started drying up, and then Bromo volcano rained down its ash. Wherever they went, the prince, princess, and their children were pursued by the fury of the gods. The royal family fled from one hiding place to the next, and one day, as they passed the foot of Bromo, fire leapt from the crater and seized Raden Kusuma.

Before he was swept into the depth of the crater, the young prince asked the people to make annual offerings to the god living in the volcano. These offerings were to be presented in memory of him, and to avoid the repetition of all the calamities they had known. This occurred on the day of the full moon of the fourteenth month in the traditional Javanese calendar, the month of Kesodo.

its blessings. It makes for an unusual and hearty meal under a smoky volcano.

Thursday, 3 P.M.

The path to the summit is steep. Now that it has reached the main core of the volcano, it runs straight up the hillside. The slope is so steep that an actual stairway has been built for scaling the last 650 feet. It is quite a crowded staircase, in fact, since two flights of steps channel a continuous flow of people who go up on one side and down on the other.

At the peak, we quickly reach a narrow ridge, only 10 to 12 feet wide. On one side is the slope of the volcano cone; on the other stands the crater wall, nearly 1,000 feet of a vertical face leading up to active mouths. Surrounded by sulfur, they emit a great cloud of gas and water vapor. When the path returns to the crowded ridge, all we can hear is a cacophony of various coughs and sneezes. The sulfurous gases are especially irritating.

Several hundred persons crowd together on this ridge, moving in all directions, but all of them are equally fascinated by the spectacle of the crater. They come to pray, but their first reflex is to watch what is happening at the bottom of the volcano. Then they exchange comments on the view, the gases, and the coolness that prevails up here. And to recover from the exertions of the long climb, they light a cigarette, the eternal Indonesian remedy of the clove-flavored *kretek*.

Only later does anyone consider the true purpose of the excursion. And then, everyone wanders along the ridge, each trying to find a small flat area that is not too crowded. There they must spread a cloth, light a charcoal fire, and burn incense. There is no more sightseeing now and no more gawking. There is nothing now but prayers and offerings. In prayer, both hands, held together at the temple, hold a few flower petals between their index fingers. After the prayer, the petals are cast into the crater like a message launched toward the gods. This is repeated several times, in intense contemplation and sometimes with harsh exchanges preceding the painstaking selection of offerings that serve as a basis for prayers.

Once the prayers are over, people relax and amid laughter they throw handfuls of the principal offerings into the crater. Subahir holds a live chicken brought from his farm, the centerpiece of his procession of offerings. When he drops his hands, the chicken takes off, flying awkwardly toward the void. But two arms suddenly leap out of the crater and snatch it in full flight. Could this be Raden Kusuma, come in person to seek his due? By leaning over the crater rim, we see several dozen people clinging to the walls. Men, women, and children have dug tiny platforms for themselves in the compacted ash that forms the walls of the crater. They move with amazing dexterity that seems to deny the danger of hanging over the deep pit. Everyone leaps, runs, climbs, and descends each time an offering of any size is thrown from the ridge. These observers have not come here to pray; they are here for what they can get. They, too, make up about 100 people. The contrast between their squealing and the calm, reflective pilgrims is somewhat surprising.

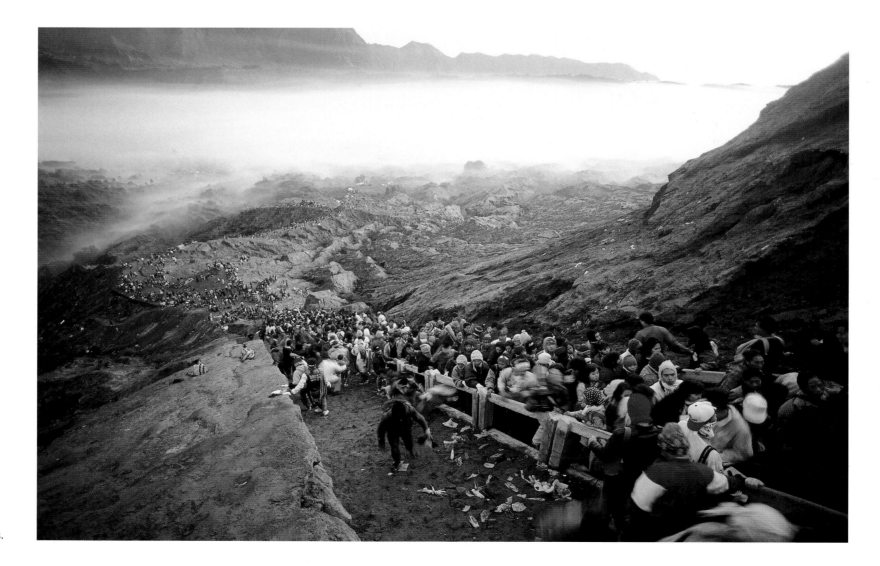

In the festival of Kesodo, long lines of pilgrims parade for several days on the heights surrounding Bromo volcano, to which they bring gifts.

The pilgrims, for their part, seem unconcerned that their offerings are falling into impious hands. Smiling, they explain that the "retrievers" come from the low plains of Java. That is, they are Muslims, they do not believe in the ancient gods and consider the offerings as nothing more than consumer goods with no religious value. As Subahir repeats, what counts is the gesture of the offering. The gods, in passing through, will surely take what is their due. And the pilgrims can be seen at various points along the ridge handing the valuable offerings—chickens, cigarettes, money—from their hands into those of the Muslims. There is no point in wasting anything.

Thursday, 9 P.M.

All day long, the crowd occupying the bottom of the caldera has been growing. Most of the pilgrims are there by now and various small trades spring into action. There are numerous peddlers of drinks, as well as young men trying to sell their photographic skills by taking shots with an instant camera. Every 100 yards, women spread tablecloths around an oil stove. Here we find nonstop tea service, there we can buy banana fritters. Near the village, a real carnival has taken shape, and the gathering offers the perfect opportunity for exchanges and commerce. In Ngadisari today, one finds everything: clothing, pots and pans, jewelry, shoes, bonnets, woolen gloves, fresh foodstuffs, grain, and so on.

All the frenetic activity calms down at nightfall. Then the great migration begins. In fact, everyone must gather in the caldera, between the temple and the crater, in the middle of the night. The trails that are accessible by all-terrain vehicles are patrolled by the Indonesian police, and starting at 11 P.M. an immense traffic jam can be seen. It will not be unblocked until twelve hours later. Meanwhile, many pilgrims, stuck in place along all the roads in the region, are unable to reach the village of Ngadisari, the entryway into the caldera.

Around the temple, the crowd gathers. Each village or neighborhood has assembled collective offerings on a kind of bamboo scaffold on which people have attached ears of corn, potatoes, sugarcane stalks, clumps of vegetables. The base is sometimes formed by a large wooden chest, which displays cooked dishes and pieces of fabric. Each village delegation, accompanied by its priests, has placed the large offerings in front of the prayer platforms of the temple. With the light of only a few lamps, a dense cloud of incense can be seen rising from the temple courtyard, competing with the cloud rising from the volcano's crater. The omnipresent volcano forms a striking backdrop. It is covered with thousands of persons, seen only by the lamps they bear. It looks something like a mountain of stars in the sky.

For several hours, the priests and their assistants face the volcano and pray over the offerings. At the same time a denser crowd blocks the stairway that leads up the cone. Step by step, the parade that blocks the stairway moves forward and grows even thicker on the rim of the crater. No one wants to miss the climactic moment.

Friday, 5 A.M.

The great offerings, blessed by the priests several hours ago, now have to be brought to the crater. Once outside the temple, the carriers are immobilized by the crowd and must battle their way. The priests push the offerings, pull them, bump against them, and sometimes even blithely shove away anyone blocking their way. It

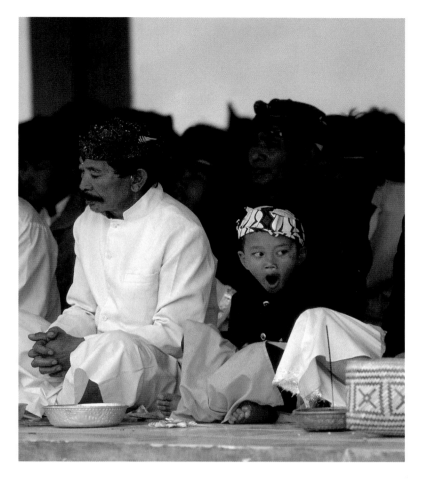

Religious rites and prayers in Poten. The little boy has been selected as the future High Priest.

is essential to reach the summit to present the offerings before sunrise, and the mile and a half between them and the summit may prove to be slow going. At a certain point, nothing moves, and the offerings are finally released by their faithful stewards and pass from hand to hand up toward the summit.

The horizon shows hints of color, and light slowly appears. Everone feels the anticipation of the coming event. In one final effort, the offerings return to the hands of the priests. As soon as they have got hold of the bamboo scaffolds, they throw them into the void without hesitation. The entire crowd lets out a shout as the offerings disappear into the shadow and smoke of the crater. The faithful are answered by the cries of the "retrievers," on whom this heavenly manna has rained down.

The gods, too, must be content. They have received their offerings, pledges of Tenggeri fidelity to the promise given by Raden Kusuma. On the horizon, the sun emerges and its first rays lend a pink tinge to the ridge and the crowd massed at the summit of Bromo. A new day is born in Tengger, promising a new year of happiness and prosperity, guaranteed by the respect of Kesodo tradition.

THE CEREMONY OF LABUHAN

The ceremony of Labuhan is an offertory ritual organized by the family of the sultan of Jogjakarta. The offerings are made to the guardian divinities of the kingdom, notably to the goddess Ratu Kidul of the southern seas and to the spirits of the volcano of Merapi. As always, we see here the duality that is dear to Javanese beliefs: sea and mountain, water and fire.

According to ancient legend, an ancestor of the present sultan was brought by Ratu Kidul into her undersea palace on the eve of a

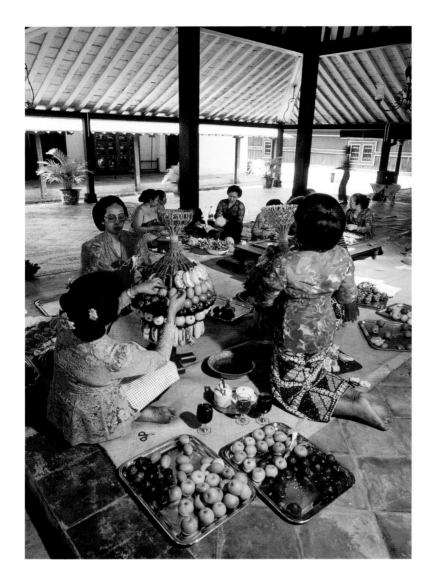

Offerings for the gods are prepared by the women of the royal family and their female servants in Kaputren, the Kraton women's district.

consequently to advance the well-being of the native population. The royal family's role here is as intercessor between people and gods.

The offerings are prepared entirely in the Kaputren, the women's district of the Kraton. It is the residence for all the women in the royal family, the sultan's wife, sisters, aunts, cousins, sisters-in-law as well as all the female servants in the palace. The first offerings are composed of flowers and fruit. First, the serving women separate the petals of numerous flowers to decorate the trays of offerings and also to create "artificial" flowers or necklaces. The fruit is decorated and assembled into great compositions. The queen, wife to the sultan, assembles the form of a bird cut out of grapefruit rind and decorated with flowers. This bird is the symbol of the Jogjakarta monarchy.

The majority of the offerings consist of cakes prepared by the women of the royal family. To start, they take a pile of flour equivalent to the sultan's actual weight. Baked by the queen, these cakes are meant to become the very body of the sultan. They form the centerpiece of all the presentations of offerings and then are shared among the palace staff, the Abdidallem. These servants redistribute their portions of cake among their families and more distant relations. Consumption of the cakes conveys the sultan's blessing and his protection. The rite is reminiscent of the Holy Communion practiced by many Christians.

The most sacred offerings, however, are the clothes the sultan has worn during the past year, as well as his hair and nail cuttings. The Abdidallem carefully arrange these offerings and take a detailed inventory according to a ritual list. If this list were not entirely accounted for, the ceremony of offerings would lose its power. The various objects are placed in wooden chests, each marked to indicate its contents and destination.

Still organized by the women, the first procession takes place inside the palace. With this procession the offerings are raised to a pavilion called Bangsal Kencono. In this throne room, the longest or most sacred ceremonies are held. Inside the pavilion is the Bangsal Proboyekso, the room where the royal treasures are preserved, including the sultan's *keris,* or magic daggers. These two rooms are the most sacred precinct in the palace, imbued with the sultan's divine presence, whether or not he is physically present. In fact, for the Javanese, the sultan is always present wherever the insignia, treasures, or magic arms are situated. While the offerings are put in position, the sultan reveals himself, first in the form of the cakes that have become his body, but his spirit and his power are also there. The eldest serving woman in the palace leads the procession carrying a sheath containing three metal blades representing the sultan's three principal virtues. An iron blade symbolizes power, a silver blade stands for purity, and a golden blade represents divinity. All participants in the offerings ceremony will pay homage to these symbols—a true personification of the sultan.

Once the offerings have been presented in the Bangsal Kencono, they are passed from the hands of the women of the royal family and the female servants into the hands of the Abdidallem. The Abdidallem organize another procession inside the palace to carry the offerings into a room where they will be divided into two portions to be sent to separate destinations.

Still carried by the Abdidallem, the offerings then go outside the Kraton enclosure. The Labuhan ceremony, a private one up to this point, now becomes public. The offerings, brought in by two

decisive battle. There the goddess was said to have initiated him into the art of war as well as into the secrets of love. It was at this point that Ratu Kidul gave her protection not just to the successive sultans but also to all their subjects. This belief remains strong today. During the sultan's coronation ceremony in March 1989, people reported that a sudden, scented breeze had wafted over the audience, proof that the goddess had passed by and that she would always be present at the sultan's side.

The volcano of Merapi, for its part, represents an idea of verticality, or elevation. The volcano is the sultan, and the sultan is the volcano. Moreover, the word *merapi,* or "mountain of fire," also means courage, strength, power: the sultan bears "merapi" in his heart. The sultan also represents verticality, or an elevated position in the world of humans. By his courage, his exemplary conduct, his piety, he serves as an example and a guide to his subjects.

The sultan's alliance with the spirits of the Merapi volcano is also a pledge of protection for the people against possible eruptions. In all the villages the story is told of the sultan Hamengkubuwono IX, who, on climbing the sides of the volcano to see the damage from the latest eruption, picked up a stone and threw it toward the crater, commanding the volcano to cease. The eruption subsided at once. This strong belief in the alliance between the sultans and the spirit of Merapi is shared by the entire population living at the foot of this dangerous volcano.

The people participate little, if at all, in the Labuhan ceremony, even though it is organized to ensure harmony in the world, and

different processions, head for their final destinations. One procession starts for the coast, south of Jogjakarta, toward the beach of Parangkusuma; the other goes northward toward the slopes of Merapi volcano.

Before the seaside ceremony, all the offerings are unpacked in the village hall of honor. The inventory of these items, conducted in public, is the guarantee for everyone that the traditional rite is being duly respected. Then the offerings are unpacked into wide baskets of bamboo weighted with large stones. Accompanied by the crowd, they are carried in procession toward the beach to be given to the goddess Ratu Kidul.

For all the inhabitants of Java, everything that comes out of the Kraton is sacred, and every object touched, or especially worn, by the sultan is imbued with magic power. Offerings to the goddess of the southern seas, consisting of clothing, the sultan's hair and nails, are thus sought after for making amulets. Often, a battle breaks out among the palace servants, who want to make offerings to Ratu Kidul by casting them on the waters, and members of the population who want to acquire their own magic object. The offerings eventually end up in the hands of the population. But first they have been submerged in water, and everyone believes the goddess has taken whatever she desired as she passed by.

The second part of the offerings goes toward the Merapi volcano. Carried in a solemn procession, they are brought above the treeline to just below the active crater. During a brief religious service consisting of prayers and the consumption of a meal prepared in the Kraton, the offerings are given to the spirits of the volcano and left on the slope. None of the faithful are here; the spot is too sacred and no one would dream of disturbing it. The offerings are not removed, and the gods can enjoy them at their leisure.

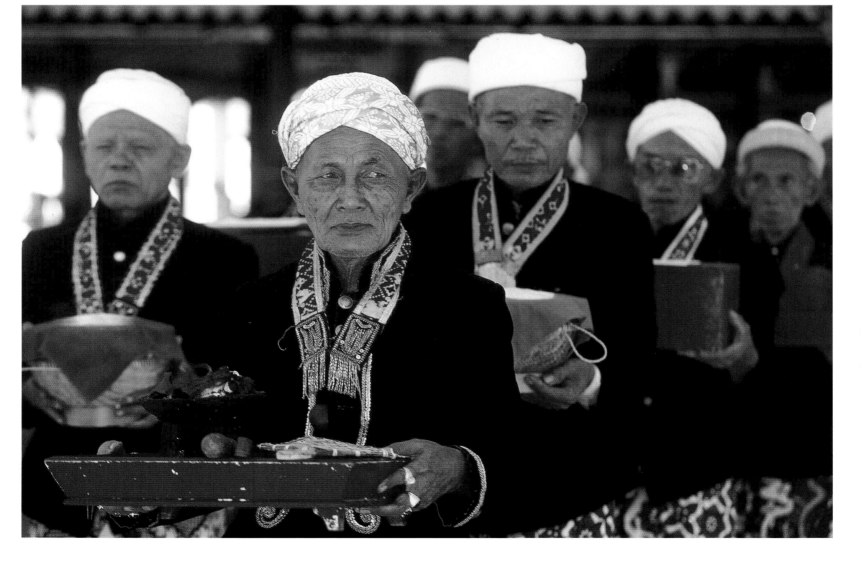

The most sacred offerings—clothes worn by the sultan over the course of the preceding year—are placed in small chests borne by the palace guards, the Abdidallem.

PAGE 89. Numerous volcanoes, scattered all along the arc of the Aleutian Islands, are the product of the convergence between the Pacific and North American tectonic plates. They have to be carefully monitored because a major airline corridor passes over this region. Alaska.

PAGES 90–91. A river tinted by the mineral salts emitted from volcanoes. Iceland.

PAGES 92–93. Ryolitic mountains in the region of Landmannalaugar. Iceland.

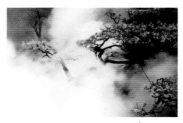

PAGES 94–95. The hot springs of Beppu all originate from volcanoes. The colors of the various basins are due to salts dissolved in the water. Japan.

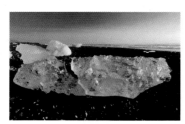

PAGES 96–97. Ice deposited on a beach of ashes by the subglacial eruption of Vatnajökull. Iceland.

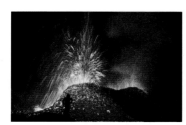

PAGES 98–99. A volcanologist observes the formation of a cone during an eruption of Piton de la Fournaise (Furnace Peak). Cones are volcanic formations ranging in height from 7 or 8 feet to hundreds of feet, the result of accumulations of expelled material from explosions around an eruptive orifice. Réunion.

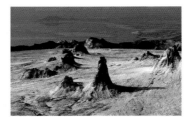

PAGES 100–101. Volcanic crater, marked by eruptive chimneys and ancient flows of carbonatite. Oldoinyo Lengai volcano, Tanzania.

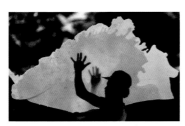

PAGES 102–3. After sulfur has been purified in a treatment plant, it is spread in liquid form on cold, damp soil. It crystallizes very quickly into fine, solid plates. Kawah Ijen volcano, Indonesia.

PAGES 104–5. Saline springs within recent lava flows on the bank of Lake Turkana. Great Rift Valley, Kenya.

PAGES 106–7. Flows of smooth lava advance to form lobes superimposed in layers. A thin film forms on their surface once the lava comes in contact with the air. Here, a bubble of fresh lava has just solidified. Kilauea volcano, Hawaii.

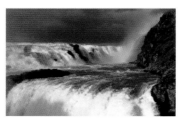

PAGES 108–9. During and after eruption, volcanoes release enormous quantities of water vapor. The water comes directly from terrestrial magma (molten rock). This is how the water cycle starts: water vapor condenses and soon falls onto the earth's surface; from stream to stream, the waters gather in torrents and then rivers. Their course erodes the original landscapes and forms a new earthly contour. Iceland.

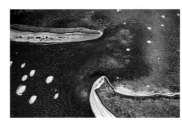

PAGES 110–11. Aerial view of Lake Natron, where the brine has been colonized by red algae. Tanzania.

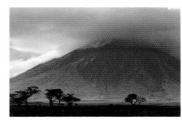

PAGES 112–13. Rising from the deep rift between pasturelands, Lengai is the holy mountain of the Masai people. They believe that their god lives in its crater. Oldoinyo Lengai volcano, Tanzania.

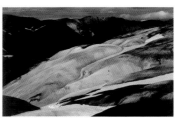

PAGES 114–15. Volcanic smoke and gas have corroded the rocks almost to the point of obliteration. The rhyolite (light-colored volcanic rock) of Landmannalaugar thus takes on an unusual appearance. Iceland.

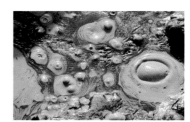

PAGES 116–17. On the flanks of Krafla volcano, large fractures from eruptions in 1975 and 1984 make for ideal release spots for rising vapor and hot water. The volcanic rocks are decomposed by acidic emanations and then attacked by rising hot water, thus forming mud that is thrown up by gases in large dough-like bubbles. Iceland.

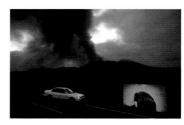

PAGES 118–19. Shelters, such as this one, have been built along roads for protection of motorists in case of sudden explosion of Sakurajima volcano. Japan.

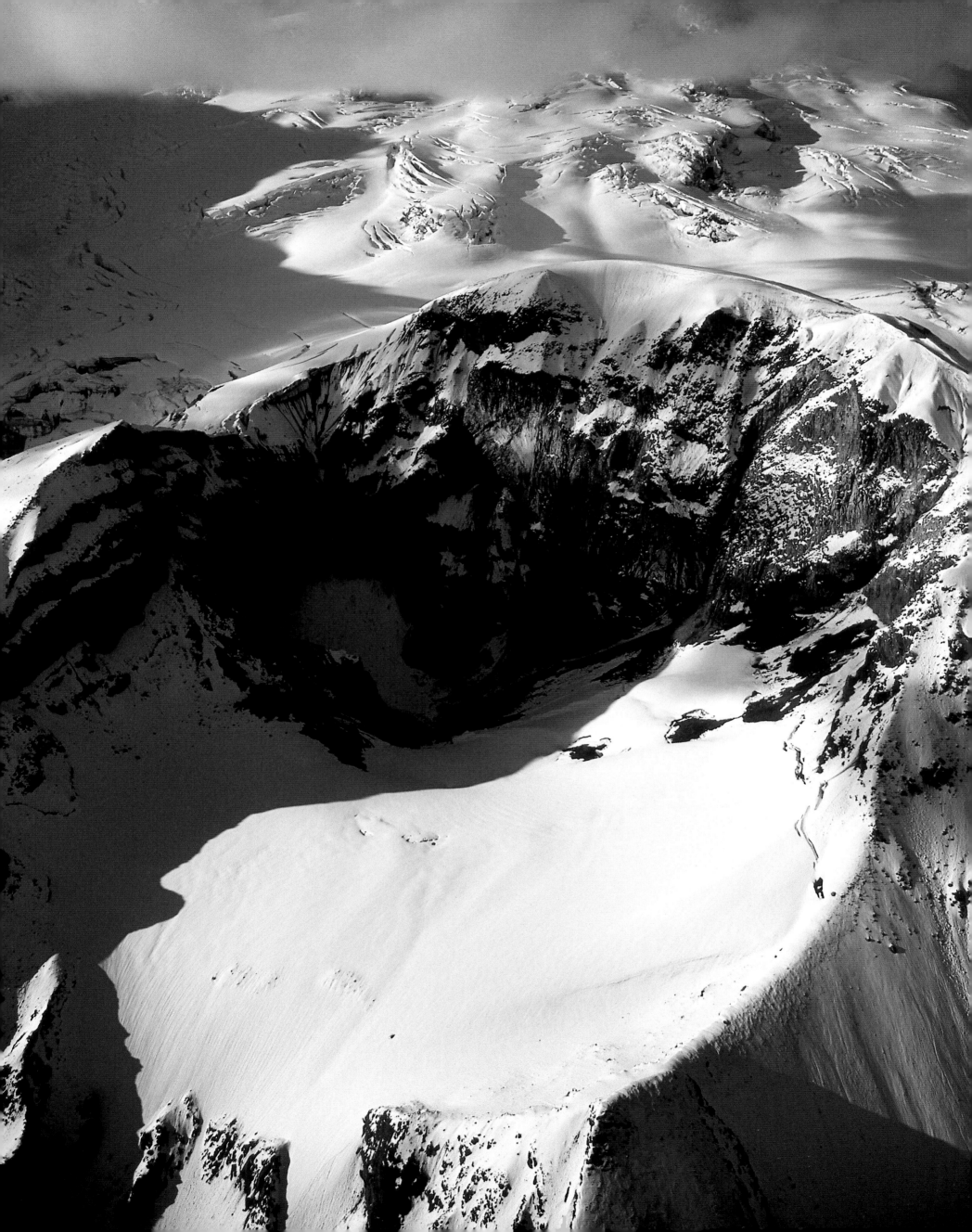

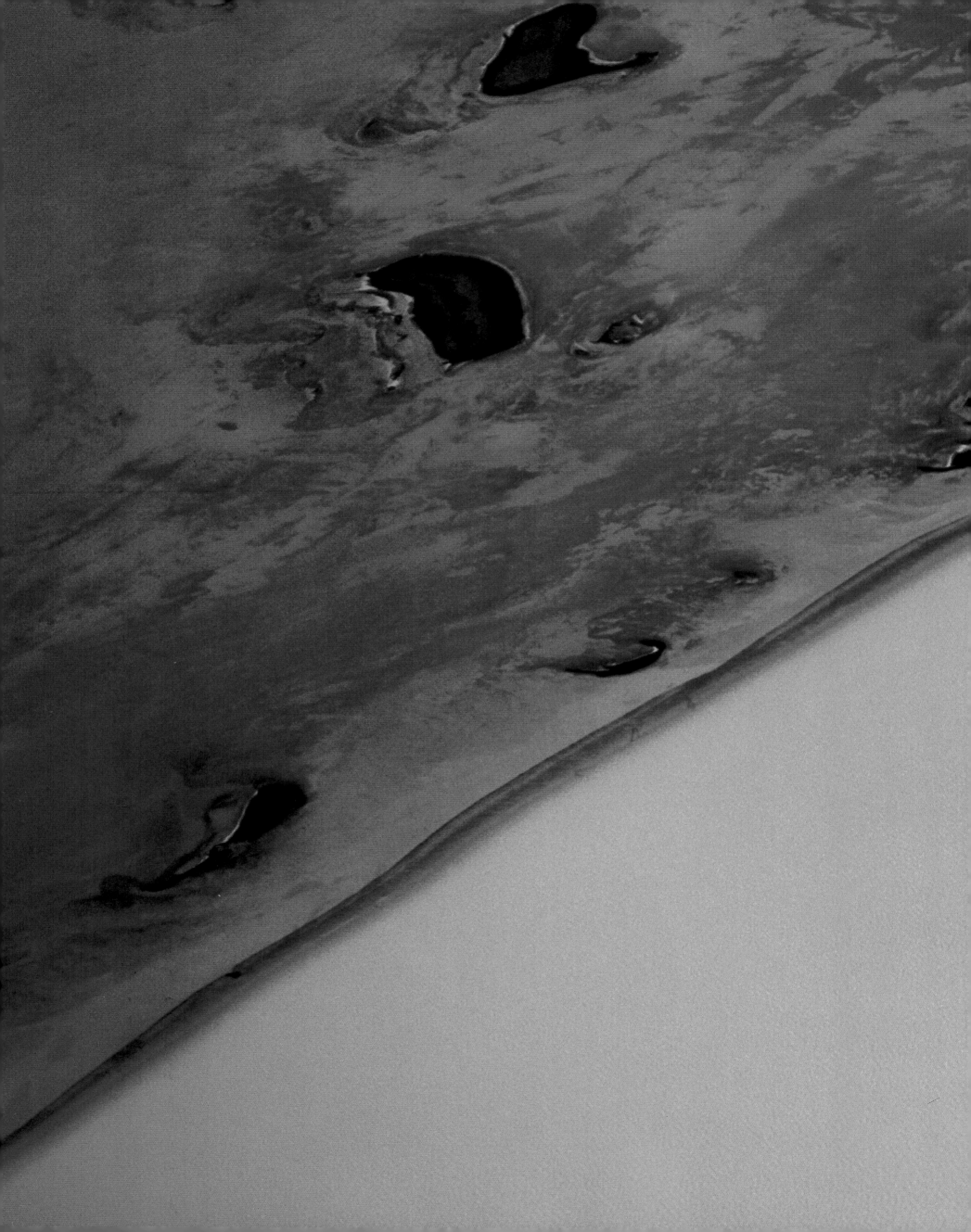

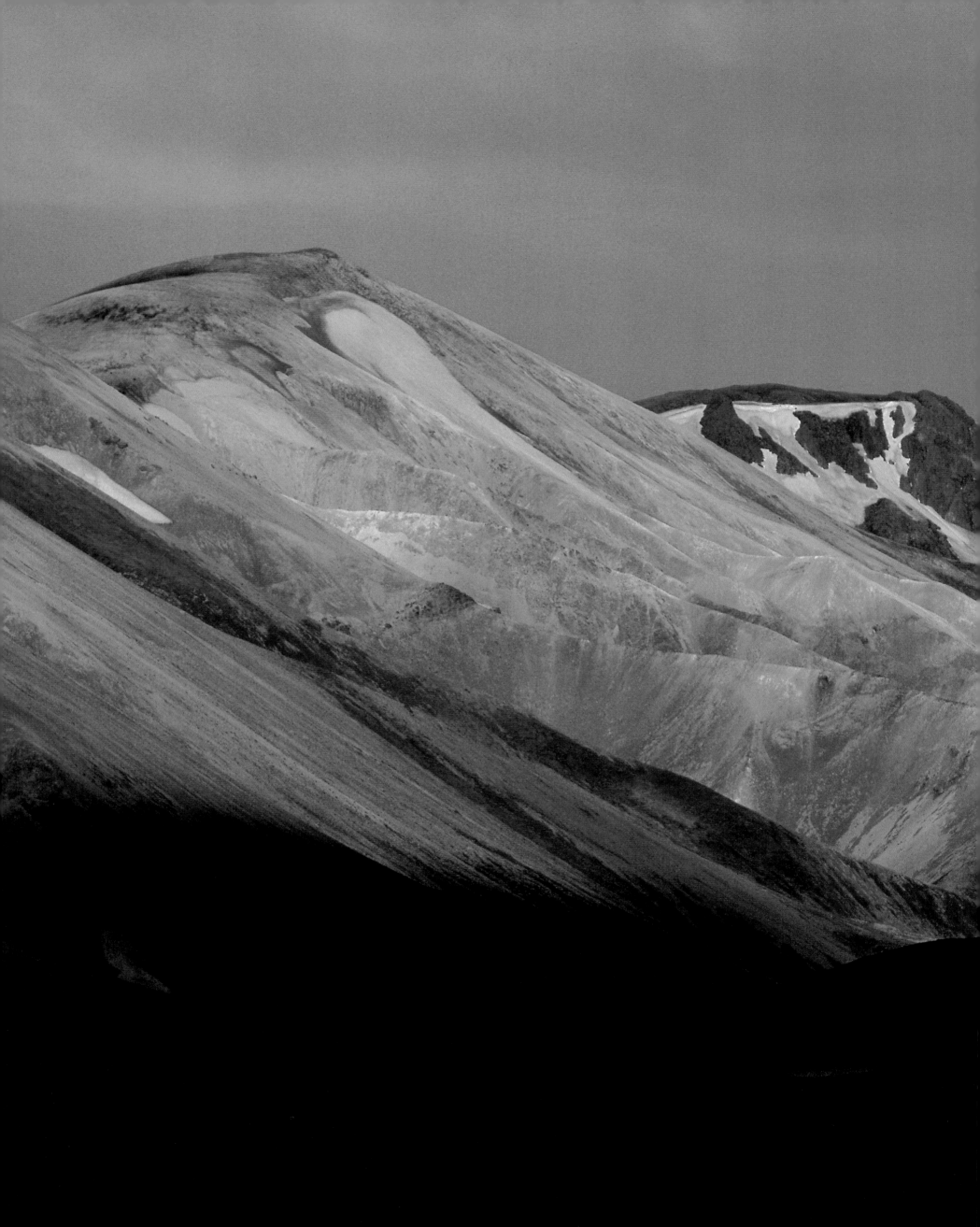

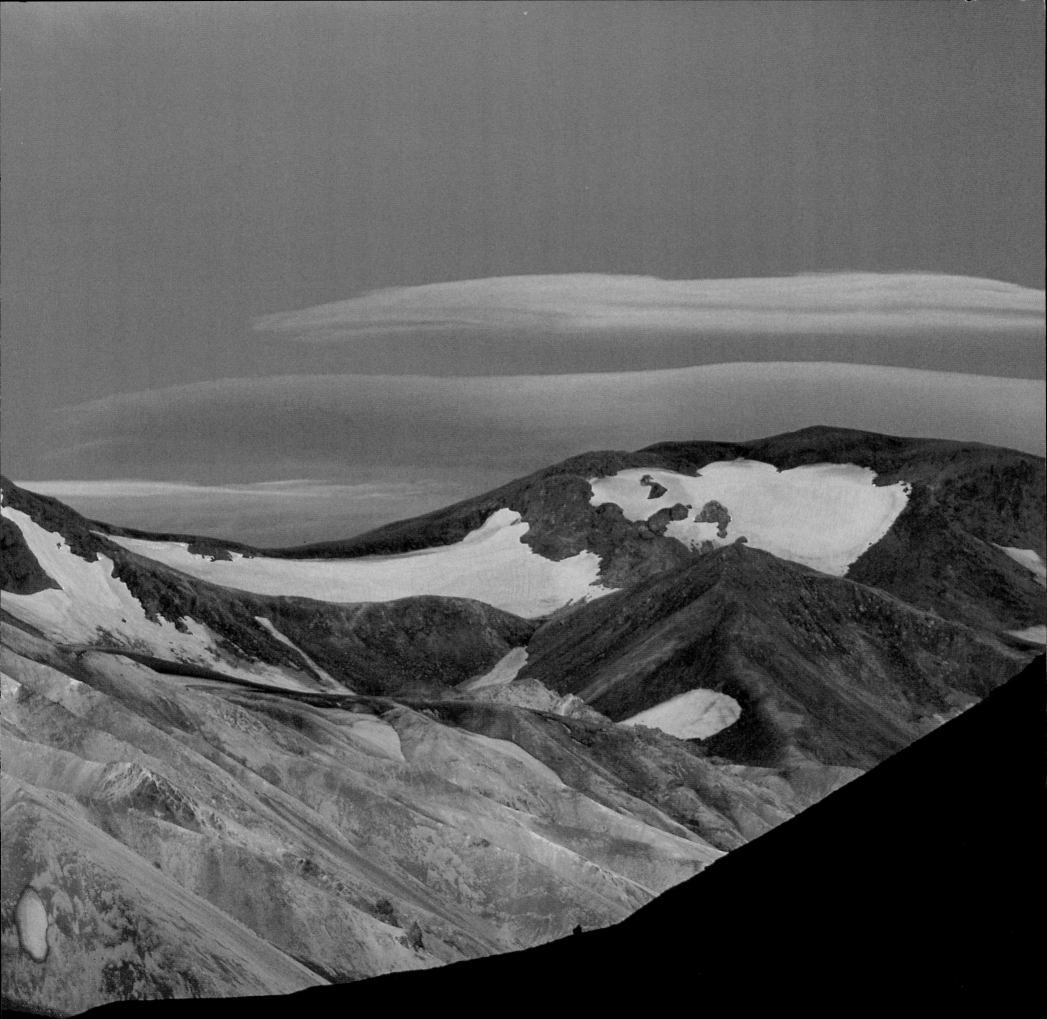

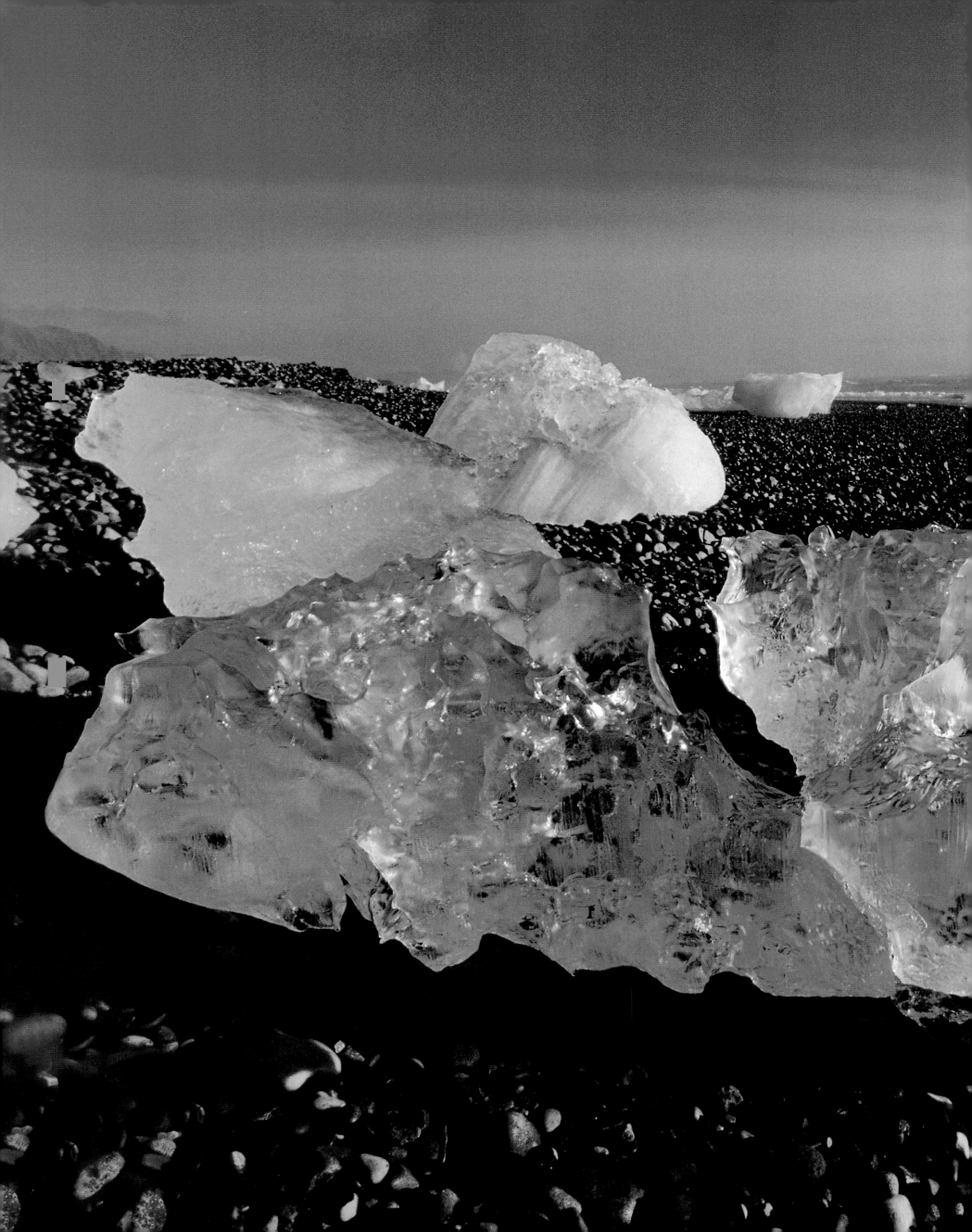

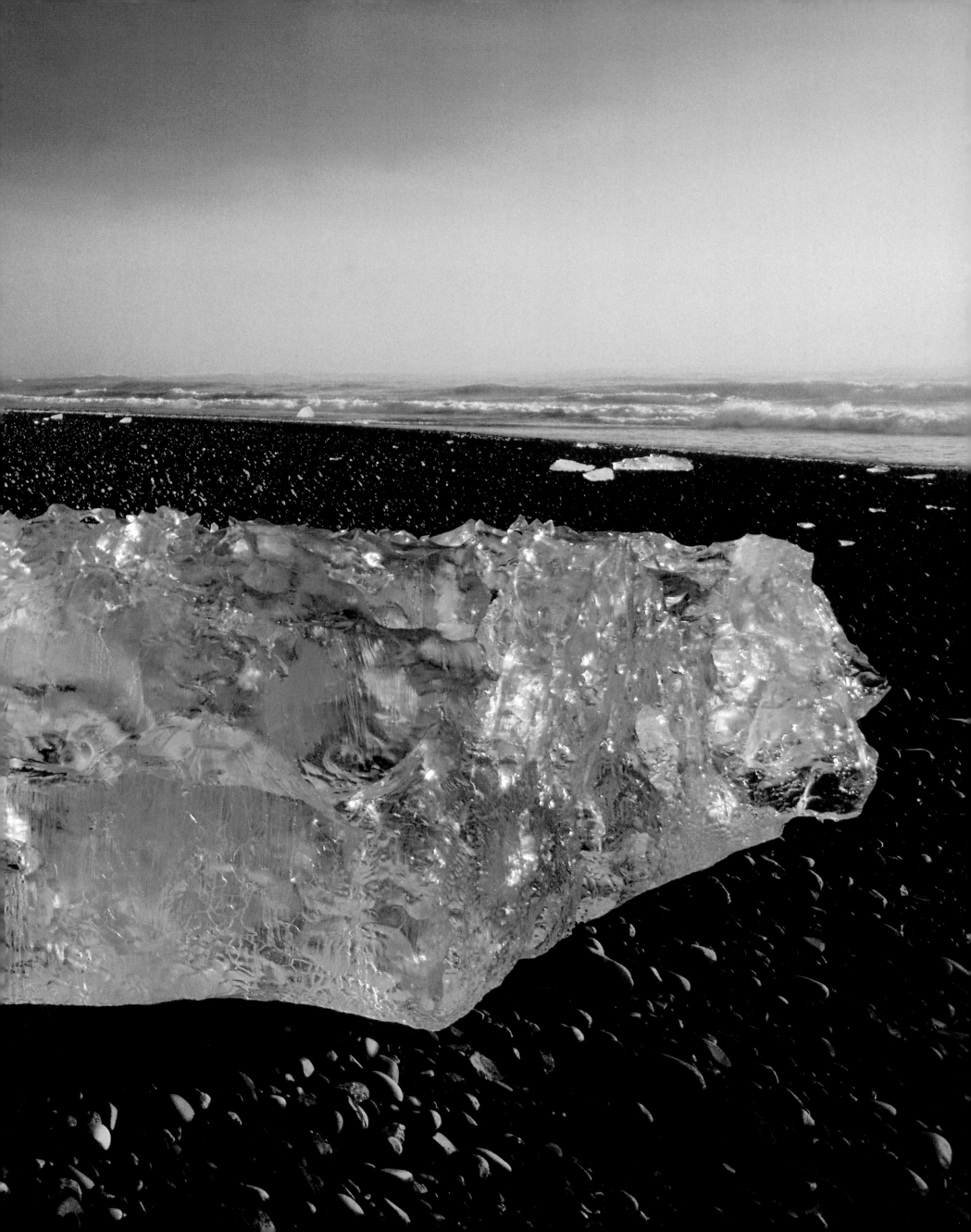

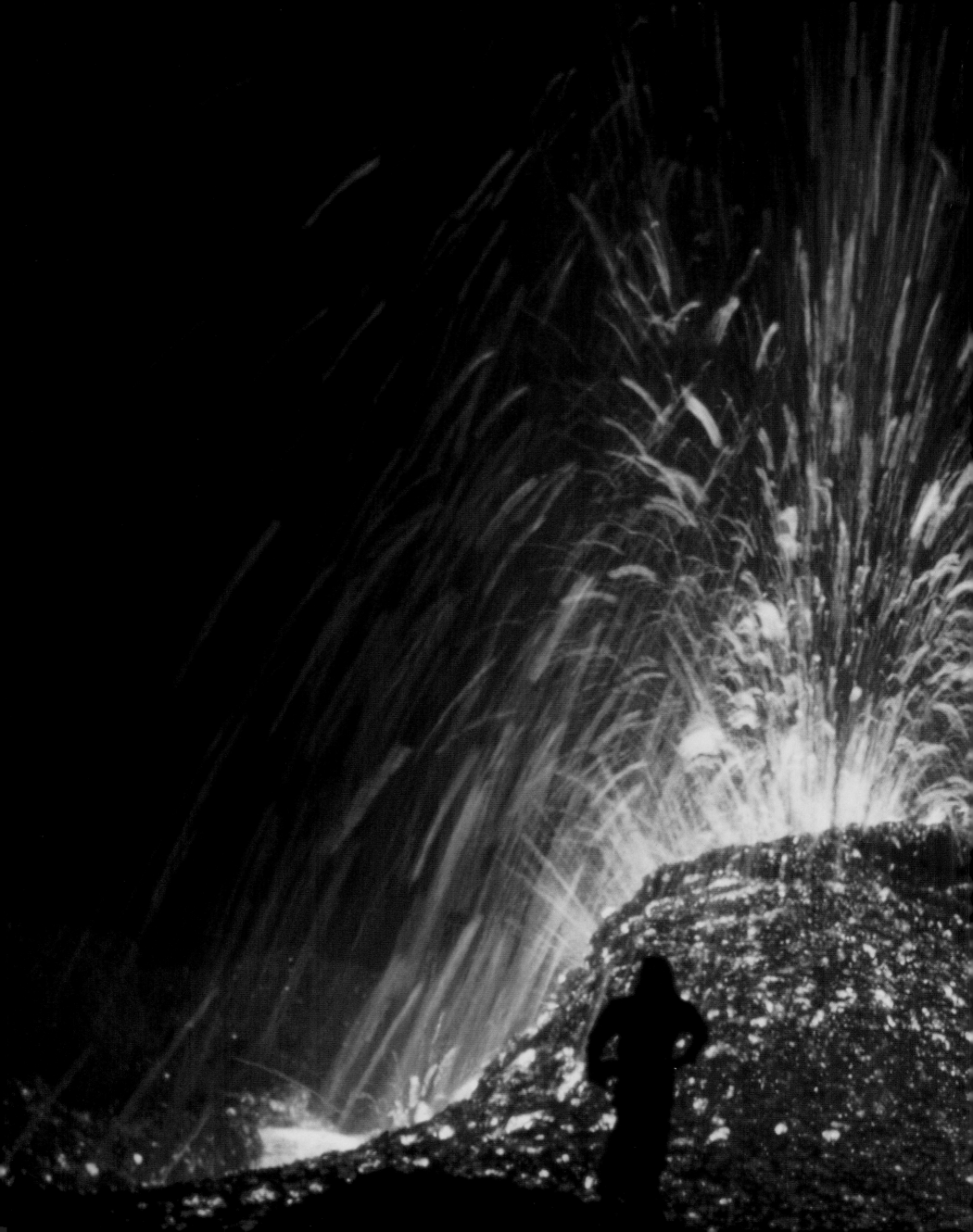

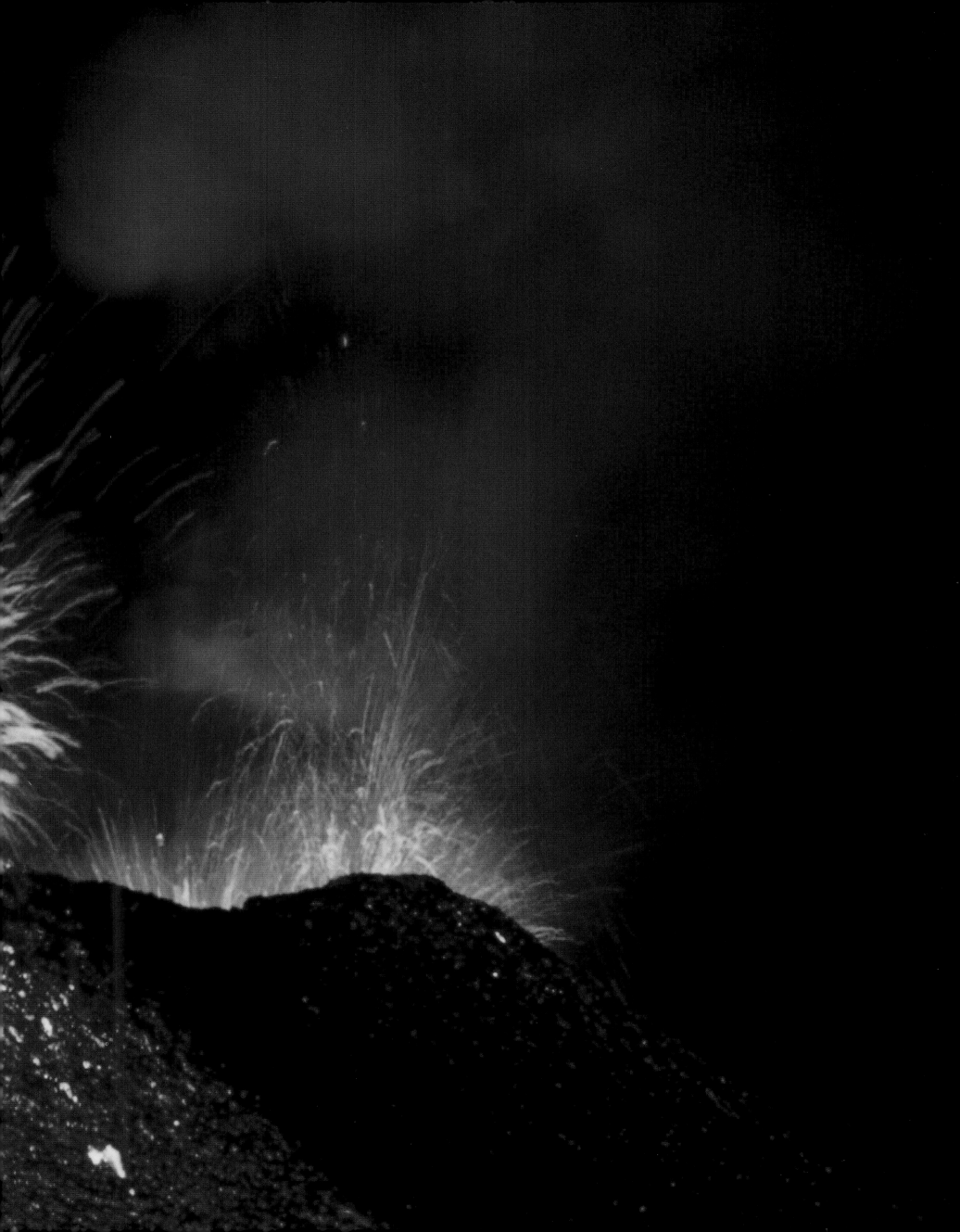

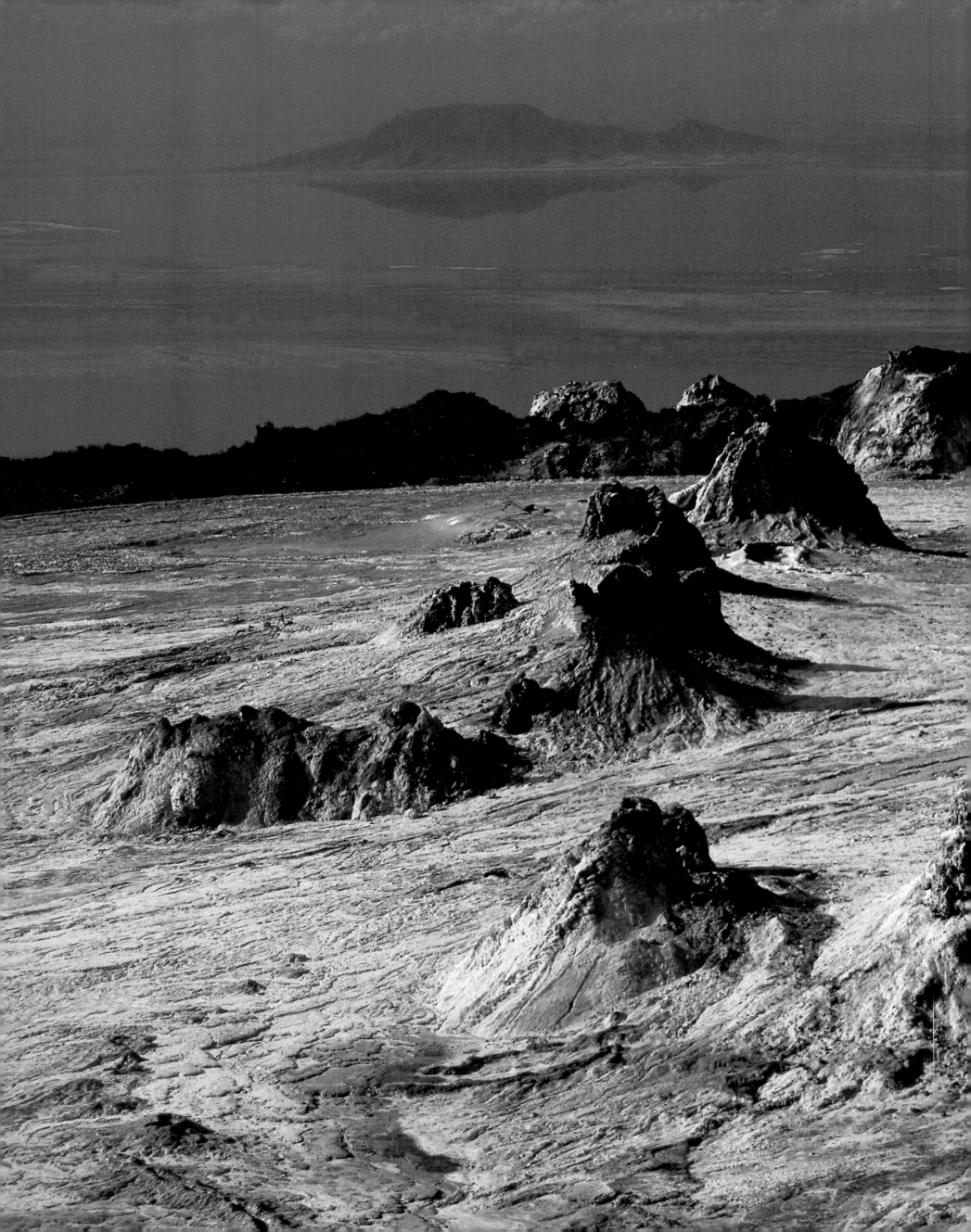

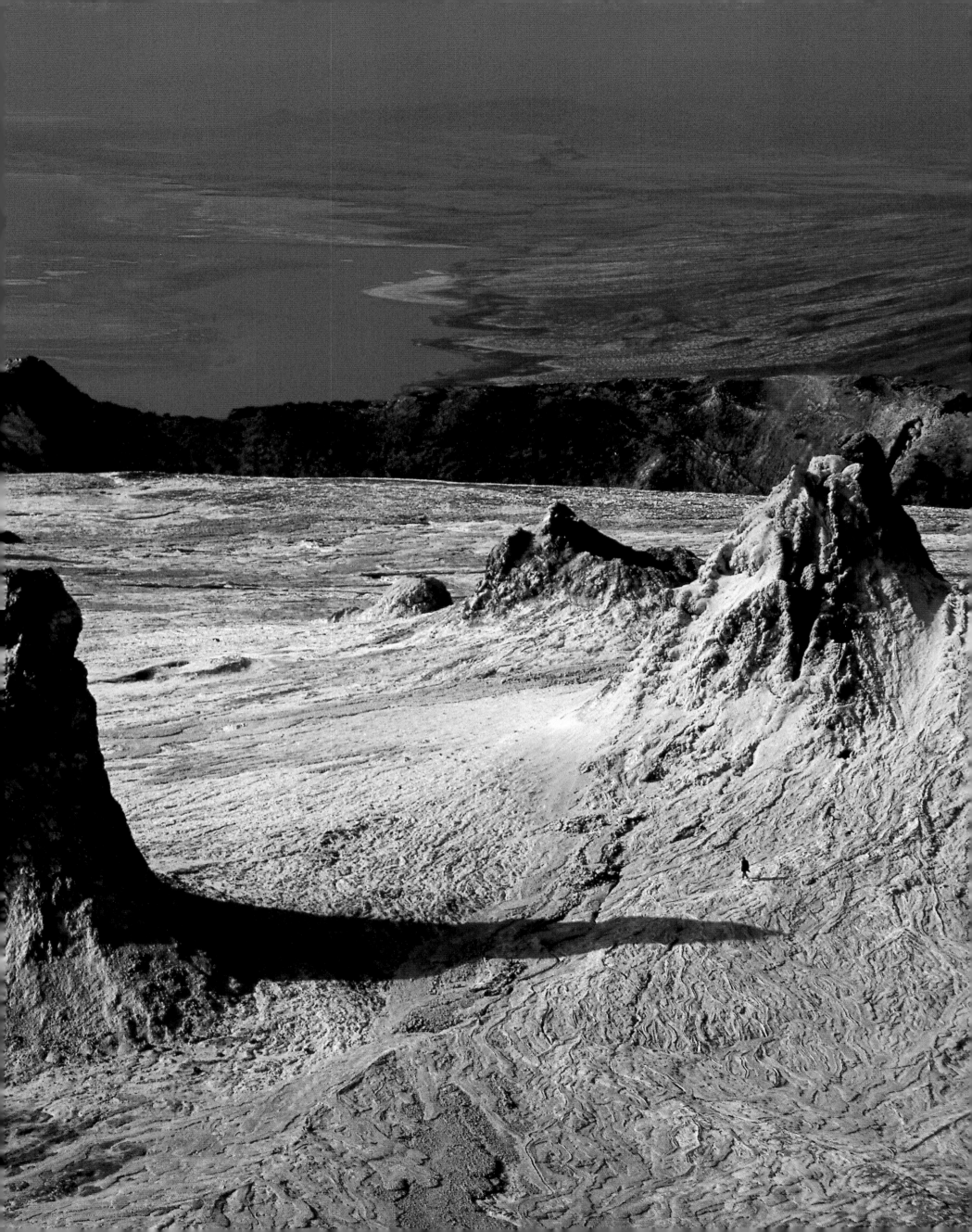

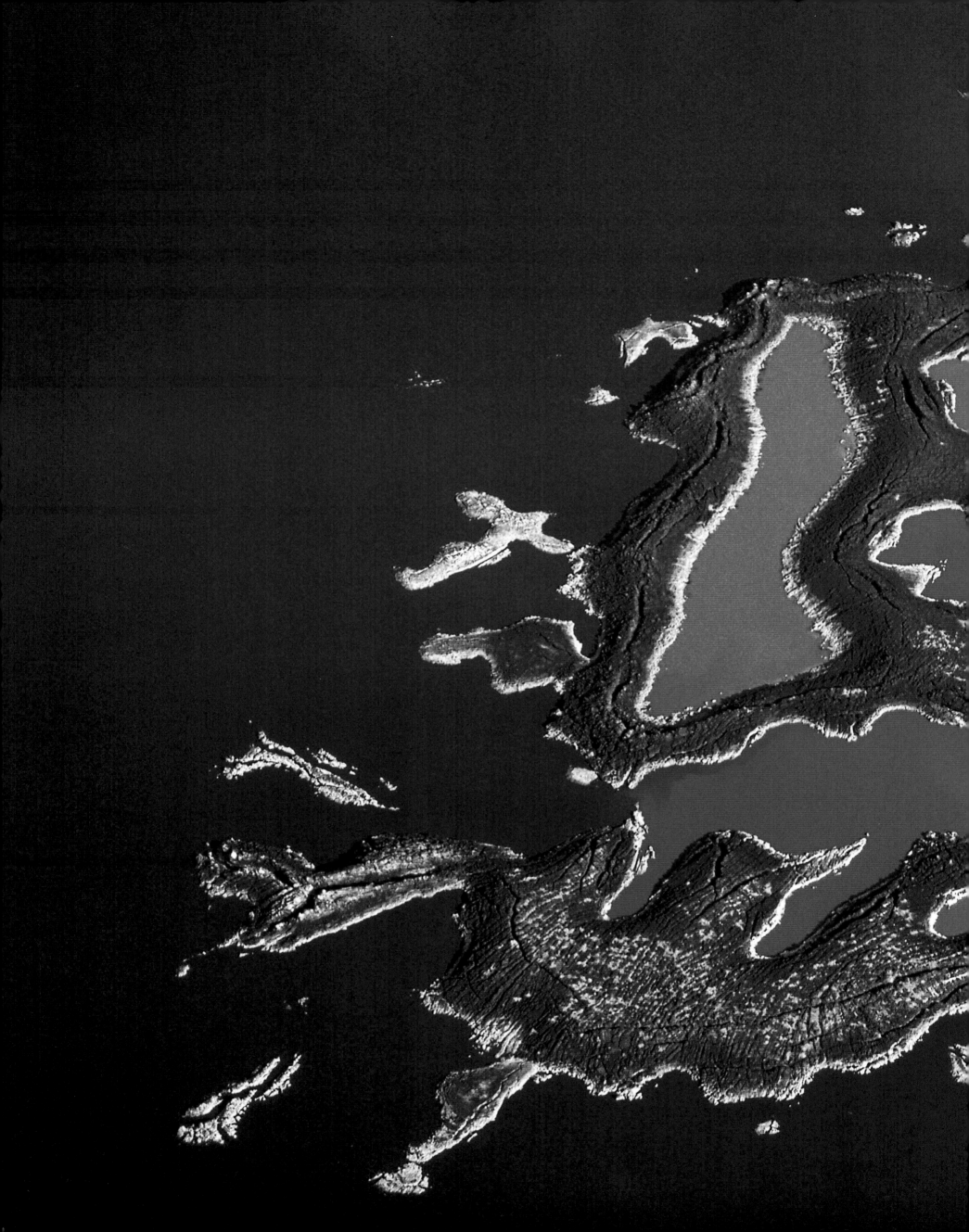

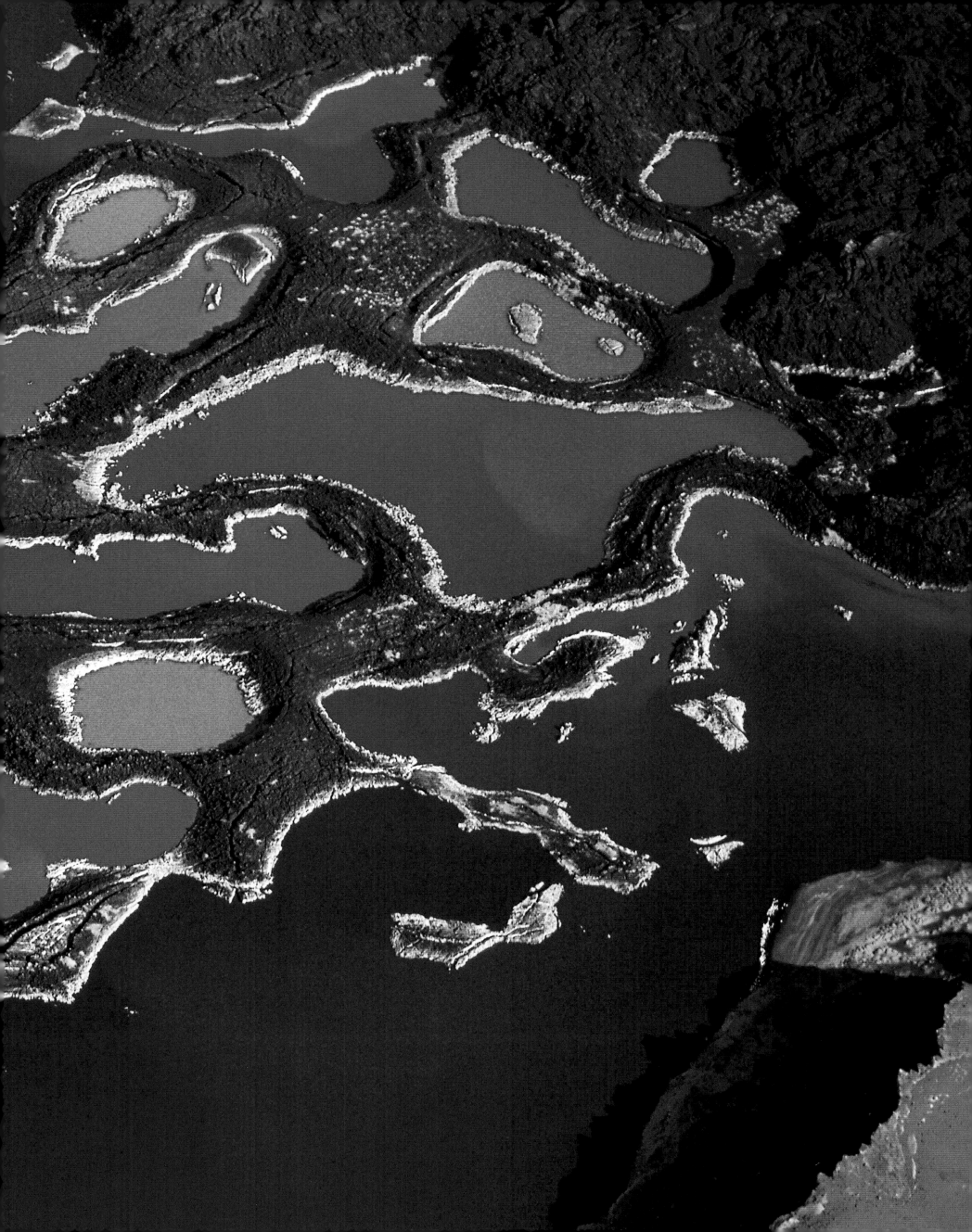

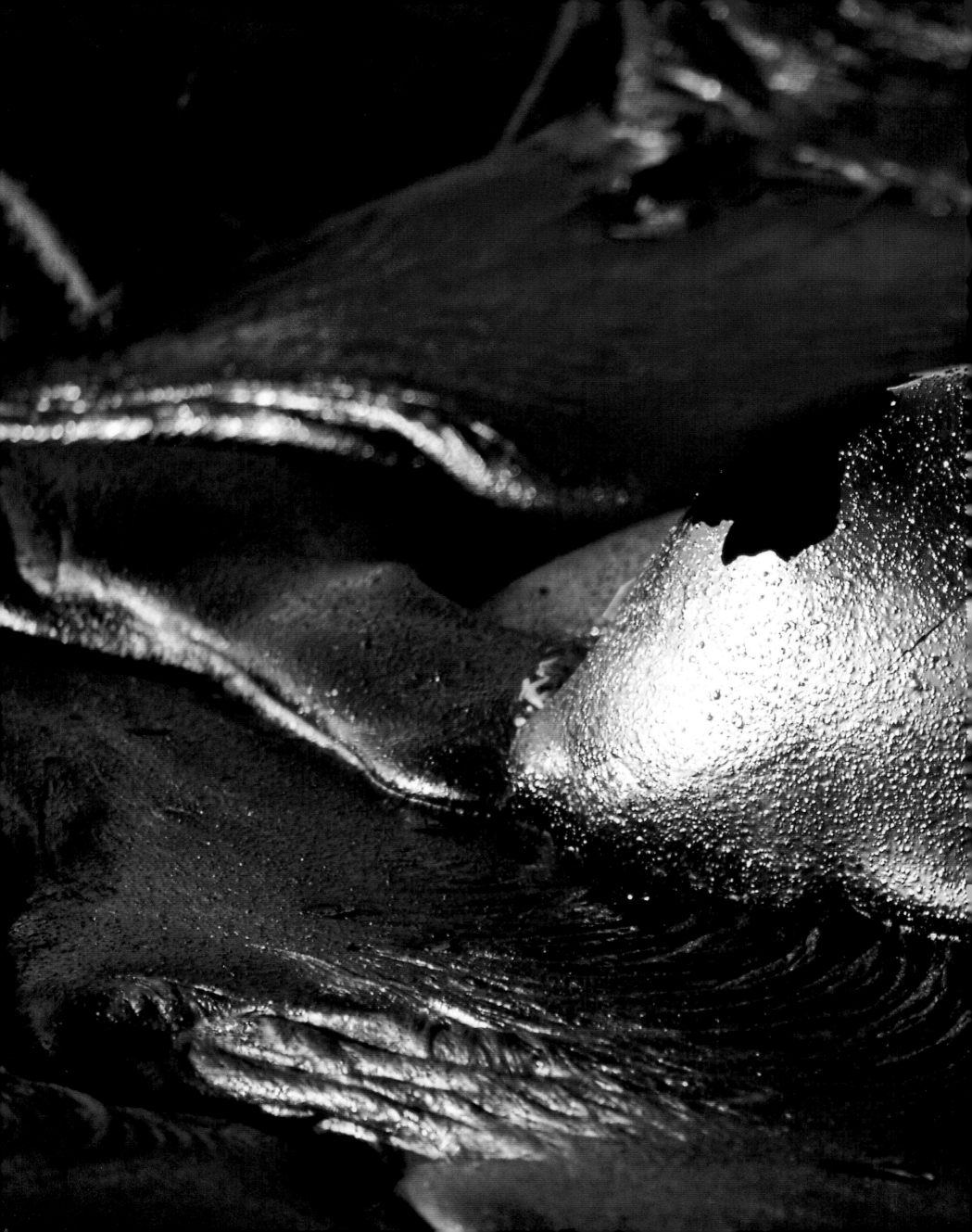

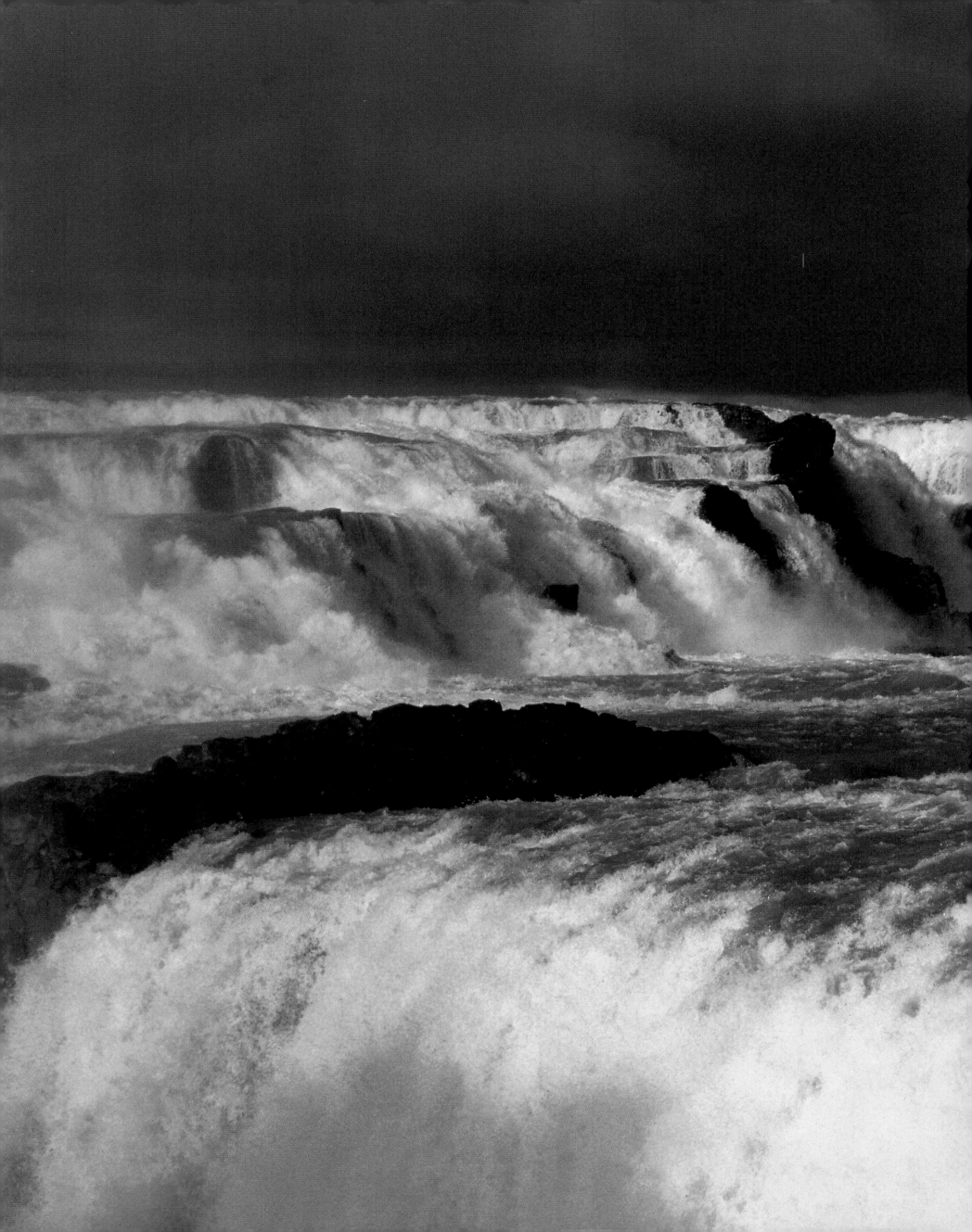

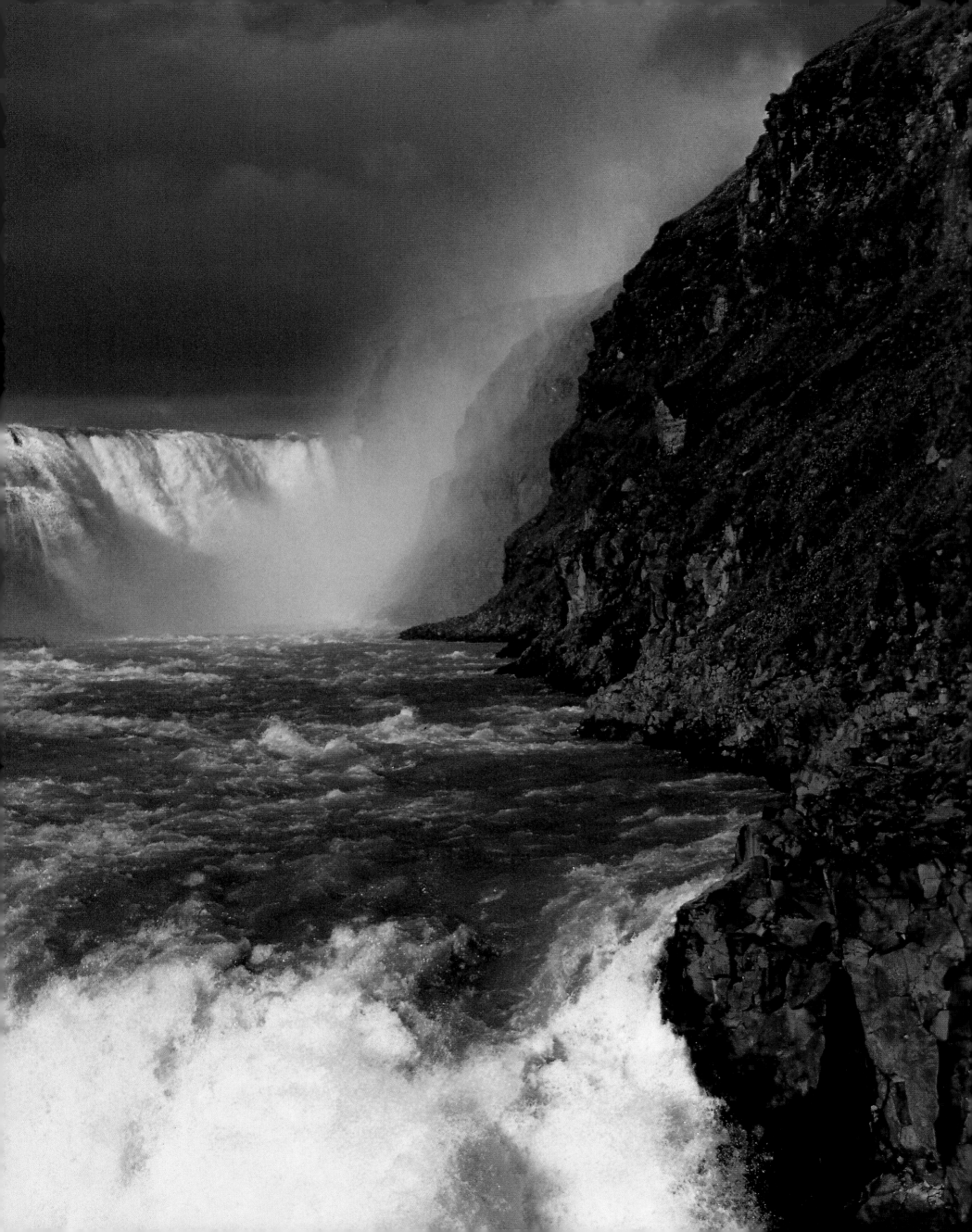

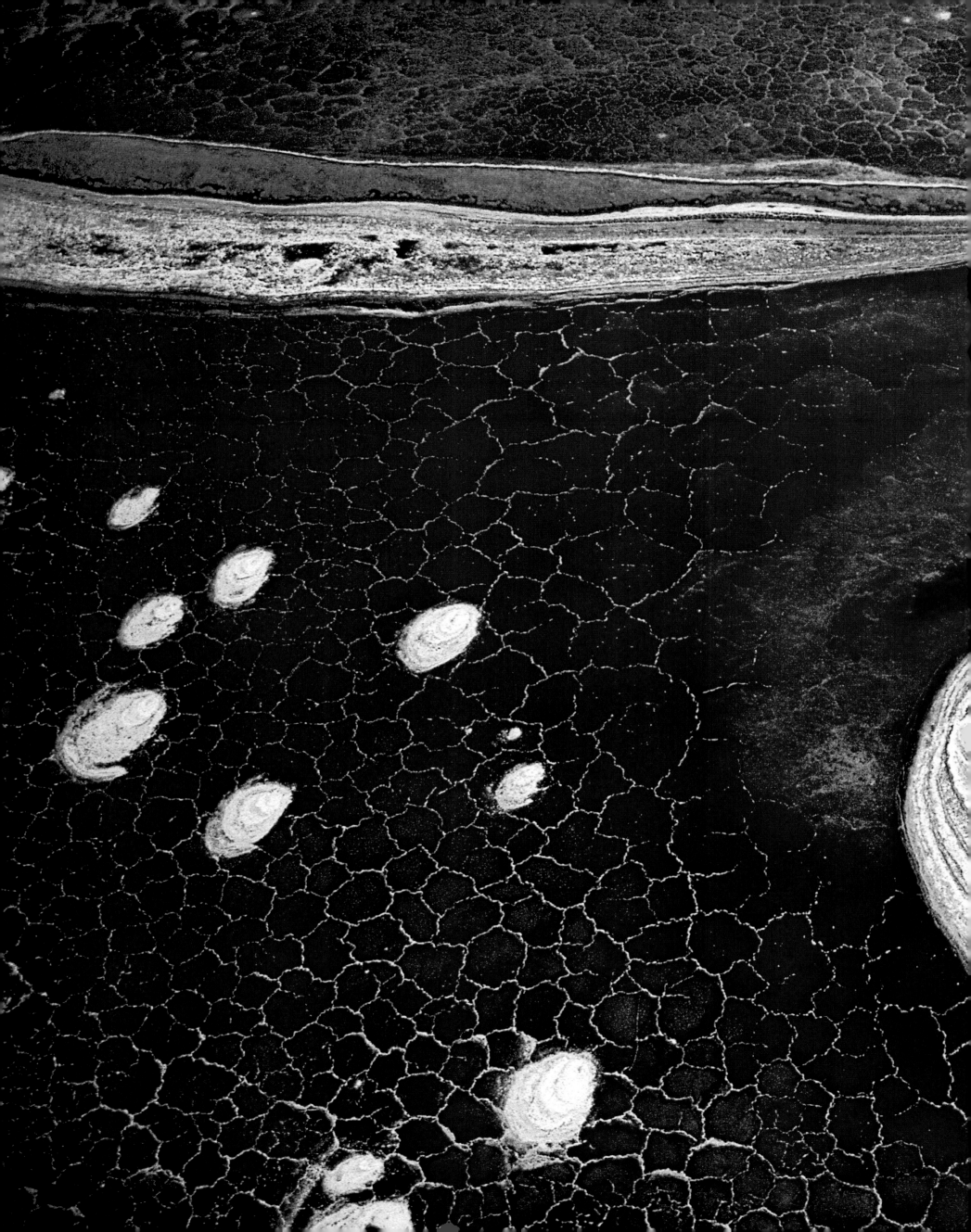

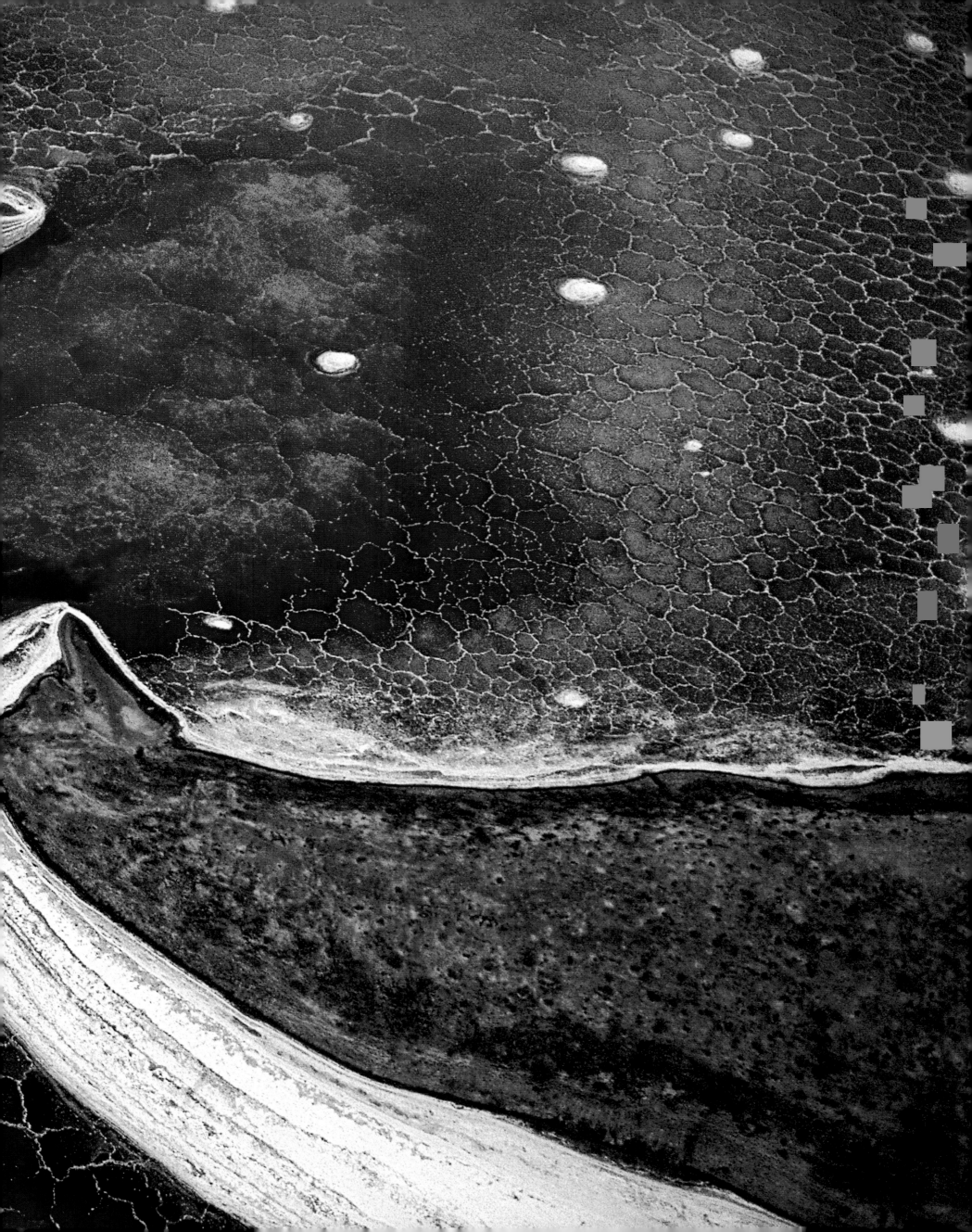

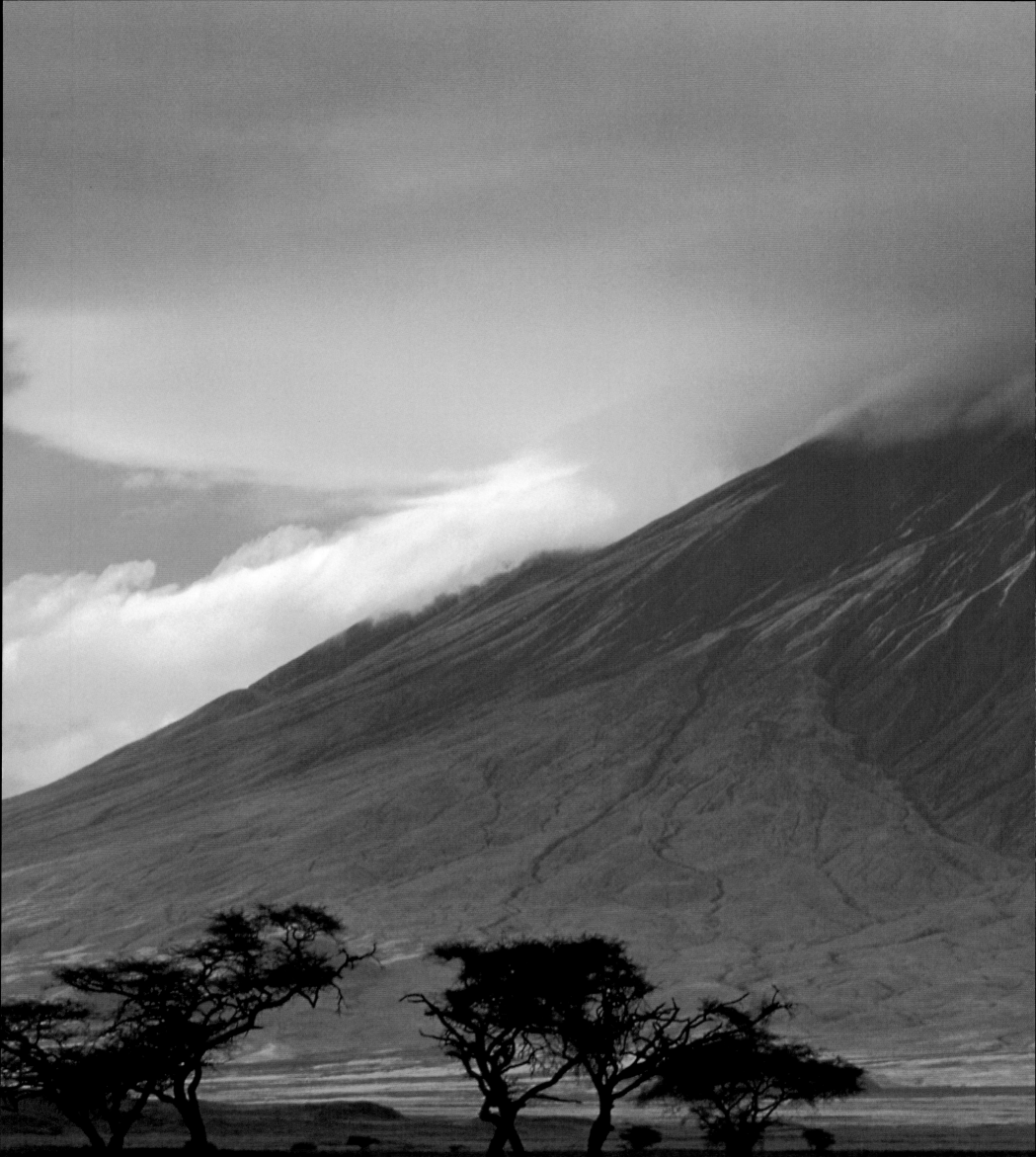

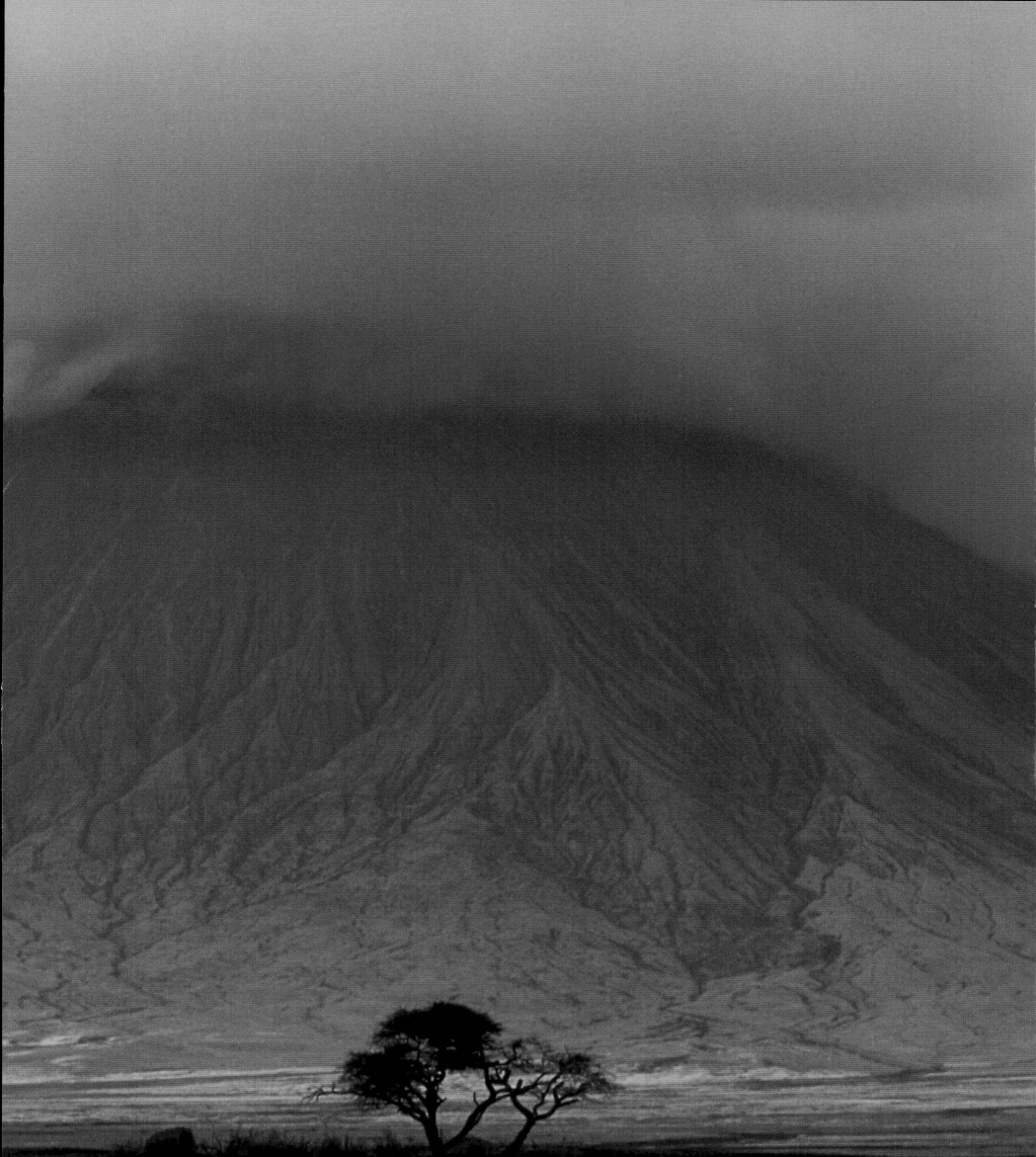

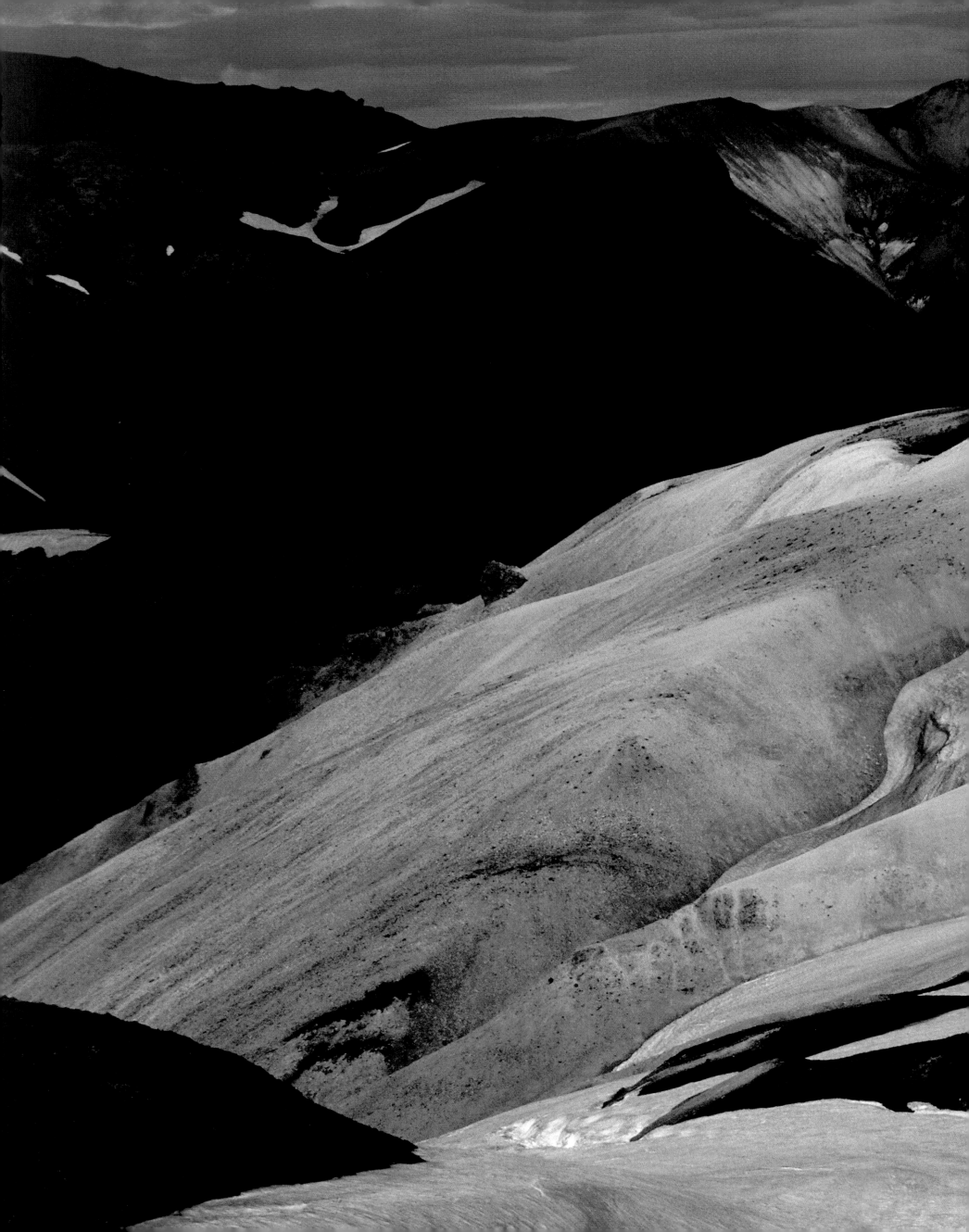

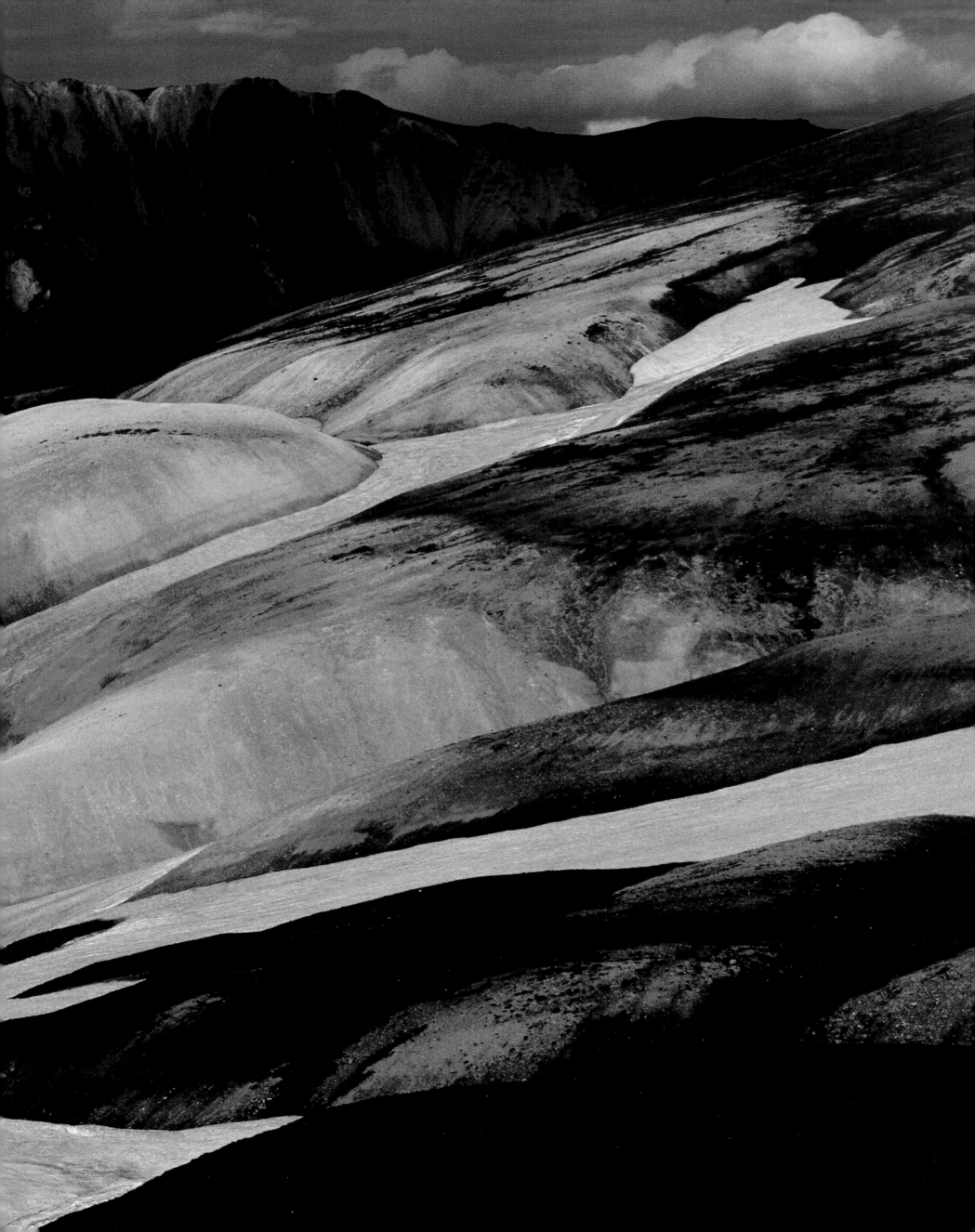

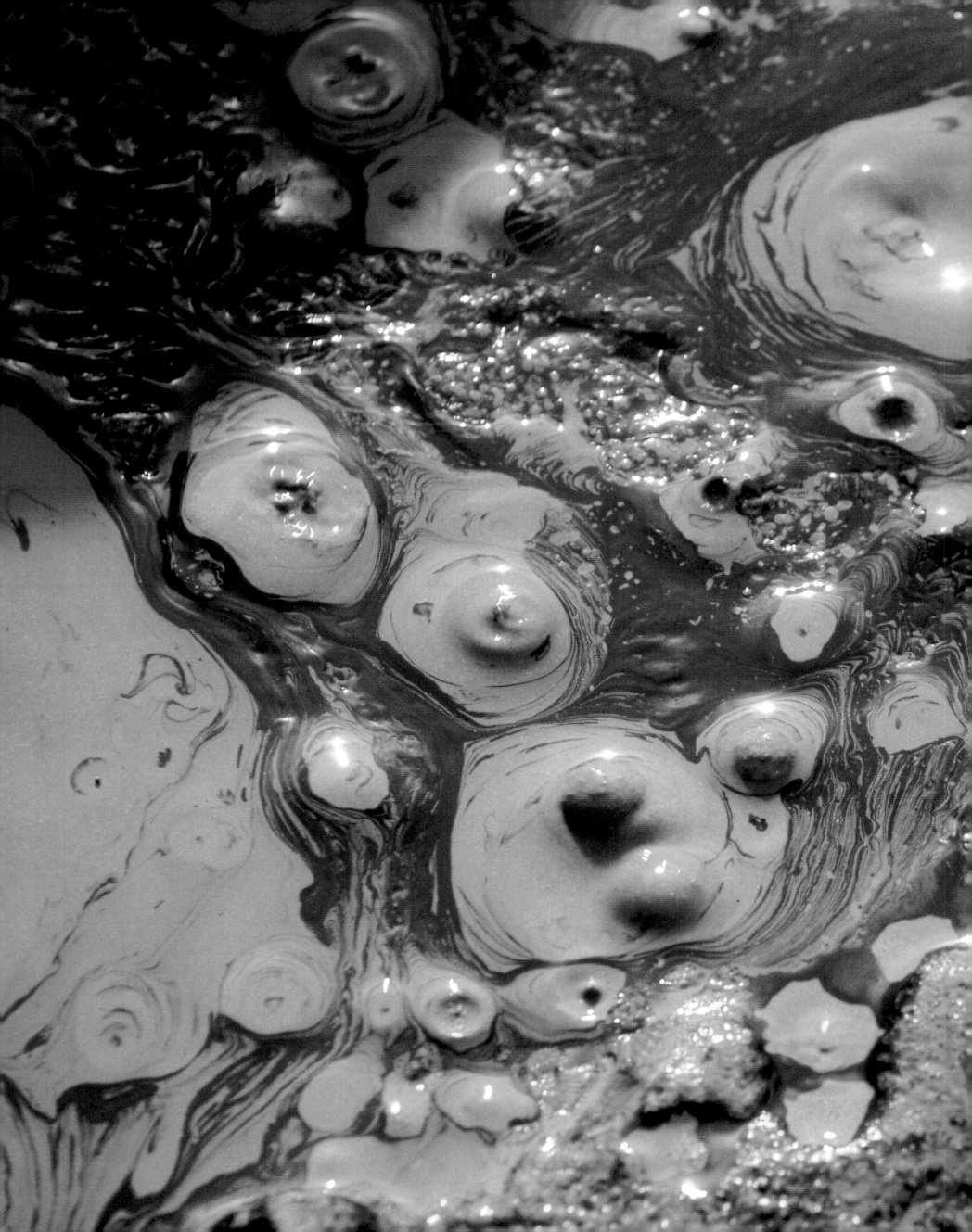

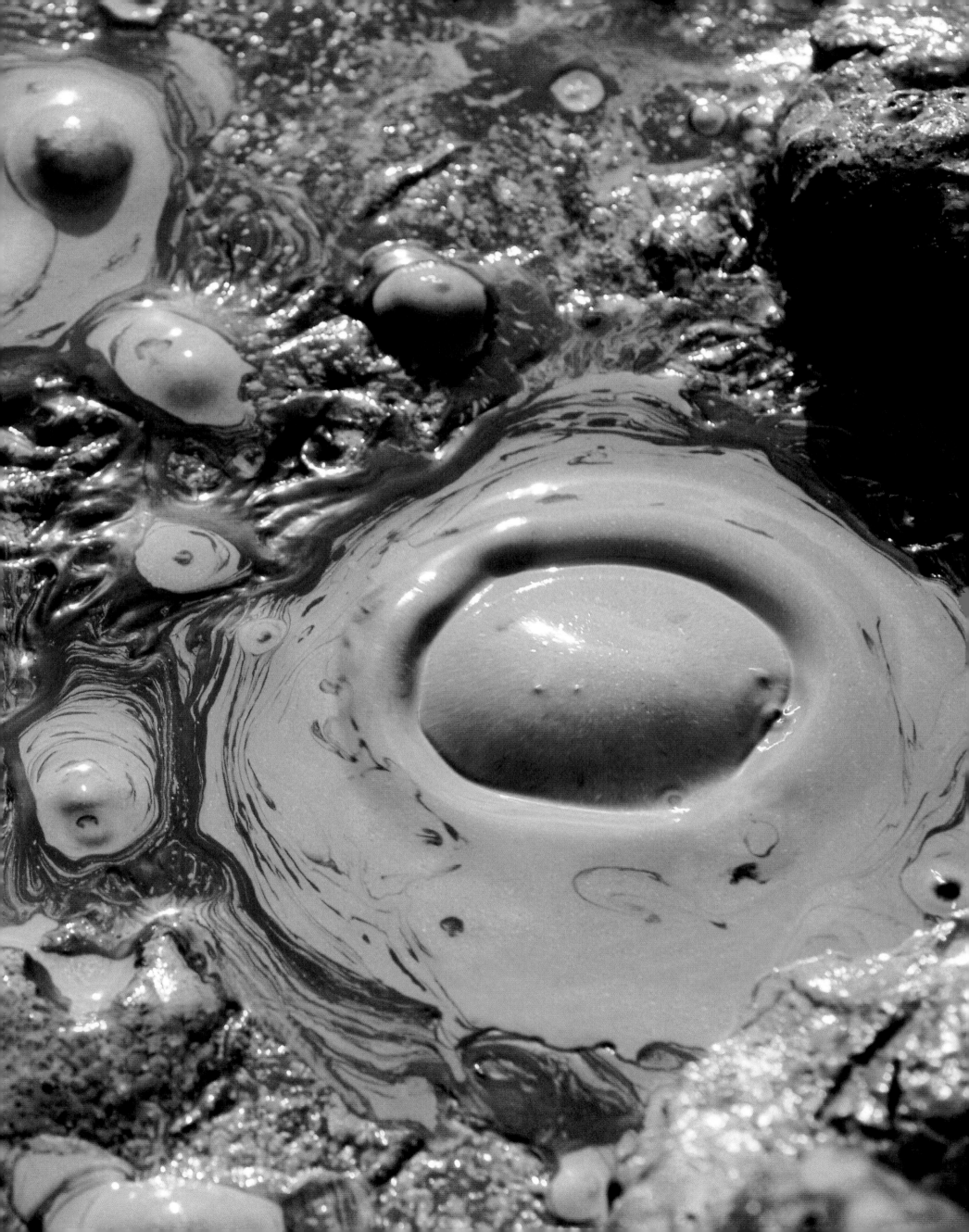

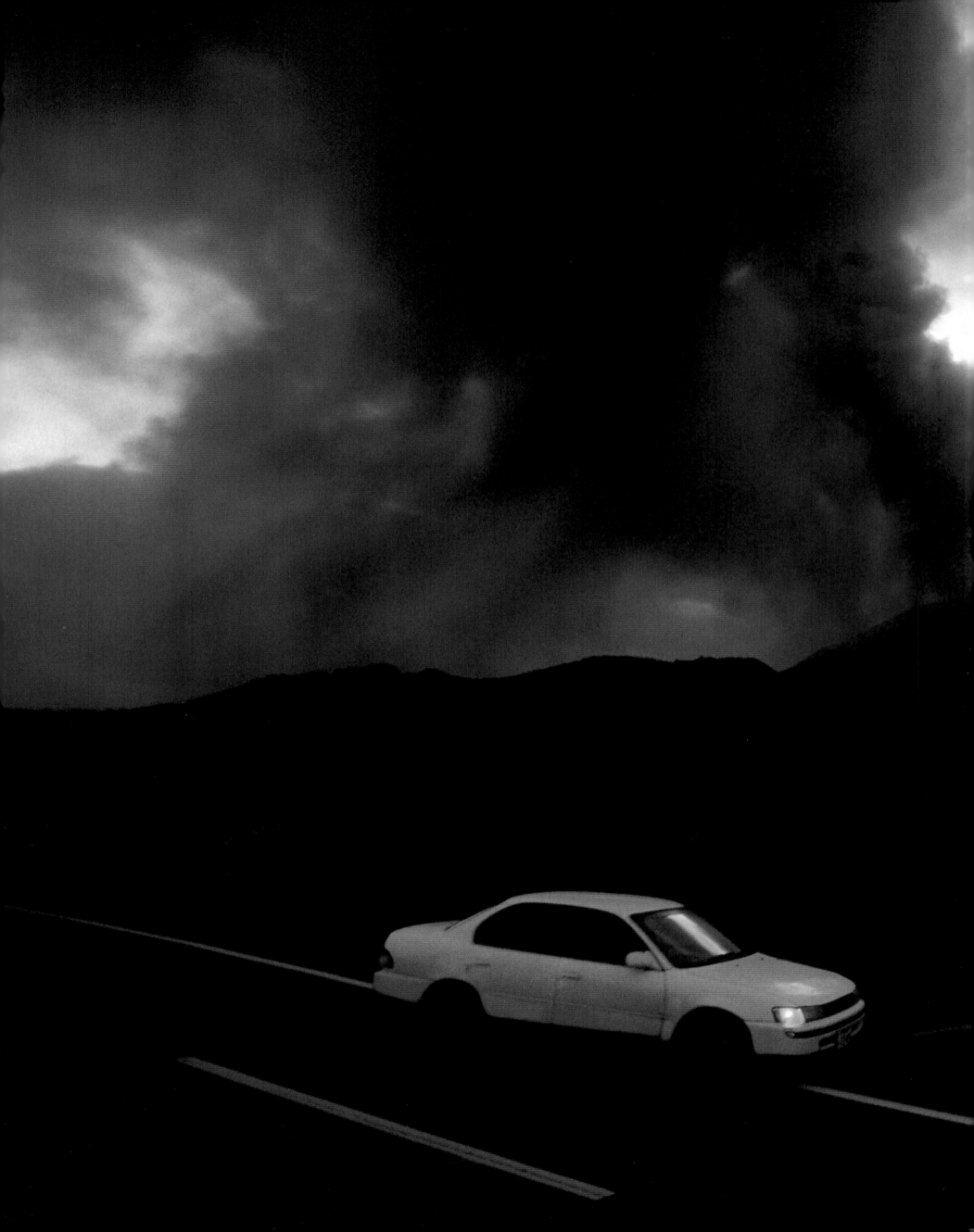

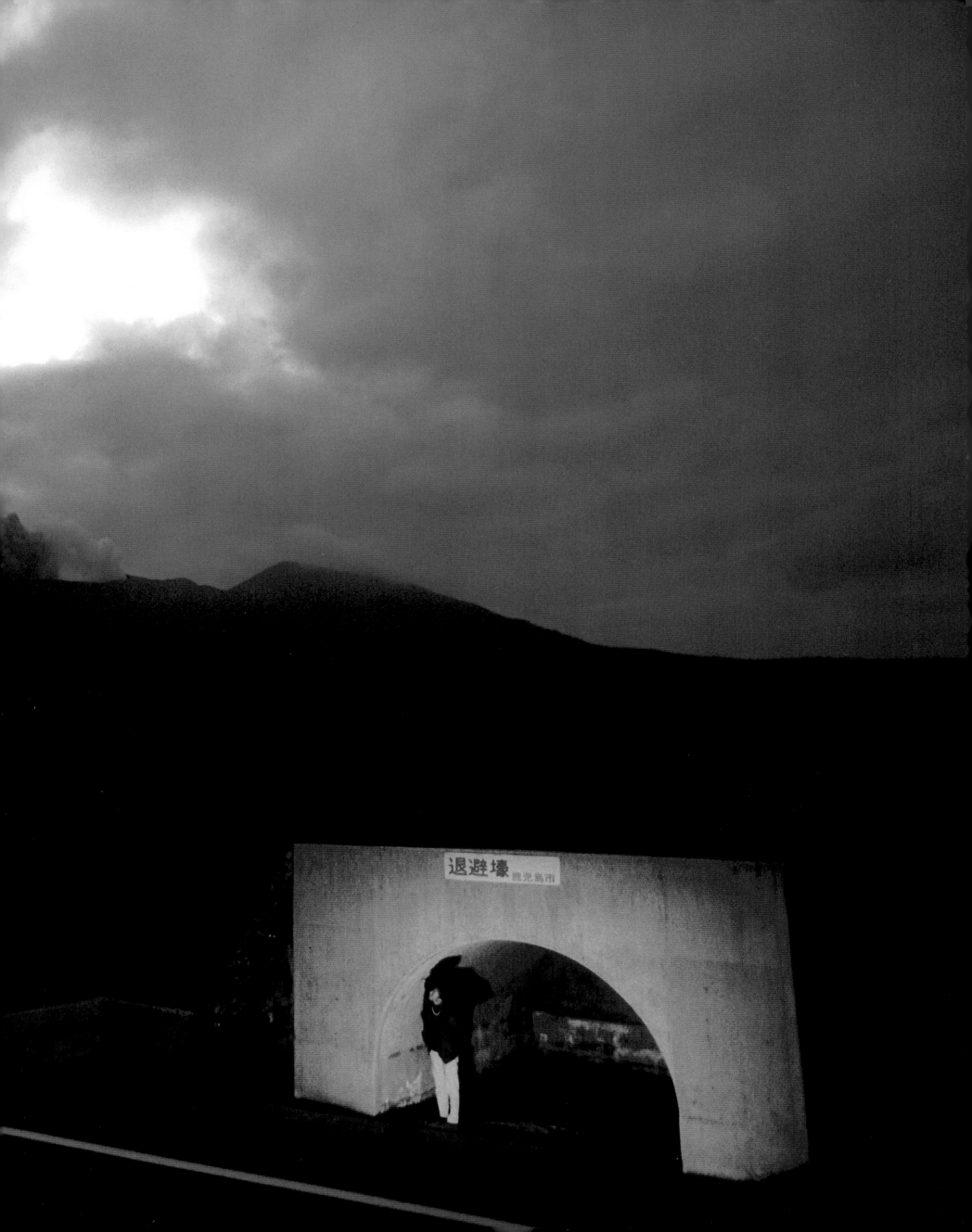

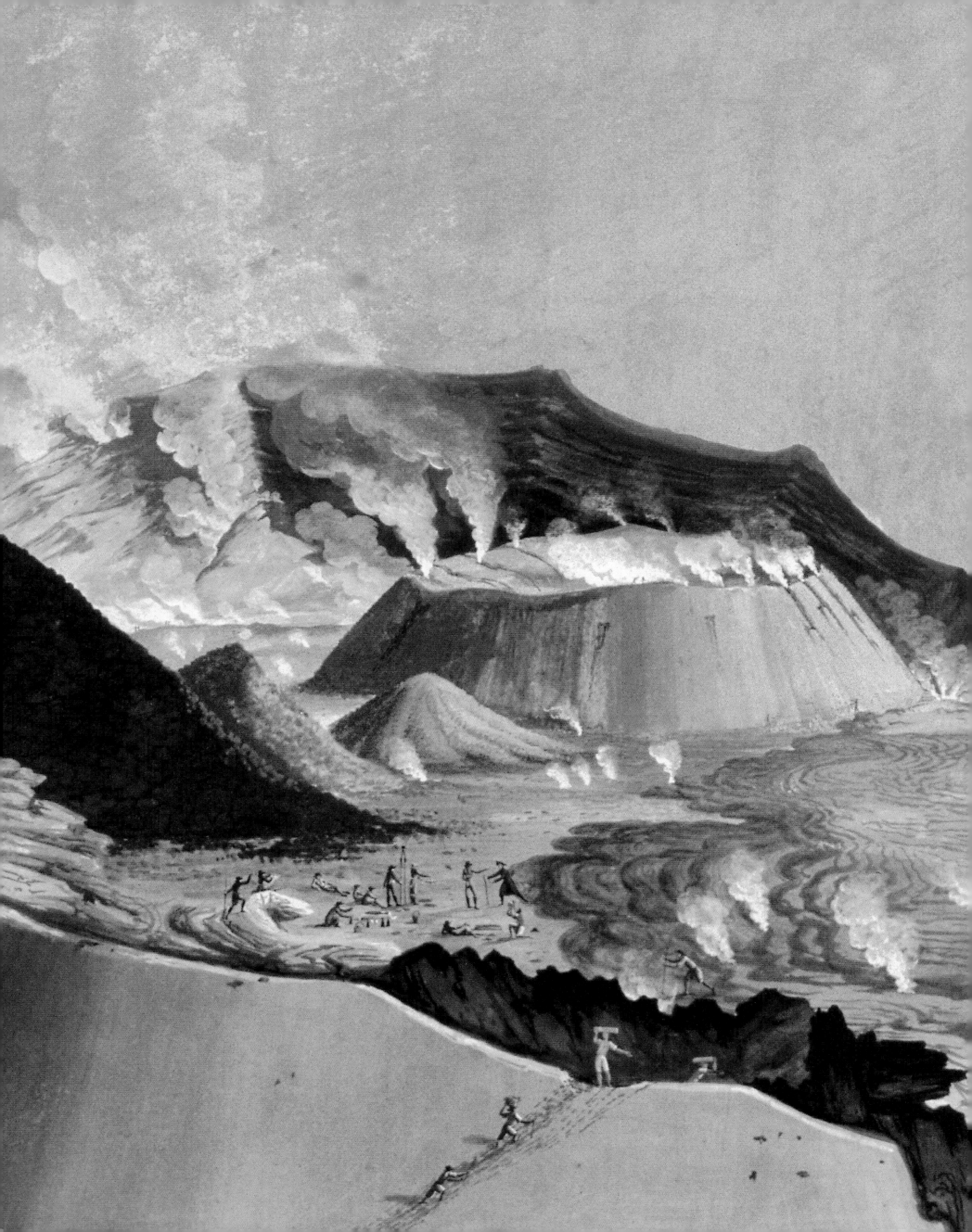

THE BIRTH OF VOLCANOLOGY

Our knowledge of volcanoes has grown over a long and circuitous path through history, moving from mythological representation to today's theoretical, computer-generated models. Knowledge has been refined as more complex questions have been addressed, and the means of investigation grow more sophisticated all the time. Our scope of investigation has broadened as well: at one time scholars studied only one type of rock, one volcano or volcanic region, one particular dynamic, or one specific eruption. Today, there is a growing trend toward a global, interdisciplinary approach to the study of volcanoes. Biologists, archaeologists, and climatologists engage in fruitful dialogue with volcanologists. Knowledge becomes richer and shows us that volcanic eruptions, whether mild or cataclysmic, can have major repercussions on human life. That, in fact, is the primary advance that has come about in the evolution of knowledge: earth is a living planet, and its life closely determines our own.

THE SUICIDE OF EMPEDOCLES, OR THE EVOLUTION OF THINKING ABOUT VOLCANOES

People have always tried to answer questions raised by the terrifying, uncontrollable natural force of volcanoes. Some have found these answers in divine or demonic manifestations. Others, driven by passionate curiosity, have visited the craters in an attempt to understand how the earth functions. Empedocles was famous for a passionate urge, late in his life, to observe and study Mount Etna. This all-consuming interest led him to build his home near the volcano. Depressed at his inability to explain what caused the eruptions, Empedocles killed himself by leaping into the crater.

Following the clumsy efforts of its early years, scientific progress in the study of volcanoes has finally come about thanks to professional collaboration, the development of protective materials, and innovation in techniques for approaching and understanding volcanoes. Little by little, humans have cast aside the demons and made a place for equations and models.

The people of the Mediterranean world, with its many volcanoes, tried to elucidate the mysteries of volcanic activity and to understand its awful effects. Even the Greek philosophers had focused on the agents that would be held responsible, for ages to come, for volcanic activity: water, fire, and wind. As for water, Thales of Miletus in the sixth century B.C. believed that the world floated on water and that the motions of this circular raft were behind the phenomenon of earthquakes. Heraclitus (c. 540–c. 480 B.C.) described a rational world far away from the gods his contemporaries saw. For him, the chief element was fire, the origin of all things. Pythagoras (c. 580–c. 500 B.C.) feared that this fire could expire for lack of fuel and put an end to all human life. Democritus (c. 460–c. 370 B.C.), another wise man, was convinced that the principal agent in volcanic energy was air. Forced to work its way through the narrow inner channels of the earth, wind burst out under pressure causing earthquakes and eruptions.

Empedocles did not appear until the fourth century B.C. He was the first to posit a complete theory of volcanism, which he con-

sidered coherent. He thought that the center of the earth was molten and that volcanic eruptions were caused by matter rising to the surface. In fact, it would take several centuries for humanity to recognize such an accurate explanation. Born at the foot of Etna, he was fascinated by this great volcano, whose eruptions he observed and described. He chose to end his days near the crater of the volcano in a place known today as Torre del Filosofo—the Philosopher's Tower. (Curiously, recent construction work on a shelter there revealed the foundations of a Greek house, possibly Empedocles's.) Empedocles's suicide by leaping into the crater has generally been understood as the act of a scientist obsessed with the search for knowledge. Some of his contemporaries claimed instead that Empedocles, blinded by extreme vanity, tried to become a god by leaving the earth's surface in this way.

At that time Etna held great fascination and was also the only active volcano accessible. Vesuvius was dormant and Stromboli seemed distant. Plato made a special trip to Sicily in order to refine his theory on the earth's structure. In his view, the central core was molten or on fire, and in underground corridors an igneous fire flowed: the Pyriphlegethon. Volcanoes were the spots where the material of this fire river could reach the surface, places where they made the earth melt, after which it would cool off to form black rocks. Etna would go on to inspire the poet Pindar, the playwright Aeschylus, and historian Thucydides, all of whom described its eruptions, particularly the flows of lava that ravaged the lower walls of the volcano, sometimes devastating cities and villages.

If Aristotle proved a remarkably astute observer of nature, he was also its great theoretician. According to him, all of matter was composed of the four elements—water, earth, fire, and air—which were organized in nature according to their density. In a perfect world, one in equilibrium, matter would be stratified without anything moving. But in this world where everything is a mixture, great quantities of air and water are imprisoned underground. Their sometimes violent reactions give birth to earthquakes and volcanic eruptions. Aristotle, like many of his predecessors and contemporaries, also often confused the two phenomena. To him we especially owe the word "crater" in its common usage. Its form recalls the cups in which the Greeks drank their wine.

Slowly the Greek world was absorbed into the Roman Empire. Although military concerns often eclipsed philosophical consider-

LEFT: *Interior View of Vesuvius on October 25th, 1805* (1805), painted by Odoardo Fischetti for Duke Della Torre.

BELOW: Explosive activity from a southeast crater on Etna.

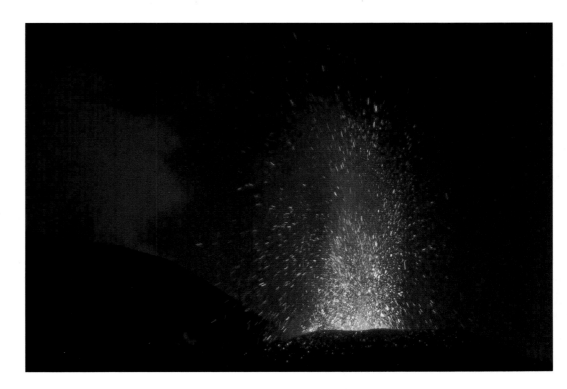

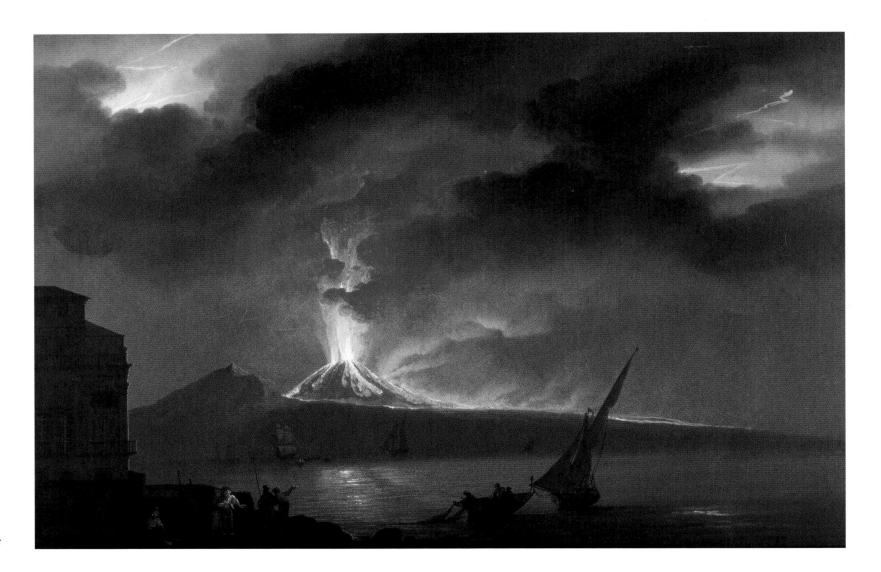

The Eruption of Vesuvius in 1822, by the Neapolitan painter Camille De Vito.

ations, some thinkers nevertheless were aware of the science of antiquity, and pursued their quest for knowledge. Thus Lucretius (c. 96–c. 55 B.C.), in his great work *De rerum natura* (On the Nature of Things), attempted to explain the universe. This was the beginning of a complete natural science, which could not fail to include volcanoes. He shared the idea that violent winds were at the source of all convulsions of the planet. He imagined the earth hollow and torn by an almost constant internal storm. These violent winds heated the rocks and then ejected them from craters. But he also observed volcanoes close to the sea, and he saw waves and tides as forces that pushed elements into volcanic chimneys. Lucretius referred often to Etna, some of whose eruptions he must have watched. Etna was also described by Vergil (70–19 B.C.) in a text of more than six hundred lines, as well as by Strabo (c. 63 B.C.–c. A.D. 23), the great geographer par excellence, who thought of volcanoes as outlets for the fury of the central fire and for winds under high pressure that arose from this fire. As a good observer, Strabo depicted with great flair the different volcanic products and the volcanoes of the Mediterranean world. Although it was not active at this time, he succeeded in studying rocks in order to identify Vesuvius as a volcano. Seneca (c. 4 B.C.–A.D. 65), a great writer of the day and a tutor of the emperor Nero, went further than his contemporaries in his reflections. He claimed that the internal heat was due to the combustion of sulfur. This combustion arose from contact of the metalloid with winds under strong pressure. These winds then served to convey heat to the earth's crust and caused eruptions. Soon a volcano would directly affect the Romans, during the eruption of Vesuvius that destroyed Pompeii and Herculaneum in A.D. 79, the eruption we know about from Pliny the Younger.

The science of antiquity rapidly fell into oblivion with the collapse of the Roman Empire. In the period that followed, other explanations for volcanoes were offered. The only description of

the world and of the universe was the one provided by the Church, and true learning took a step backward. Volcanoes became, and would long remain, the mouths of hell that no one dared approach. People at the time even claimed that curiosity and the quest for knowledge were no longer necessary, for they had nothing to do with humans' ultimate goal—to ensure their ascension to heaven.

Diverse events, however, brought volcanoes back into the scientific arena. The first was the invention of printing, since this technology permitted knowledge to circulate widely and brought different theories in contact with one another. An eruption occurred in 1538 that revealed a new volcano in the caldera of the Phlegraean Fields near Naples. Volcanoes were ready for a comeback. Not only was a new volcano born in the world of human beings, in a "civilized" country, in front of witnesses, but the city of Naples proved at the time to be one of the world's cultural capitals. It was a city that published more books than Paris. News of the eruption therefore spread quickly and became of some concern to men of learning, who were now well informed through a recent network of universities.

A few decades later, Europe set out to discover the world and learned that, in far-off exotic countries, there were other volcanoes that were often very different in shape or activity. Was volcanism therefore a universal phenomenon? Science was ready for a leap forward.

Agricola propounded a new theory that broke with ancient science. If he accepted the idea of a subterranean fire, he still sought its origin in the sun rays that penetrated the earth's sphere. Then came Athanase Kircher (1602–1680), a Jesuit of great erudition, who elaborated on Aristotle's theory of the central fire in a work called *Mundus Subterraneus* (Subterranean World), devoted entirely to geology. Kircher made a detailed study of a few active volcanoes, Vesuvius, Stromboli, Vulcano, and Etna. Extrapolating from what

he saw on the surface, especially hornitos and sub-lava tunnels, he suggested a new approach to volcanology. From the molten center of the earth, canals transported igneous materials into smaller reservoirs situated not far beneath the surface. These superficial reservoirs fed the craters of volcanoes or heated the water with all its springs. Armed with this theory, he drew magnificent pictures of the cross-section of volcanoes he studied, as well as an astonishing section of the spherical earth.

It was also at this time that alchemy gave way to chemistry. This new science set out to explain the functioning of volcanoes. People sought the origin of earth's fire at that time in phenomena of combustion, which involved sulfur, iron, seawater, as well as coal, bitumen, and the like. In 1669 an enormous eruption took place on the sides of Mount Etna. Lava flows descended all the way to the sea, destroying the city of Catania on the way. Sicilian scientist Francesco d'Arezzo was assigned to study the phenomenon. What he found on the terrain, to his great surprise, was very different from the rivers of liquid sulfur of bitumen on fire that literature had promised. He came very close to the flows of lava, trying to assess its viscosity by poking it with metal rods. His deduction was extraordinary for its time: Lava was molten rock that became glassy on cooling. But the real problem that intrigued his contemporaries was the origin of the heat generated by volcanoes.

According to George-Louis Leclerc de Buffon (1707–1788), the earth was a star that was cooling. He even computed its age (about 120,000 years) in comparison with the speed of cooling of metal spheres that he heated in a forge. He accepted the notion of a central core fire, the residue from the original star. He believed, however, the origin of the energy of volcanoes resided in the more superficial phenomena of combustion. And, based on the fact that many volcanoes known at the time were either close to a coastline or to islands, he figured that seawater, reacting with these subterranean fires, caused eruptions.

Seawater in the mid-eighteenth century fueled an intense debate. Jean-Etienne Guettard (1715–1786), a naturalist, was drawing the geological map of France when, to everyone's surprise, he discovered volcanic rocks in Auvergne (southwestern France). Along with his description of the volcanoes of the Massif Central, the mountain range in France's south-central region, he also devoted himself to describing basalt, a characteristic volcanic rock that sometimes appears in the form of great prismatic columns. For Guettard, the case seemed obvious. Basalt came from a giant crystallization that had occurred as the earth was forming. In opposition to this, Barthelemy Faujas-de-Saint-Fond (1741–1819), a geologist, expounded a completely different theory: Basalts were a product of volcanoes, born of the cooling lava. A debate raged between the neptunists, partisans of water, and the plutonists, believers in fire.

For several decades, the dispute went on. Once again the earth itself provided an answer. In the mid-eighteenth century, people of means took to traveling, and the tradition of the Grand Tour was born. Tourists felt obliged to visit Germany, France, and especially Italy, where volcanoes became a prime attraction. They were picturesque and drew painters, poets, and dreamers as much as the enthusiasts of natural history. Among these volcanoes, Vesuvius held a unique place. Situated near Naples, it was in close proximity of several antique monuments and it erupted frequently. It was an obligatory stop for proper European society. As more and more people observed volcanoes, many were able to apprehend the causes and mechanism of eruptions, past as well as present. Efforts in volcanology flourished in many places with the rise of the great discoveries.

The study of the Old World continued, and many French scholars excelled at it. Anselme-Gaétan Desmaret (1784–1838), a member of the French Academy of Sciences, detailed the geological history of the volcanoes of France's Massif Central. He expounded numerous arguments that supported the plutonic thesis. He became so famous that he was selected to write the chapter on volcanoes in a French encyclopedia.

Two great figures who would accomplish extraordinary things appeared at this time. Deodat de Gratet, Chevalier de Dolomieu, born on 23 June 1750, was barely two years old when his father inducted him into the Order of Malta. He seemed destined for a military career, but in 1768 he killed a peer in a duel. Sentenced to life imprisonment by the Order of Malta, he was freed nine months later thanks to the intervention of the French king. After this incident he devoted himself to the natural sciences and studied physics and chemistry. Soon he took a stronger interest in mineralogy and joined forces with many scientists of his time. He traveled in the Alps and then to Portugal, where he collected volcanic rocks near Lisbon. He started to explore the problem of the volcanic origin of basalt. On 19 August 1779 he was named a correspondent of the Academy of Sciences. He spent several years on various scientific voyages, in France, Italy, and Corsica. Passionate about these studies, he published several works including the very famous *Voyage aux Iles de Lipari* (Voyage to the Lipari Islands, 1785) and *El Catalogue Raisonne des Produits de L'Etna* (Inventory of the Products of Etna, 1788).

Dolomieu had very liberal ideas for a man of his rank and

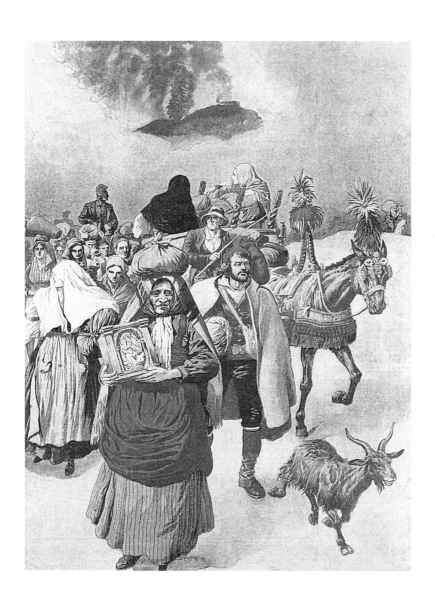

A popular engraving depicting the population fleeing an eruption of Etna.

time. His sympathy with the French Revolution led to a definitive break with the Order of Malta in 1790. As a token of his commitment to freedom and science, he contributed all his collections to the brand new United States Congress. He then studied limestone formations in the Tirol and Trentino, describing all their particularities. In his honor the rock later became known as dolomite, and the mountains where it originated became the Dolomites. As his scientific reputation continued to grow, he became an instructor at the French School of Mines and was a member of the French Institute from the time of its founding in 1795.

Embarking with many other scientists on the Egyptian expedition with Napoleon in 1798, Dolomieu realized, early in 1799, that the project was merely a vulgar military conquest. He tried to return to France in the company of General Dumas (father of

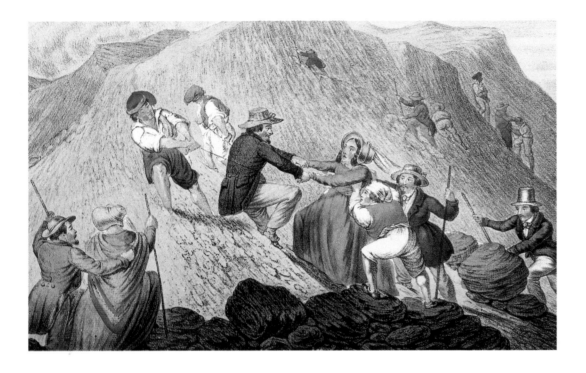

author Alexandre Dumas) but was taken prisoner in Messina, Italy. By special request of the Order of Malta he was separated from his companions and put in chains in total isolation for twenty-one months. Using the smoke soot from his candle, he wrote a complete treatise in the margins of the book by Faujas-de-Saint-Fond, *Mineralogy of Volcanoes*. Dolomieu's imprisonment attracted attention and the Royal Society of London took umbrage. The Consular Government of France also tried to have its illustrious scientist freed, while several members of the Institute—notably Joseph de Jussieu, Albert Camus, Pierre-Simon Laplace, Louis-Antoine de Bougainville, Louis-Benjamin Fleuriau de Bellevue—brought their influence to bear. Even the Spanish king became involved, while the French statesman Charles Maurice de Talleyrand (1754–1838) launched negotiations. Finally, after Napoleon's victory at Marengo in March 1801, both Dolomieu and Dumas were set free. Dolomieu received a hero's welcome back in France, but was exhausted by the harsh conditions of his captivity. He died in November of the same year, at age fifty-one. His studies on the origin and nature of lava established him as one of the first great volcanologists, and his contributions to knowledge of the origins of basalt gave a strong boost to the plutonist school of thought.

At the foot of Vesuvius, another remarkable man soon distinguished himself. Lord William Hamilton, a man of learning with such diverse passions as music, fine arts, archaeology, and mineralogy, and a ruthless collector, was British ambassador to the court of the king of Naples. The sight of Vesuvius erupting made a passionate volcanologist of Lord Hamilton. He set down his precise, enlightened observations in a series of letters to the Royal Society of London. He returned repeatedly to the volcano, even in full eruption, joined by the painter Pietro Fabris, who made remarkable illustrations for Hamilton's book on Vesuvius and the Phlegraean Fields. Hamilton studied all the eruptions of Vesuvius from 1766 to 1794, visited the other Italian volcanoes, and, above all, drew interesting conclusions from his minute analyses. Among other projects, he defended the idea of a deep origin of volcanoes and, more important, challenged the general belief at the time that volcanoes "burned." Since oxygen was absent deep underground or in water, no combustion was possible.

Hamilton's knowledge of Vesuvius and its eruptions was such that he succeeded even in predicting one eruption and called for an evacuation. He studied everything related to the dangers of volcanoes in his time and in his environment, and proposed various countermeasures. Like Dolomieu, Hamilton was one of the first great volcanologists of modern times. His minute observations of the dynamics of eruption also tilted the scales in favor of plutonism.

Laboratory research, in time, also played a part in advancing scientific knowledge during this period. English chemist James Hall conducted numerous experiments on the melting and crystallization of glass, then compared his findings with on-site observations. He proved definitively that rock could melt, to become glass on cooling.

The rejection of the neptunist thesis came about gradually, especially after the writings of the great explorer Alexander von Humboldt (1769–1859). A true well of learning, interested in several disciplines, he was favorable at first to the idea of the aqueous origin of basalt. However, he would soon reject this theory after his travels, first in various European mountain ranges and then in his impressive explorations in the Andes, where he went from volcano to volcano studying the geology, botany, and climatology of the region. For five years he gathered information, which he would treat and analyze for the rest of his life. His discovery of different volcanoes allowed him to elaborate a complete theory of volcanism. Renouncing his youthful writings, he ardently defended the plutonist theses, enriching them further with new evidence.

The dispute was now over. The believers in neptunism fell silent. This quarrel might seem just a normal step in the evolution of scientific thought. In reality it represented much more. Thanks to the vehemence and passions of its proponents, it proved a powerful driving force. Every scientist of the period had to have an opinion on the matter, thus spurring the exploration of volcanoes. Many learned men took an interest, and at the conclusion of this period of intellectual ferment, a number of scientists, together, created a new science, volcanology. They included Leopold Von Buch, George Scrope, Sir Charles Lyell, Leonce Elie de Beaumont, Ferdinand Fouque, Charles Sainte-Claire Deville, Wolfgang Sartorius, and many more. They made volcanology a modern science by developing its theoretical approaches, its on-site investigations, and its laboratory experiments. In 1841 the world's first vol-

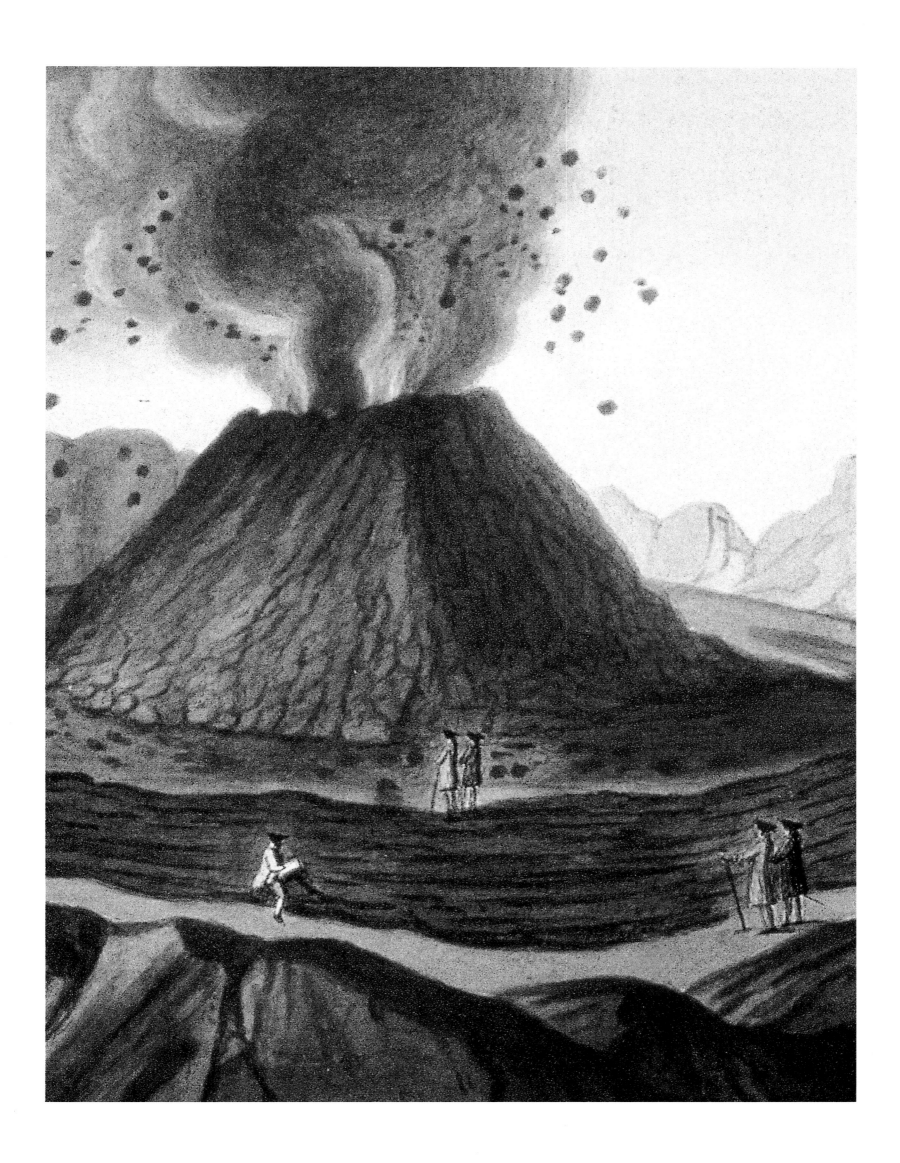

canological observatory was constructed on the slopes of Vesuvius. At the same time, the world's volcanoes were being explored even on the most far-flung islands. The few major eruptions that occurred could have benefitted from better communications technology, which would allow the entire scientific community as well as the public to be kept informed and to be mobilized around the event. This was the case with the eruption of Krakatoa in 1883, but even more so with Montagne Pelée (Peeled Mountain) in Martinique in 1902. This eruption, which destroyed a city and left 29,000 dead, captured the imagination of many scientists. Three of them, quite different in character, would remain forever changed.

Alfred Lacroix (1863–1948), French geologist and mineralogist, already had a great career behind him at the time of the eruption on Martinique. He had studied volcanism, metamorphism, and meteorites. As soon as the catastrophe was reported, he was sent to the site by the French government. Confronted with the ruins of Saint-Pierre, he asked: How was this destructive ashen cloud formed, and why had it moved laterally rather than rising as a vertical cloud? After a year studying the site and gathering testimony, Lacroix managed to identify the role played by the dome of solidified lava that blocked the chimney of the volcano in the genesis of the phenomenon. In 1904 he published a work that marked a major point in volcanological history, *Montagne Pelée and Its Eruptions*. In it, to describe the burning avalanche that ravaged St. Pierre in 1902, he borrowed the term *nuée ardente* (a term still used in the original French, meaning "burning cloud"), which a witness had suggested to him. After this experience, Lacroix became an active promoter of volcanological observatories. His conviction was based on the need to pursue in-depth study and continuous surveillance of volcanoes in order to avoid catastrophes like that of St. Pierre in Martinique. He himself built the first observatory of Montagne Pelée, in 1903.

Because the Antilles are near the United States, several American observers and scientists reached the site very quickly. Thomas Jaggar (1871–1953), a brilliant American geologist, was among them. The speed with which he reached Martinique allowed him to follow the catastrophe. Overwhelmed by what he discovered, he decided to devote himself entirely to volcanology, to help prevent such disastrous results from ever recurring. He was convinced in fact that such a natural phenomenon was foreseeable if the volcano could be surveilled. The cause adopted by Lacroix was thus carried forward by Jaggar, who campaigned tirelessly for the construction of volcanological observatories on different volcanoes around the world.

Having worked on volcanoes in Italy and Japan, Jaggar found himself in Hawaii, where he put his recommendations into practice. After three years, the observatory was established on Kilauea at the edge of the crater of Halemaumau, then filled by a lake of molten lava. But finances grew scarce and Jaggar was forced to practice various occupations to save the observatories. Today the Hawaiian Volcano Observatory is the most famous in the world. The original building has been converted into a museum.

A few years later, in 1906, on the slopes of Mount Vesuvius in eruption, Lacroix and Jaggar met Frank Perret (1867–1943), an engineer and inventor of genius who was an associate of Thomas Edison. During one of his frequent tours, he reached Naples just in time to admire Vesuvius. Fascinated by the phenomenon, he henceforth devoted all his talent as an inventor to the observation and surveillance of the dynamic of eruption, and joined forces with Raffaele Matteucci, another inventor, who was the director of the Vesuvius observatory. Perret visited all the Italian volcanoes, sometimes giving sound advice to the authorities who were confronted with risk-management problems. He also defended new theories of volcanism, claiming that gases carried by the magma caused

Entrance to the former volcanological observatory of Vesuvius, now a museum.

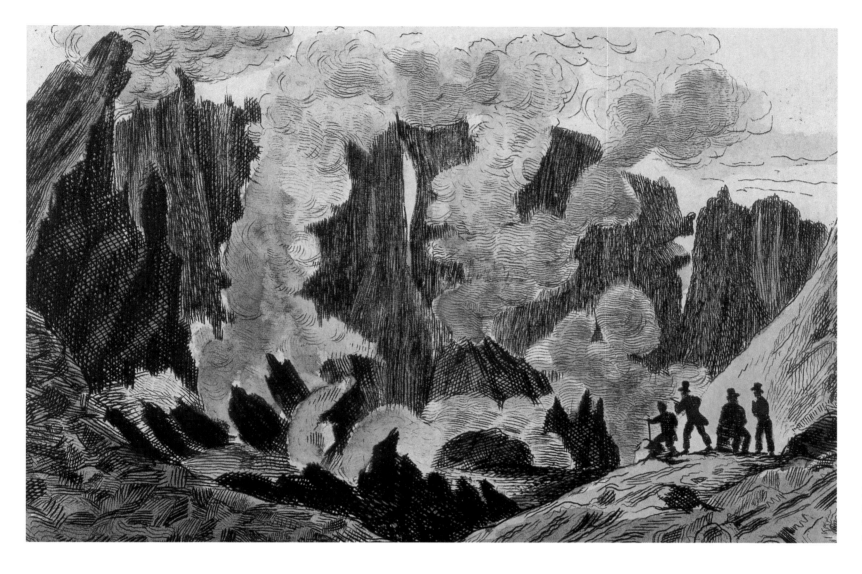

eruptions. During the strongest phases of eruption of Vesuvius, he focused on the vibrations and discovered what would come to be called the tremor, a continuous shaking due to the rise of lava in the feeder chimney. This particular seismic signal, even today, is the typical marker of eruption phases. Perret then went off to reconnoiter the volcanoes of Japan, and around 1929 returned to Montagne Pelée as the volcano awakened. He set up a small personal observatory near the crater and, despite the violence of the eruption, steadfastly pursued his observations. Several times he had to protect himself from the flaming clouds by taking shelter in his cabin, where he covered all the openings with wet cloths. His courage fascinated the people of St. Pierre, who followed his strug-gles from a distance. He demonstrated, rightly, that the city was in no danger and that there was no cause for fleeing. The thankful residents of St. Pierre erected a statue in his honor.

After these notable precursors, volcanic science entered its modern phase. It was confronted with new theories, such as plate tectonics; it also assimilated technical progress and created more and more methods of investigation, from the hammer to the satel-lite. Today, volcanology is offered as a course of study in most uni-versities, while observatories are built in countries all over the world and the researchers now number in the thousands. Mean-while, the passion remains, and on the site, it is not uncommon for people to catch themselves thinking of Empedocles.

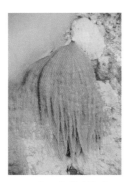

PAGE 129. Between 203° and 187° F, the sulfur of volcanic gases crystallizes into needles. Above this temperature, it melts and is transformed into an orangeish liquid, as seen here in the crater of Kawah Ijen volcano. Java, Indonesia.

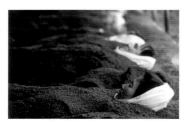

PAGES 130–31. There are many thermal resorts around Sakurajima volcano where visitors take "baths" of sand heated by the smoke from the volcano. Japan.

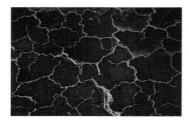

PAGES 132–33. Aerial view of Lake Natron. The soda, dried and hardened by contact with the air, forms white garlands that stand out against the red background of the lake. Tanzania.

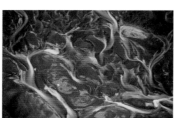

PAGES 134–35. The Thjórsá is the longest river in Iceland. Its source lies in the volcanic ranges in the south; mineral salts give it its characteristic color. Iceland.

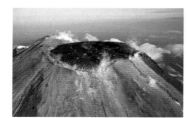

PAGES 136–37. Achavinsky volcano, 20 miles from the city of Petropavlovsk, reaches an altitude of 8,970 feet. Its active crater, filled with lava, is a favorite observation site for Russian volcanologists. Kamchatka, Russia.

PAGES 138–39. Jokuldalir region: a typical landscape shaped by a volcanic eruption. Iceland.

PAGES 140–41. The lateral blast from the 1980 explosion totally stripped the forests on the slopes of Mount Saint Helens, as well as trees on the surrounding mountains within a radius of 13 miles. Washington State.

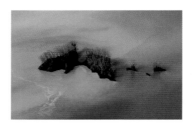

PAGES 142–43. The acid lake Voui is in one of the calderas at the peak of Aoba volcano. Rising magma releases gases that acidify the water, turning it a strange turquoise blue. On an islet of black earth, trees have been eaten away by the acidic vapor, and only ferns resist this chemical onslaught. The water temperatures range from 101° to 104° F and the pH is less than 2. Vanuatu.

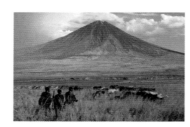

PAGES 144–45. Lengai volcano is the sacred mountain of the Masai. During its eruption people climb close to the crater where they cover their bodies in the ash to purify themselves. Tanzania.

PAGES 146–47. In the Torfajökull mountain range, intense volcanic smoke and gas dig huge caves in the glacier, to depths of 410 feet under the glacial dome. Iceland.

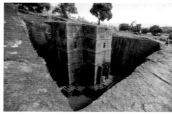

PAGES 148–49. At Lalibela the upper portion of traprock deposits, formed by pyroclastites, were carved from the block to decorate troglodytic churches in the twelfth and thirteenth centuries. Ethiopia.

PAGES 150–51. Pink flamingoes on Lake Natron. These birds are the only animals that manage to survive in the harsh environs of the soda lake. They even make good use of it. During the nesting period, flamingoes build small mounds of soda dried in the sun as a place to lay their eggs. The birds also ingest red algae that develops in brine. Tanzania.

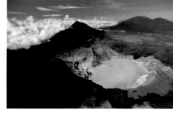

PAGES 152–53. Volcanic massif of Kawah Ijen ("Green Crater" in Indonesian) with its acid lake, the world's greatest reservoir of sulfuric and hydrochloric acids. People mine the sulfur that accumulates in great quantities on the banks of the lake. Java, Indonesia.

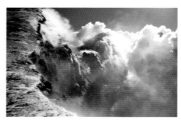

PAGES 154–55. Etna is the largest active volcano in Europe, with four large, active craters at its summit. Reaching a height of 11,150 feet, it is snow-covered in winter, with near-Alpine conditions. Sicily, Italy.

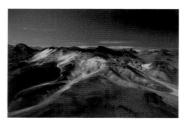

PAGES 156–57. Many volcanoes are found in the desert of Atacama. Their typical colors are due to smoke and gas that have corroded the volcanic rocks. Chile.

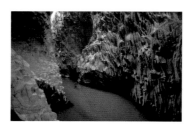

PAGES 158–59. At Alcantara, great flows of basaltic lava poured from the earth before Etna was formed. Of great thickness, they have formed visible columns on the walls of this canyon. Sicily, Italy.

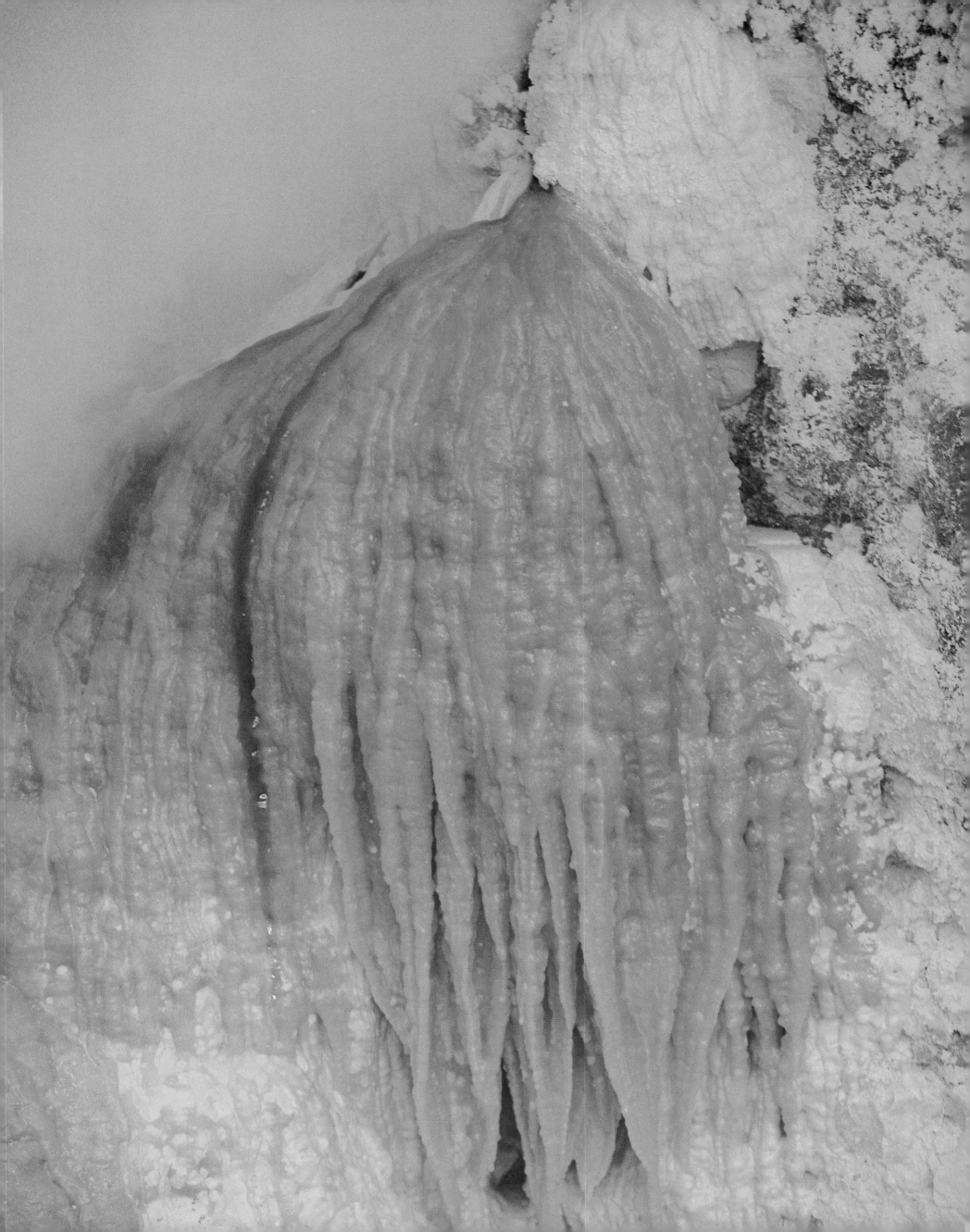

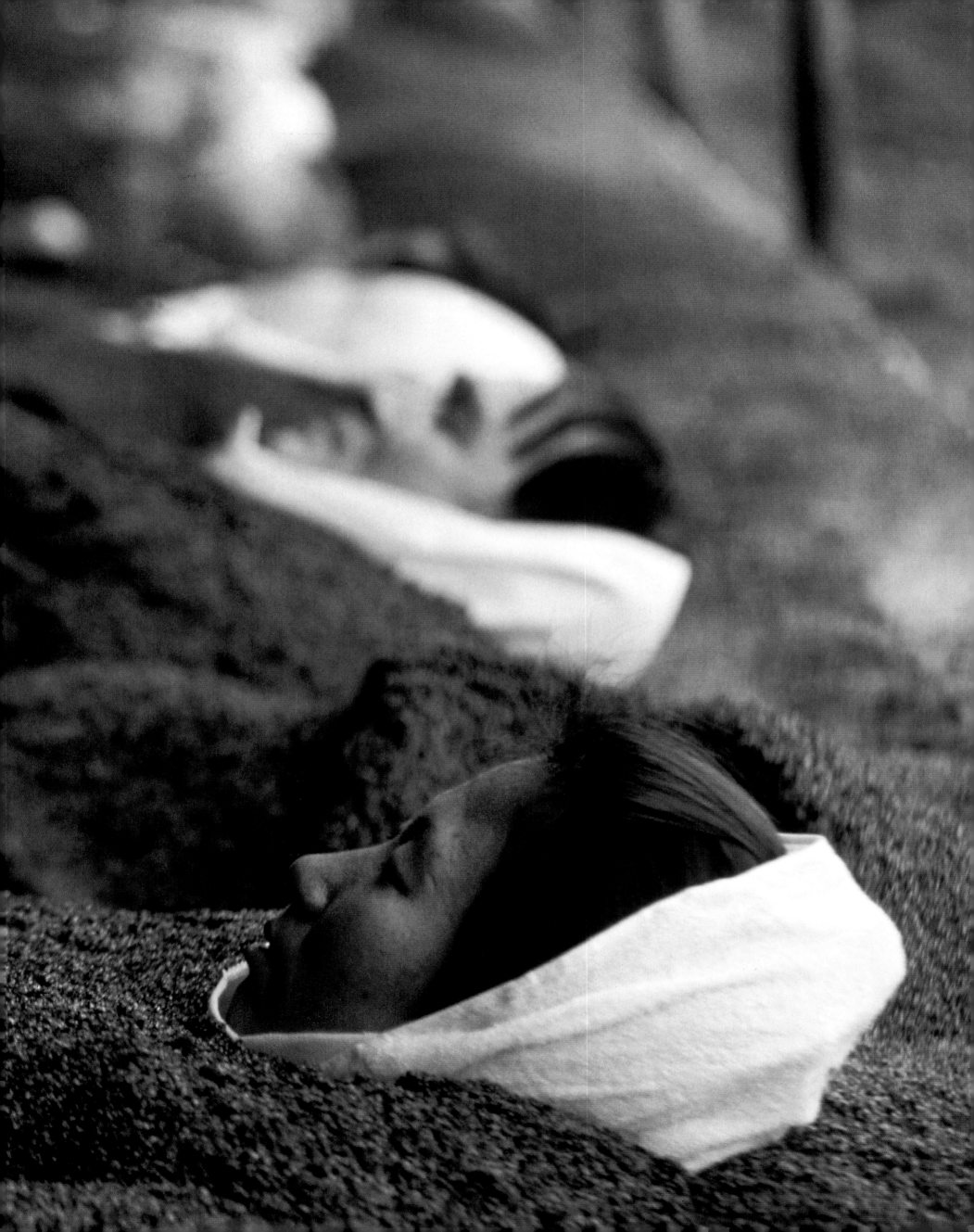

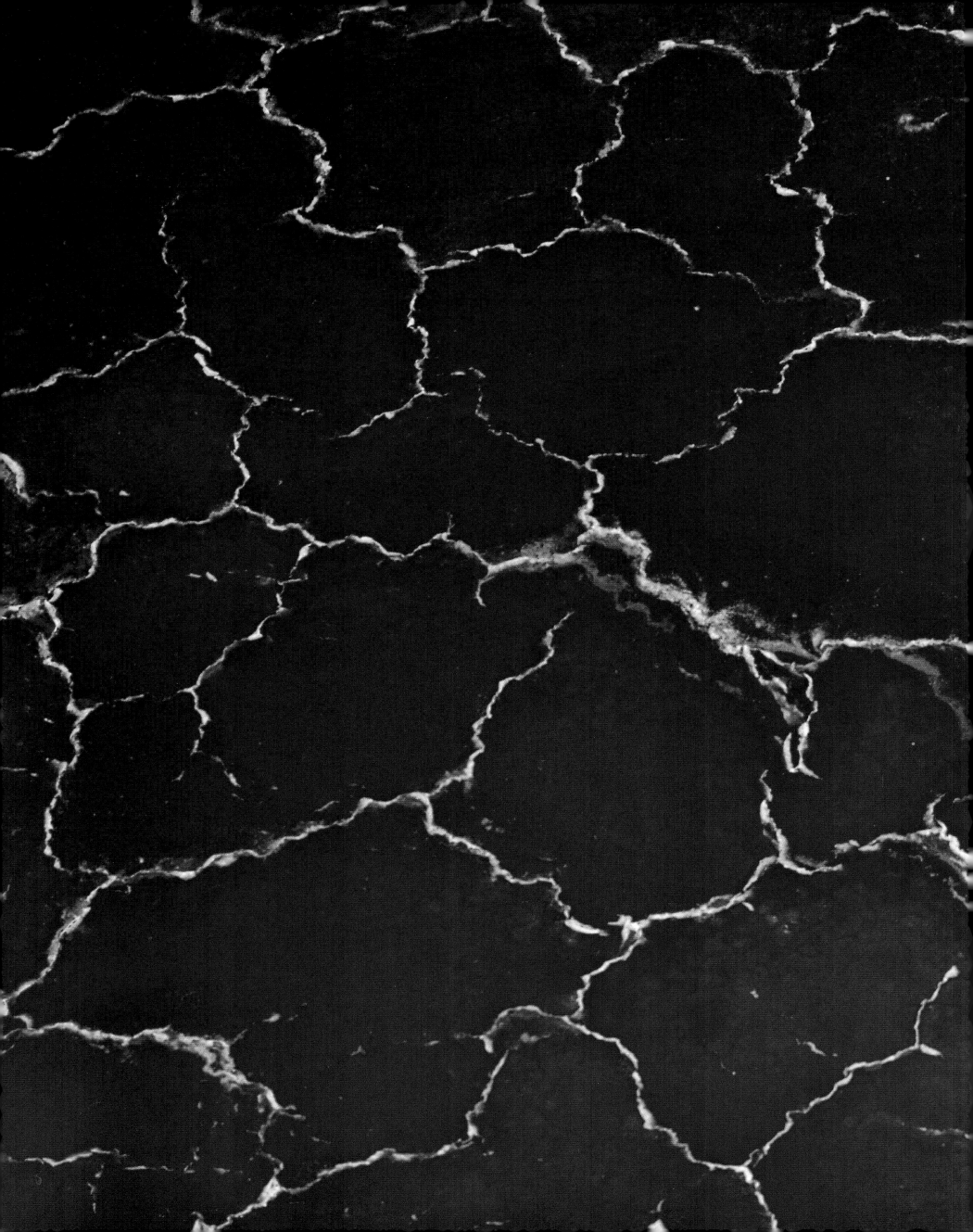

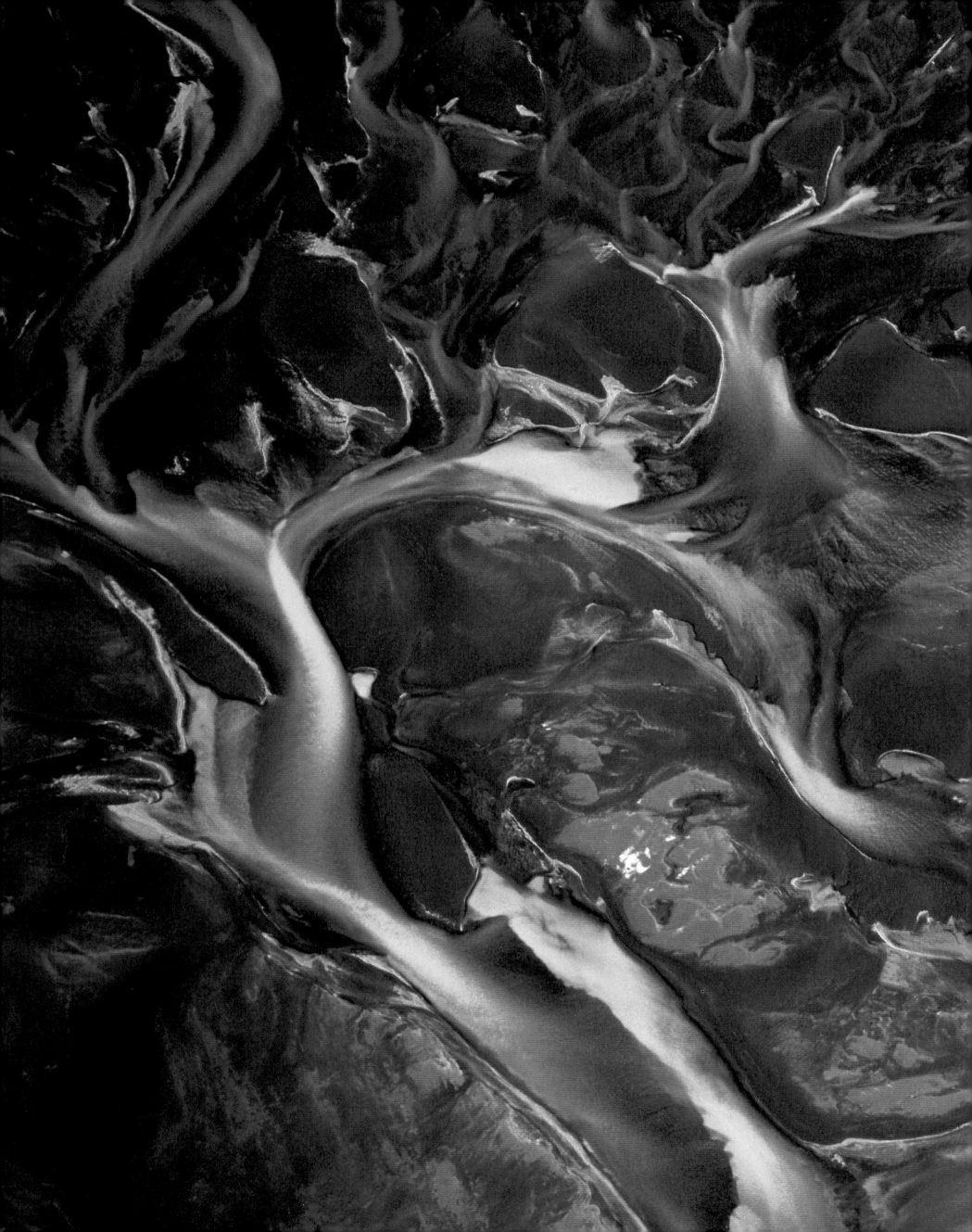

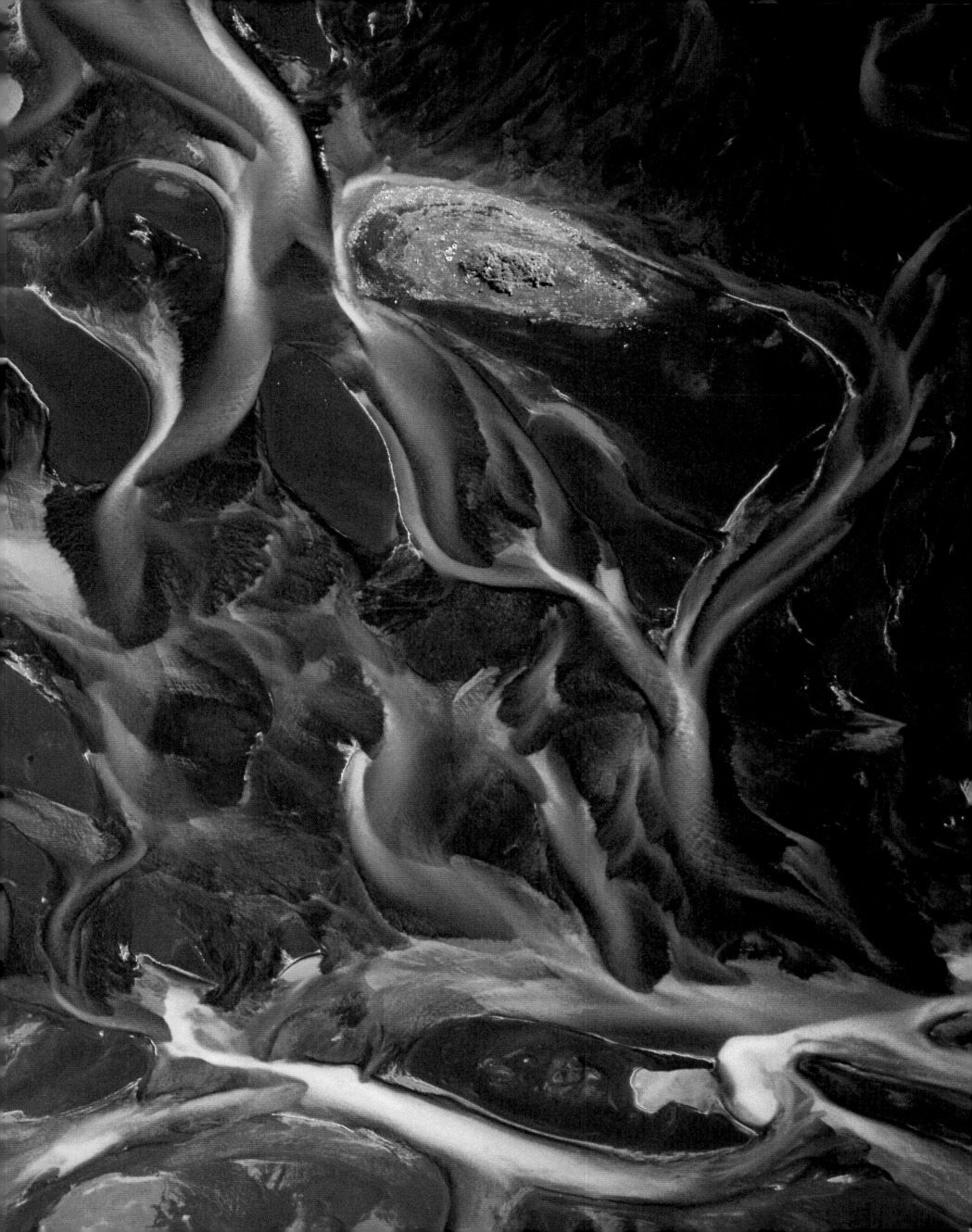

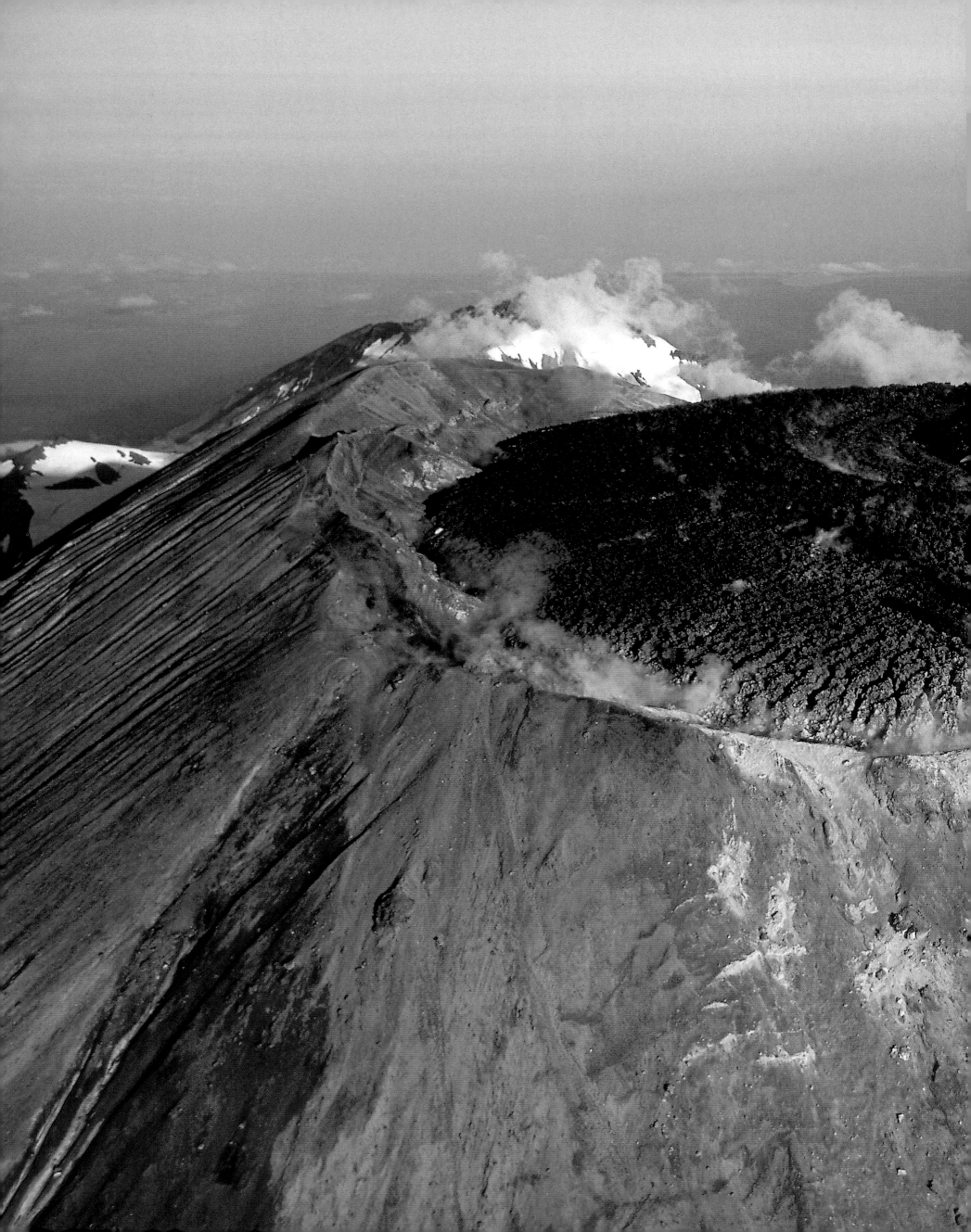

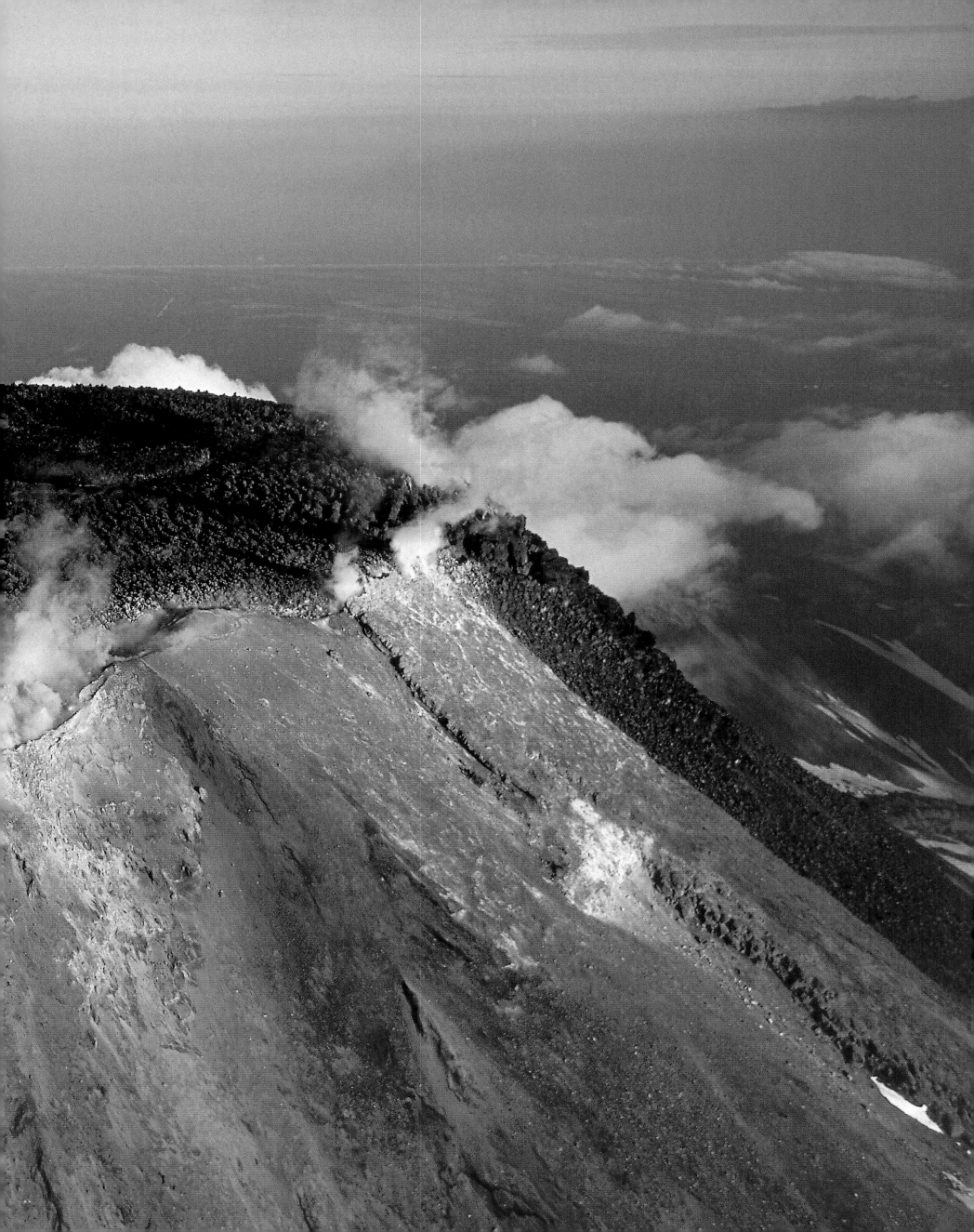

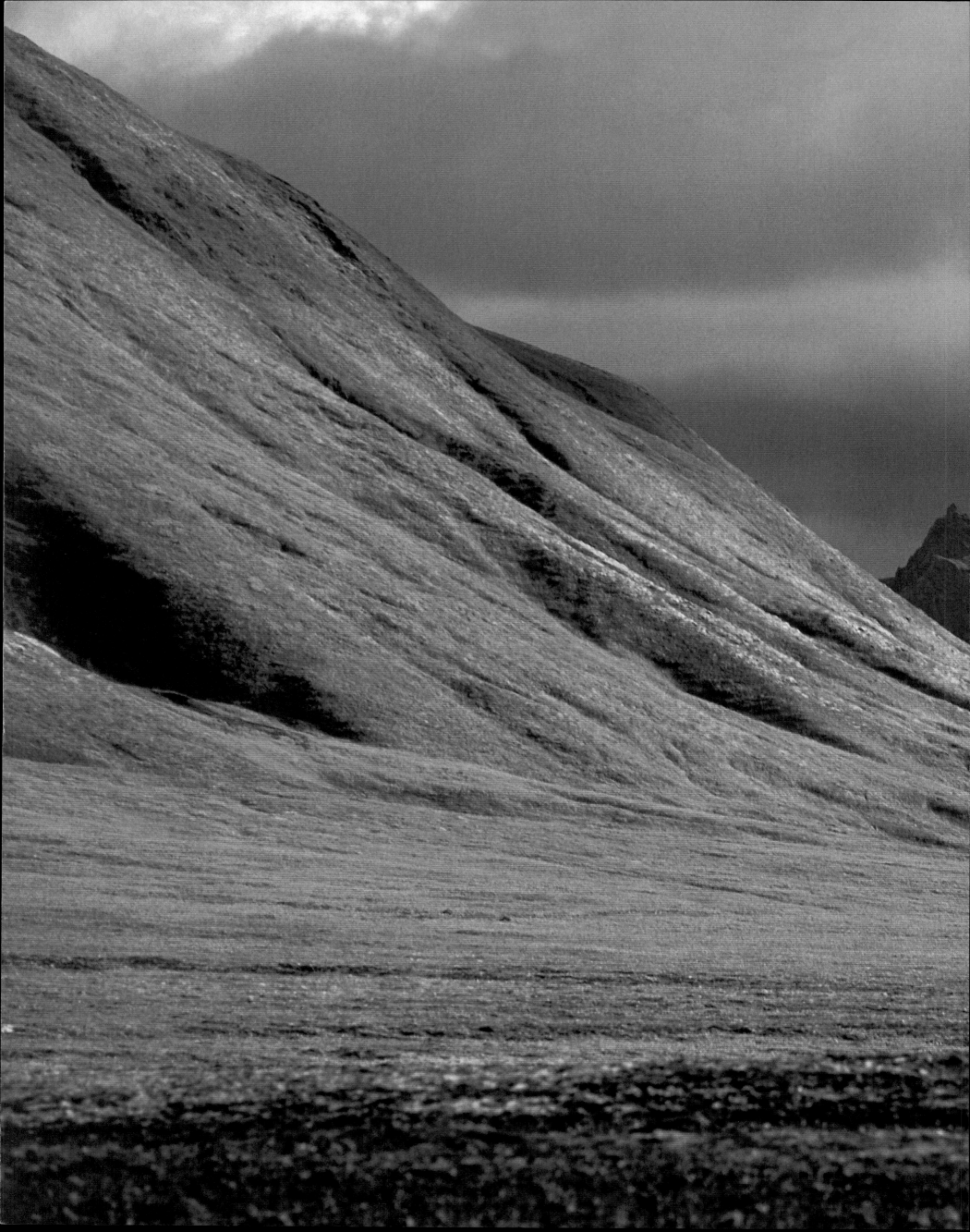

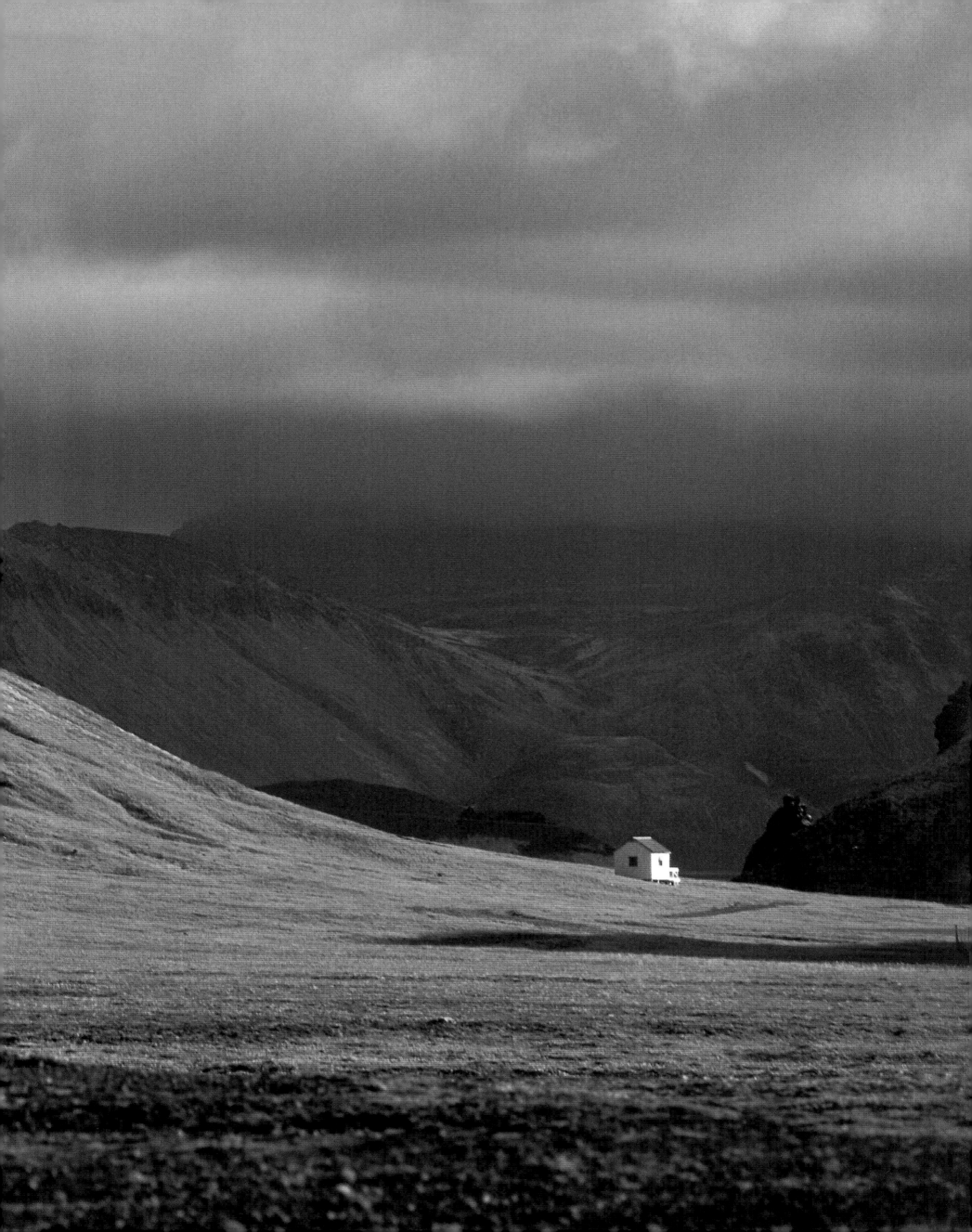

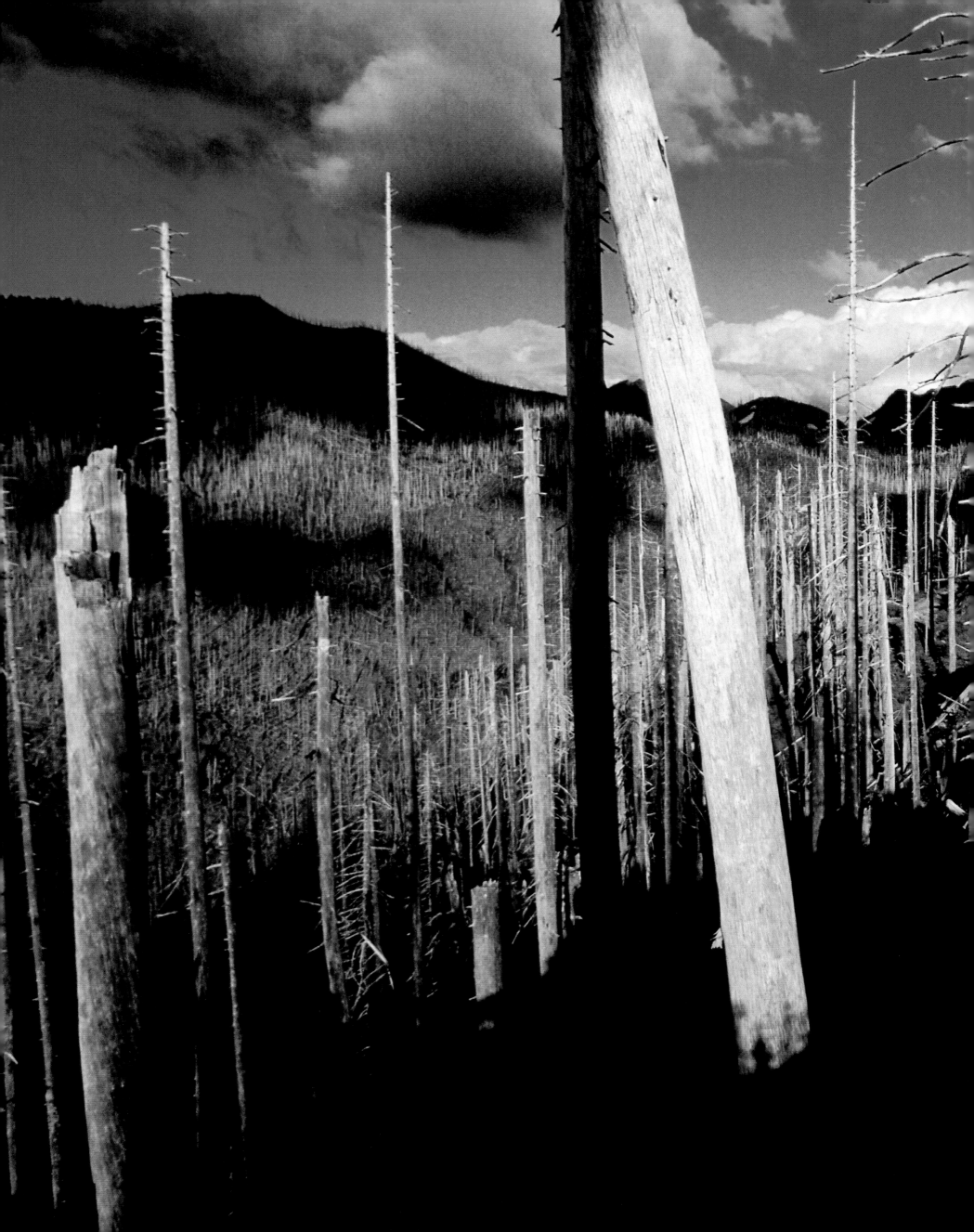

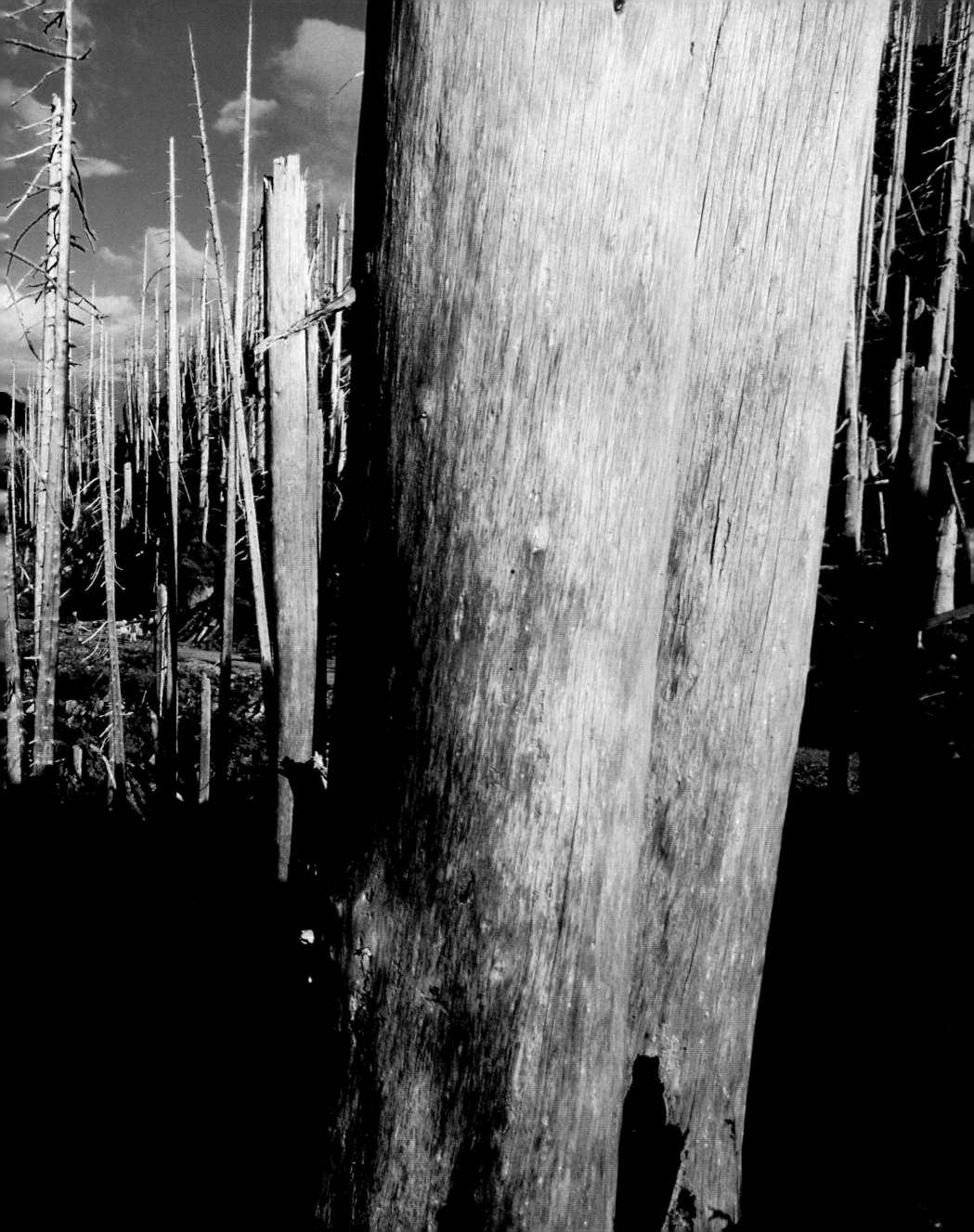

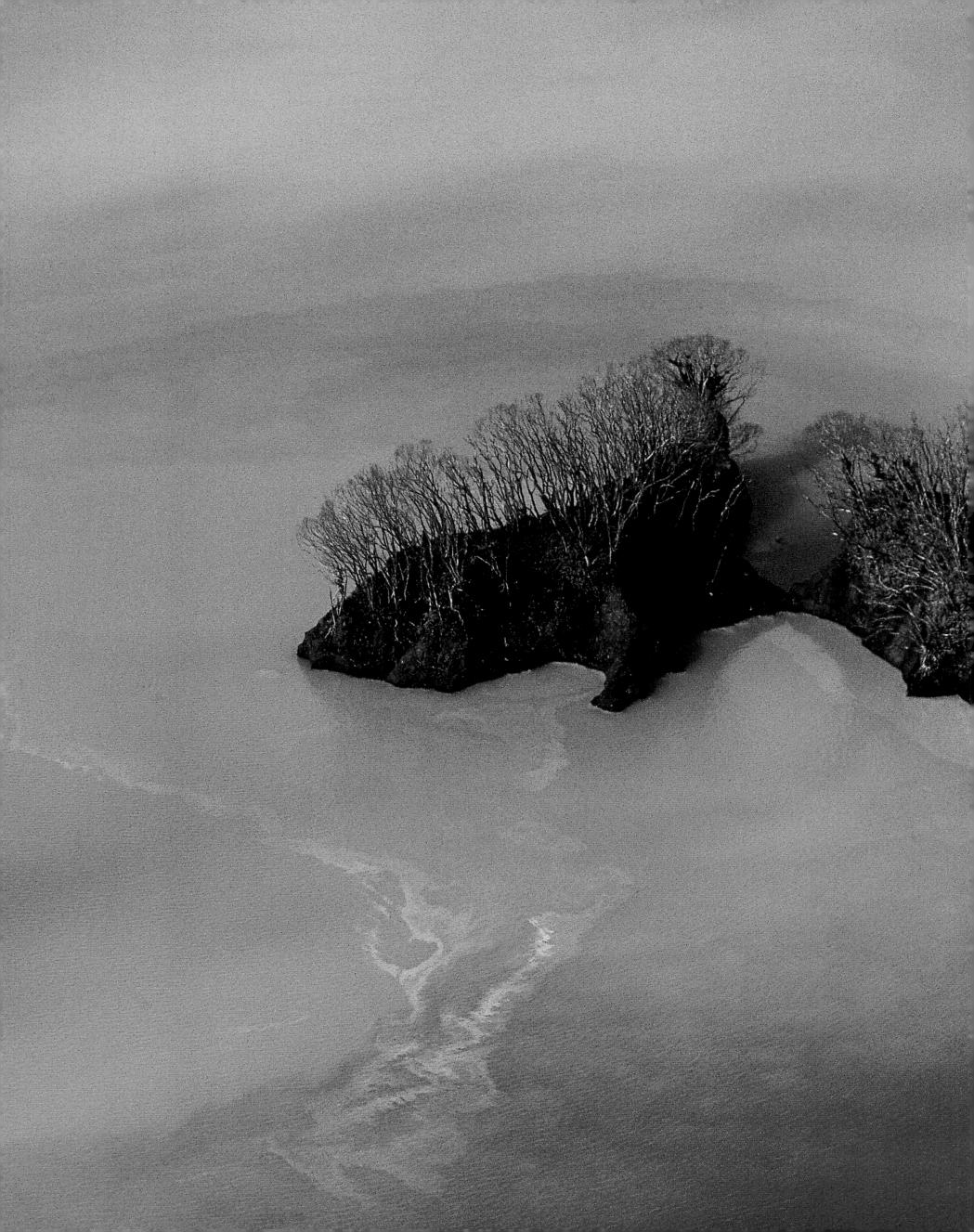

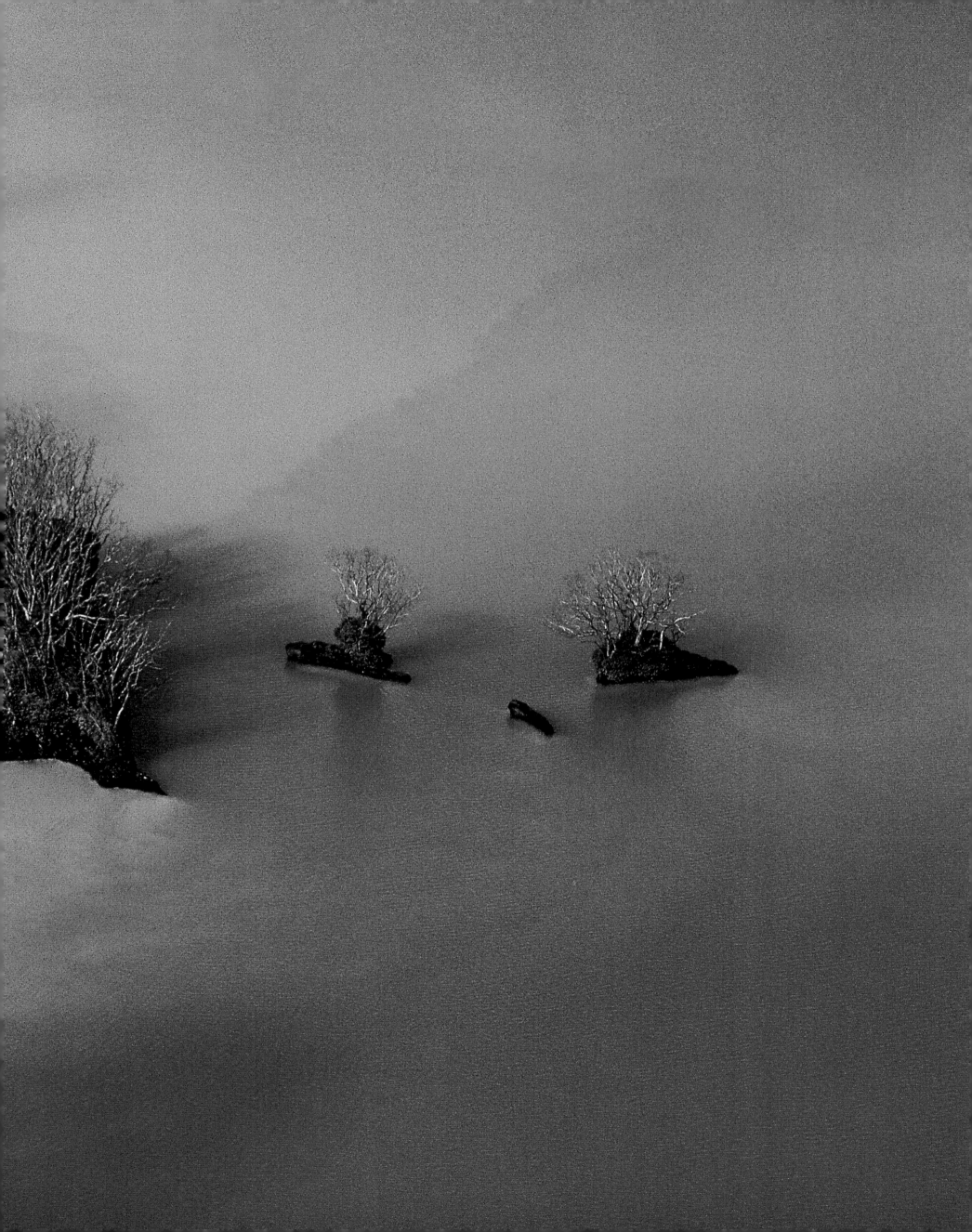

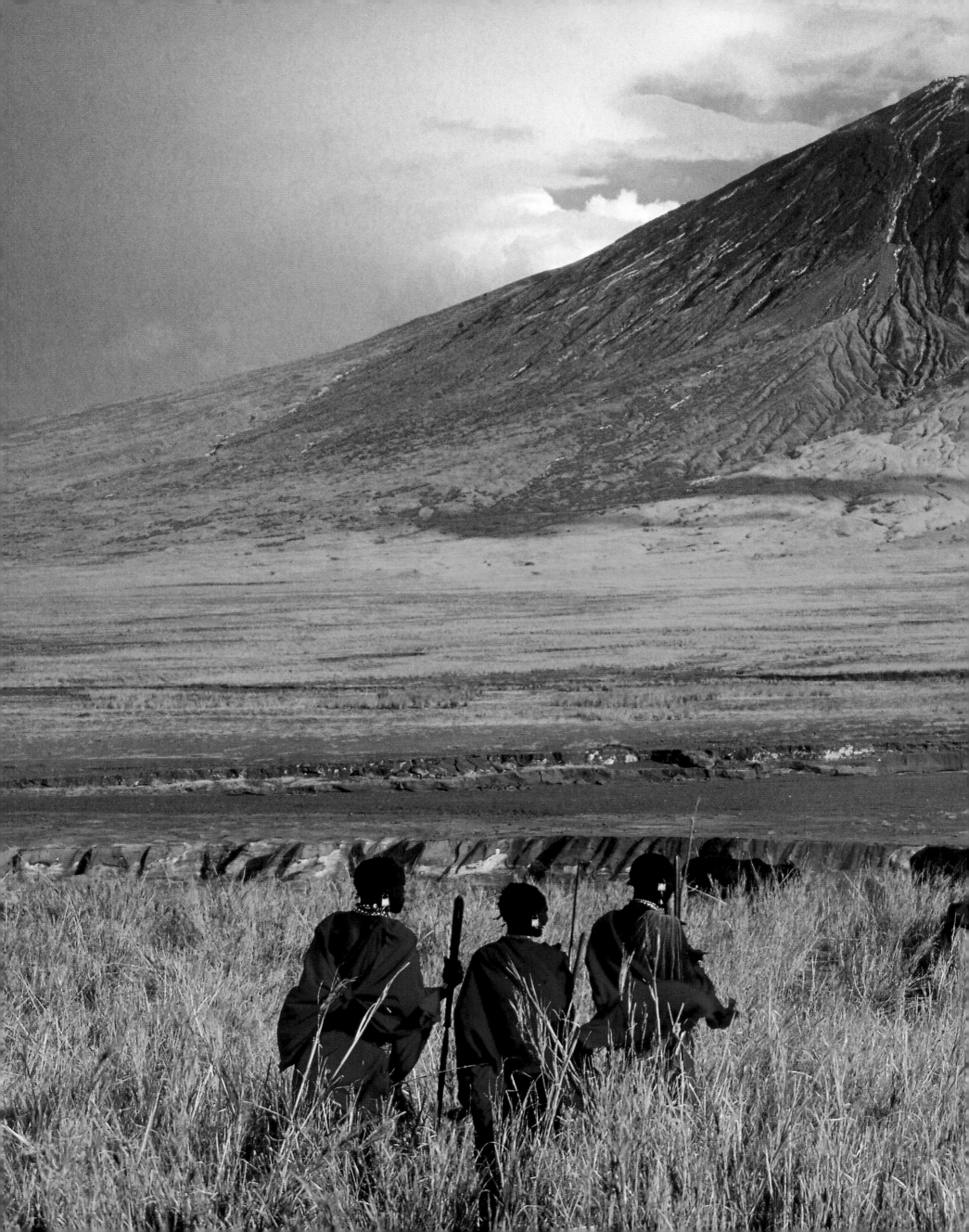

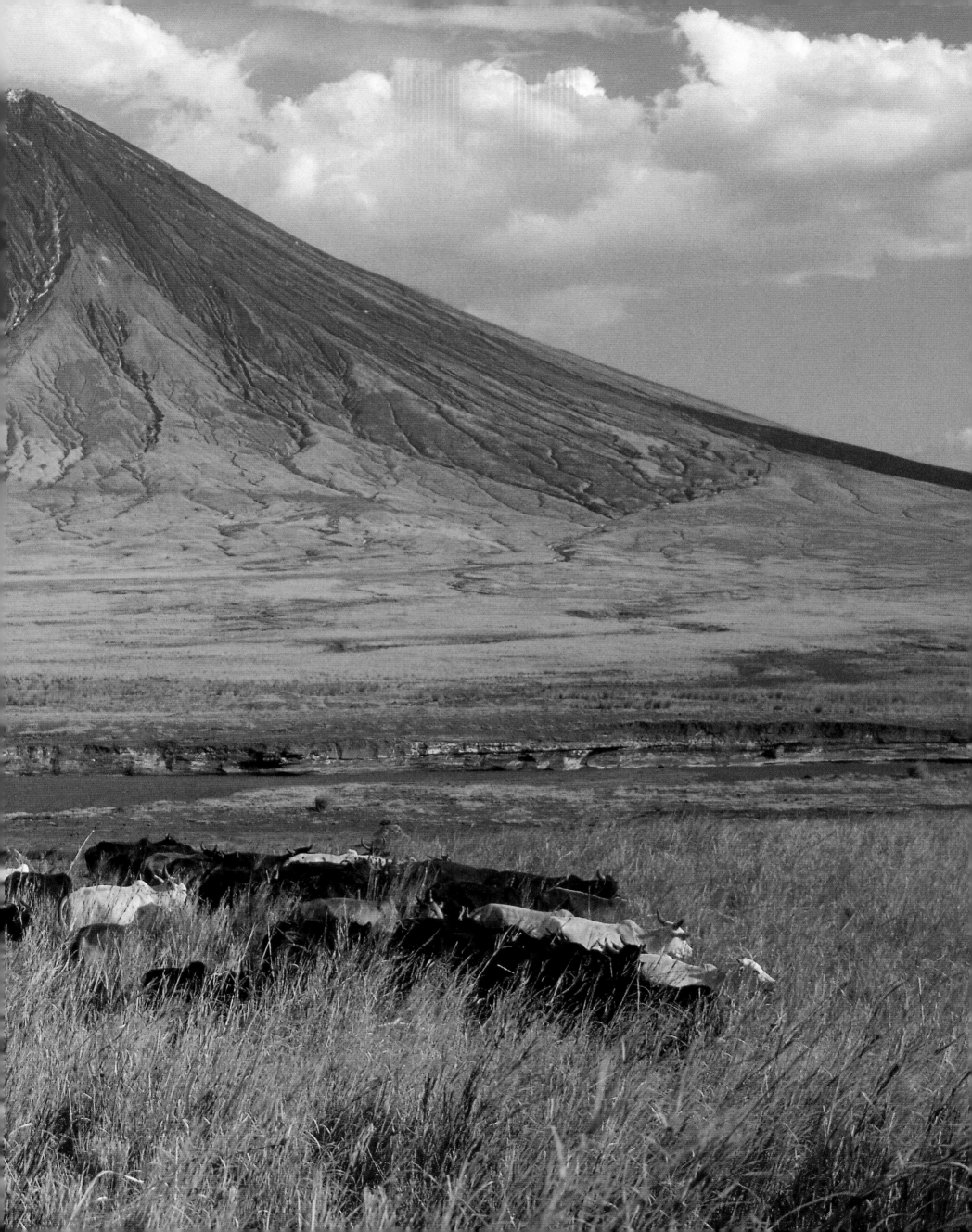

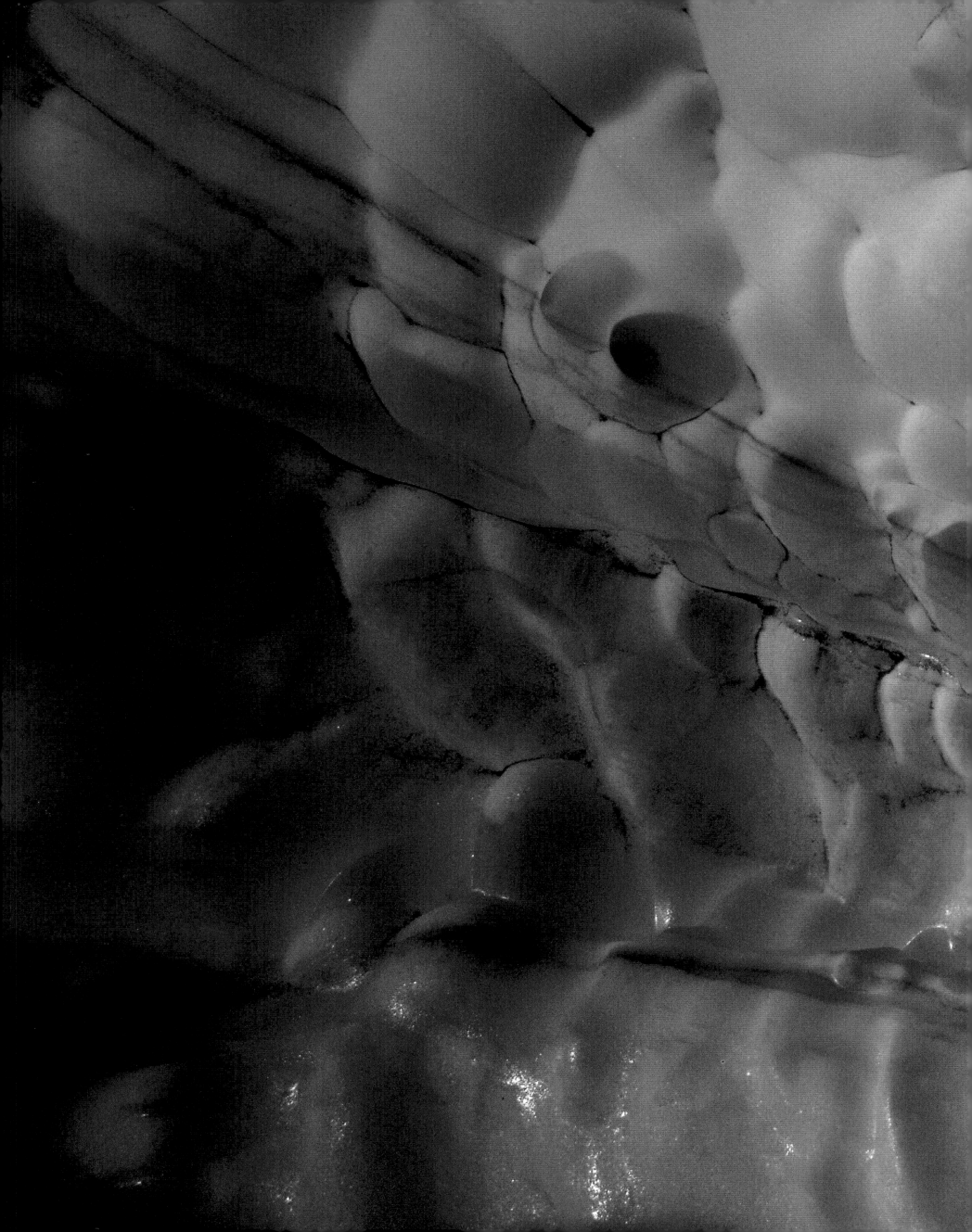

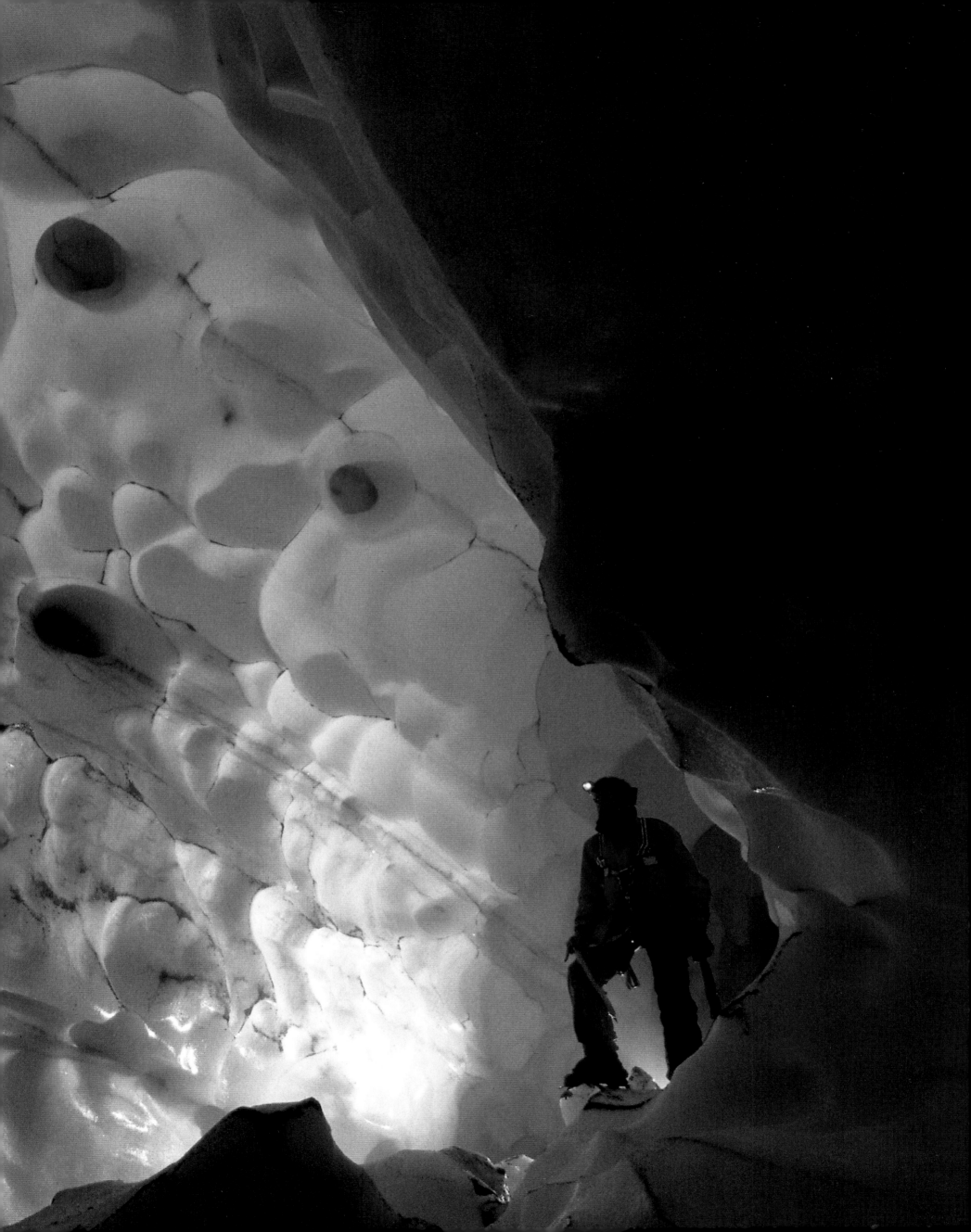

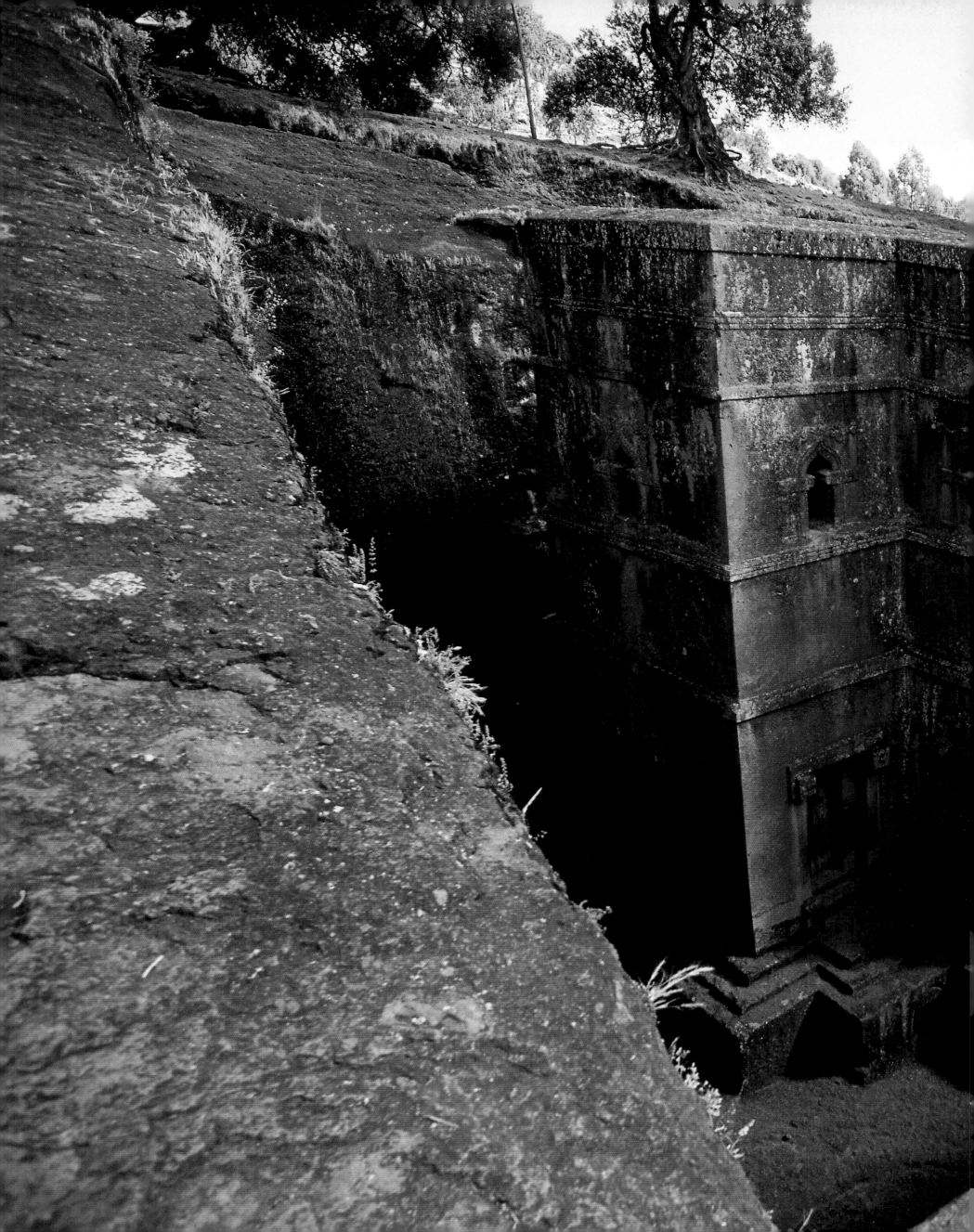

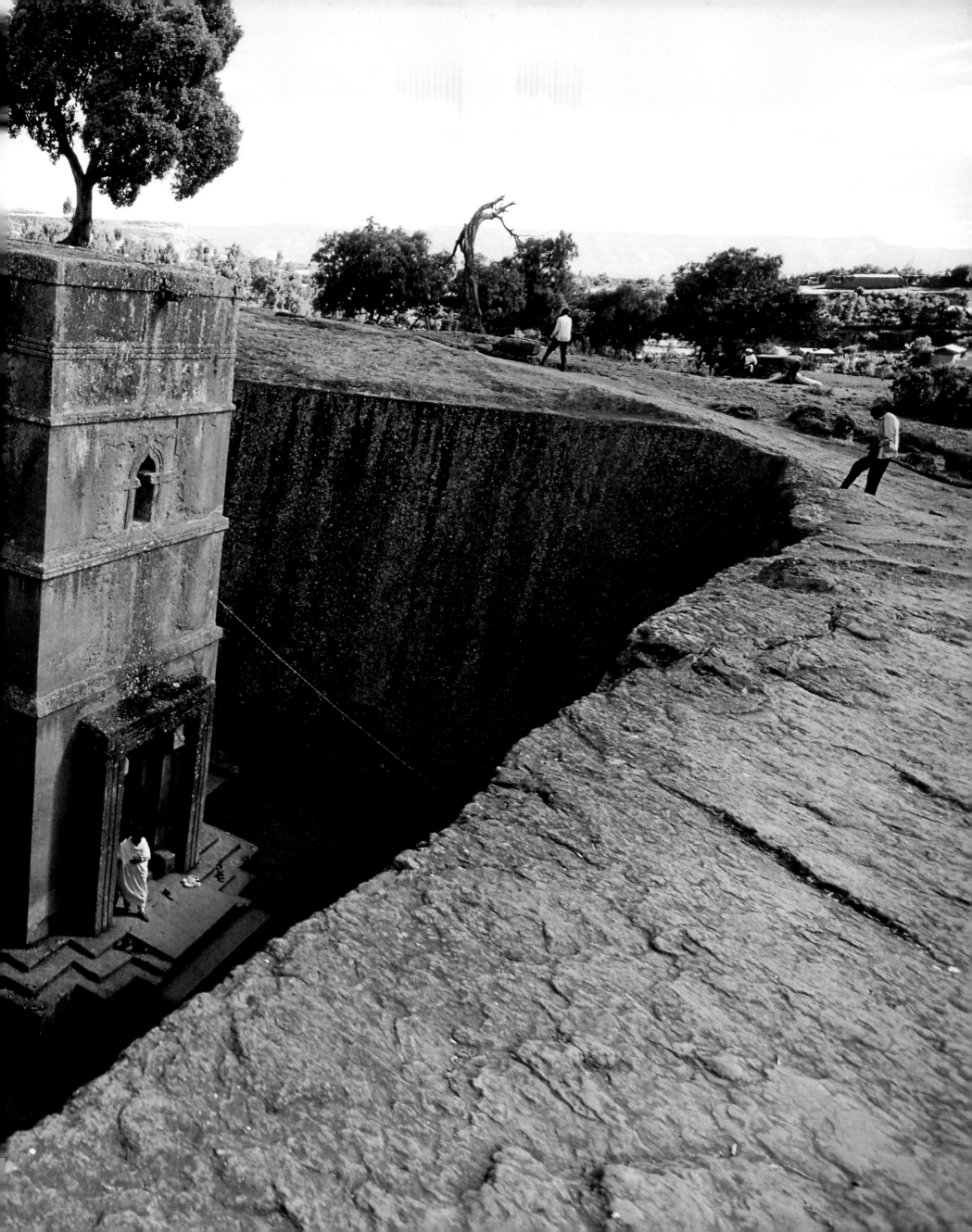

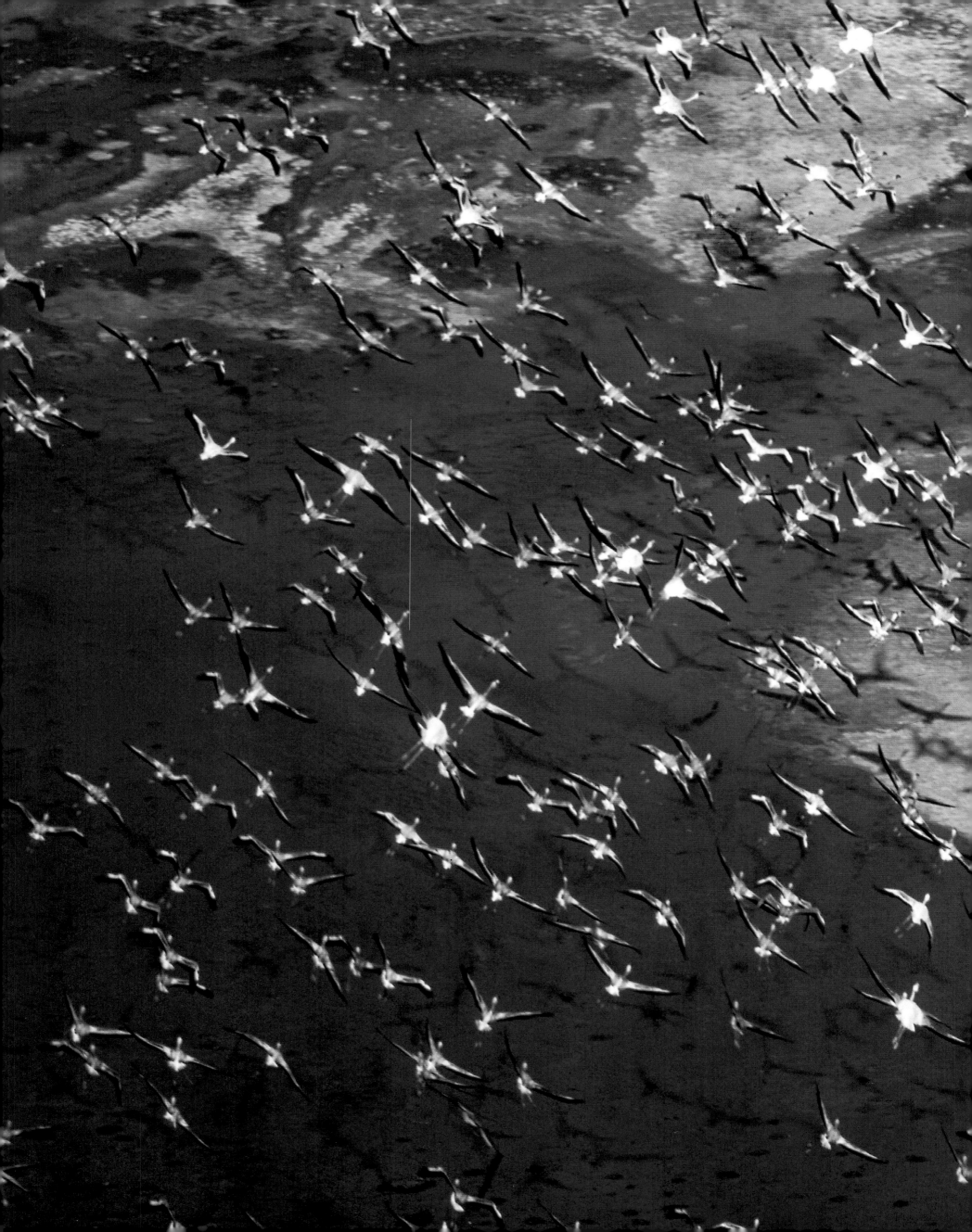

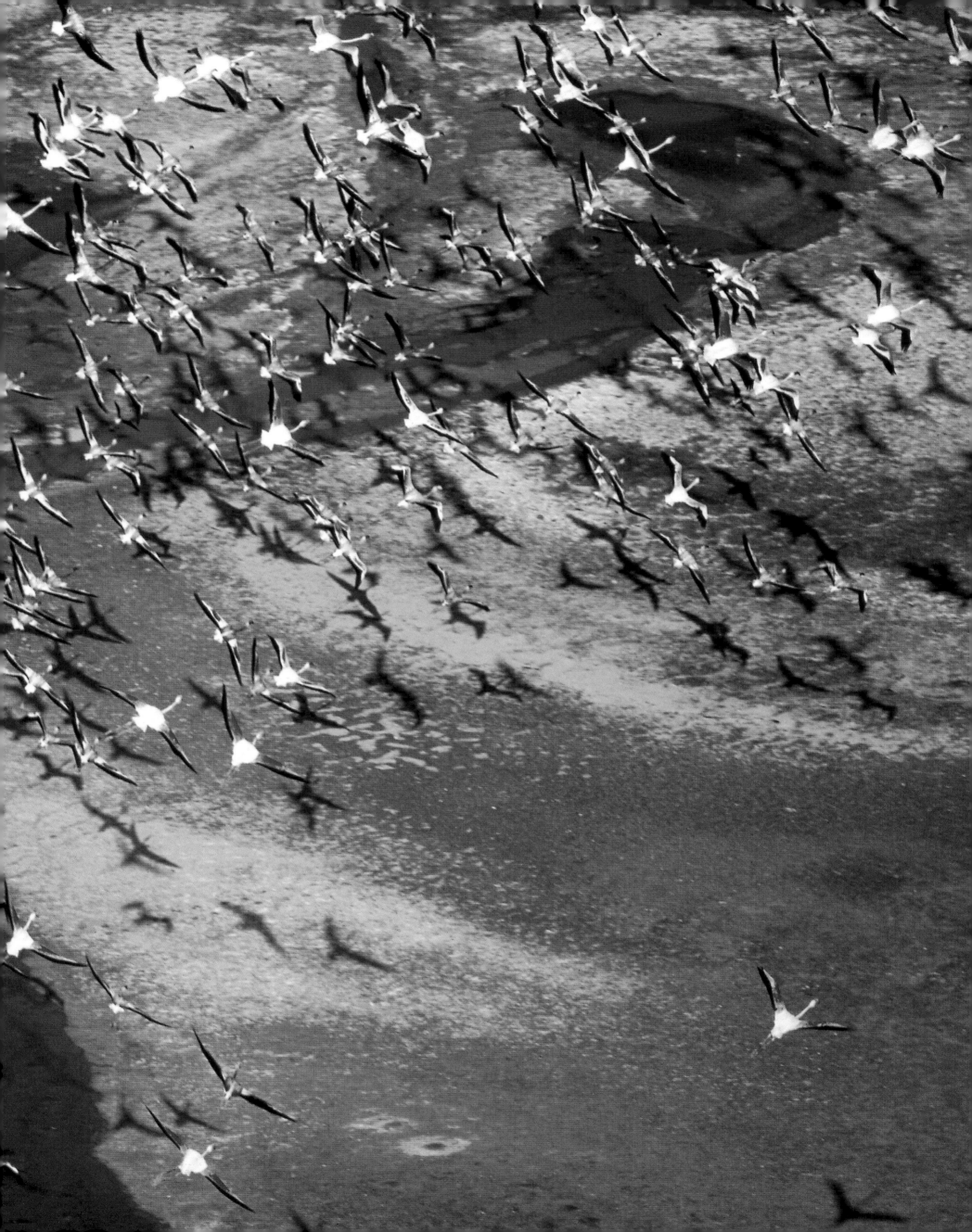

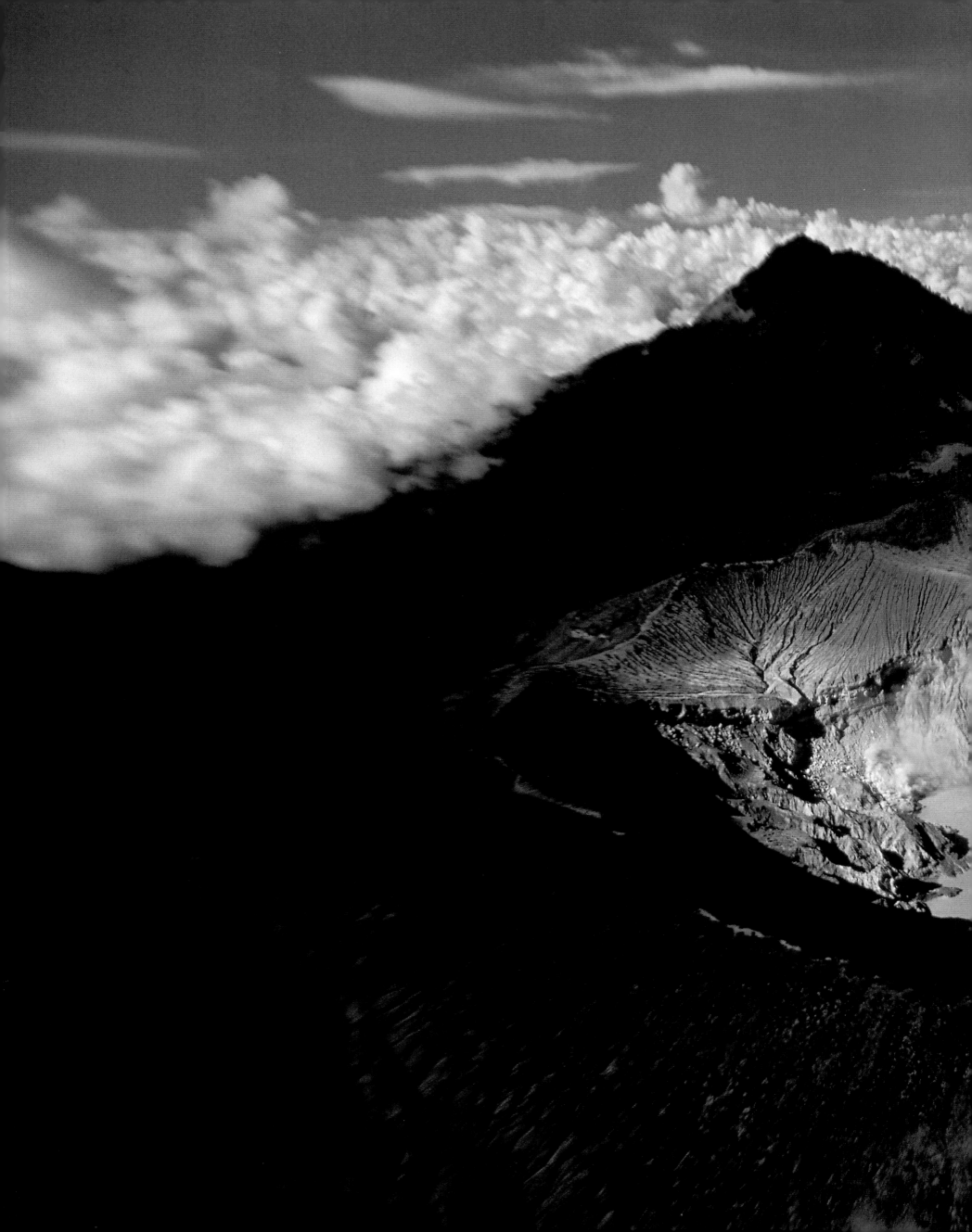

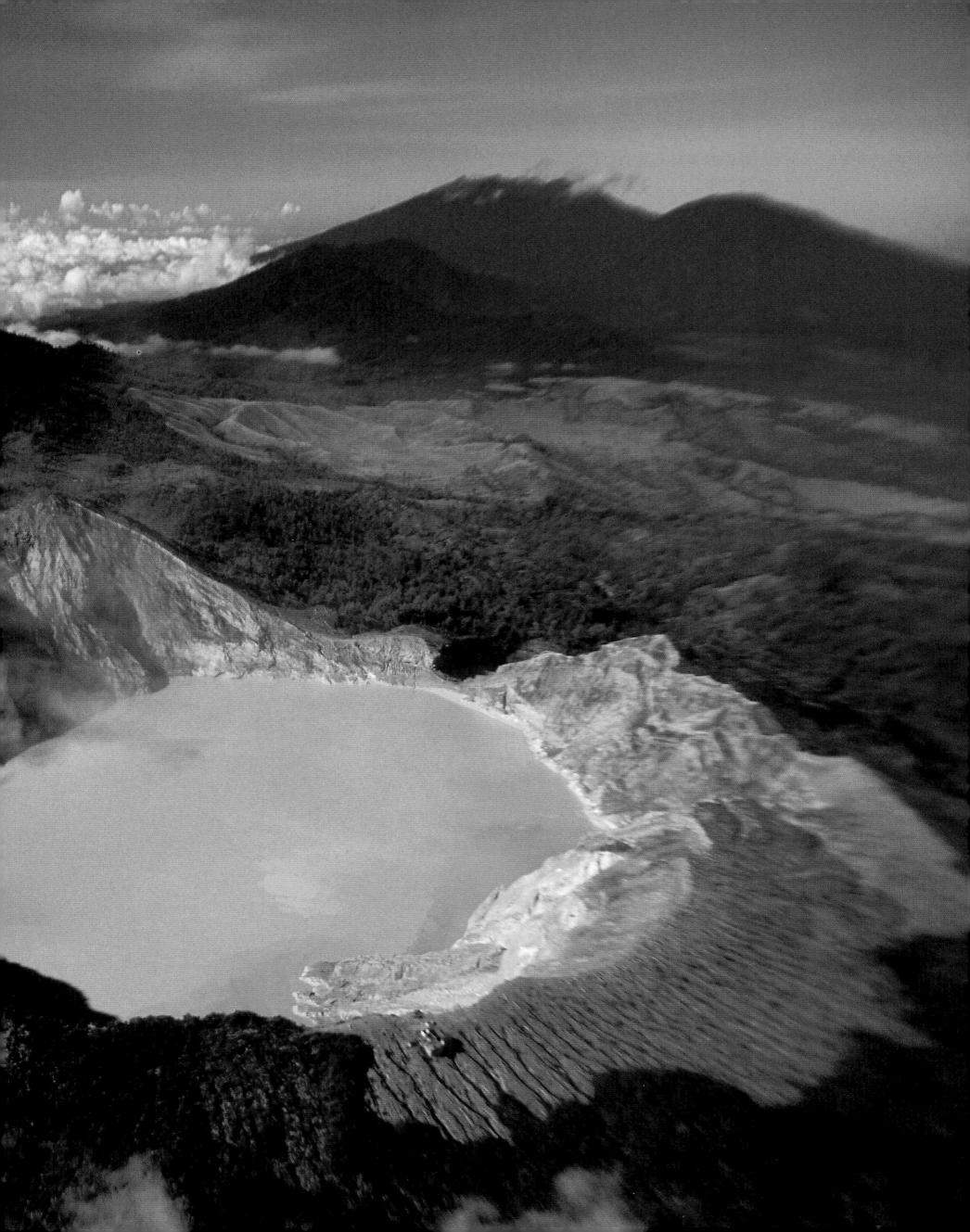

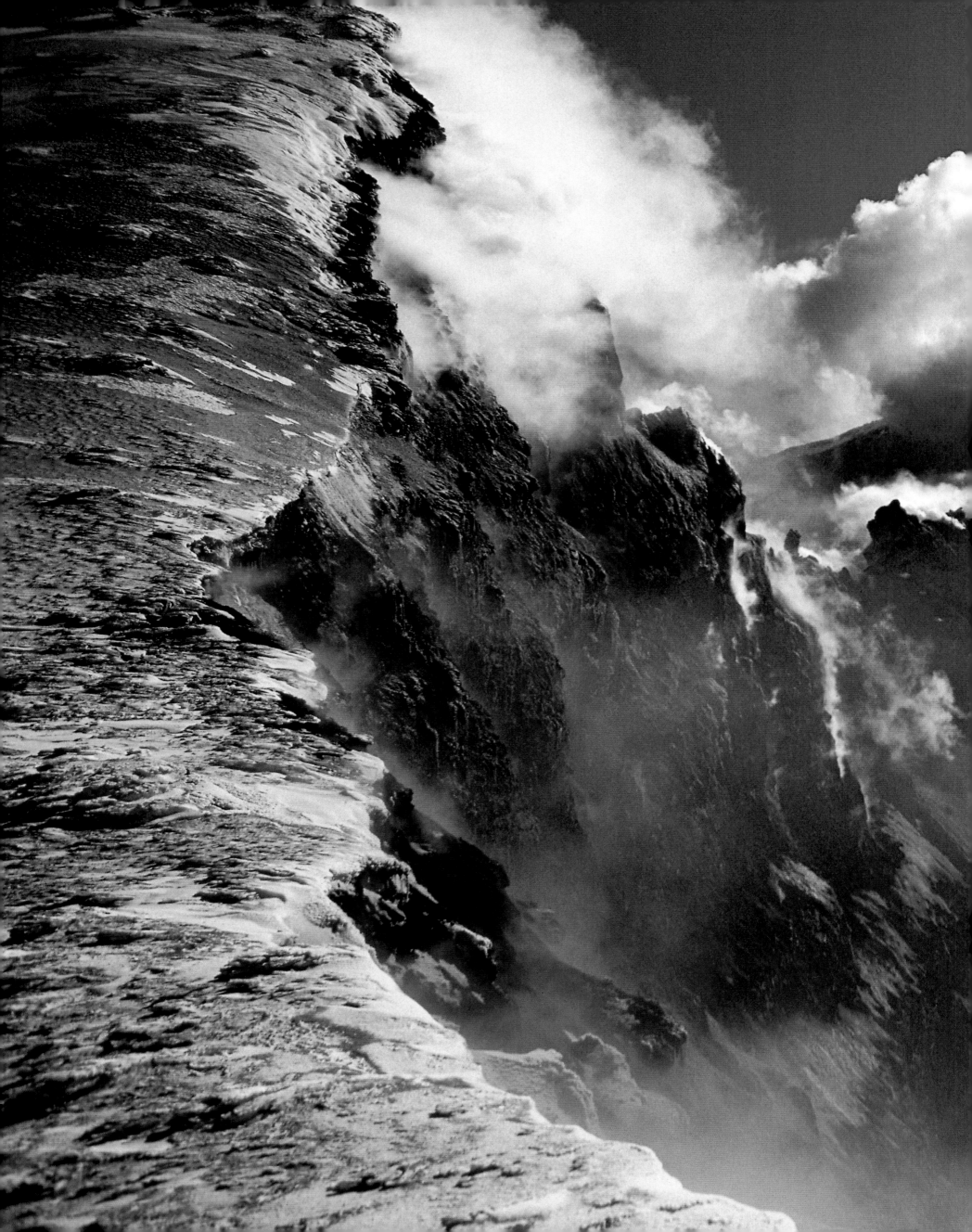

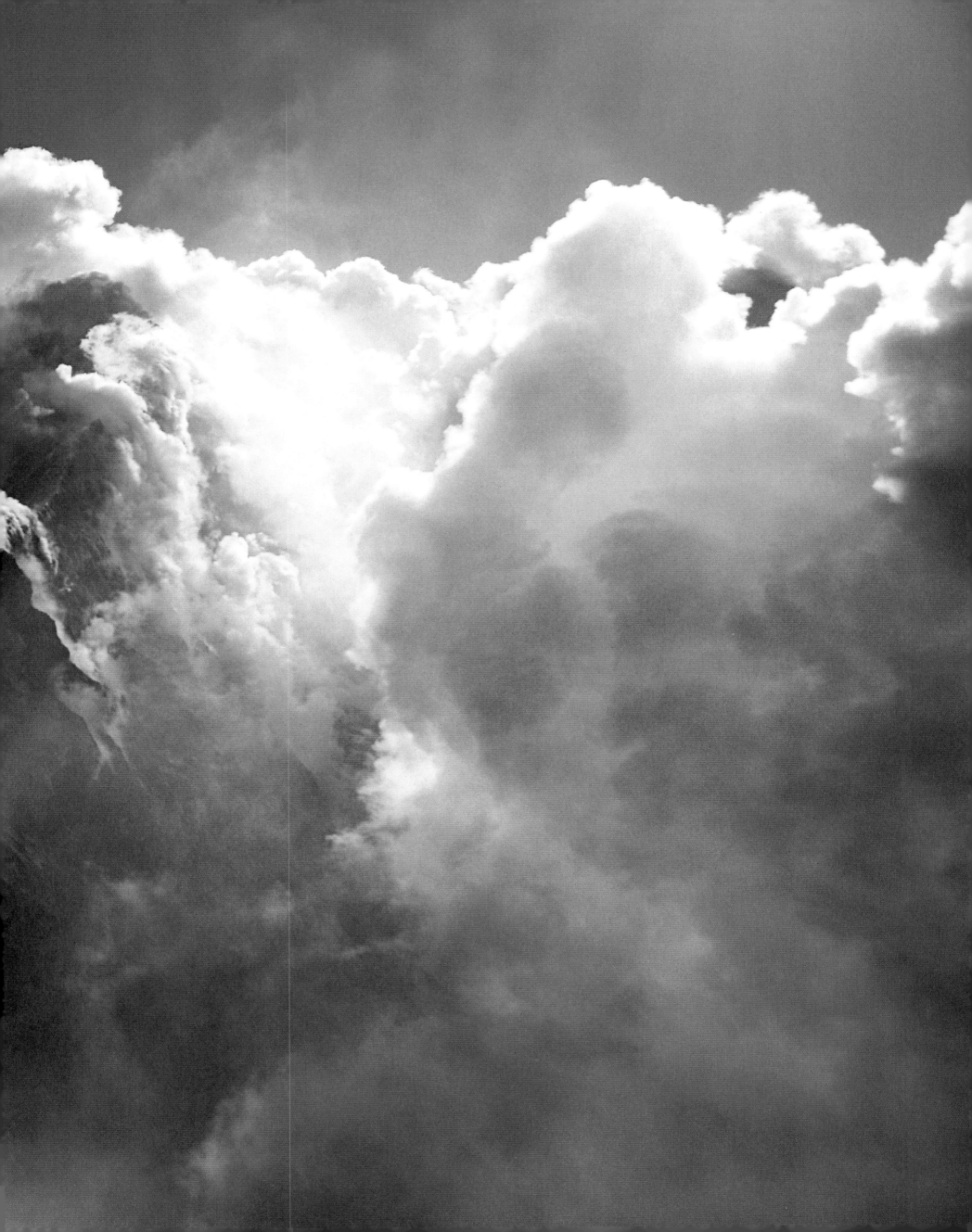

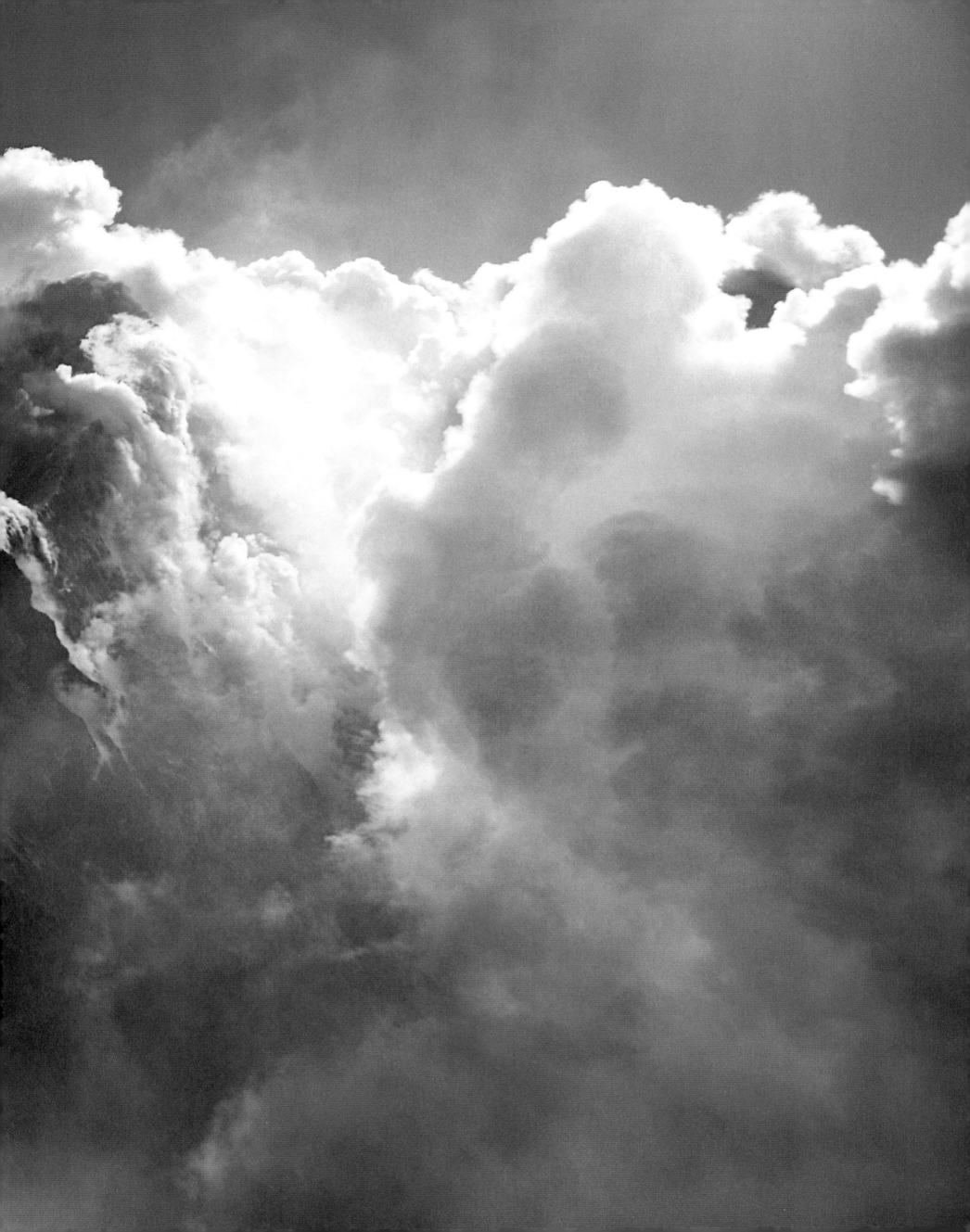

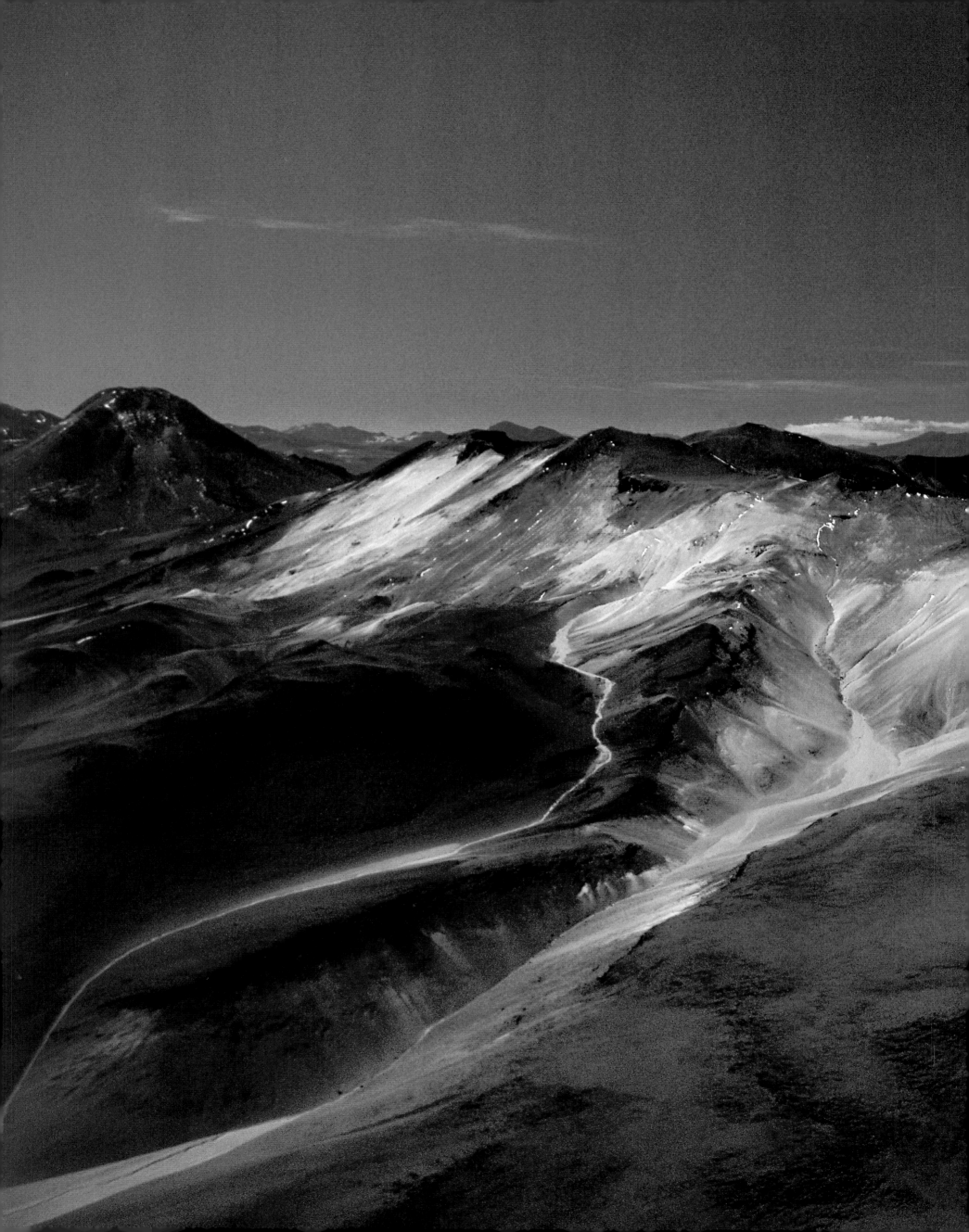

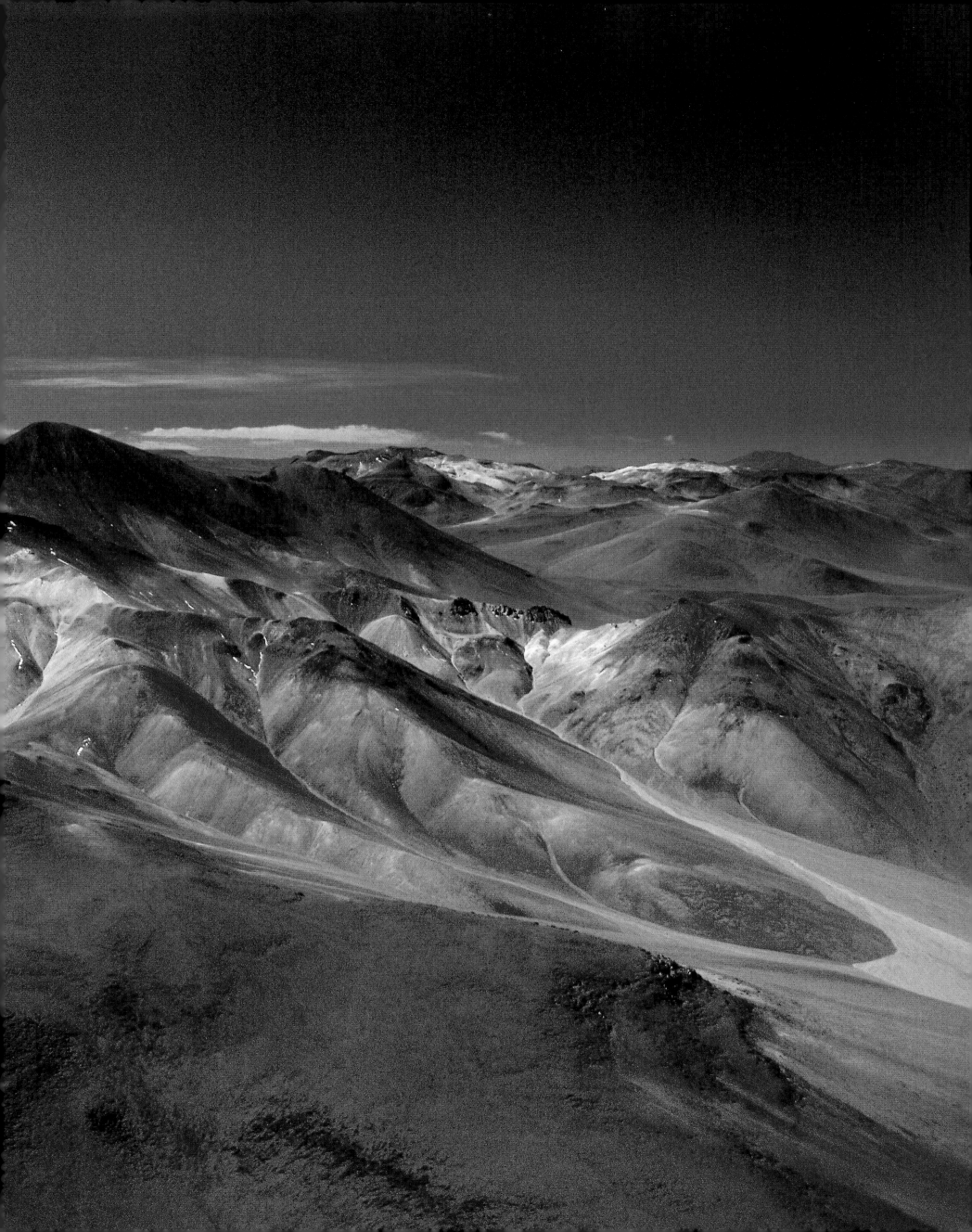

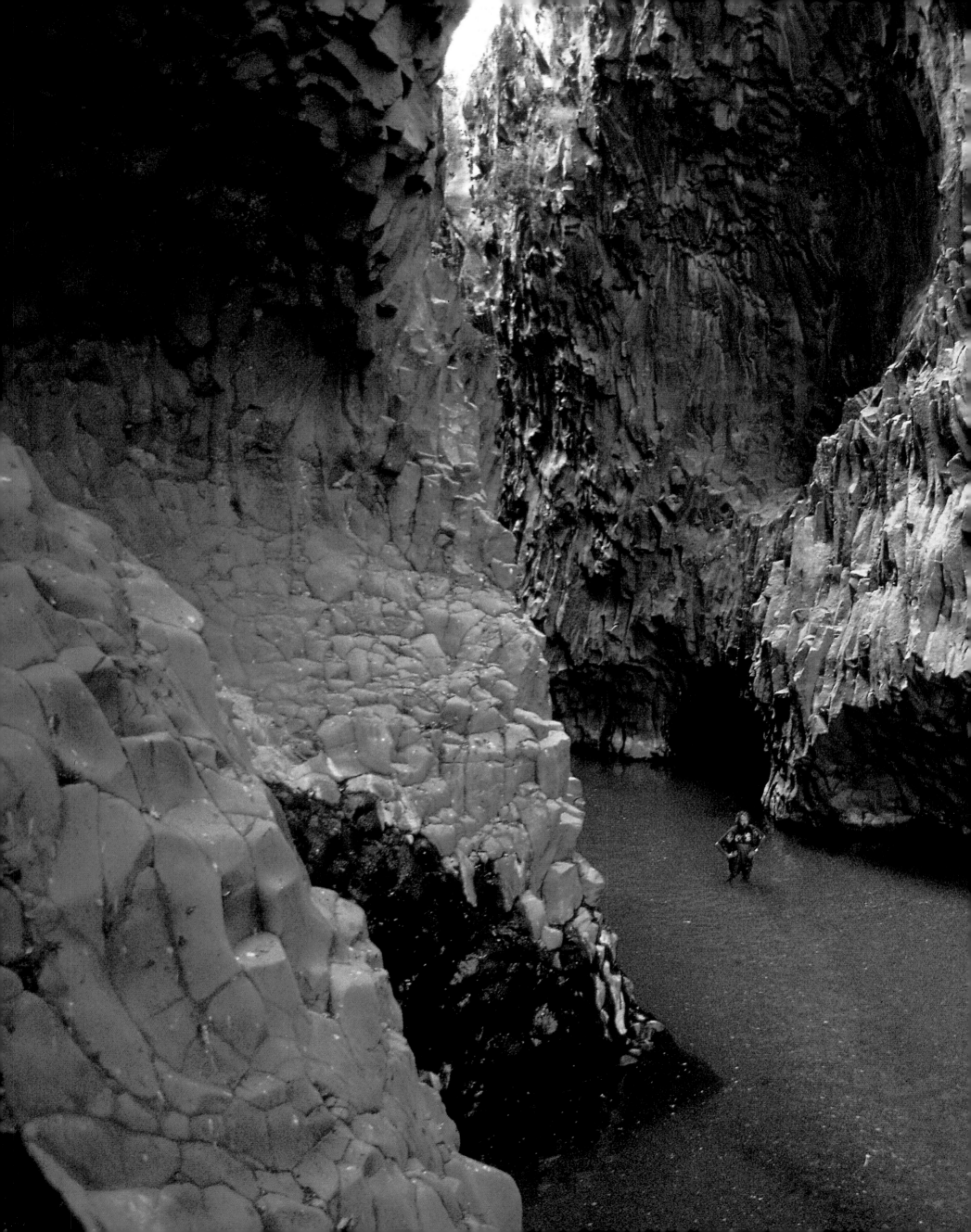

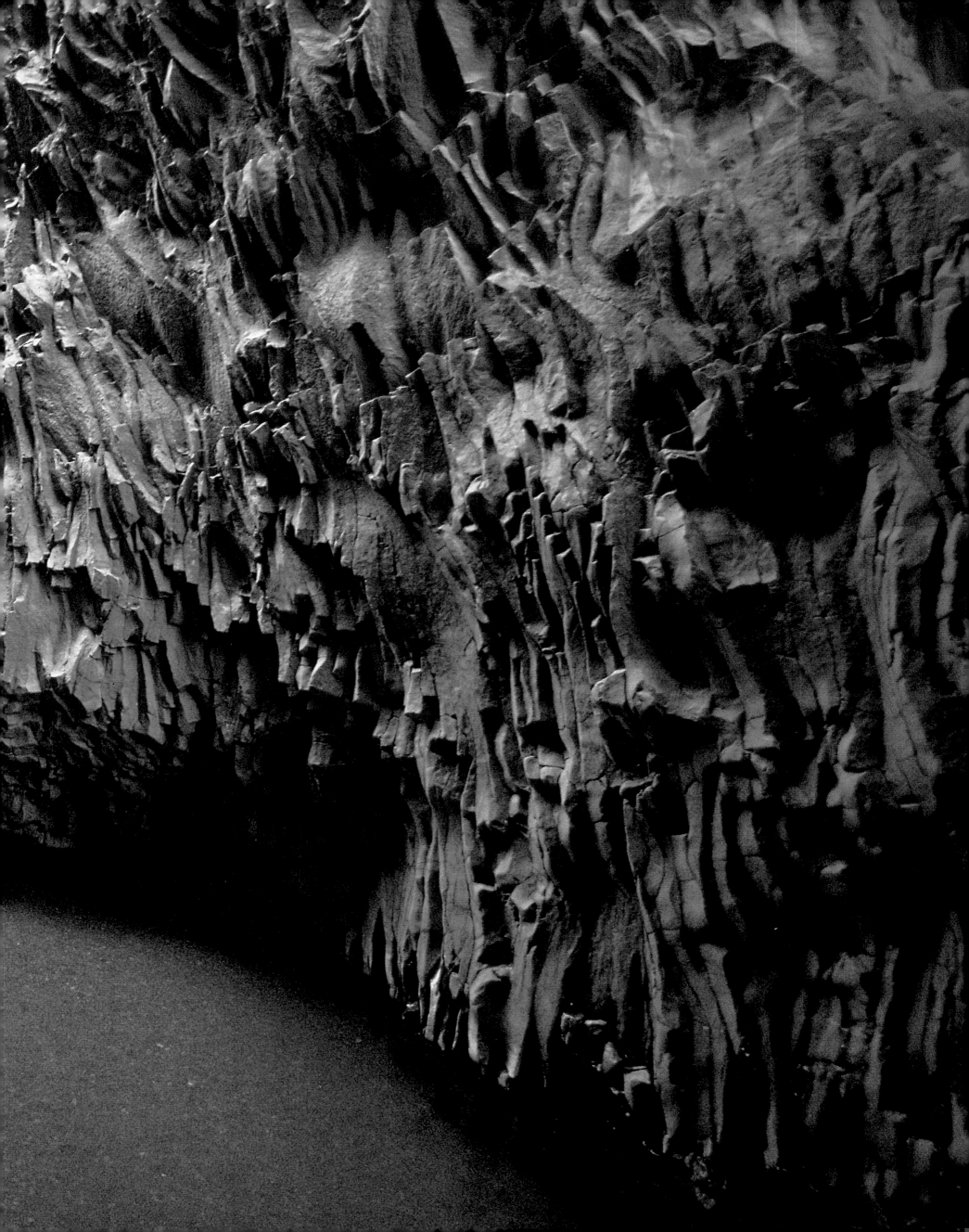

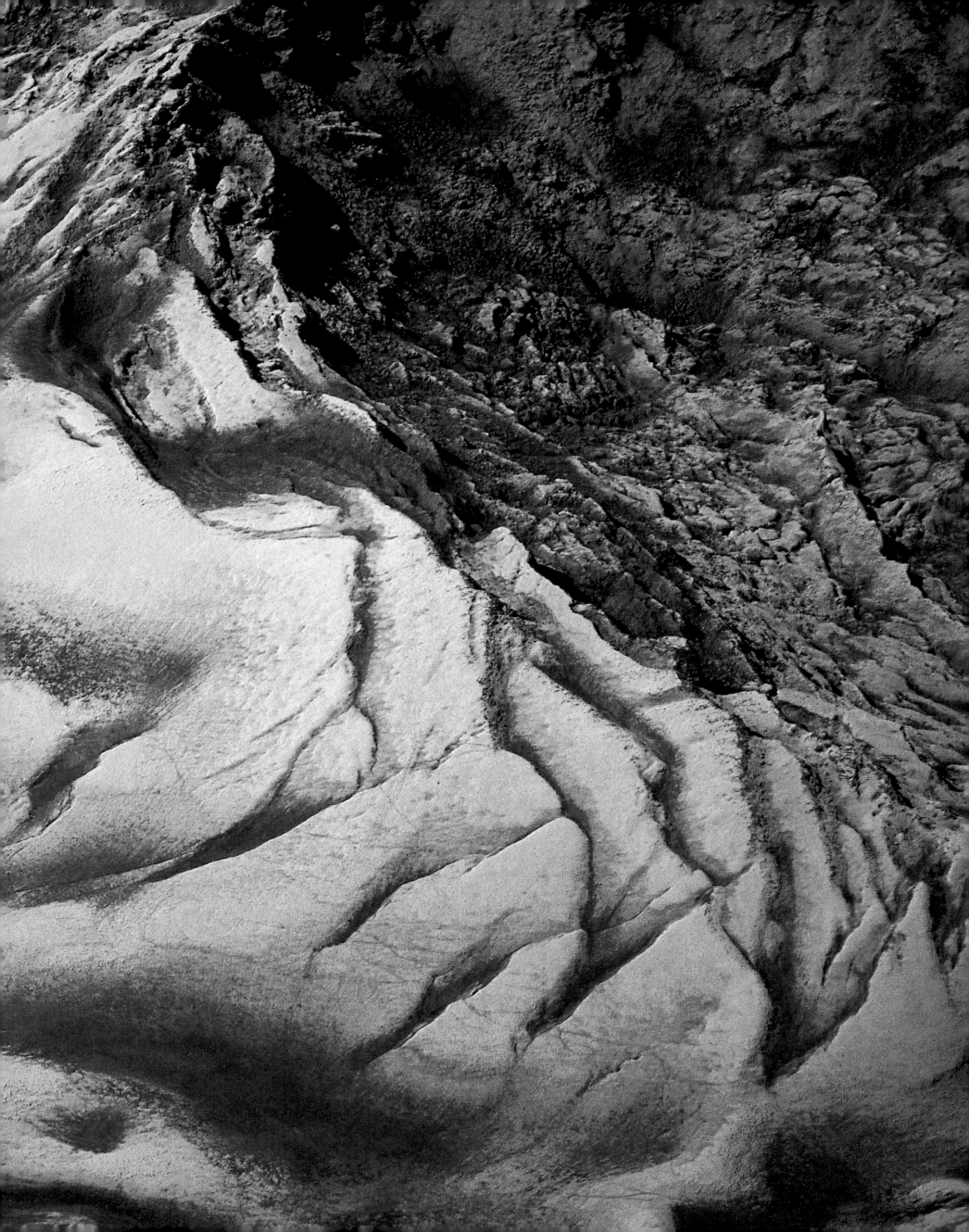

THE EAST AFRICAN RIFT

The East African Rift is a concentration of landscapes and animal life that has made the entire continent renowned. Astronauts tell us that they saw it with their naked eye from the moon. Nearly 2,500 miles in length, the rift extends from the Red Sea to Mozambique. This geological colossus, for scientists, is relatively young. Born 30 million years ago, it is still in the formative process. Its exploration reveals the forces that the earth put into play to create the region. The process has many consequences for the landscape, the climate, and the fauna.

30 Million Years Ago

Long ago Africa formed a tectonic plate much larger than the one we know today, since it included the present-day Arabian peninsula in its entirety. Stretched at its borders by the broad movement of the tectonic plates (for about 150 million years the Atlantic Ocean opened on its western flank), this African plate managed to remain intact. However, a hot spot, an up-cropping of hot, light mantle material, struck against the lithosphere (the outer shell of the solid earth). The hot cloud exerted vertical pressure on the lithosphere while also heating and thinning it. The African plate was then deformed at first: it inflated, bulged, stretched thinner, and tore. Over a thick network of long fissures, the hot magma was ejected toward the surface, where it was expelled in the form of gigantic lava flows. Thirty million years ago, a fabulous eruption occurred, which lasted nearly 500,000 years. The basalt flows accumulated on top of one another to a thickness of some 9,800 feet on a surface equal to the area of France; some 720,000 cubic miles of matter were expelled. This accumulated lava, known as traprock, is found today on high plateaus in Ethiopia, Somalia, and Yemen.

The enormous eruption had major consequences for the African plate. Pierced by the rising magma, torn by the fractures, thinned and heated, and thus softened, the plate could not withstand for long the forces to which it was exposed. After the impact of the hot spot that caused the break, the plate tore. For several reasons this tear was not continuous but occurred in three branches: one of these formed the East African Rift, which extends southward; the second formed the Rift of Aden; and the third, the Red Sea Rift.

Surprising Consequences

The opening of the East African Rift had repercussions on the landscapes and climate of the whole of East Africa. The convex bulge of the African plates, at certain points, raised the ground levels to an altitude of nearly 5,250 feet. At the summit, they broke, forming an enormous crevice that is the rift, several miles wide, and sometimes as deep as several hundred yards. This long gash, and the raised margins that surrounded it, made a climatic barrier that separated the eastern and western slopes. In the west, there remained a dense, humid primary forest (as is found in the Congo today), constantly hydrated by the prevailing winds bearing clouds from the Atlantic Ocean. But these same winds were stopped by the barrier of the rift, so the eastern slopes of this rift were much dryer. Here, the forest was replaced by a savanna, with tree-lined galleries along the rivers. The drying was reinforced by the heating of the eastern slope nearly 8 million years ago.

In the primary forest, large apes remained in their habitual biotope (or uniform habitat), evolved somewhat, and, over time, became hominoid apes that we still see there today, such as chimpanzees or gorillas. Some of these apes were later isolated, east of the rift, or in the rift itself. The natural milieu had thus disappeared, giving way to a savanna. Far from the shelter of the trees where they habitually found refuge and food, apes had to evolve in order to adapt to this new landscape. Their move from the trees to live in the grasses modified the morphology of these animals, who had to stand erect. In this new space, which is more open, they were transformed into potential prey for predators. New strategies were essential to their survival. Some researchers believe that these apes first stood erect in order to peer above the grasses. In this way the apes changed to biped status (and traces of biped footprints have been found dating to more than 3 million years ago). The new posture, which raised the vertebral column, apparently tilted the head and increased the cranial volume, and thus had a role in the development of the brain. Socialization of the individual within the group seems also to have started then and, little by little, the hominoid apes were transformed into hominoids.

Most of the paleontological discoveries concerning hominoids were situated along the rift, from North Danakil to the heart of Tanzania. Such a wealth of discoveries could be due simply to tectonics. The innumerable faults that cut gashes in the rift raised blocks,

At the base of a volcanic cone, prehistoric men left footprints in what was once mud on the shore of a lake. Great Rift Valley, Ethiopia.

made others collapse, and thus revealed ancient fossil layers that crop up today over several square miles. The many volcanic eruptions also provoked great deposits of ash, which played a dual role: first, it protected the fossil remains; second, by their irregular dispersal over wide surfaces, the fossils contributed considerably to establishing chronology and to the dating of the deposits.

It seems clear to everyone today that the rift played a primordial role in the emergence of human beings. Through its geological activity, it also contributed seriously to humans' survival and thus to their evolution. The cliffs and escarpments formed by tectonics served as protective barriers, just as some lava flows or volcanic craters may have been used as shelter or actual habitats for life. These same volcanoes gave humans the materials necessary for making tools, from the first fragments of expelled rock to form primitive pieces to the arrowheads and scrapers minutely carved from obsidian, natural volcanic rock. For a long time, humans lived in close proximity to this volcanic environment. Today, on the slopes of volcanoes much younger (hundreds to tens of thousands of years), we still find the traces of this human occupation, whether in the form of actual workshops for carving tools out of obsidian, or in the form of footsteps frozen in a deposit of volcanic ash on the edge of what was once a lake or swamp.

Tectonics Still Active

If the tearing of the East African Rift has not completely opened the African plate, this was not true of the rifts of Aden and the Red Sea. These two cut out a part of the plate and are still active today in driving present-day Arabia away from the continent of Africa. Once Arabia is completely detached, a new ocean will emerge between the African and Arabian plates. It will be a new ocean in the geological sense; that is, the two continental plates will be separated by a portion of oceanic plate that will continue to extend, separating the two continental plates. However, we have not yet reached that point, because there is still a continental bridge between Africa and Arabia.

Although the hot spot was the origin of the tectonic tearing, it was also responsible for the fact that the continental plates are not entirely detached. The two rifts—the Red Sea and the Aden—moving closer together have reached the spot where the African plate was pierced by the hot spot. And there, for the past 20 million years, they are at a standstill. The hot mantle up-croppings in this area, the Afar triangle, have heated and softened the continental plate, making it less brittle and more elastic. Squeezed between the two rifts that draw closer together, this portion of the continent fissures, tears, and stretches without breaking. The Afar triangle is situated between the high plateaus of Ethiopia to the west, the Danakil depression to the east, and the republic of Djibouti to the south. It is opening by rotation, mainly from the action of the Aden Rift. In the middle of this zone, the landscape is marked by forces in motion. In fact, geologists are observing "live" the separation of two continents, the birth and opening of a new ocean. The mechanisms in play are directly visible, unlike those in the middle of the Atlantic, which are going on under thousands of feet of seawater.

The earth machine is at work shaping the future face of our planet. The fragment of continental plate that still separates Africa and Arabia has been stretched, so that numerous normal faults have marked it. Between them, great panels have collapsed, thinning the crust to the point of digging the Afar ground into a depression that now lies below sea level. Several of these faults have allowed the magma to rise, and on reaching the surface, it

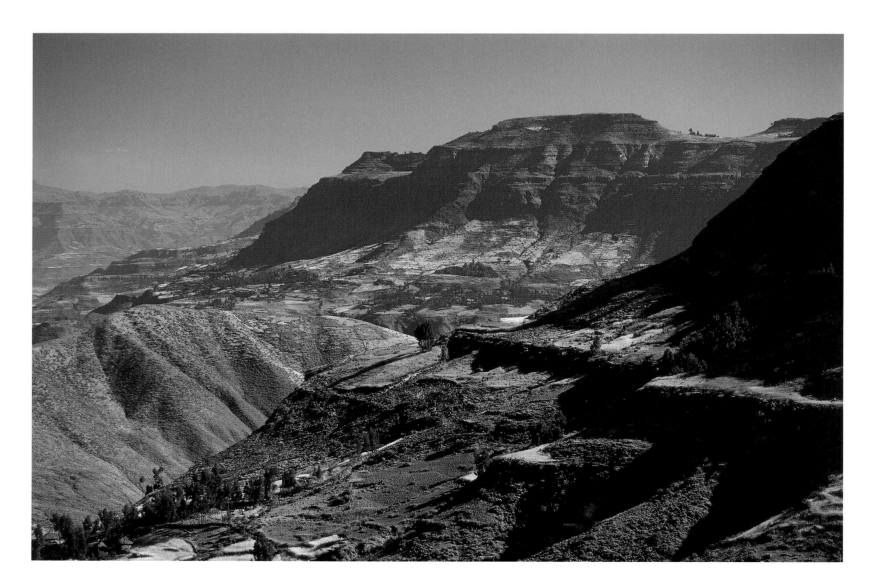

On the high plateaus of Ethiopia formed by volcanic traprock, residents benefit from particularly fertile soil.

gives birth to volcanoes. When one of these faults takes action, the effects are spectacular, as was seen in 1978 in the southern part of Afar, at Djibouti. Violent earthquakes struck the region, the rift tore suddenly for about six feet and deepened by about one yard. Magma rose through freshly opened breaks and a new volcano was born: Ardoukoba. Its eruption was brief, but other volcanoes are in constant activity, such as Erta' Alé, in the northern Afar triangle, in the Red Sea Rift.

Erta' Alé dominates a chain of volcanoes more than fifty miles long. This chain extends almost the whole width of the rift, and the production of magma has been such that most of the tectonic structures (faults and escarpments) are hidden under accumulations of lava. However, the elongation of the entire chain, as well as of the caldera of Erta' Alé, shows clearly the tectonic control that led to its placement. Erta' Alé contains in its crater one of the very few lakes of lava that are still active in the world. Regular eruptions over the past one hundred fifty years proves the rift's activity in this region, an activity in which magma has taken over from tectonics.

The lowest part of the depression of the Afar triangle (the Danakil depression), situated between 300 and 400 feet below sea level, is occupied by a vast salt plain. Soundings and seismology have shown that at several points this salt deposit reaches a thickness of more than 6,500 feet. It consists in fact of marine salt. Since the creation of the rift, the Red Sea, coming from the north, has invaded this area on eight different occasions. Each inundation was followed by eruptions of the Alid volcano, at the very spot where the Red Sea Rift penetrates the Afar triangle. Each time, the accumulation of lava flows dammed the water and isolated the new inland sea. Under the intense heat of these regions, this sea quickly evaporated and its salt content crystallized creating a new layer. The last of the marine invasions dates from about 80,000 years ago.

Currently, volcanic ranges or chains have peaks several hundred feet higher than these salt plains, which are perfectly level. The image prefigures what may be the landscape of tomorrow, as the opening of the future ocean continues between the Ethiopian high plateau and the Danakil depression. At the current rate, 2 million years from now the fractures will be so open that waters of the Red Sea will pour in to occupy all the low points of the Afar triangle. Today's volcanoes will become, at that point, volcanic islands in the middle of a new ocean. This ocean, at first, will still have a continental floor that is simply covered by seawater. It will take at least an additional 2 million years for a true oceanic crust to form between the two continental blocks. The actual ocean, whose creation we are now seeing, will continue to grow; the desert of Afar, currently one of the world's hottest, will be bordered by tropical beaches.

LABORATORY VOLCANOES: OBSERVATORIES

Some of the world's volcanoes, which, for the most part, have constant or very frequent eruptive activity, have been transformed into natural laboratories. On their slopes, permanent volcanological observatories have been established.

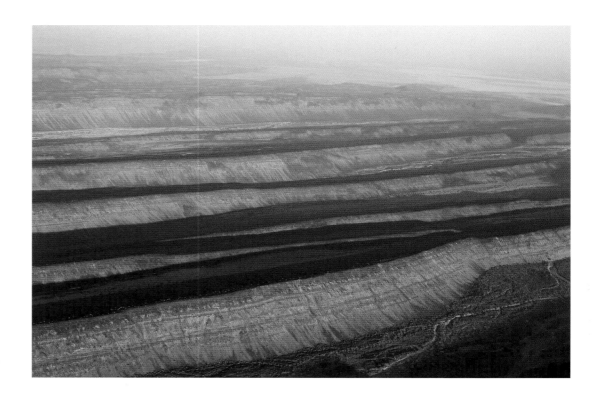

It was only natural that the first of these observatories should appear on the most emblematic of volcanoes—Vesuvius. In 1841 King Ferdinand II of Naples decided to found a meteorological and volcanological observatory. He appointed Macedonio Melloni (1798–1854) as director, a famous geologist and physicist, specializing in magnetism and heat radiation. Melloni was instructed to make the new observatory a driving force in coordinated international scientific research. Such an agenda would be ambitious for any observatory today. Unfortunately the project did not survive the political crises of the revolution of 1848.

The Osservatorio Vesuviano was revived in 1852 by Luigi Palmieri (1807–1896), an important scientist as well as a brilliant inventor. Palmieri gave himself completely to research, inventing a series of instruments for taking the volcano's pulse, living almost full-time on its slope. He became a national hero in 1872 when he remained alone on the mountain during eruption near the observatory. To the amazement and disbelief of Neapolitans who followed his activities from a distance, he lived and worked between the flows of molten lava, the layers of toxic gas, and the clouds of ash.

Vittorio Raffaele Matteucci, who succeeded him, was cut from the same cloth. Between them they set up a complete scientific program enriched by many international exchanges. All the great researchers of the late nineteenth and early twentieth centuries came to the Osservatorio Vesuviano, where they found a setting conducive to their studies and to comparisons between their work and that of their contemporaries or predecessors. At this time, the observatory was also equipped with an exhaustive library on volcanism, a collection that has deteriorated since then. New discoveries were also made here. Frank Perret, an American engineer formerly associated with Thomas Edison, stayed at the observatory beginning in 1904 and was in residence throughout the eruption of 1906. In one strange observation, he noticed that by biting

View of the rift at Djibouti, showing recent volcanism and the earth collapsing into steps. This network of normal faults helps the rifts to break apart the desert.

down on the metal bars of his cot, which was cemented to the floor, he felt a strange vibration in his skull—and thus he discovered what is called the tremor, a continuous vibration that accompanies the emission of magma on the surface.

Unfortunately the creation of this impressive laboratory, right on the scene of the eruption, had no imitators and the world's other volcanoes were not equipped with volcanological observatories. There were, in fact, two very different motives for the construction of observatories. The first, which inspired the construction of the Osservatorio Vesuviano, was to establish a pure research laboratory. In this approach, the observatory is devoted to the study of the volcano, its evolution and geological history, its dynamism, and its characteristics during eruptions. On the basis of these analyses, certain knowledge can be extrapolated about other volcanoes, and volcanic phenomena in general can be better understood. The other motive, not necessarily contrary to the first, is to consider an observatory as a base for monitoring the volcano. Scientists strive to record and interpret signals that precede an eruption and to create a predictive scheme for eruptions. These observatories will help regional authorities to limit the damage of the foreseen eruption, either by treating the threatened areas or by evacuating the population exposed to the risks. Several major volcanic catastrophes made this second goal the main reason for building observatories, in accordance with a very basic economic logic. The analysis of volcanic disasters shows that studies for predicting and mitigating risks cost far less than the damage, especially when such damage includes human lives. Each catastrophe is a sign that both the scientific community and the authorities of the particular countries must acknowledge, as well as a reminder that the media has the power to alert the greater public, which is always aware of the risks created by volcanoes. Thus, almost systematically, a great catastrophe was at the origin of the creation of each new observatory, such as advancement of knowledge generally followed a large eruption (see "Two Decades to Understand" in Chapter 5).

The first of these disasters occurred in May 1902. The city of St. Pierre on the Caribbean island of Martinique was swept by an eruption of Montagne Pelée, which had a formidable echo across the world. The instantaneous loss of 28,000 lives was immediately reported globally, and the news struck the public imagination and caused an understandably emotional reaction, especially from the first scientists who reached the site. Three of them went on to become prominent volcanologists: Alfred Lacroix, a Frenchman, and two Americans, Thomas Jaggar and Frank Perret. All three were convinced that the systematic study of dangerous volcanoes would make it possible to avoid such catastrophes (see "The Suicide of Empedocles" in Chapter 3).

The first observatory at Montagne Pelée was established in 1903, the year after the eruption, by Lacroix. Built less than six miles from the crater, with a direct view of it, the observatory was outfitted with the best monitoring equipment then available; the telescopic observation glass was one of the basic tools. Unfortunately, twenty years of inactivity by the volcano seemed to drain the facility of its purpose, and the authorities decided to close it. But they could not shut down the volcano, which had an extended eruption from 1929 to 1932. Lacroix again insisted on the importance of a permanent observatory. The new one, again among the best equipped of its time, was opened in 1935. Since then, Montagne Pelée is watched constantly.

Lacroix argued for observatories at other volcanoes, as well, recommending construction both on the Soufrière in Guadeloupe and the Piton de la Fournaise in Réunion. It would take some time before these active volcanoes would be provided for. Soufrière did not have its observatory until 1950, while Réunion had to wait for the eruption of 1977 and the destruction of the village of Sainte-Rose before the first observatory would be built.

The other two witnesses of Montagne Pelée's 1902 eruption shared Lacroix's ideas on the need for volcanological observatories. Perret left for Italy, where he put to use his talent as an engineer and inventor at the Osservatorio Vesuviano. Jaggar returned to the United States and campaigned tirelessly for the construction of an observatory on Kilauea volcano in Hawaii, which then had an active lava lake in its crater. During a visit to Vesuvius in 1909, Jaggar met Perret and convinced him to assist on the project in Hawaii. An initial observation post was set up in 1911 on the edge of Halemaumau crater and, in 1912, the Hawaiian Volcano Observatory was officially founded. At first it was financed by a group of Hawaiian businessmen, who were aware such an undertaking was important. This was an observatory for scientific purposes, and most of the researchers were devoted to studying the fabulous lava lake on their doorstep. Their work also benefited volcanological knowledge in general by establishing new techniques for taking samples in molten lava, measuring temperature, and sampling gases.

At about the same time, faced with the dangers of Asama volcano, the Japanese built their first observatory on the site. Over time, from one critical eruption to the next, numerous observatories were built, sometimes in a chaotic way or in the urgency of an unexpected situation. This trend continues. The famous eruption of Mount Saint Helens in 1980 led to the construction of the Cascades Observatory as well as of the Alaska Volcano Observatory.

At the start of the twenty-first century, we have about sixty volcanological observatories throughout the world. Together they keep watch on approximately 150 volcanoes considered active, potentially active, or dangerous. These observatories, under the aus-

Stationary stations transmit directly to the observatory the seismic data recorded within the volcano of Piton de la Fournaise, Réunion. The data are immediately analyzed.

pices of the Association of International Volcanology and Chemistry of the Earth's Interior, are coordinated by an international body, the World Organization of Volcano Observatory (WOVO).

Permanent surveillance of a volcano is very expensive, both for the equipment for recording, transmitting, and analyzing data and in the salaries for researchers assigned to these units. In addition, the resources allocated to volcanology vary enormously from country to country. Some nations can finance complete, close-knit networks, which have very sophisticated means of communication, while others sometimes rely on simple ongoing visual observation. A current practice to compensate for this lack of equipment at certain potentially dangerous volcanoes is to equip them with a simple "alarm bell." When the parameters that define the approach of an eruptive risk show a significant change, a pre-alert is sounded and a mobile team (national or international) comes to the site to set up an entire surveillance system in the shortest time possible.

The existence of volcanological observatories has been justified time and again by the prompt response to various volcanic crises. Nevertheless the vital need for constant surveillance can be very difficult to explain, either to financial sponsors or to some scientists, even those well aware of the problem. Some observatories do maintain permanent surveillance of volcanoes on which, between eruptions, very little happens, but many people would like to see these funds allocated to more basic research, not to "technological" supervision of volcanism. A clear analysis of the crisis of recent years shows, however, the importance of a permanent, seasoned scientific team, possessing both knowledge of the terrain on which they are working and the indispensable theoretical background. Such a team has the advantage of an effective monitoring network tested over time, all of whose stations have proven the importance of their location and of their measuring systems—in other words, a full-fledged observatory. Such a facility is the best guarantee of proper management of a critical eruption. Moreover, a permanent observatory on the site allows researchers to understand the socioeconomic constraints of the region and to build trust among the concerned population and the local authorities—all of which contribute to the success of effective risk prevention.

Monitoring and Predicting

Surveillance of volcanoes from observatories has the principal aim of foreseeing eruptions or the evolution of ongoing activity in order to mitigate their risks and limit their damage. It is essential, above all, to define what we mean by prediction, true scientific diagnoses as opposed to the prophecies by volcanological preachers of old. In order to be useful for risk prevention, prediction has to be able to answer: What? Where? When?

"When?" is the most crucial question, one whose answer can directly affect the safety of people living in the menaced zone. The response is most eagerly sought after by the public and officials alike. It is the most difficult answer to get; indeed, the registered parameters sometimes indicate the probability of an eruption in a more or less immediate future. However, the event can be delayed, or sometimes not occur at all. Several volcanic crises have been seen developing in very obvious ways, and then stabilized into an extended delay that can go on for years. And yet, time is critical in ensuring the safety of the population. Some eruptions include very

violent explosive phases from the beginning, and the only protection for humans is immediate evacuation.

"What?" refers to the type of activity to be expected from the volcano in question; the information is sought above all in past eruptions. A good and thorough geographic study gives us the history of the volcano. Ancient deposits show what type of dynamic caused the latest eruptions. The extent and depth of these same deposits indicate the power of the eruptions. A basic law of geology stipulates that events that occurred in the past remain possible in the future. Study of the geological history of the volcano and the minute reconstruction of its activities therefore yield a profile of eruptions to come and lead to a modeling of the dynamic of an eruption. This model is refined by theoretical simulations based on physics: influence of the slopes, the ruggedness of the terrain, or the viscosity of the lava on the extent of the flows, constraints on pyroclastic flows from morphology of the channels that guide them, and so on.

"Where?" defines the zones that will be affected by the eruption, and the determining factors are many. For instance, the placement of lava flows is determined by the relief lines, which also constrain the orientation of pyroclastic flows. In the great basalt volcanoes, the eruption is often manifested by the opening of an eruptive fracture on one of the volcano's flanks; monitoring the migration of the magma helps foresee such areas of opening.

Answering the questions "what?" and "where?" enables us to map the risks; that is, to establish a map showing the type of dynamic and thus of risk that may strike all the areas surrounding the volcano. This map will also describe the intensity of the danger according to the distance from the site of the eruption, the instability of the ground, and so on. Drawing up this map is the first step in prediction; the information it provides will determine the zones to be protected or evacuated.

Predictive diagnostics are based on the interpretation of various data registered by constant monitoring of the volcano. A volcanic eruption occurs when magma rising from the depths of the earth reaches the surface. The rising of this magma, the length of time it has been accumulating in magma chambers of whatever

An early seismograph with vertical component recording on a drum using smoke soot. Osservatorio Vesuviano.

depth, its propulsion into fractures, its gaseous output—all these elements give physical or chemical signals that reach the surface well ahead of the magma itself.

Surveillance of a volcano consists of detecting, recording, and analyzing these signals. Detection is carried out by a network of several stations rather than by a sole monitoring source; this ensures a better spatial distribution of the phenomenon. A volcano, or a volcanic range, presents a geography that is often complex and encompasses vast areas. A network of receptors allows the origin of the registered signal to be located in three dimensions within this volcano, and for the movement of this source of signals to be followed. A complete observatory will consist of several networks each devoted to one type of signal. In general, in modern observatories, the registration centers are autonomous and operate in real time or with a very slight delay. These stations, sometimes built at points quite distant from the "mother" building of the observatory, receive energy from a system of solar panels and accumulators. The recorded signals are sent to the observatory by radio, telephone, or even by satellite transmissions. The observatory receives from several different stations multiple signals that are recorded on various media (paper, magnetic tape, computer hard drives, and so on). They are analyzed by scientists but may also be treated in real time by specific computers that quickly detect a rise of magma beneath the edifice of the volcano.

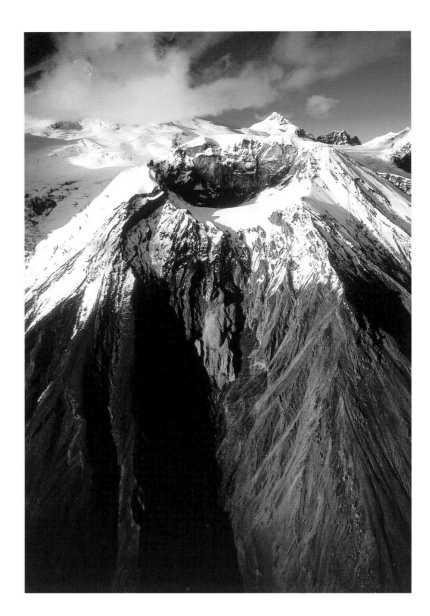

The Networks of Seismic Surveillance

Here we come to the most common physical signal that comes from a volcano: the seism. It is essential to distinguish clearly the seisms, or quakes, of volcanic origin from destructive earthquakes. Although earthquakes are immediately evident to human beings, most quakes of volcanic origin go unnoticed, since their energy is so weak.

When magma rises, it traces a course through established rocks, generating high pressure within the volcano, deforming and fracturing it. Each time that solid rock gives way, its sudden breaking causes a blow of varying intensity known as a seism. Seisms generate a series of waves that radiate out in all directions from their point of origin, the center. They are recorded by a seismograph, which can vary widely in form and process and which have functioned on the same basic principle since their invention in the nineteenth century. An inert mass is suspended from a vertical or horizontal arm attached to a stand level with the ground. When the ground is shaken by a seism, the inertia of the mass makes it move with respect to its support, and this motion is then recorded. In the first seismographs, these movements of the mass were directly noted by a stylus attached to the mass onto rolls of paper coated with smoke deposits. If the physical principle of the seismograph remains unchanged, the apparatus has undergone many technical improvements. Current seismographs (or seismometers) consist of a magnetized mass suspended within a solenoid; the movements of this magnet set off an electric signal that can easily be transmitted long distance by radio or telephone, recorded on multiple media, or even retranscribed in different ways onto paper or a computer screen. The reading of the same seism by several seis-

mographs makes it possible to situate it beneath the volcano and thus to locate the magma that caused the fracturing.

These measures reveal both in space and in time the migration of seismic centers and thus the migration of the magma. It becomes possible then to anticipate its arrival on the surface and, in the best case, the time and place of the beginning of a volcanic eruption.

Deformations of the Soil

The rise of magma causes, within the magma chamber, strong pressure that modifies its form and thus that of the volcano above it. In the same way, an ejection of magma into the volcanic edifice changes its structure. Broadly speaking, these deformations are transformed into swellings that are either global, concerning the entire volcano, or punctual, concerning just one crater or flank of the volcano.

On the surface, these swellings are evident from increases in the angle of slopes, the opening of fissures, the displacement of crater edges, and the tilting of blocks. Depending on the volcanoes studied, these deformations can be of various orders of magnitude, from a few inches for fluid lava volcanoes up to several yards, even tens of yards, for volcanoes with viscous lava. In most cases these deformations are associated with seismic crises linked to movements of fluids. The swellings are thus caused by the ejection of magma; when it reaches the surface, the eruption begins and the lava pours out of the volcano in the form of lava flows, ashes, ponces, and so on. The pressure on this lava causes a deflation of the volcanic edifice, and during or after the eruption an inverse

deformation of the ground is often seen. Some particularly large eruptions, displacing enormous quantities of lava and thus causing a large drainage of one or more magma chambers, can be followed by extreme changes to the volcano such as the collapse of calderas, some of which have volumes of several cubic miles.

However, the recorded deformations do not always lead to an eruption; in some cases an inflation can be observed corresponding to a rise of magma that does not reach the surface but settles, sometimes for an extended period, while cooling in its depths. In other cases, after the first inflation due to magma rising, there is a deformation of the ground that steadily moves away from the volcano; it corresponds to lateral ejection of magma in networks of fissures (known as dikes). This magma will not necessarily emerge at the surface to cause an eruption.

Global surveillance of the deformations of a volcano is a complex matter. In fact, the movements of magma inside the volcano are not always the same and their other effects on the surface may vary. The ejections occur in different volumes and at various locations. Only the analysis of several volcanic activities and of their precursors, as well as the use of theoretical models, make it possible to select the sites for recording deformation measurements. In addition, surveillance of these deformations should not be just local or punctual, but must be done by a network covering the entire edifice. The mechanism of the deformations can vary from one site to another or from one eruption to another, and thus several measuring techniques must be used simultaneously. Finally, the volcano to be monitored should be covered by several different networks, each applying one of the measuring techniques.

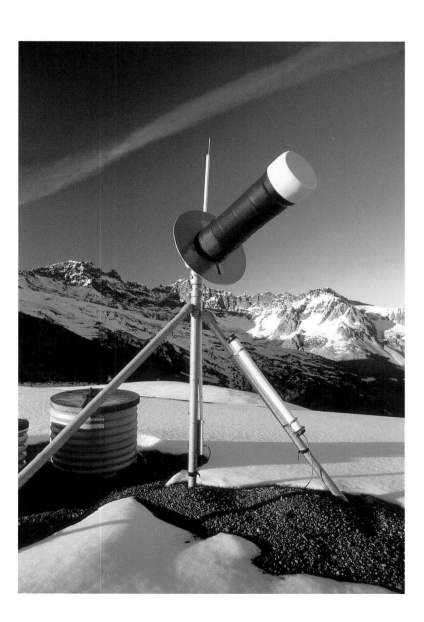

Inclinometry Networks

Changes in the inclination of a slope signal a swelling affecting the flank of a volcano. Inflation increases the angle of inclination, while deflation reduces it. Two different means of measuring change in incline include using liquid levels and pendulums. Liquid levels apply the principle of communicating containers; two graduated containers are filled with liquid and communicate with one another by a pipe, some as long as 30 to 60 feet or more. If one container is raised above the other, a difference in the liquid's level will be recorded, the two liquid surfaces remaining always horizontal. This measurement of a change in level can be made either by a human or by an automatic measuring system and transmitted to the observatory.

Pendulum inclinometers consist of a stand level with the ground, in the center of which is suspended a pendulum that remains vertical; a change in the angle at which the inclinometer stands will cause the position of the pendulum to change. This change in position can be recorded electrically and the signal transmitted to the observatory. A modern inclinometric station consists of two inclinometers. One is in radial position—that is, it measures the slope leading to the summit of the volcano. The second is perpendicular to the first and measures a tangential deformation in the volcano's slope. These measuring systems are precise and enable us to measure down to the micro-radian, an angle of inclination corresponding to a difference in altitude of a millimeter between two points situated a kilometer apart.

An inclinometric network consists of several stations, often automated, which transmit data to the observatory; all these stations are coordinated by a high-precision clock. Data received at the observatory permit the tracing of deformation vectors and to see where pressure is exerted, how, and at what intensity. Reiteration of the data and their analysis in real time allow the tracking of the deformation under way, and thus to follow the ejection of magma as it occurs. In some cases regular propagation of the deformation clearly shows the direction and speed of the fissures. Foreseeing these data, it is possible to predict relatively quickly when the magma will arise and to anticipate where and when the eruption will start.

Distance Measurement

Distance measurements give a more global vision of the swelling of a volcano. When a volcano does swell, the entire surface moves in relation to a fixed point situated on the volcano's exterior. "Targets," are assigned to the volcano and attached to its flanks. A stationary measuring device, which is located in a stable area away from the volcano, is then aimed at these targets to take readings. Today we have electronic distance meters that can make highly precise measurements. The targets consist of mirrors (totally reflecting prisms) aimed at by a laser beam emitted from a base that records the time necessary to receive the ray's reflection from the target mirror. Each measurement is punctual, but taken at regular intervals—by day, hour, or minute, a variable rate in case of a crisis—which allows a deformation to be followed with great precision. Current distance meters with lasers are precise within one millimeter per kilometer measured.

Retransmission antenna for data picked up by an automated station on Mount Spurr, Alaska.

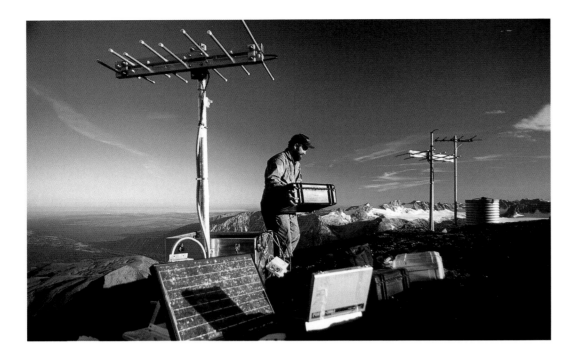

Mount Spurr, in Alaska, is visited by volcanologists who come to monitor the automated stations that send data directly to the observatory.

Extensometers

When magma is ejected, the outer envelope of the volcano is deformed. However, since rock is not elastic, the volcano tends to break. Successive deformations accumulated in the course of numerous eruptions open a multitude of fissures. With each new ejection of magma, new fissures may appear as the former ones are still in play. As prior eruptions have shown, movements of these fissures are representative of those of the magma: they open during inflation and close during deflation following the eruption. Extensometers measure the relative movement between two points, each placed on one of the lips of the fissure. In fixed, non-automated systems, an observer calculates the variation in distance between two graduated rulers attached to the edges of the fissure. There are several automatic systems: the most common consists of a magnetized shaft secured on one edge of the fissure, which slides inside a solenoid fixed on the other edge. The electric current generated in the solenoid allows the movement to be picked up. Good electronic support allows for strong precision. Today this means a millionth of a millimeter. These electronic signals are easily relayed in real time to the observatory by radio or telephone line.

GPS Network

Positioning by satellite is more and more common and is now part of our daily life. Precise information is recorded by several satellites with perfectly fixed orbits. Since these orbits are totally independent of the terrain on earth, a receptor fixed at any point on the globe will mark the movement this point makes. To increase the precision of measurement, a GPS differential is used. With the help of responses from several satellites, we measure relative movements between a base located at a point fixed outside the volcano and a beacon attached on the measured volcano. This technique allows precision within a millimeter. This would seem to be the technique of the future, since the cost of reception stations is steadily decreasing. The registered signal, however, is also easily transmissible by radio and can readily be analyzed at the observatory.

Other Measuring Systems

Seismic measurement and deformations of the ground are the most common predictors of a volcanic eruption and are closely tracked by nearly all volcanic observatories in the world. However, magma ejections into the volcanic edifice are the source of quite different phenomena. Movements of the masses of magma, their gas emissions, production of gases, and disturbances in the circulation of fluids all generate diverse signals that can be registered by specific analytical tools and, in some cases, can assist in forecasting.

Gravimetric measurements at a definite point determine the value of the weight field; normally this value is stable for the point being considered. However, an injection of hot magma, possibly of a different composition than the area under the volcano, indicates a transfer of mass and will change the value of the weight field. Many repeated gravimetric measurements over different points will serve to indicate local changes in the weight field and thus will reveal movements of magma injections.

The mechanical constraint generated by the injection of magma on the rocks below the volcano, the heating of these rocks by the proximity of the fresh magma, and the circulation of hydrothermal fluids can create local magnetic fields that locally perturb the earth's magnetic field. Continuous modifications in the resulting magnetic field, registered by magnetometers placed at fixed points, also give information on the migration of magma within the volcano. When magma is injected and rises toward the earth's surface, the pressure applied to it diminishes and the magma emits gases. These gases are more mobile than the residue of magma and, preceding it, they quickly reach the surface by percolating through different fissures or by passing through pores in the rock. A quantitative and qualitative study of the composition of some smoke and gas can be a good indicator of an ejection of fresh magma. Similarly, the volcano's hydrothermal system undergoes major modifications and the gases tend to dissolve in water; it is therefore important to study changes in the chemical composition of the various thermal springs on the slopes of a volcano. The ejection of fresh, and therefore hot, magma heats the fluids circulating inside the volcanic edifice. A record of the changing temperature of the smoke and gas, as well as of the water in the various springs, can be a valuable indicator.

Fresh magma is a source of radon, a radioactive isotope of radium produced by the uranium contained in the magma. Radon, which is very volatile, is conveyed to the surface by the water vapor and carbon dioxide released by the magma as it generates gas. Variation in the radon level is easy to measure and can also serve to indicate the rising of magma.

A Promising Prospect: Satellite Surveillance

Many volcanoes, including highly dangerous ones, can be rather inaccessible. Their eruptive or pre-eruptive activity often poses a definite risk, without ample time for sending site teams to set up measuring and recording stations. Not all countries, however, can afford to have a volcano monitored by an observatory linked to several networks of measuring stations. There is strong interest therefore in perfecting remote monitoring techniques at reduced cost. Satellite observation seems to be a good solution.

In an initial phase, satellites are used to retransmit data registered by ground stations. Not every volcano is equipped with a

complete observatory close by. The measuring station network can compact these data and direct them to the satellite that will briefly house them and then relay them to a ground station for recording and detailed study. We have already noted the role that satellites can play in positioning by GPS. The numerous satellites observing the earth also provide diverse images of it, often at wavelengths beyond visible range. Satellites can therefore work in infrared and locate any heating due to magma activity. These images are constantly improving in precision, and the most recent satellite generations provide images closer to what is actually happening on the ground. Another technology on the horizon is differential radar imagery. A great advantage of radar images is that they can be taken regardless of the climate conditions of the zone in question. These high-quality images are made each time the satellite orbits above the monitored volcano. Differences between two images from successive orbits are analyzed, yielding not just a detailed view of the volcano relief but an evolving picture of this relief and the terrain's deformations, updated each time the satellite goes over. Such technology today is yielding precision within a millimeter.

The volcanoes of the Aleutian Islands are permanently monitored by volcanologists of the Alaskan observatories, who have developed techniques for surveilling ash clouds by satellite.

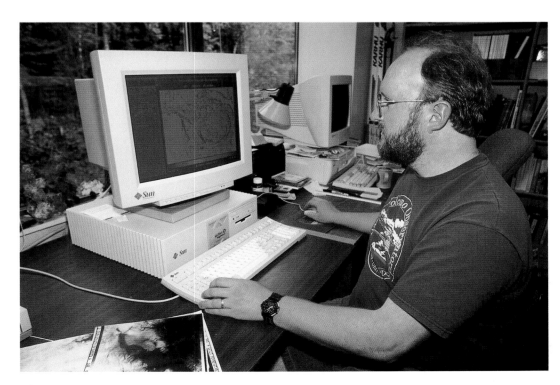

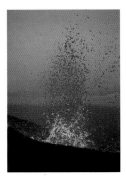

PAGE 173. Lava is projected into the air by pressured gases contained in the magma. Piton de la Fournaise, Réunion.

PAGES 174–75. A volcanologist enters the eruptive cone of Piton de la Fournaise volcano to observe a lava fountain. He is protected from thermal radiation by an aluminum layer covering his fireproof suit. Réunion.

PAGES 176–77. As the surface of the lake of lava cools, an elastic layer made up of panels slides to its surface. Erta' Alé volcano, Afar, Ethiopia.

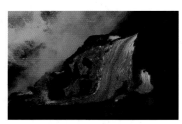

PAGES 178–79. Lava flows emanating from Kilauea volcano have been pouring into the Pacific Ocean, thus enlarging the Big Island, since the eruption began in 1983. Seawater evaporates on contact with the molten lava. Kilauea volcano, Hawaii.

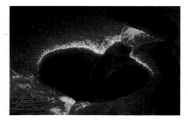

PAGES 180–81. Flows of fresh lava gradually surround solidified lava. Kilauea volcano, Hawaii.

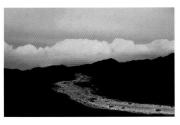

PAGES 182–83. Eruptive cone and its lava flow on the northern flank of Piton de la Fournaise volcano, Réunion.

PAGES 184–85. Gases captured in the molten lake of Erta' Alé are released with projecting lava. Afar, Ethiopia.

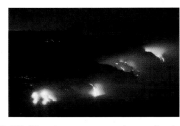

PAGES 186–87. The shore seems to be on fire in this lava cliff in progress in the waves of the Pacific Ocean. When the lava reaches the coast, it tumbles from the cliffs into the ocean in cascades, which then coagulate and are borne away by the waves. Water and fire fight a merciless battle. The water smokes as the lava spreads below water level. Since the first period of eruption, lava flows have traversed the eight miles from the active crater to the water's edge. Kilauea volcano, Hawaii.

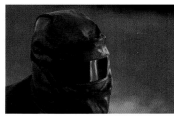

PAGES 188–89. A volcanologist protected from thermal radiation by a fireproof diving suit of aluminum. Such protection is indispensable, because the lava temperature reaches 2,192° F. Piton de la Fournaise, Réunion.

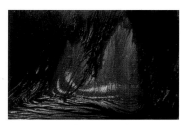

PAGES 190–91. Formation of "string" and "rope" lava. Several types of lava flow exist. In Hawaii lava is of the "smooth" type. Typical of fluid lava, it can spread for tens of miles and form tiles, becoming strings (string lava) and bowels (rope lava). They are referred to collectively by the Hawaiian term, as *pahoehoe* flows. Kilauea volcano, Hawaii.

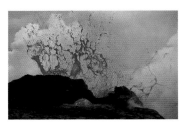

PAGES 192–93. Where lava enters the ocean, clouds of vapor rise in great white scrolls. Often explosions occur with a muffled hissing sound. The lava is frequently so fluid that it explodes noiselessly in shreds that twirl like ribbons in the air. Kilauea volcano, Hawaii.

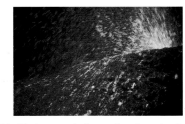

PAGES 194–95. Accumulations of projected volcanic material gradually build the eruptive cone. Piton de la Fournaise, Réunion.

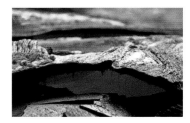

PAGES 196–97. Explosion of lava bubbles into shreds. Kilauea volcano, Hawaii.

PAGES 198–99. While the surface of lava flows solidifies forming a hardened crust, molten lava continues to travel great distances, losing very little heat under these protective "tunnels." Kilauea volcano, Hawaii.

PAGES 200–201. Lava fountains on the surface of the lava lake of Erta' Alé volcano. Afar, Ethiopia.

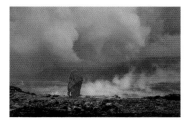

PAGES 202–3. The formation of a lava bubble at dawn. Kilauea volcano, Hawaii

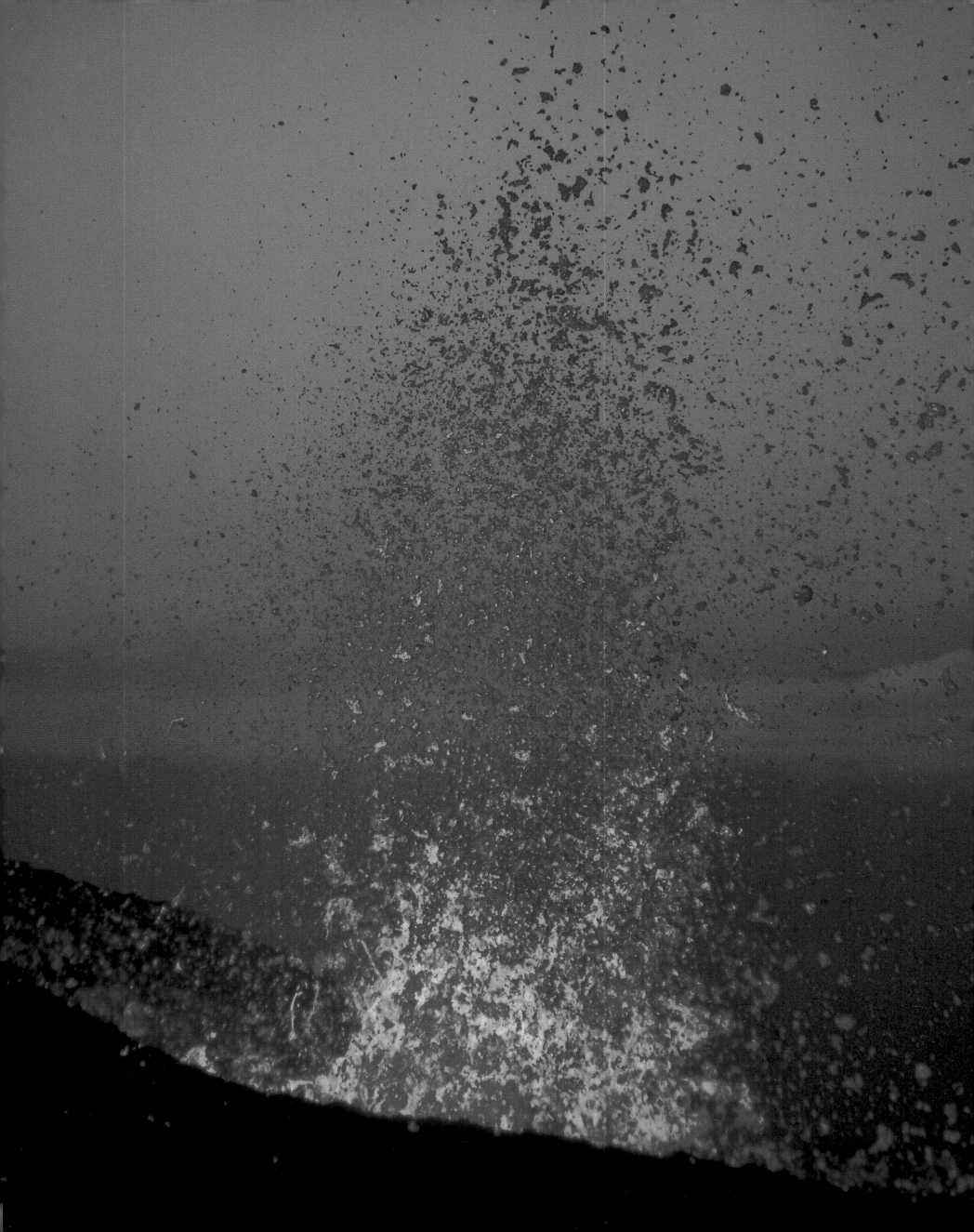

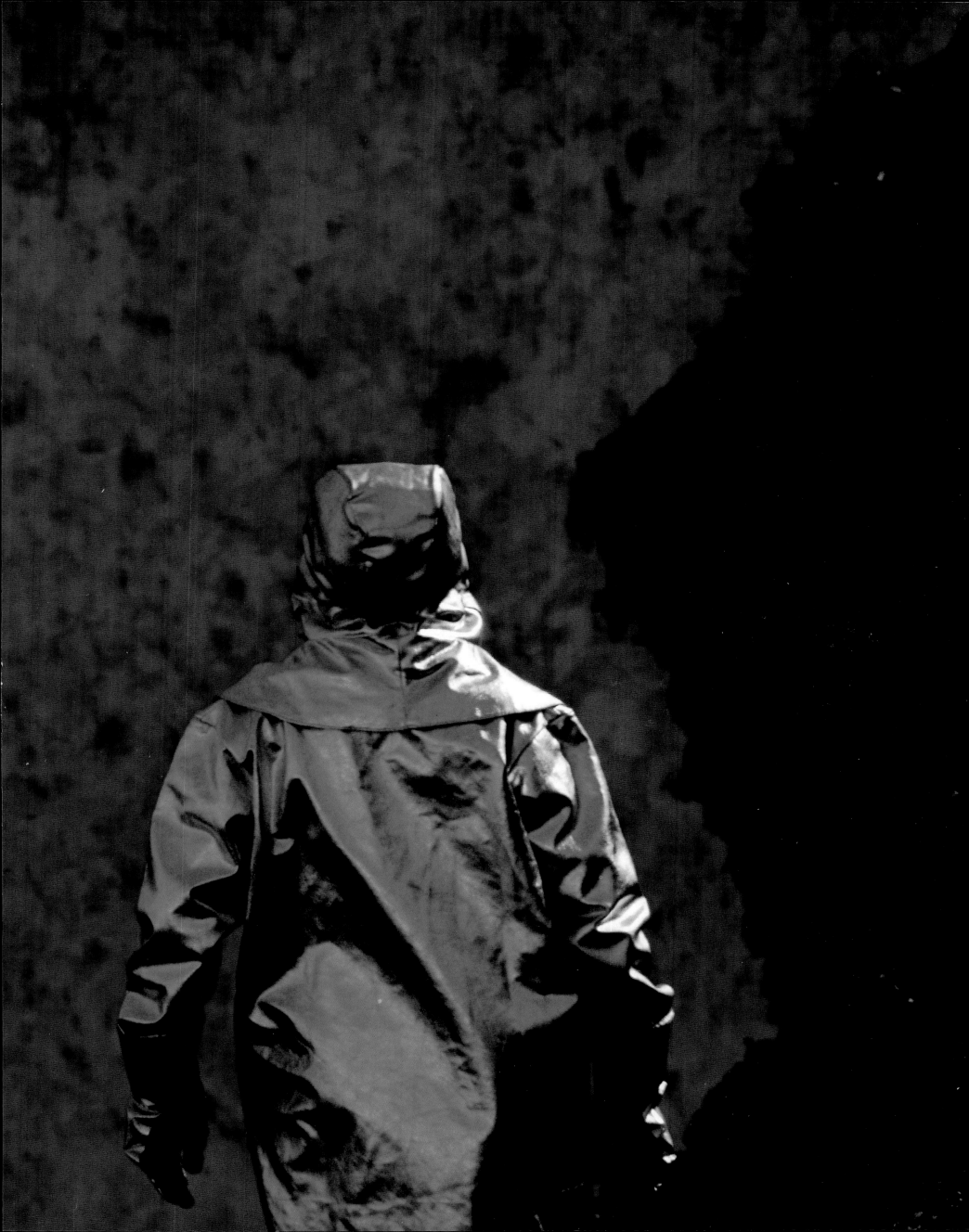

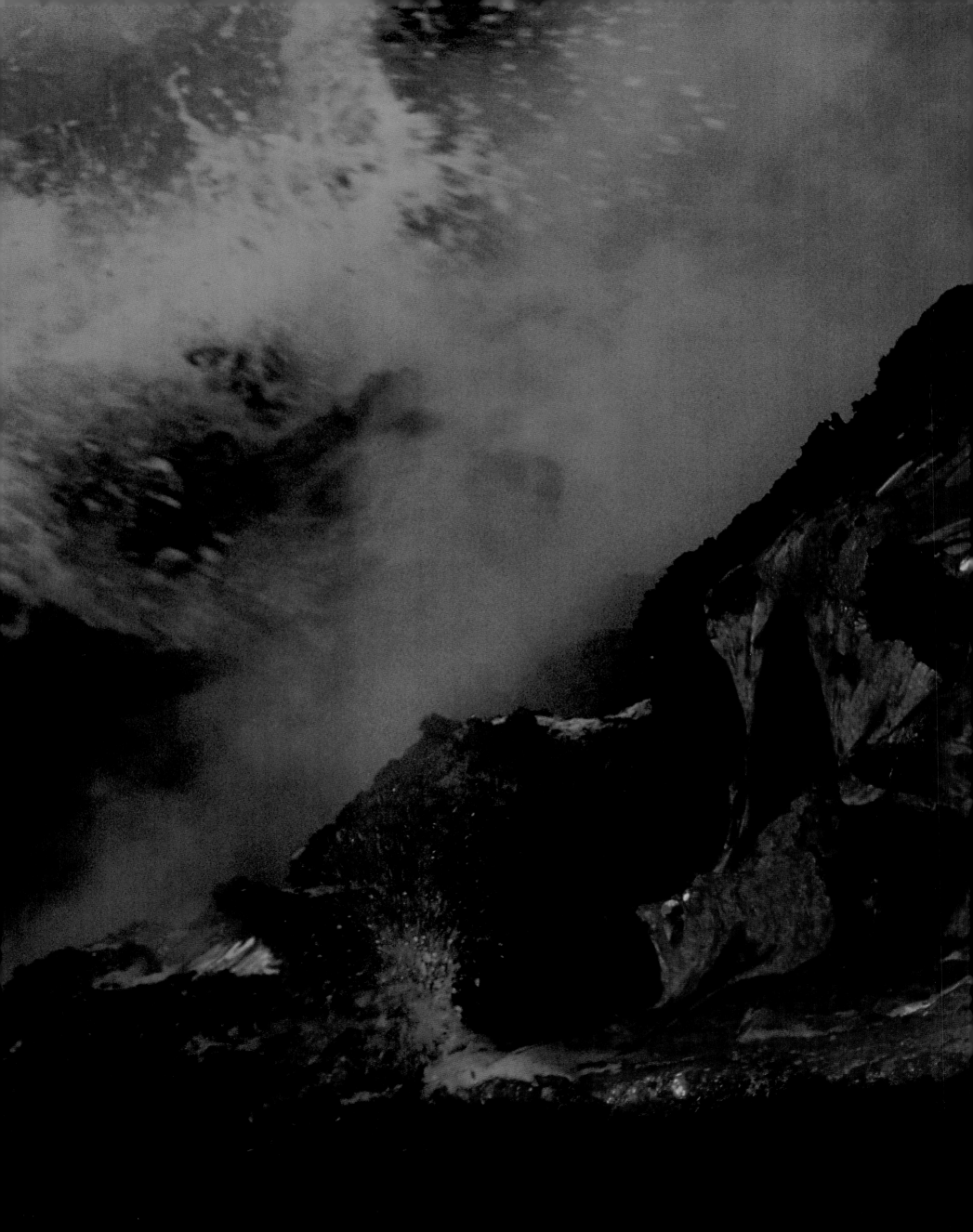

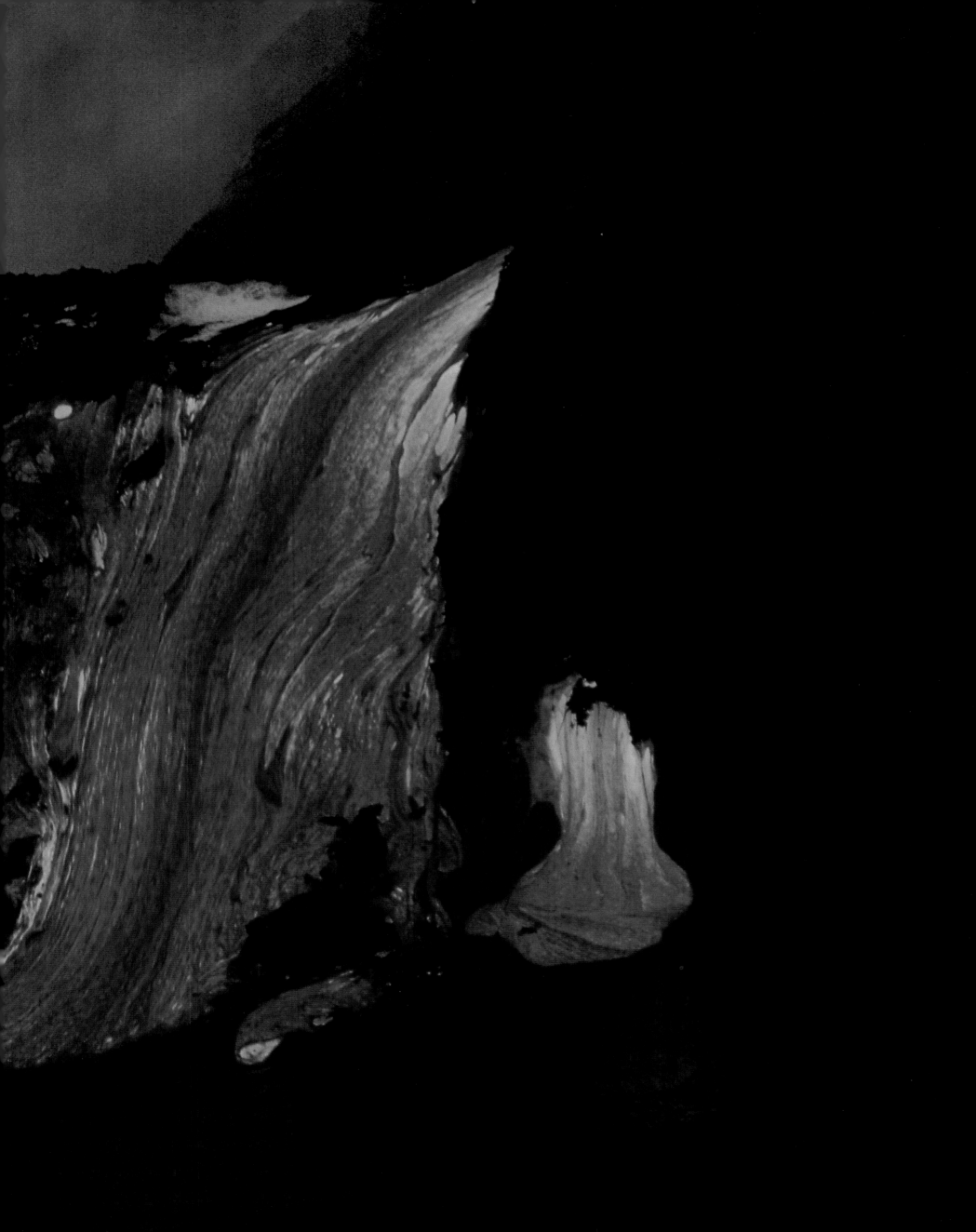

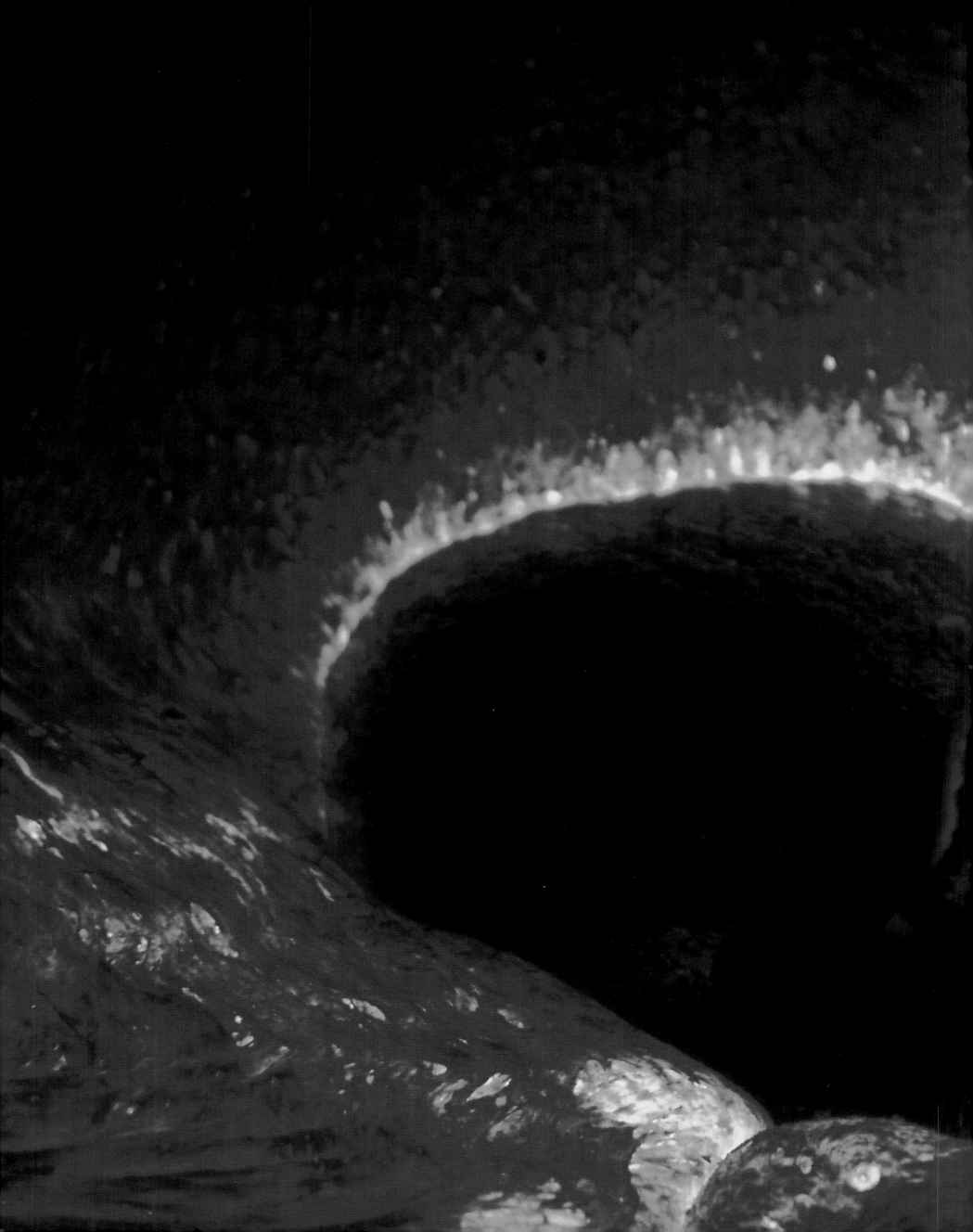

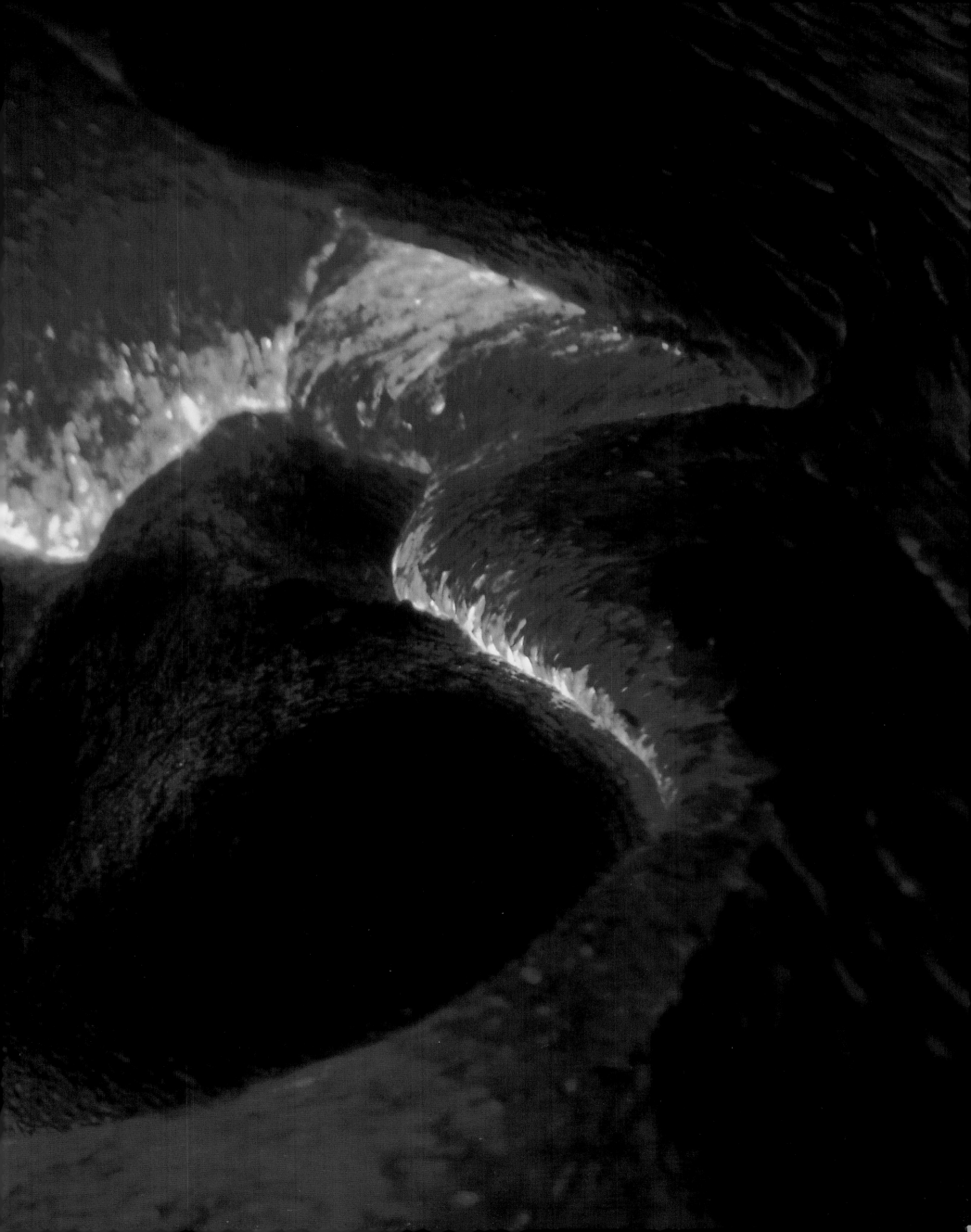

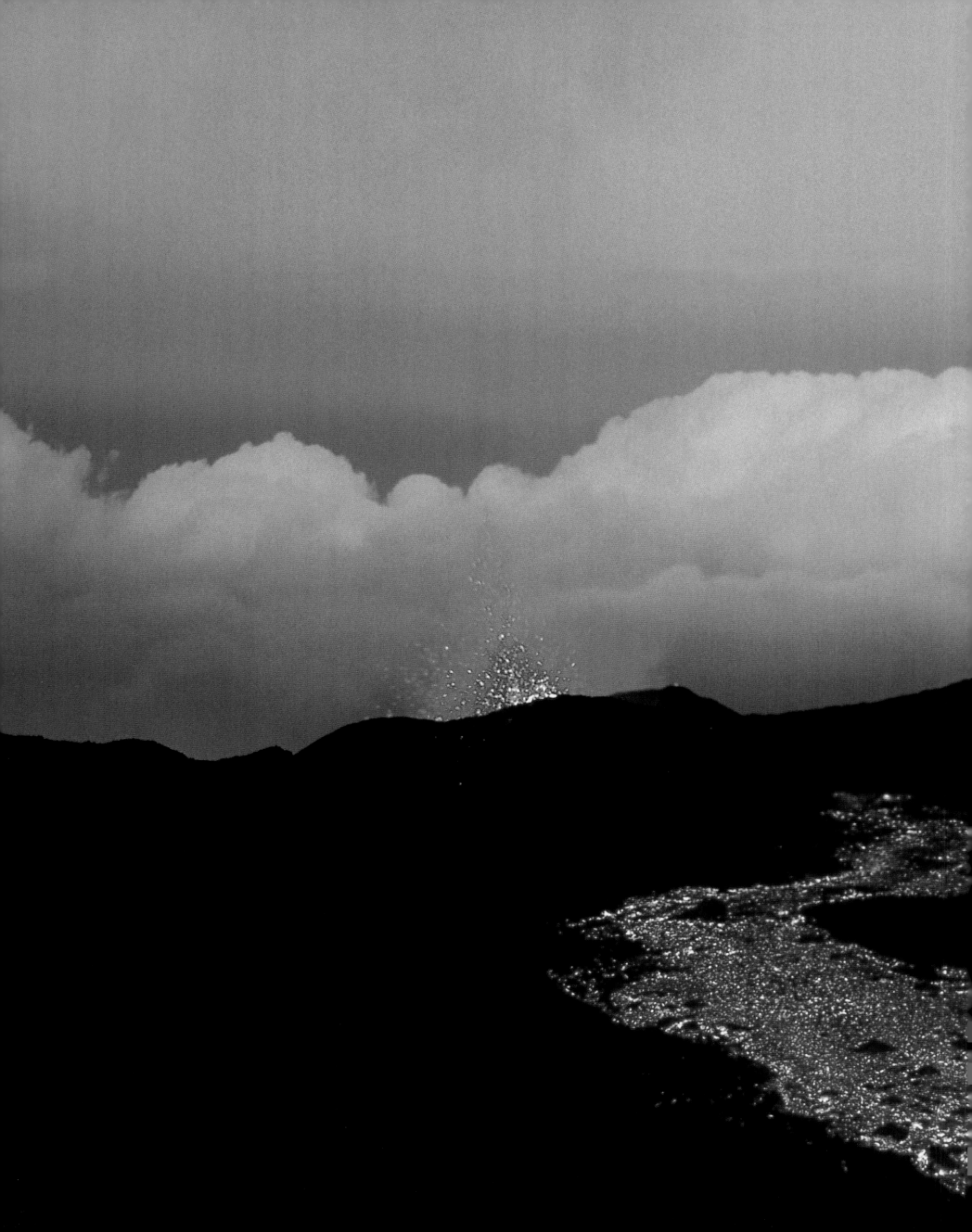

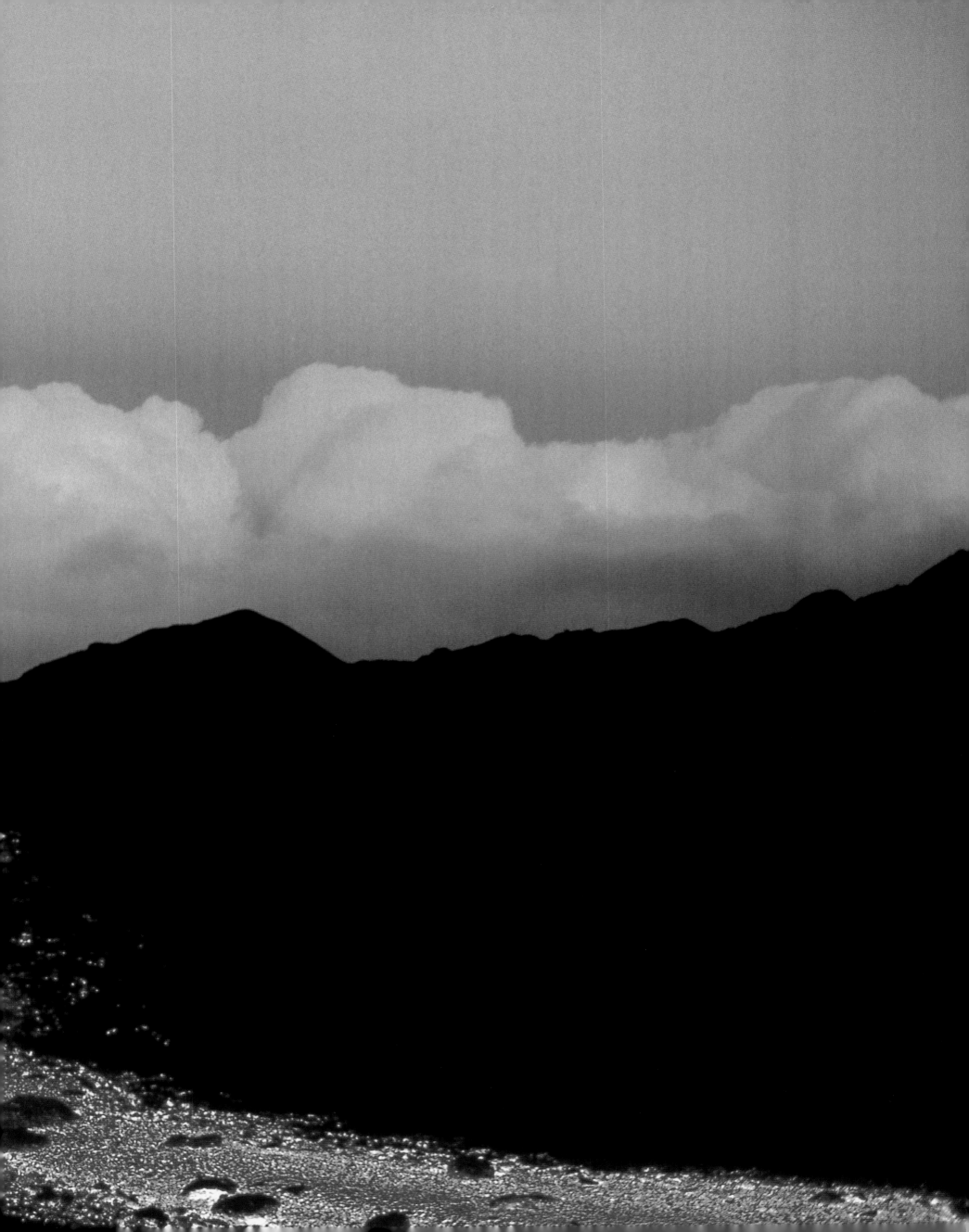

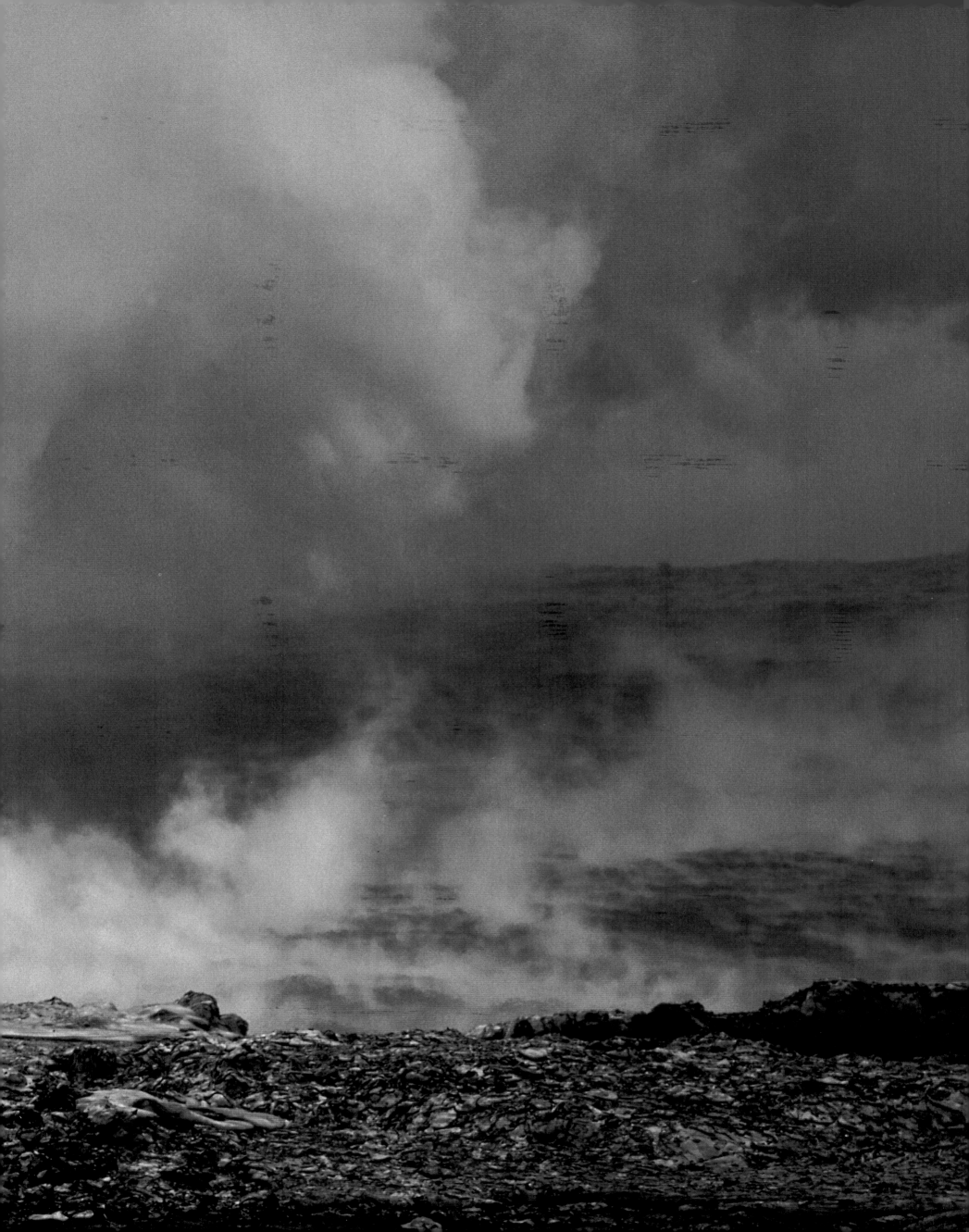

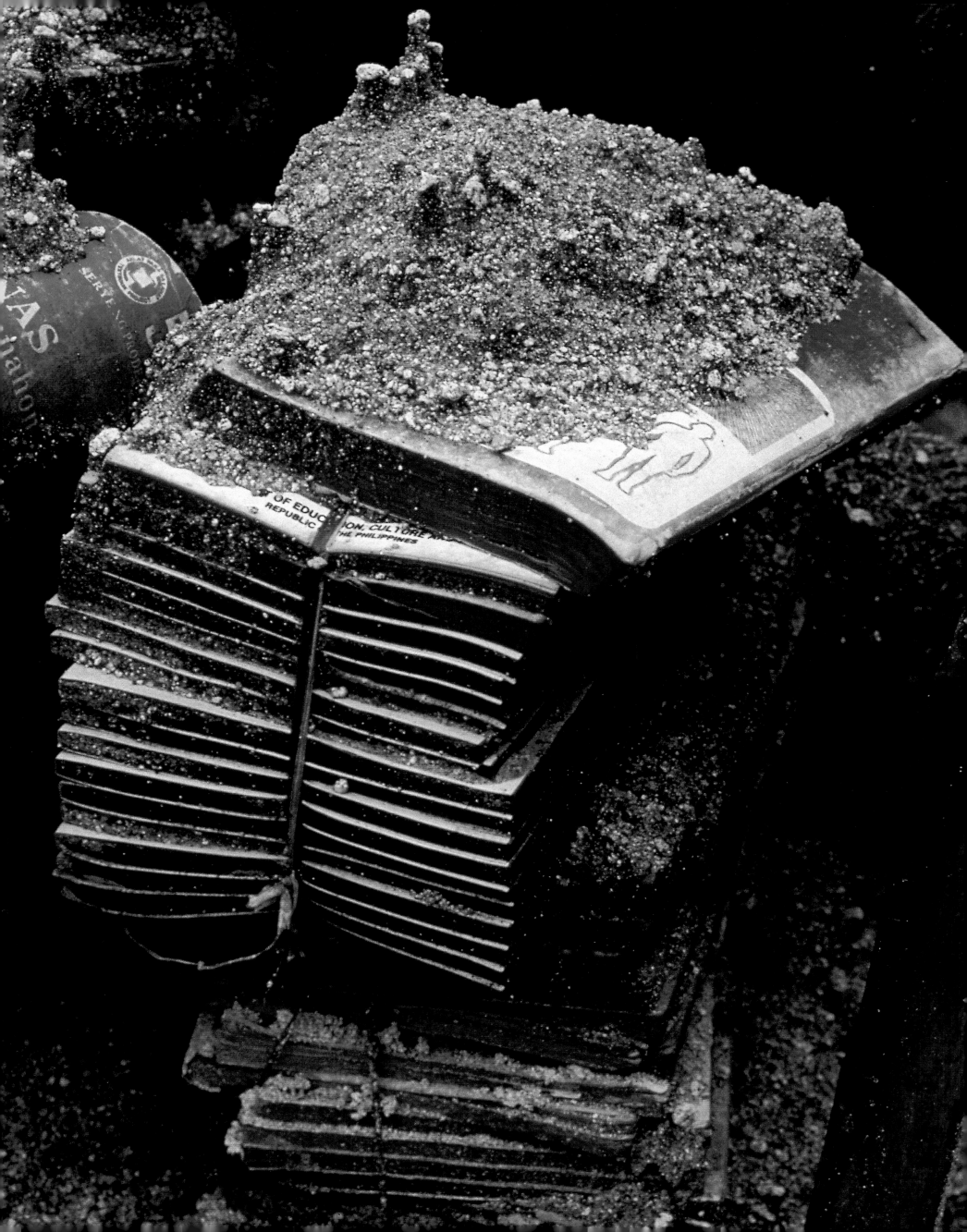

ASSESSING THE RISKS

VOLCANIC RISKS

For Western civilization the knowledge of volcanic risks goes back to the first century A.D. and the eruption of Vesuvius in the year 79. Much later, in 1631, the same volcano had another destructive eruption, which killed more than four thousand. Fearing a similar occurrence in the future and testifying to what he had seen, the viceroy of Naples at the time had inscribed in marble a solemn address to the population. Today this engraved plaque is on his monument at Portici facing the volcano. Although nearly four centuries old, its warning is more relevant today than ever.

Generations to come, generations to come,
I appeal to you:
The present illuminates the future with its light.
Listen . . .
Twenty times since the sun has appeared,
if history tells more than legend,
Vesuvius was turned to flame
always followed by great extermination for any who hesitate.

I warn you lest it find you indecisive.
This mountain has its belly full of alum pitch,
of iron, sulfur, gold and silver
of saltpeter and of springs of water.
Soon or late, the volcano catches fire and with the help
of the sea, engenders it.
But before engendering it, it shakes itself and the earth.
Its fire turns red and emblazons,
horribly ravages the atmosphere.
It shouts rumbling and thunder,
it pursues the inhabitants all around.
Flee while you still have the time.
Here there is lightning, explosion, and vomiting
of liquid matter mixed with fire
flowing at great speed, cutting off the route
of escape of anyone who delays.
If it catches you, you are done: you are dead.
In such a way that more than there are humans,
still more abundant is this fire
that is to be feared by all who scorn it.
It punishes the imprudent, the miserly
who pay more heed to their homes and goods
than to their own life.
If you have any common sense, heed the voice of this stone
Do not care for your house, nor your baggage,
flee without delay.

In the year 1632, 16th January, of the reign of Philip IV, Emmanuel Fonseco Y Zunica, count of Monterey, viceroy.

It is an extraordinary, indeed prophetic text. Not only does it testify to the phenomena that precede the eruption, it also delivers the fundamental message in managing volcanic risks: Flee while there is still time. As will be seen, 360 years later this message remains valid and also misunderstood. The result of such misunderstanding was one of the major catastrophes of the twentieth century.

The Reality of Risk

Since the year 1600, volcanoes have killed about 281,000 people. It is an extremely low figure in comparison to the fatalities of other natural catastrophes such as tornadoes, earthquakes, and floods (and compared to losses caused by humans themselves, such as war, murder, and automobile accidents). It should be noted that nearly all of these victims resulted from a small number of deadly eruptions. Thus, 77 percent of the fatalities were caused by only eight eruptions, each of which accounted for at least 5,000 victims.

All volcanoes present certain risks, and it is the task of volcanological officials to try to protect human beings from them. We must distinguish, however, between direct volcanic risks, that is, those determined directly by eruptive activity, and indirect risks, associated with the combination of the eruption and external factors.

There are seven major volcanic risks: falling tephra, pyroclastic flows, lava flows, gas emanations, mudflows, landslides, and tsunami. Famines and epidemics linked to the catastrophes constitute secondary risks. But volcanoes could almost be considered innocent killers. The behavior that humans adopt toward the dynamics of eruption can lead them to take reckless risks. Such a careless attitude has evolved over the course of history.

The Evolution of Risk

Volcanoes do not always reveal their dangers in the same way. Each of them presents particular risks. Although volcanoes no longer kill in great numbers as they have in the past, they remain a threat for modern societies.

We will examine only well-documented eruptions, those that occurred in a relatively recent historic period: post-1600. After this date, in fact, nearly all of the world's regions have been discovered and explored, and the eruptions are known to us through direct or indirect testimony. It is clear that risks decreased during the period extending from 1600 to 1900 and the twentieth century. This corresponds to a nearly total reduction in the number of fatalities from the consequences of illness or famine. Medical progress, the organization of assistance, the use of rapid means of transport, and international cooperation in cases of catastrophe all contributed to this evolution. It can be hoped, with some expectation, that these secondary risks will be eradicated for all future eruptions.

There has been, however, an extraordinary increase in risks caused by lahars (landslides or mud slides) and pyroclastic flows.

LEFT: Ash that fell from the eruption of Pinatubo volcano in 1991 was so thick that rooftops collapsed under its weight, like the roof of this school. Philippines.

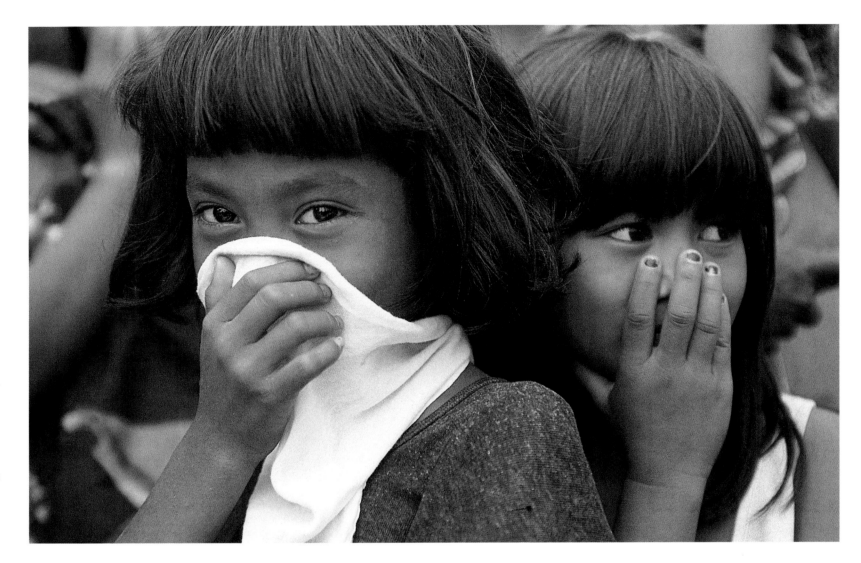

Nearly 300,000 people were evacuated from the area near Pinatubo volcano. Children and the elderly, in particular, had pulmonary and digestive problems owing to the high concentration of very fine ash particles in the air. Philippines.

Those, however, are risks known as "proximate," meaning they exist only within a radius of a few miles, capable of reaching several tens of miles beyond the erupting volcano. Both types of risk, secondary and proximate, might seem to affect only small numbers of people. This is far from the case, largely because of urbanization. With the growth of population density and the formation of large, sprawling cities at the foot of these volcanoes, volcanic effects become all the deadlier. The two major catastrophes of the twentieth century, the eruption of Montagne Pelée in 1902 that left 29,000 dead and that of Nevado del Ruiz in 1985 with its 25,000 victims, accounted for nearly 70 percent of the fatalities due to volcanoes of the twentieth century. Both struck cities that were totally destroyed. A catastrophe of similar dimension was avoided in 1994 thanks to the evacuation of Rabaul, a city of more than 30,000.

Volcanic eruptions do not strike in a random manner, nor do they strike just anywhere. There is a true geographic distribution of volcanic risks. Their location arises from the specific geotectonic conditions of various zones, conditions that directly determine the dynamics of an eruption. In zones of accretion and zones of hotspot volcanoes, molten magma causes eruptions that are not very explosive and thus not particularly dangerous. In zones of subduction, viscous magma causes explosive eruptions that are always threatening.

Subduction zones, with explosive and thus destructive volcanoes, occur in regions with high population density. The correlation between the size of the population and the increased volcanic risks can be explained by volcanism itself, insofar as frequent eruptions project voluminous ash clouds. This ash, high in mineral salts, falls to earth as natural fertilizer, enriching the soil and allowing for excellent agriculture. Naturally, it is desirable to inhabit these rich lands. This presents one of the paradoxes of volcanoes: they can bring life and productivity as well as death and destruction. However, despite the many victims, it is widely recognized that volcanoes today are more fruitful than deadly to humans.

In zones of subduction and explosive volcanism, in Indonesia, the Philippines, Japan, Central America, the Antilles, or South America, it is Indonesia that holds the sad record for the most killed. Indonesia has the world's highest concentration of volcanoes, and its 76 active volcanoes have accounted for 1,180 eruptions since the seventeenth century. Indonesia also has an extremely high population density. In some cases the vicinity of active volcanoes provides the only solid ground in this archipelago of more than 1,300 islands. Finally, the dynamic behavior of the Indonesian volcanoes is always violent and includes explosions, ash clouds, pyroclastic flows, and lahars, which alone make up four of the seven counted risks.

Risks and the Volcanoes' Age

Between eruptive phases of an active volcano are periods of rest that can vary in length ranging from several decades to as much as hundreds or thousands of years. They often precede a particularly fatal eruption, for several reasons. First, most volcanoes in zones of subduction, explosive volcanoes with viscous lava, have very brief and infrequent eruptions, which implies extended inactive phases. For years, gases and magma accumulate gradually within the volcanic edifice. Their emission during an eruption is thus all the more violent. The human element also plays its part. Over time, people become accustomed to their environment despite past catastrophes. Without any sufficiently recent dynamic examples, it is unimaginable that a neighboring volcano, now dormant, could suddenly wreak havoc. Behavior becomes reckless or carefree, to the point where people settle on or at least farm the slopes of volcanoes that now seem inactive.

Confronted with a frequently active volcano, however, people draw conclusions from fresher memories. They often experience the consequences, by losing property or even loved ones. Once a personal encounter with the risk has occurred, the most threatened zones are often abandoned and left unoccupied. Whether the reasoning is volcanological or human, and as paradoxical as the rule-of-thumb may seem, the more active the volcano, the less dangerous it becomes.

Evacuations

For the past twenty years, forecasting eruptions has made possible a proactive approach to the risk of volcanoes, with intervention before rather than after an eruption. This approach involves either technical steps during the eruption, such as rechanneling lava flows, or evacuating populations before the catastrophe begins.

One of the earliest preventive evacuations took place in the late eighteenth century. Noting the increasing number of seisms, Lord Hamilton foresaw an eruption and recommended that residents evacuate the zone threatened by possible lava flows. Unfortunately, this historic example remained largely unknown. Fortunately, the scientific and technical means necessary for prediction have benefited from the advances in recent research. In the course of two decades, preventive evacuations, especially in the face of major, uncontrollable risks, such as pyroclastic flows or lahars, have become more frequent. In this period, 77 evacuations have taken place, mobilizing nearly 1,053,500 people; 68 of these evacuations were followed by actual eruptions, each of which claimed less than ten lives.

Future Risks

Every analysis presents a clear picture. The more densely populated the surrounding area, the greater the risks, especially when megalopolises have grown around potentially dangerous volcanoes. A few examples are particularly eloquent. Two million people live around Merapi, 4 million near Popocatepetl, 3 million surround the foot of Vesuvius. It is estimated that, at the beginning of the twenty-first century, there are about 500 million persons exposed, to various degrees, to volcanic risks.

How do we limit those risks? Preventive action can be taken by retrofitting buildings, constructing shelters, and establishing dikes and channels, but really effective protection involves removing the population from the risk it faces. Current demographic pressures tend to rule out timely evacuations, and instead are restricted to temporary resettlement before an immediate risk. A precise definition of the risk is essential. To anticipate it, scientists must know the type of eruption, the zones threatened, and the timing of an eruption. This will enable those at risk to take the appropriate precautions.

1700–2000: THE MOST FATAL ERUPTIONS (MINIMUM OF 2,000 DEATHS)

Year	Volcano	Victims
1631	Vesuvius (Italy)	4,000
1672	Merapi (Indonesia)	3,000
1711	Awu (Indonesia)	3,200
1760	Makian (Indonesia)	2,000
1772	Papandajan (Indonesia)	3,000
1783	Laki (Iceland)	9,300
1792	Unzen (Japan)	15,200
1815	Tambora (Indonesia)	92,000
1822	Galunggung (Indonesia)	4,000
1856	Awu (Indonesia)	3,000
1883	Krakatoa (Indonesia)	36,400
1902	Montagne Pelée (Martinique)	29,000
1902	Santa Maria (Guatemala)	6,000
1919	Kelut (Indonesia)	5,100

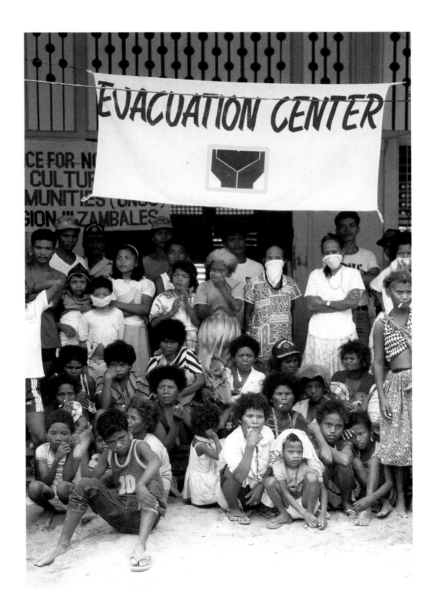

When Pinatubo erupted, evacuation centers were set up outside the danger zones. Philippines.

1951	Lamington (New Guinea)	2,900
1982	El Chichón (Mexico)	2,500
1985	Nevado del Ruiz (Colombia)	25,000

TWO DECADES TO UNDERSTAND

As for many sciences, understanding volcanism takes patience. However, unlike some other natural sciences, volcanology today still looks back to its past, sometimes very far back. If a biologist refers to discoveries dating at most from a decade earlier, a volcanologist is still searching today for information in the accounts of Vesuvius by Pliny, 2,000 years old, or in deposits of eruptive products that are older yet. This is because the comprehension of volcanic activity depends on the study of eruptions, which are, paradoxically, rare and very brief in terms of the volcano's history. The average lifetime of a volcano can last several hundred thousand years while its eruptions each last only a few days and can

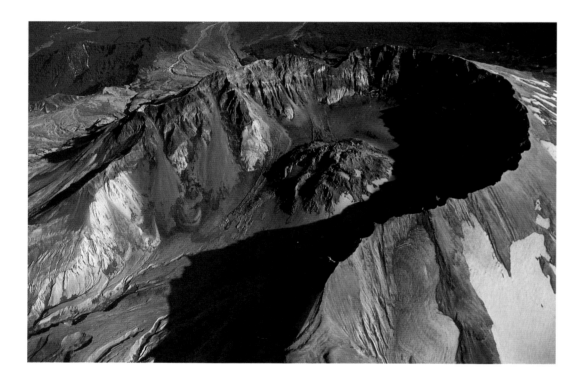

An aerial view of the active dome in the crater of Mount Saint Helens, Washington State, after the 1980 eruption.

occur several centuries apart. Each eruption is a rich source of information about the particular volcano as well as on volcanism in general and the mechanisms by which it is governed. Chris Newhall, one of the truly great contemporary volcanologists, suggests that studying volcanoes is like looking at an Advent calendar. On the calendar, each day reveals a new image. For volcanoes, each eruption is like a window opening up to teach us more. The greater the number of open windows, the keener our understanding becomes. Unfortunately, windows do not open every single day.

In this respect, the two last decades have afforded us a better understanding of volcanic phenomena. Recent eruptions have advanced the way we apprehend the science of volcanoes. Until not

long ago, volcanologists went to volcanoes, especially to the explosive, and dangerous, ones after or even during eruptions. Science was entirely speculative. It sought to reconstruct the great phenomena of the past, to explain its functioning and its origin, and to deduce laws. The study of eruptive activity considered the why and how of these phenomena, and the consequences of a mistaken judgment were not grave. At worst, they only jeopardized a few academic honors. The picture has changed. Researchers now reach the site before the eruption. The progress in their science presents volcanologists with new, serious responsibilities in the twenty-first century. Science asks them to locate and to forecast future eruptions. Three important volcanic crises of recent times are worth considering in order to grasp their mechanisms and draw relevant lessons.

1980: Eruption of Mount Saint Helens

Mount Saint Helens in Washington State is a jewel of the American West, at a height of 8,600 feet towering over lakes and rivers, forests and prairies. Its shape and its snowy peak earned it the nickname "the Fujiyama of the Americas." The Native Americans who lived in the area for thousands of years never approached Mount Saint Helens, which they called "mountain that smokes."

A Long Geological History

A stratospheric volcano, part of the Pacific fire belt, Mount Saint Helens proved particularly active in the nineteenth century, with continuous eruptions between 1831 and 1857. Because the region was sparsely inhabited, there were few witnesses to its activity. Had it not been for a few accounts left by Native Americans and trappers, the memory of these eruptions would have been totally lost. However, a few geologists took an interest in the volcano. Dwight Crandell (b. 1923) and Donal Mullineaux (b. 1925), with strong scientific training, made a detailed study. They observed all of the volcano's deposits, discovered obvious traces of great explosive episodes, identified the remains of powerful mudflows. Above all, they dated the various eruptions and established their chronology. Though lacking in experience of active volcanoes, they followed the constant theme in geology that any phenomenon of the past is most likely to recur in the future. They ended their report, published in 1978, by stating that Mount Saint Helens would have additional activity, including violent and probably destructive eruptions, and that an eruption was likely before the twentieth century's end. The volcano did not take long to prove them right.

Advance Indications

After sleeping for 123 years, Mount Saint Helens showed the very first signs of reawakening in March 1980. An earthquake measuring 4.2 on the Richter scale marked the beginning of a series of shocks that quickly intensified. Starting on 25 March, several hundred tremors were recorded each day. On 27 March, the volcano made news. At 12:36 P.M., after a violent explosion that was heard throughout the state, Mount Saint Helens began to expel clouds of vapor and ash.

At once, a crowd of various volcanologists rushed to the

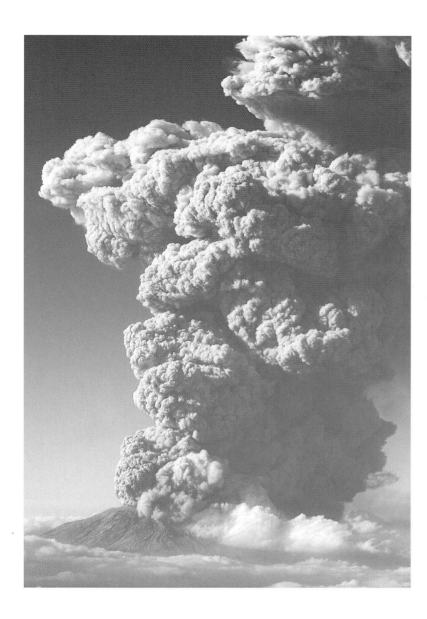

In 1980 Mount Saint Helens began to erupt. For three days it produced an ash cloud more than 12 miles high.

veritable monster that had left clearly identifiable evidence of its past furies. For the first time, moreover, surveillance techniques would be applied to an explosive volcano. Observers from Hawaii had mastered surveillance techniques but had trouble imagining the dynamism that might emerge; local geologists, by contrast, were familiar with the terrain and with the potential risks but were not necessarily up-to-date with the techniques of dynamic surveillance and interpretation of recorded signals.

Throughout the month of April, the volcano's crater grew through numerous explosions that gradually dirtied the snow with their ash. The volcanologists closely following developments quickly realized that these explosions were of phreatic origin and were slowly destroying an ancient dome. At the same time, a continuous tremor began, suggesting that fresh magma was accumulating within the volcanic edifice. Major deformations could also be seen. Their unlikely size at first made the scientists doubt their own figures, which were so far beyond the norm. Magma intrusion deformed the summit and caused a protuberance that, by 12 May, had reached a height of 490 feet and kept growing at a rate of five feet daily.

Surveillance of the volcano, thanks to seismic recording and gauges of deformation, was a real challenge; several new techniques were tested, including those available from declassified military technology. Mount Saint Helens became an impressive trial laboratory for forging the surveillance tools of the future, foremost among them, the computer. For the first time, scientists could process in real time an enormous quantity of very complex data.

From the first seism, the U.S.D.A. Forest Service closed off access to the mountain, for fear of avalanches caused by seismic tremors and explosions. Beginning on 27 March, volcanologists of the U.S. Geological Survey announced their eruption prediction and tried to cut off access within a radius of 20 miles around the volcano. But Mount Saint Helens was a favorite tourist spot and its forests were also actively used for their natural resources. Some specialists doubted the reality of an imminent eruption and their opinion was picked up by some of the media who fed the debate. The State of Washington finally determined an evacuation in two stages: one zone of forbidden access and another zone of restricted access.

If loggers, residents, and visitors failed to recognize the real danger and continued to frequent the restricted zone, most of the volcanologists of the U.S.G.S., for their part, now analyzed the risk perfectly. They predicted an explosive eruption with vertical components, although some saw the likelihood of directed lateral explosions. But their conclusions did not prompt them to desert their surveillance posts, and they stayed put.

On Saturday, 17 May, volcanologist David Johnston arrived for guard duty at the Coldwater II station, relieving his colleague, Harry Glicken (who would disappear later in the Unzen volcano explosion in 1991). The weekend promised to be fine and sunny, and spring caught nature in a peaceful, smiling mood. That same day, under pressure from the "anti-eruption" lobby, authorities opened some of the barriers to allow residents of the exclusion

scene. The situation was clearly unusual and fascinating. Rarely does anyone have the chance to observe firsthand the activity of a great explosive volcano, let alone to observe its awakening. What made this even more unusual was that such violent eruptions are very infrequent. Most similar volcanoes, located in faraway, exotic places, prove all the more difficult to observe; scientists usually arrive on the site just to assess the damage and study the eruption after the fact.

Here, at the foot of Mount Saint Helens, things were different for two basic reasons. Because the volcano is situated in a country with a high degree of scientific and technological development, and occupies a zone of economic activity, the impact of any eruption posed a real threat. The research conducted by Crandell and Mullineaux had also served, by this time, to emphasize the volcano's potential and the violent dynamism that could be triggered. The entire geological context was familiar. All that remained was to outline the dynamic scenario.

By 1980 observation of active volcanoes was not new, but studies focused mainly on the effusive type of volcano. For American scientists, the education of a volcanologist specializing in surveillance and observation had to take place in the Hawaiian Volcano Observatory. That was the site, after all, of two volcanoes, in America, almost continually active and, better yet, of one of the oldest observatories in the world. The entire development of monitoring technology as well as the training of researchers had occurred on Mauna Loa and Kilauea. The specialists quite naturally brought their "Hawaiian training" to bear at Mount Saint Helens. The volcanologists had to go from relatively calm, "nice" volcanoes to a

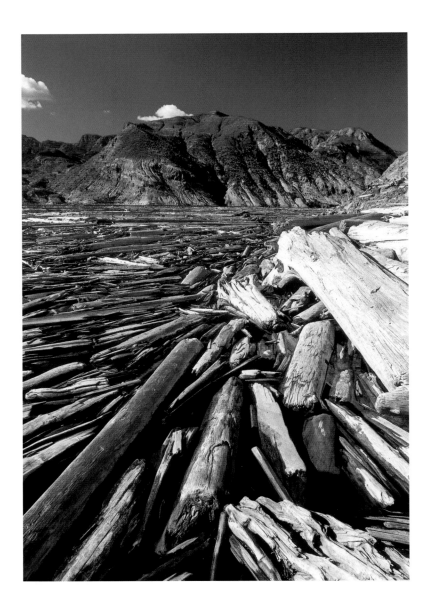

Spirit Lake was swept by a wave 980 feet high, set off by the force of the blast of Mount Saint Helens volcano. All the trees on the lake shore were sucked into the center of the lake.

cano's flank. The water vaporized and gases were released with colossal violence. The cloud formed by the lateral explosion exceeded the initial avalanche of debris. Charged with incredible energy, it careened down the slopes, leaped over peaks, moving at nearly 660 miles per hour.

The wind tore up all the trees in a 230-square-mile area. The interior temperature of the cloud reached 500° F, and it spread to more than 16 miles from the volcano. This lateral blast probably lasted only 30 seconds. The avalanche of debris now following it carried ash, stone blocks, pieces of ice, uprooted trees, a total of more than 65 billion cubic feet of refuse that ended up piled in Spirit Lake and the Toutle River, which was filled for a length of more than 20 miles; and at some points the deposit was more than 590 feet thick. Mudflows followed, resulting from the melting ice and snow. They carried ash and rocks more than 30 miles from the volcano. In just fifteen minutes the vertical cloud of ash reached a height of 16 miles and continued for nine hours.

When the volcano was at last visible again, the summit of Mount Saint Helens showed a new crater one by two miles in area and 2,300 feet deep. As if decapitated by the explosions, the mountain summit had been lowered by 1,300 feet. The eruption claimed about sixty lives, destroyed 200 miles' worth of roads, and felled several million trees. The casualties did not stop there, since nearly 6,500 deer and elk as well as 200 black bears were killed.

A new dome later appeared in the crater and gave rise to several explosive phases until 1986. None of the explosions matched the power of the one on 18 May 1980, which let loose a force 17,000 times greater than the bomb at Hiroshima.

Far from merely permitting a specific case study, this catastrophe was rich in lessons for volcanology as a whole. It clearly showed the need to view each eruption in the geological context of the volcano and to reconstruct its particular history. Also, for the first time it had been possible to witness directly the approach and sequence of a great explosive eruption. Surveillance techniques were refined while being adapted to this type of volcano. Above all, it was possible to identify the early indicators of such eruptions, which revealed themselves through changes in seismic activity and deformations of the terrain. A multidisciplinary approach and teamwork proved therefore to be indispensable for surveillance. The risk map drawn up by volcanologists was also the opportunity for testing ourselves against the economic and social problems that such an eruption can pose to our modern societies. This awareness meant a major advance in modern volcanology. Finally, the outbreak of such an eruption in a technologically advanced and developed country led to the availability of larger research budgets and the creation of numerous new scientific programs.

The Mount Saint Helens eruption was a turning point. Not only did authorities establish new volcanological observatories on American soil, but a great many researchers were motivated to study different volcanoes farther away. Study and surveillance missions thus took shape in Central and South America, Indonesia, and the Philippines.

1985: Eruption of Nevado del Ruiz, Colombia

Nevado del Ruiz, 100 miles west of Bogotá, is a vast strato volcano 17,675 feet in altitude. It is among many active volcanoes in Colombia, part of the great alignment of volcanic peaks that, from Alaska to the southern Andes, form the eastern part of the Pacific

zone to return to their homes to recover belongings. Everyone was ordered to leave the red zone by sundown.

The Eruption

At 7 A.M. on 18 May, Johnston, from the observation base five miles away from the volcano, transmitted the last observations on the volcano by radio to the coordination center at Vancouver. Seisms, deformation, sulfur dioxide emissions, everything resembled what had already been known for several weeks. The residents began to crowd around the barriers. They had been told that at 10 A.M. they could return to their homes.

At 8:32 A.M. Johnston's radio began to broadcast: "Vancouver, Vancouver, this is it!" Then silence. Nothing was ever found of Johnston's equipment, his vehicle, or his camp. Mount Saint Helens had begun erupting. The first minute of this eruption was catastrophic. There was hardly time for anyone to realize that the maximum power was reached. In response to a major seism of a 5.1 magnitude, the bulging visible near the summit collapsed. The entire northern flank turned into an enormous avalanche of rubble that charged down the slope. Below this flank and its bulge, the intrusive dome grew larger; with its "cover" disappearing, it decompressed very rapidly together with the overheated water surrounding it. Two explosions occurred simultaneously. A cloud rose straight into the sky while a second appeared laterally on the vol-

fire belt. It has a history of several eruptions, including in 1595, 1828, 1829, and 1833. All produced clouds of ash from explosions, along with great mudflows.

Beginning in November 1984, a series of seisms was felt throughout the region, and some mountain climbers noticed increased melting of the glacier that surrounds the crater. A seismic surveillance network, installed in August 1985, showed increasing seismic signals that seemed ever closer to the surface. They bore a close resemblance to the ones experienced before the Mount Saint Helens eruption. The seisms were by now occurring $4^1/_2$ miles beneath the crater. Volcanologists interpreted them correctly and warned of an imminent eruption. Colombian scientists asked for the help of various foreign colleagues, and an international team was formed that monitored the volcano and made an estimate of future risks. Officials were informed and kept apprised of all developments. The size and potential power of an eruption were widely discussed, but all the specialists agreed that the ice and snow at the summit indicated aggravated dangers, even in the event of a moderate eruption. Mudflow deposits were identified in a radius of 40 miles around the volcano. They had proved extremely fertile, and fields were cultivated and farms continued to be built, along with villages and towns.

In September 1985, the events began. Violent explosions hurled rocks more than a mile from the crater, ash fell over a distance of 20 miles, extendng to the inhabited areas. Many people remained indifferent, but the volcanologists were concerned, and

they drew up a risk map showing the zones exposed to new ash showers or mudflows. These flows resulted from the snow and ice melting under the onslaught of hot ashes. The thick mixture of these two elements rolled down into all the valleys that radiate from the volcano. Publication of this risk map unleashed an outcry. The Colombian government, plagued by political and terrorist problems, considered it too alarmist. On the site, there were fears of a local economic slowdown and declining land values. The Church was reluctant to use its considerable influence.

In early November 1985, volcanologists demonstrated that the mechanism of mudflows had a 67 percent likelihood of destroying the city of Armero, and published an updated risk map. Once again the authorities dismissed this prediction. The passivity of public officials was reinforced by poor communication, the lack of understanding of technical concepts, insufficient financing, and especially the fear of giving false alarm. Better to wait for certainty rather than risk an evacuation for nothing.

Suddenly the volcano struck. On Wednesday, 13 November 1985, it was shaken by a series of explosions. The eruption started at about 4 P.M. At Armero, 27 miles from the crater, ash began falling at about 5:30 P.M. Violent explosions were heard from about 9 P.M. At 10 P.M., an immense rain of ashes hit the city again. At these threatening signs, the Red Cross decided to evacuate on its own initiative, but it was already too late. At 10:30 P.M., after enormous rumbling, a flow of mud, ice fragments, tree trunks, and various debris headed toward Armero. A wave 131 feet high crushed

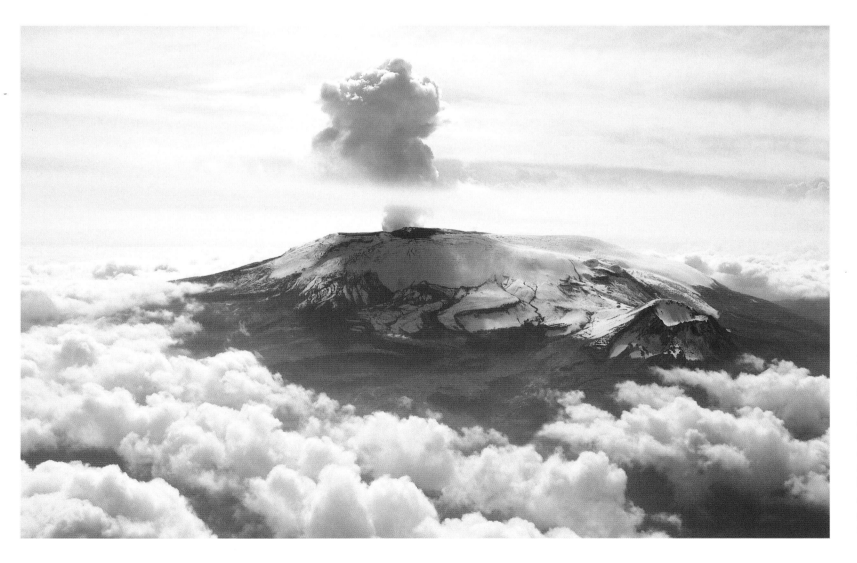

Nevado del Ruiz volcano is covered with glaciers. When their ice began to melt from contact with hot lava, it aggravated the risks during the eruption in 1985. The eruption itself was average in size, but it had catastrophic consequences. Colombia.

houses and ripped out roads and bridges. Of the town's 4,500 houses, only 80 survived, while 25,000 persons were killed. The city of Armero was never rebuilt over the corpses that it still grips in its muddy grave.

For volcanologists all over the world, this disastrous eruption was an important wake-up call. Prediction was no longer enough; they also had to take action. Too often emergency management was reduced to providing help after the fact. It is obvious today that arrangements made before an eruption are far more important, as well as less expensive. If it is imperative to intervene before a catastrophe, and if we have today the technical means for predicting it, convincing evidence must be presented so that damage can be limited. This was the chief lesson from Armero: the need to obtain the means of persuasion.

Using the best communication tools of our time, the International Volcanologists Association decided to launch a program alerting people to volcanic risks. The program included creating a videocassette that would identify the seven main volcanic risks and demonstrate their effects on human activity. Maurice Krafft, who had filmed eruptions around the globe, volunteered to produce this video program.

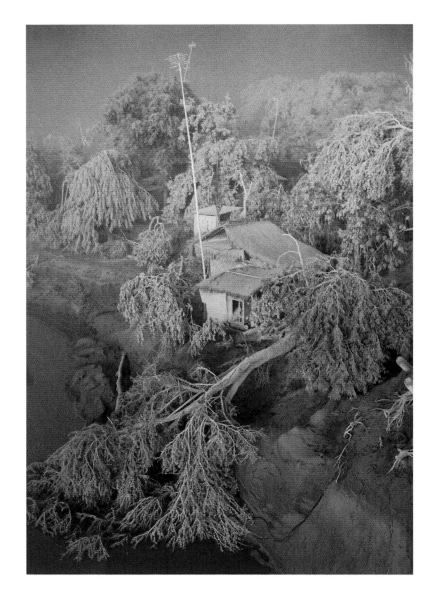

During the eruption of Pinatubo, trees collapsed under the weight of ash made heavier still by rainfall. Philippines.

1991: Eruption of Pinatubo, Philippines

Pinatubo is one of twenty-one active volcanoes in the Philippines. It is the center of the volcanic arc that parallels the west coast of the island of Luzon, some 60 miles north of Manila. The last eruption of this volcano, which was born more than a million years ago, dates back to 1380. Since then, very serious erosion in the tropical area has dried this range. All the flanks of the volcano are covered with thick forests broken by many canyons from which wide rivers flow. The volcano's summit is formed by an ancient dome nearly two miles in diameter. In fact, aside from a thermal zone at the foot of this dome, nothing in the landscape recalls its volcanic origins. The last eruption has nearly faded from human memory. Nearly 15,000 people inhabit small villages at the foot of the volcano, and 500,000 more in nearby urban centers. The area also includes two large American military bases, Clark Field and Subic Bay, which include more than 30,000 personnel. The slopes of the volcano itself house 500 families of Aetas, an aboriginal people that live off a few crops, gathering, hunting, and fishing. Their survival depends directly on the rivers and the forest of Pinatubo. This whole order was swept aside on the afternoon of 2 April 1991 when explosions were heard at the summit of the volcano.

Warning Signs
The explosions were of phreatic origin and continued for several hours. Destroying square miles of forest, ejecting stones and powder from old lava, they dug several craters in the north flank of the summit dome. The next day a series of clouds of gas and smoke followed the same course.

Officials were immediately alerted and a race began between volcano and volcanologists. Experts of the Philippine Volcano Service (PHIVOLCS) understood the dangers of their volcanoes, all of which were highly explosive. It was immediately decided to evacuate 5,000 people living within a radius of 6 miles around the summit of Pinatubo. Volcanologists rapidly installed a network of seismographs around the volcano, which had never been monitored until then. They measured between 40 and 140 tremors per day. But the question remained: Were these tremors punctuating the volcano's normal development, or rather were they warning signs of an awakening?

Foreign experts arrived to assist their Philippine colleagues for an emergency installation of a new observatory, the Pinatubo Volcano Observatory. It quickly became clear that the seismic shocks showed signs similar to the warning signs at Mount Saint Helens, which indicated the rise of magma. A complete geological study of the volcano was immediately ordered. A review of past eruptions could help sketch a portrait of an impending eruption. The report promptly came to some disturbing conclusions, showing that for the past thousand years Pinatubo had had very violent, explosive eruptions. They had produced voluminous pyroclastic flows, deposits from which had been found as far as 13 miles from the crater. These deposits had caused lahars that covered all the slopes of the volcano.

These data were reported on a map tracing the various risks in the area. The map served as a basis for civil and military authorities in deciding on preventive measures. The chief resistance came from American military officials, who refused to yield to the threat of a small volcano. American volcanologists sent to the Philippines had to persuade, one by one, the various officers at the bases. For some of them, only a helicopter tour of the zones affected by

phreatic explosions, as insignificant as these events were compared to the real danger of the volcano, proved frightening enough to compel a change of attitude. The Philippine authorities interpreted the American reaction as a desire to disengage militarily from their country, which was dependent on the rent paid for the bases. It was not certain whether this fear of eruption was real or a pretext.

Nevertheless, mindful of the lesson of Armero, experts worked tirelessly at persuasion. Authorities were shown the videocassette that described the various volcanic risks, and the film proved essential in alerting the Philippine authorities and the entire population. Each time it was shown, it was duplicated and soon more than eighty copies were circulating in the region to explain in images what could happen at Pinatubo. From this point on, the scientists' efforts involved not just the observation of the volcano but also a heightened communication campaign among the authorities and populations affected.

On 3 June events began to accelerate. Explosions, falling ash, and seismic activity became more intense. Also on 3 June, Maurice and Katia Krafft, Harry Glicken, and some forty Japanese were killed by an explosion of Unzen volcano on the island of Kyūshū. The news was a powerful shock both for the American military and for the Philippine government. On 5 June the volcanologists decided to declare a number three alert, which implies a "possibility of eruption within two weeks." On 6 June a large deformation was observed at the summit, which was swelling. There were fears of a drama on the scale of Mount Saint Helens.

On 7 June a violent explosion emitted a cloud of ash and vapor that rose to 4 1/2 miles in height. A number four level alert ("possibility of eruption within 24 hours") was declared and new evacuations took place at the foot of the volcano. If alerting the local population now proved easy, there still remained the job of rounding up the Aetas living in the forest. Franciscan nuns went to work calling them together to encourage them to join the refugee camps. Military authorities from both American bases finally believed what they were told.

From 8 to 12 June the growth of a dome could be seen at the summit of the volcano, accompanied by uninterrupted explosions that emitted ash. On 9 June, alert level number five was declared. They had reached the point of "an eruption in progress." The evacuation radius now extended to 13 miles and 25,000 persons were removed. The next day, under falling ash and to the rumbling of the first mudflows nearby, 14,000 American military personnel evacuated Clark Field Air Force Base. The volcanologists remained on the site to continue their surveillance effort.

Great Explosions
The first great explosive eruption occurred on 12 June. The ash cloud, more than 12 miles high, was accompanied by small pyroclastic flows affecting the north side of the volcano. The evacuation radius was increased to 20 miles, and 58,000 were removed. From 12 to 15 June, explosions proliferated and it became so difficult to see the mountain that people wondered whether night had fallen or if the heavy ash was darkening the sky. The explosions were

known only from the seismic signals they generated, whereas the clouds were detected by the radar still operating at Clark Field.

On 14 June the weather cleared, revealing the summit of the volcano. On the 15th, in the morning, explosions were heard but in a lateral direction, as if emanating from the base of the cone. Could this mean it was collapsing? The alert was repeated and evacuation proceeded.

So far a wind had been blowing, saving the island of Luzon from the falling ash. As a typhoon approached, the winds turned and the ash showers began to hit the center of the island. Many began leaving the region. On 15 June at 2:30 P.M., night fell in the middle of the day. At this point just one of the seismographs was still working on the volcano. All the others, located near the cone, had already been destroyed by pyroclastic flows, some of which reached Clark Field where the volcanologists were installed. Pieces of ash, nearly 2 inches in diameter, were falling 13 miles from the crater. Sudden fluctuations in atmospheric pressure showed that an enormous explosion was under way.

Ash now covered the entire region, causing the eclipse of the sun. Radar and satellites proved the size of the explosion that created an ash cloud more than 20 miles high. Up in the stratosphere this cloud mushroomed more than 250 miles in diameter. At that height, ash was carried by winds that spread it virtually across the globe. Accompanying the explosive phases, pyroclastic flows spilled from the crater and ran down the slopes of the volcano. One after another, they filled the valleys, smudging its contours, accumulating to create a different landscape. Under such a lava cloak

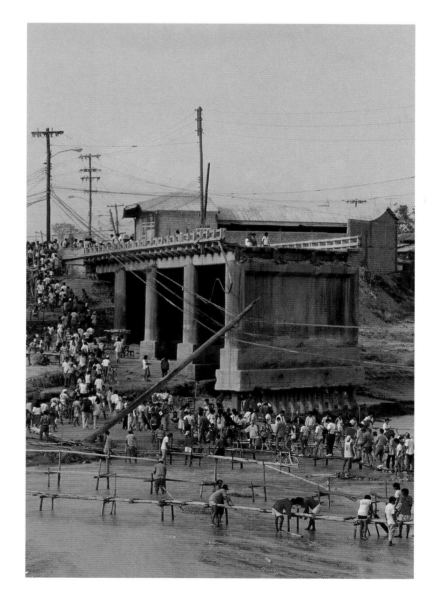

The main bridge in Angeles City was knocked out as rain washing down the ash-laden slopes of Pinatubo caused an onslaught of mudflows. Roads and villages were destroyed as far as 40 miles from the volcano. Philippines.

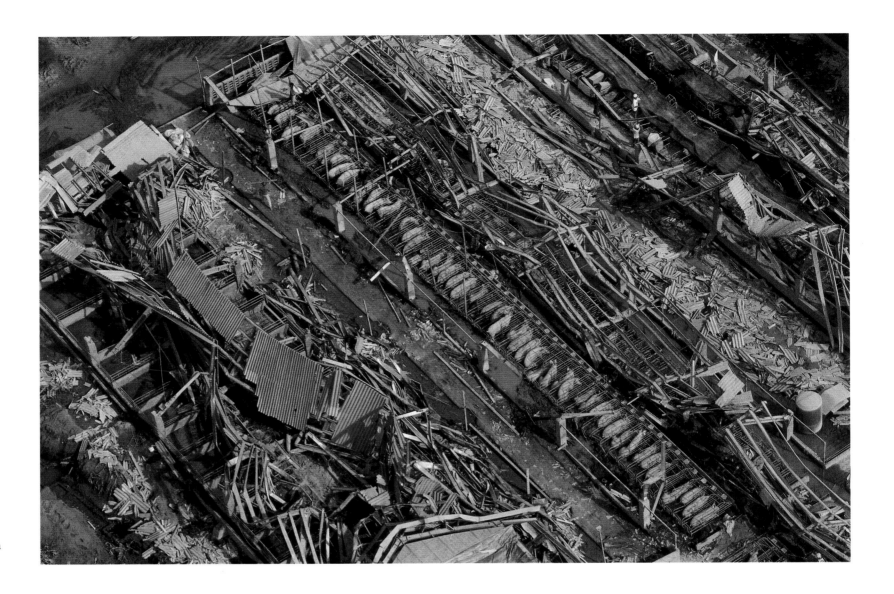

Wreckage in an industrial pig farm caused by falling ash from Pinatubo.

lay the forest, evacuated villages, and the few Aetas who could not be reached or had refused to leave.

While the volcano was at its peak of activity, typhoon Yunya hit the island. It served to intensify all the misfortunes of the eruption. The worst occurred when violent rains added weight to the ash covering the whole region—electric pylons broke and roofs collapsed killing many people—and formed lahars whose damage reached more than 25 miles from the crater.

By the end of June 1991, the volcano was still active but its cloud of ashes reached heights of only 10 to 13 miles. It was then possible to get closer to the zone and to make an initial assessment of the damage. The entire summit of the volcano had disappeared. In its place was a deep caldera 1 1/3 miles in diameter. A mantle of ash varying in thickness from 4 to 40 inches covered a zone of some 1,560 square miles, even though most of the ash had fallen into the China Sea. Total volume of the tephra deposits was estimated at 10 to 13 million cubic feet. All the slopes of the volcano were covered with great pyroclastic flows. Within a radius of 10 miles of the crater, these deposits reached a thickness of 154 to 656 feet. The estimated volume of the flows was 20 to 23 million cubic feet. All vegetation was gone, valleys were filled, rivers were digging new beds. The Aetas' territory was swept off the face of the earth. Study of all the deposits indicated that they probably came from the expulsion of 13 to 16 million cubic feet of dense magma, more than ten times the volume from Mount Saint Helens.

While this eruption led to the most massive organized evacuation, the eruption was also undoubtedly the greatest in the twentieth century. More than 300,000 persons had to flee the area. Some 300 victims were mourned, but their number would probably have reached 15,000 to 20,000 had there been no evacuation. Human lives were saved thanks to management of the crisis by the teams of volcanologists, and especially thanks to the close collaboration between them and the Philippine government. Good understanding by the concerned population of the decisions made also proved critical. There can be no doubt that this cooperation could not have been possible if information flow between the different authorities had been less efficient. The excellent management of this incident at Pinatubo certainly makes it a "model" eruption for events that will occur in other parts of the world.

From Prediction to Mastery

The city of Rabaul (population 30,000) in Papua New Guinea is situated deep inside a great volcanic caldera on whose edge rise two active volcanoes, Tarvurvur and Vulkan. Everyone here is clear about the volcanic risks. The city was already destroyed almost completely in 1878, and again in 1937. It experienced another eruption in 1943, and since then, the volcanoes are monitored attentively by an observatory.

In 1992 a serious volcanic crisis began, and both scientists and the public followed it closely. Strong links in communication were

put in place, risk maps were drawn and published, and all residents were mobilized, warned of the possible risks and of necessary countermeasures. Evacuation of the city was planned and rehearsed. For once, the precautions were largely obeyed, and yet no eruption occurred. The magma halted its rise under the caldera, and the situation calmed down.

In September 1994 a new crisis seemed imminent. Preliminary signs were clear, well analyzed by the scientists, and also accepted and discussed by the population. Such pressure was exerted by magma under the caldera that the resulting deformations raised coral reefs above sea level. In addition, many seisms were felt throughout the zone. The situation was so impressive that the inhabitants of Rabaul, alerted by the crisis of 1992, made an immediate, orderly evacuation of the city. A few hours later, scientists and authorities announced an official evacuation order to a city that was already deserted. The city stood between two volcanoes that began erupting at the same time. Rabaul was 80 percent destroyed. Not one life was lost.

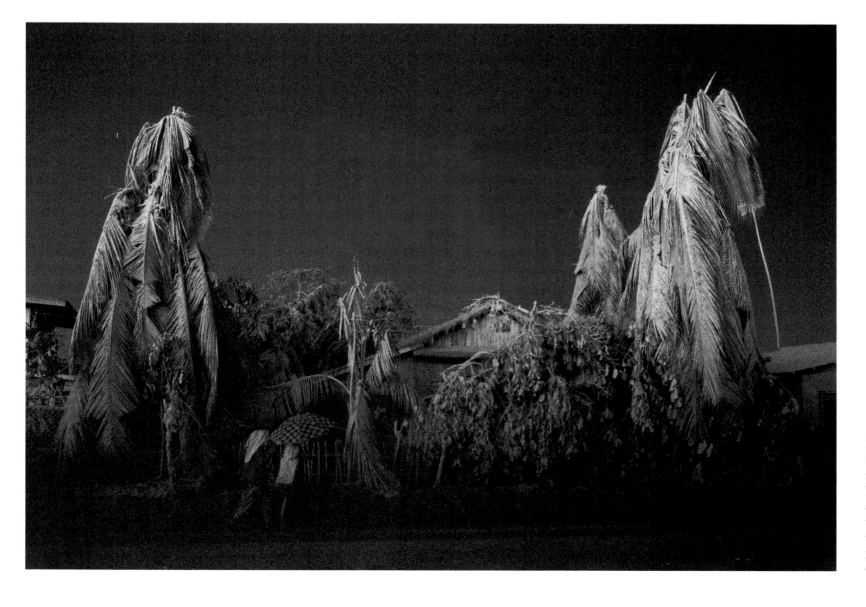

During the eruption, Pinatubo released so much ash that, in broad daylight, within a radius of 50 miles of the volcano, parts of the countryside were plunged into total darkness. Philippines.

PAGE 217. Near Lake Turkana, a volcanic edifice was severed in two by one of the fractures of the African rift. Kenya.

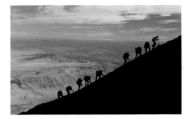

PAGES 218–19. People climbing the summit slope of Oldoinyo Lengai volcano, just before reaching the crater's edge. These slopes are steep because periodic explosions have built up the Lengai cone. Tanzania.

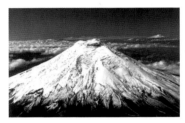

PAGES 220–21. Cotopaxi is the highest active volcano in the world at a peak of 19,000 feet. Covered with glaciers, its summit crater measures 2,624 feet in diameter by 2,100 feet deep. In 1877 lahars flowed more than 60 miles from the volcano toward the Amazonian basin of the Pacific coast. It last erupted in 1907. Ecuador.

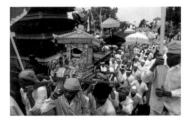

PAGES 222–23. Three days after having left the sea, the procession in the Hindu ceremony of Panca Wali Krama, loaded with offerings, reaches the temple of Besakih at the foot of Agung volcano. Bali, Indonesia.

PAGES 224–25. The surface of a smooth lava flow rapidly forms a skin as it cools that remains flexible enough to be creased by the underlying current. Kilauea, Hawaii.

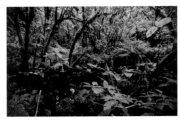

PAGES 226–27. A high-altitude tropical forest covers the flanks of volcanoes of the island of Réunion.

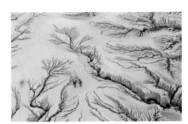

PAGES 228–29. Early erosion by streaming waters that dig into the deposits of pyroclastic flows near Pinatubo volcano, just after the 1991 eruption. Philippines.

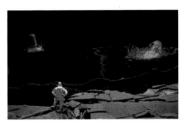

PAGES 230–31. Erta' Alé volcano contains a permanent lake of lava. It is one of just three volcanoes in the world that possess such a lake. Afar, Ethiopia.

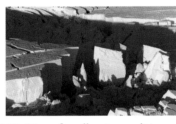

PAGES 232–33. View of a collapsing vault in a vertical glacier where water pours from the caldera of Grimsvötn. Vatnajökull, Iceland.

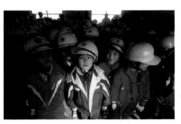

PAGES 234–35. Evacuation exercise near Sakurajima volcano. While awaiting boats, children protected by helmets are gathered in a building designed to resist seismic shocks and falling ash, as well as atomic bombs. Japan.

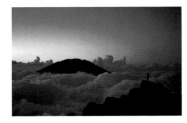

PAGES 236–37. Nightfall over Merapi volcano. In the background, above the clouds, Merbabu volcano can be seen. Indonesia.

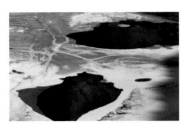

PAGES 238–39. At the foot of Tousidé peak stands the Trou au Natron caldera, 4 miles in diameter and 2,300 feet deep, where the Toubous, a Saharan people of Tibesti, came to take curative baths in the hot springs of the crater. Tibesti, Chad.

PAGES 240–41. Aerial view of the soda lake of Magadi, Kenya.

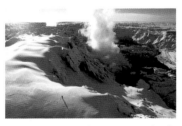

PAGES 242–43. An eruption fissure 1 1/3 miles long with smoke and gas, and a river of hot water, at the opening of the subglacier eruption of Vatnajökull. Iceland.

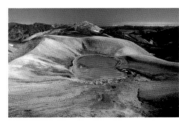

PAGES 244–45. Region of Landmannalaugar. Iceland.

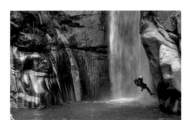

PAGES 246–47. Basin at the foot of a waterfall 150 feet high in the Bras-Rouge canyon. The ochre coloring on the wall corresponds to iron-rich salt deposits left by hot springs under the massive lava flows carved out by the waterfall. Réunion.

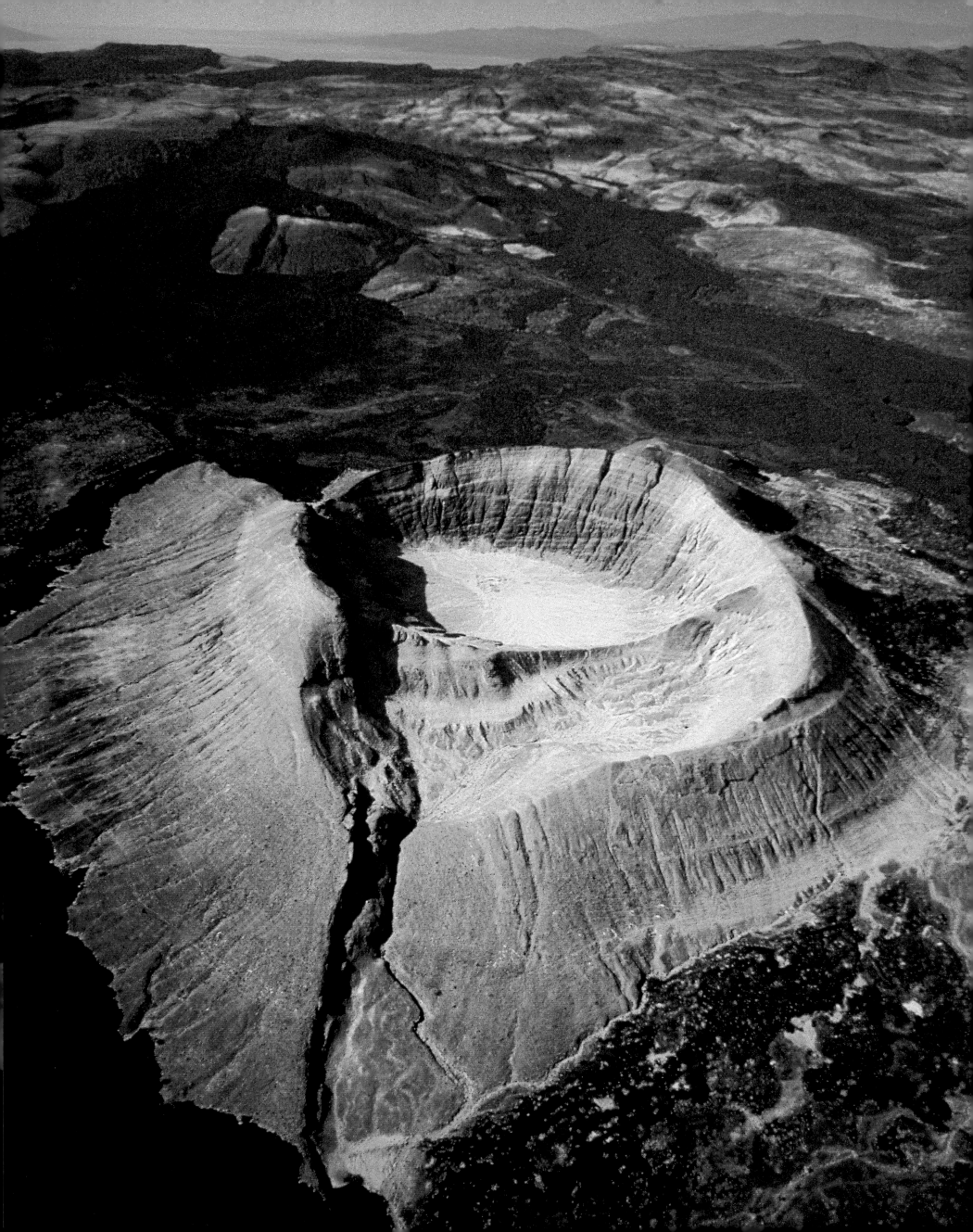

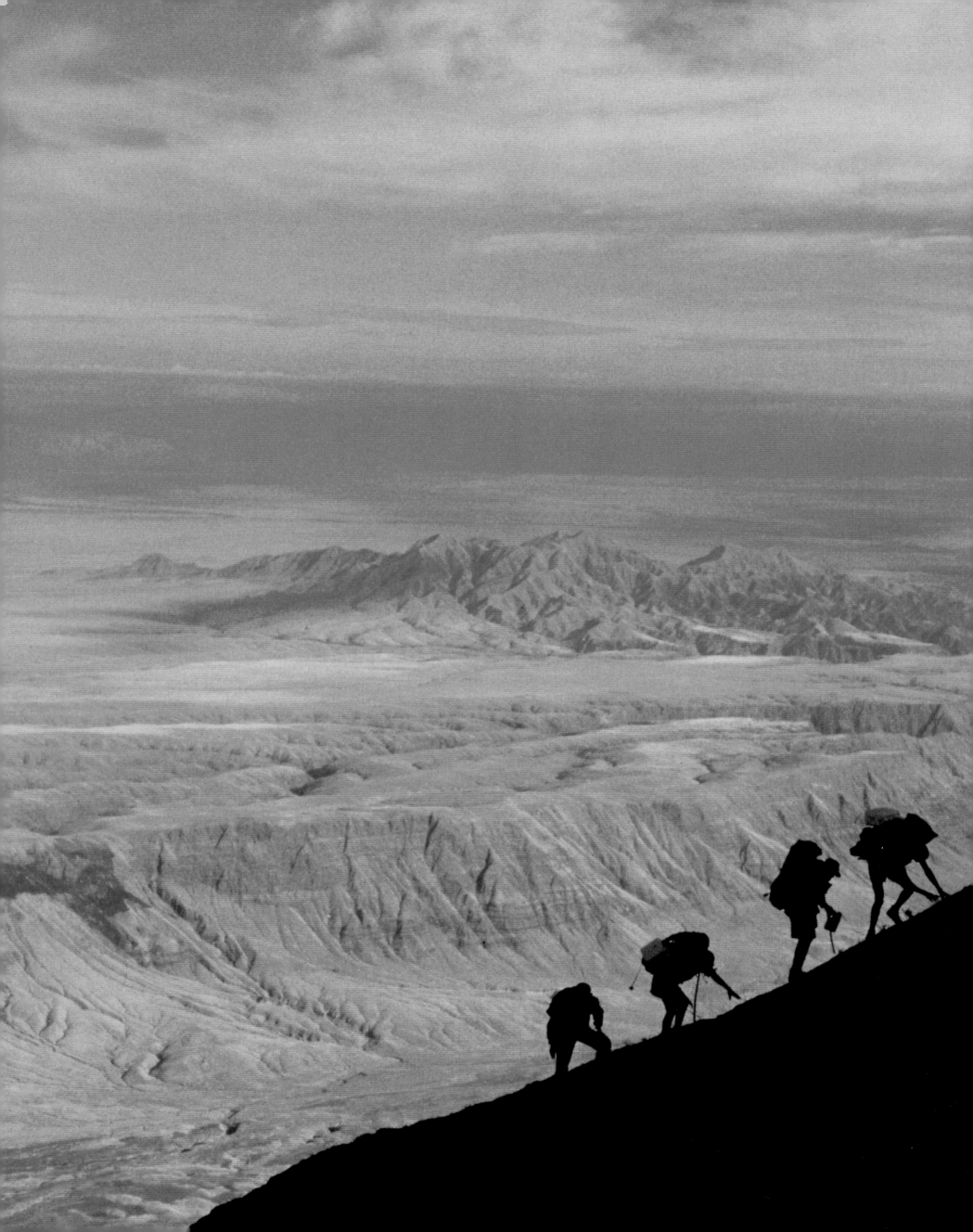

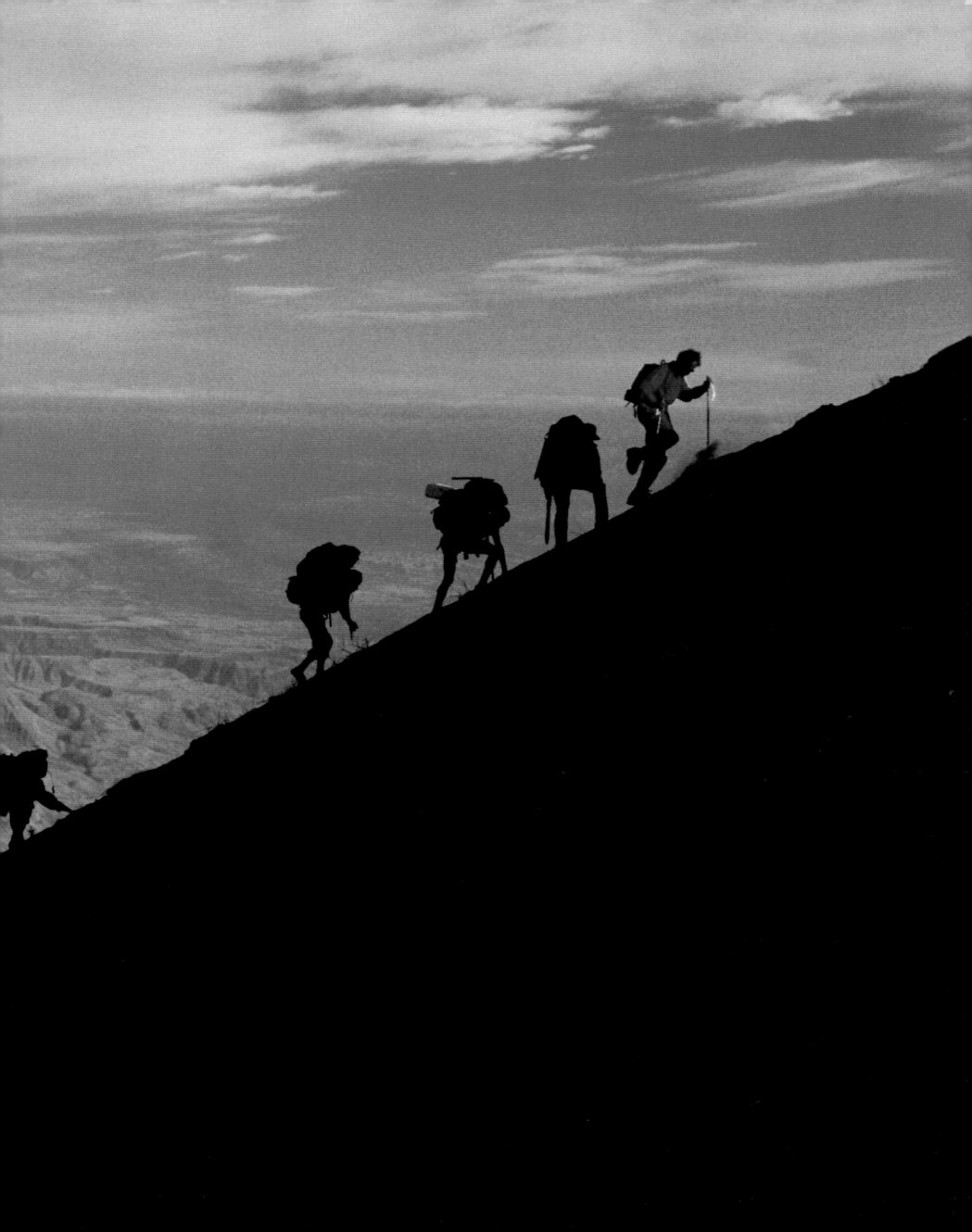

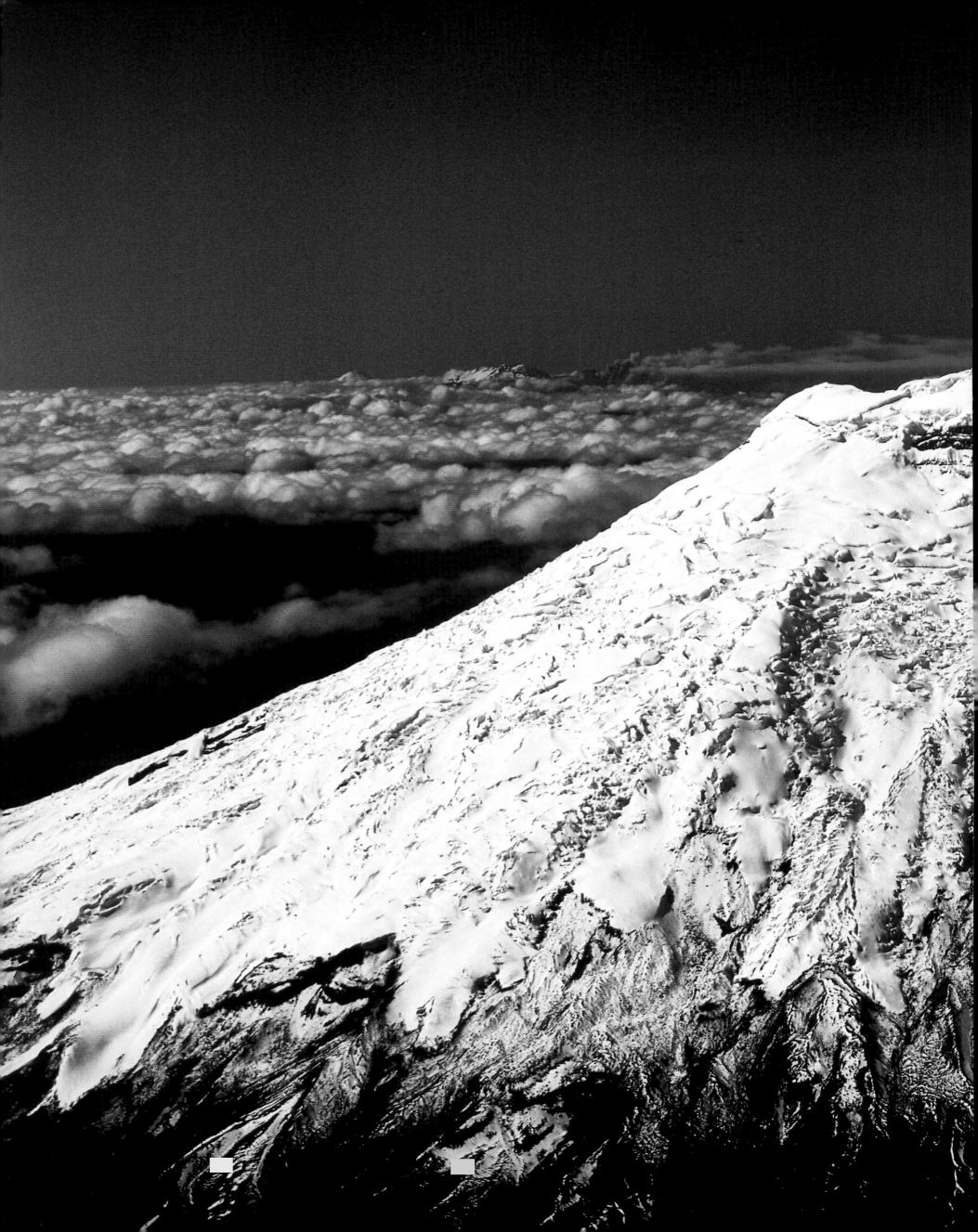

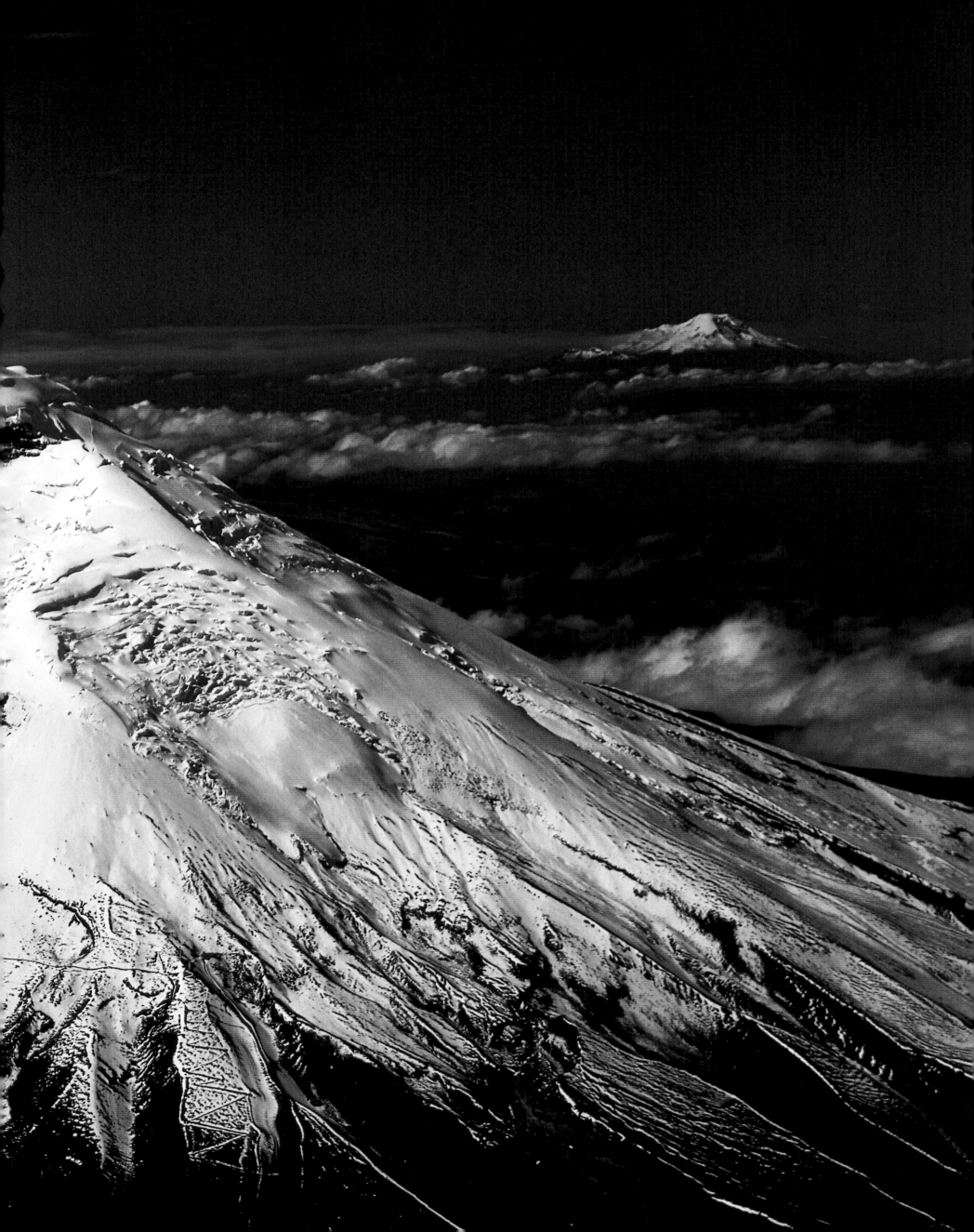

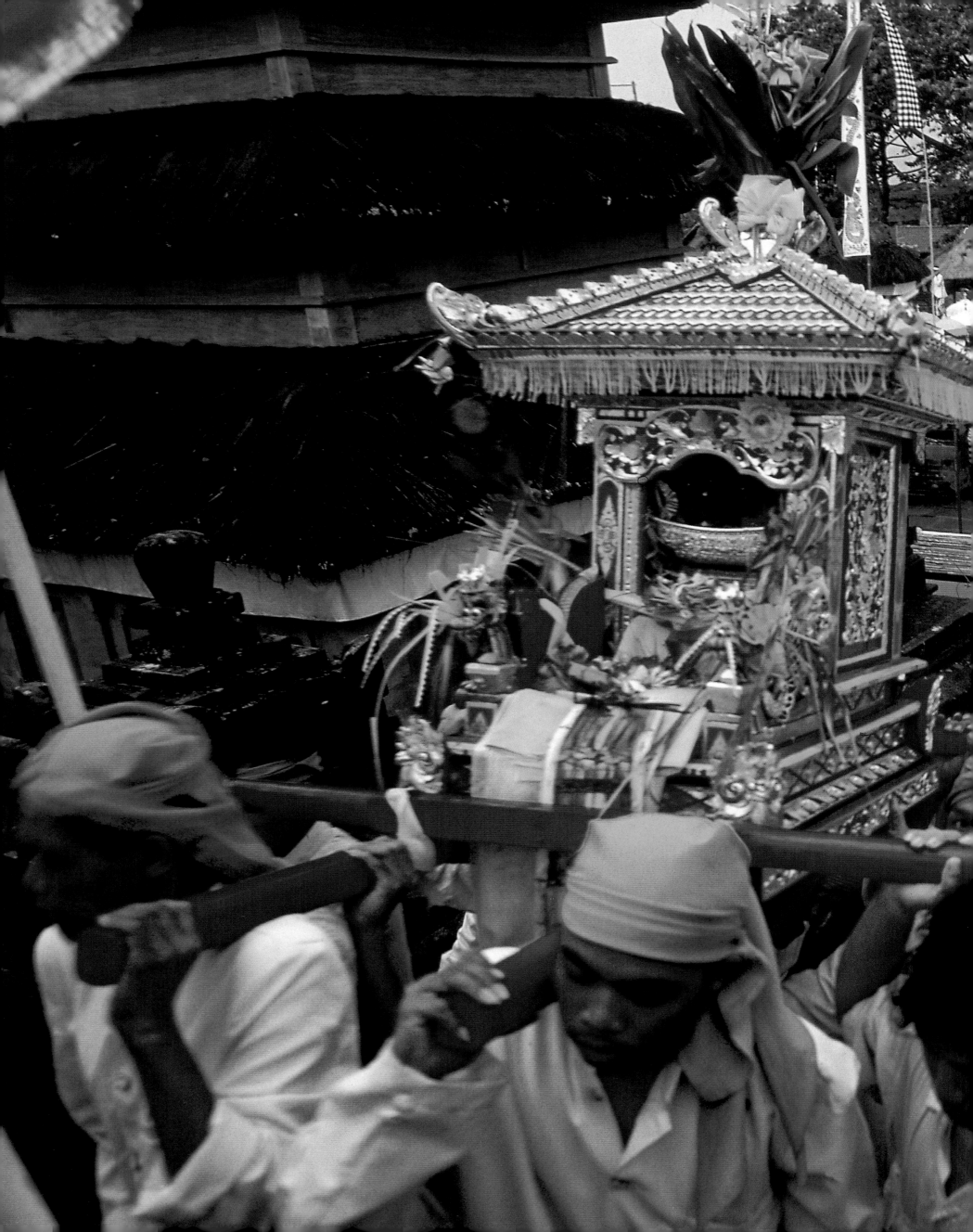

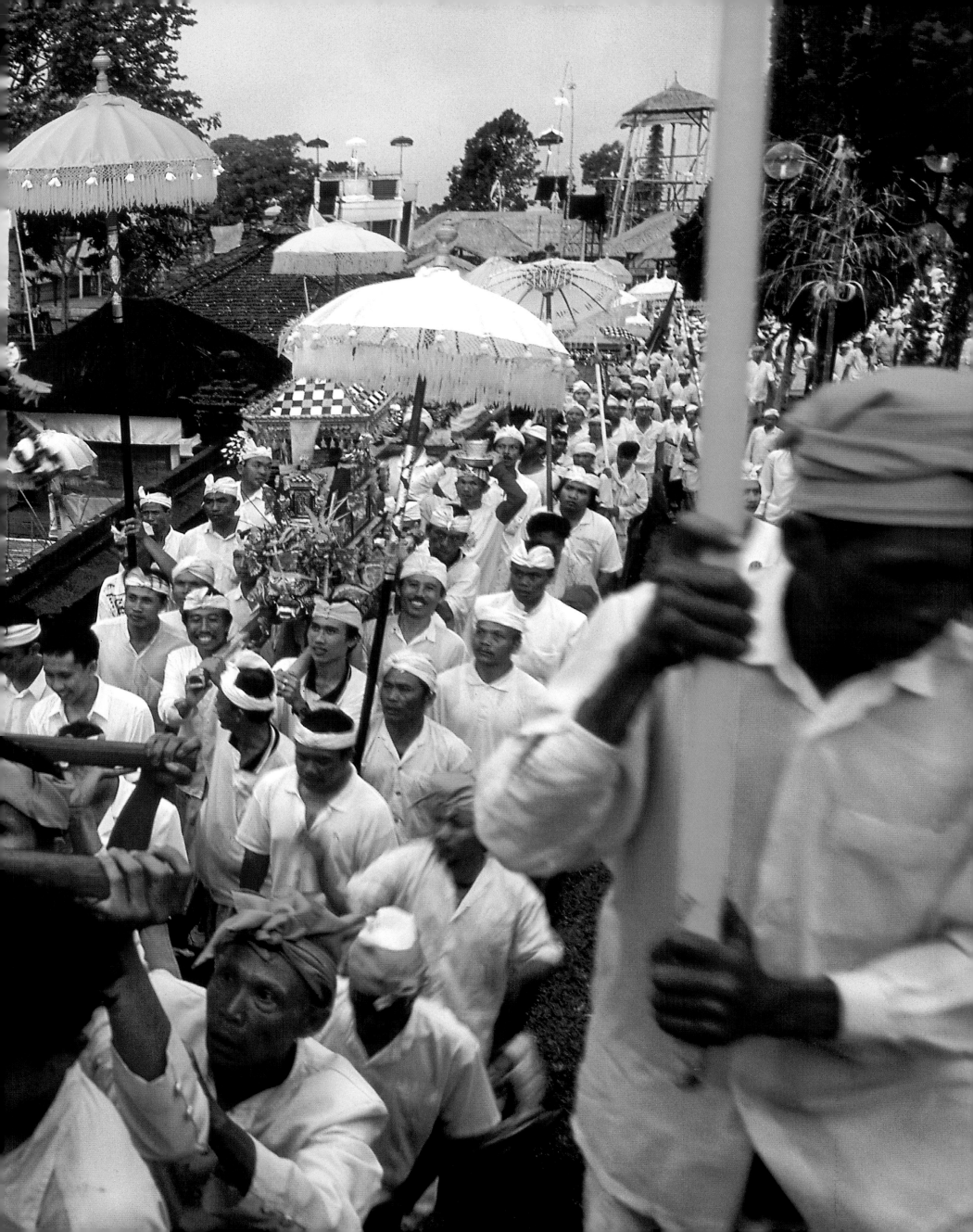

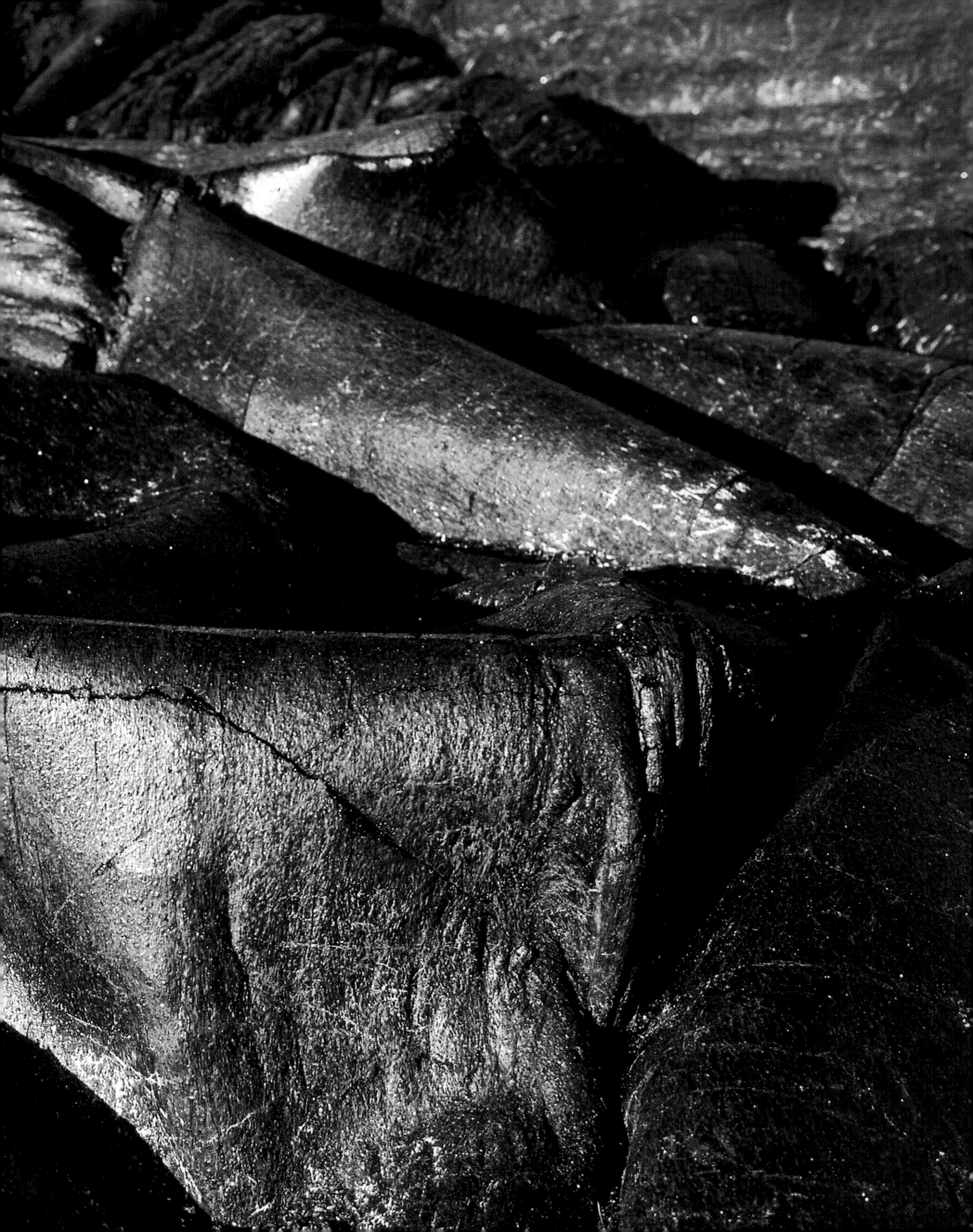

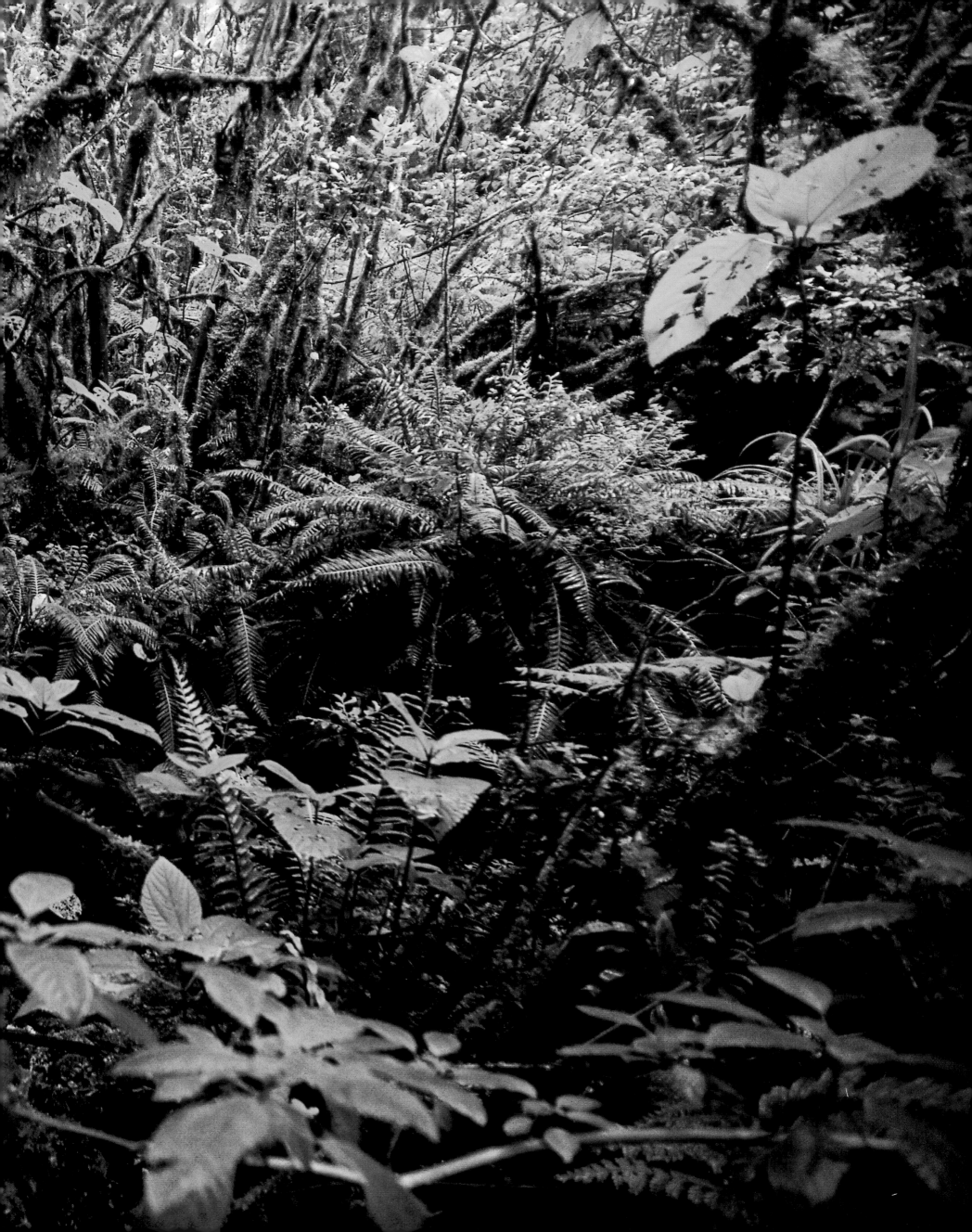

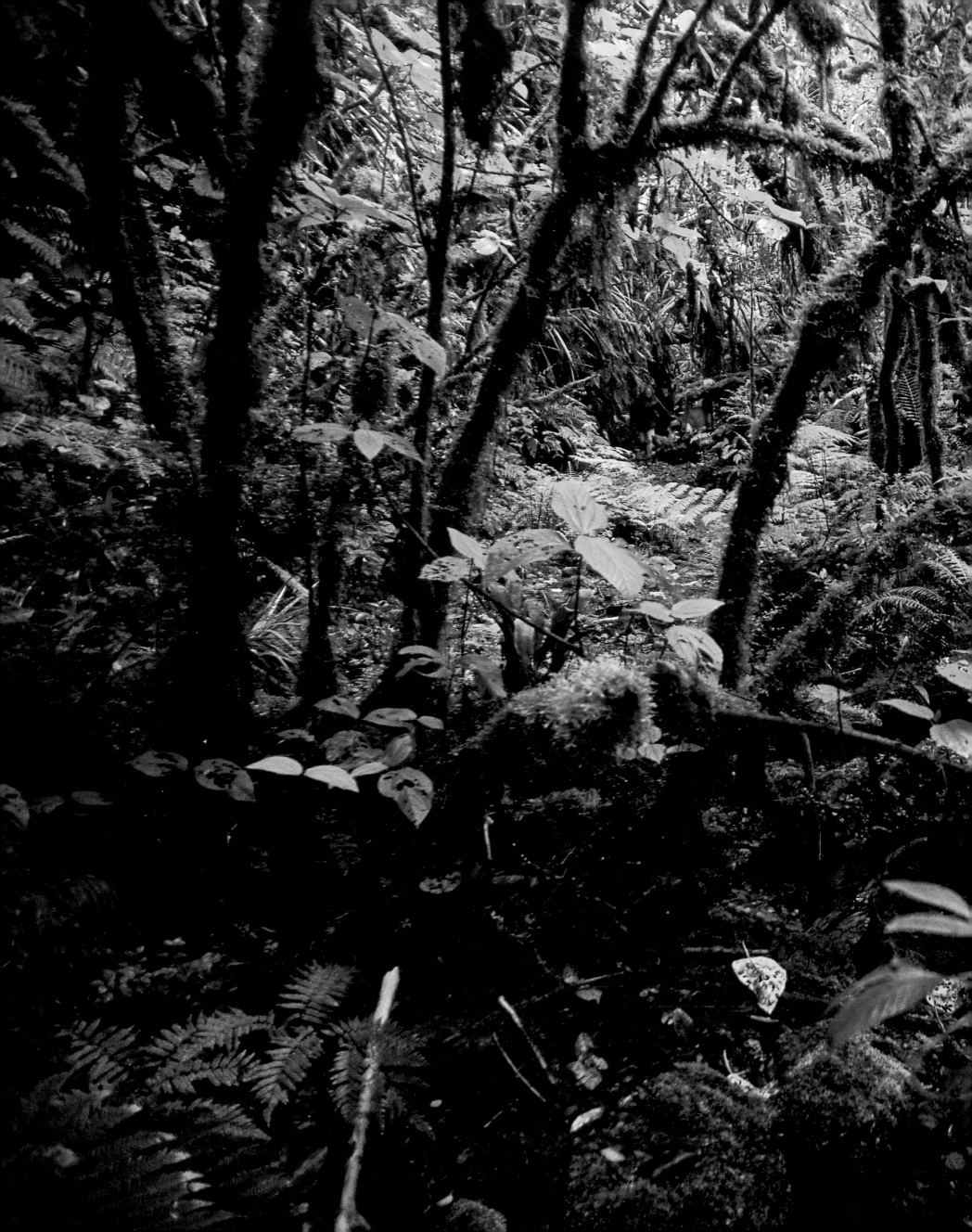

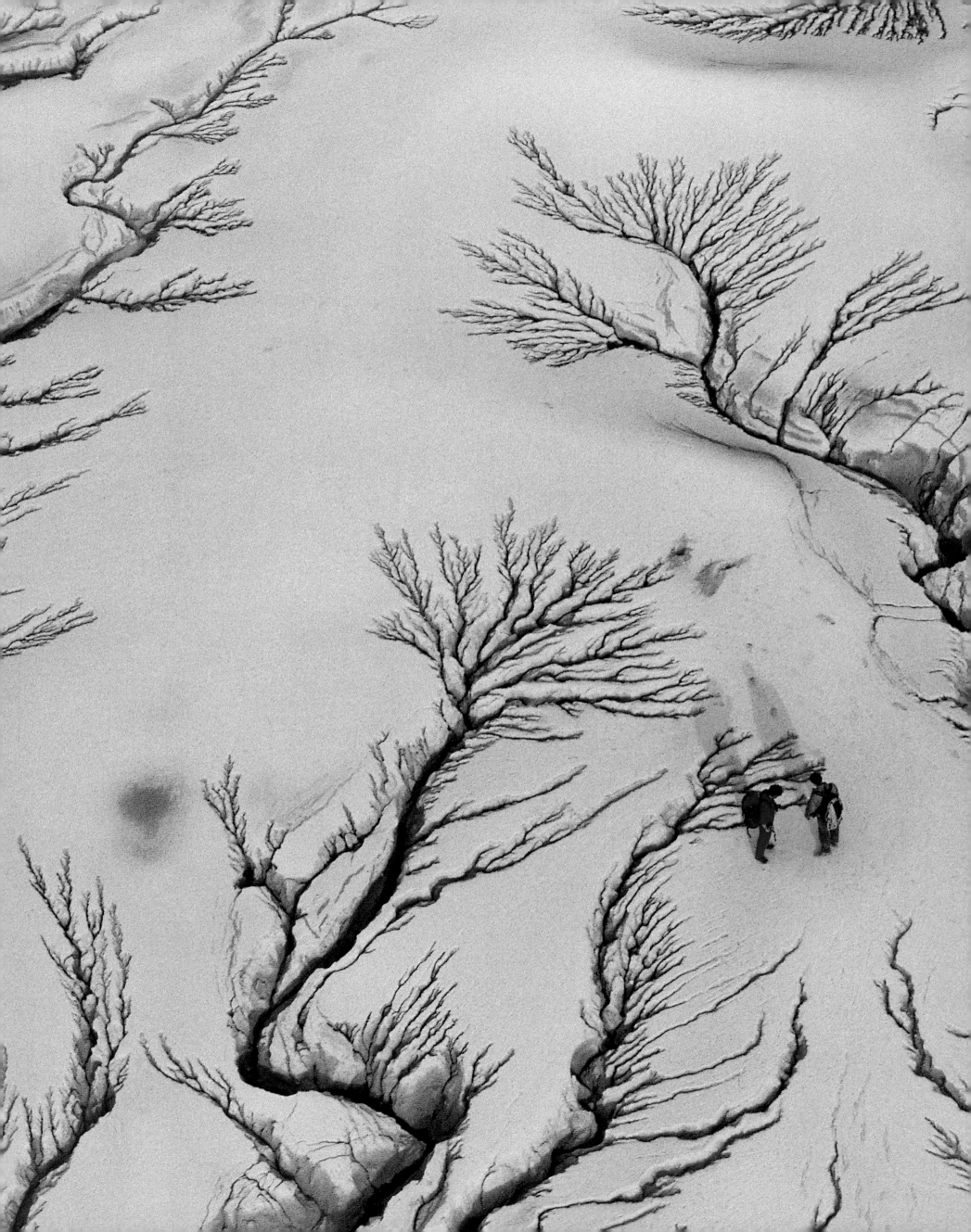

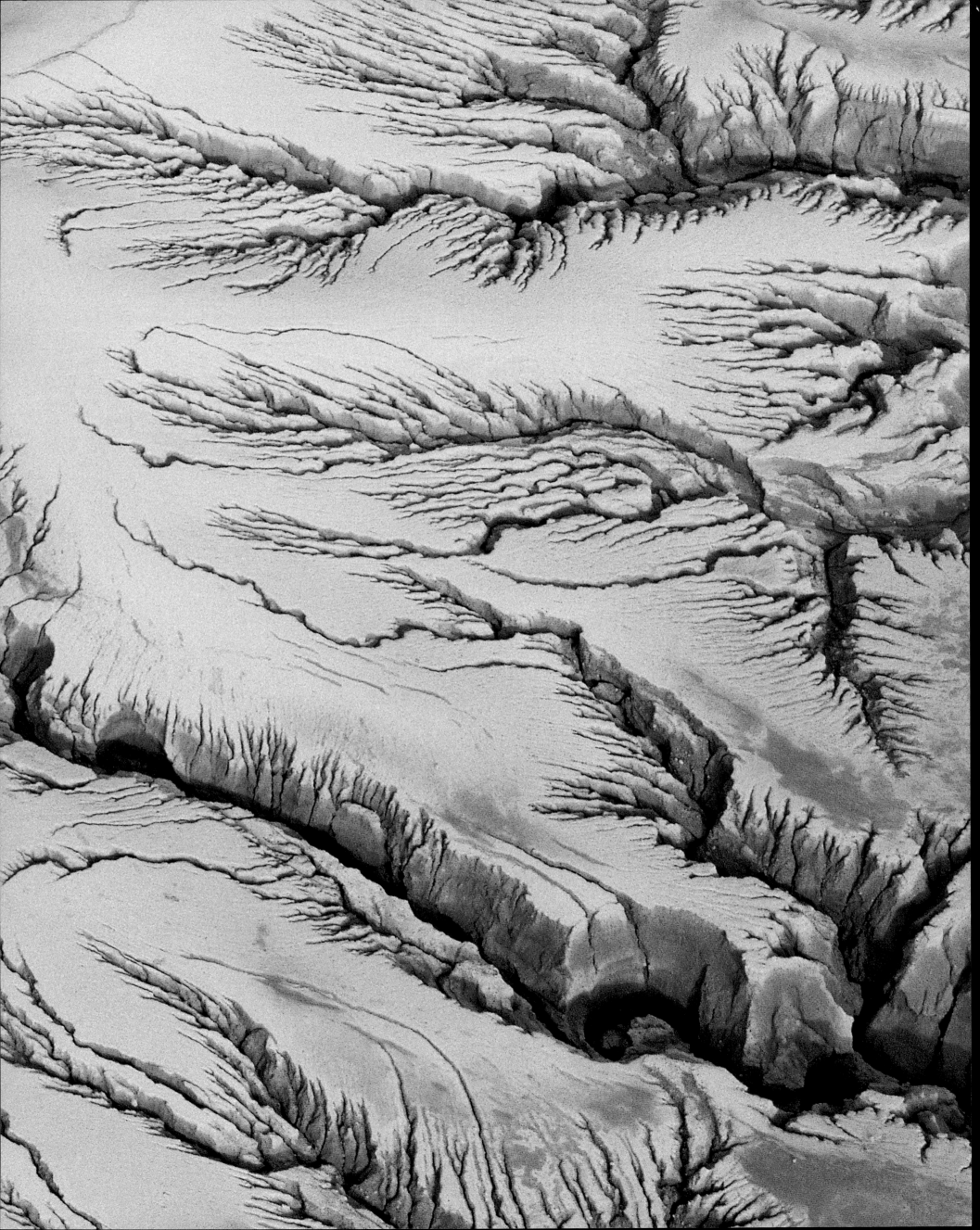

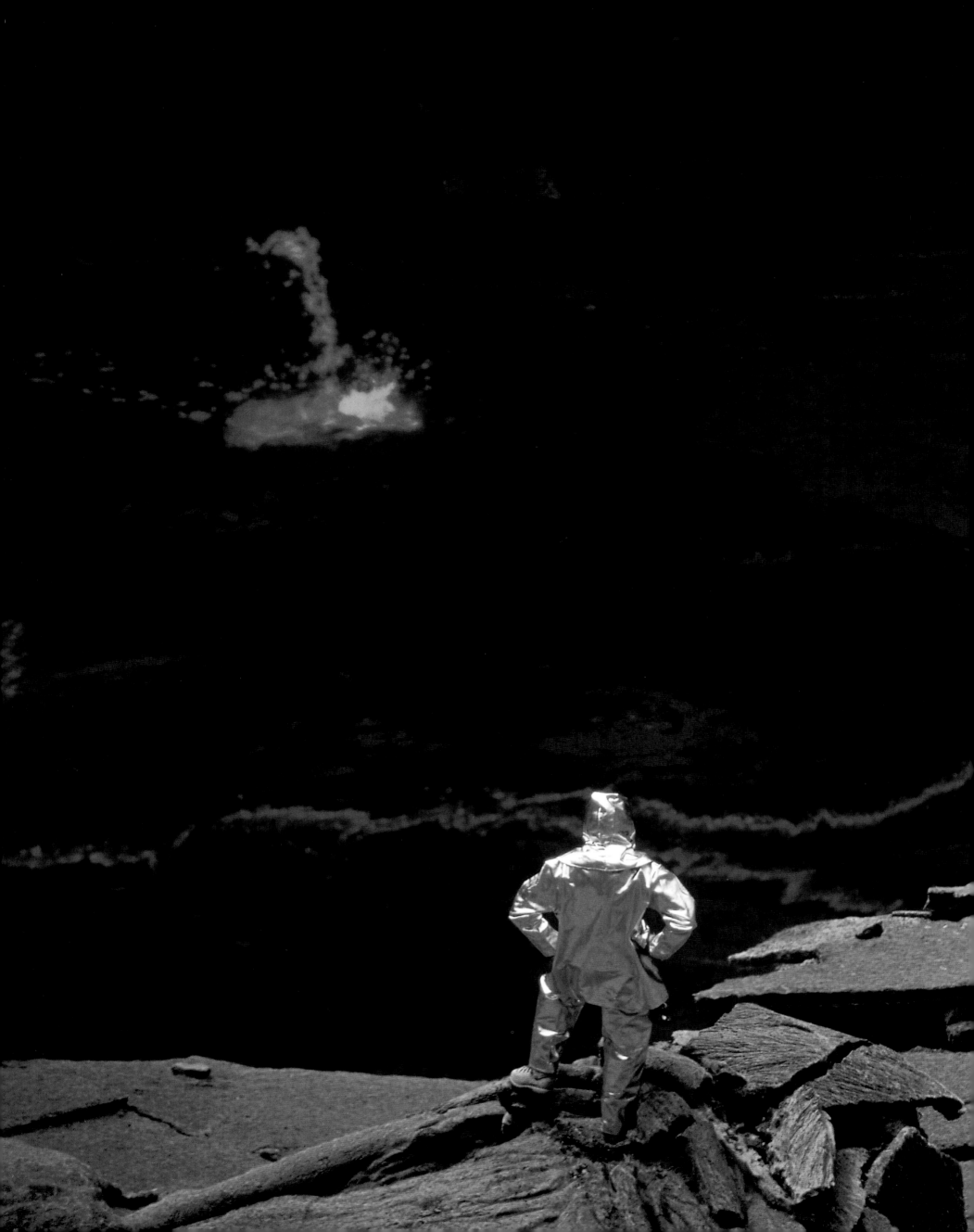

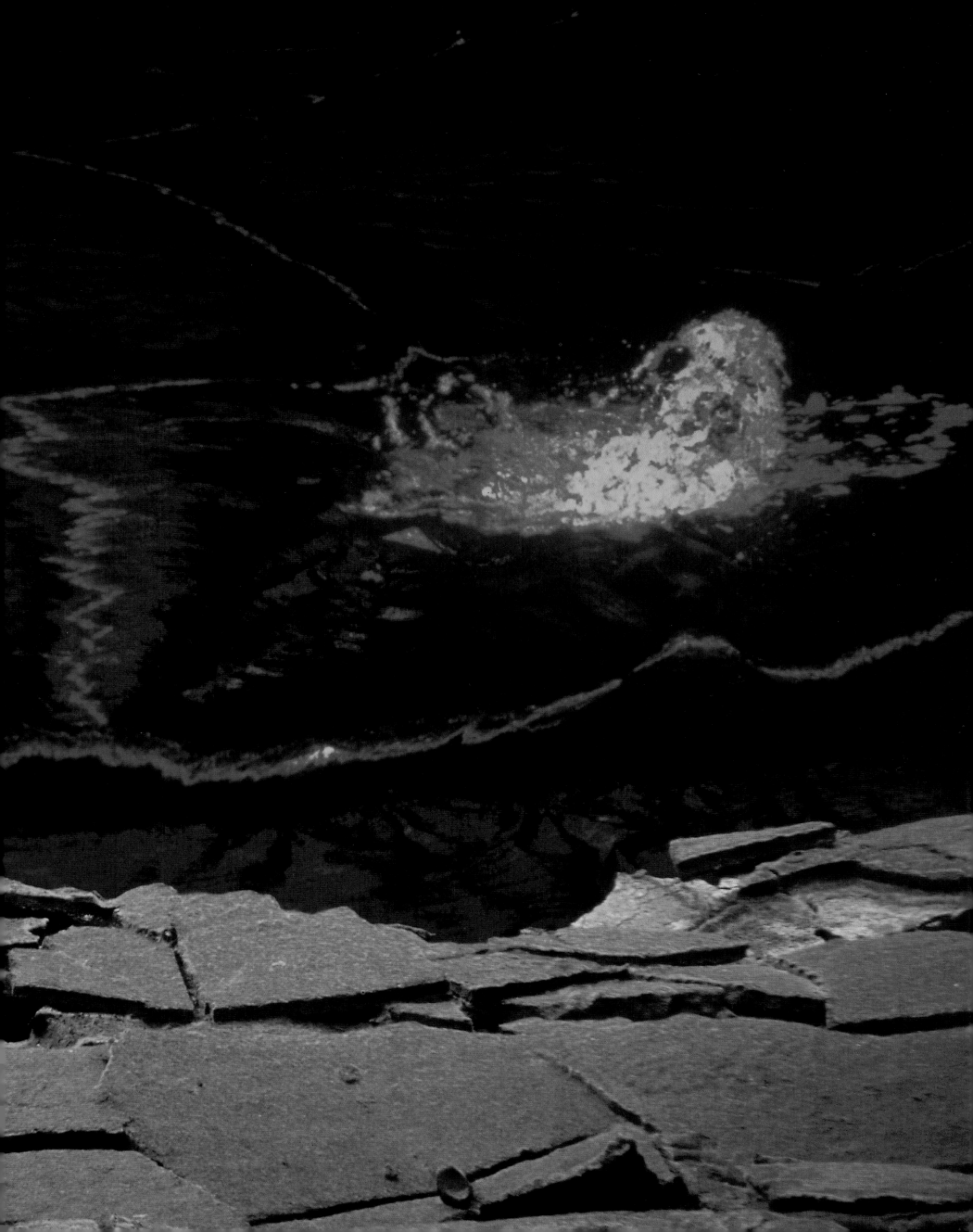

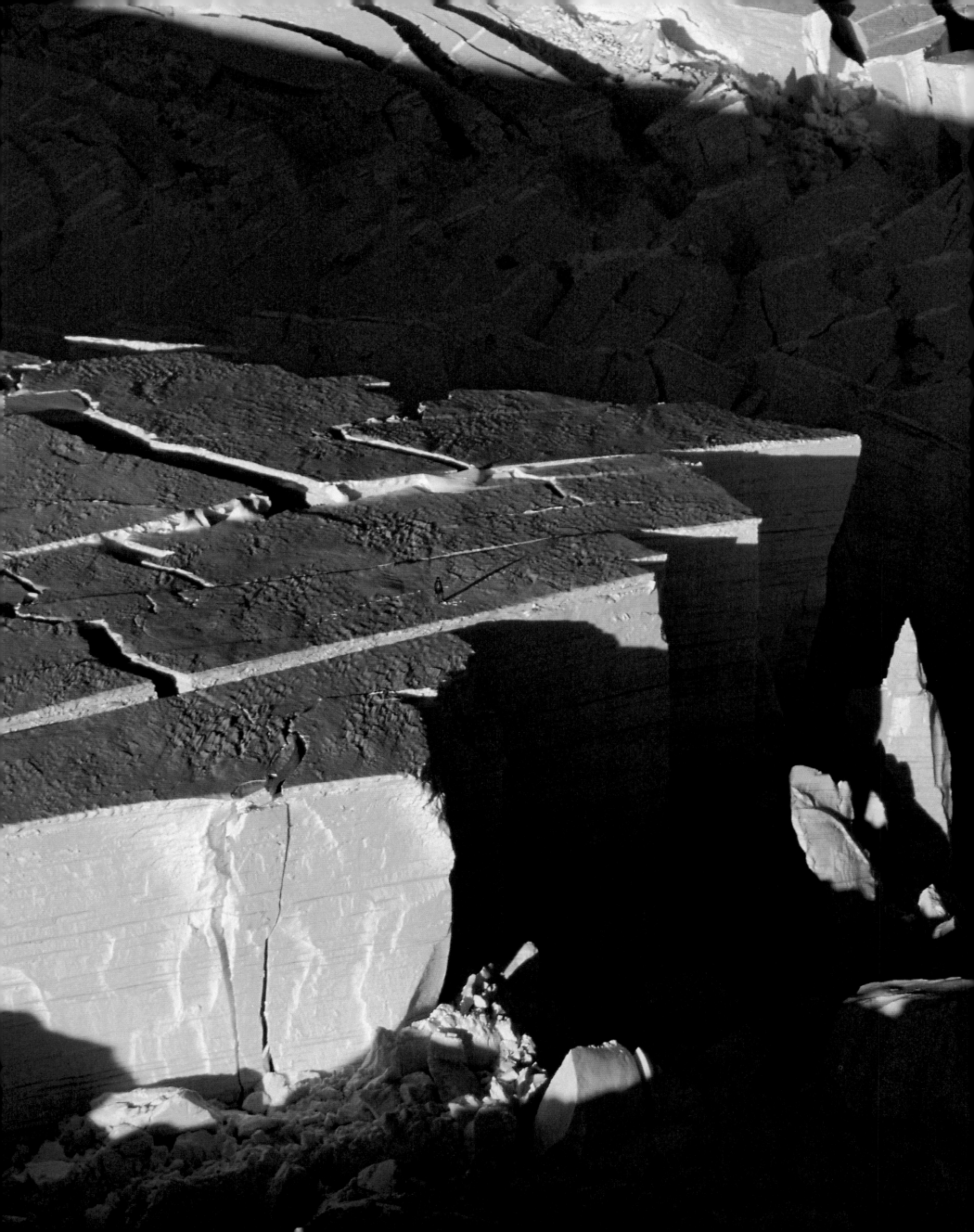

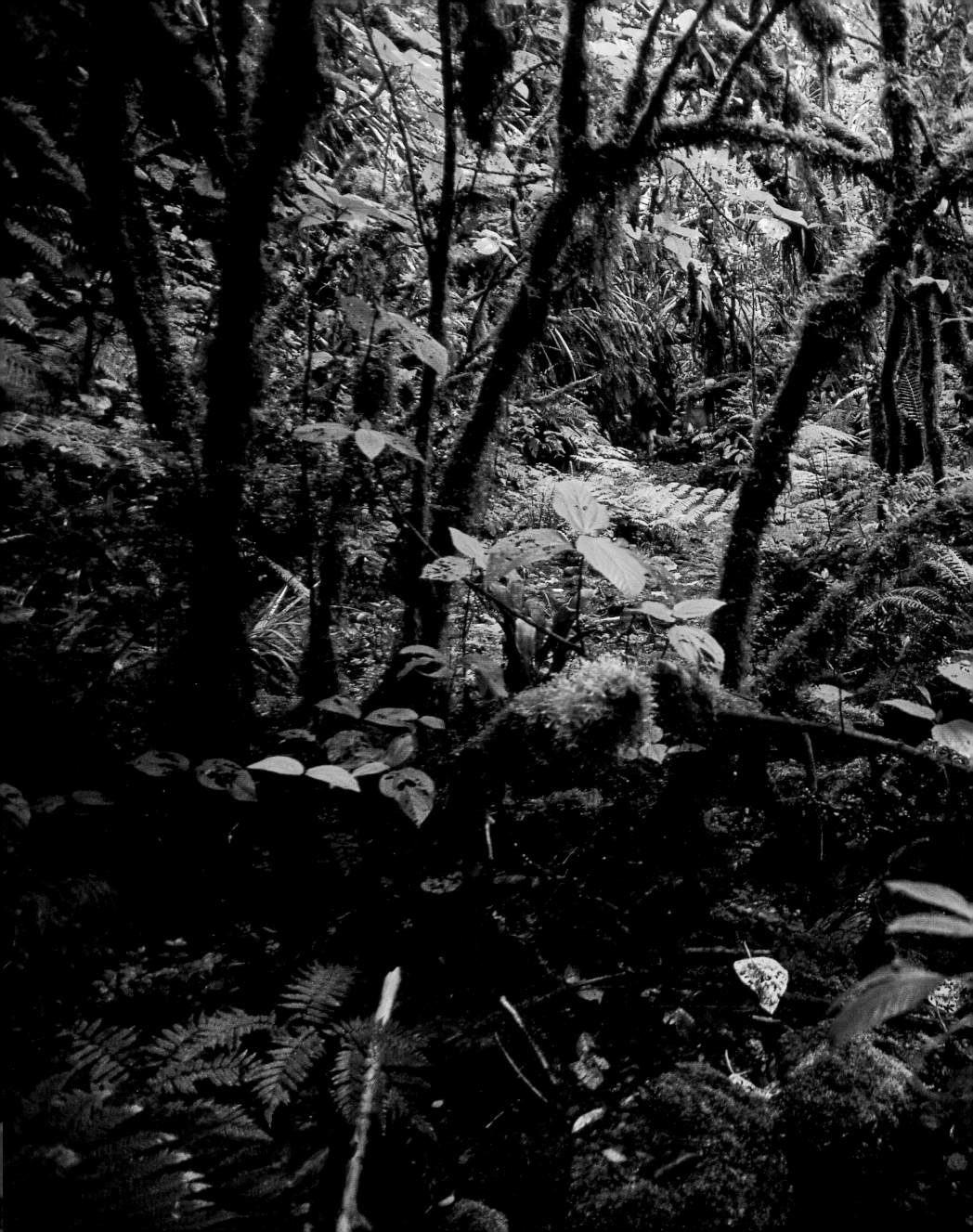

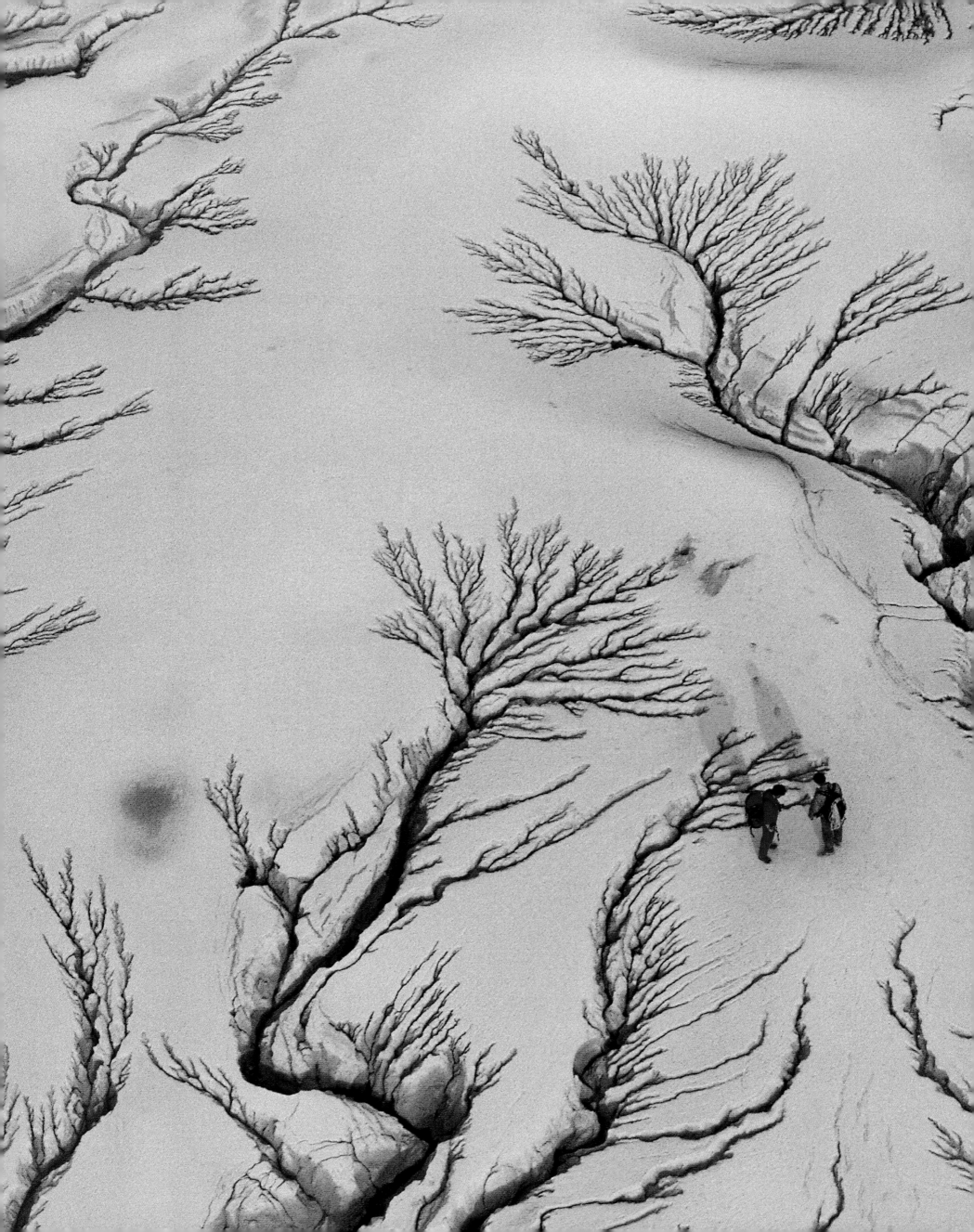

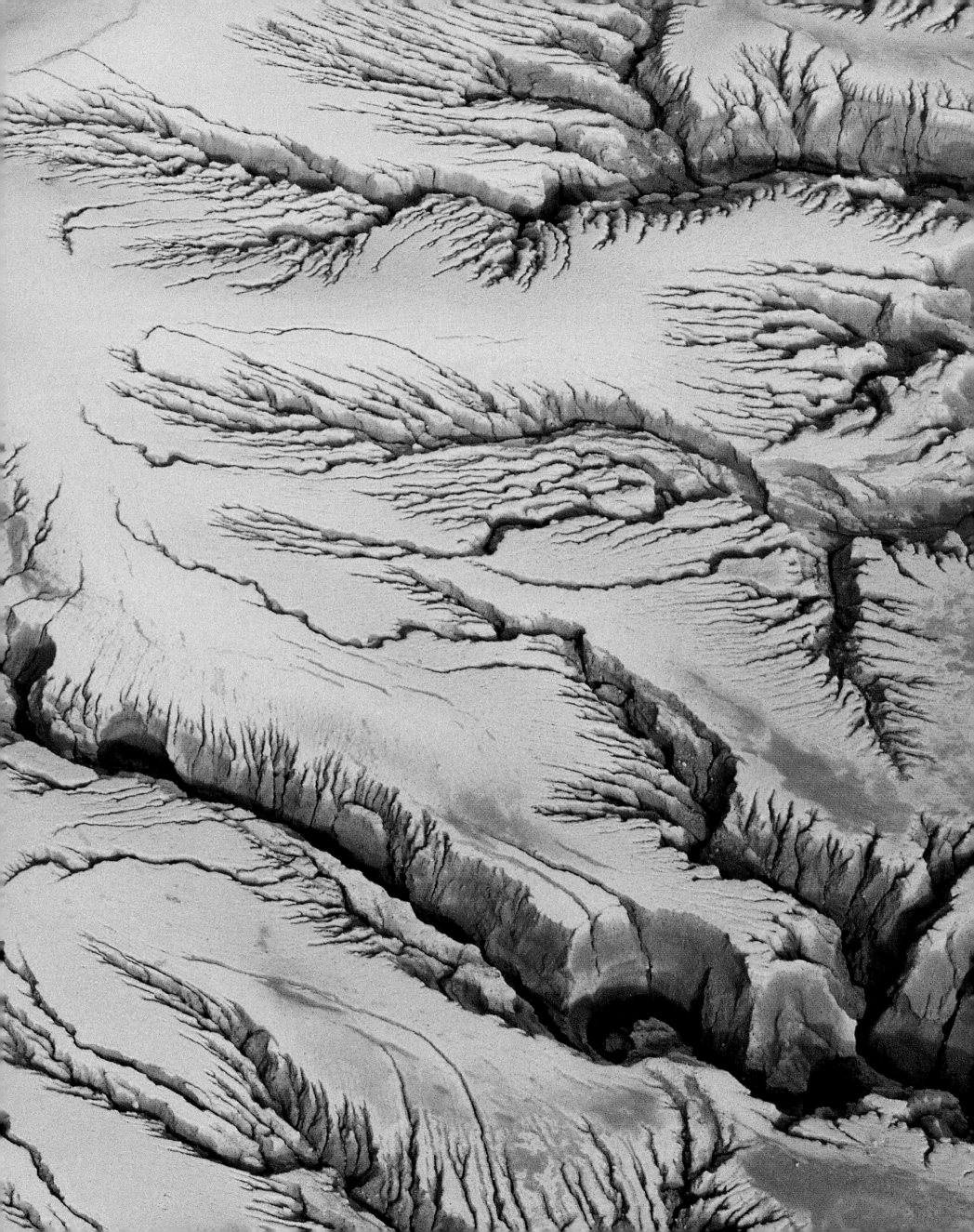

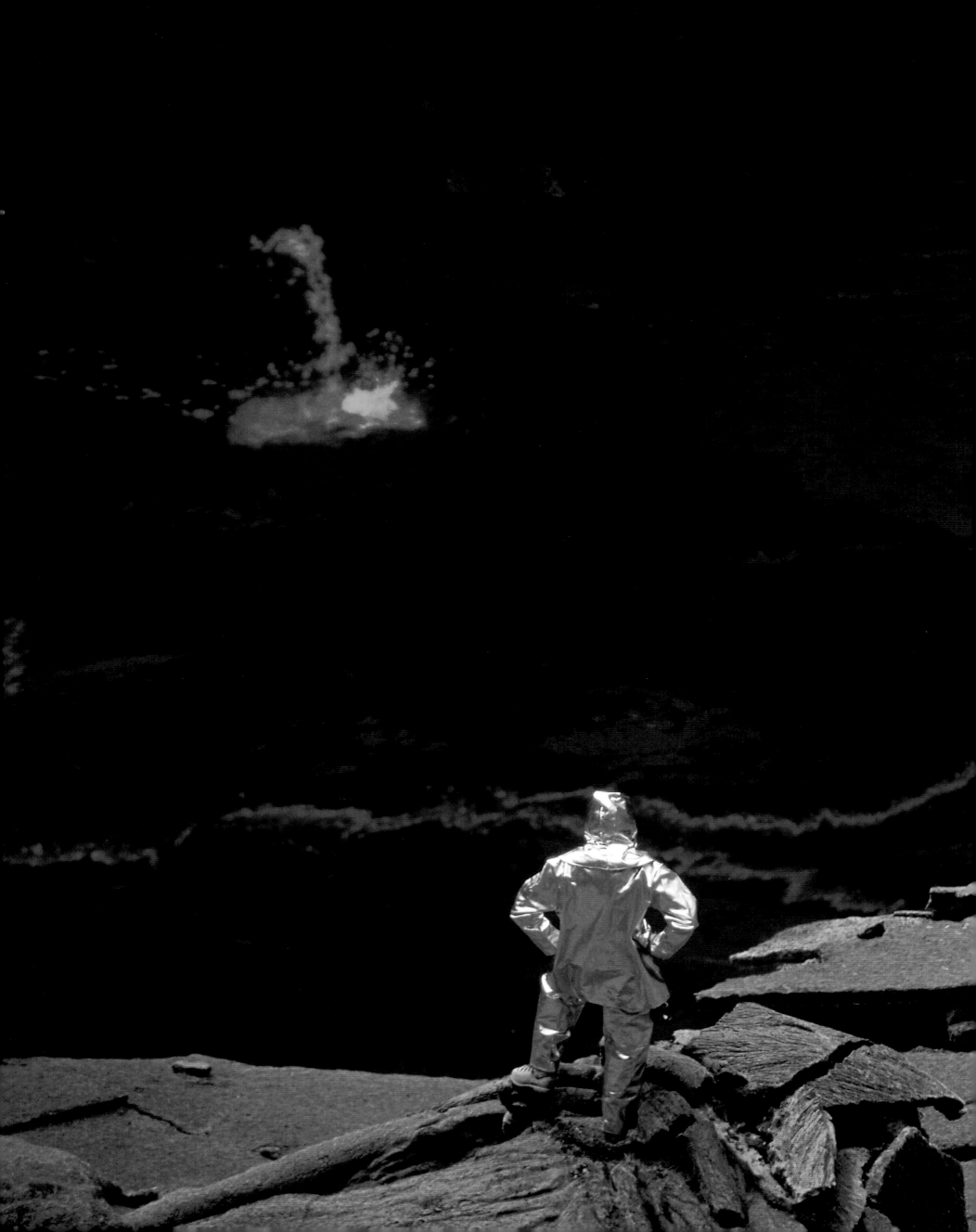

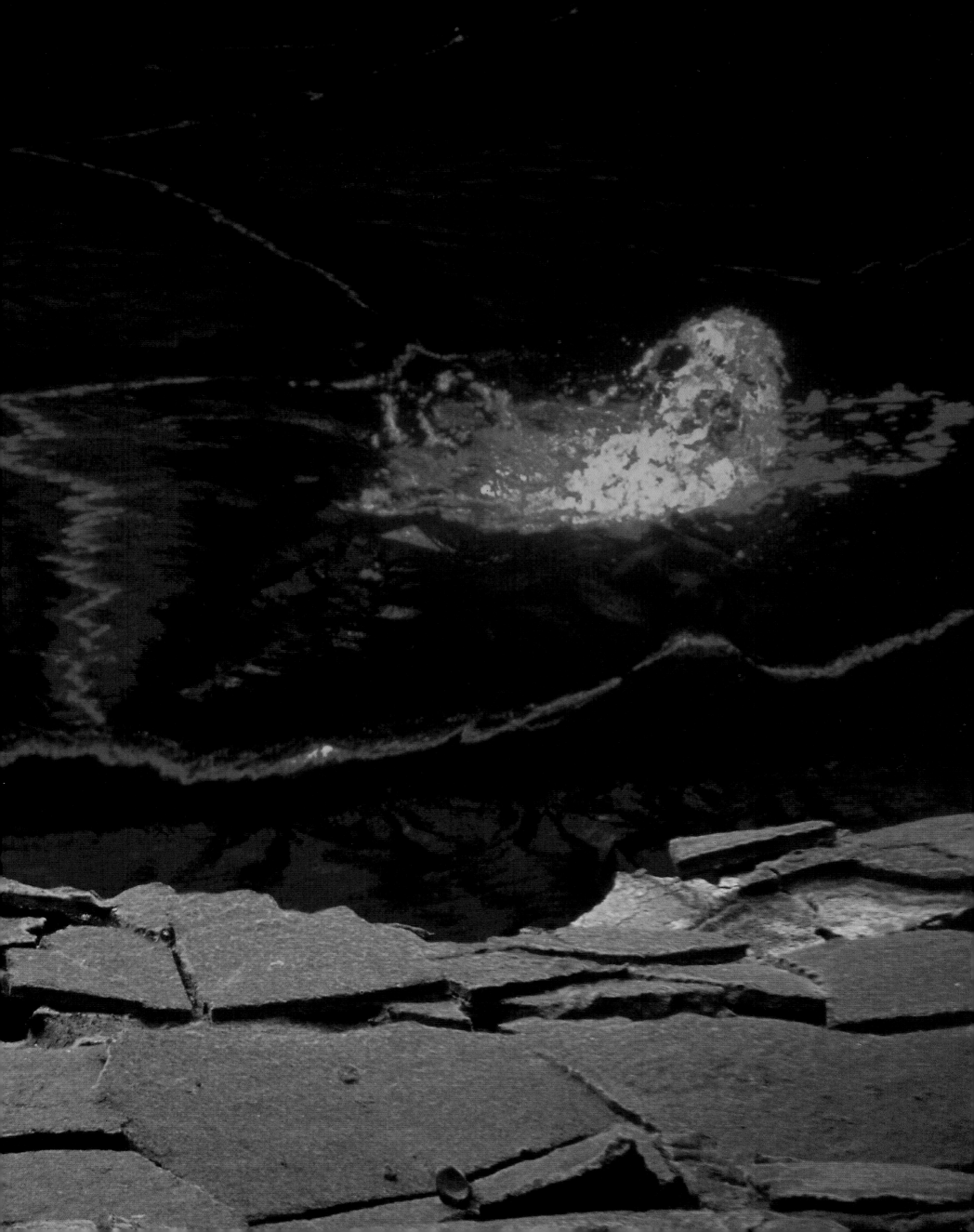

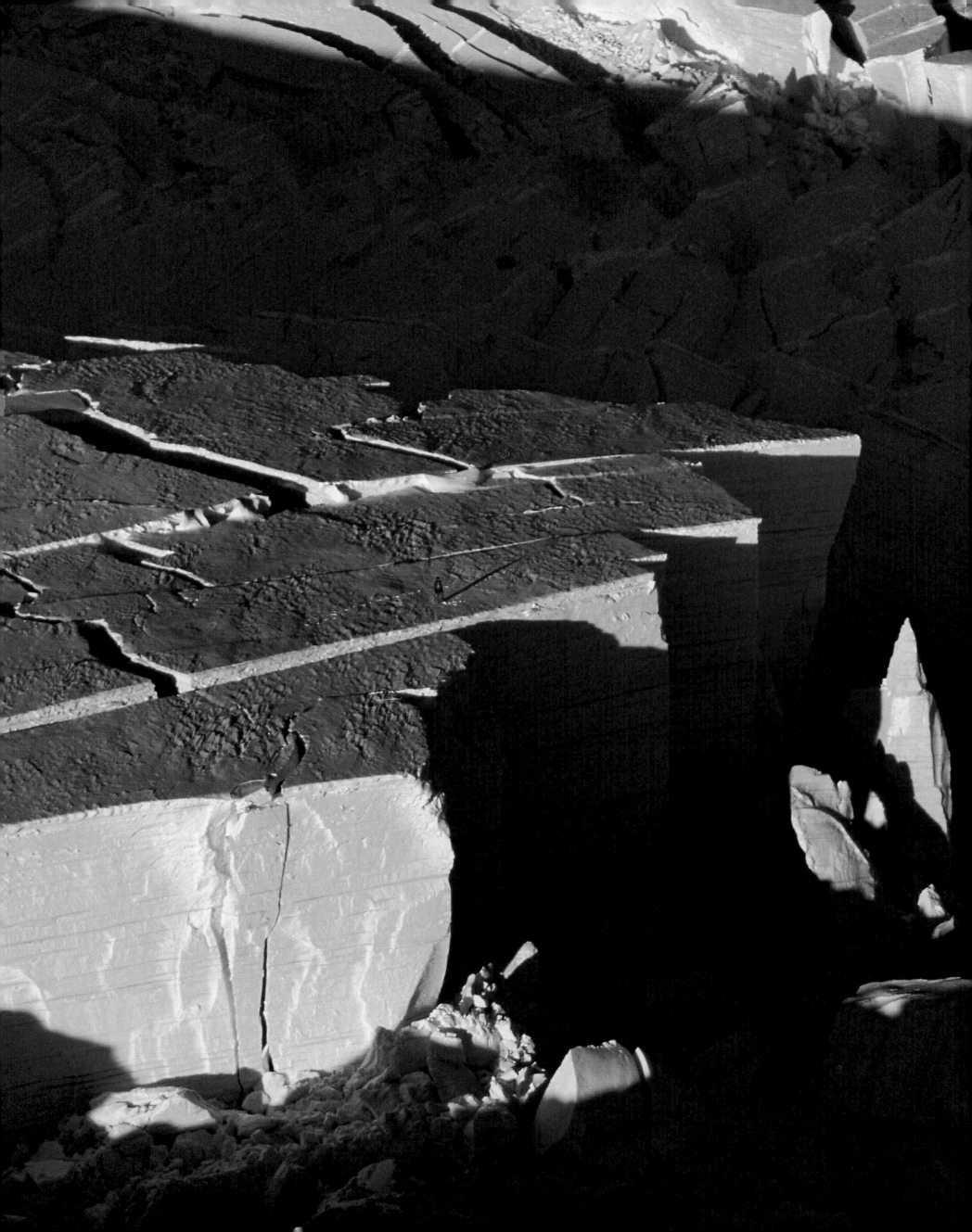

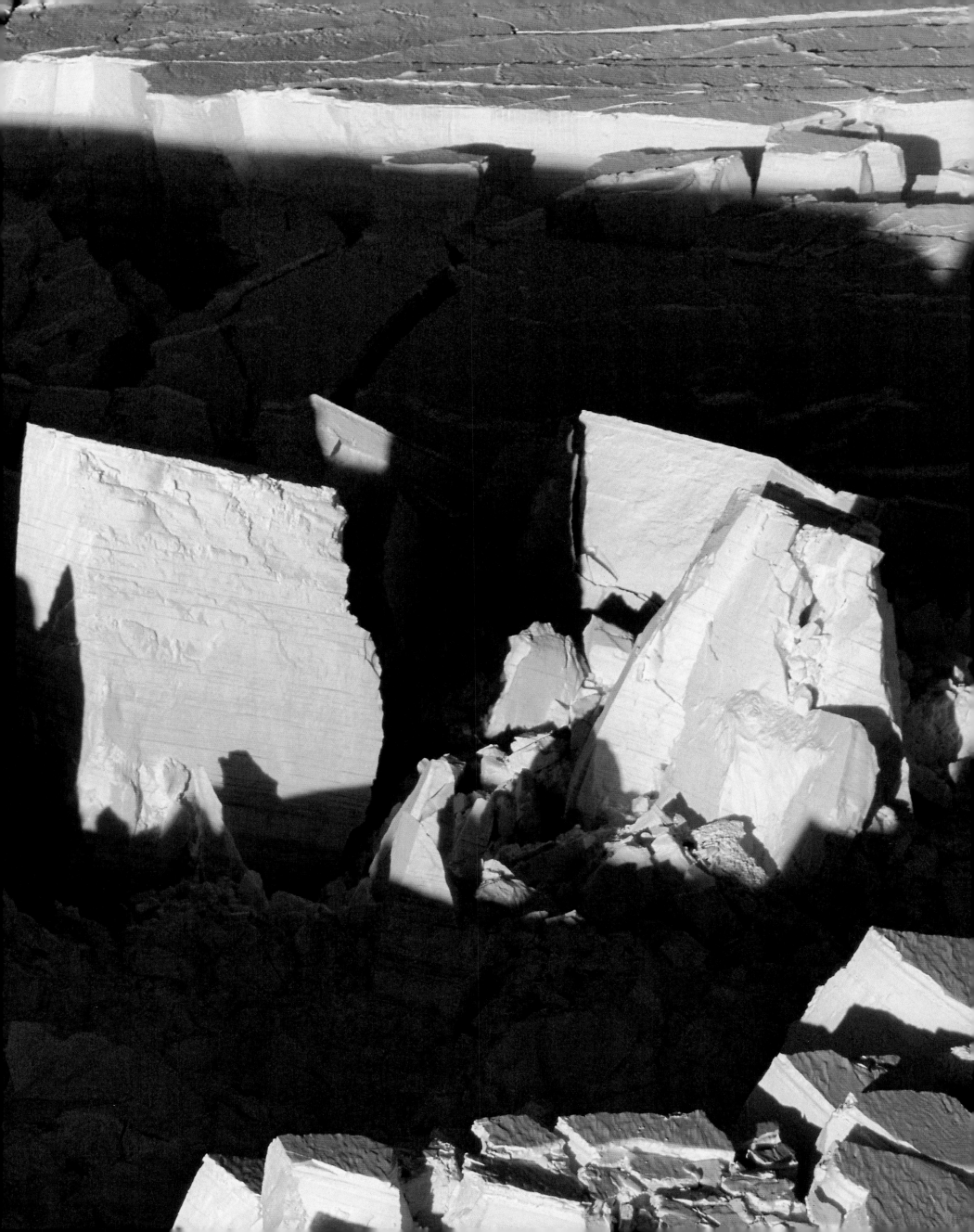

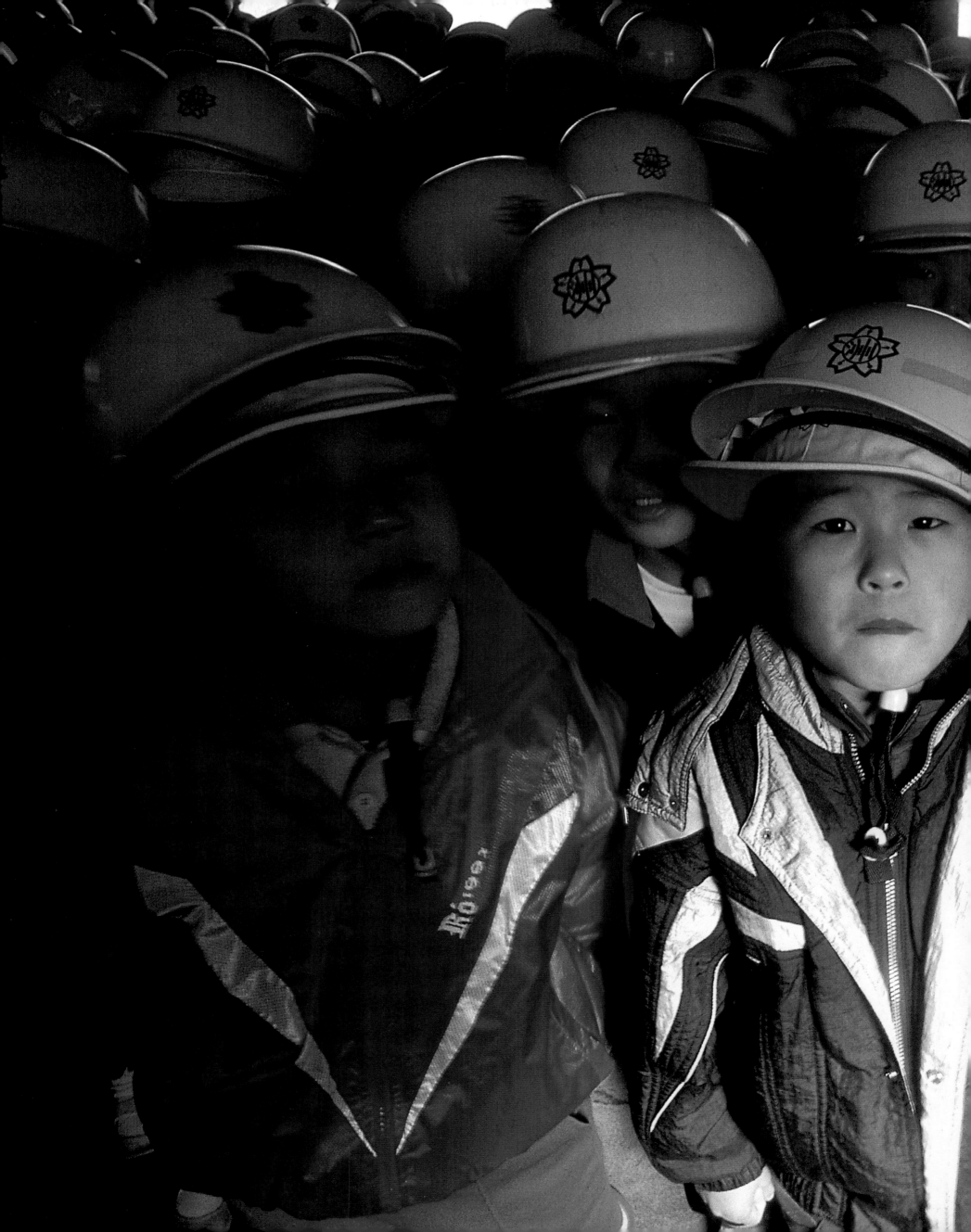

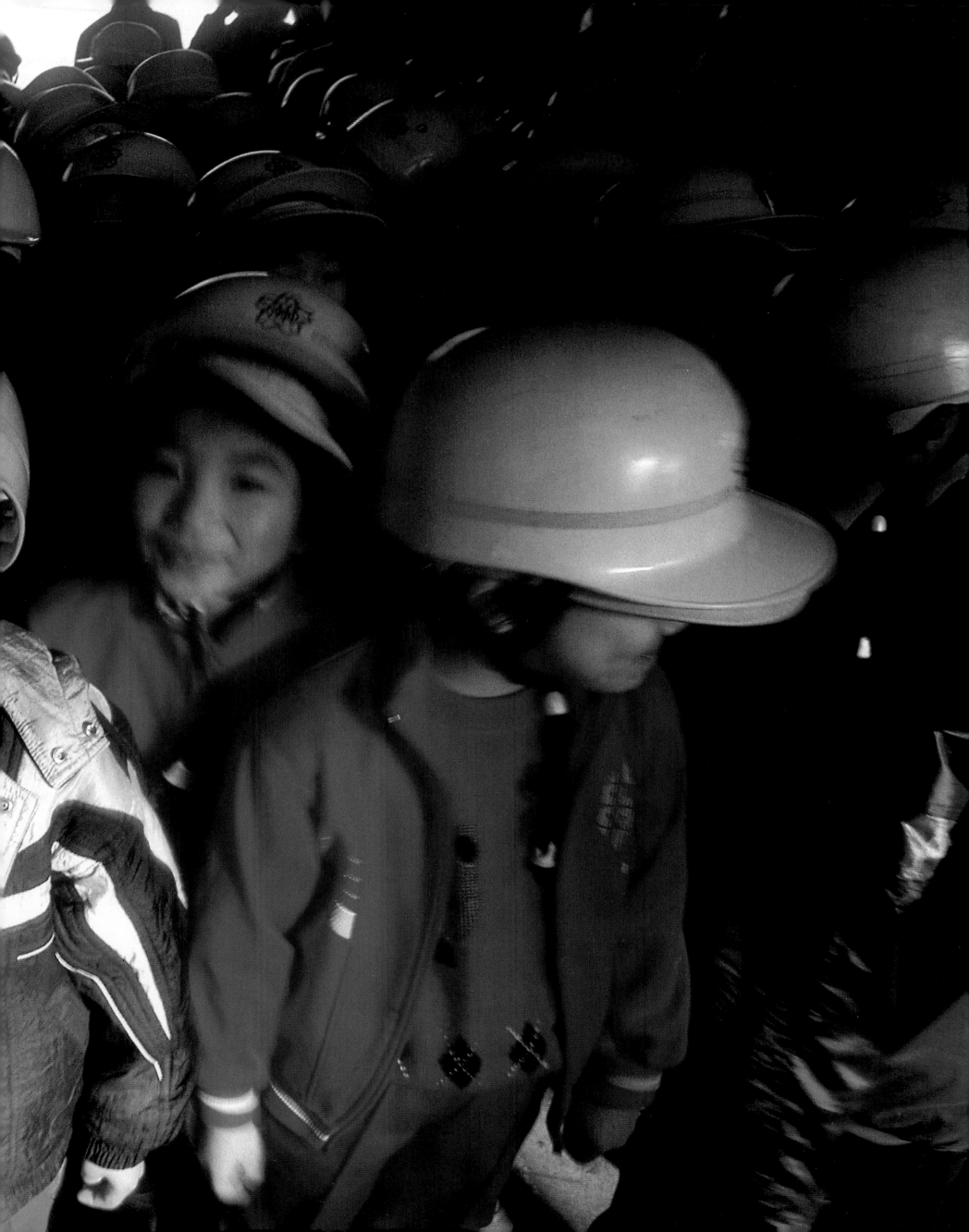

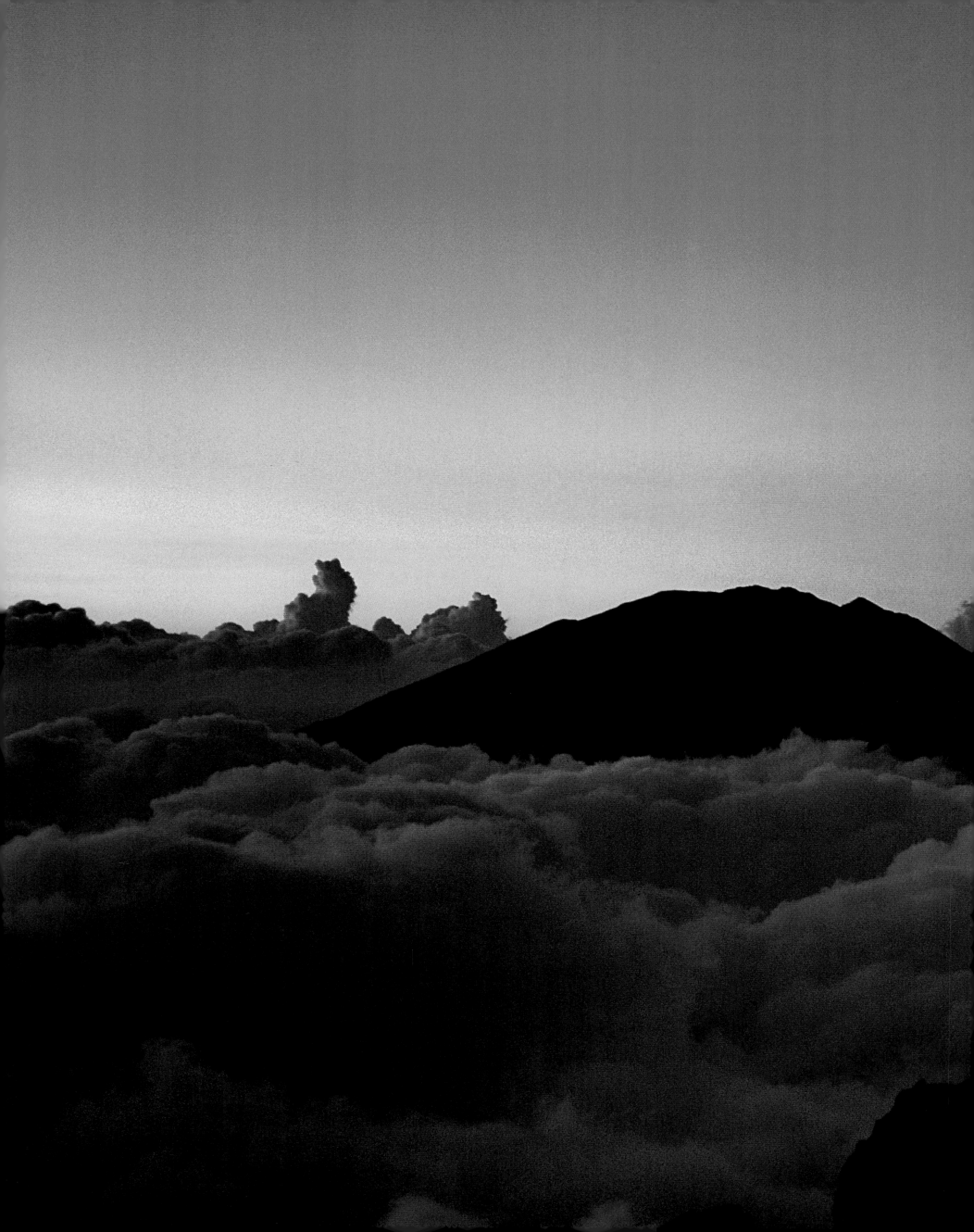

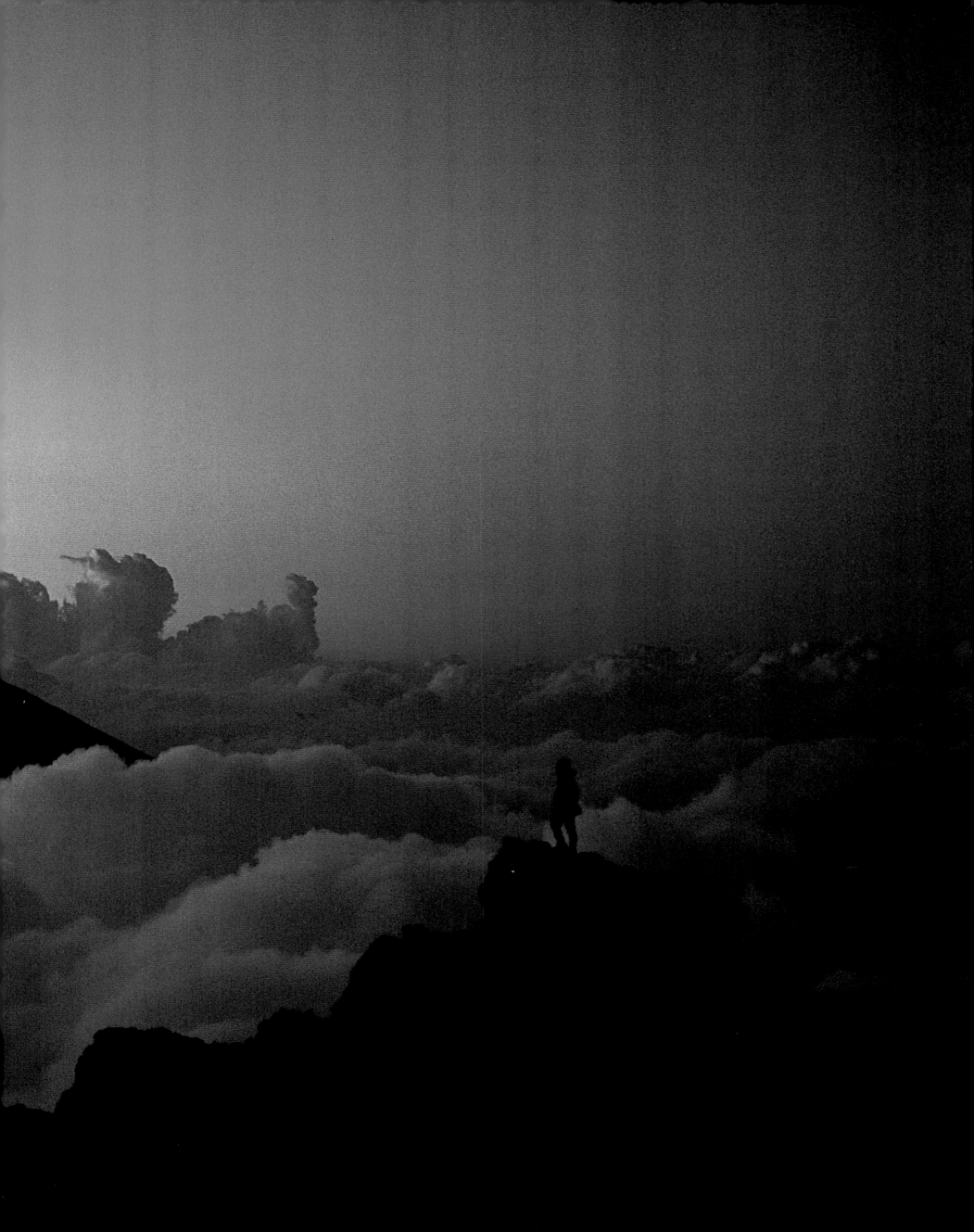

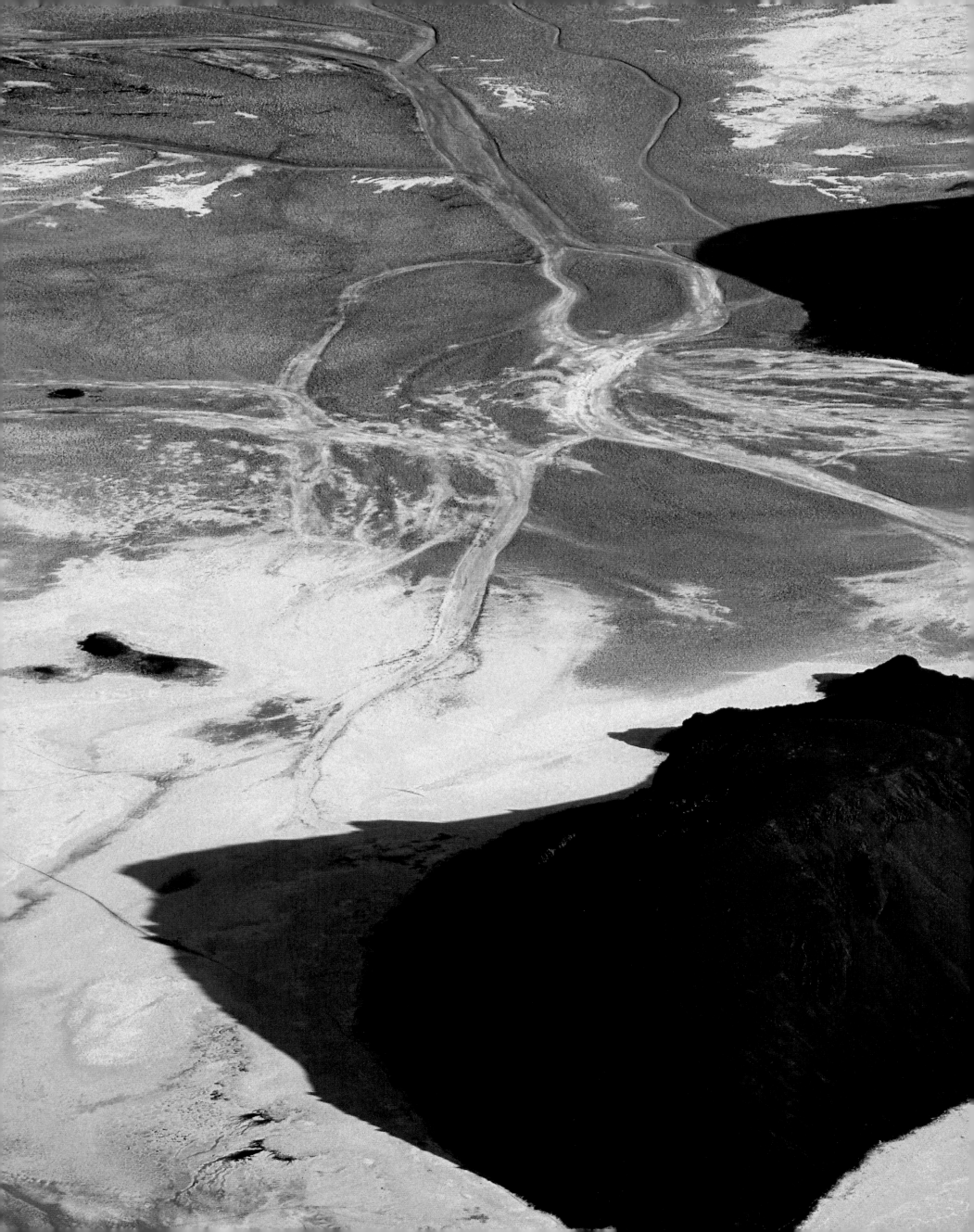

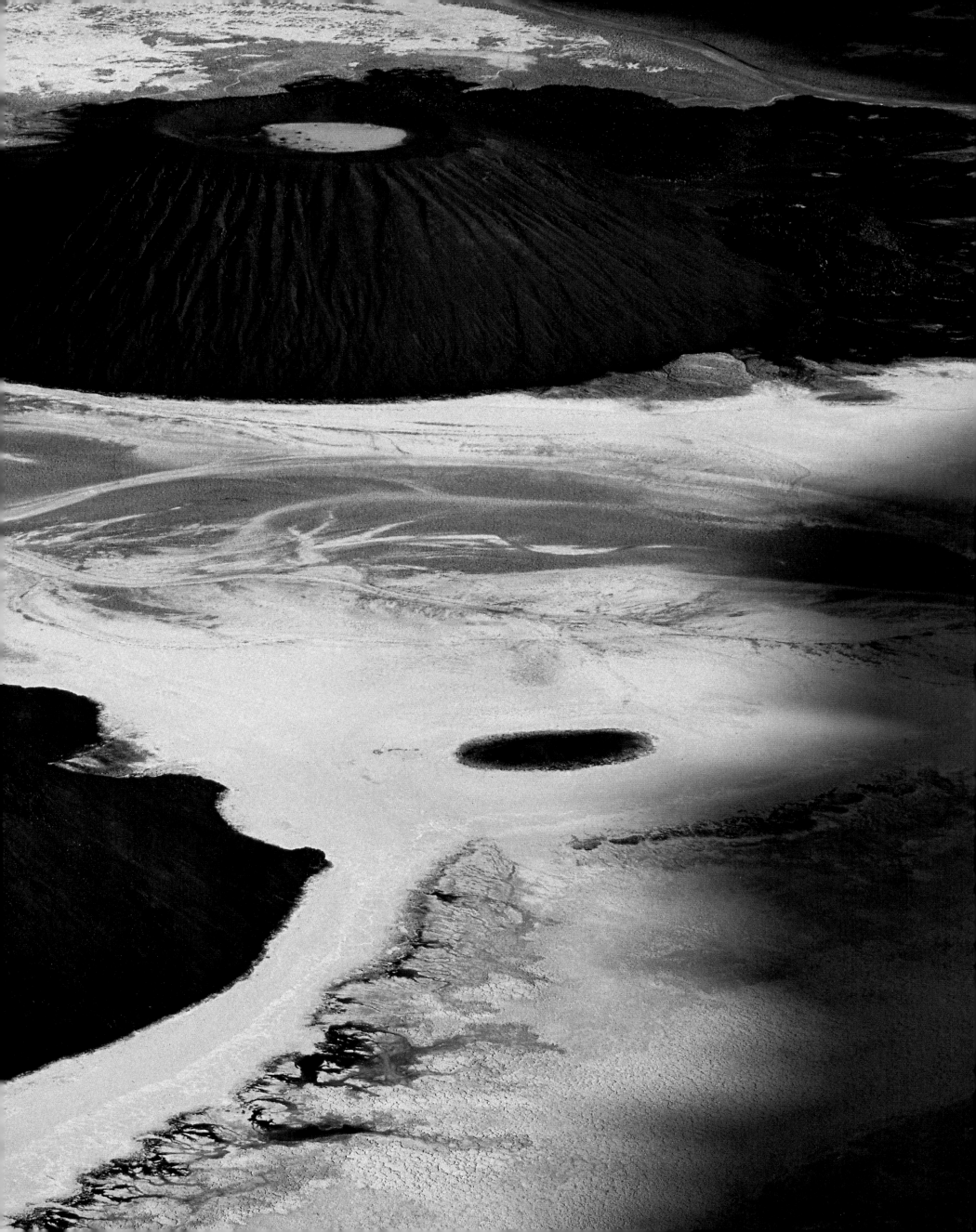

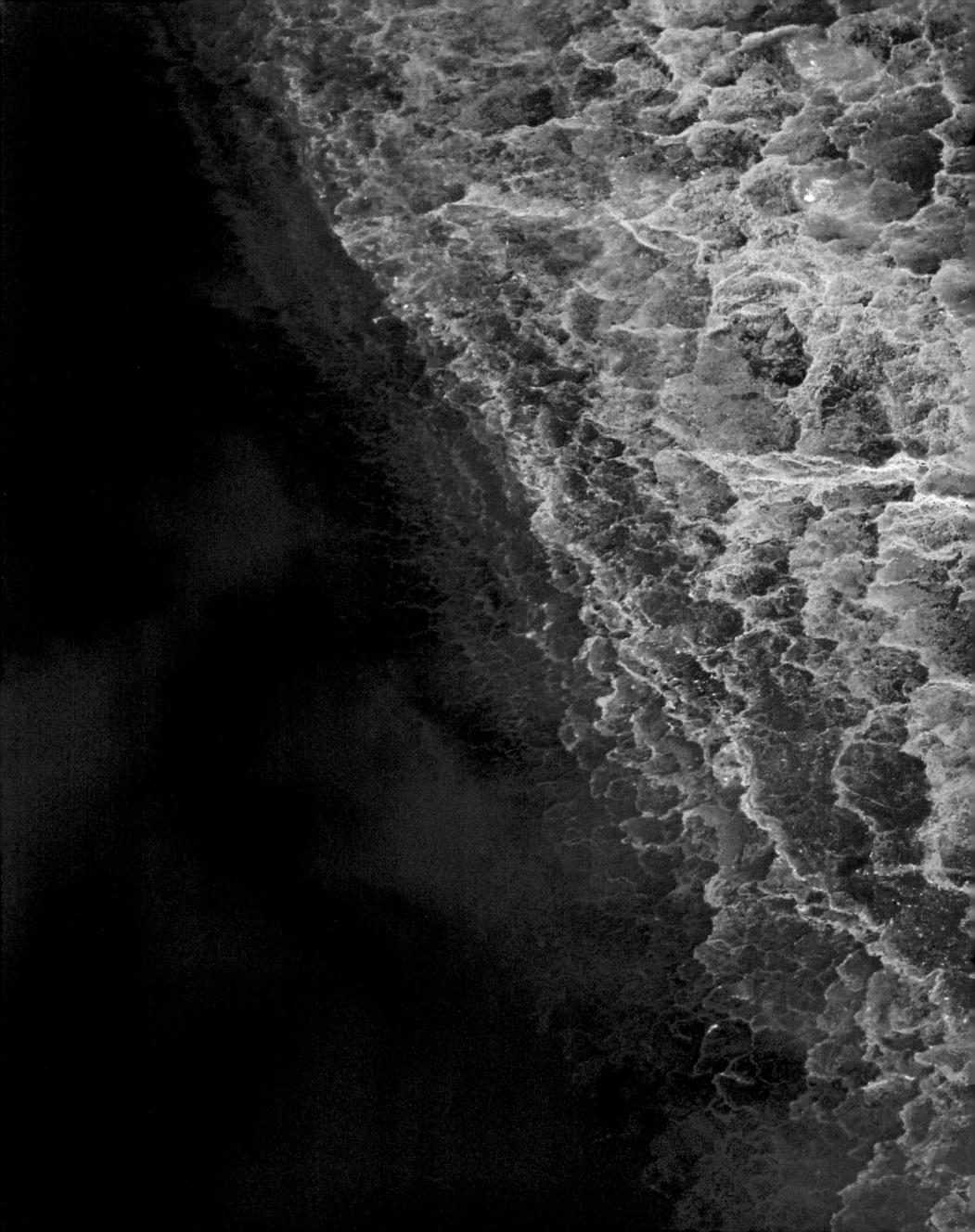

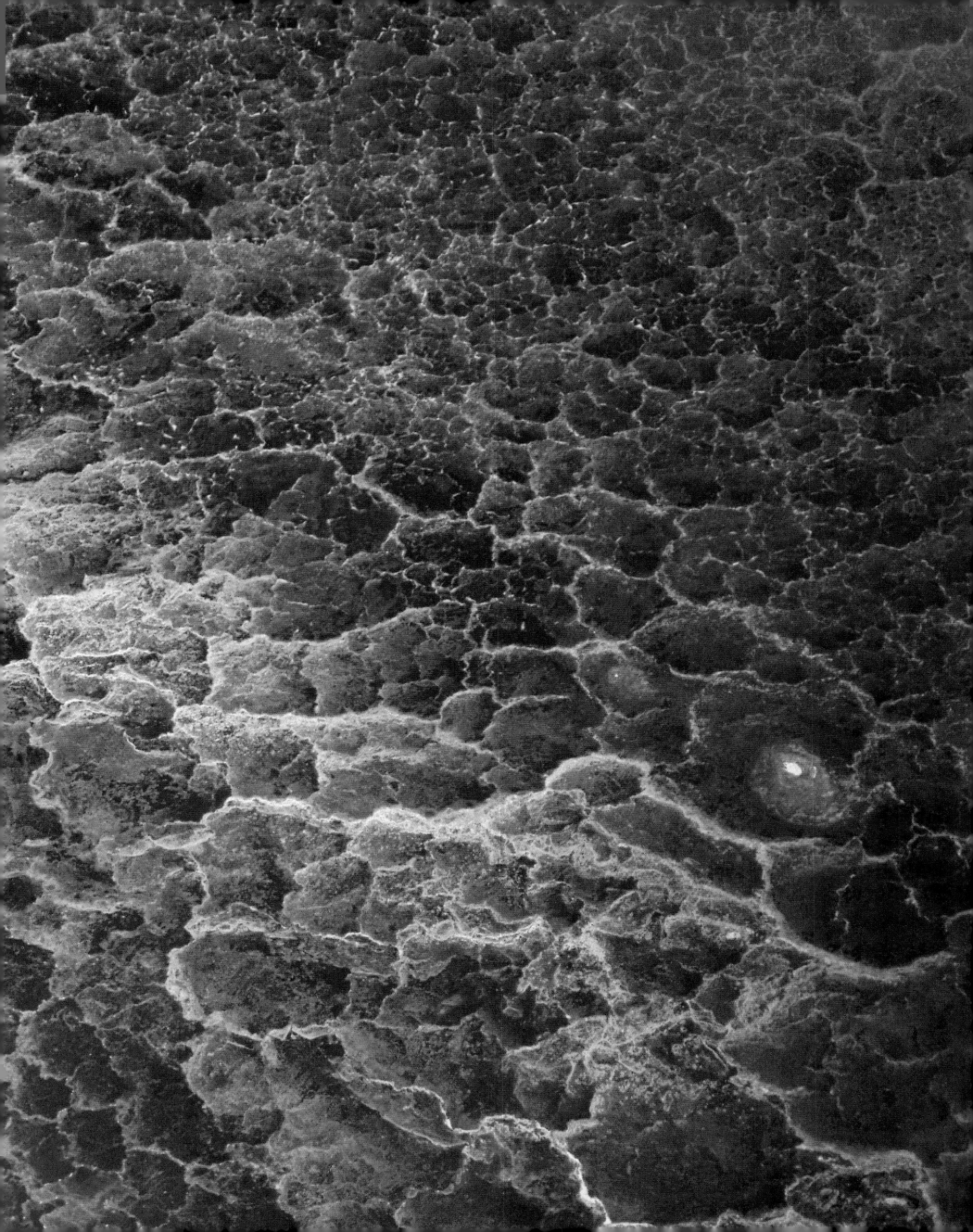

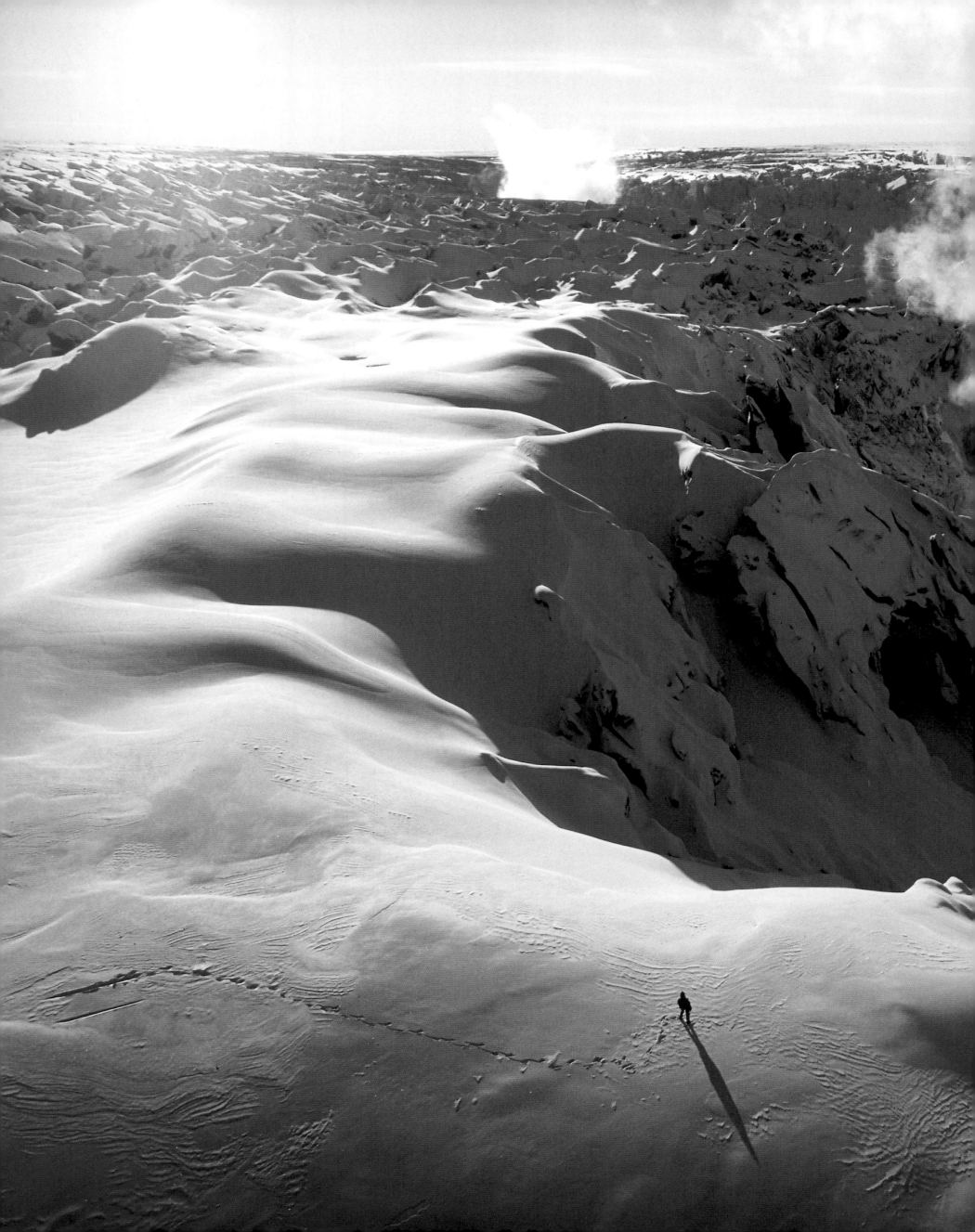

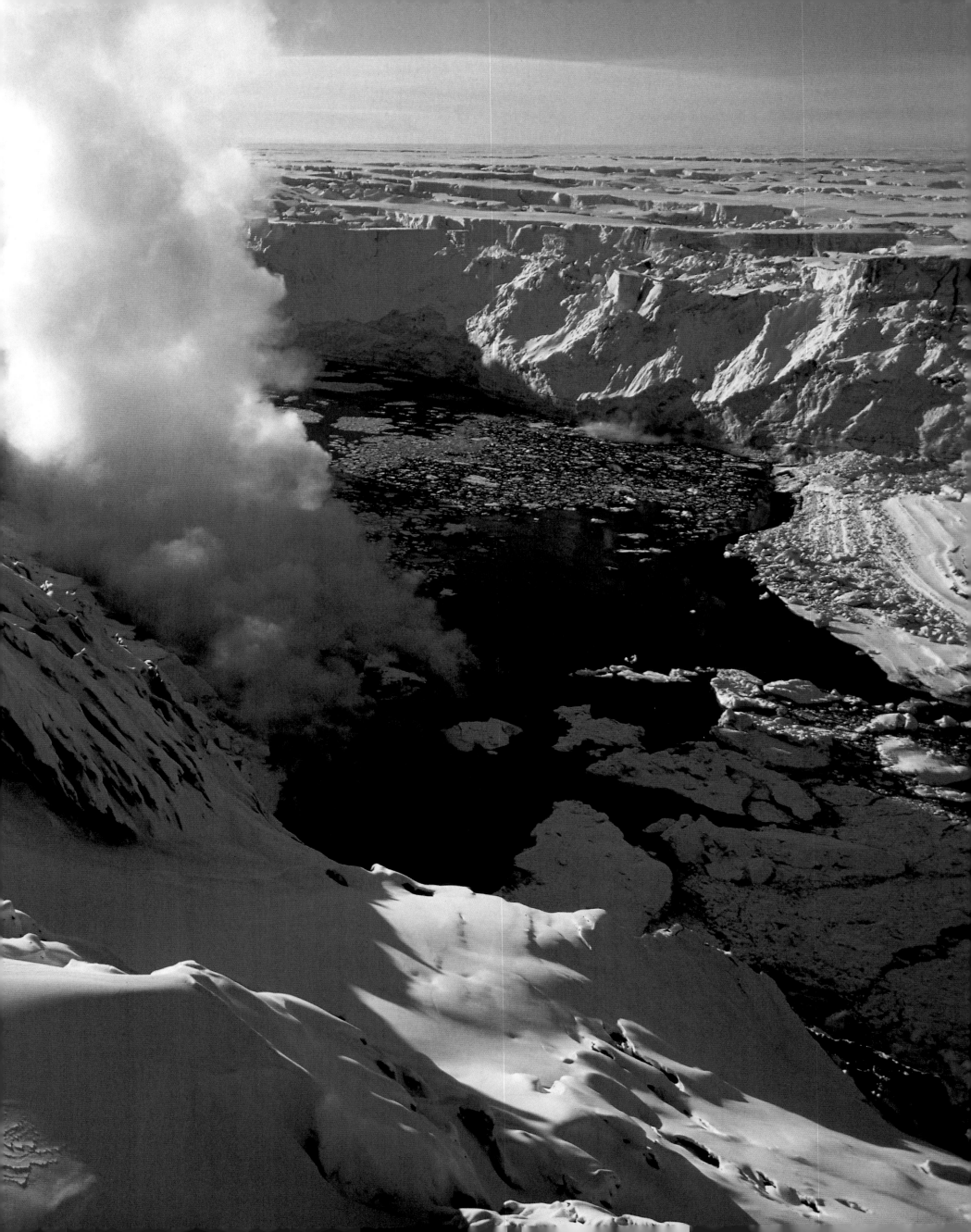

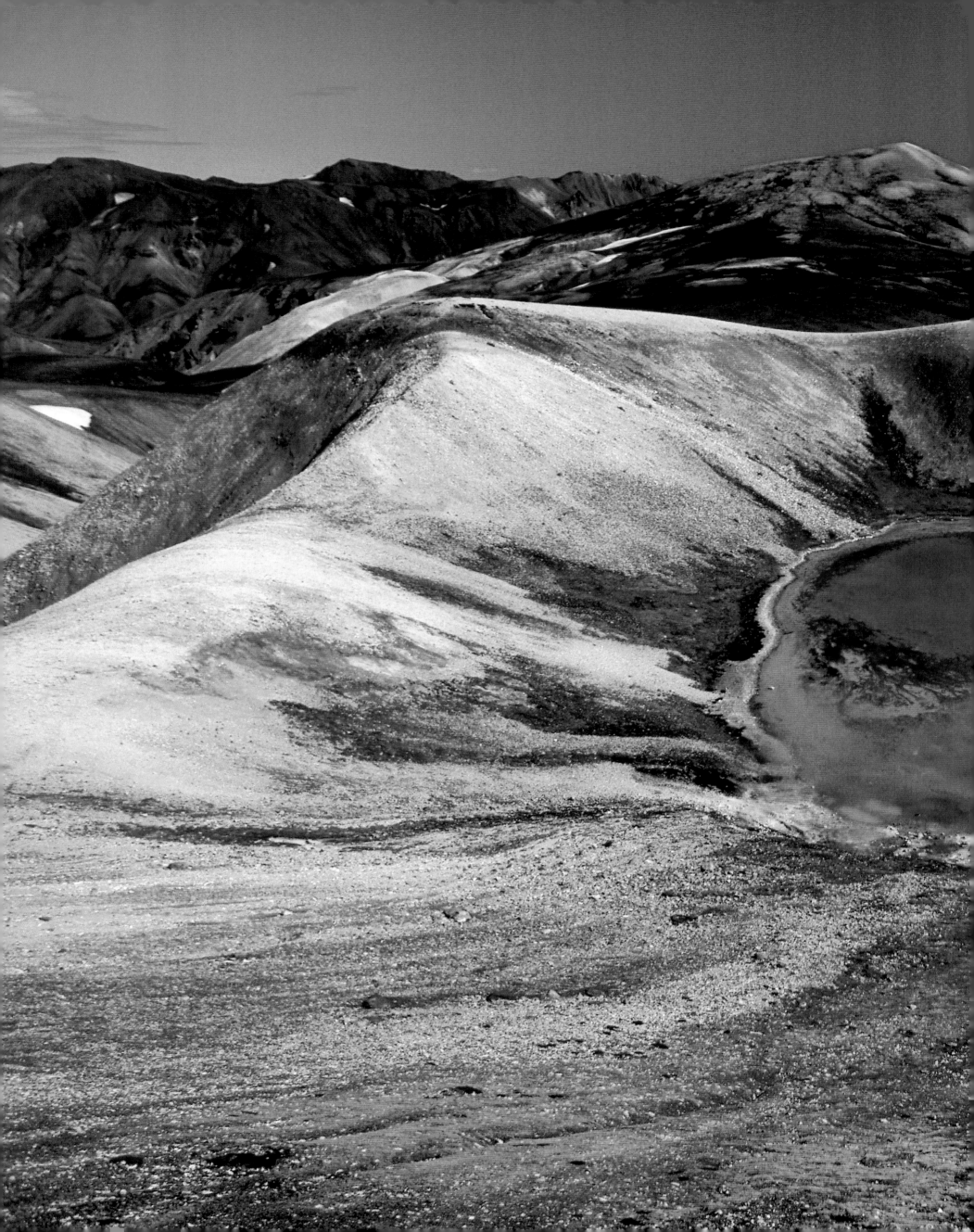

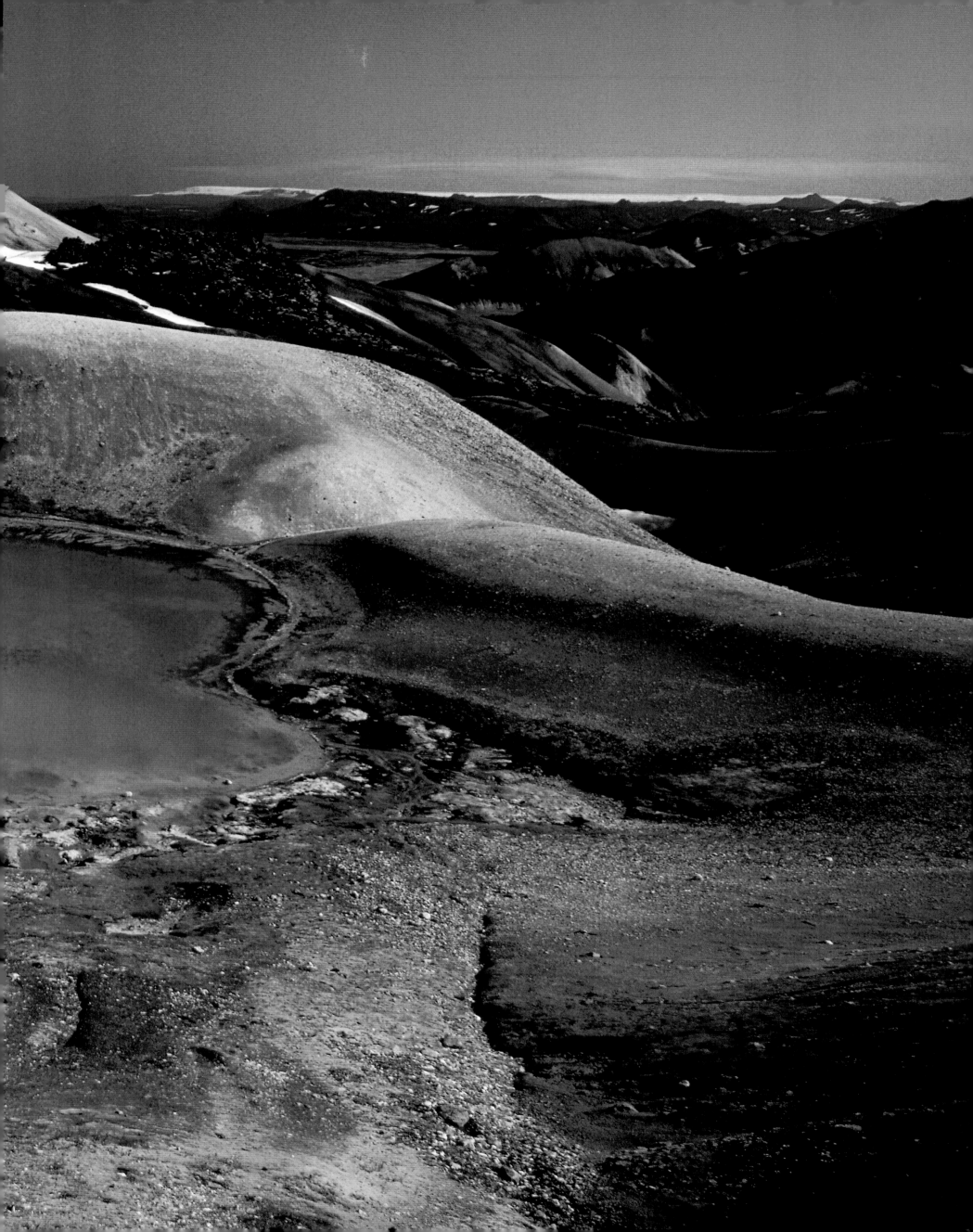

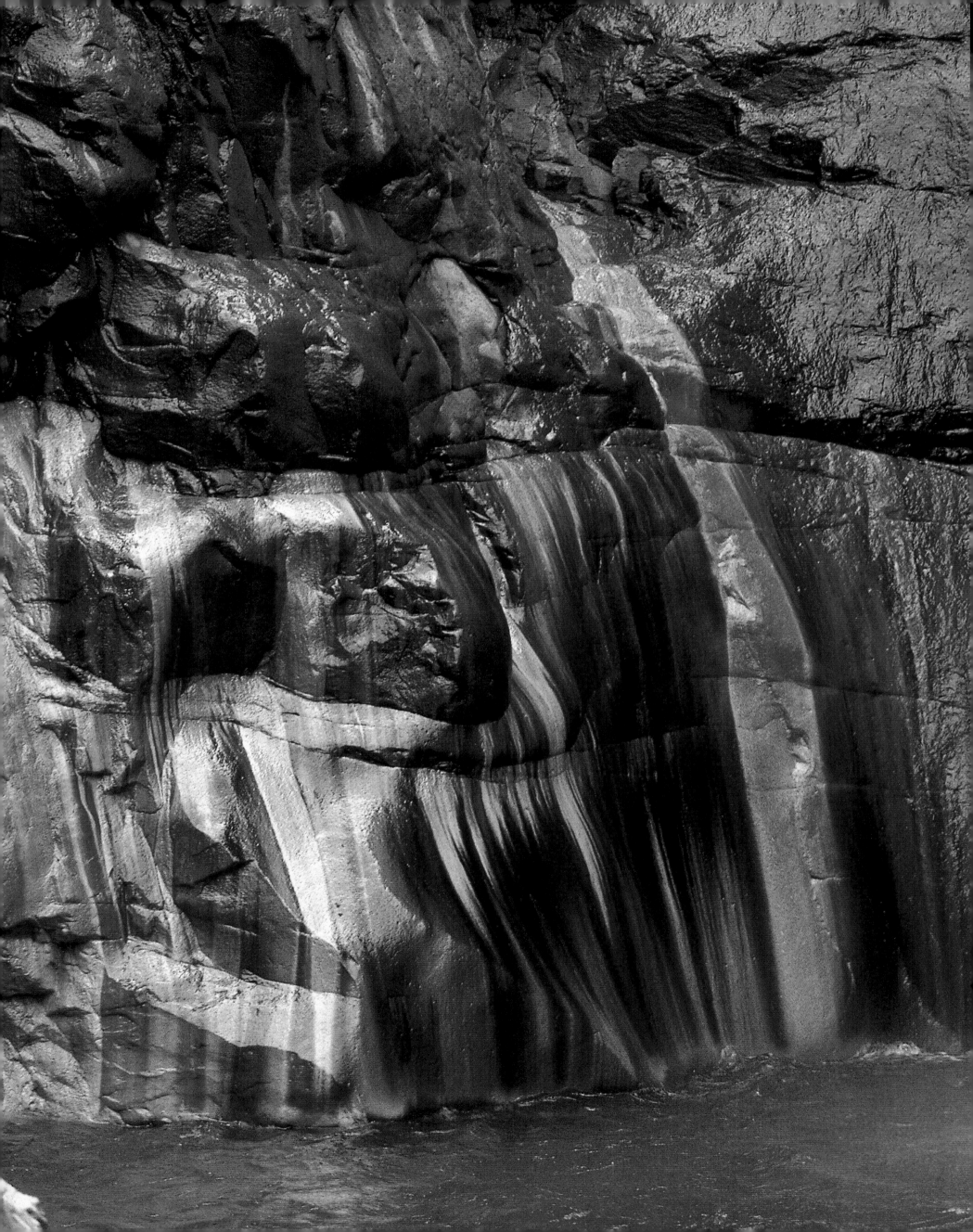

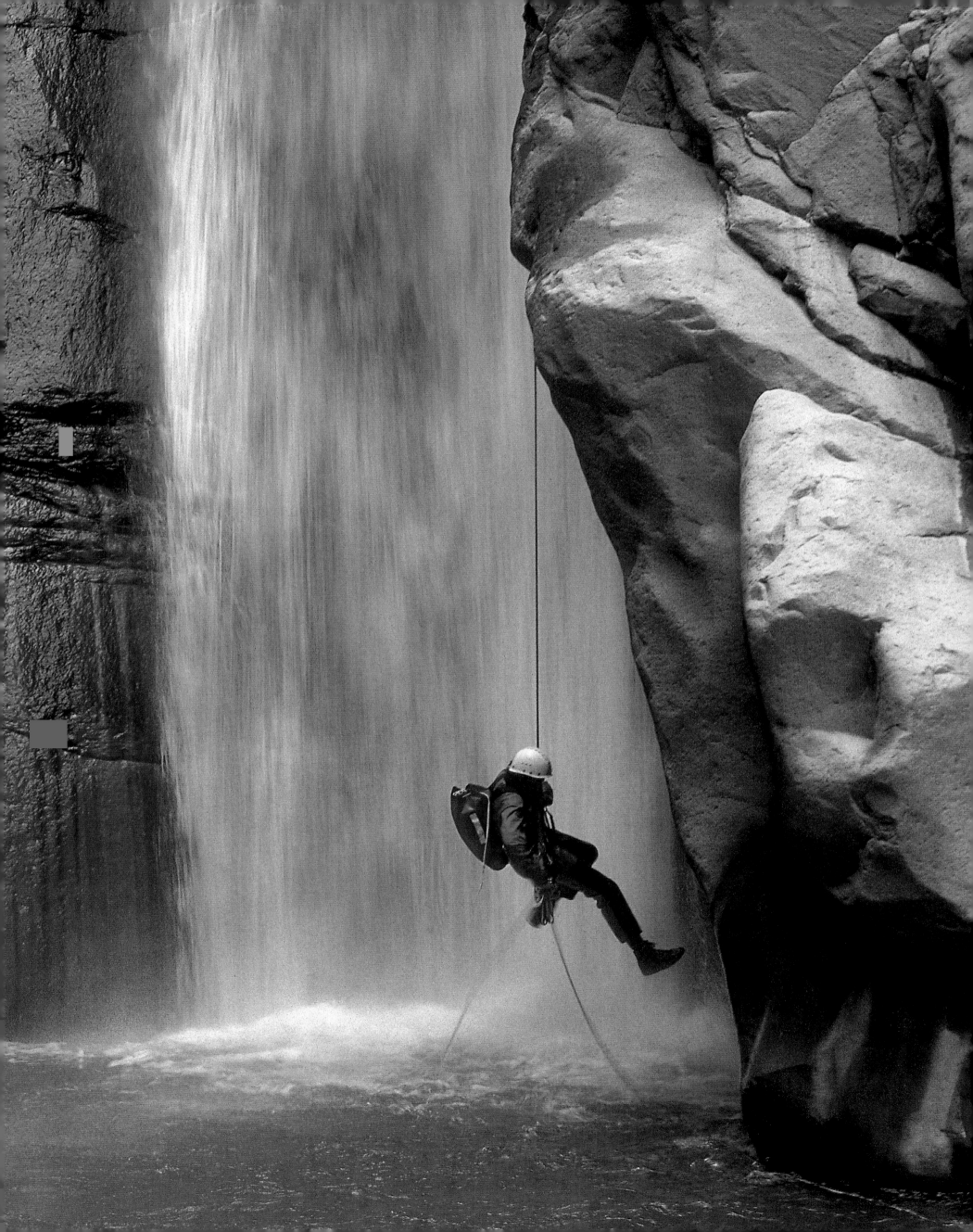

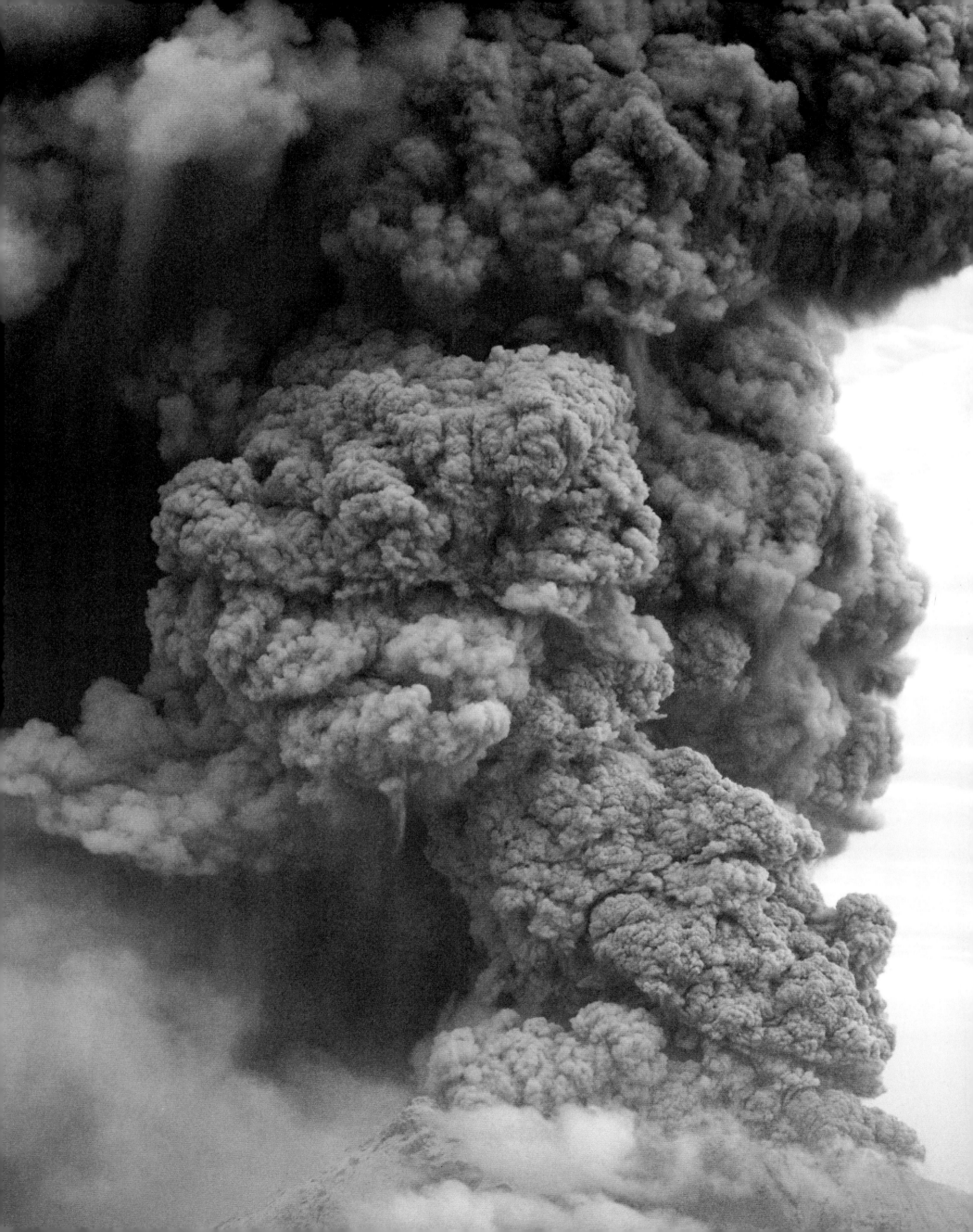

COEXISTING WITH VOLCANOES

WHEN VOLCANOES THREATEN AIRPLANES

For a long time, airplane pilots and volcanologists had little to say to one another. For pilots, volcanoes were remarkable elements of the landscape, landmarks along certain routes or attractions to be pointed out to passengers. For volcanologists, the airplane was, above all, the most practical means of getting to the site, a means of observing volcanoes, calderas, and flows.

Air traffic has been widely developed over the past twenty years in a constant effort to serve an ever greater network. As a result, flights are common over numerous volcanoes, often in very isolated regions. Certain incidents in the course of such overflights have shown that the time had come for pilots and volcanologists to speak.

On 23 June 1982, at the center of the island of Java, Galunggung volcano awoke. In a formidable explosion, it expelled a cloud of ash that quickly exceeded a height of 10 miles. A Boeing 747 between Malaysia and Australia was flying over the Indonesian territory. No information appeared on the control screens until the airplane found itself surrounded by innumerable electric arcs. All on-board electronic devices shut down, smoke poured into the cabin, and a strong sulfurous odor spread. After violent turbulence shook the plane, one, then two, and finally four of the jet engines stopped. Without engine power, the plane went into a dizzying downward spin. The pilots tried to stabilize it while struggling to restart the engines. The plane had already fallen from an altitude of 39,360 feet to 13,120 feet. The situation seemed desperate, and a crash unavoidable. In its fall, the plane met a layer of air that was denser and richer in oxygen. After several attempts, a motor began to function haltingly. A thousand feet lower, two more motors kicked in. The Boeing recovered some power and managed to approach the airport of Jakarta. Although unable to see the runway, despite the lights, the pilots succeeded in touching down.

The intense relief at surviving the emergency did not delay inquiries into the cause of the incident. At cruising speed of more than 500 miles per hour, the plane had passed through the ash cloud of Galunggung. At that speed, it was like putting the plane through a sandblaster. All paint on the cabin had disappeared, the edges of the wings, ailerons, and helm were eroded, the technical captors and air intakes were out of commission, and the windshield completely coated, blocking all visibility. Even more damaged were the four engines. Volcanic ash had been injected into the turbines and the combustion chamber. Temperature there had reached 1,832° F. Since fine volcanic ash dissolves at about 1,292° F, it is not surprising that the ash had melted and blocked all the air intakes with a layer of glassy ceramic.

Three weeks later, on 13 July 1982, another explosion of Galunggung sent a cloud of ash to meet another Boeing 747. The same scenario played out. Losing power in two engines, it fell more than 6,560 feet before the pilots could restabilize it and land at Jakarta. Once again it was a close call.

After these two incidents, the authorities and the airline companies discussed the dangers of the situation, but reached no satisfactory conclusions. It was regrettable, they agreed, that the radar on board could not detect clouds of ash. It was decided, however, to retransmit to the civil aviation authorities the alert bulletins concerning volcanic eruptions. Despite transport officials' worries, their decisions betrayed a certain reluctance to cooperate. After all, the volcano that had twice struck is remote from the modern world.

On 15 December 1989, in Alaska, in the surveillance center of a newly built volcanic observatory, seismographs recorded some important signals. Redoubt volcano had just gone into eruption. Civil aviation was immediately informed in order to send alerts to the various airlines.

A Boeing 747 out of Amsterdam, bound for Tokyo by the circumpolar route, had touched down at Anchorage for refueling and was informed of the eruption. The pilot then took precautions to avoid the ash cloud. It was dawn, with clear skies, a rare occurrence in the region, and no sign of any eruptive cloud. Suddenly the plane found itself in total darkness, with all the instruments going haywire. The pilots quickly changed course to escape the ash, but it was already too late; the four engines stalled. The plane was at 26,000 feet altitude when it started to fall. After a drop of more than 9,800 feet, the engines restarted with difficulty and the pilots managed to land at Anchorage. Another catastrophe was just barely averted.

A thorough inspection of the aircraft turned up the same damages as after the incident at Galunggung: melted, glassified ash in the engines, abrasions, and so on. The damage was assessed:

LEFT: After six hundred years of silence, Pinatubo erupted in June 1991. Clouds of ash rose nearly 20 miles into the air. Philippines.

BELOW: Satellite surveillance of an ash cloud above the Aleutian Islands.

On the slopes of Tokachi volcano on Hokkaido island, Japanese engineers and volcanologists built the world's largest screener dam. At a length of $^2/_3$ mile, it protects the plains city from mudflows in case of eruption.

repairs would require a total of more than $100 million—for a plane that had cost about $200 million.

This new accident had far-reaching effects. The incident had occurred in a developed country, not some exotic land. Clearly, this type of catastrophe not only posed dangers for passengers, but was costly for the world's airline companies affected. Moreover, the incident had struck a flight that followed one of the world's major air-traffic corridors. The North Pole route, serving all of Southeast Asia, is one of the most traveled. Nearly 200 planes passed along it daily, carrying some 17,000 passengers. It went over a good many volcanoes, including 40 active volcanoes in Alaska, 30 in Kamchatka, 30 more in the Kourile Islands, or a total of 100 potentially eruptive volcanoes scattered along this trajectory. Keeping in mind that, of these volcanoes, four or five eruptions occurred each year, and that each eruption generated ash clouds, it was only natural that the Alaska Volcano Observatory in Anchorage would take an active interest in the problem. Thus it became one of the world's four surveillance centers of volcanic clouds.

While awaiting the launching of particular satellites currently in construction based on observatory scientists' specifications, specialists in the processing of satellite images are using information provided by meteorologists to trace an outline of ash clouds. They are tracked hourly and their route is predicted according to weather forecasts. The resulting data are distributed to pilots worldwide to ensure maximum safety.

Once again the heart of the problem is revealed: Volcanoes are not dangerous by themselves; very real risks are incurred through human behavior. The close network of air traffic means that dangerous volcanoes are flown over today in regions once distant and little known. The frequency of flights increases the risks to which aircraft are exposed. The very nature of the machines, their sophistication, their operation based entirely on electronics, makes them still more vulnerable. In all the incidents related, the on-board electronics and the navigation systems malfunctioned. If the traditional propeller planes, which have air filters, were never damaged in the past, this is not the case with modern reactors that swallow enormous quantities of air and thus of ash.

The information gathered by the Alaskan observatory and relayed globally by different networks was used to set off-limit zones for all flights and to define new airplane routes based on eruptions. It was a modern response to a modern risk. Satellites came to the assistance of airplanes threatened by volcanoes.

JAPAN: TECHNOLOGY AT THE FOOT OF VOLCANOES

For many around the world, Japan evokes the image of Fujiyama. In the Japanese archipelago, volcanoes and people are obliged to coexist. Due to limited space, the slopes of volcanoes are built up and cultivated. In numerous regions we find great cities, expanding over the centuries, rising just a few miles away from active craters. Thus Japanese civilization has long since learned to live with volcanic risks.

It should be recalled that this country of volcanoes is an integral part of what is called the Pacific fire belt. The entire periphery of the Pacific plate is made up of subduction zones and the associated volcanism is always explosive and therefore dangerous. Confronted with this direct risk, the only response is evacuation from the threatening volcano. This is why Japanese volcanologists have increased the systems of surveillance and alarm that permit the necessary evacuations. They have also implemented a proactive routine to protect property and lives from the major risk posed by mudflows at the foot of volcanoes. Here, too, the lesson of Armero, destroyed by the lahars from Nevado del Ruiz, has led to action.

The most striking example is seen at Hokkaido, at the foot of Tokachi volcano. The island of Hokkaido, in the northern part of the Japanese archipelago, has a very cold climate. In winter it is customary to see several feet of snow. This mantle of snow magnifies the volcanic risk since an eruption heats the cone or drops hot ash over wide areas. In either case, melting snow cover provokes a quick release of great quantities of water, which, mixed with juvenile ash or old unstable deposits, can provoke destructive lahars.

Furano, a modern city sitting at the foot of the volcano, is built on a plain at the outlet of a narrow valley that runs straight down from the volcano. Japanese volcanologists have traveled to Colombia and, at the sight of the damage in Armero, put their engineers

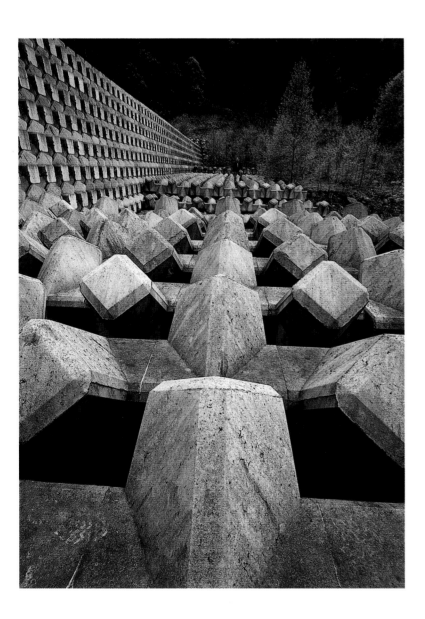

to work. The result has been an impressive range of different technological solutions. All along the valley leading from the volcano to the city are a series of dikes that block the course of mudflows. The two dikes farthest uphill are enormous grids of steel tubes forming a screen or riddle more than 23 feet high, and running to lengths of 2,300 feet and 3,300 feet, respectively. These giant filters are designed to retain blocks or rocks and tree trunks carried by the flows. Such large objects move at high speeds with the lahar, and can become ballistic projectiles of real destructive capability. It is essential to stop them as soon as possible. Lower down, the concrete zigzag dikes break the force of the mudflows. They are interspersed with other "filter" dikes that surround great sedimentary basins, which will capture finer-grained elements (ash, sand, and gravel) that greatly increase the density of the liquid mass in motion.

After the successive effect of all these dikes, the original lahar should be reduced to just a flow of torrential waters. This flow is then directed to canals with high concrete walls that contain and divert it far from populated areas. Automatic pressure monitors are installed on each of these structures. Their activation sets off an alarm in the lower part of the valley. Automatic cameras also surveil dikes, basins, and canals. All information is relayed in real time by an ultramodern surveillance center, a control tower that guards the outlet of the threatened valley and the city of Furano. It has been calculated that, after mudflows are released on the volcano's flanks, it takes them twenty minutes or more to reach the city. From the control center, at the first signs received by the monitors, the civil protection authorities alert the population. The people, well informed and prepared by several simulation drills, know exactly where to go and how. For anyone unable to evacuate the lower parts of the city within a few minutes, since they are too far from the neighboring hills, artificial platforms have been constructed, raised ten feet or more above ground level. Each platform includes, besides ample parking space and wide regrouping areas, a central building with shelter space, a well-equipped and stocked kitchen, meeting and conference rooms, a communication center, as well as a medical center. The entire unit has an independent power supply. Several helicopter landing pads are also close by. This full-scale technological response, which combines dikes, alert capabilities, and evacuation centers, has yet to be used, but since it was inspired by recent experiences with volcanic catastrophe, there is every indication that it will prove highly effective.

There are, of course, limits to such technology and this model is not necessarily applicable to other cultures. Because Japan is such a disciplined society, its population can be expected to respond promptly to an evacuation order. Only under conditions such as these can one afford to count on emergency evacuations. Also, infrastructure of this type, costing several billion dollars, would be unthinkable if Japan were not a wealthy nation. There is no way that developing countries could tackle such expenses, especially if their territory includes several dangerous volcanoes. The model needs to be adapted in such cases. On the basis of Japanese designs, anti-lahar dikes have been constructed in several valleys at the base of Merapi in Indonesia. Here the limited financial resources are offset by natural ingenuity and an abundant labor force. Enormous dams were built by hand, stone by stone, by hundreds of laborers, tearing massive stones out of the ancient flows that contain them, and breaking them up. Blocks are then hoisted

Disseminated in each valley near Tokachi volcano, Saba dams have been built by Japanese engineers to retain the lahars, if necessary.

to the top of great bamboo scaffolding and assembled with mortar mixed with sand from previous mudflows. Through a kind of recycling marvel, the Indonesians defend themselves from the volcano with material left by the last eruption.

In the volcanism of the Pacific fire belt, people are learning to live close to volcanoes. Some are very explosive, and yet a large population continues to live under them. On the isle of Kyūshū in southern Japan, Sakurajima is almost continuously in eruption. Several times a year, its violent explosions shake cities and villages all around. Here, too, people adopt a specific behavior dictated by their dangerous neighbor. A number of unusual details of the region serve as a clear reminder of the nearby volcanic dangers. On one side, a telephone booth is covered with a concrete shield to protect it from possible falling volcanic debris. Elsewhere, a riverbed is interrupted by various dikes to break the force of the mudflows. Farther along, an illuminated sign by the road warns motorists of falling ash and of limited visibility that results. Every few miles along these roads you find concrete shelters to receive any travelers overtaken by a sudden explosion. Beside the road are groups of houses specially designed to resist earthquakes and not to collapse under the weight of accumulating ash. The pitch of roofs is calculated to let ash slide off, and gutters are oversized to accommodate ash drainage. Power is supplied by protected underground cables, while special filters equip air conditioning and heating units.

The volcano and its activity are completely integrated into the life of citizens, as is seen every year on 12 January, the anniversary of the great eruption of 1914. For everyone it is a day of general training and mobilization. All possible intervention forces are mobilized on 12 January to demonstrate the speed and effectiveness of their action. After an initial alarm, volcanic activity is simulated, generally violent explosions of the summit crater, falling ash, and lava flows south of the volcano. Immediately, an operational announcement defines the steps to be taken and mobilizes all necessary forces. The civilian population, well informed and trained, plays along, and although they know it is only a simulation, everyone takes his or her role seriously and reacts calmly and diligently. The instant the alert siren goes off, all the city elementary school pupils get under their desks with speed and determination, taking momentary shelter from possible collapsing roofs or falling volcanic explosions. After a few minutes, teachers give precise directions. Everyone gets up at that point, goes to the coatroom for a helmet, a small knapsack with a few personal belongings, and an obligatory survival kit. Teachers, civil protection specialists, and parents accompany the children, and everyone hurries to the main street of town, where many are gathered. Children are not the only evacuees; several adult citizen groups also practice each year.

Under the roaring of the helicopters flying over the mountain searching for possible wounded, everyone descends in good order

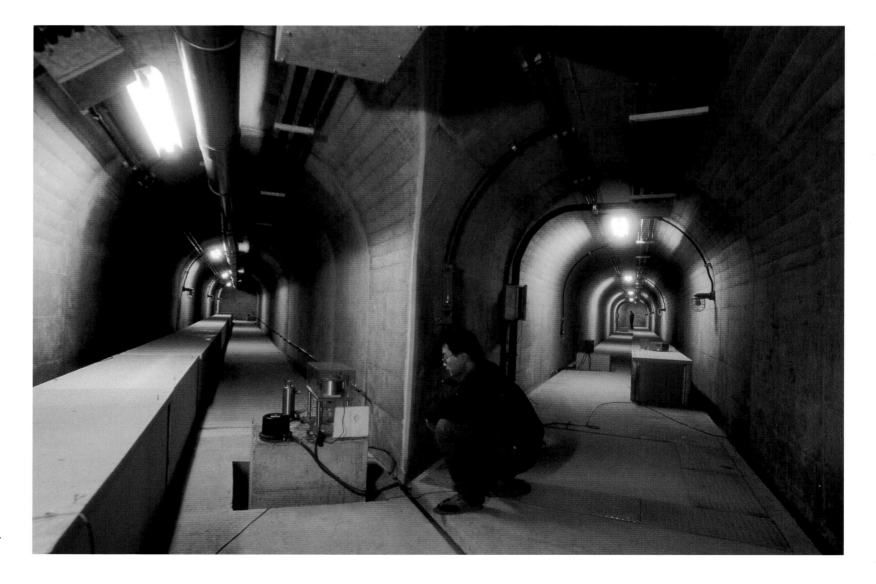

In this unique facility, a tunnel is dug under Sakurajima volcano leading toward the feeder chimney. It is filled with monitors that trace the slightest quakes accompanying rising lava in the cone. Japan.

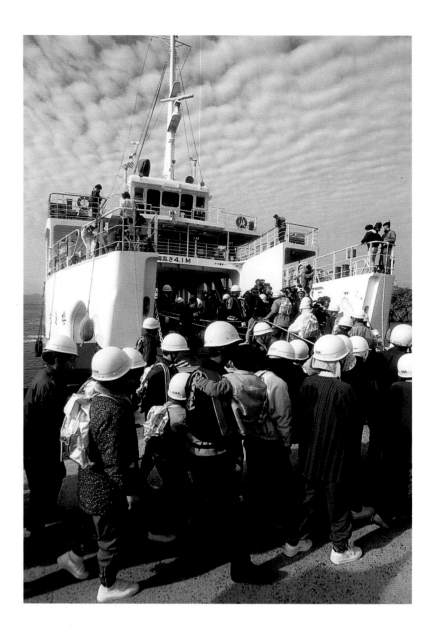

sense, they could end up making the risk look routine. This perfect organization, so deeply ingrained and without any room for the slightest improvisation, however, could be thrown into a quandary by anything unforeseen by the evacuation plan. An element of surprise could upset the whole system, causing it to collapse.

VESUVIUS: THE CATASTROPHE OF TOMORROW

The eruption of A.D. 79 that completely destroyed Pompeii and Herculaneum is known as the "Plinian eruption" in honor of the author who described it so vividly. It is also the largest, most violent eruption in recorded history. However, alternating with several periods of inactivity, Vesuvius has had many other eruptions. Some were violent, like the sub-Plinian eruption of 1631. A tall column of ash preceded the emission of *nuées ardentes* (burning clouds) that descended to the sea; heavy rains also set off several lahars. The villages of Ottaviano, San Sebastiano, and San Giorgio were completely destroyed. More than 12 inches of ash fell on the city of Naples. This eruption left at least 4,000 dead at a time when the region was relatively sparsely populated. The intensity of the activity and the extent of the damage meant that this eruption, in its time, was a real media sensation. It was mentioned in many books, inspired engravings, and led to the publication of maps of the destruction and the eruptive deposits.

The eruptions that followed were frequent, usually smaller in scope, and especially devoid of destructive pyroclastic flows. They were more like Strombolian eruptions, with projections of lava around the crater, sometimes voluminous ash clouds, and emissions of lava flows. These eruptions naturally caused their share of damage to orchards, vineyards, farms, and even villages by lava flows. But, on the whole, these events were benign in comparison with the catastrophe of 1631.

Study of past events, along with the evolution of the chemical composition of the lava and what we know of the activity of magma chambers, shows that there can be three different types of Vesuvian eruption. Which type occurs will depend on the period of rest between eruptions. Plinian eruptions of massive scale appear after several centuries or even a millennium of dormancy; sub-Plinian, more moderate eruptions, take place after just one or two centuries of inactivity; and Strombolian or effusive eruptions occur at intervals of a few years or, at most, decades.

The most recent incident, in 1944, seemed to close a cycle and initiate a dormant phase. How many years will it last? No one knows. Yet there is every reason to believe that the next eruption will be of the sub-Plinian variety, and the more time passes, the more probable the prediction becomes. In any case, the principle of caution dictates that we base preventive measures on this forecast and that we analyze the characteristics of the 1631 eruption.

For 450 years the Bay of Naples has known many changes. The city and its surrounding towns and villages now form an enormous conglomeration. Three million persons live within a radius of 20 miles around the volcano, and a million live less than 4 miles from the crater. The region has become a major railroad and highway hub traversed by all major north-south arteries in Italy. Communications links are squeezed in between the volcanic slopes and the sea, less than 6 miles from the crater.

A case study has been made of the eruption of 1631, and the

Evacuation drill at the foot of Sakurajima volcano. The population boards boats that will take them to the mainland. Japan.

toward the port of Arimura. There, a concrete building, specially designed to resist falling volcanic bombs and ash, serves as a shelter and gathering place to await evacuation boats. A field hospital is set up on the municipal sports field, where members of the Red Cross, under the direction of several doctors, receive those pretending to be wounded. All information collected about their condition is used by medical companions who consider the best means of evacuation for each particular case. Within a few moments the wounded will be in the hospital best suited for their care.

From another direction, children and adults, having met in the bunker of the emergency ports where they received orders, form orderly lines on the dock. Since lava flows have been announced, they must leave the area. A large ferry quickly docks and, after attendance is taken, everyone gets on board. At the same time a complete telecommunications station is set up with satellite antennas. Despite the eruption, the zone will not be cut off from the rest of the world—there is even an image hook-up so that the country can follow on live television what is happening on Sakurajima.

This practice of prevention takes place every year and is followed attentively by the various Japanese authorities. If the infrastructure of dikes and dams seems absolutely secure, there may be reservations about the usefulness of these regular, systematic drills. In a

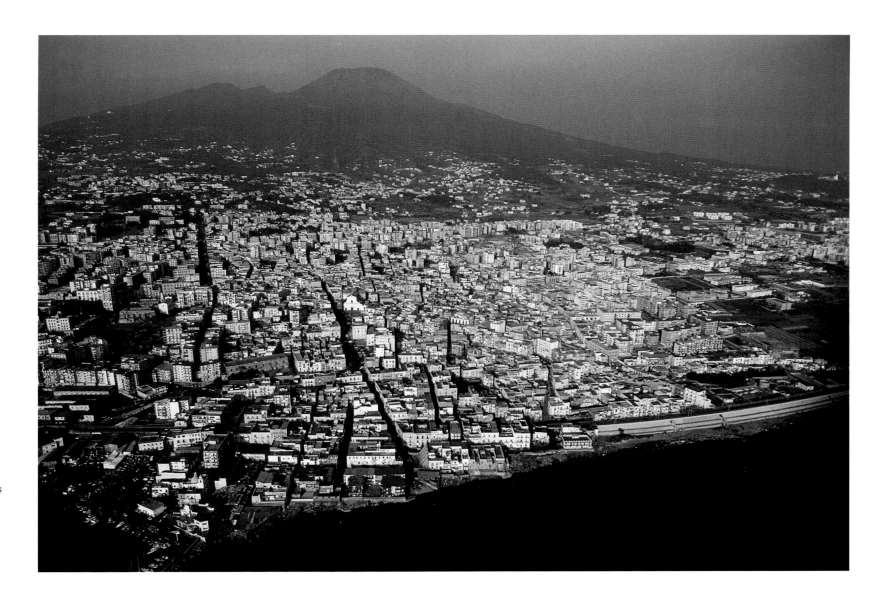

The villages and cities of the Bay of Naples form a megalopolis built directly on the slopes of Vesuvius. Italy.

reconstruction of its activity shows that pyroclastic flows reached the Tyrrenian Sea (an arm of the Mediterranean) in less than 300 seconds. If this model is applied to today's urban complex, the scenario is disastrous. Within five minutes nearly 400,000 persons would be killed by pyroclastic flows. Roads, expressways, and railroad lines would be destroyed. The port and airport would be paralyzed by falling ash. There could be no more travel in the region and no help could reach the site. The eruption would reach its peak intensity in a few minutes, therefore it is useless to consider leav-

ing the area after the volcano became active. Confronted with such a force, only an advance evacuation of more than 800,000 persons could avoid an unprecedented catastrophe. But that kind of action could only occur under two conditions. Anticipating an eruption is one thing; total cooperation on the part of the population must also be guaranteed to carry off the evacuation.

Vesuvius is under close scrutiny today, and scientists interested in it are confident that indicators of a future eruption would appear at least two to three weeks in advance. This lead time would

Future Eruption of Vesuvius

Simulation of the development of the Plinian cloud and the pyroclastic flows. (Source: Dobran and Macedonio.)

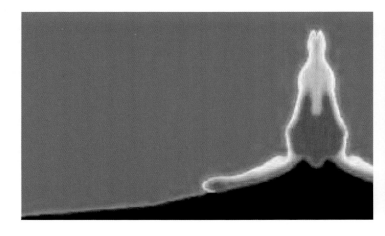
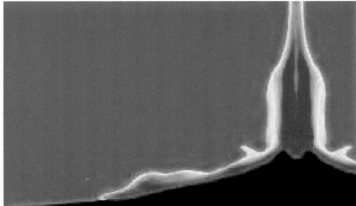

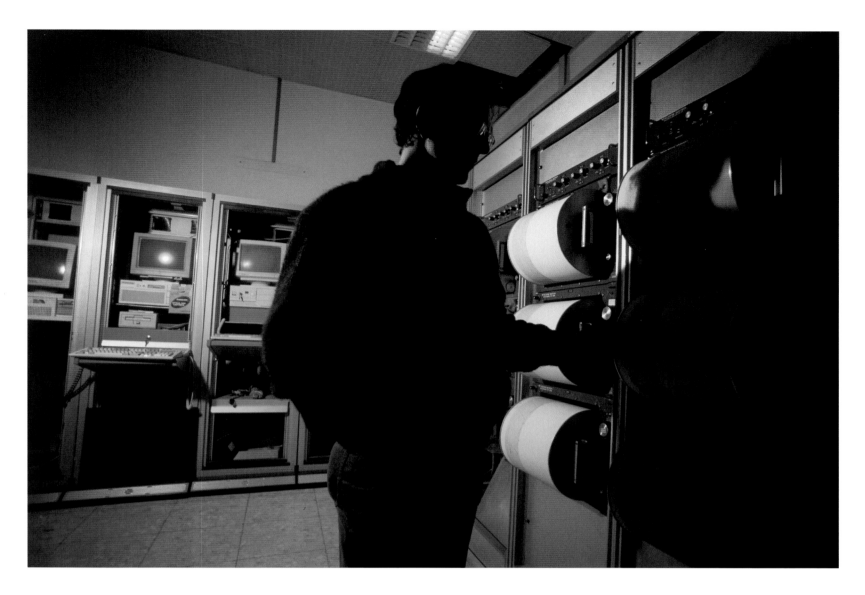

In the electronic bay of the Vesuvius observatory, a geophysicist monitors the recordings of earthquakes caused by magma rising under the volcano. Eleven seismic stations keep a permanent eye on the region. Italy.

theoretically suffice in order to organize an evacuation. If the population were not convinced of the validity of the decisions taken, if it had less than total confidence in the scientists and officials, the situation could quickly become chaotic. There would be no way to manage the panic and refusals to leave. Major communication and education programs are thus under way among the threatened populations. Nevertheless, Neapolitans still see Vesuvius as a "nice" volcano. They have painted and sung about it for centuries. They have guided thousands of tourists to the summit. The scientists, then, have difficulty convincing the populace that such a volcano can change its behavior and turn extremely dangerous in an instant. The Neapolitans still have San Gennaro to turn to whenever danger threatens.

Accurate and clear forecasting, good management of an evacuation, effective communication and education of the community—such are the challenges posed by Vesuvius. All this and more will have to be undertaken to ensure that the twenty-first century does not experience the worst volcanic catastrophe of all time.

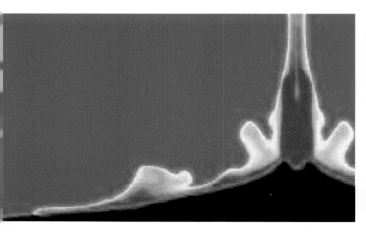
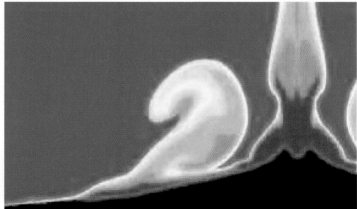

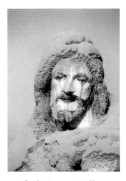

PAGE 257. A statue of Christ partially covered with ashes during the Pinatubo eruption. Philippines.

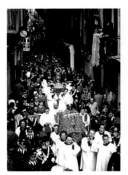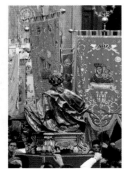

PAGE 258. The procession of San Gennaro, or Saint Januarius, in the streets of Naples, Italy.

PAGE 259. In a somewhat superstitious practice, priests carry San Gennaro's relics in procession through the city to forestall the dangers of Vesuvius. Naples, Italy.

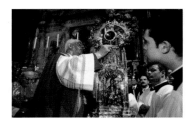

PAGES 260–61. In the Naples cathedral, or Duomo, the most precious treasure takes the form of two vials containing the blood of San Gennaro, guardian of the city. When the blood liquefies, the city is ensured protection in the coming month from the furies of Vesuvius. Italy.

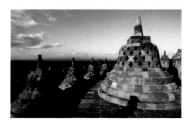

PAGES 262–63. In 1002 the Buddhist temple of Borobudur was engulfed by a violent eruption of Merapi volcano. Uncovered in 1965 and restored by UNESCO, this building, carved entirely from lava blocks, offers visitors more than two miles of frescoes narrating the life of Buddha. Indonesia.

PAGES 264–65. Families prepare offerings for the festival of Kesodo by cooking produce from the fields following traditional recipes. Indonesia.

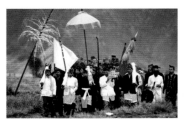

PAGES 266–67. During the Kesodo festival, a procession of priests conduct the sacred water to the temple. Bromo volcano, Indonesia.

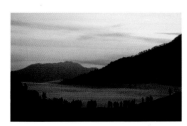

PAGES 268–69. At sunset the pilgrims begin to gather on the peaks of Bromo volcano. Indonesia.

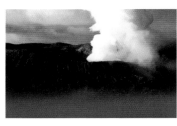

PAGES 270–71. Tengger is a volcanic range in east central Java. It includes two active volcanoes: Bromo and Semeru. Bromo is the annual site of the ceremony of Kesodo. Indonesia.

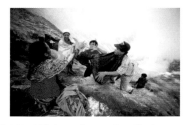

PAGES 272–73. Offerings thrown by pilgrims are recovered by Muslims who hang from the internal walls of the crater. The whole exercise is conducted peacefully. In fact, for Hindus, what matters is the gesture of making an offering, not the fate of the items themselves. Bromo volcano, Indonesia.

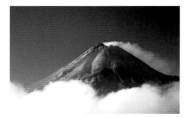

PAGES 274–75. Summit of Merapi. The active dome is visible on the left side of the image. Indonesia.

PAGE 276. The Abdidallem guard the sultan, who represents the direct link with Merapi volcano. Popular belief invests the sultan with the power of stopping the

volcano's furies, a conviction that does not help the volcanologists' efforts to ensure possible evacuation. Indonesia.

PAGE 277. All the Abdidallem carry *keris*, a magic dagger imbued with special powers. People salute them and pray to them. Once a year they are washed in holy water, rubbed with flower petals, and finally coated with perfumed oil. Indonesia.

PAGES 278–79. Every ten years, on the island of Bali, the Hindu ceremony of Panca Wali Krama is celebrated. It is a ceremony of prayers and offerings that moves from the sea to Agung volcano 42 miles away. Indonesia.

PAGES 280–81. As the procession crosses the rice fields, priests "summon" a god to inhabit the symbolic houses. Indonesia.

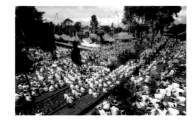

PAGES 282–83. Three days after leaving the sea, the procession reaches the temple of Besakih at the foot of Agung volcano and the great rites begin. Indonesia.

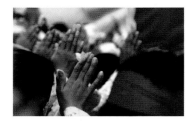

PAGES 284–85. Prayers are said in various small temples scattered within the walls of the temple of Besakih. Indonesia.

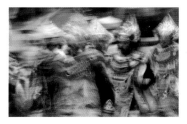

PAGES 286–87. To welcome the gods, dances are performed around the clock. Indonesia.

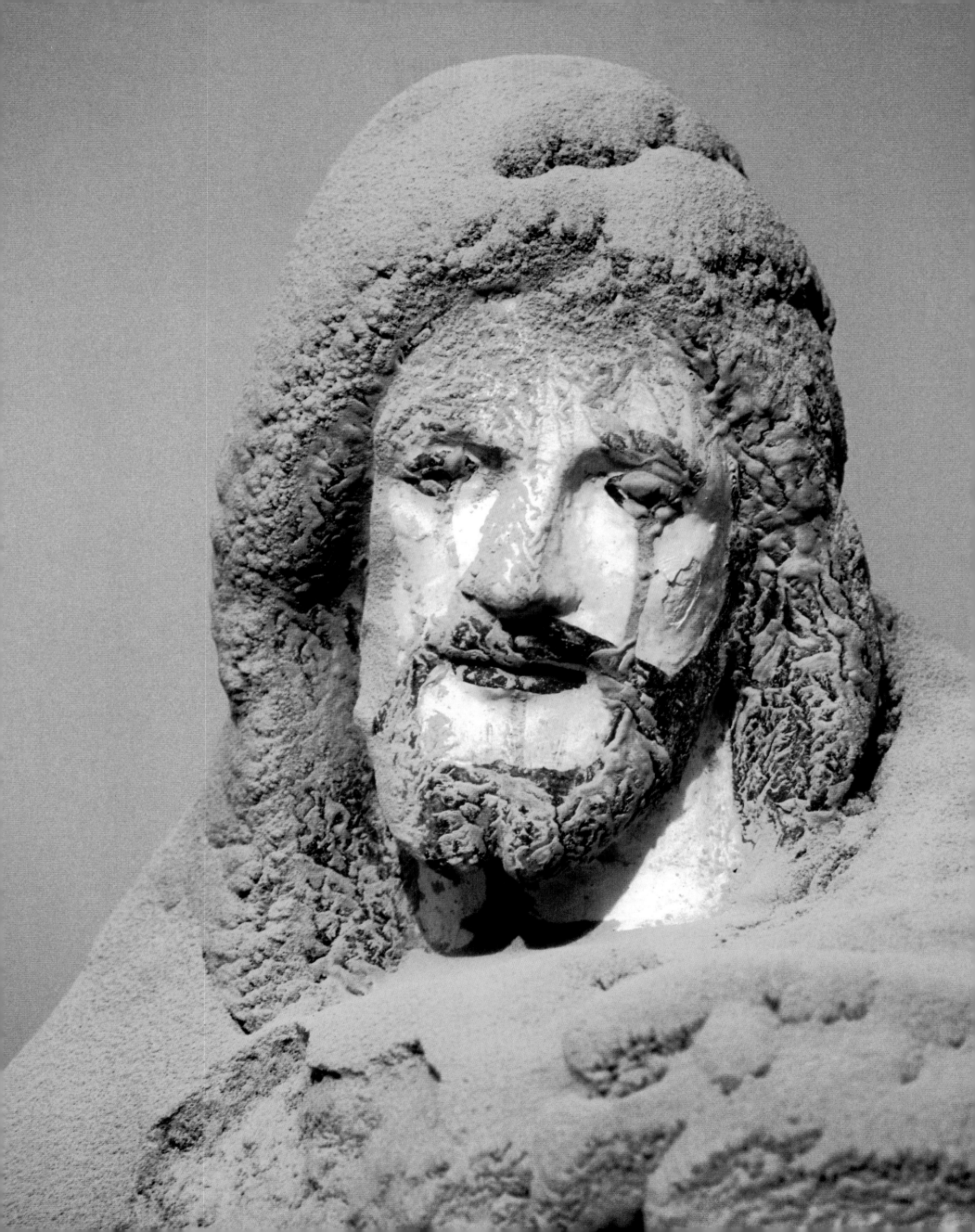

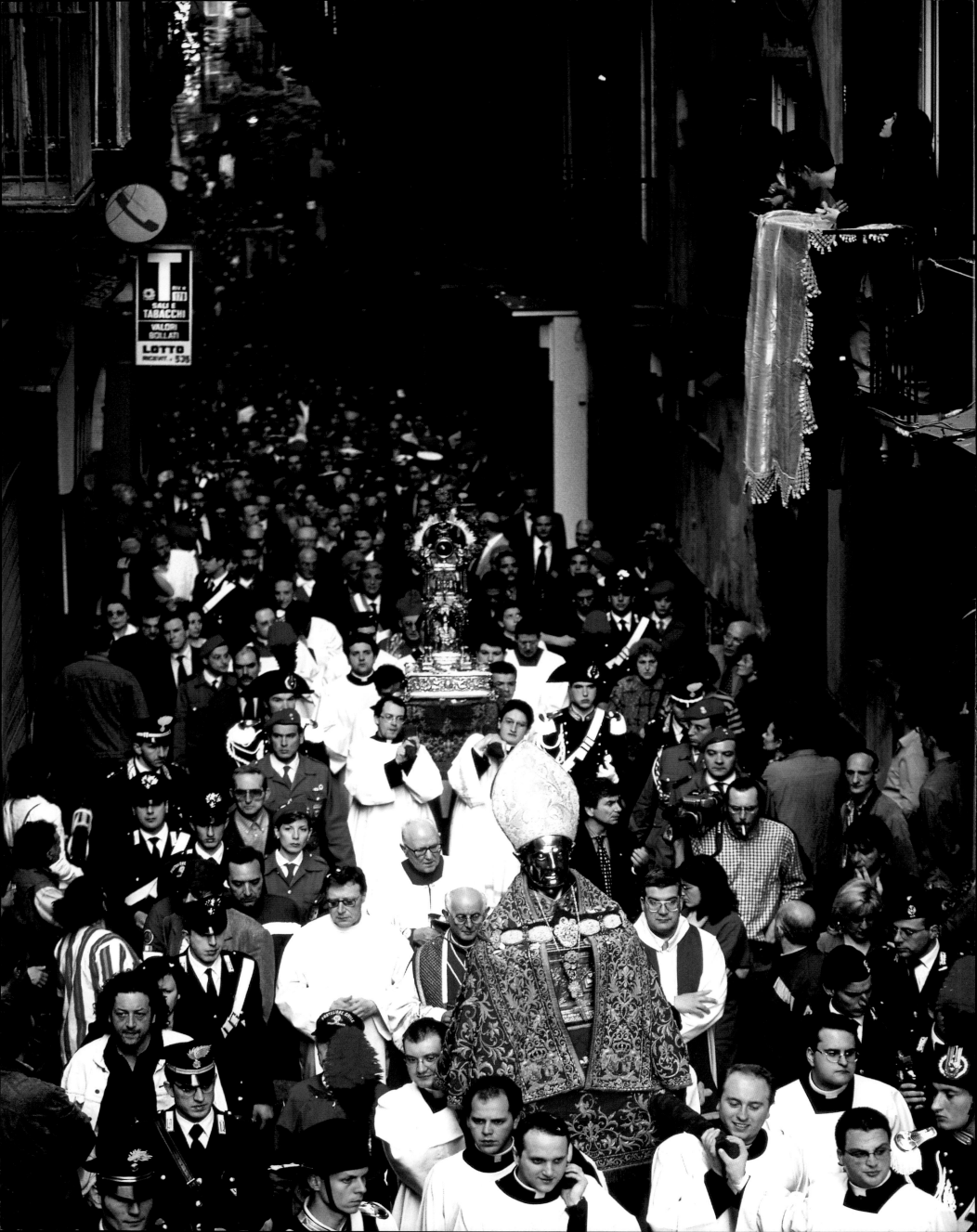

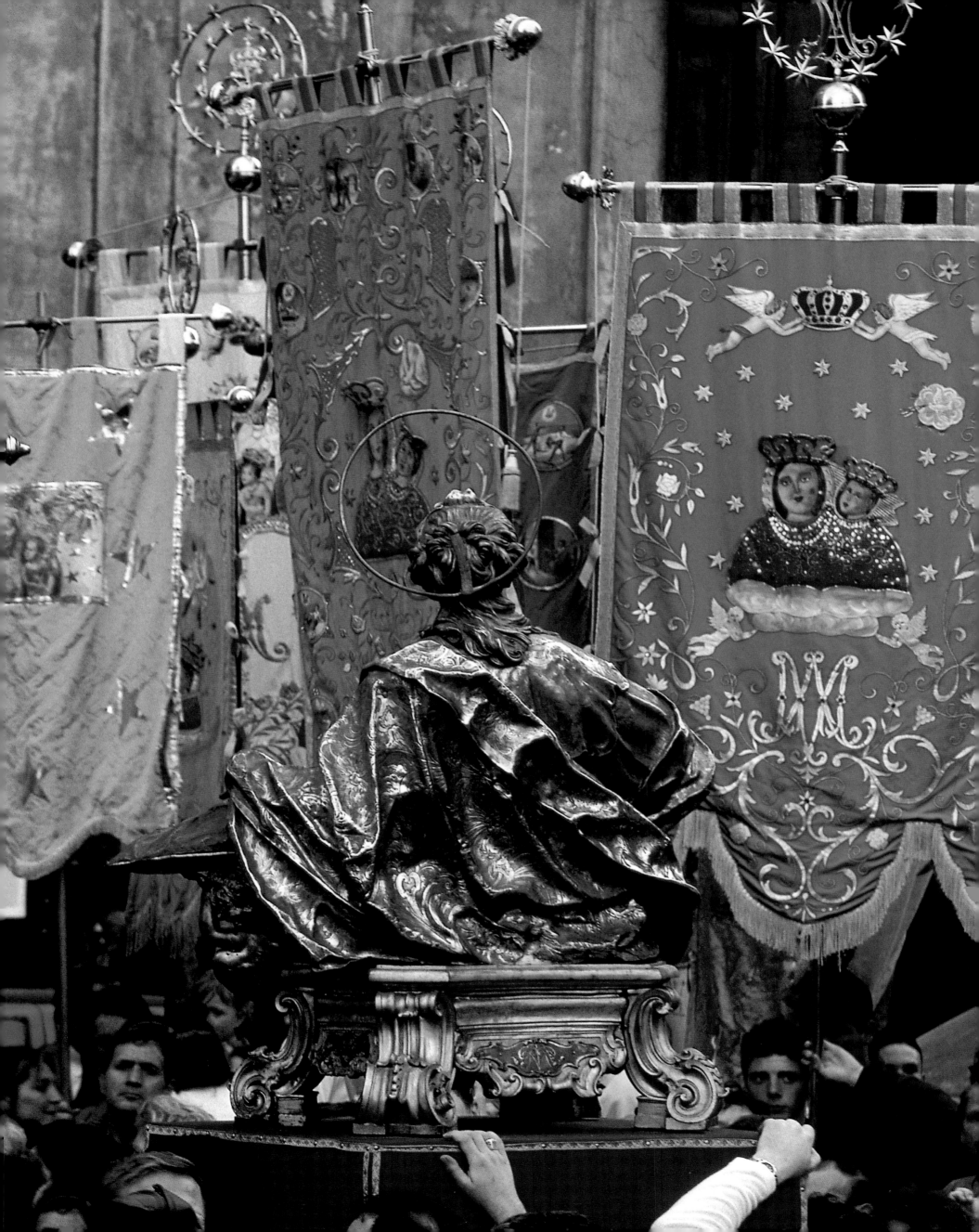

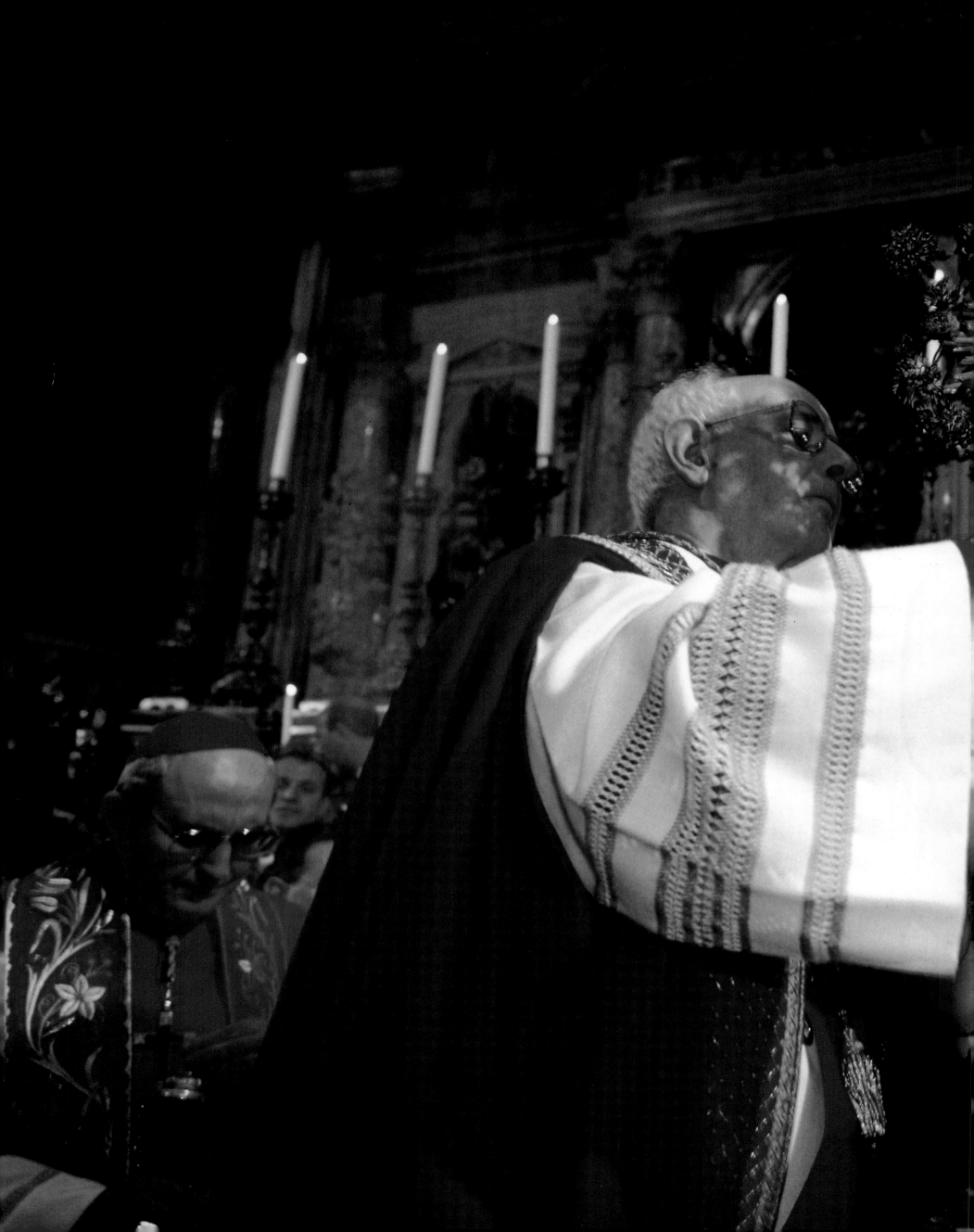

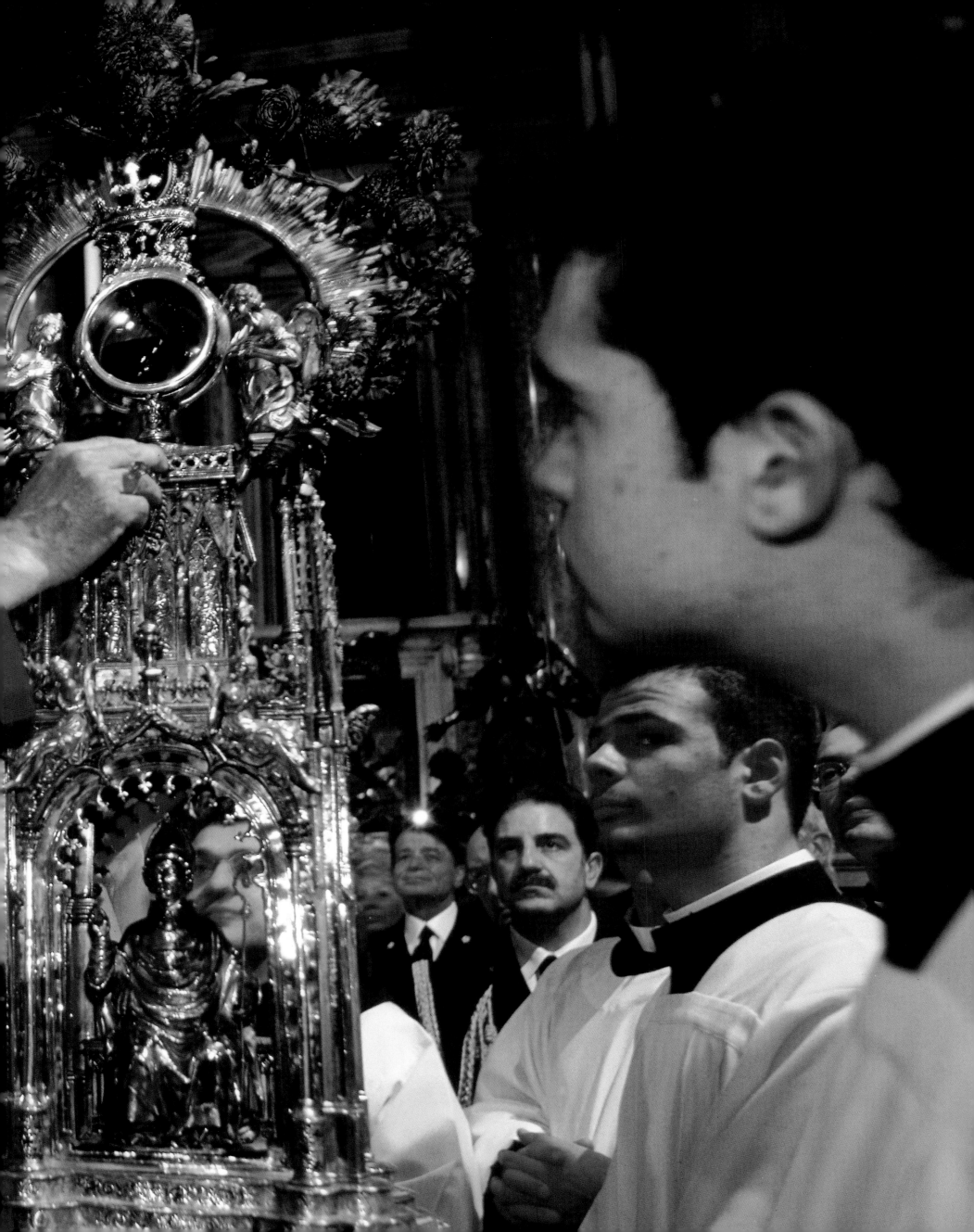

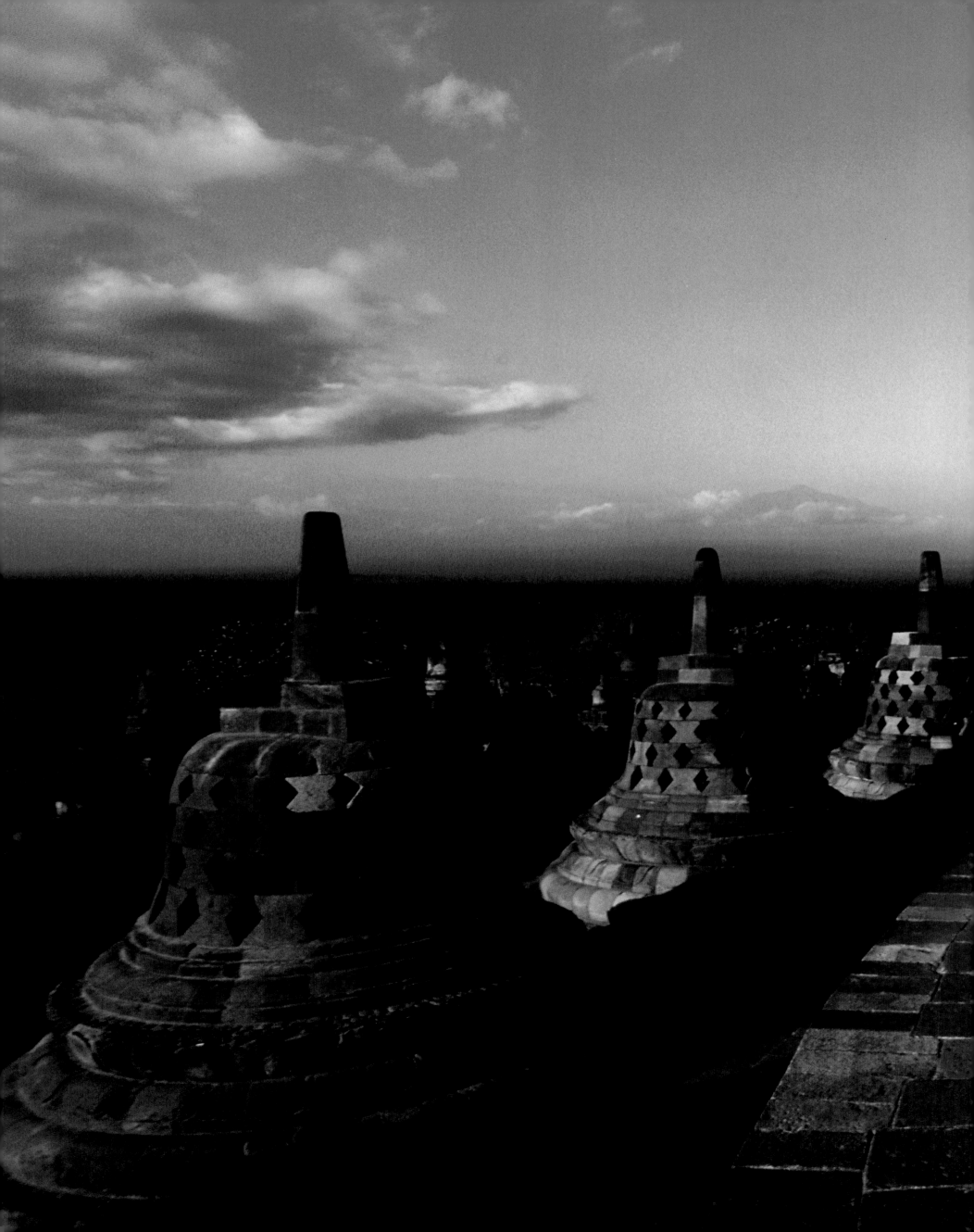

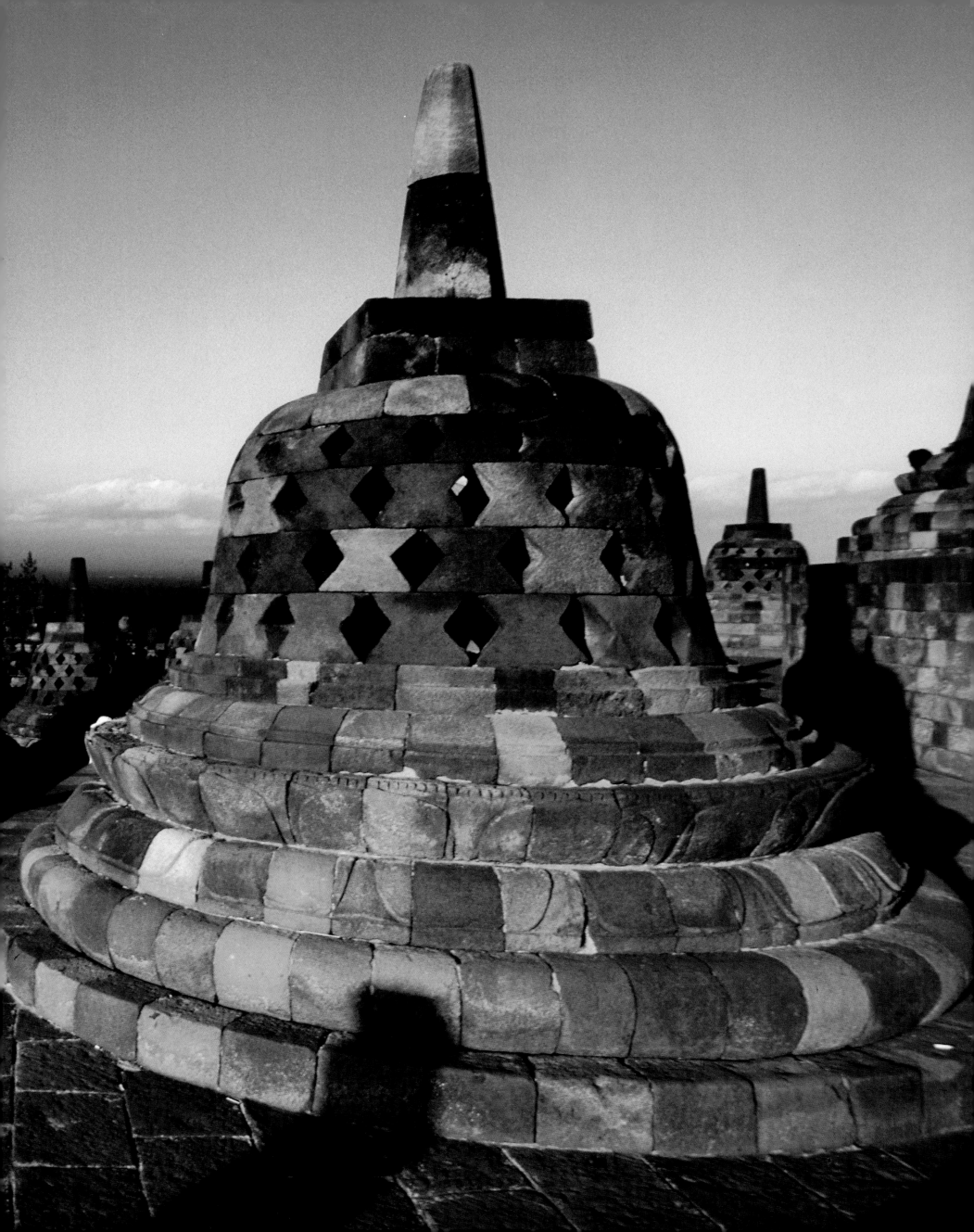

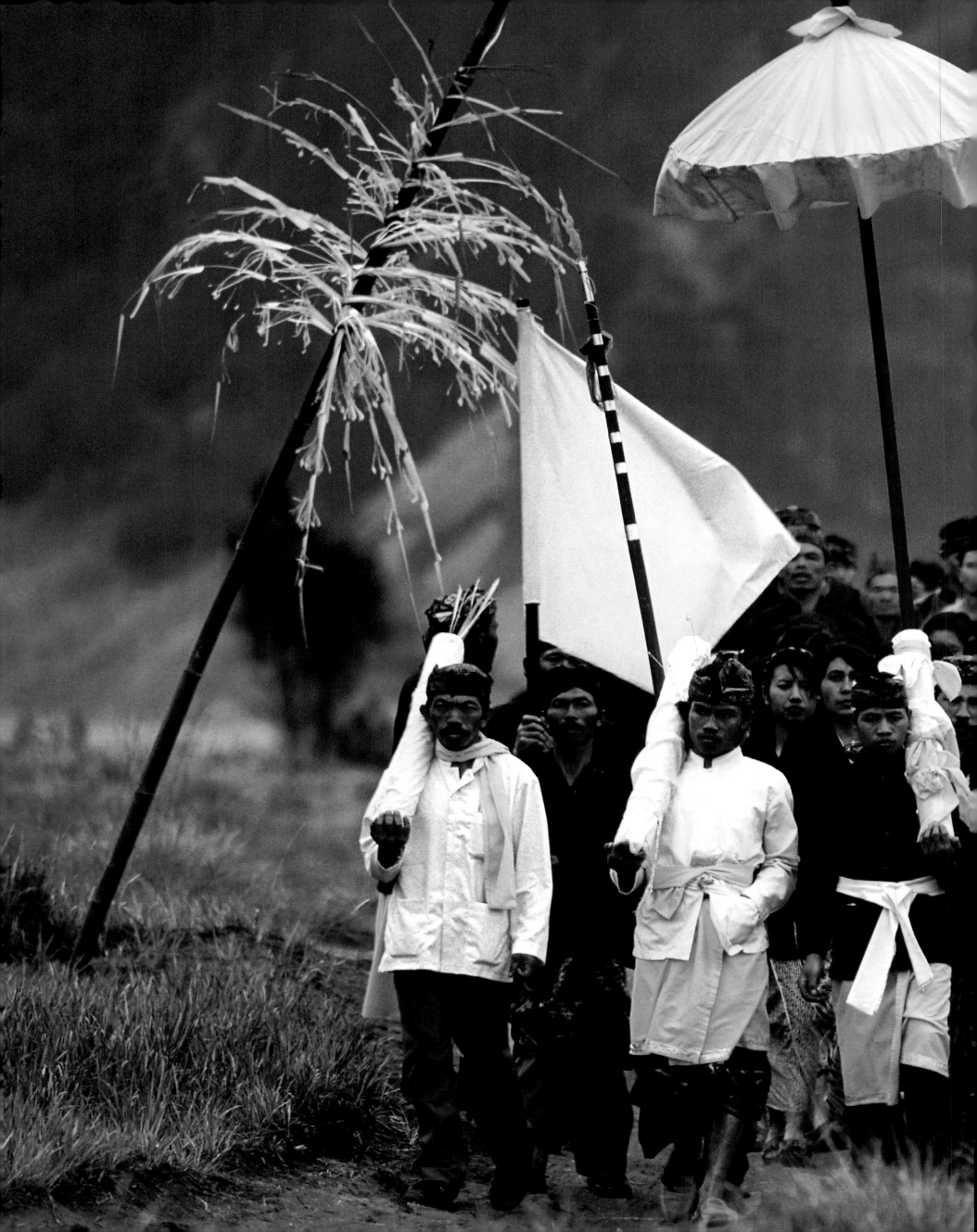

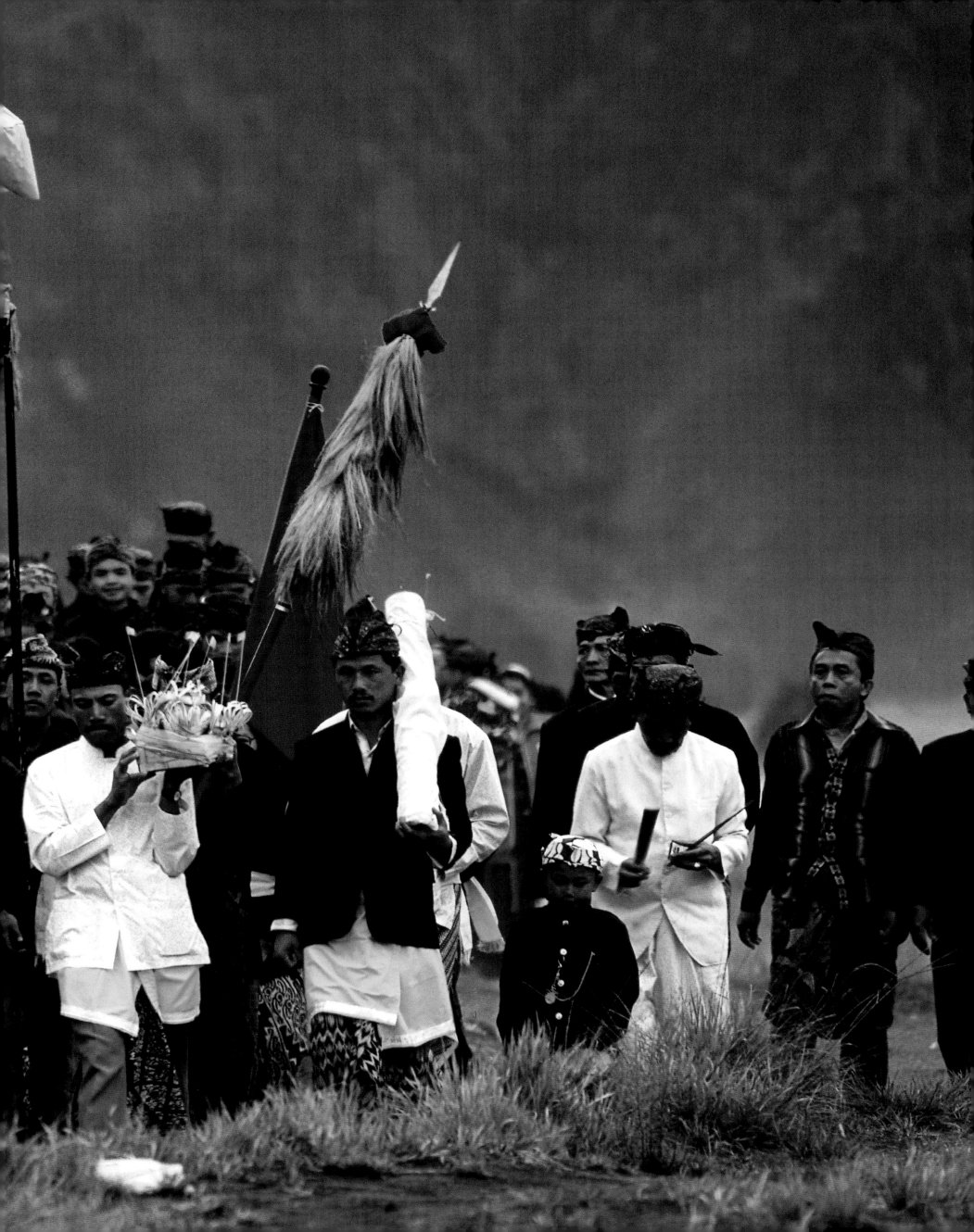

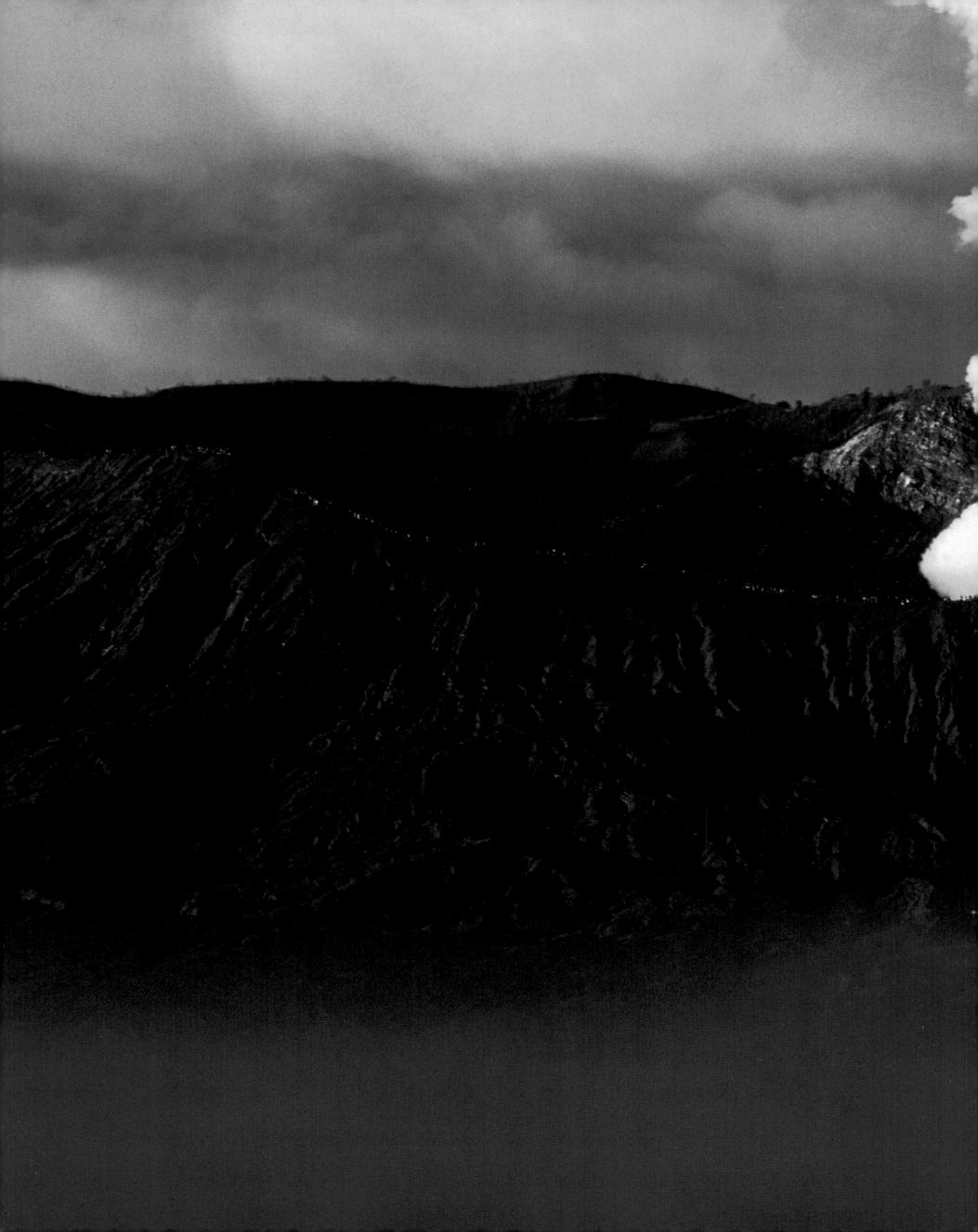

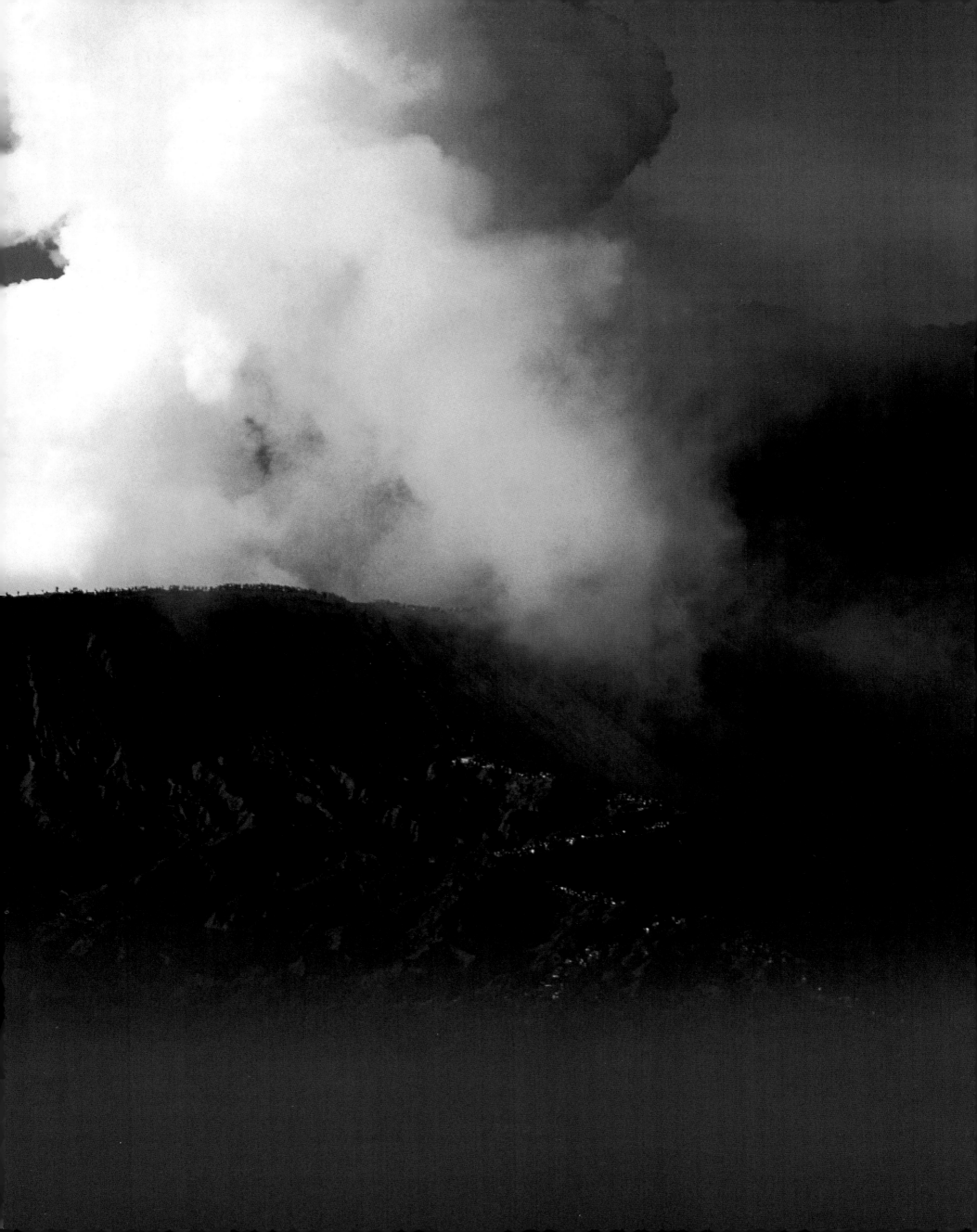

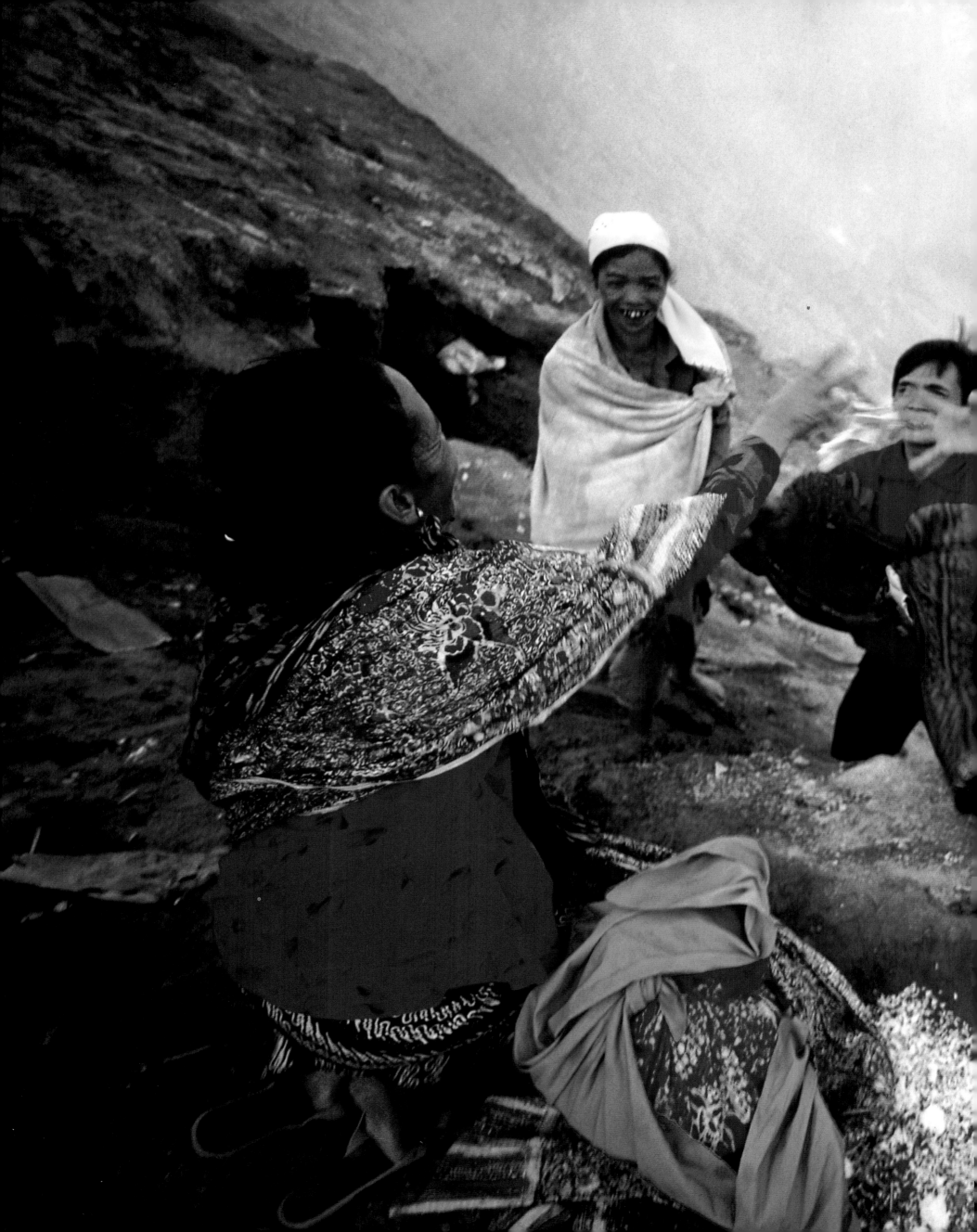

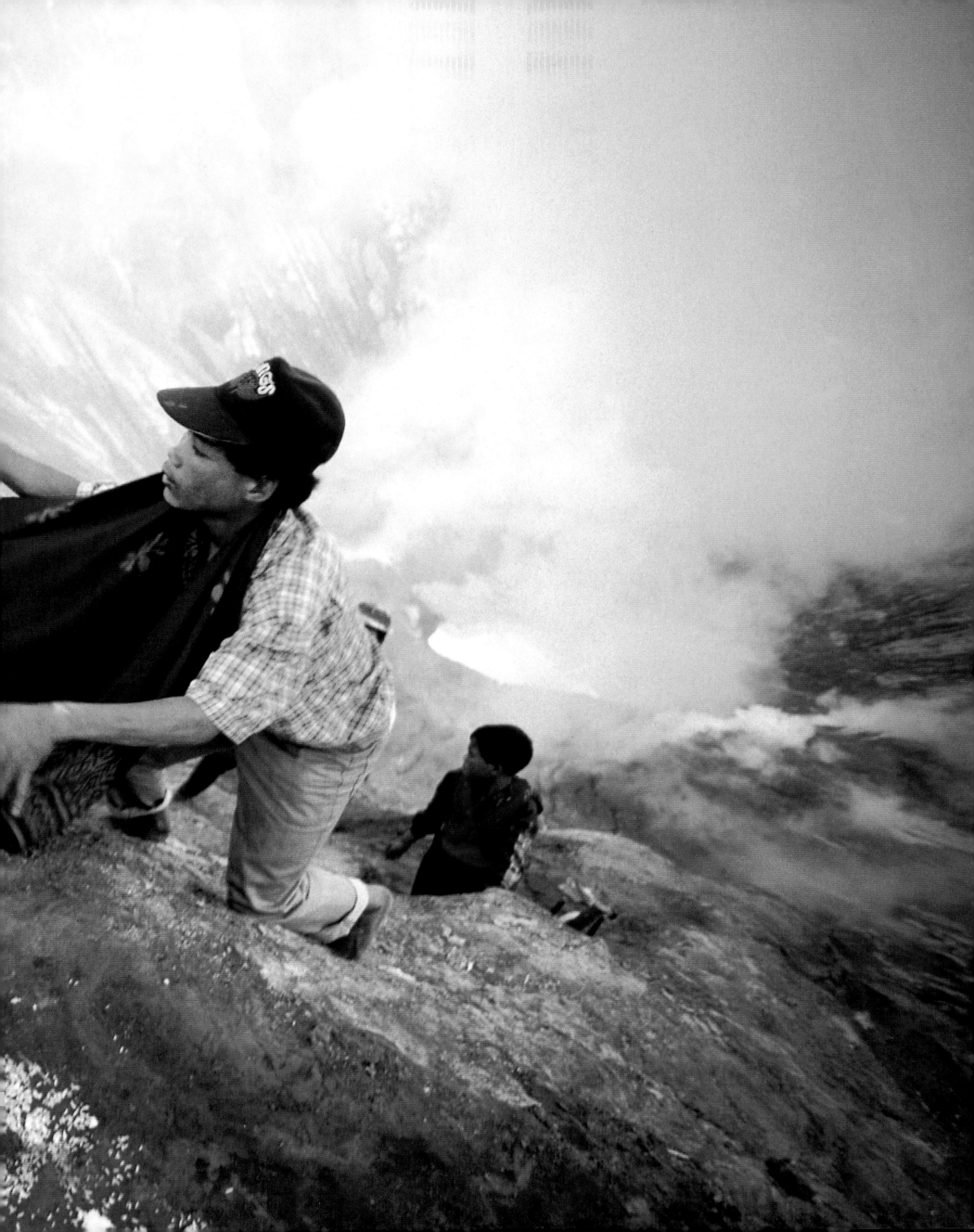

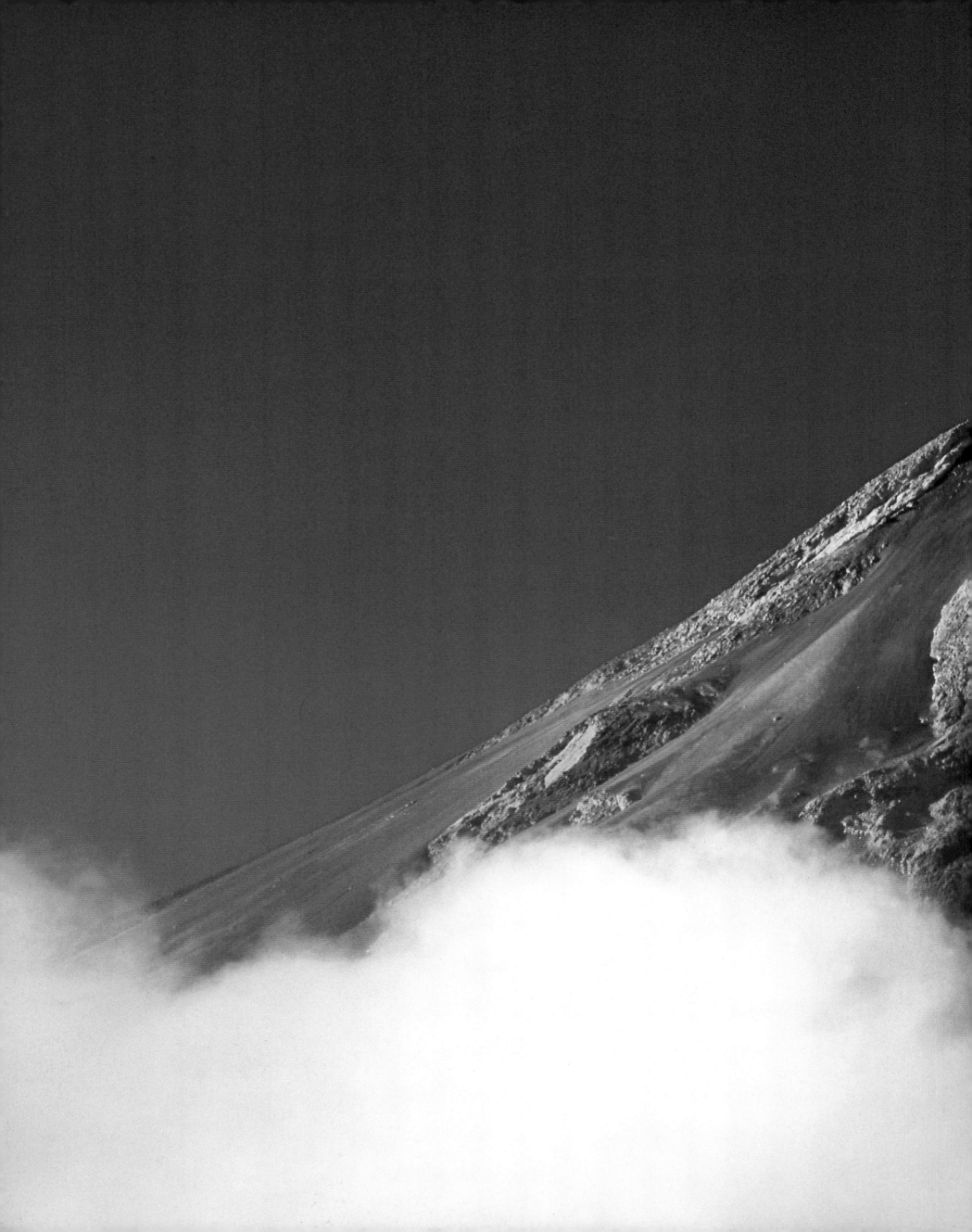

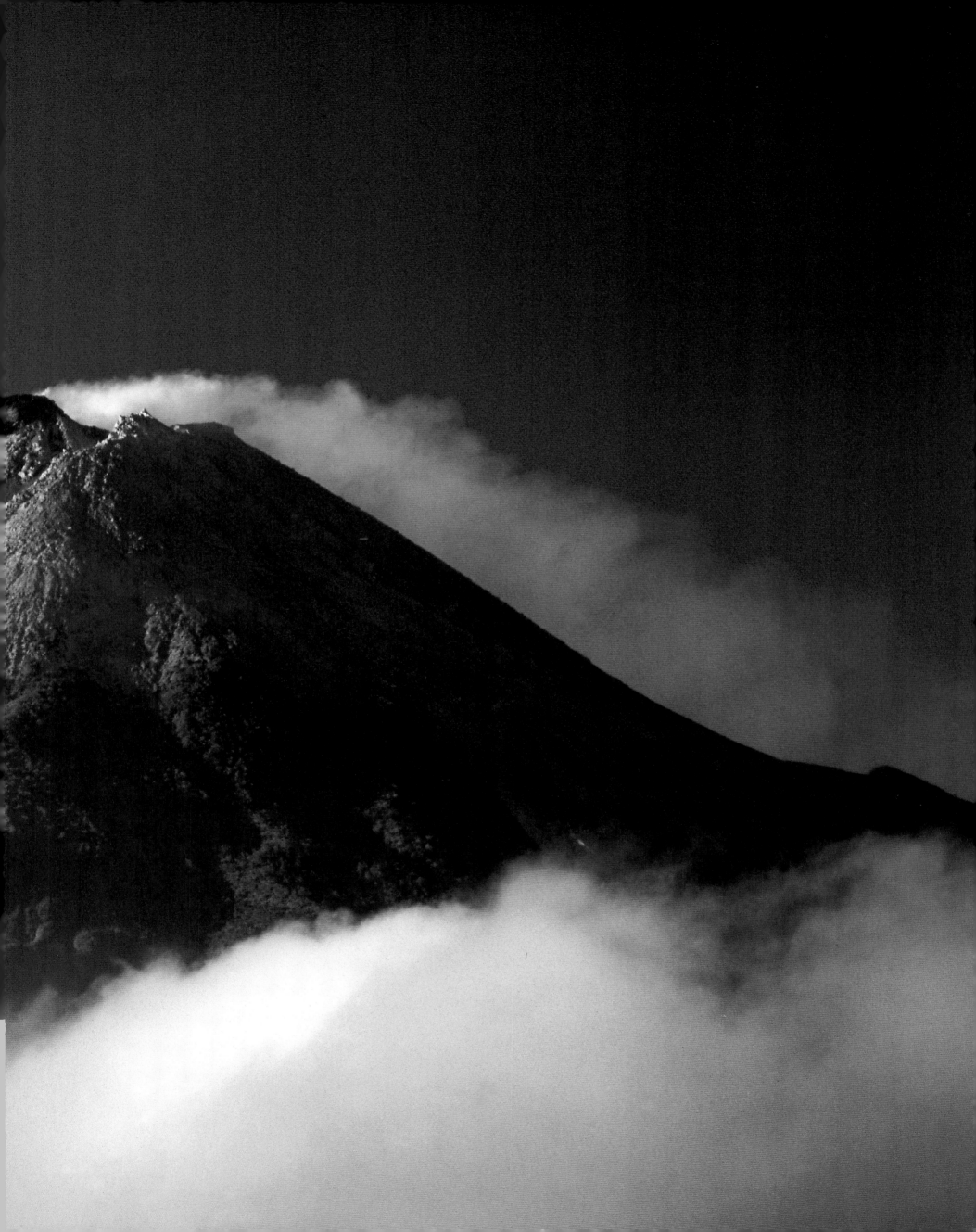

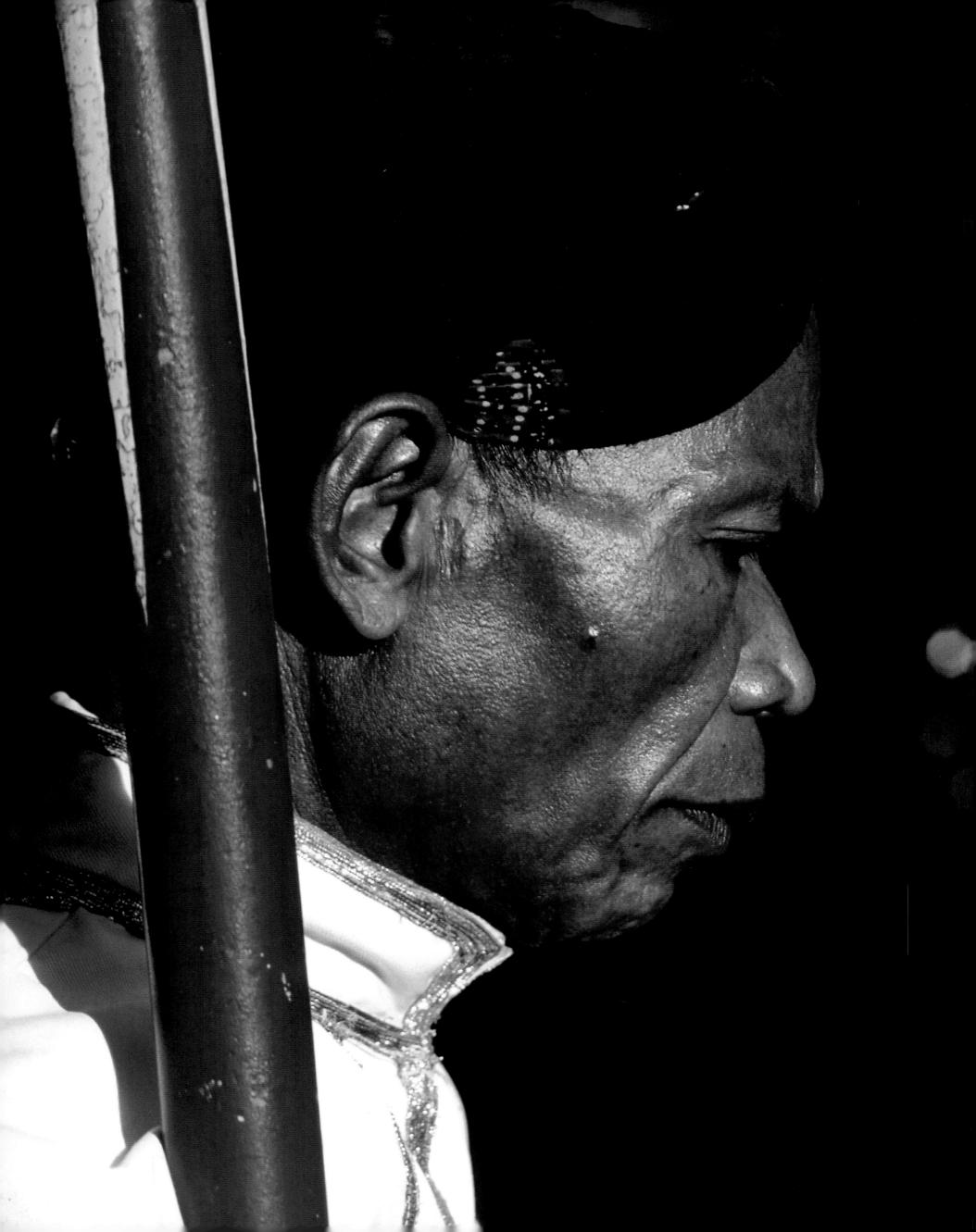

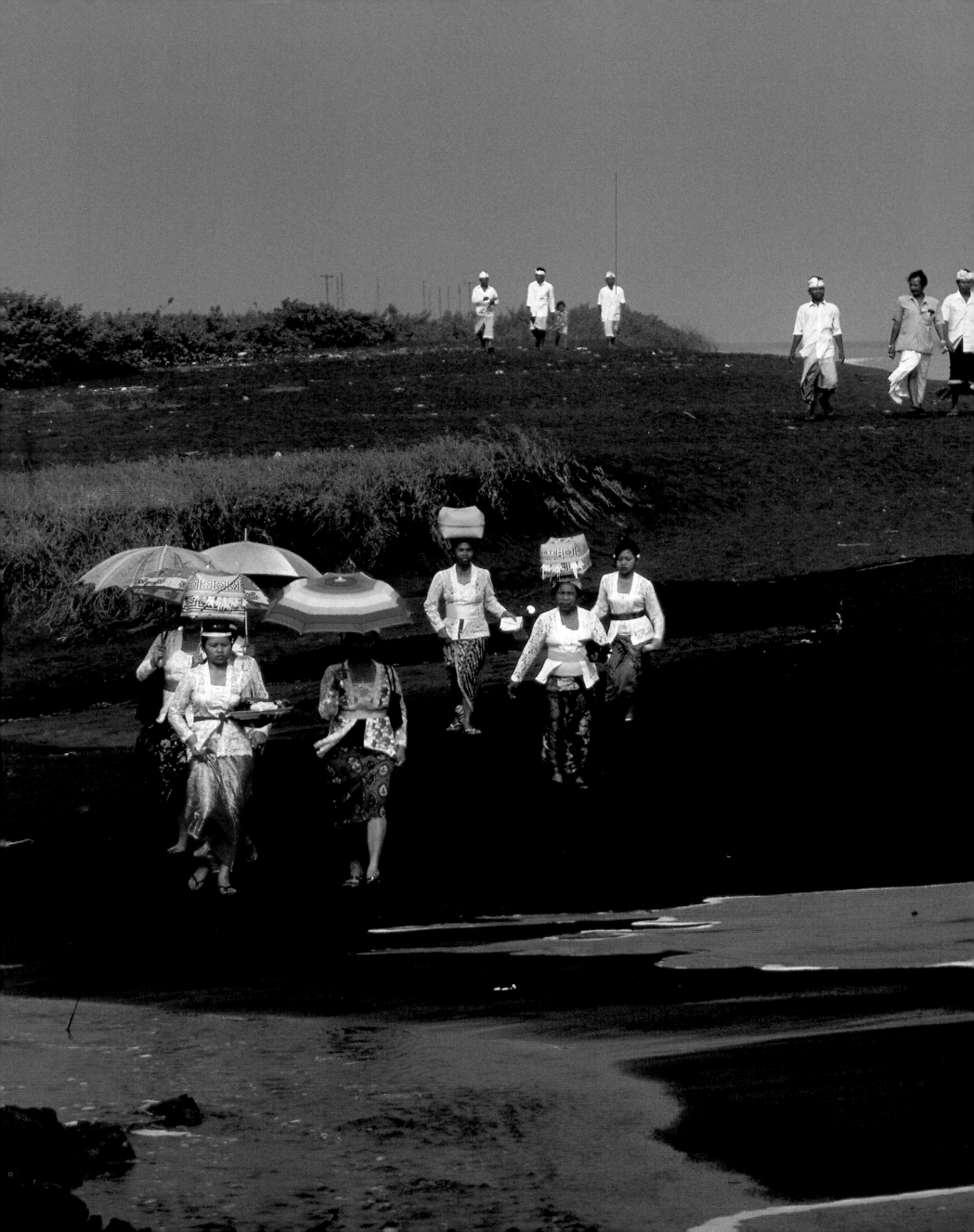

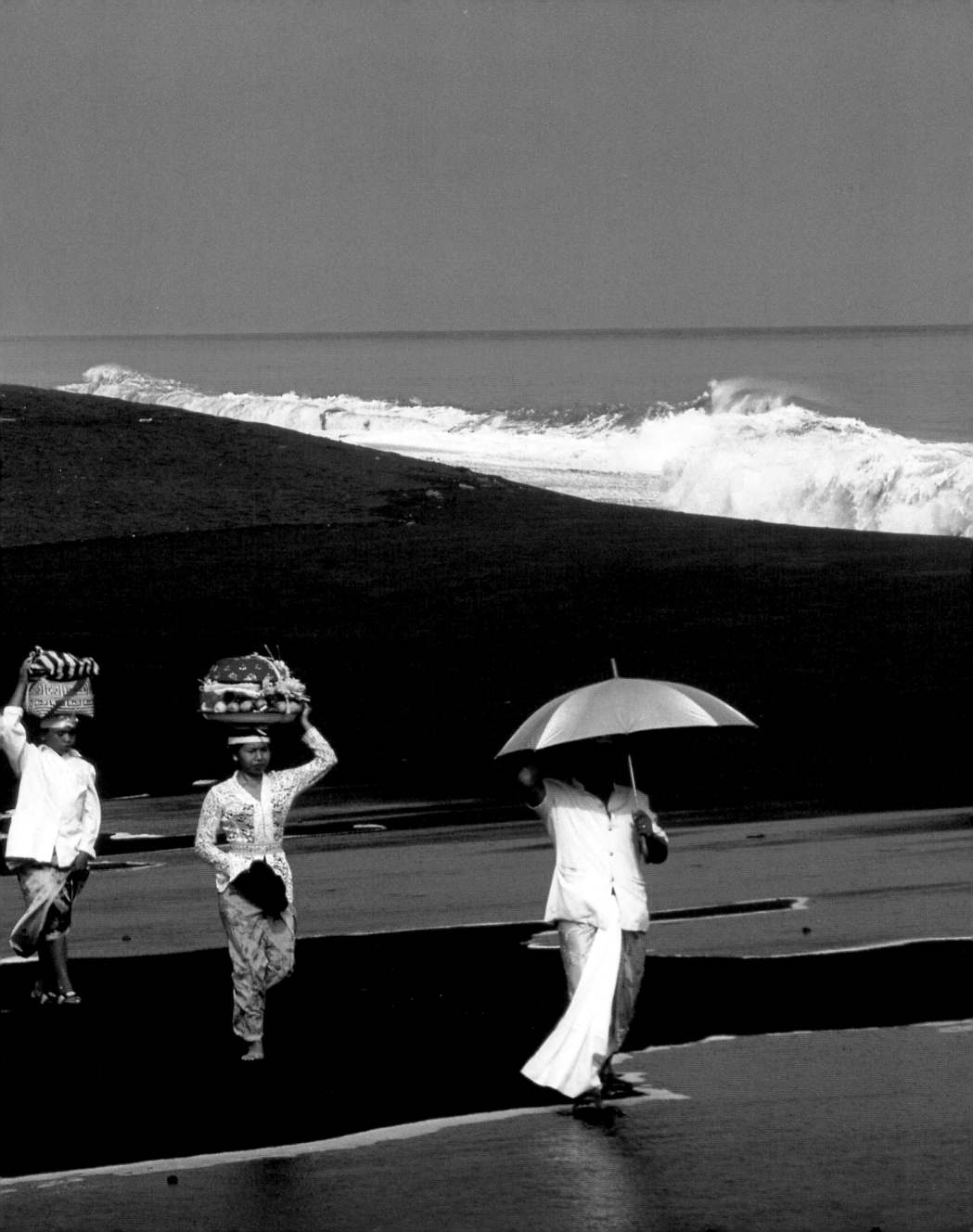

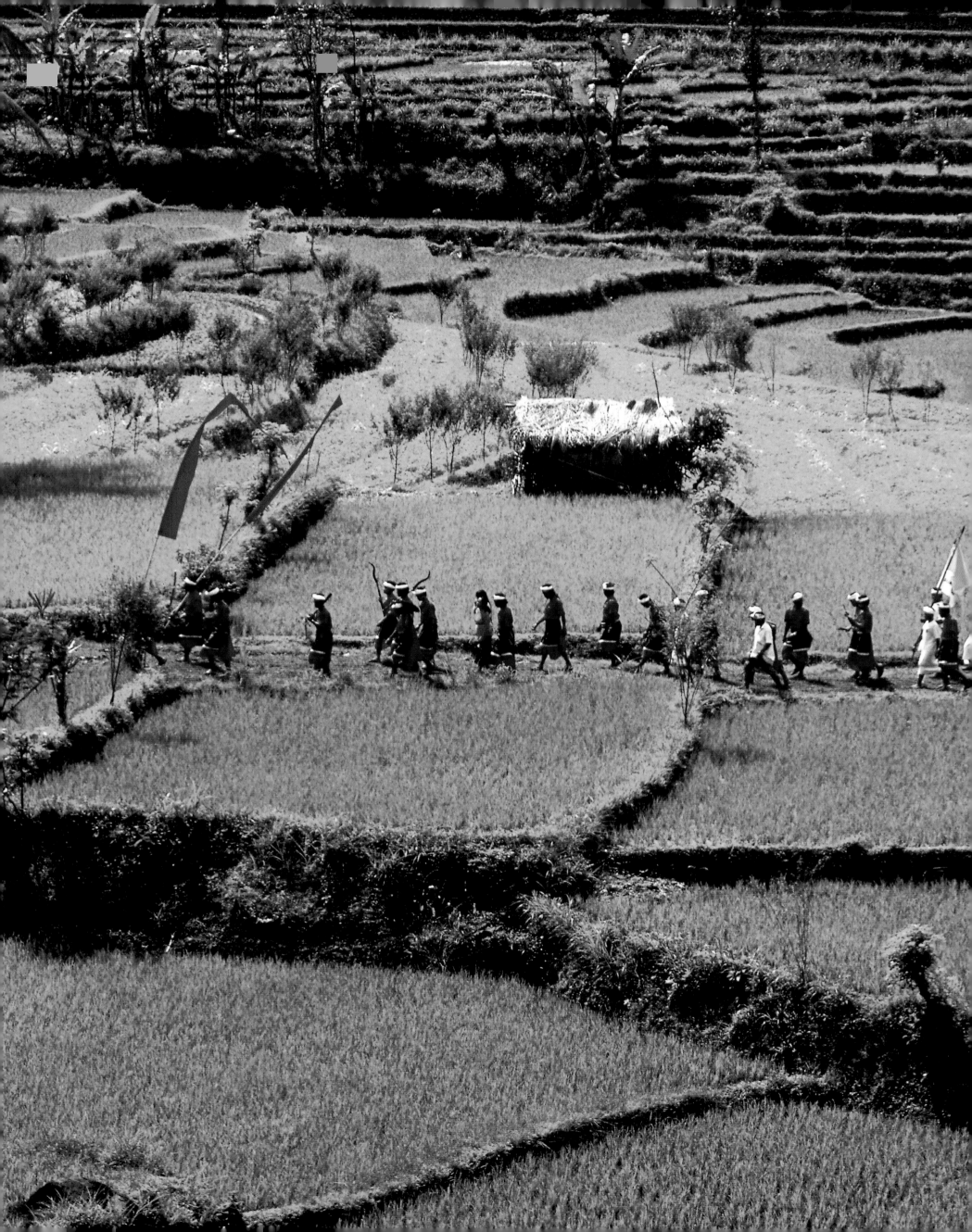

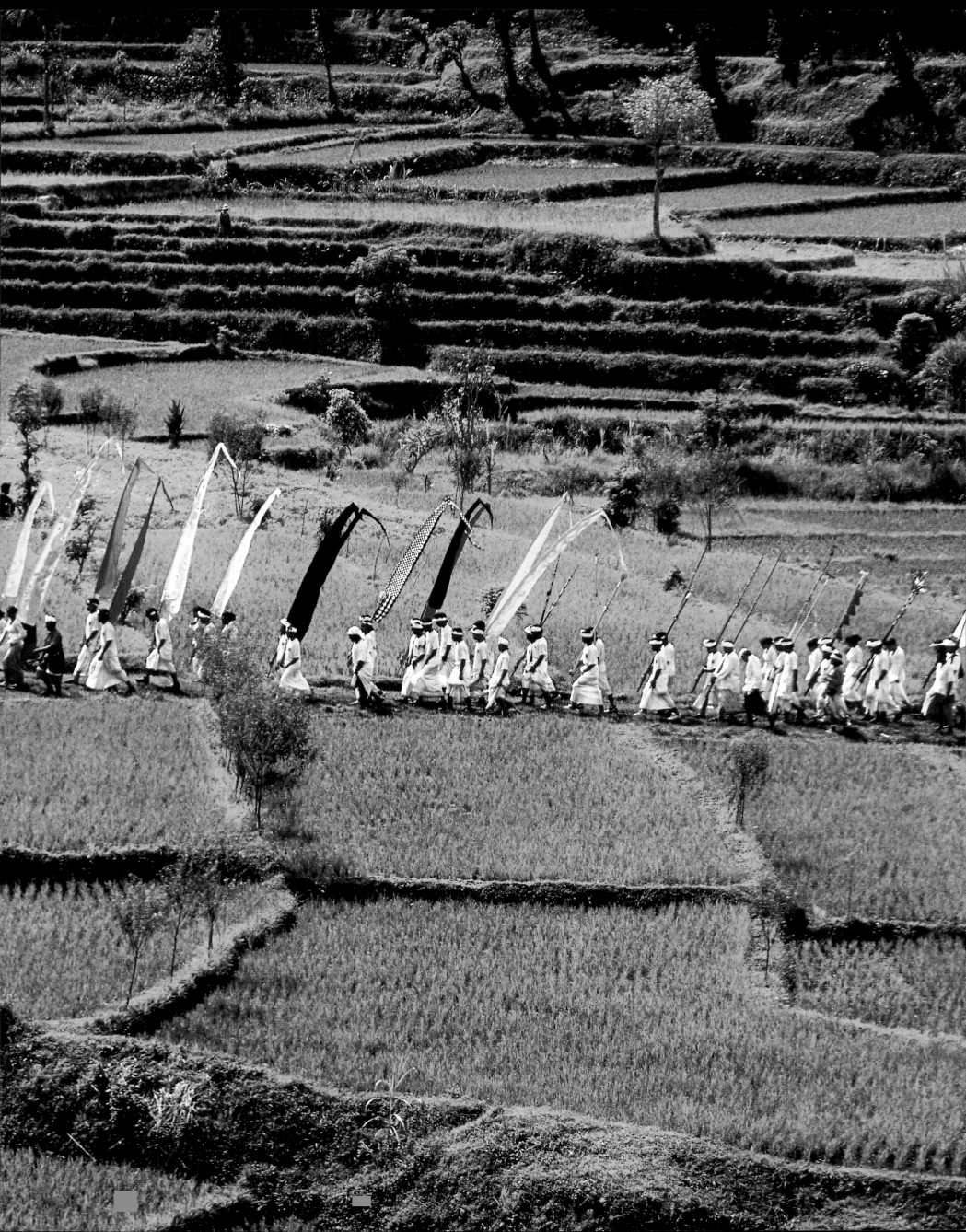

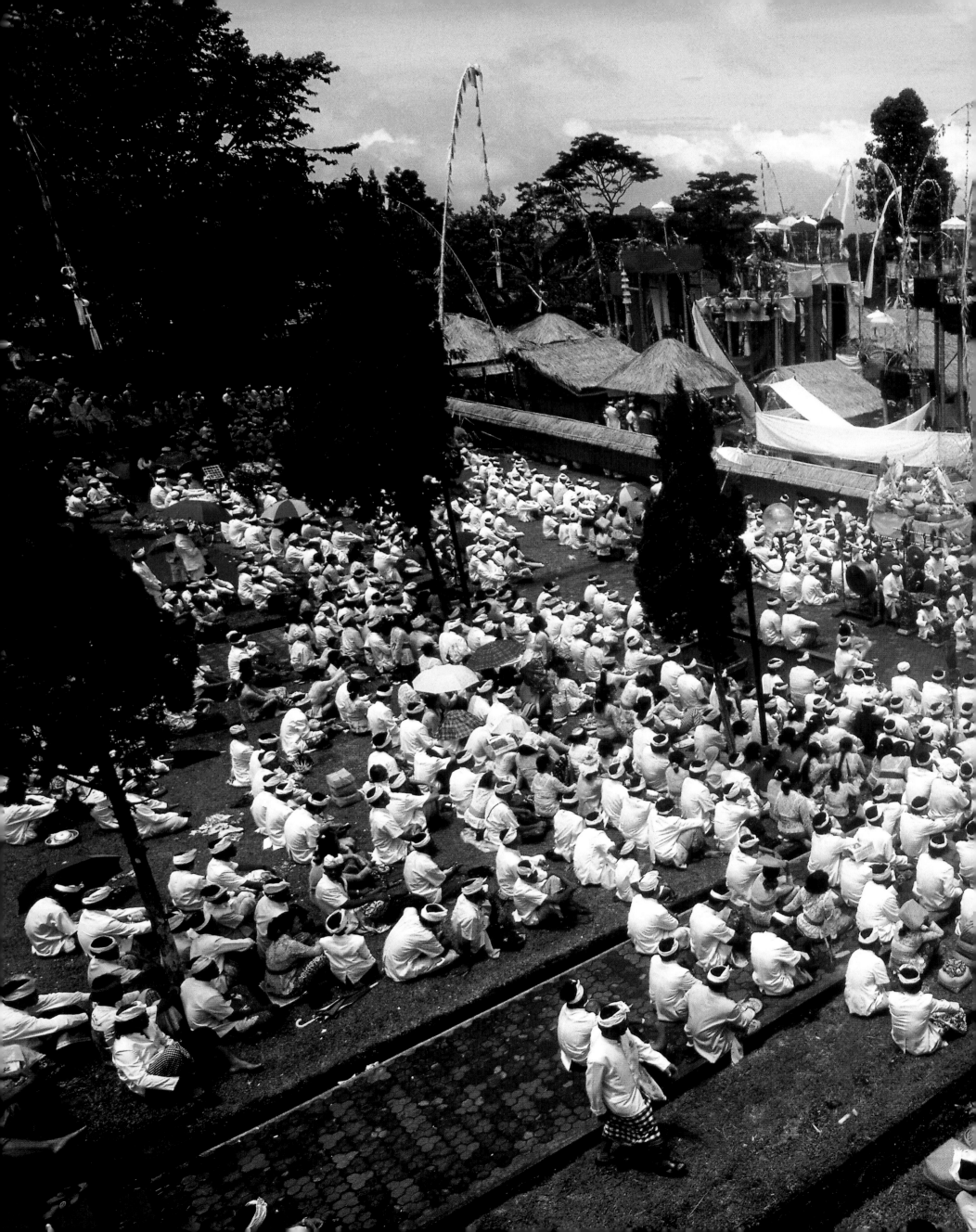

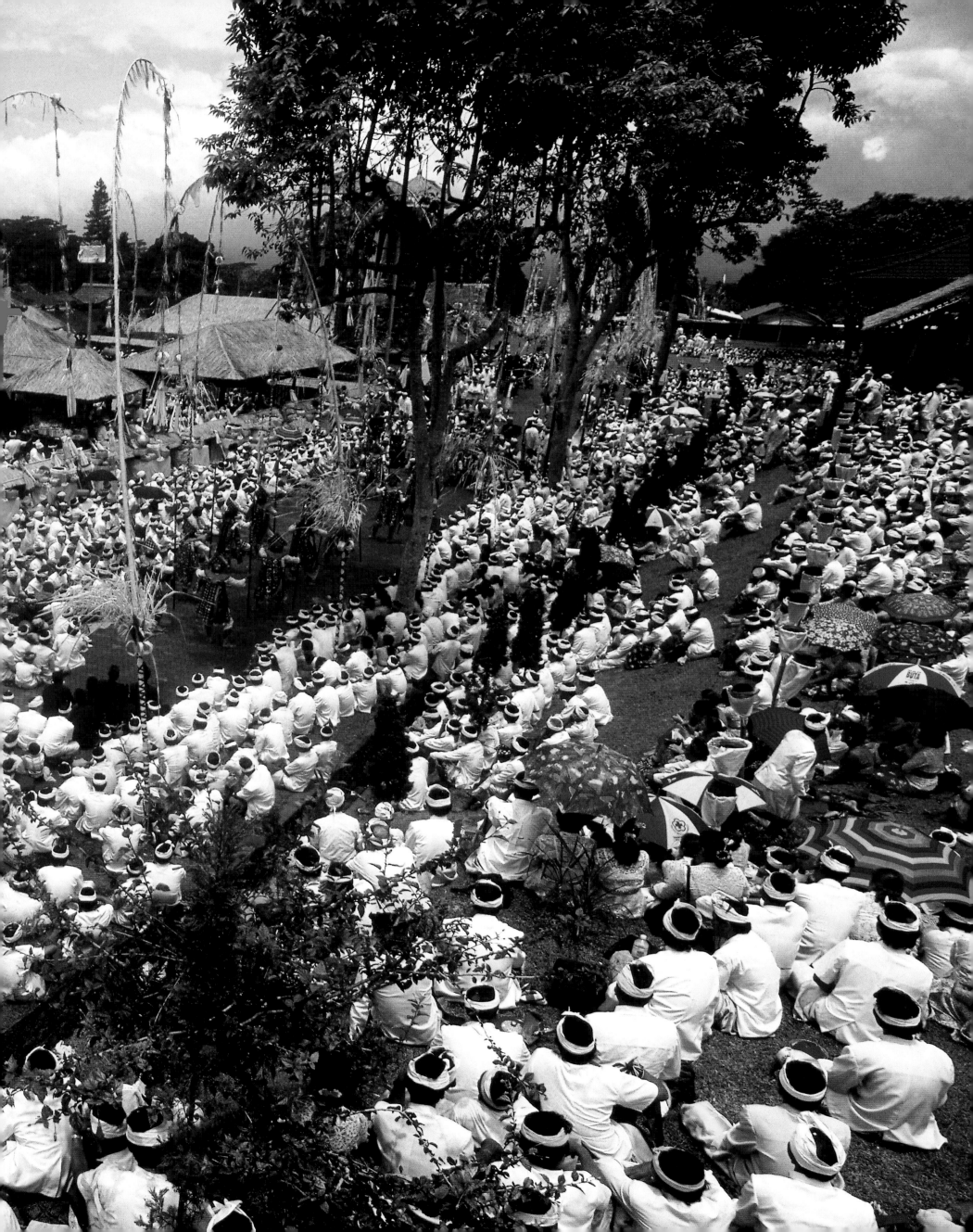

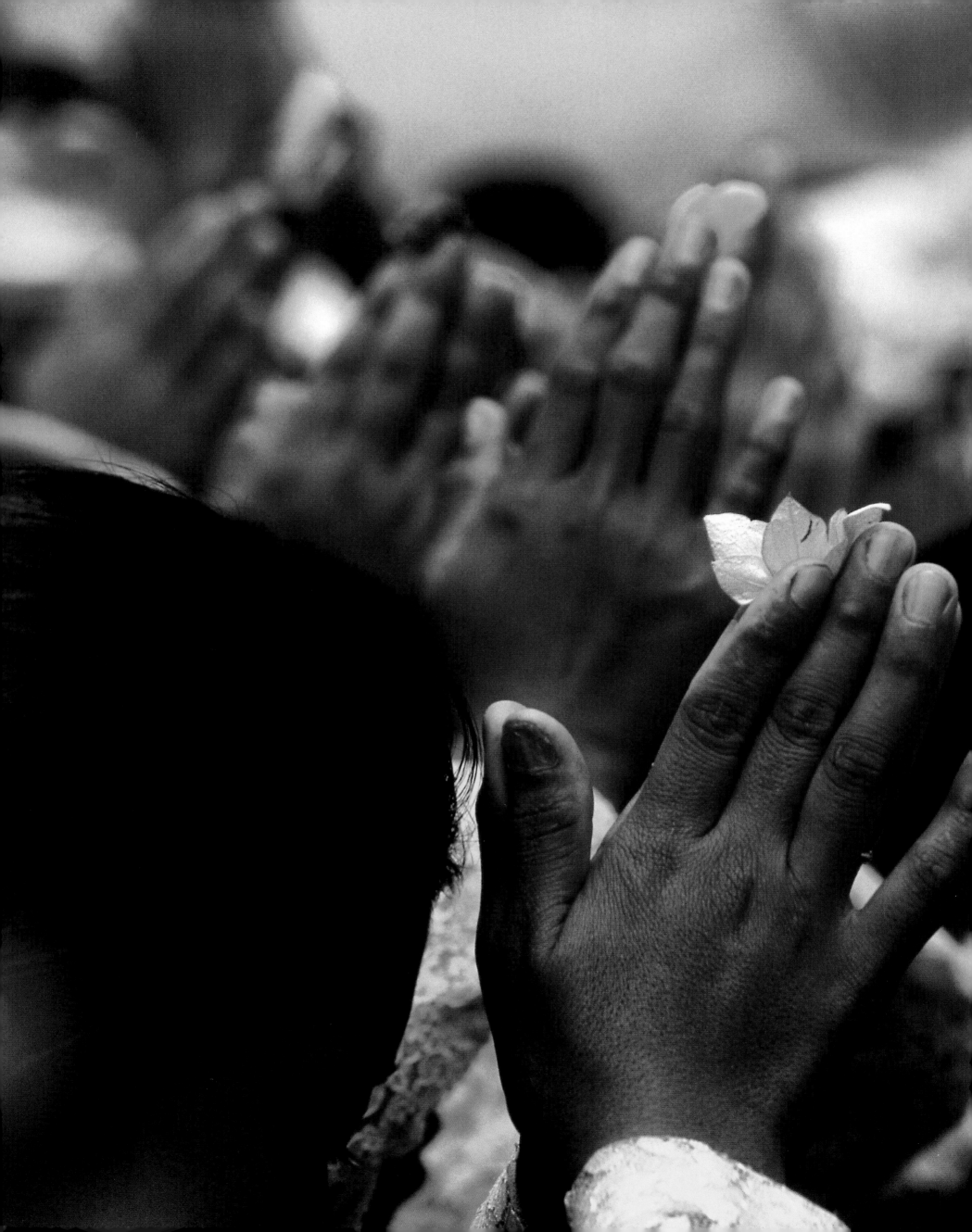

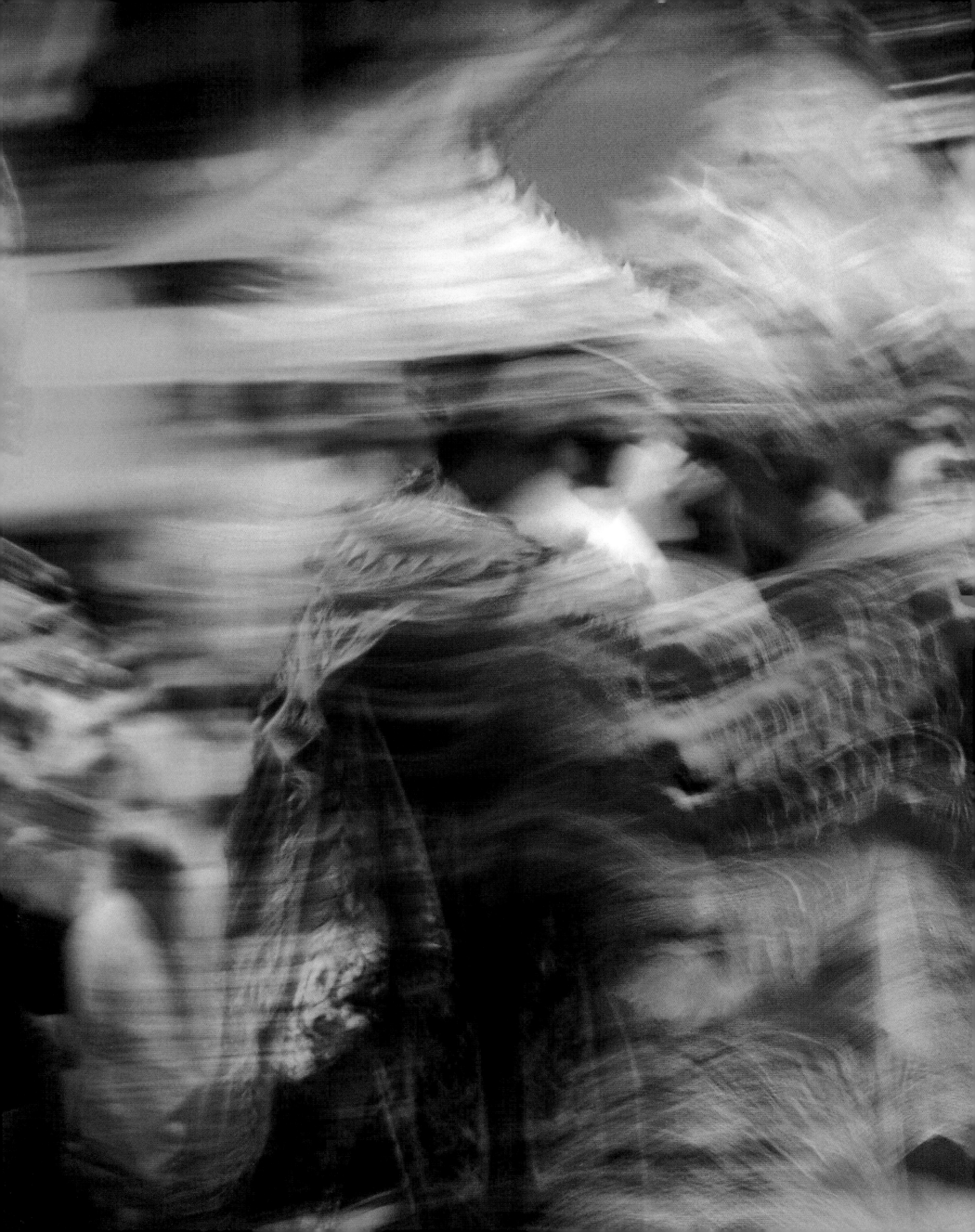

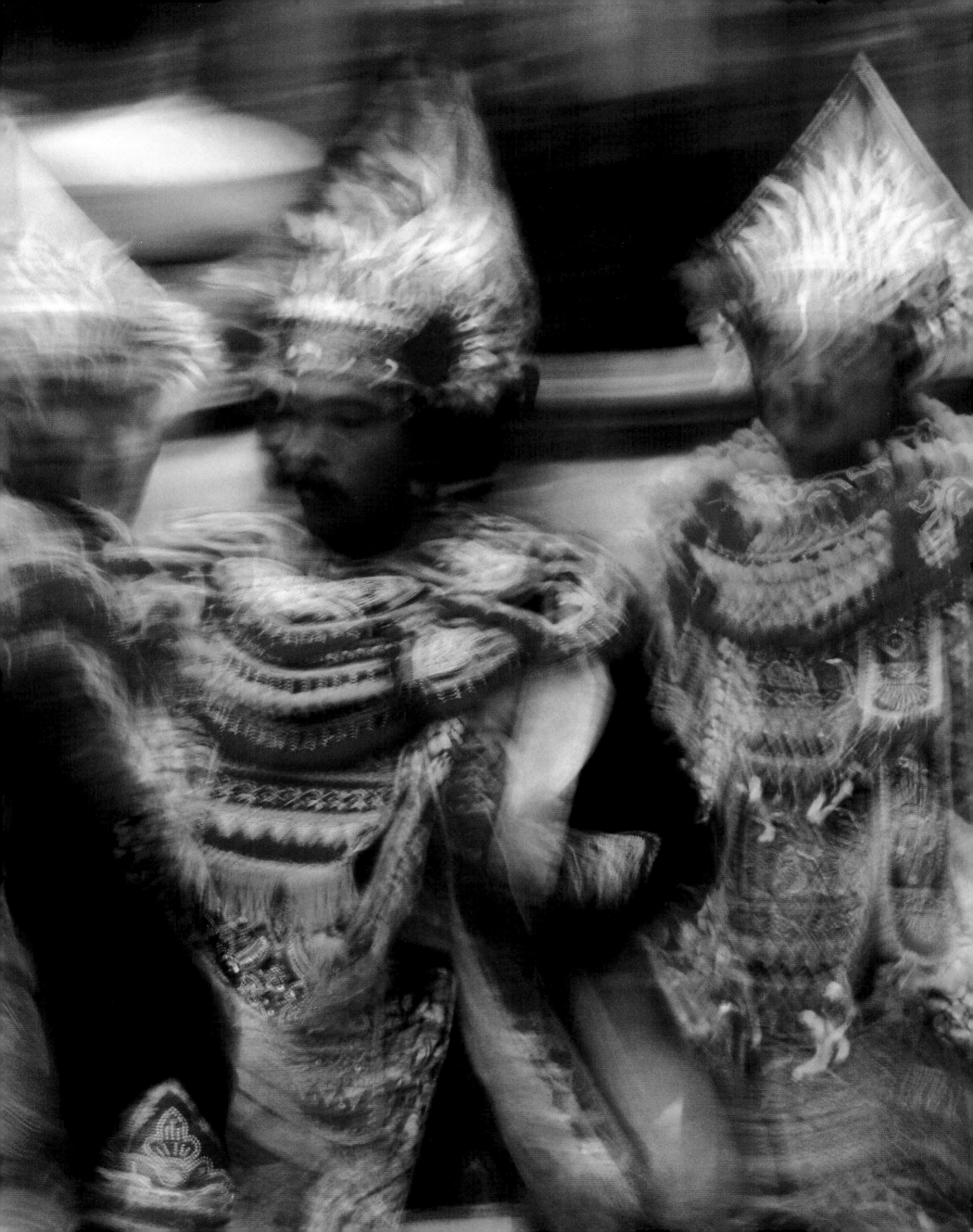

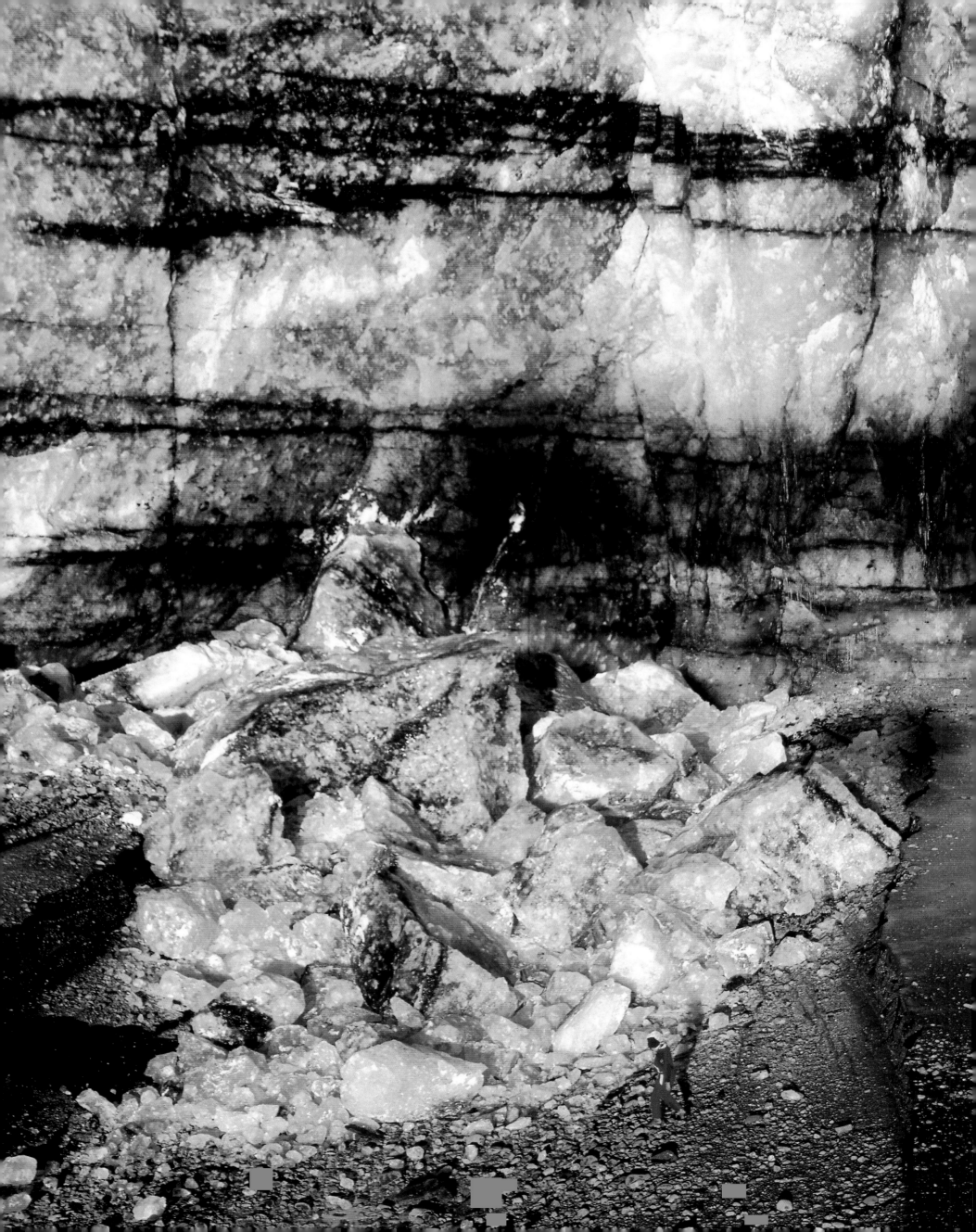

ERUPTIONS IN ICELAND AND RÉUNION

CHRONICLE OF AN ERUPTION IN ICELAND

1 October 1996

The first news came by telephone. A few days earlier, a violent seism had shaken the rocky base covered by the great glacier of Vatnajökull. There was as yet no precise interpretation, but as soon as the earth shakes in Iceland, the possibility of an eruption must be considered. Further information was transmitted on 30 September. The seisms were more frequent and were now followed by a tremor, a continuous vibration of the ground that characterizes lava emission. There was no longer any doubt: A volcanic eruption had taken place under the glacier. The news had a major impact on anyone interested in volcanoes and eager to follow their activity. However, the situation was not simple. A subglacial eruption does not necessarily show itself on the surface. Often, when the eruption is weak or the glacier very thick, no sign of the incident transpires except seismic signals captured at a distance and the eventual flooding of rivers that descend from glaciers. Such overflowing is fed by the melted ice from the eruptive action. The immediate question arises: What is to be done? The only answer is to wait.

By afternoon more news arrived. Icelandic volcanologists had flown over the glacier and observed the appearance of several round depressions in the glacier. These depressions formed a line more than three miles long, tracing on the surface the active eruption zone under the ice. This was interesting information on two levels. First, it indicated a possible fissural eruption, that is, eruptive activity spread along a fissure. Second, if the activity underneath the glacier was deforming it, the same activity could break through to the surface.

I learned that the Icelandic authorities had warned the relevant airline officials of the potential danger that this eruption could pose. The message stated that the next hours or days could bring an explosive activity on the surface, involving a cloud of vapor, ash, and gas that would be dangerous for airplanes. At the same time, highway traffic was likely to be disturbed by the possible flooding.

2 October 1996

Early in the morning we learned, thanks to an airplane flight over the volcano, that an explosion had just broken through the glacier. Visibility and navigation were extremely delicate because of the difficult weather conditions. But the observatories had been able to see clouds of black ash in the midst of a great panache of white vapor.

Since these weather conditions, according to Icelandic scientists, made it impossible to approach the volcano for now, I decided not to leave immediately but instead to keep an eye on developments and to prepare a more deliberate departure. My impatience grew by the day.

4 to 11 October 1996

Bad weather spread over Iceland. A few overflights still took place. The fissure had lengthened, and there was now no question that we were observing a subglacial eruption of the fissural type. On the surface, black clouds of ash were ejected from a lake formed by the melting ice. A river of hot water flowed under the glacier and was gradually filling up the subglacial caldera of Grimsvötn. Glacier experts tried to monitor the level of the ice that was gradually rising as the filling occurred. As soon as weather conditions will allow, they will set up a precision automatic GPS that will keep track of changes in the altitude of the glacier's surface.

If it is necessary to go on-site, we have to think of everything. Conditions in this season can be harsh: rain at the base, intense freezing higher up. One has to be ready for any situation. The decision has been made, and it is a departure for Reykjavik. All I can think of now is to get up there where no one has been before. I am sure it can be done.

12 October 1996

A day of total frustration. An amazing crowd of journalists fights for a seat on one of the light planes flying over the glacier. The one available helicopter is even more in demand. What's more, because of bad weather there is no guarantee of seeing anything once we are up there. The tension is clearly growing. The seismic signals are weakening and we seem to be approaching the end of the eruption. Everyone would like to take advantage of any clearing to go see what is happening at the volcano.

When good weather returns, the only available Cessna is in Reykjavik and the helicopter has broken down. Disappointment, even anger, drive most of the journalists away. We still have some Icelandic scientists hanging around and a filmmaker from Reykjavik. After the early days of euphoria, when foreign correspondents poured in from everywhere, we are pretty much alone now in Freysnes.

14 October 1996

Freysnes, at the foot of the great glacial tongues of Vatnajökull, provides some shelter for a few farms hidden against the cliff shielding them from the most violent winds. Here nature rules. Walls of dark palagonite enclose falls of serac from the glacier. Morains expire here in the *sandur,* vast, flat expanses of black ash through which rivers wind their way to the sea. On slopes beaten by wind and rain, the only vegetation is a layer of grass and moss. No room here for humans. And yet houses cling to the rock, and a family welcomes us in the small hotel that replaced the ancestral farm established here in the year 1200.

After all the mayhem of last week, total calm settles in, beginning with the volcano. The eruption has subsided, but not our interest. I have got to get up there, finally get close to this new volcano, sound this fracture that has opened in the heart of Vatnajökull. And most of all, try to get samples of this fresh lava. By telephone from Reykjavik I get the results of the first analysis of a handful of ash collected on the glacier when the eruption started. A very unusual magma, highly developed and not common in this type of activity in Iceland, was responsible for the eruption. We would like to know more, but that will require more samples. And

LEFT: Fracture in the front of the glacier showing, embedded in the ice, some deposits of ash left by earlier eruptions of Vatnajökull. Iceland.

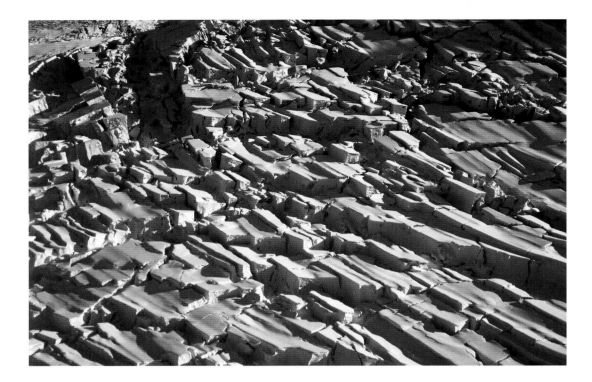

that means approaching the volcano once more, descending into the fracture to tear out a few pebbles from the new cone.

15 October 1996

The sky is half covered. The helicopter is still in Reykjavik. Jòn Björnsson, its pilot, says the forecasts look bad for the coming days, so he prefers to stay in Reykjavik, not wanting to be trapped by bad weather. In the afternoon a small Cessna plane reaches the gravel runway opened by a bulldozer in the *sandar* of Freysnes. A few breaks in the fog could mean a clearing up at the glacier. We take off.

As soon as it takes off, the plane heads for the glacier tongue of Skeidararjökull. This is where the mudflow should begin sliding. The glacier with its smooth surface is impressive for its size. Skeidararjökull is crossed in twenty minutes flying time, extending more than 25 miles. At its summit is a void—just white, uniform and without relief. Only up here do I become aware of the facts that I've known for several years. The glacier cap of Vatnajökull covers nearly 3,200 square miles. It is actually more like a continental cap, appearing almost level, but that is just an optical illusion due to its size; I know that several volcanoes deform it. Feverishly I look for landing spots. But we are still far away, apparently, and the GPS will take us straight to the eruption.

On arriving near the caldera of Grimsvötn, we see its rocky rim still emerging above the ocean of ice. At its feet the "hollow" is now filled; opened crevices all around in an area 6 miles in diameter show that the caldera's whole ice lid is rising, pushed up by the melting water accumulating in this vast basin. Sitting on the ice, the GPS of the Nordic Volcanological Institute, relayed by radio, is continuously monitoring the altitude changes. Today it measures 4,920 feet. According to glacial experts, this figure corresponds to the alert level, which means that the flood should now be starting.

After two wide swings around Grimsvötn, the plane heads again toward the north and the eruption. At first we cannot see much. Soon there is a crevice, then two, then three. It is downright chaotic. A subsidence zone of several miles has deformed the glacier. The crevices are almost all oriented on the north-south axis and caving in toward the center of the hollow zone, like enormous tilting dominoes. Between two veils of fog, it can be seen in its entirety. It is not perfectly rectilinear but zigzags a little, fairly typically shaped like a bayonet. Several vapor clouds rise from it; the

largest one in the northern section rises out of a black island. The volcanic cone has finally emerged from the lake of melted water, and a new volcano is born. All around the island is a wide river of black water, thick and viscous, filled with ash, that carries blocks of collapsed ice from the walls. The current draining the water toward the south and the caldera of Grimsvötn seems violent. Then we come back toward the cone, which draws our eyes to where we have to go.

Of course it seems impossible to reach it overland. Not only would it require two long days' walking to get there, but the crevice zone also seems uncrossable to me. Even if we got there, we would also have to descend the vertical, unstable walls of the eruptive fissure. The only possible solution is to arrive there by helicopter.

At the last minute, out of the corner of my eye, I notice what seems to be a colored spot that is moving on the glacier's surface. It is actually another airplane, flying low over the crevices. Until now I had been fascinated by the beauty and strangeness of the eruptive fracture, but suddenly I grasp the extent of the phenomenon. Until then I had been in a world without points of reference, without scale. The small plane barely perceived below has just made me realize the immensity of what I am seeing. The dimensions, 3 miles long, between 650 and 1,650 feet wide, 1,300 feet deep, begin to make sense. Now I look at the new volcanic cone with much more respect. No matter—I'm still going!

Back in Freysnes I telephone Jòn in Reykjavik. He repeats that the weather forecast is bad and that he feels compelled to wait, adding, "Don't worry, I'll get you there just as soon as possible." Burning with impatience, I am expecting a long wait.

16 to 27 October 1996

After Freysnes slowed down its agricultural work, landowners built a small hotel, typically Icelandic in style—very simple, extremely clean, more functional than hospitable, very large and well heated. That's where I wait for twelve days.

Outside, a leaden sky won't quit, gray and black, with wind, glacial rain, and partially melting snow—without a break, from sunrise around 9 A.M. until sunset at 4 P.M. At first everything looked fine. We had to expect a day or two of bad weather, at most, which seemed an ideal period in which to really get ready. We organized our days logically: 7:30 A.M., breakfast; 8:30 A.M., measure the level and composition of water in the rivers. Normally the variations in these figures indicate the imminence of a flood. The GPS at Grimsvötn shows a steady rise of about a meter each day. Estimates are revised, so that the cutoff would now be 4,936 feet. The high point of each day is the weather report at 7:45 P.M. Fortunately the maps tell the story, since we do not understand Icelandic. There is an atmospheric depression on Greenland, another over Scandinavia, one below Iceland, and we are smack in the middle. Bedtime at 8:30 P.M. Tomorrow's another day, and we can always hope.

Days go by . . . time drags on. The weather maps seem to promise an improvement in the next few days so Jòn decides to bring the helicopter from Reykjavik to Freysnes. He arrives late in the afternoon. We will set up a schedule, down to the minute. There will only be about 40 to 45 minutes on the eruption site. Bags are packed for the hundredth time, and I'm readier than ever to get going.

Next morning, the sun is still not up. Lying in bed, I mentally review all the upcoming activity and the various steps that will finally get us to the volcano. The Goretex suit and the large furs are folded at the bottom of the closet, in the exact order they will be put on. At the foot of my bed are shoes in plastic shells and garters, a pair of gloves and a hood for the suit. I go to the window to reassure myself that it really has cleared as promised. But it is raining and fog covers the glacier. And so the wait continues, day after day. Always the same routine, the 200 square feet of my room, trips with the scientists to take soundings in the immovable river, the meals, the weather report and news on TV, our mutual encouragement. We have to hold on—one day of good weather is bound to come.

28 October 1996

Good weather was forecast for the weekend. Today, Monday, will be bad again. But at 7 A.M. the sky is totally clear. I waken Jòn, who is somewhat surprised by this early call, since we normally can't take off before 10 A.M.

We refuel the helicopter, de-ice the propeller with warm water, take several readings, and finally get on board. Contact: the engine begins to growl, the propeller reaches its normal rotation speed. At last we take off.

The lower part of Skeidararjökull, an acceleration zone of the glacier, is deeply marked with crevices. Higher up, its surface is more uniform and is covered in snow, following the bad weather of the last few days. It is a strange sensation to navigate in the clear, pure air of this morning, realizing that just below us, under the immaculate, scintillating ice, tons of hot, muddy water are slowly making their way toward the *sandar*.

We are at 4,900 feet. We reach Grimsvatnfjall, the rocky cliff emerging from the ice that marks the southern edge of the great

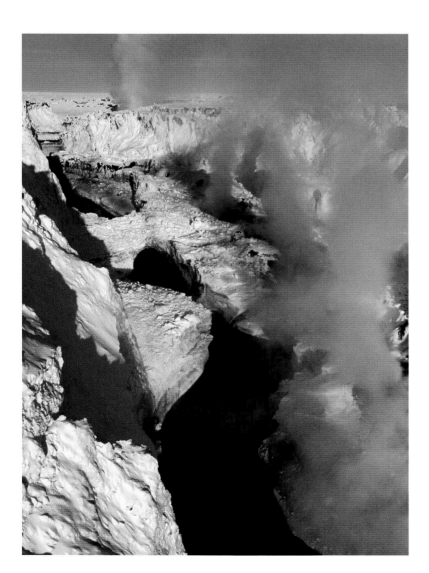

caldera of Grismsvötn. We set down swiftly to remove the helicopter door, to allow more elbowroom for our operations. The temperature change is brutal. A glacial wind beats through the opening of the craft, and we close all the vents. Gloves, hood, suit are on and buckled all the way up.

On taking off we find ourselves well above the caldera. The glacier surface, which is still rising at a current rate of 20 inches a day, now stands at 4,940 feet, or 6 1/2 feet higher than the so-called maximum alert. As Icelandic glacierologists have been telling us for two weeks: "It's just a matter of days before the flood arrives." The surface of the glacier is riddled with crevices that are rounded toward the south, from west to east. They mark roughly the shape of the caldera that is filling with water. According to estimates, more than 3/4 cubic mile of water and mud are stockpiled here, posing a major threat to Route 1, just 25 miles to the south. In the winter landscape before me, nothing gives any sense of such a threat. The "innocence" just makes it more impressive.

Straight ahead, we again make out a cloud of steam rising from the eruptive fracture. The warm river keeps flowing, slowly mining the walls of the ice canyon. Although the eruptive activity is finished today, the ice is still melting from the residual heat of the expelled lava. The crevice zone surrounding the fracture is still just as imposing. The peak of each serac, of each delicately balanced ice column, all leaning toward the center of the fissure, wears a double hood: a layer of black ash surmounted by a layer of fresh, perfectly white snow. Inside the crevice, the volcanic cone has changed its morphology and the walls around it are spotted with black ash. No doubt some phreatic explosions occurred due to the violent release of the vapor formed by contact between the melting water and the still-hot lava of the cone.

We make a prudent approach to the bottom of the crevice, just above the river, in the direction of the cone. Part of this cone is still emitting water vapor; the western part is already covered with a fine layer of frost and snow. Large blocks of ice, melted from the overhanging wall, practically cover it. We are at last face-to-face with the new volcano.

The helicopter comes down slowly, its nose toward the shore where the pilot agreed to try to stabilize the chopper so I can jump to the ground. We are still a few feet from the ground, I have one foot outside the helicopter, when a horn blows suddenly in the speakers of my helmet, followed by Jòn's voice: "Watch the control screen!" The needles are in the red zone, we are losing power. Still calm, Jòn gives it gas again and, slowly, the helicopter rises between the walls of the glacier fracture. It is impossible to climb immediately, so the pilot traces a wide spiral from one flank to the other. Suddenly sunlight appears, and we are out of the hole.

Despite the fear, Jòn tries to explain that the lack of power is due no doubt to the combination of the altitude, the heat of the air above the cone, and the concentration of gas in the bottom of the crevice. But we have to collect samples of the lava emitted by the volcano. There is one more possibility, then—we can collect ash emitted by the phases of the explosion.

There are no problems this time, and the helicopter reaches the peak of the ice cliff, situated just at the vertical face of the cone. They put me down and the helicopter takes off again. It is strange finding myself alone in this enormous landscape. Just a few steps

Lengthy, eruptive fissure with several clouds of vapor. Vatnajökull, Iceland.

ahead, the glacier cliff plunges to the river of hot water that flows a few hundred yards lower. Behind me is a long slope of ice that is gashed, collapsed, creviced on every side. There is no way out of here except by air. I take a very brief moment for myself, one that is all too brief but leaves me with some strong, lasting memories. The clock is running.

First I have to dig through the snowfall of the last few days, already more than twenty inches deep. When winter comes, it will erase all traces of this eruption. Under the snow is the ash. It comes from the fragmentation of the hot lava on contact with the melting water from the glacier, and it has risen in these great vertical bouquets we call cypressoid clouds or columns. The ash fell to earth and, swollen with water, was directly struck by the freeze. Today it proves to be a solid mass. Vigorous digging uncovers compact blocks, just in time to collect some samples from the upper part of the deposit, then the lower. And so we have some lava from the beginning and from the end of the eruption, which will allow us to trace a possible evolution of the magma during its course of activity.

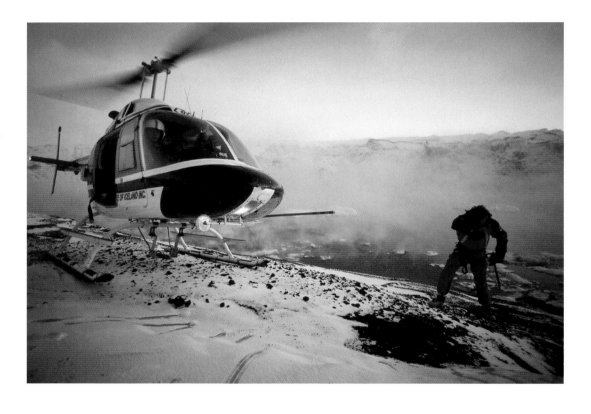

First landing on the cone inside the fracture to remove samples. Vatnajökull, Iceland.

The helicopter is returning. We take off and fly over the fissure for its entire length. The river flows and smokes, the sun is higher now and draws golden halo effects in the rising vapor. My curiosity is still strong. All I want is to come back again.

Jòn tries a new angle of approach. Slowly and with great care, he reaches an enormous ice cube that is like an aircraft carrier in the black ash, hits it with one runner, stabilizes, and lets up a bit on the gas. "You've got one minute, not a second more," he says. I remove the helmet and jump down. As soon as I step off the ice, both feet sink into the ash—my first contact with this entirely new earth, soil that did not exist two weeks ago. Ahead of me is the river of hot water that, from here, seems as wide as a lake. There is a

strange contrast between this water so black and thick and the walls of white ice. It is odd to find myself here. No feeling of victory or conquest, but rather of great humility. This volcano we just touched, where I can only remain for a brief moment, as yet has no name. It will be up to the Icelanders to give it life by naming it.

My professional reflexes quickly take over. It is difficult to get to the water's edge to take samples and measure its temperature; it would take too long. At my feet are ashes but also blocks of lava. They are fragments of what are called cauliflower bombs, incandescent lava fragments projected by explosions through the water. I collect a few pebbles, which I pile up in the cabin of the helicopter. Short on fuel, we will have to return to base. The nervous tension built up over these two weeks of waiting and during the intense moments we just experienced is now easing. We are filled with good feelings as the helicopter heads back to Freysnes, facing the sun.

That same evening, out of force of habit, we watch the weather forecast. A new depression is coming to Iceland; the outlook is worse than pessimistic for the next week. But no matter. We got what we wanted. Jòn decides to take the helicopter back to Reykjavik in the morning. As soon as I can turn in the samples for analysis, I'll be off for France.

5 November 1996

Since my return I have never considered this eruption "finished." Sure, its activity had stopped, but there was still the tidal wave, the immediate aftermath of the eruption. No one cared to make any predictions about it. From peak level to peak level, the altitude of the ice covering of Grimsvötn had reached 4,950 feet, and still nothing had happened.

Then news arrives: Seisms have shaken the glacier all night. The *jökulhlaup*, the long-awaited mudflow, was imminent. Jòn assured me of it. No question about it, we have to leave. The road was swept away in the very first moments of the flow. Two possible solutions remain—either to make a tour by way of northern Iceland (but that means a thousand-mile detour) or find an aerial means of reaching the east coast and then find an all-terrain vehicle available there. Two hours later, we decide on the latter.

7 November 1996

After a long trip, I finally reach Freysnes. The landscape has really changed. It has snowed, everything is white, the ground is hard, deeply frozen. And there is no sunshine. The forecast even calls for two days of fine weather. Jòn sets down his helicopter just then and brings the latest news. The road is out for several miles, several feet of giant bridges across the *sandar* were torn out; electric lines have disappeared in several spots. The flow rate of the *hlaup* has reached levels unheard of in Iceland: 165 cubic feet per second, or nearly twenty times the rate of the Rhone at its outlet.

I am eager to see all of that from the ground. But it is absolutely impossible to get near via surface routes, and the helicopter has been requisitioned by the roads department and civil protection. Jòn assures me, though, that the chopper will be available as soon as he has finished his mission. At 3 P.M. the helicopter lands. While we are refueling, Jòn explains what he just saw. The flow of muddy water has dried up. More than $3/4$ cubic mile have

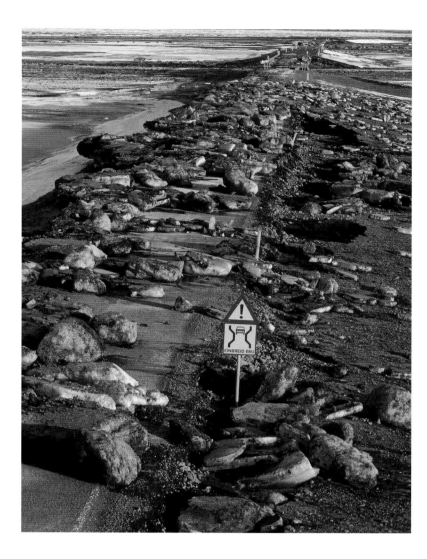

unbelievable field of icebergs, and then go up the glacier. Once we are past the chaos below, its surface still seems just as innocent. At barely six miles from Grimsvötn there has been a change in the glacier line, like a slight collapse, a softness in the landscape, that gives the impression something is happening above.

It gets clear, dramatically so. The whole mass of the glacier that served as a vault over the reservoir that collected melting water coming from the eruption, and the whole vault, also of the upper part of the tunnel that guided it downward, have collapsed after the liquid mass drained. But this is no small collapse. The "hollow" must be more than 330 feet deep. The entire zone is turned upside down, fractured, creviced. High, narrow ice pillars lean in a precarious balance toward the abyss. Once again we are overwhelmed by the dimensions and the surprising, unusual aspects of this eruption. Our curiosity pushes us toward the eruptive fissure.

From here, everything is quick. A few wisps of vapor still climb here and there, but in the southern part all the water has been drained out, leaving a deep, empty trench that indicates its bed at the bottom of the fracture. Little by little, the glacier tends its injuries, the wounds heal, everything is filled in; the new volcano will certainly soon be hidden. It will disappear from the human landscape, but will certainly remain in our memory as one of the most surprising eruptions we have had the privilege of seeing.

My last night in Iceland. Tonight I fall asleep without anxiety, but somewhat meditative after a brief talk with the director of the highway department. He asked me: "Do you think we could have another eruption? Because, within six weeks, we expect to have repaired the road and traffic will resume at the foot of the glacier."

Roads and bridges have been damaged by mudflows and blocks of ice carried by the mud. Vatnajökull, Iceland.

RÉUNION: PITON DE LA FOURNAISE

It's morning. The tent has been set up facing the volcano. It is blowing and rumbling while continuously activating three great lava fountains. Their gleam tints the whole countryside with red and orange.

At 4 A.M. a warm breath of air invades the thin canvas shelter, and strong light pierces the wall. For the last few hours I have been trying to sleep, on the one hand exhausted by three days and almost three nights of intense work, but on the other hand excited by the sight of the cone erupting, a spectacle I never tire of. So it is a light sleep, from which I jump up suddenly, alerted by the light and heat. At the foot of the cone in front of us, the lava flow makes a wide arc before the location of our camp. A retaining wall just broke, offering a new outlet to the lava. It seems to be heading straight to our camp! I get dressed quickly and try to take stock of the situation. It's not just an overflow; the flow is well fed and is advancing quickly. But I cannot panic. First I wake my two colleagues from the volcanological observatory. Together we organize the evacuation of the camp. We only have to go a few hundred yards to be safe on a small rise of land, with about 1,320 pounds of material to carry.

The Beginning of an Eruption

On Saturday, 7 March 1998, the routine of the volcanological observatory of Piton de la Fournaise (Institute de Physique du

been emitted; the entire front of the glacier has been broken under the pressures of the water, and icebergs are scattered over several tens of square miles. He saw Grimsvötn caldera from a distance. It appears that after the draining of the water it contained, its ice cover collapsed. But that is something we'll get to see tomorrow. There is no time today.

After takeoff we follow the road that crosses the *sandar* facing the glacier. The ribbon of asphalt continues smoothly between its two yellow lines; then suddenly it's cut as if by a knife. Behind, there is nothing except a black delta crossed by small arms of water. The mudflow has taken everything, the road as well as the causeway it rested on. Everything's gone except the totally flat expanse of the *sandar* that runs from the glacier to the sea. A mile or two later, a fragment of road some 600 feet long emerges like an island; it is entirely covered with pieces of ice, small icebergs transported by the *hlaup*.

We reach our first destination. The first and last pillars as well as the apron they supported have totally disappeared. It has a strange appearance, like a bridge thrown into the void. It's useless. On every side, the road is strewn with blocks of ice. Thousands can be seen as far as the horizon. Some are more than 33 feet high. Finally we arrive at the glacier wall. The whole front has been fractured and carried off, leaving deep cuts in a circle more than 330 feet high. Once again, the scope of the phenomenon, as well as its violence, is surprising. It is difficult to imagine that all this could have happened in two days. The light is already low, the days are shorter, and we have to get back to Freysnes.

8 November 1996
It has been a really cold night, and this morning it is freezing again. No question about it, winter has come. We don't take off until afternoon, with damage inspection as our priority. We again cross the

Globe de Paris) was suddenly turned upside down by a new alarm. Swarms of seisms were registered by the different seismographs distributed on the volcano. They are followed by various shocks felt since the end of 1997. This time, though, the number of seisms is rising steadily and could reach several hundred a day. Analysis of the phenomenon shows a rise of magma from a superficial chamber at about 6,560 feet below sea level, or more than 14,750 feet below the peak of the volcano. From the magma's pressure, fractures are opening, at first down below and then, starting on Monday, 9 March, at 3:05 P.M., on the surface, at the north flank of the volcano. The eruption has begun.

These eruptive fissures are each at least 1,000 feet long, and emit lava fountains 100 to 160 feet high. Very rapidly the eruptive activity is concentrated on two fissures at 7,050 feet of altitude. Lava flows pour down toward the lower slopes, while spurts of lava projected by the fountains form a rampart around these fountains, creating numerous cones on the volcano's flank. This eruption is not at all unusual for Piton de la Fournaise; however, it was awaited impatiently. Although we regularly find here an average of one eruption per year, for the past five and a half years the volcano has been quiet. Today it is back in action, weather conditions are ideal, and the site of the eruption is fairly accessible. All the conditions are right for volcanologists to collect a maximum amount of information. At Piton de la Fournaise there are no direct threats from the volcano. For the moment the eruption is confined in a remote, deserted part of the massif and no short-term destruction is expected. The job of volcanologists will not be to protect the population, but rather to follow the course of the eruption at close range, measure it, and analyze it to gain a better understanding of how Piton de la Fournaise "works." Later this information can perhaps be extrapolated to other volcanoes and possibly move volcanological science a few steps forward.

Back to Work

Watching one of my colleagues, Nicolas Villeneuve, I see myself at the same age, wanting to do it all, to know everything, skipping meals and staying up all night to get a jump on things. For him, this eruption was not expected. He is preparing a dissertation on the lava flows of Piton de la Fournaise, and suddenly the volcano he has been studying has just provided him with unique data and samples.

It is hard to walk here and we cross what we call a flow's "scraps," piles of broken blocks, which are sharp and jagged and

Volcanologists remove samples from a lava flow. Collected samples are cooled in distilled water.

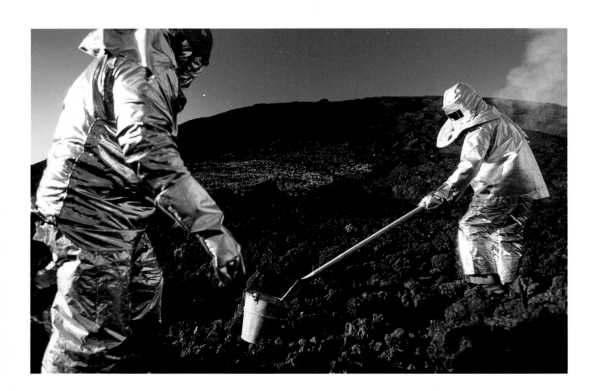

not very stable. With each step we have to check our footing and struggle to keep our balance. It is not wise to fall down on these hot, jagged rocks. Although we are bent under the weight of our bags, wet then dried out by proximity to molten lava, we still can't ignore the setting. An erupting volcano is not just a geological curiosity, a subject of interest for a stubborn, eccentric scientist; it is also one of nature's most splendid sights. We are submerged in a world of sounds, smells, light, and heat.

Ahead of us the crater rumbles. Below, a lava lake swirls with enormous bubbles of gas at high temperatures. On bursting, they shoot incandescent gold and purple spurts that rise, changing shape in the air, and then they come crashing violently to earth. There are no very marked explosions, but instead a continuous spurting. The spectacle never seems repetitive; it has a fascination that one could watch for hours. At the foot of the crater the flow advances steadily, like a hot, red-orange river; it is only a slight noise like crumpled paper. Its steady hissing reminds us, however, that this is not water but melted rock that is spreading. Nicolas knows something about it: Having approached without adequate protection, he has a third-degree burn on his cheek.

This flow is the subject of our study. To accomplish the work, we have to collect lava samples at regular intervals, which is easier said than done. The molten lava flowing past us reaches temperatures of more than 1,800° F, and it is not at all easy to get close.

If our bags are so heavy today, it is because we have got good diving suits, jackets and trousers of Nome aluminum, a nonflammable material that reflects thermal radiation as a mirror throws back light. On top we wear a helmet, a very wide hood with a window consisting of two plates of glass with a sheet of polished gold sandwiched between them. Here, too, the heat is reflected as by a mirror. These diving outfits are not always necessary on volcanoes. You can come within a few yards of molten lava with just regular long-sleeved clothing. But pretty soon you are up against a "heat wall" that keeps you from coming even a few inches closer. Here, we are to go four or five yards beyond that, so our astronaut suits are indispensable.

Heavily harnessed, we get closer to the lava, walking side-by-side so that we can each keep an eye on our neighbor and see that he is not surprised by an unexpected spurt from the flow or by projections from the crater. My colleague is handling a long spade; dipping its blade into the molten lava, he extracts a piece of incandescent matter and turns toward me. I am carrying a metal bucket filled with distilled water. We dump the sample into it to cool it quickly in order to block its crystalline process. Later the lava fragment will be sawed into slices, put under the microscope, and analyzed. It will yield precious information on the nature of the deep magma responsible for the activity of Piton de la Fournaise.

The heat permeates our thick boots and begins to burn our feet; under the helmet and jacket, we are streaming with perspiration. It is time to step back, but we still have to take a temperature reading. A thermocoupler is dipped in lava and plugged into the electronic thermometer. It takes thirty or forty seconds to stabilize the measurement. The temperature rises to 1,900° F. These samplings occur three times daily on three different sites; the bags of samples pile up quickly and the helicopter takes them away each day to the volcanological observatory.

To the Bottom of the Crater

Monday, 16 March. For more than a week, the volcano has been active. Cones are continually forming from the accumulations of lava projectiles. The two main edifices, on the north face, are already more than 150 feet high. Our activity goes on with the same intensity. The lava flows have already traveled more than three miles and, today, having descended the slope of Piton de la Fournaise, they spread out in a depression with a horizontal base, the Plaine des Osmondes. There flows pile on top of one another, creating a foundation more than 1,000 feet wide and about 150 feet thick. Volcanologists have just christened the new crater. The one we consider the most beautiful will be called the "Maurice and Katia Krafft" crater in memory of two volcanologists who were killed seven years ago.

I've been watching this crater for two days because it has an unusual morphology. Its broad shape is circular, formed of a rampart with steep slopes. There is a narrow breach in its east side, through which a flow pours from an active lava lake boiling in its depths. Jets of shooting lava are projected to heights between 60 and 150 feet in a continuous eruption, a fountain of molten matter. Because of the deepening of the breach, the lake and flow levels have fallen inside the crater, leaving a broad ring around the interior walls of the cone. This track, 6 to 9 feet wide, leads to the interior of the crater and stops at the bottom, on the edge of the lava lake boiling with magma gases and raised by the burning fountain. This narrow balcony seems stable and for the moment gives no sign of collapsing into the molten lava that surrounds it. Today the wind blows from the east and whips waves of heat and gas toward the bottom of the crater. The conditions seem as good as possible, so we decide to take advantage of this narrow passage to go inside the cone, all the way to its source, where the lava fountain springs up in the heart of the crater.

Approaching an active volcano is like walking along the edge of a highway: as long as you stay outside the white line, the passing vehicles can be very menacing but remain relatively harmless. Cross that line and you get crushed. The only problem with volcanoes is that there is no clear line drawn on the ground. Only your experience and sometimes your intuition can tell you just how far you can go. In this case, my feeling is to enter.

Rarely have I prepared so carefully, not only with protective equipment but more in terms of the mental concentration that I maintain. Soon, I am all set. Inside my diving suit a radio crackles, linking me to my colleagues who stay 30 feet or so behind. With the diving suit and helmet I am wearing, visibility is limited, especially looking upward, so I am relying on them to signal any extra violent projectile that might fall my way.

Slowly I go forward, one step at a time, inspecting each point of this new space. On my left the lava flow moves in a channel; on my right stands the wall of the cone, formed by the accumulation of lava projected by the fountain. Straight ahead, the lava emits intense waves of heat. A few yards farther, the ground is burning and trembles under the lava waves. Soon I am face-to-face with the fountain that, like a wall of fire, blocks any visibility toward the depth of the crater. Heat is everywhere: I feel it through the soles of my boots, I feel it slowly seeping through the diving suit. Time to take a reading. The thermocoupler says 1,164° F, which is the hottest we will get. We are really at the source now. Here, two or three yards ahead of me, is where the magma, after rising along fractures in the base of the volcano, spurts for the first time. It is now impossible to get closer.

What an amazing sensation, to touch the origin of things. For a few brief seconds, the heat, discomfort, and risks are forgotten, leaving nothing but fascination. And I am reminded of the Hawaiians who see Pelé, goddess of fire, dancing in the fountains. Crushed by heat inside my suit, I'm close to believing I am dancing with her. But I have got to retreat; these few minutes have felt like hours. I am exhausted in body and in nerves. And yet I feel a smile on my lips and I tell myself: "I've watched Earth being born, I've walked on rocks that are younger than I am."

Through pressure from gases, streaks of lava are projected straight up from the eruptive opening.

PAGE 297. Lava tunnels are common in basalt volcanoes like Kilauea. Well insulated thermally, lava inside them maintains high temperature and fluidity, allowing it to run for several miles underground until it breaks out sporadically on the lower slopes of the volcano. Hawaii.

PAGES 298–99. At the bottom of the rift, Lake Assal extends to 525 feet below sea level. It is fed by deep saline springs. Djibouti.

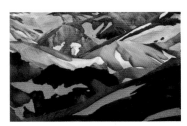

PAGES 300–301. Ryolite mountain of Landmannalaugar. Iceland.

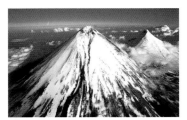

PAGES 302–3. The Klyuchevsky volcano range was formed on a former plateau occupying an area 60 miles in diameter. Mount Klyuchevsky is the highest summit on the peninsula of Kamchatka. Regularly active, it displays spectacular eruptions. Russia.

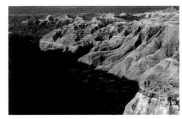

PAGES 304–5. An eruption of Pinatubo swept away the nearby forests and created new landscapes. Ash deposits with an average thickness of 980 feet created gigantic canyons, very quickly eroded by tropical rains. Philippines.

PAGES 306–7. An avalanche of incandescent lava falls under the active dome of Merapi volcano, which sometimes emits *nuées ardentes* that can be fatal to the residents close to the volcano. Indonesia.

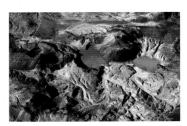

PAGES 308–9. Erosion from combined effects of wind and rain has created new landscapes around Mount Saint Helens, in Washington State.

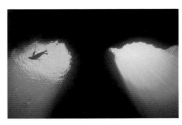

PAGES 310–11. An otter plays in the sun rays in a submarine lava tunnel. Galapagos.

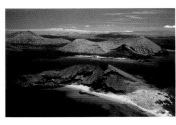

PAGES 312–13. The Galapagos archipelago was born from successive eruptions of a submarine volcano that is still active. Bartholomew Island and Sullivan Bay, Galapagos.

PAGES 314–15. Giant tortoises live on the heights of the crater of Alcedo volcano, where they find grass and water in the humid climate created by the many clouds that permanently encircle the summit. Galapagos.

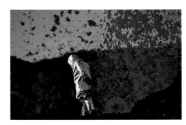

PAGES 316–17. Protected from thermal radiation by his fire-repellant clothing, a volcanologist watches the movement of the lava fountain from the cone summit. Piton de la Fournaise, Réunion.

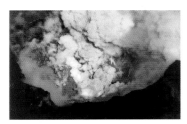

PAGES 318–19. The crater of Tungurahua volcano awakens after eighty-one years of dormancy, and spits clouds of ash. Ecuador.

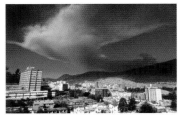

PAGES 320–21. After a violent explosion of Guagua Pichincha volcano, an immense ash cloud spread over the city of Quito, gradually darkening the sky. Ecuador.

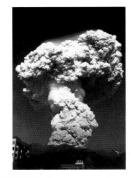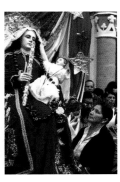

PAGE 322. During a major explosion of Guagua Pichincha volcano, an ash cloud develops above the city of Quito, reaching a height of 46,000 feet. Six hours later, satellite images report it above Colombia. Ecuador.

PAGE 323. Procession of the Miraculous Virgin who protects the city of Baños from the awakening of Tungurahua volcano. For several centuries the statue of the Virgin was paraded through Baños in case of eruption or other catastrophes. Faith in the Virgin is very strongly embedded in the population. Ecuador.

PAGES 324–25. After extracting sulfur with their bare hands from the crater of Kawah Ijen volcano, miners will carry it on their back in loads of 220 pounds each for a distance of nearly 25 miles across the volcanic massif to reach the treatment plant. Java, Indonesia.

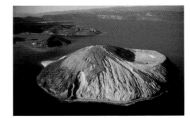

PAGES 326–27. Koma volcano, born from a submarine eruption, is situated at the bottom of the Gulf of Goubbet, south of the Red Sea. The gulf was created by the inflow of seawater, and is situated in a future oceanic channel. Djibouti.

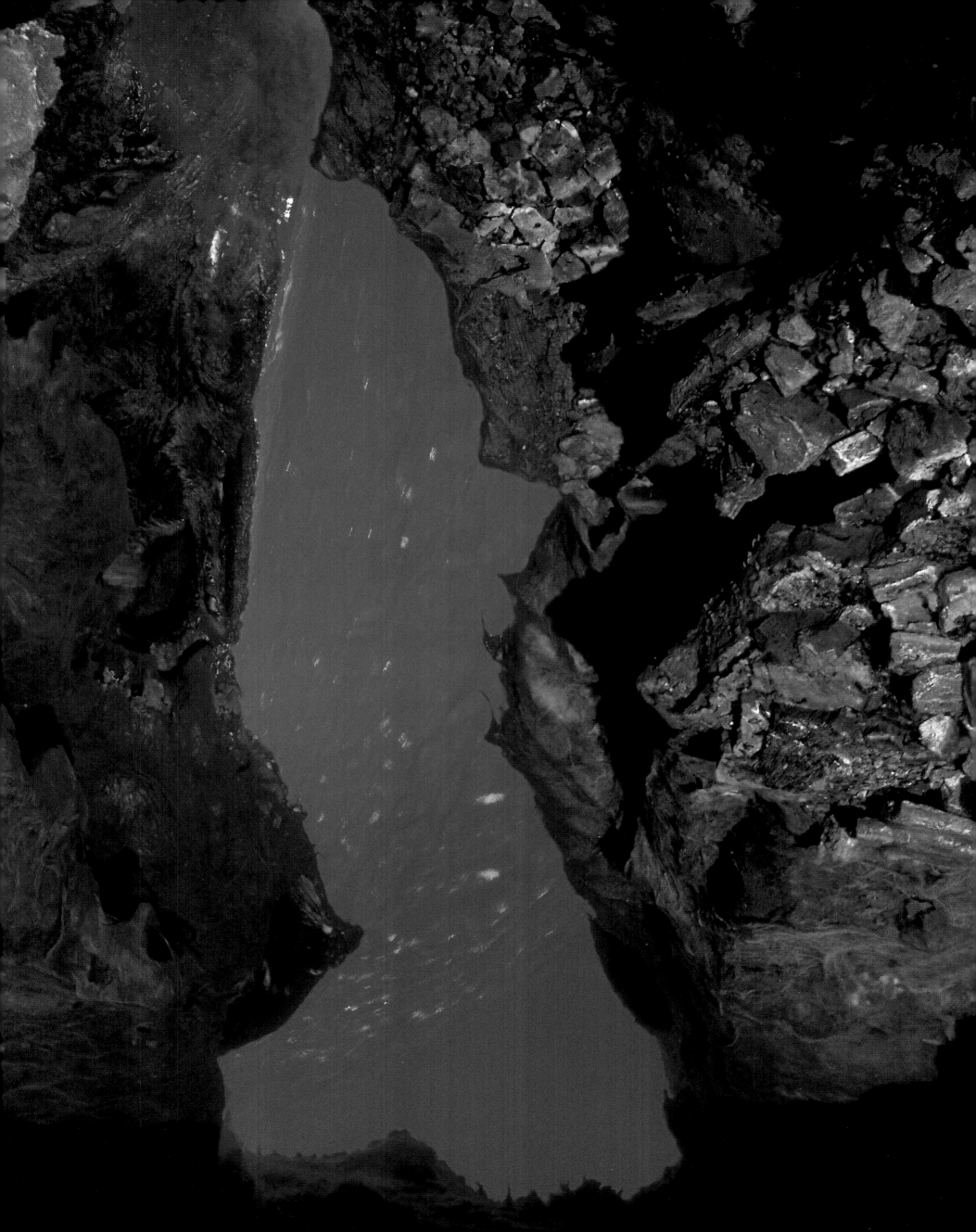

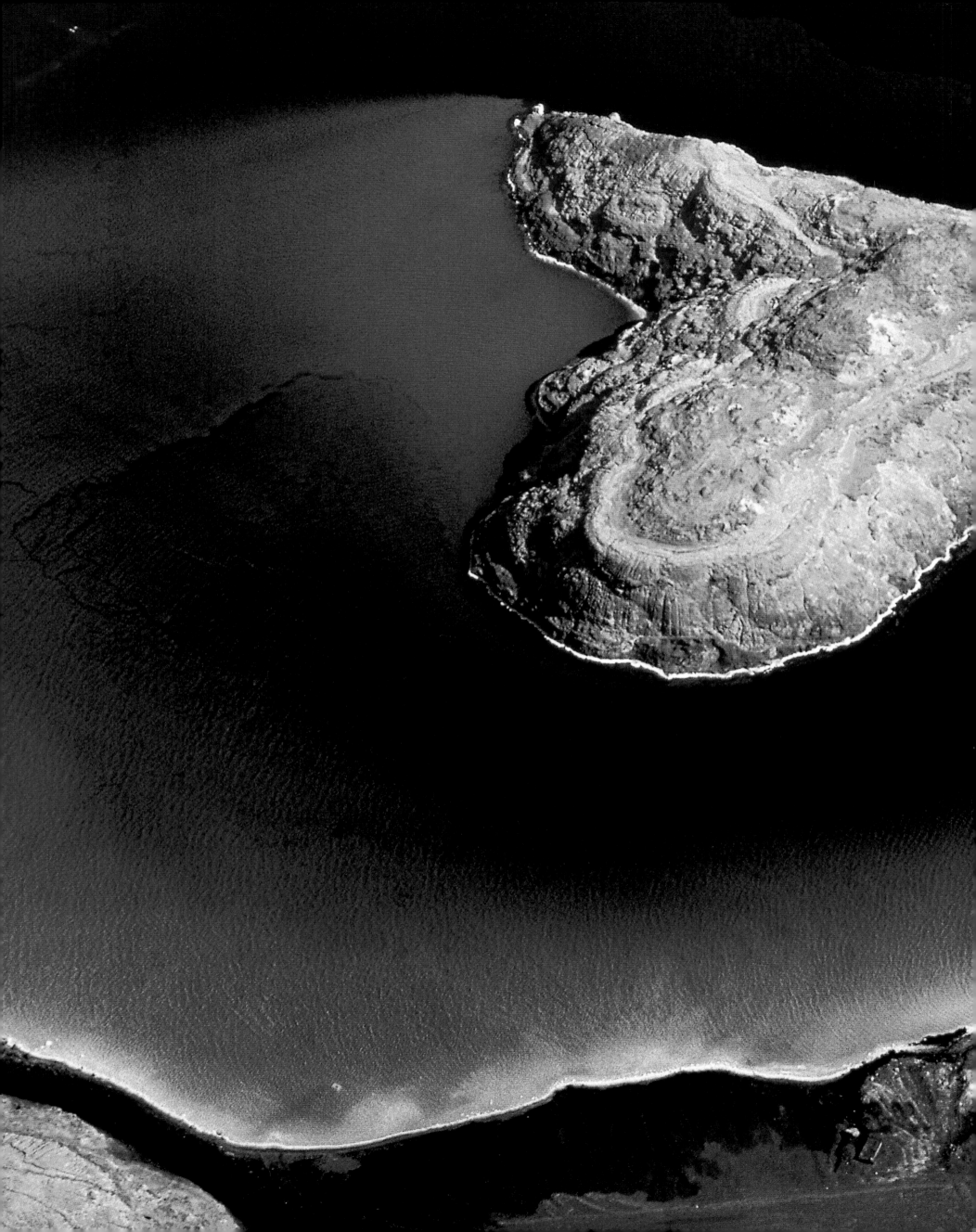

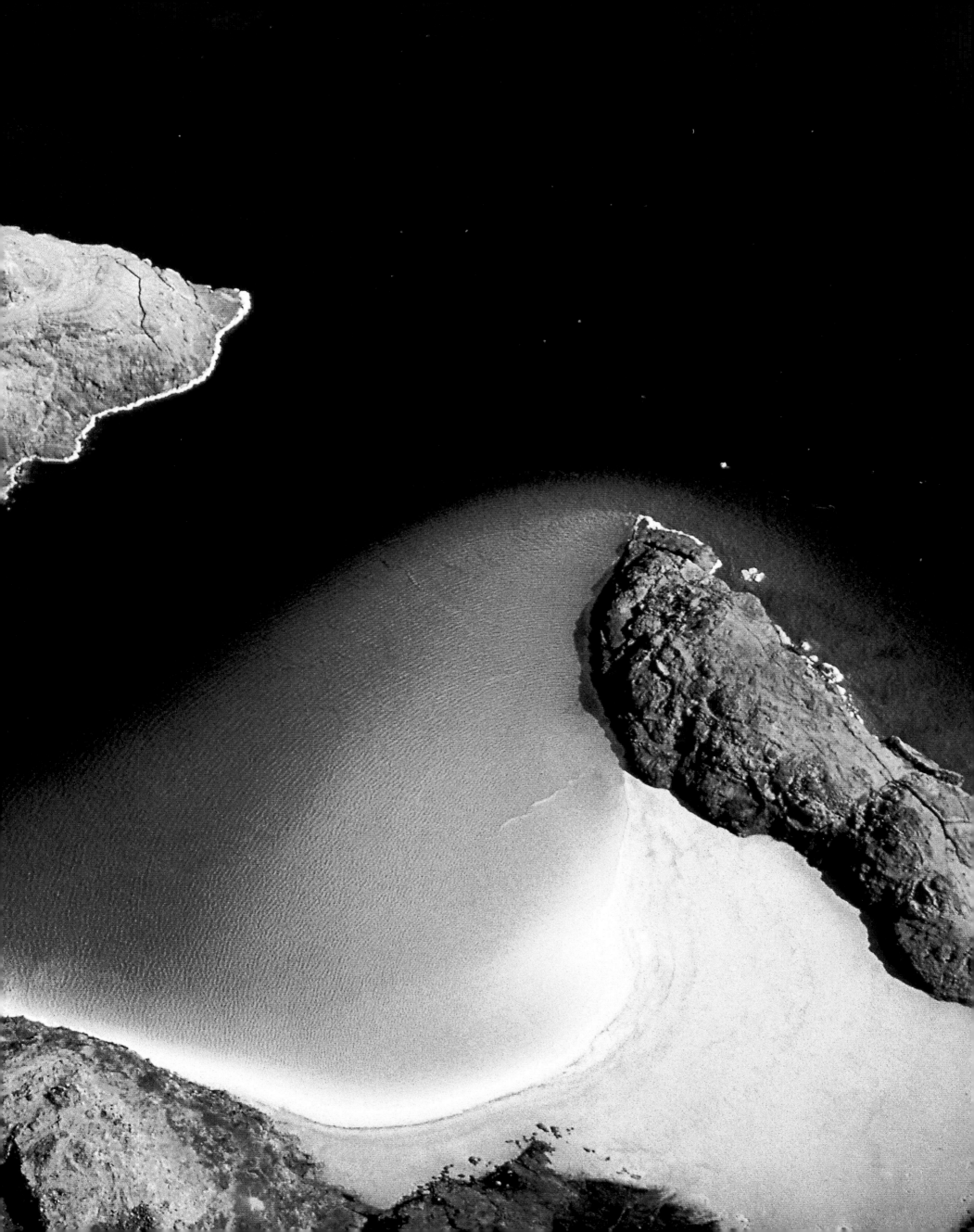

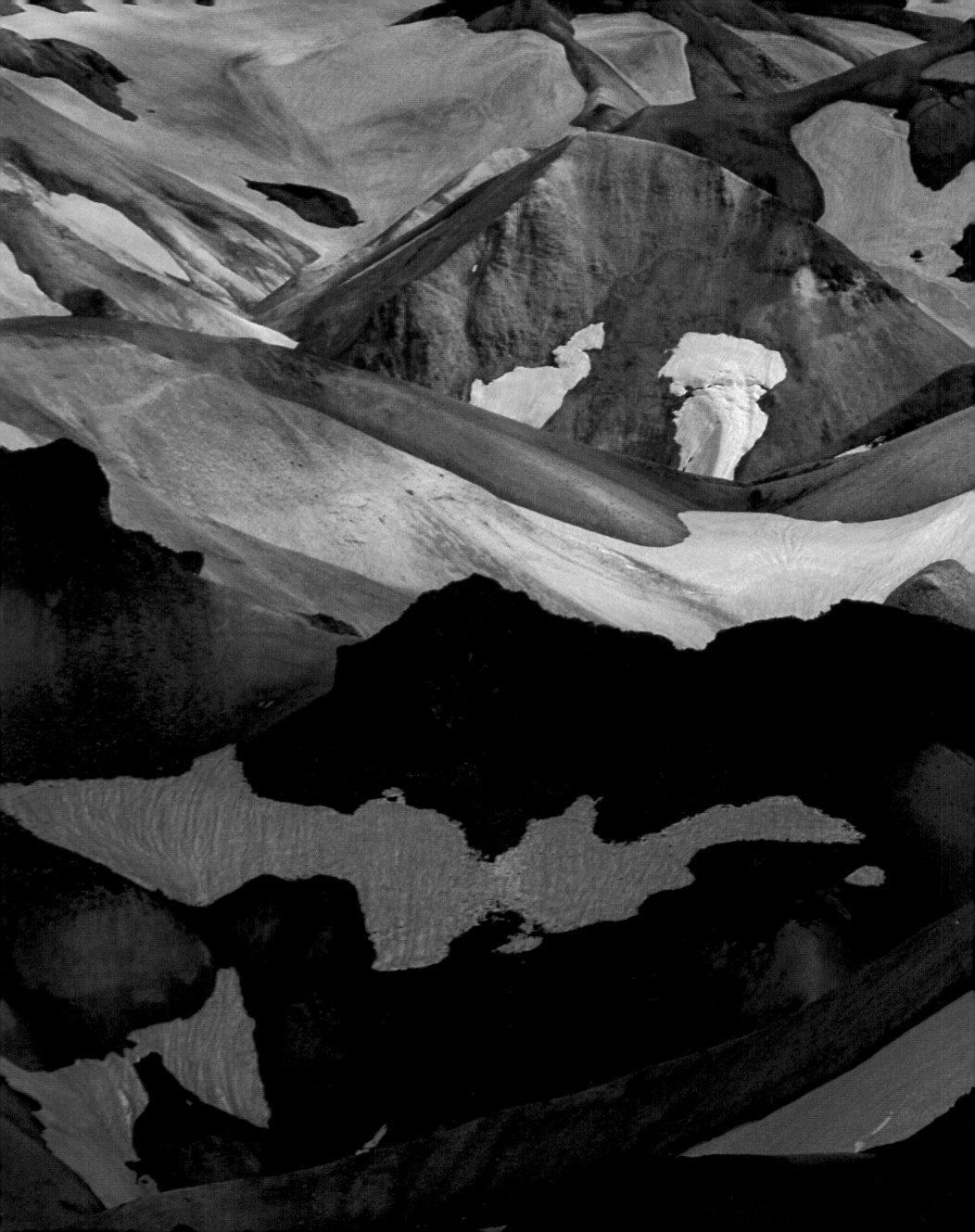

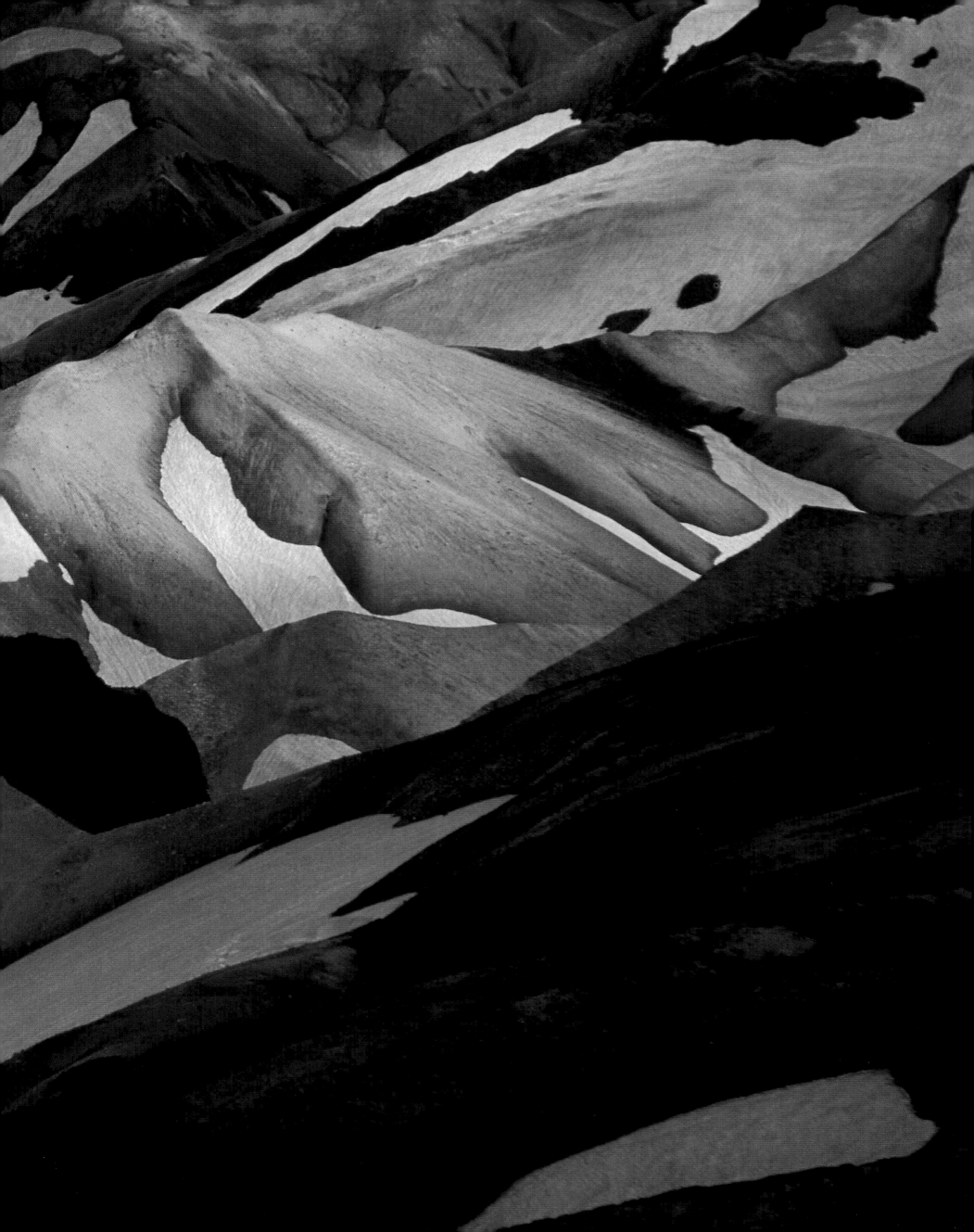

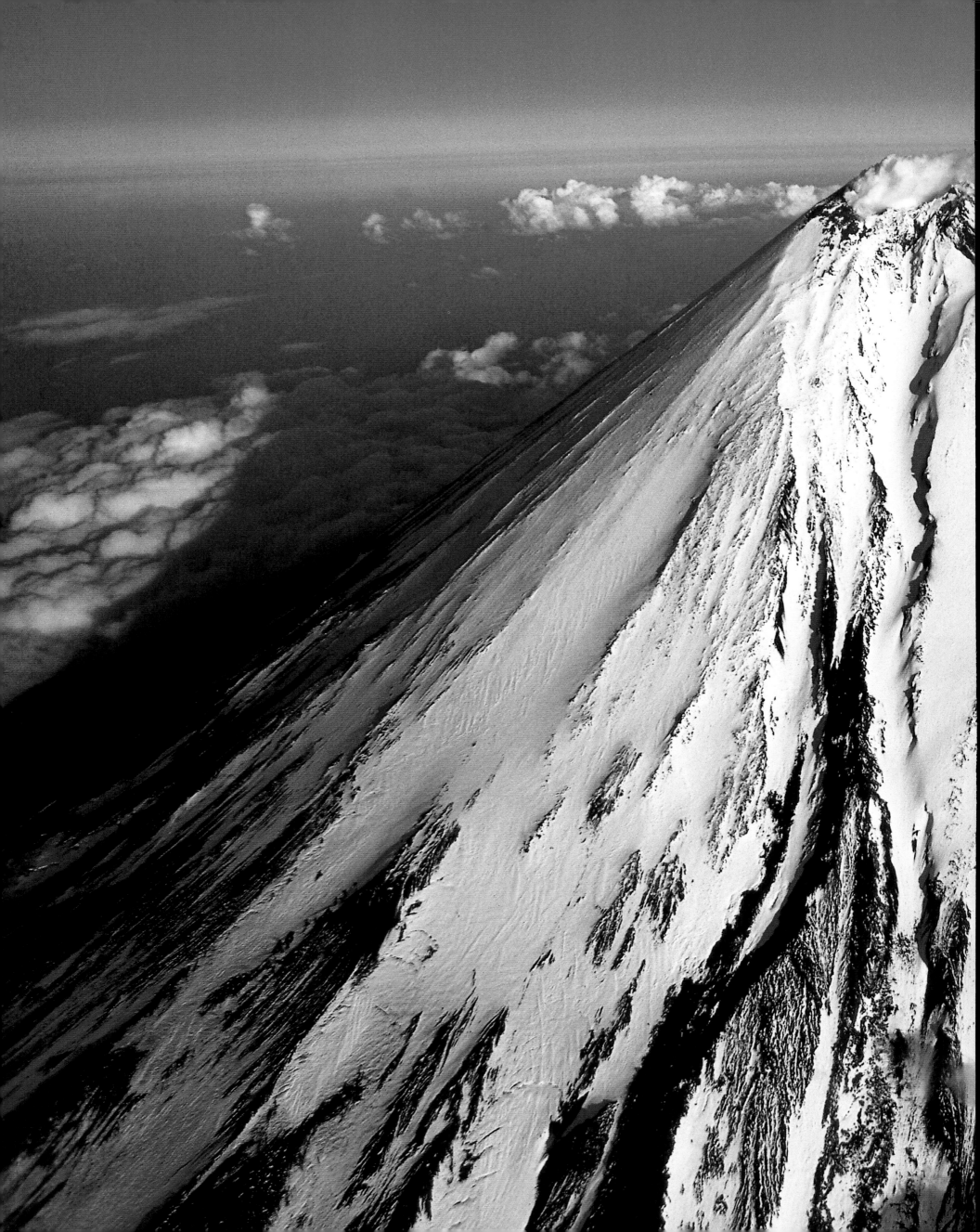

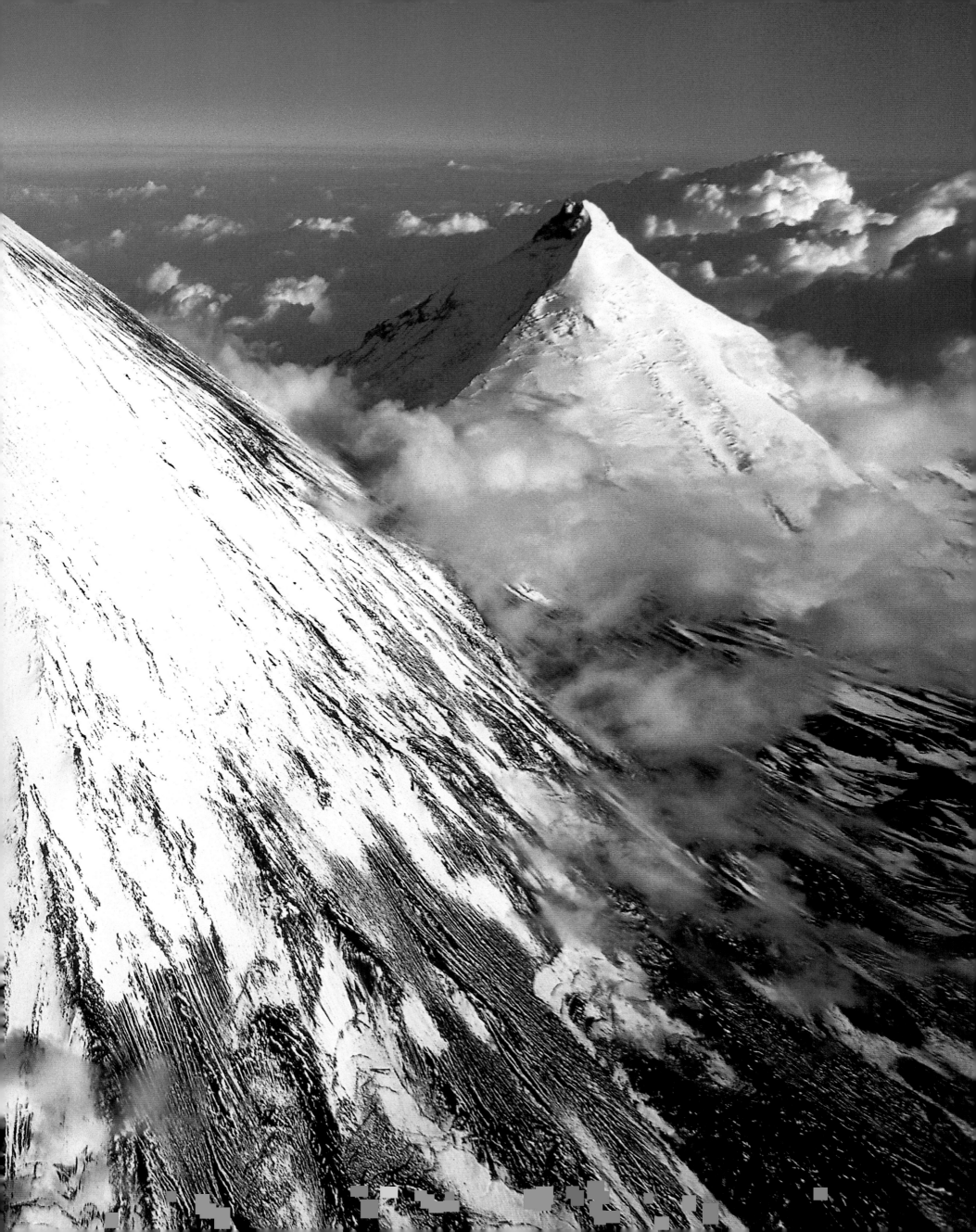

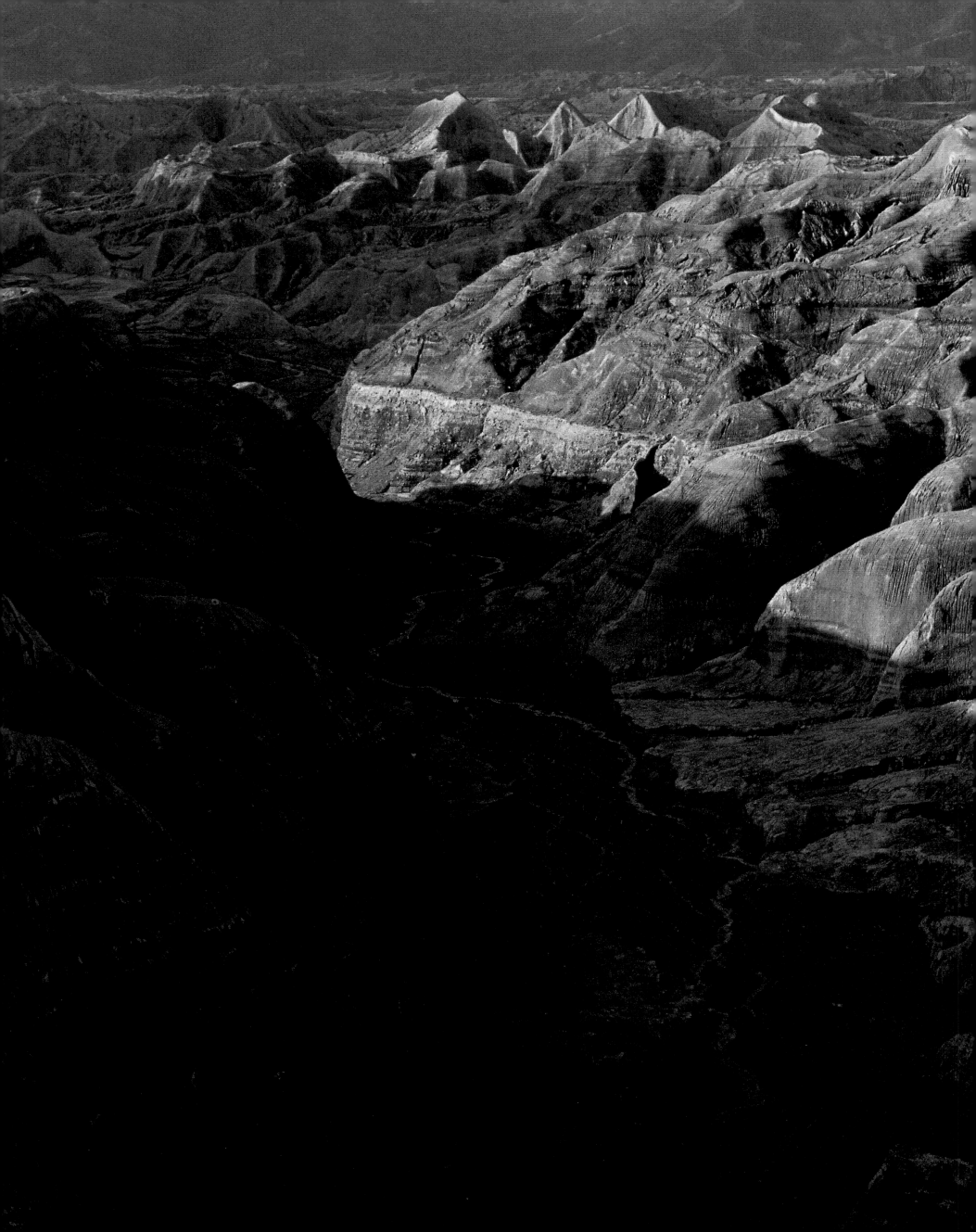

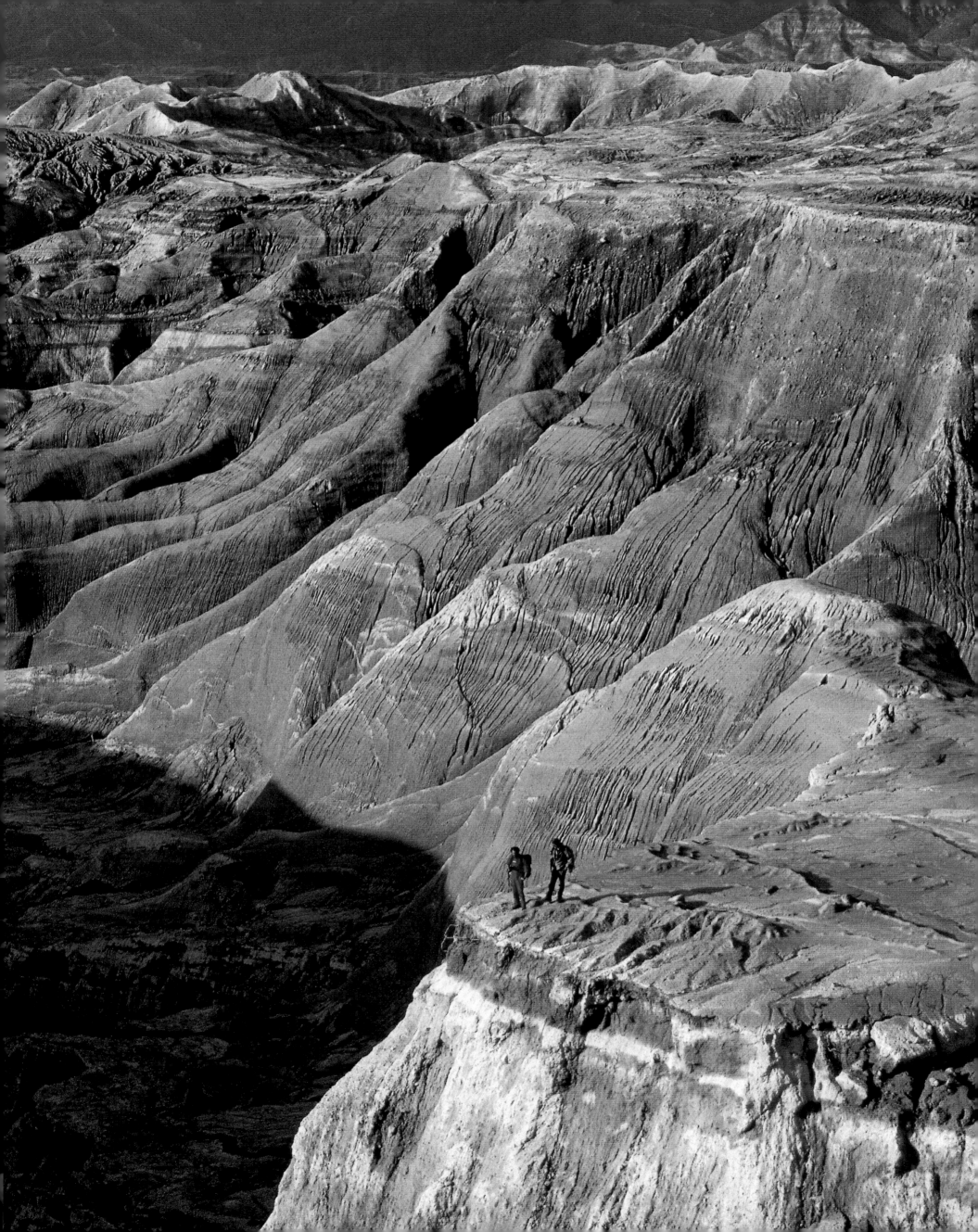

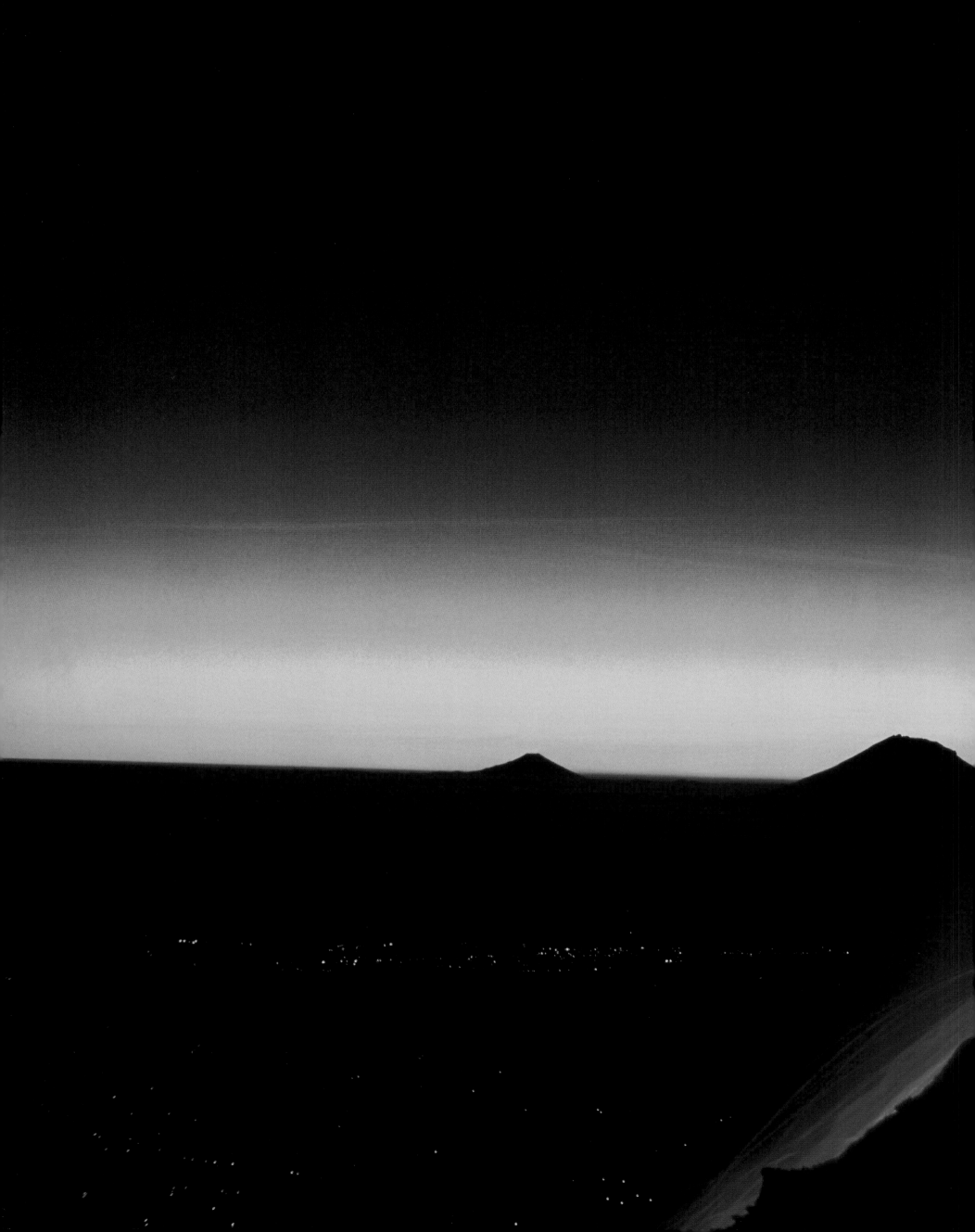

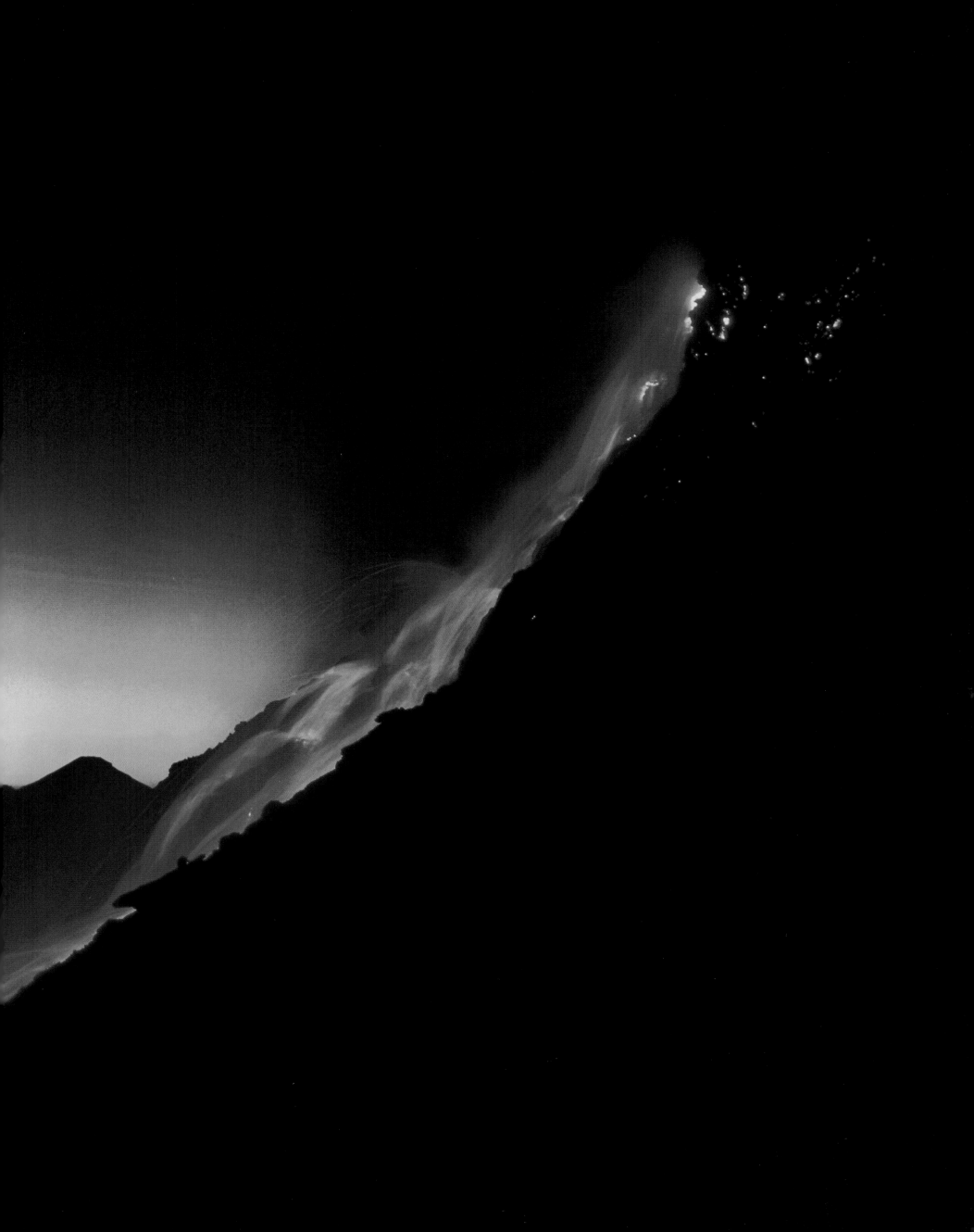

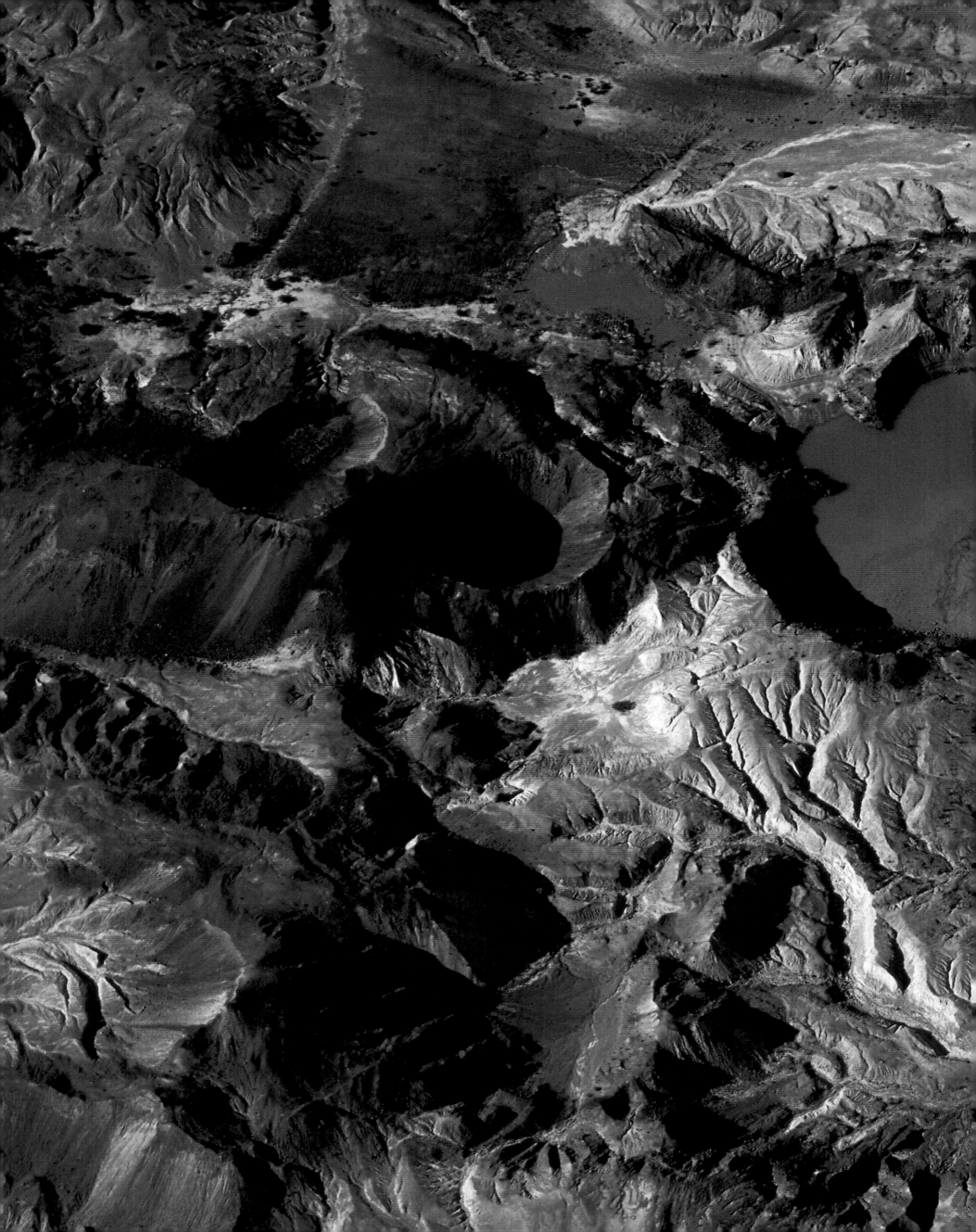

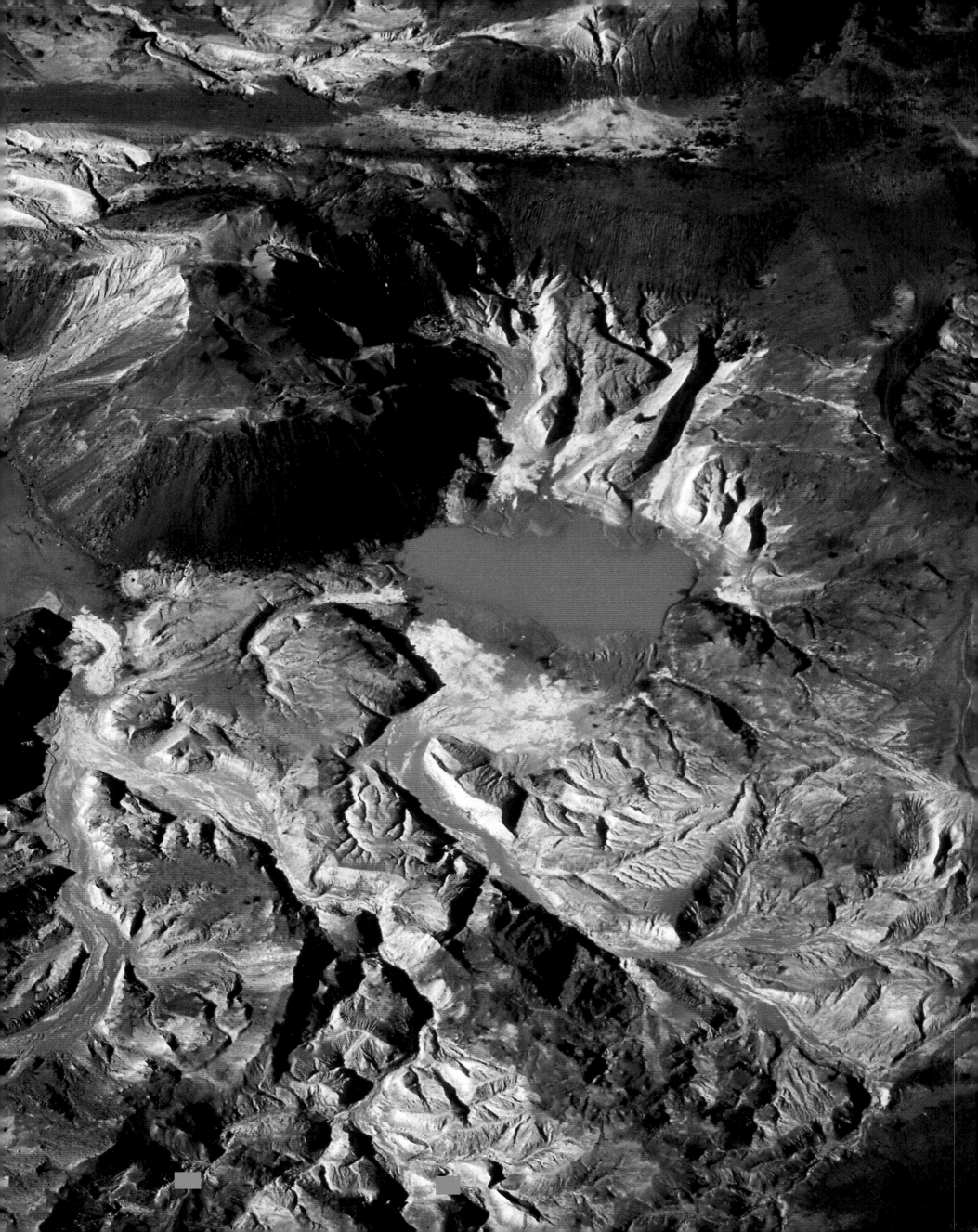

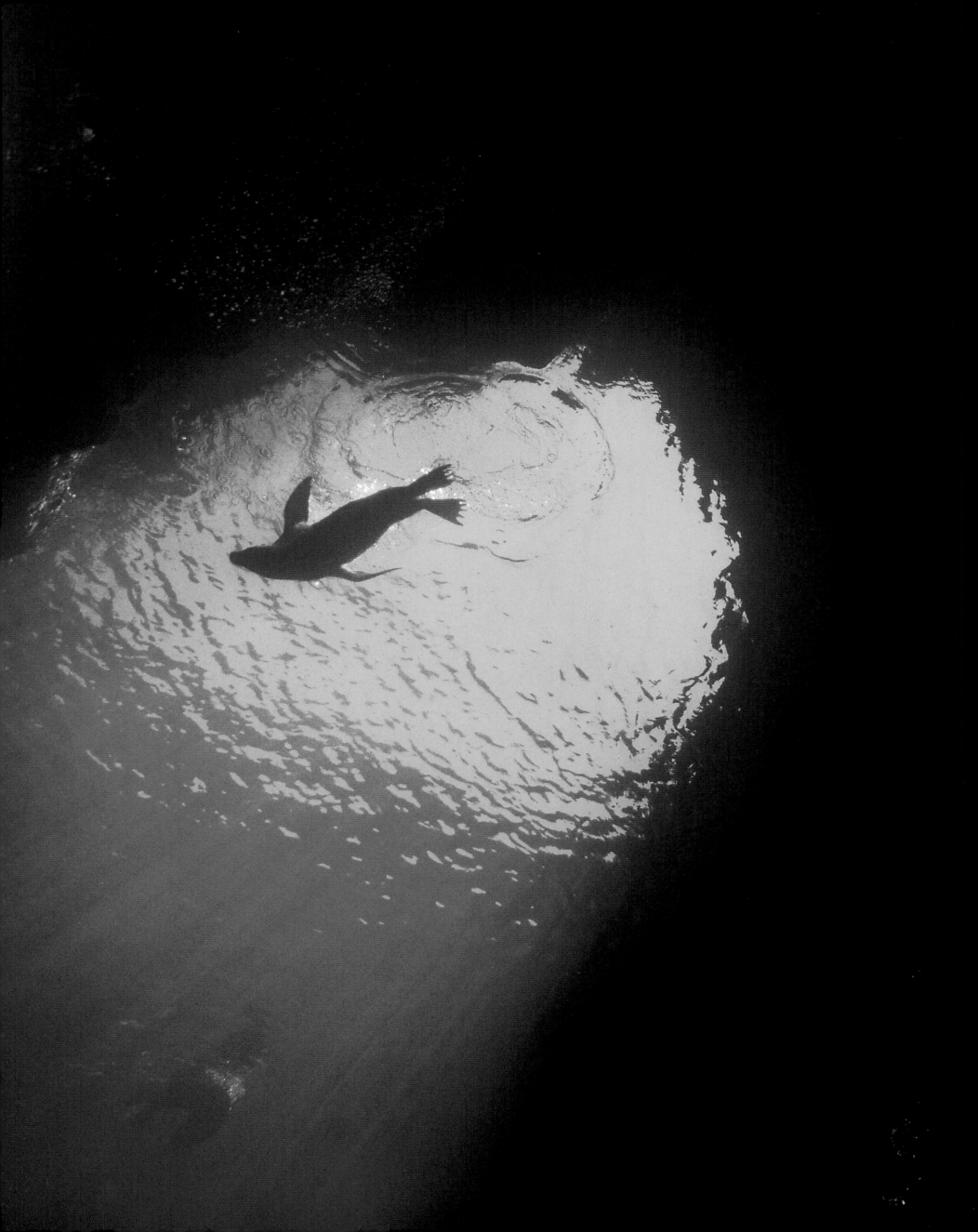

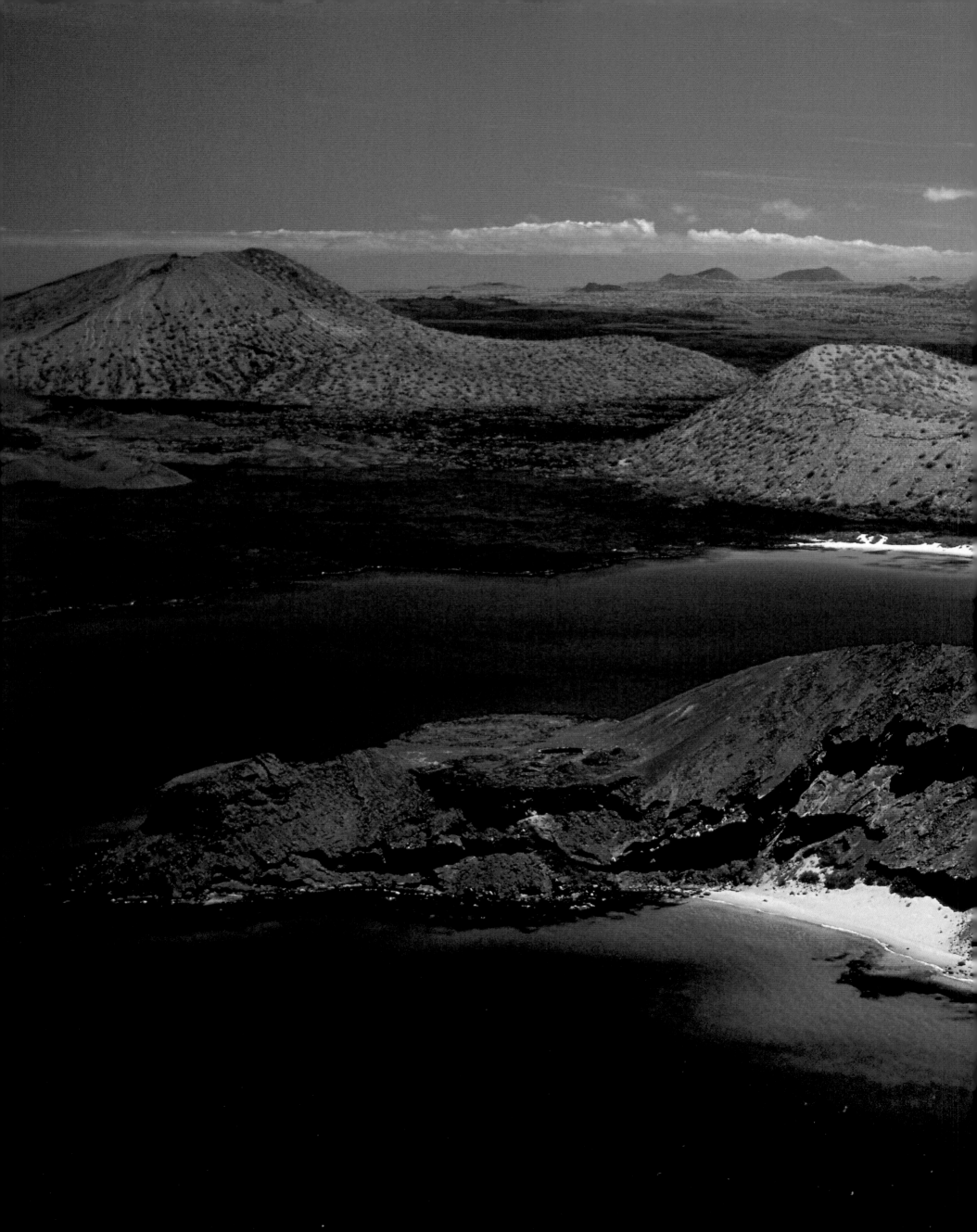

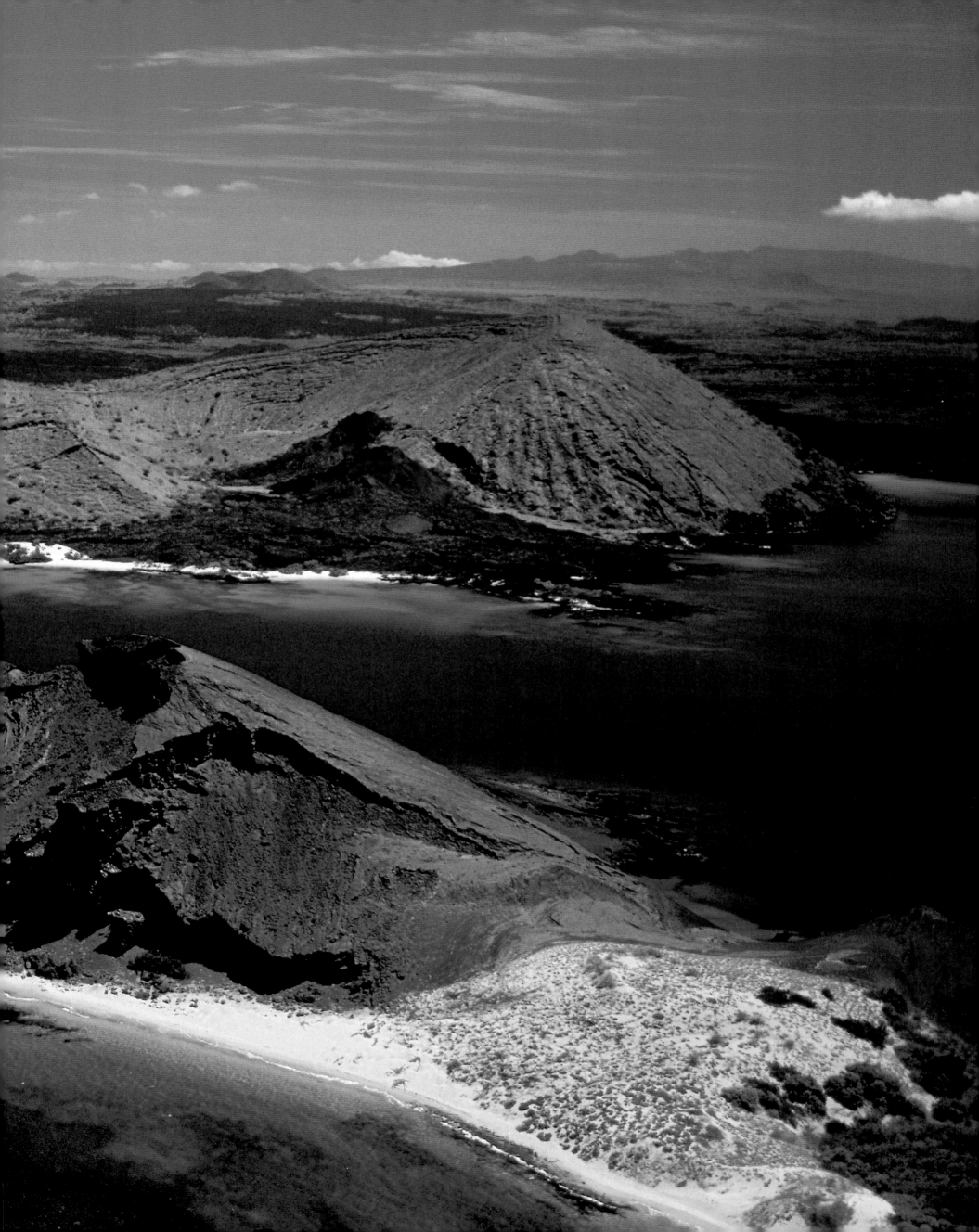

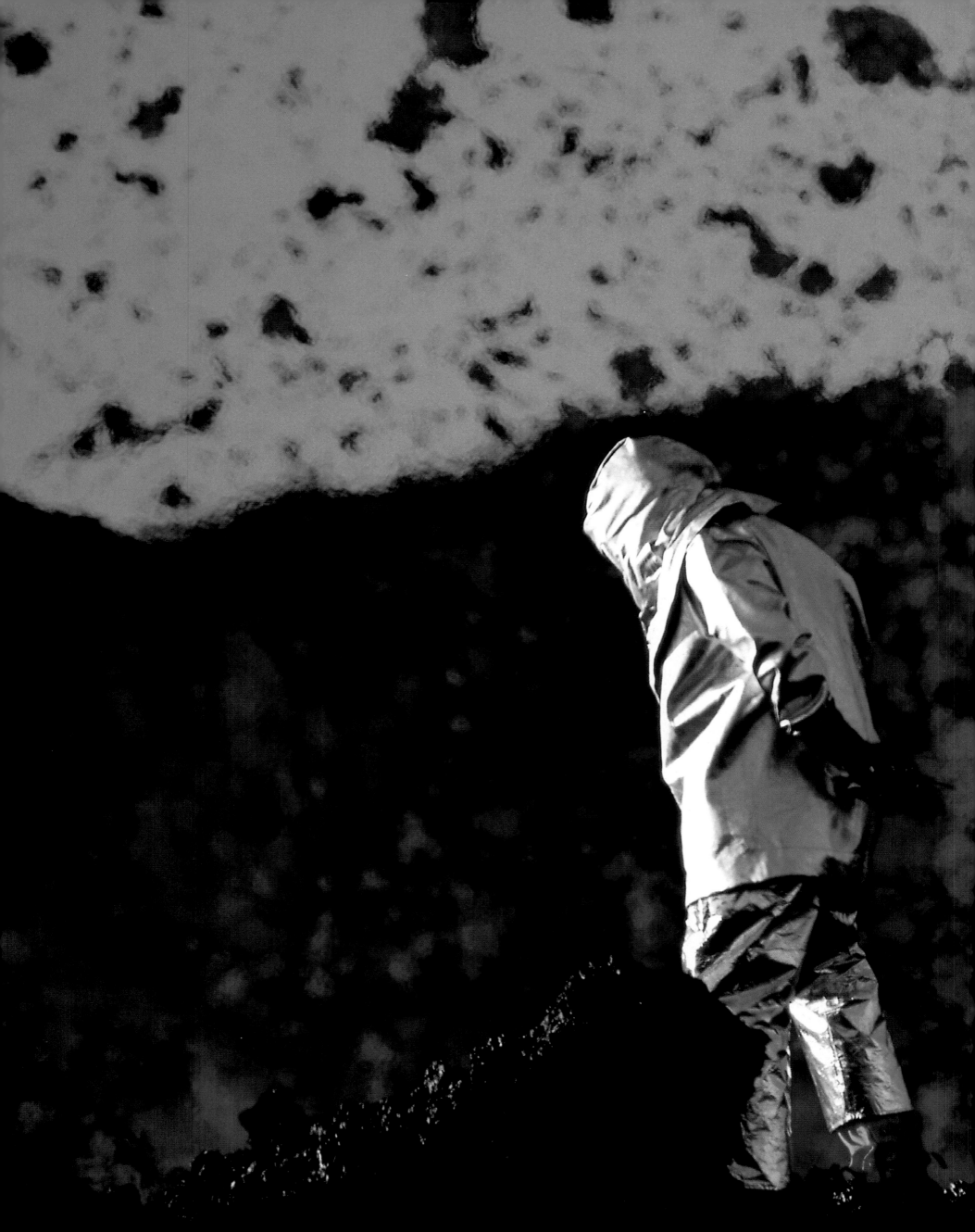

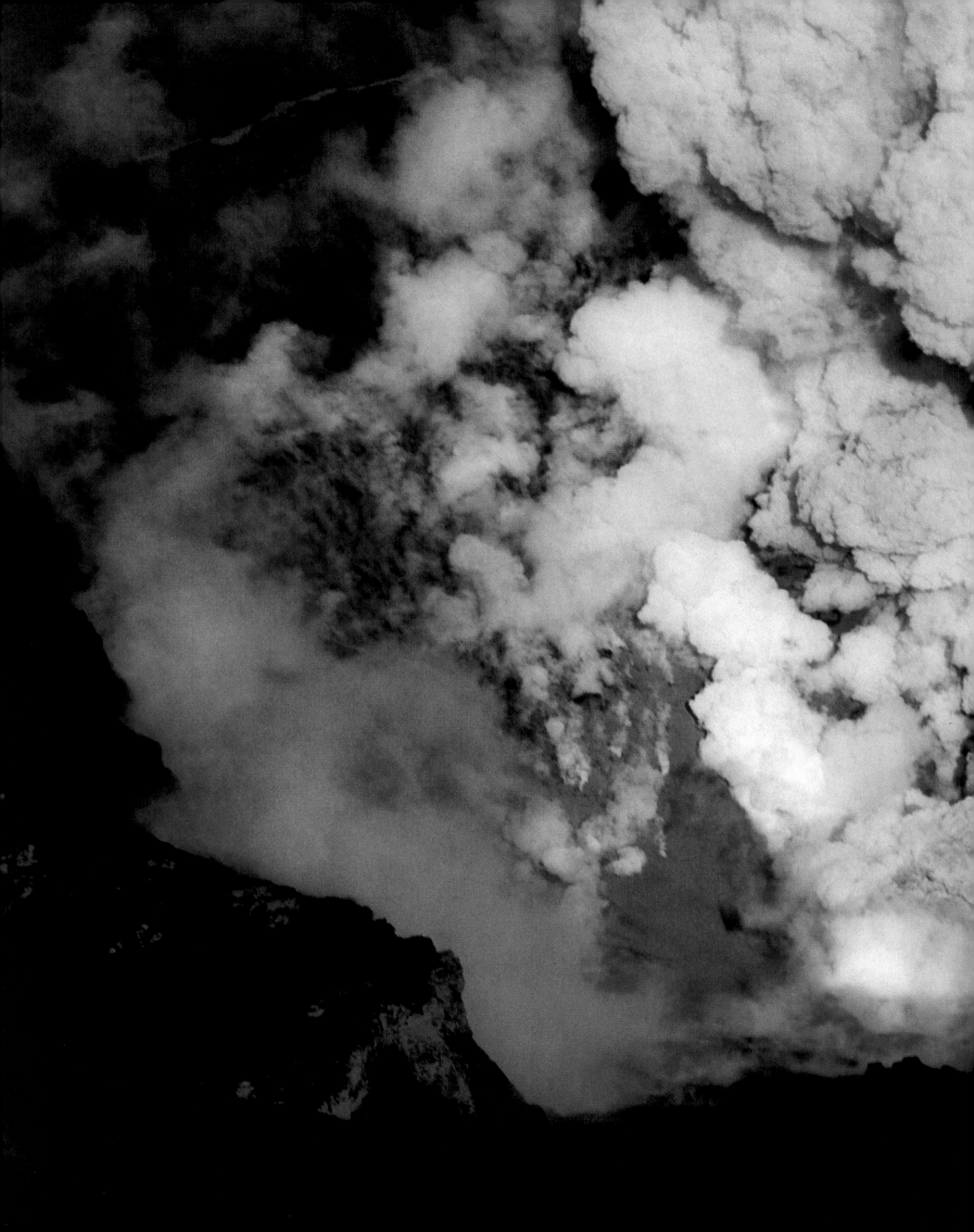

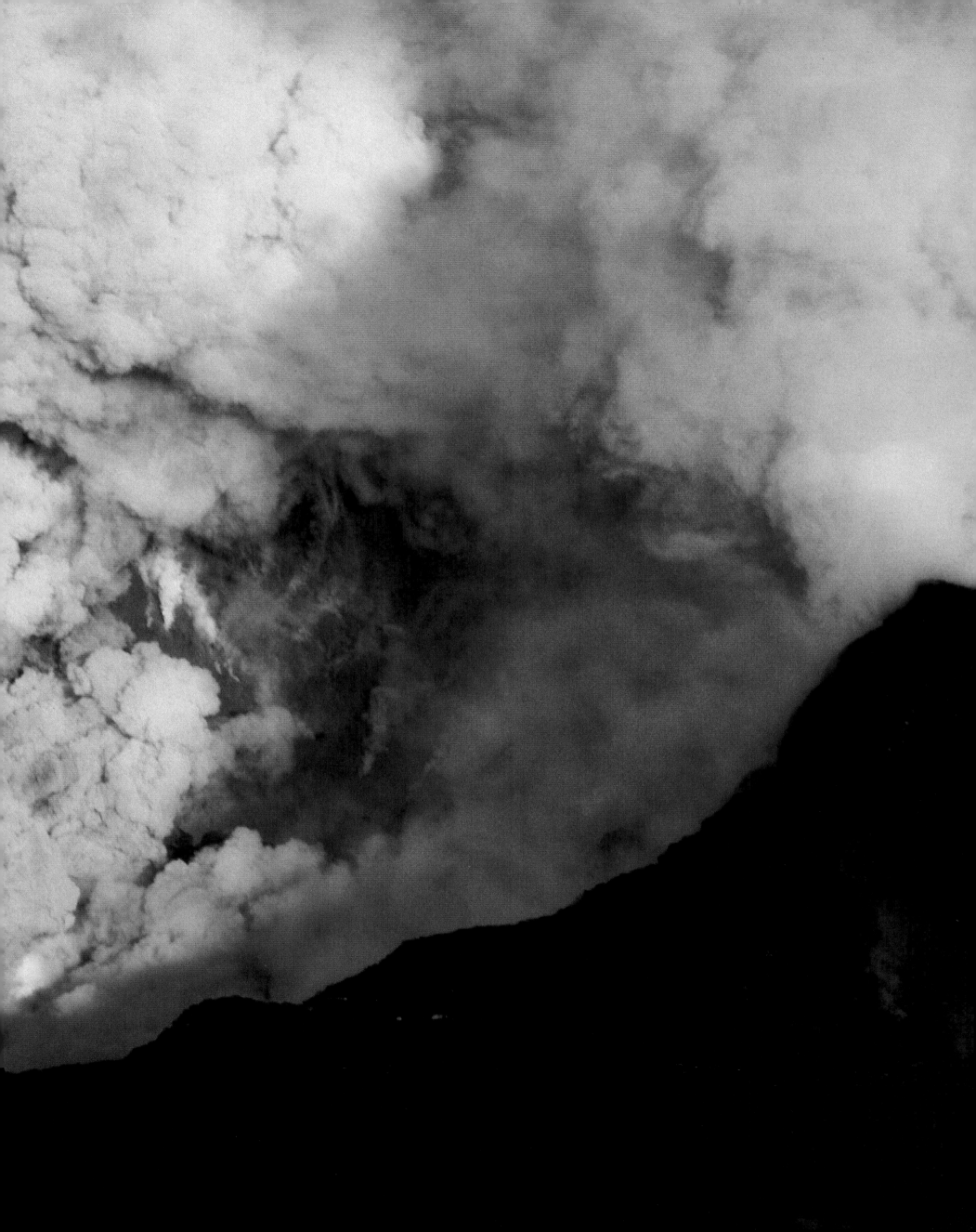

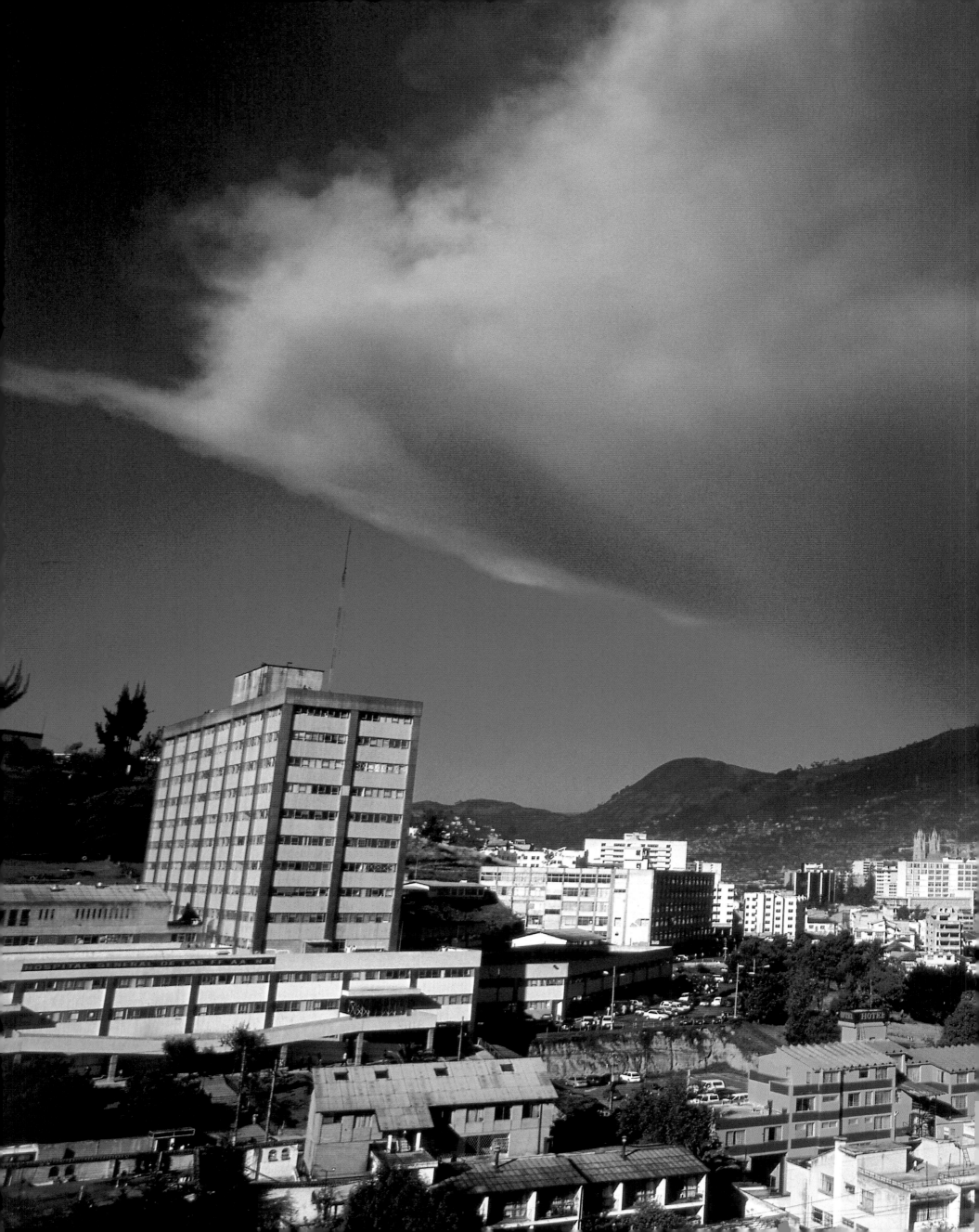

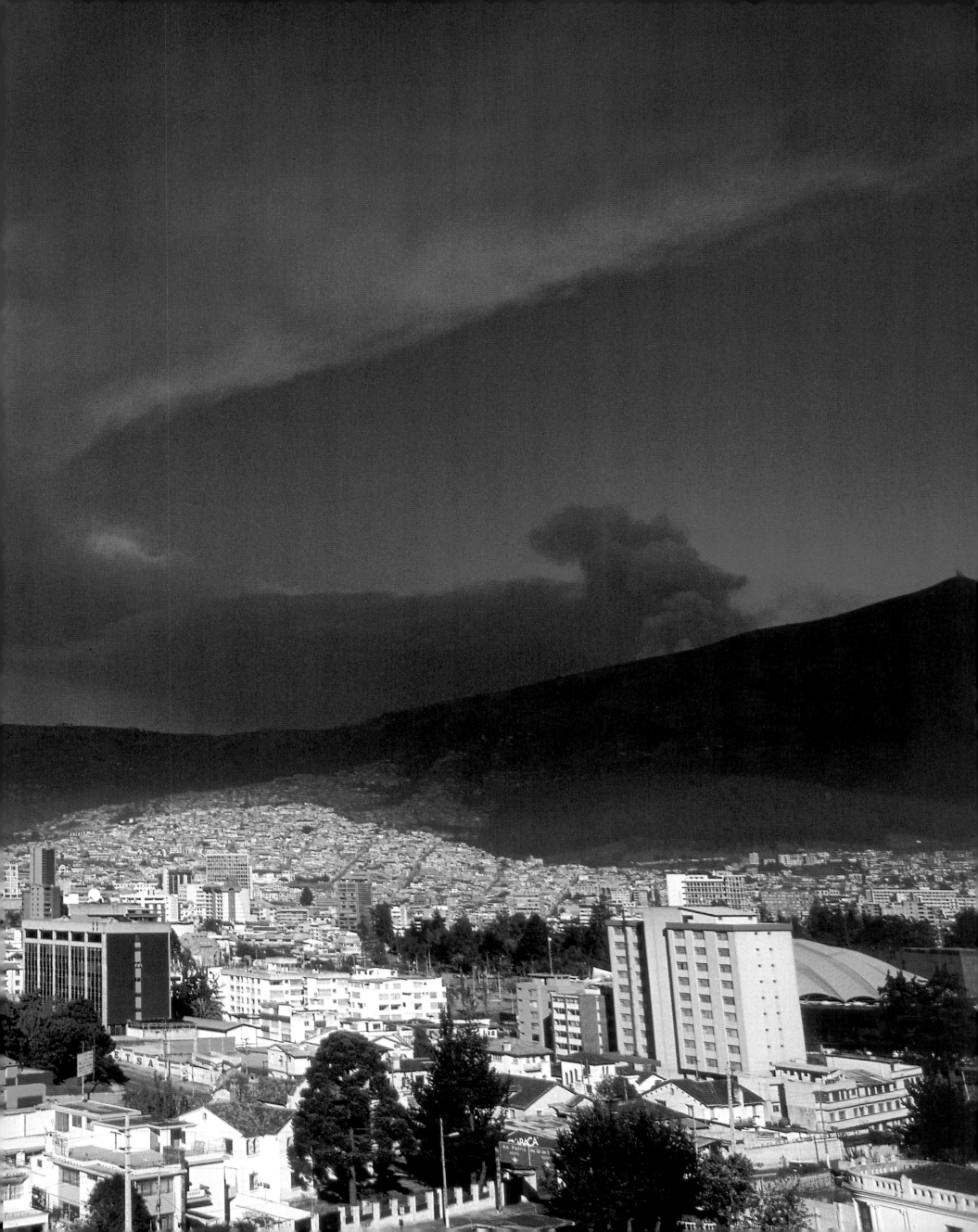

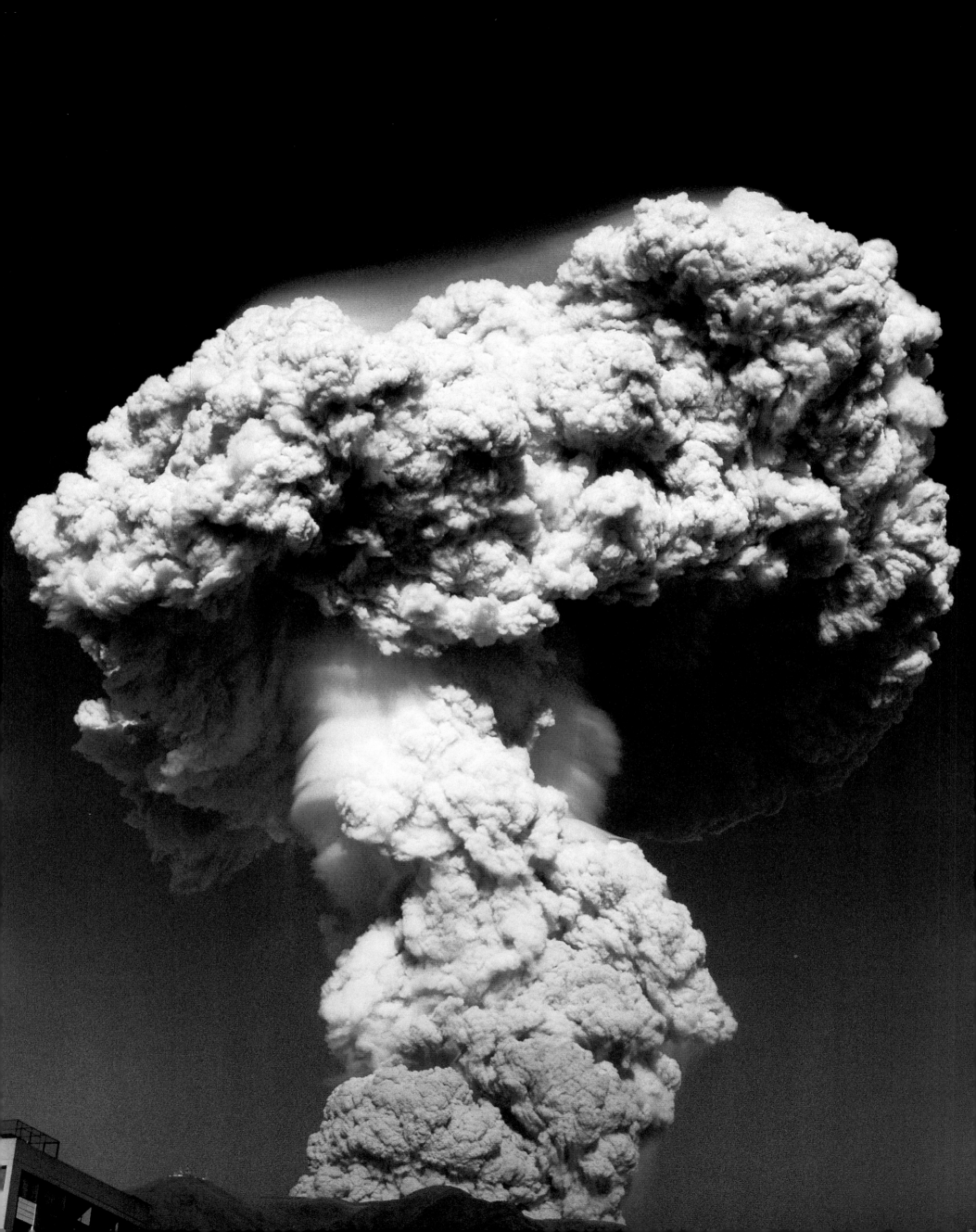

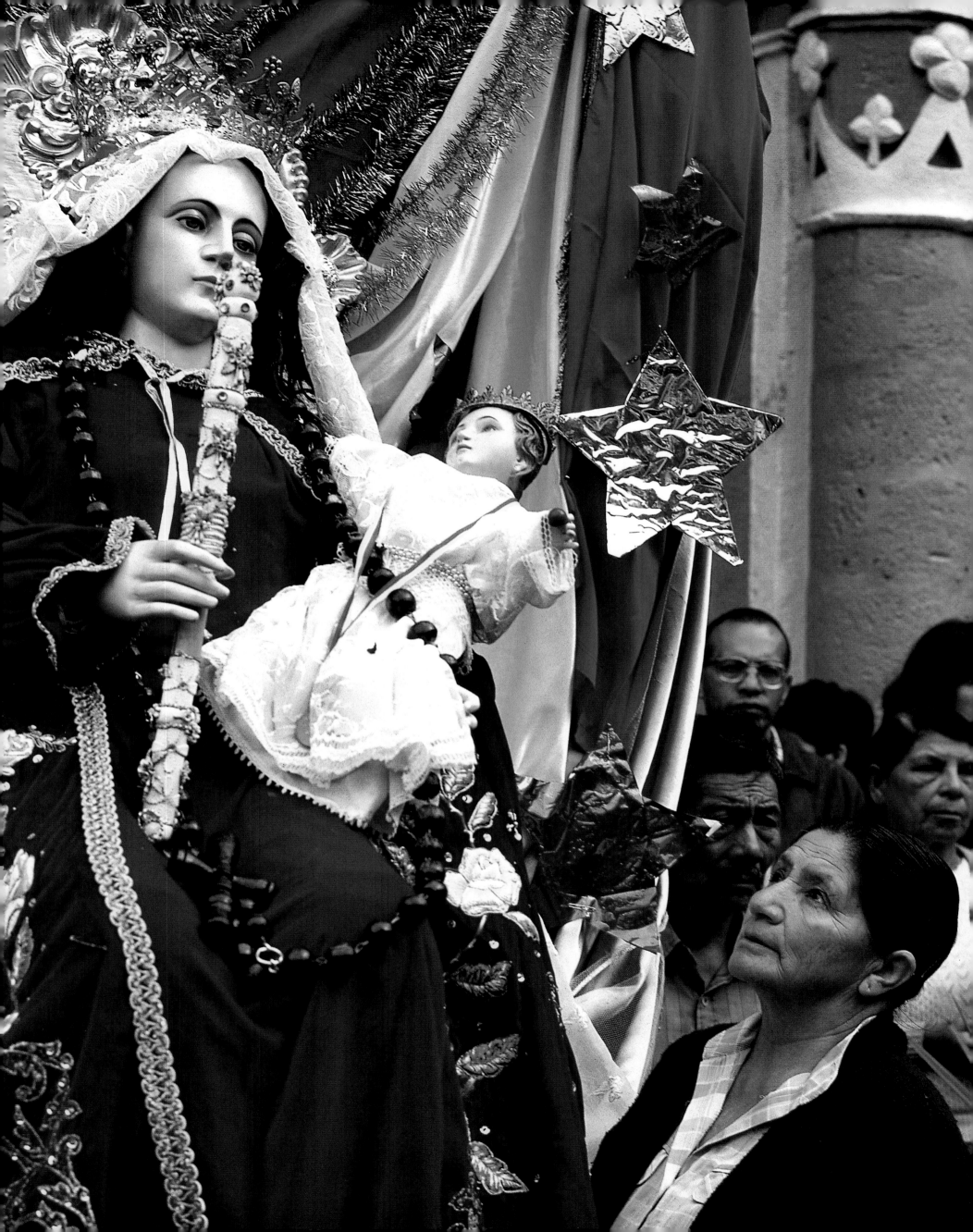

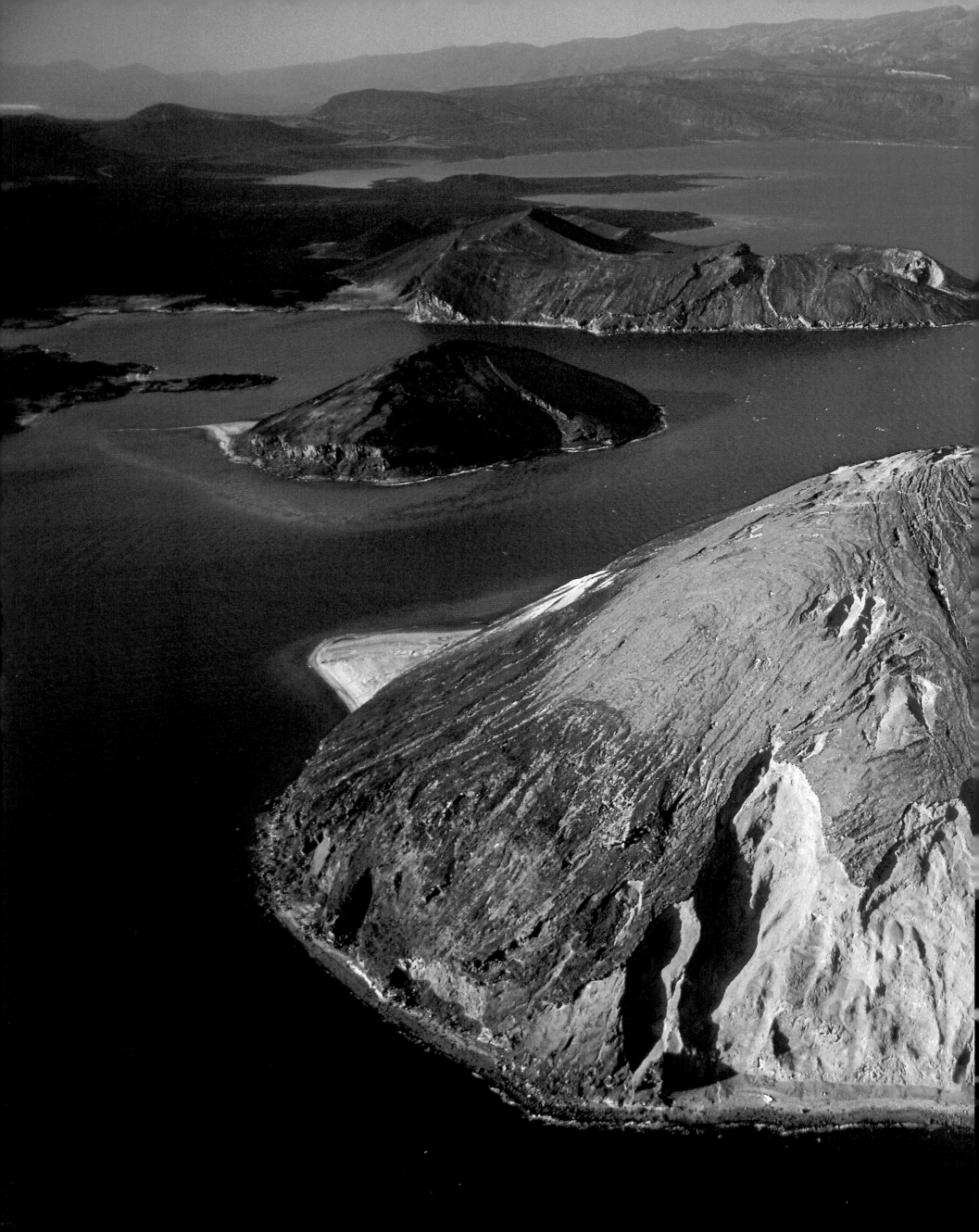

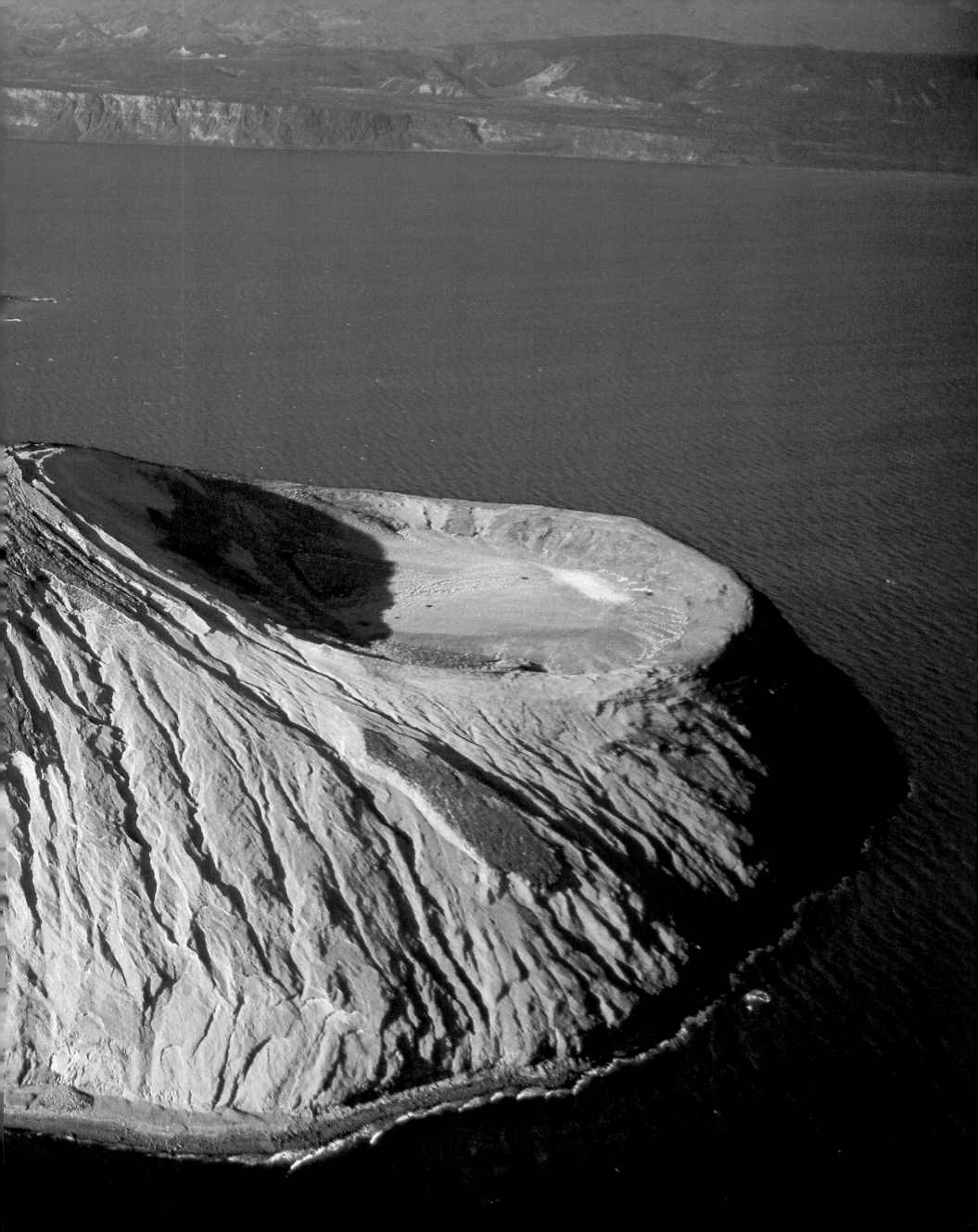

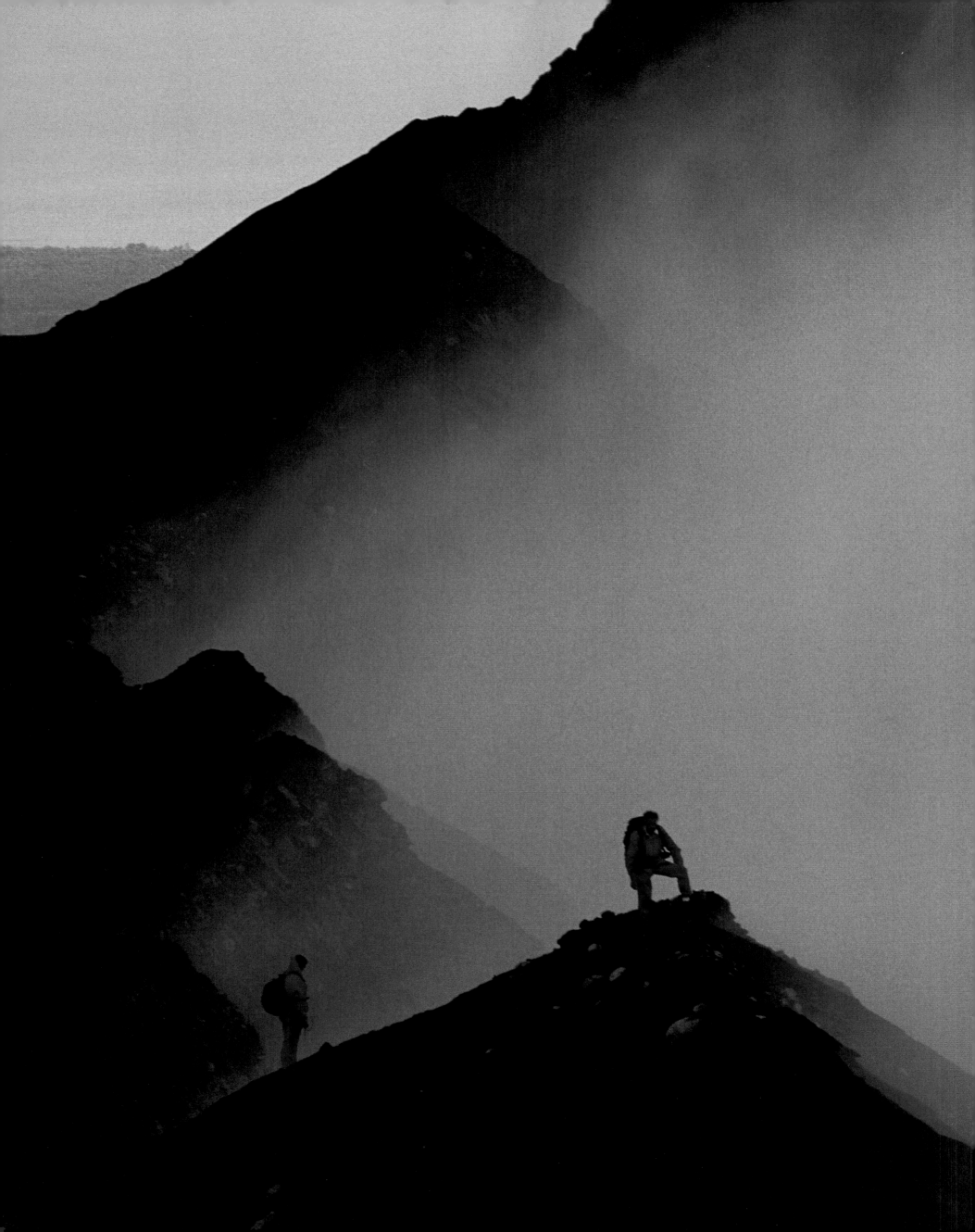

ERUPTIONS IN VANUATU AND ECUADOR

VANUATU: AN EXPEDITION TO BENBOW CRATER (AMBRYM CALDERA)

Saturday

Departure from Port-Vila, capital of Vanuatu. The plane seems rather small for all the equipment we want to carry. Airport employees, perplexed, eye the twelve large bags we have just arranged opposite the bay of the small Twin Otter. The first ones fit without much trouble, but, unable to carry one whole load, we "sacrifice" a few passengers to accommodate the baggage. In the end, only six persons can board.

Craig Cove, Ambrym Island. We are far from the modern airport of Port-Vila, with just a strip of bumpy grass between palm trees and tropical forest, a concrete cabin with a wind pocket, and three or four vehicles nearby. It is the start of a new adventure.

In the back of a rickety pickup truck, we take a worn-out road along the south coast of the island to our destination, the village of Lalinda. Obeying the ironclad customs of Vanuatu, we first must locate the village chief. We had hoped to reach him by telephone, but the complexity of the task was beyond me. We would have had to phone the day before to another village, where someone would bicycle to Lalinda to inform the chief that we wanted to call him. He would then return to the first village the next day where he would duly await our communication by telephone. Preferring direct contact, we had thus chosen to come straight to Lalinda. Ten or twelve huts with dried-palm walls and roofs, two water pipes—it won't take long to find the chief.

After meeting him, we explain that we would like to climb up to the volcano and we request the necessary authorization. We also request lodging for the night and a dozen porters for the next morning. The kindness of the people of Vanuatu is no myth. Within minutes we are given everything we wanted.

Sunday

Well before sunrise, we hear the porters outside our house. The road to the volcano is a riverbed that descends from the volcano. The entire valley floor is covered in a broad lava flow, since lava and water both follow the laws of gravity down the same topographic hollows. Around us, everything testifies to the violence of the elements. Lava has poured in great volume, and the river has moved vast quantities of volcanic block and ash during floods that must have been phenomenal. In some spots the deposits are more than 33 feet wide. Higher up on the volcano, a system of ridges leads us to the edge of the caldera, where we spread out.

After climbing the steep slopes, we are suddenly on the perfectly level surface of a sea of black sand. A thin crown of vegetation lines a depression 8 miles in diameter that is completely filled by deposits of black volcanic ash. A violent wind lifts the ash, which whips our faces. Farther along, the wind tugs at clouds of thick fog that mask the horizon. On our left, we can barely see a slope through the mist. It must be the volcanic cone that has brought us here. The cold, wet wind, the flying ash, the gray light on the black landscape—it is a particularly hostile environment. But a promise seems to rule over this landscape, drawing us to discover it.

As eager as we are to move straight on to the crater, our porters explain that it is difficult to set up camp in its vicinity. The blowing sand won't allow any anchoring of the tents, the wind is fierce, and floods can occur at any moment. Everything we see makes us believe our guides, and we follow them to the fringe of vegetation ringing the caldera. A slight depression filled with trees and vines makes a good shelter. During an earlier voyage, the porters had built a hut that will be a pleasant residence beside our small mountain tents. Camp is set up quickly, and our friends from Lalinda request to leave. It's Sunday, but I think that they just want to escape, as the weather conditions worsen by the minute.

Oilskin, waterproof trousers and an umbrella (if we manage to open it): we make protective gear out of anything. Despite the fine Nordic rain carried by the rough winds, our sights are set on the crater. Benbow has experienced very large explosive eruptions in the past that expelled ash that covered the floor of the caldera. Near the crater, these deposits are several dozen yards thick. The massif has been deeply rutted by intense erosion caused by tropical rains—more than 23 feet of rain fall here each year. The area around Benbow is nothing but a jumble of ravines, canyons, and steep, sharp ridges. It is not easy to find a route, but we discover a line through the fog. A long series of ridges seems to lead from peak to peak toward the topmost flank of the crater. Near the summit we scale some steep passages followed by one last ash-covered slope where we have to make extraordinary efforts to go on. When our heads reach open sky and the wind blows in our faces, it's hard to keep our balance against the gusts as we straddle two voids: the slope we've climbed and the crater. We are finally at the peak.

The edge of the crater is out of sight in the fog to our left and right. Straight ahead is the enormous enclosure nearly $2/3$ mile in diameter, but how do we approach a crater we cannot see? From the void rises a dense, white fog, laden with volcanic gases. We seem to be on the rim of a vast chimney. Under our feet is a wall 590 feet high, which we will have to outfit with ropes to climb, but all we see now are the first 30 feet. The slope littered with black ash fades off into a white fog carried by the gusts of wind. No one would claim to be particularly eager to tackle this descent, yet this is our route. For now, we head back to camp.

Monday

This morning we are up even earlier than usual, at 5 A.M.; the sun won't appear for another hour and a half. All night a deluge pelted the camp. In my tent, my living space was slowly reduced, leak by leak, by the rising flood. For nearly half the night, anything that could be saved from water was packed under several plastic bags.

LEFT: An expedition reaches the rim of the crater of Benbow, engulfed in fog. Benbow is an active volcano on the island of Ambrym in the archipelago of Vanuatu.

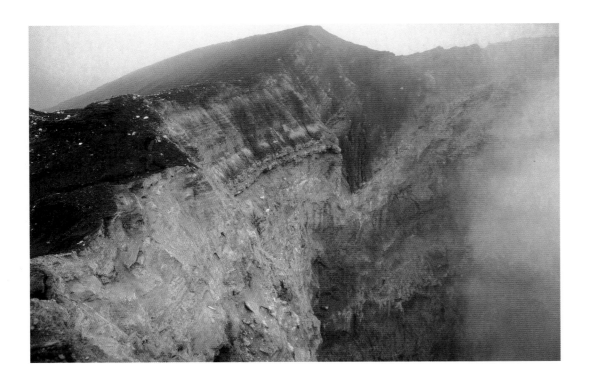

I eventually gave up, letting my mattress float in the middle of the flooded tent. I finally hurried to the hut built earlier by the porters, which proved far more waterproof than our "sophisticated" materials.

We thought we had planned for everything for Vanuatu; in fact we had arrived over-equipped and over-informed. We must admit, however, that in these places we rely on colleagues who have worked in cooperation with local researchers for many years. They have generously sent us pages of notes, of itineraries, of precise and judicious counsel and observations. So we set out, without the slightest doubt about the success of our mission. We had thought of everything—except that we would have the elements against us.

The image of the first wall we have to scale was not particularly appealing yesterday. The memory of the sight is even less so this morning. Rain is still falling and the wind keeps whipping across the floor of the caldera. Hoping for a clearing, we mill around our camp putting off as long as possible the moment when we will be on the summit ridge. Thinking we can see a break in the weather, we decide to set off.

Three porters are still here to help us bring material up to the summit, and we manage to get all the loads up in one trip. An hour later the small platform carved in the peak ridge is littered with sacks of various equipment: more than 980 feet of rope, steel spikes for moorings, food reserves, a tent, water for a camp we plan to set up at the bottom of the crater, gas masks, a diving suit. Everything is here. All that is left is to get started.

Water pours down from everywhere and visibility is not much better than yesterday. Two moorings are placed downhill from the crater, and 330 feet of rope is attached to it, as well as the rappel device. I can feel my heart tighten on climbing over the rim of the crater. The wall is not completely vertical, but its composition is not stable so we have to climb gingerly, with special attention to falling blocks that could damage the rope. A new mooring is placed 330 feet lower, and the end of its rope is attached to another steel spike 330 feet below the summit.

Soaking wet and somewhat disconcerted by the site, I take a piece of rope from the sack and head for the wall. I feel comfortable now, as familiar sensations and reflexes come back to me from years spent on other, similar volcanoes. I attach the new rope to the mooring and take off once again downhill, one more relay,

and then the rope ends at a steep slope of compact ash. Another 130 feet to descend and here is the horizontal surface of the first platform. This is where we'll set up an intermediate camp from which to work in the lower part of the crater. Back up to the ridge; it is still raining and the ropes are slippery and wet when I take hold to hoist myself up. My oilskin suit protects me from the streaming water and here, against the crater wall, I'm sheltered from the wind and warm enough. I soon find myself soaked by condensation from so much exertion inside my watertight suit. I take comfort in the thought that if I must be wet, it may as well be from my own heat. At the summit the team has scattered in the rain. After conferring quickly, we decide to put off the next stage of operations until tomorrow.

Tuesday

It rained all night again. Wind blew in gusts. A tarpaulin shelter stretched over branches above the tent prevented my getting flooded out again. We debate during breakfast before finally deciding to set up operations at the base of the crater. That will have us all primed to go as we wait for better conditions. This arrangement should also make it easier to prepare the wall leading to the second platform. Again, through gusts of rain we cross the caldera and climb to the top. We go back and forth to the first platform to equip our camp. The tent is set up at some distance from a floodable area. The severity of this place, the extreme atmosphere of this circular world opening only to the sky, the haunting presence of the volcanic cloud and of rumblings rising from the central crater, combined with the weather conditions have discouraged most of the team, and only two of us remain.

The platform on which we are located is occupied in its center by a vast crater that sends up a wide, continuous column of gas and steam. We're south of the crater. To the east, its contour brushes up against the great wall separating us from the summit. A series of narrow ravines cut into the deposits of ash between the two zones; through there we must find our passage to the northern part of the first platform. Just as we are about to set out, the weather clears enough to let us get our bearings. We take a series of readings with the compass and the GPS, taking pains to leave wide tracks in the ash to help us find the way back. We are soon wandering in a dense network of narrow canyons, but we finally find a passage that gets us to the edge of the central crater, which we follow until it is cut by an enormous active spout at least 100 feet in diameter. The walls of this great open chimney in the ground are coated with yellow sulfur. As though alive and breathing, regular exhalations of burning gas rise from the abyss. At each discharge a blast of heat makes us step back, much as we want to see what is down there. The expelled gases are very irritating, making our gas masks indispensable for the rest of the advance. I find the odor and the onslaught typical of sulfur dioxide, but there is something else too. A colorimetric tube connected to our hand pump gives us a rough idea that hydrofluoric acid is present in the atmosphere. It is the most aggressive acid, capable of eating away glass within a few hours. Fortunately, a few good breezes sweep it away, enough so we make our way around this active chimney. We are now on the northern part of the platform. From here it is possible to climb up the rim of the central crater, which will then

reveal all its secrets. A wall descends just ahead of us. About 330 feet farther down, it leads to a second platform, looking more like a slope of ash clinging to the lower wall. This slope leads to a projection of about 200 feet that finally overlooks the lava lake, our final destination.

From our lookout, we see the strange lava lake for the first time. I've been fortunate to have worked on many lava lakes, but this is definitely the most unusual, and also the most remote in a way, tucked far away in the bottom of the crater, nearly 1,300 feet below the volcano summit. Rather than an actual lake of lava, it is more like a skylight about 200 to 260 feet in diameter, opening straight above a rapid molten lava river that seems to flow nonstop at the bottom of the volcano. The lava is churning wildly and, from time to time, gas bubbles burst and splash on its surface. This skylight reminds me of the collapsed vaults sometimes seen above great lava tunnels in Hawaii and in Réunion. This unusual basement window sends up a cloud of hot gases that carry small fragments of lava projections, ashes that fall regularly as far up as the first platform. When the gas bubbles burst on the lava surface, the material stretches and the fragments become threads of volcanic glass, sometimes scattered like strands of hair, called "Pelé's hair," in homage to the goddess of fire. We spend an hour observing from the rim of the pit, calculating the route we'll have to follow in the coming days along the various walls.

During the last descent, we discover a new danger, unknown until then: the rope is drenched with water, and ash falling from the volcano cloud has accumulated on it. When the rope passes through the rappel device of light metal, this same ash, consisting essentially of hard silica, acts like an abrasive, cutting the device like a wide saw blade. In just one descent, my device loses nearly half its thickness. There is no way we can repeat this—we would risk

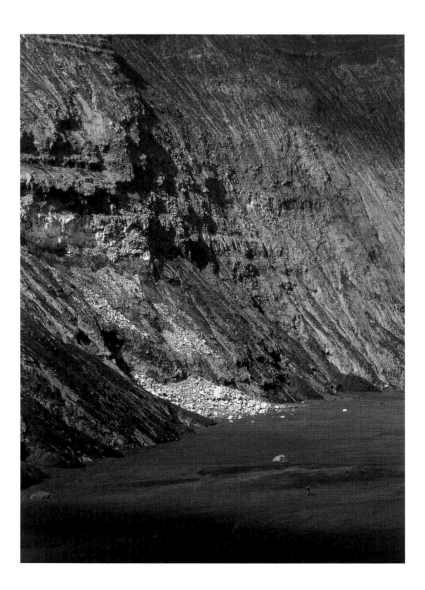

becoming detached from the rope, right over the void. We'll have to come up with another makeshift solution for the next descent.

Wednesday

Next day we set the goal of returning to the northern part of the crater. Visibility is better this morning; the sky is still leaden gray, but it is not raining. It's a luxury to be able to walk without the waterproofing gear.

For the first time we can see the entire wall surrounding us, tightly enclosing the gas and vapor cloud rising from the crater of the volcano. A new rappel device is placed on the rope that is solidly attached to the mooring, and we're off into the void, 650 feet below, where the lava lake roars and snorts. A few minutes later, the whole atmosphere changes. Bad weather is back. I am in an odd situation, suspended from the end of a rope on an unstable wall, whose summit and base are lost in thick pea-soup fog. Gases descend and, for some time now, I've been wearing my mask. My whole face, and especially my eyes, are itching. The gases from the volcano dissolve in the rainwater and form acid. Things are not helped by the needle-like lava particles, plus the "Pelé's hair" borne by the wind.

We ascend, return to camp, and wait in the tent whose stakes pull up with every strong wind. Waiting, more waiting, for days now. Rain, wind, fog, gas, and acid rain that eats away not just our equipment but our patience and resolve. Finally a difficult descent gets us close to the lake. Direct access was prevented by the unstable overhanging rim that shakes with each burst of underlying lava, each breath of gases it expelled. On this moving, agitated rim, forming a perilously balanced vault above the current of lava, we can't cover the last few feet to reach the bottom of the volcano. But that is no longer necessary. Although we can't fetch the precious lava samples that provide the best way of learning its exact composition at its source, samples are coming to us. Lava projectiles land right at our feet, where we can just pick them up.

And then it is time to dismantle equipment, remove ropes and material from each of the walls, in the wind and the gas. Our masks seem to be less effective in the corrosive air; we are short of breath in the middle of the wall, since our masks are now too clogged to guarantee us breath at full exertion. With acid all over our oilcloths, and our faces burning; with equipment that corrodes and rusts in one day of contact with these aggressive gases; with bags that get heavier all the time and seem to multiply as we climb, we struggle up the walls one inch at a time. In short, it was all that and more—until the first breath of fresh air in the wind at the peak of the volcano. Our few days spent on a mission to Benbow, beautiful volcano in a tropical paradise, were now over.

VOLCANIC CRISIS IN ECUADOR

Suddenly Pete calls: "Jacques. We've got a problem. Now there are two volcanoes, and we don't know which one will start erupting first." Pete is the nickname for Minard Hall, an American volcanologist who has been working in Ecuador for twenty-five years. We are on the top floor of the Instituto Polytecnico de Quito, the headquarters of the volcanological service. We all have our eyes

The camp on the first platform of Benbow. Ambrym, Vanuatu.

glued to a long series of seismographs. At regular intervals the needles shake, then speed up and trace a set of curves quite close together. A new shock has just shaken a volcano. Under the most active monitors we can read the names of the volcanoes they are recording: Pichincha and Tungurahua.

I have known Pichincha for a long time. More than fifteen years ago I spent a few days at the edge of its crater. It is a volcano that stands above the city of Quito, the capital of Ecuador. The city is just ten miles from the crater. The hillside streets of the colonial city seem to run right up against the flank of the volcanic massif. And the road up to the volcano begins at a bend in a street that starts at the city's cathedral.

The last time I had seen the volcano, it was in a deep sleep. An ancient dome occupied the crater bottom, surrounded by smoke and gas, covering itself slowly with sulfur. A few years ago, small sets of seisms were registered under the volcano and it was clear that magma was slowly working its way up to the surface. Since then, monitoring was stepped up and the Ecuadoran volcanologists reinforced the networks of measuring stations. On 12 March 1993 a violent explosion shook the volcano. Two Ecuadoran volcanologists who worked in the crater were killed. Since then this type of explosion has become increasingly frequent, a clear sign of rising magma that, when it reaches the surface, will set off a more classic eruption. Geological study of preceding eruptions showed that they had been of the explosive kind, projecting great quantities of ash and generating pyroclastic flows. These are dangerous eruptions, which, from what we are seeing now, won't be long in coming.

Situated above the tourist city of Baños, Tungurahua volcano, at 16,500 feet, is easily approachable and offers a challenge to many hikers. I myself had walked to it for the sake of a workout before going off to study taller volcanoes like Sangay or Cotopaxi. I have to admit, however, I had almost forgotten about the smoke and gas near the summit. I had never considered Tungurahua a potentially dangerous volcano, or at least no more so than several others.

With advice from Pete and some Ecuadoran volcanologists, we quickly sketch out an itinerary for the next few days. Since Pichincha is located just on the edge of Quito, we decide to reconnoiter there first.

Pichincha, the First Ascent

We have just left the outskirts of town on the slopes of the volcanic massif. A pebbly road leads to the ridge, where we get a true sense of the threat hanging over Quito. At the volcano's feet lies the old city, full of mansions and baroque churches, dating from the Spanish conquest, a modern city with skyscrapers and wide avenues choked with frenetic traffic. This urban agglomeration is contained in a wide basin, with Pichincha massif forming one side of its rim. On the other side of the ridge, the road dips back down into a wide, verdant caldera. Accumulations of volcanic ash have built up extremely fertile soil here. The whole caldera is an important livestock area, and its products feed the neighboring capital. Handsome farmhouses, or *estancias,* punctuate the landscape, while in the most open area rises the small town of Lloa with its administrative buildings, school, church, and the houses of a few thousand farm workers. At the center of the caldera is a large volcanic cone, Guagua Pichincha, or Little Pichincha, on which we are focused. The slopes of the cone are green, covered with meadows and cultivated fields. Near the top, a steeper slope leads to the edge of the crater; the upper part of the volcano is lightly powdered with snow, and, beyond the lip of the crater, a modest white cloud of gas and water vapor rises into the sky. This "small" volcano seems innocent, but the risk is real enough.

We think right away of the proximity to Quito. The capital of the country is undeniably threatened by a volcanic eruption. However, close inspection of the site allows us to allay these fears somewhat. The active volcano, Guagua Pichincha, is located in the middle of the caldera and its edge, a wall hundreds of feet high, offers a topographic barrier protecting the city from direct danger. In fact, if pyroclastic flows are emitted, they will be contained by the wall and will follow the natural slope leading them out of the caldera through the bed of Rio Cristal, on the opposite side of town. There are, however, still threats to Quito. When fresh magma reaches the surface, it will set off explosions that may be numerous and powerful. These explosions will loosen ash that, carried by the wind, could rain down on the city. Although the danger is not lethal, the volcano could seriously disturb the life and economy of a modern city. More critical is the situation of the town of Lloa, directly under the crater. Faced with the real risk of pyroclastic flows, authorities have just called for an evacuation. All residents not directly involved in the livestock trade have been removed. Those who remain only come to work by day and then leave the caldera at evening. The entire zone is guarded by military forces to prevent pillaging.

From the rim of the crater we finally see what is happening in the bottom of the volcano. The ancient dome is deformed under the pressure of rising magma. A long fracture is forming, littered with heavy smoke and gas emissions. Continual rumbling accompanies these high-pressure emissions. Here again we feel as if we are inside a pressure cooker. It would be interesting to get a detailed analysis of the gases escaping, but with the volcano's

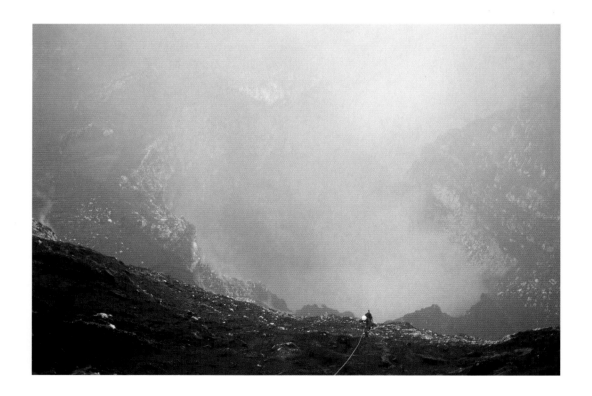

A rappeled (roped) descent toward the bottom of the crater of Benbow, filled by a lava lake. Ambrym, Vanuatu.

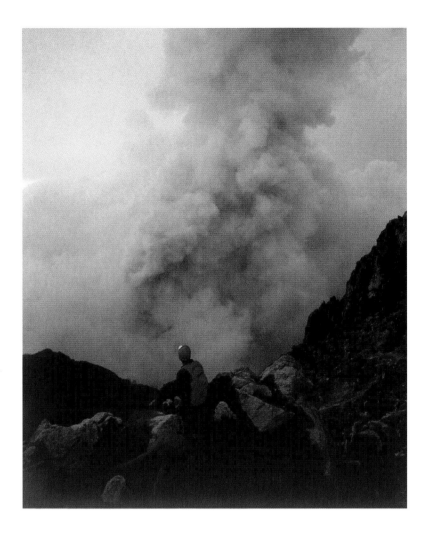

current instability, a descent into the crater's interior would be too risky.

One or the Other

Both volcanoes look "nervous," and urgent steps are called for. A complete inventory of the livestock is taken around Lloa at the foot of Pichincha; daily press conferences are held, and news is transmitted by the media.

An evacuation drill is planned all around Tungurahua volcano. More than 300,000 people are directly threatened and, in case of a major eruption, will have to be quickly evacuated. Alert code "yellow" is declared for Quito and Baños, the more serious "orange" in the farms and villages around Pichincha.

Both of the volcanoes look menacing, so it is not easy to decide which one to visit. At Baños the population is worried and you hear many stories of hasty departures, houses sold, and so on. Pete chooses to go to Baños, to work on the volcano on his own, and especially to live in the town. The presence of volcanologists among the people helps to convince residents of the seriousness of the forecast. By the same token, volcanologists' departure during evacuations could only be a sign worth acknowledging for the same population.

Pichincha Awakes

I decide to go back to the foot of Pichincha. At Lloa everyone seems calm; the military on the site have a well-organized center and help local farmers and agricultural experts to inventory and mark the livestock. Some landowners have already found pastures some distance from the volcano, and a number of trucks loaded with sheep and cows are leaving the caldera.

We are talking calmly with Colonel Aguas in front of the village church when a deep rumbling surprises us. Instinctively everyone looks up at the volcano. An enormous black cloud rises

from the crater. Dead silence follows, which means the start of an eruption, and we are much too close to the volcano. Soon, deep detonations shake the atmosphere; these are not explosions from the volcano but from lightning caused by static electricity crossing through the white cloud. I try to make out whether a gray-black cloud is approaching us; that would be the sign of pyroclastic flows—but at the speed at which they normally travel (several hundred miles per hour), there wouldn't be much we could do. Luckily there seem to be no lateral extensions except toward Rio Cristal, where the crater is howling far away. Suddenly the immobility that had gripped us is broken, and everyone tries to do efficiently what he or she must. The military sounds the alert sirens, the command center tries to contact the volcanological service by radio—no luck, we are totally cut off, probably the fault of the lightning flashes shooting through the cloud.

After a brief huddle, we join the colonel in evacuating everybody left in the area. Military trucks and jeeps immediately take off in different directions and quickly return with the remaining population. Without panic, people quickly board busses waiting outside the village. In less than an hour they have all reached the reception centers set up around Quito.

Above the volcano the cloud keeps growing and ash begins to fall on the outskirts. Having evacuated all civilians, the military prepares to follow. It is decided that they will go back up to the ridge over the caldera and, from there, will guard all access routes and watch the volcano at the same time. On the volcano, the intensity of the explosions seems to be declining, but the cloud of ash covers the whole sky. We, too, decide to leave the area for now.

City under the Ash

Two hours after the eruption began, the cloud of ash, pushed by the wind, falls on Quito. In the late afternoon, dual night engulfs the city. It grows very dark, except for public lights and headlights of cars still driving around. Otherwise it is a strange, almost palpable darkness. Passersby hurry along, protecting themselves as well as possible with umbrellas, newspapers, and articles of clothing covering head and face. Most are wearing dust masks that earlier had been distributed. Everything remains calm; most noises are muffled by the ash falling like snow. The city empties itself slowly and the population regroups around radios or television sets, since the mayor of Quito is now dealing directly with the crisis. His speech is clear, factual, honest, and without false promises. He explains that what we are now experiencing is only the beginning, that it could be worse, that it will be worse. He also makes clear that there is no mortal danger, though it may become necessary to live with the falling ash for a few weeks, or months, or maybe even a few years, that life will be difficult but not impossible. And the first emergency measures are enacted: all schools are closed for several days, all safety regulations are tightened, the airport is closed for at least forty-eight hours. A few hours later calmness reigns in town; the numbers tell us the explosions have stopped, but no telling for how long.

Next morning, a grayish white atmosphere reigns over the city, with every movement and every passing vehicle stirring up clouds of dust. Passing the cleaning women who are busy sweeping up on their first round, we take the road toward Tungurahua.

At the summit of Pichincha volcano, at an altitude of 15,690 feet, the crater that is usually inactive shows quantities of smoke and gas, indicating that magma is rising. Ecuador.

Evacuation

Tungurahua volcano rises on the edge of the central mountain chain of Ecuador, on its Amazonian slope. It dominates a deep valley that descends to the Amazon basin. As one descends the valley, the temperature gradually rises, as does the humidity, while the vegetation gets richer. Halfway between the mountain and the forest is the city of Baños. Here, 30,000 people live at the foot of the slope that descends from the volcano.

The volcanological service has a temporary office in place. On our arrival, Pete decides to reinforce the seismic network, and new equipment is arranged around the volcano. Then we try to measure the quantity of gas in the cloud from the volcano. We use a device called Cospec, which can take continuous remote measurements of the amount of sulfur dioxide emitted. A vehicle is outfitted with Cospec, and with the lens of the device pointed to the sky, we drive along the road circling the volcano. Before the crisis, the levels of sulfur dioxide were at a few hundred tons per day. This afternoon, after measuring for a few hours, we reach an average of 4,500 tons. It is an impressive figure, which certainly confirms that fresh magma is present under the volcano. When the magma gets to the surface, a major eruption could occur. Back in town, we look for passing currents, that is, sites where breaks can be seen in the ground. There we would distinguish the most recent geological layers, which could inform us about the latest activity by the volcano, dating back a few hundred years. Finally, in the upper part of town, near a place called the Vascùn, we find a construction site. The trenches dug open for foundations will give us what we seek.

We quickly realize that the ash deposits have a thickness varying between eight and sixteen inches, which is considerable. More impressive yet, between these deposits from falling ash, we find sizeable traces of ancient pyroclastic flows, some as thick as ten inches or more. This discovery corroborates various accounts that we have collected among the population concerning the most recent eruption, which was in 1916. There is no doubt that we are dealing with a volcano that could be—as it has been in the past—very dangerous.

The next morning, the municipal authorities, assisted by police, army, civil protection, and the Red Cross, carry out the evacuation drill. I am very impressed by the level of preparedness among the people. It is true that they have been widely alerted and instructed; numerous very detailed articles are published daily in all the papers, signs are displayed on the streets and in larger stores, and many informational meetings have been held. Nevertheless the exercise, taken very seriously by everyone, is a clear success and will surely prove useful in the near future. A few days after the drill, a great procession is held to bring out the miraculous statue of the Virgin Mary, who reportedly protects the city from the volcano. Two precautions are better than one. And the dean of the cathedral, convinced as he is of the power of the miraculous statue, tells me that the Virgin will also be evacuated, since there is no point in exposing such a relic to any risk.

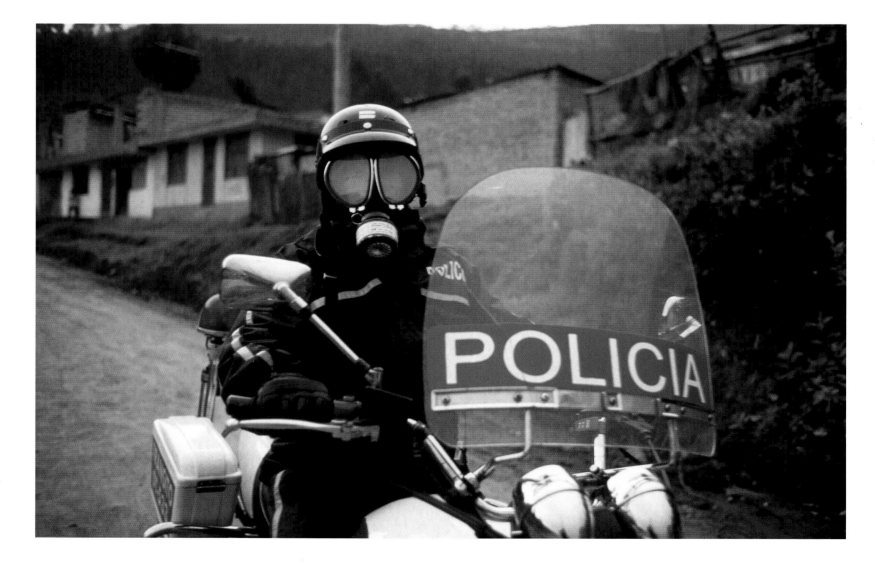

Outfitted with gas masks, the police patrol the streets of the village of Lloa to avoid pillaging during the evacuation by residents. Lloa is situated directly under the crater of Guagua Pichincha volcano. Ecuador.

334

The next morning, phreatic explosions are registered at the crater. Late in the afternoon, when the cloud cover finally lifts, we observe for the first time a plume of ash that rises above Tungurahua. A week later, increasingly stronger explosions rock the volcano and the emission of ash is almost continuous. With this growing risk the authorities decide to evacuate Baños; all residents leave the valley to seek refuge at Riobamba and at Quito. Are these people aware that they are fleeing one volcano to find shelter near another?

Return to Quito

Quito is calm, but all eyes are on Pichincha. The press, radio, and television speak only of the volcano, and the Ecuadorans are learning to live with risks of eruption. It is our opinion that, for these two volcanoes, the situation is still pre-eruptive. If some fairly impressive explosions occur today, they are still benign compared to what could happen during the climax of a great eruption. Let's hope that vigilance can be maintained over the coming weeks and even months. The current instability could persist for some time.

One Year Later

A year later, in 2000, the same situation persists. The volcanoes are in a state of great instability, both shaken by numerous seisms, and both ejecting ash that fell on Quito and Baños. Some pyroclastic flows from Pichincha have poured into the bed of the Rio Cristal, but were only of slight volume. Mudflows descended from

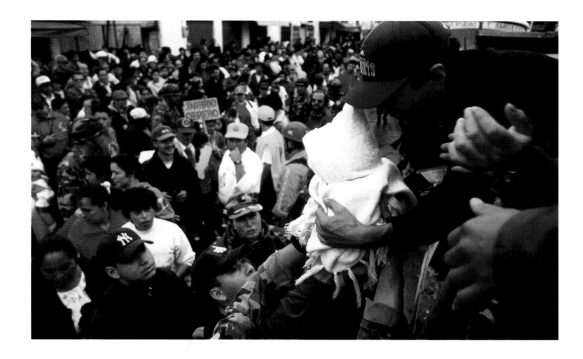

Tungurahua, but they were not very large and did not destroy anything. The great eruption or eruptions that were predicted have not yet occurred. The zones near the two volcanoes are still classified on the risk scale as "orange."

At Baños, however, the population decided to return to town after considering the modest nature of the current explosions and the innumerable social and economic problems caused by a long evacuation, and despite all official opinion. The army remained on the scene, ready to lead a new evacuation, but it appears, in 2001, that this eruptive period is coming to an end. We hope that in the future the volcano will send enough clear and readable signals so that an evacuation can occur well before the catastrophe.

An evacuation drill for residents of the city of Baños, menaced by the awakening of Tungurahua, one of the highest active volcanoes in the Andes. Ecuador.

PAGE 337. The piles of ash accumulated during a volcanic eruption are highly noxious to animals. Numerous bovines will die trying to feed themselves, since the ingestion of ash causes stomach perforations among these ruminant animals. Pinatubo volcano, Philippines.

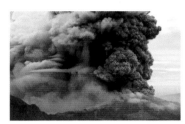

PAGES 338–39. After a dormancy lasting more than six centuries, Pinatubo exploded on 12 June 1991, although it does not even appear on the list of the world's active volcanoes. During this eruption the volcano sent clouds of ash 20 miles into the air during the peak of the crisis. *Nuées ardentes* (burning clouds) covered the slopes of the mountain, and rivers of mud spread through the valleys destroying everything in their path as far as 25 miles from the crater. While most of the population was evacuated in time, there were nevertheless 300 victims. Philippines.

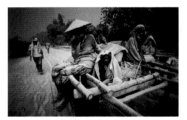

PAGES 340–41. The eruption of Pinatubo was one of the largest in the twentieth century. It drove half a million Philippinos onto the roads to flee the area, which had become temporarily uninhabitable. Philippines.

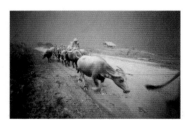

PAGES 342–43. Peasants attempted to save their livestock that were unable to feed, since a thick layer of ash covered the prairies. Pinatubo volcano, Philippines.

PAGES 344–45. A resident evacuates with his pig from the region menaced by the eruption of Pinatubo volcano. Philippines.

PAGES 346–47. A thick carpet of ash covered the rice and sugarcane fields within a radius of more than 20 miles around Pinatubo volcano. Philippines.

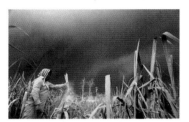

PAGES 348–49. A farmer tries to harvest his crop of sugarcane despite the layer of ash that fell from Pinatubo. Philippines.

PAGES 350–51. Ash ejected during volcanic eruptions can considerably enrich the soil. Such fertile land from ash deposits explains the high population density near volcanoes. Pinatubo volcano, Philippines.

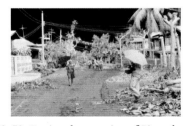

PAGES 352–53. During the eruption of Pinatubo, the residents of a village located about 13 miles from the volcano took advantage of a break—as the ash rains diminished—to leave their homes. Although the sky appears black, this photo was taken during the daytime. Philippines.

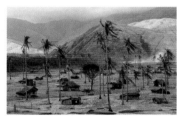

PAGES 354–55. At the foot of Pinatubo volcano, the village of the Masquisquis was struck by a passing pyroclastic flow. Fortunately all the residents had been evacuated. Philippines.

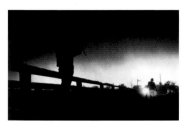

PAGES 356–57. Falling ash was so thick that even in the middle of the day the light disappeared. Inhabitants of villages fled the region, evacuating their families and property by any means. Pinatubo volcano, Philippines.

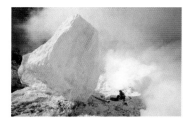

PAGES 358–59. In the eastern part of the island of Java, Kawah Ijen volcano produces 4 tons of sulfur per day. On the shores of the acid lake in its crater, sulfur accumulates abundantly. It is harvested by a handful of miners who work under extremely harsh conditions to extract precious metalloids. Indonesia.

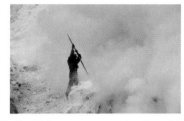

PAGES 360–61. Without any protection from highly corrosive gases, miners climb a "hill" of sulfur to break off new accumulations from the previous night. To accelerate the formation of sulfur, Indonesians channel gas and smoke into great iron tubes. The acidic vapors are condensed and the mineral precipitate turns from gaseous to liquid form, flowing to the ground in long red streaks that then crystallize to a lemon yellow color. Miners seize this moment to hack off plates of newly solidified sulfur. Kawah Ijen volcano, Indonesia.

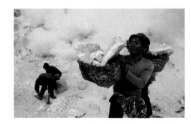

PAGES 362–63. Porters carefully balance blocks of sulfur in wicker baskets attached to the ends of wooden rods. They climb up from the crater with loads exceeding 175 pounds that have to be taken to the treatment plant 25 miles away. Kawah Ijen volcano, Indonesia.

PAGES 364–65. Despite loads of sulfur weighing more than 175 pounds on their shoulders, the miners attack the sharp climb on the internal wall of the crater of Kawah Ijen volcano. Indonesia.

PAGES 366–67. Porters reach the edge of the crater of Kawah Ijen volcano, bending under the weight of the sulfur. While this exhausting labor pays them considerably more than the average Indonesian can earn, it also limits their chance of reaching an age of more than about 40. Indonesia.

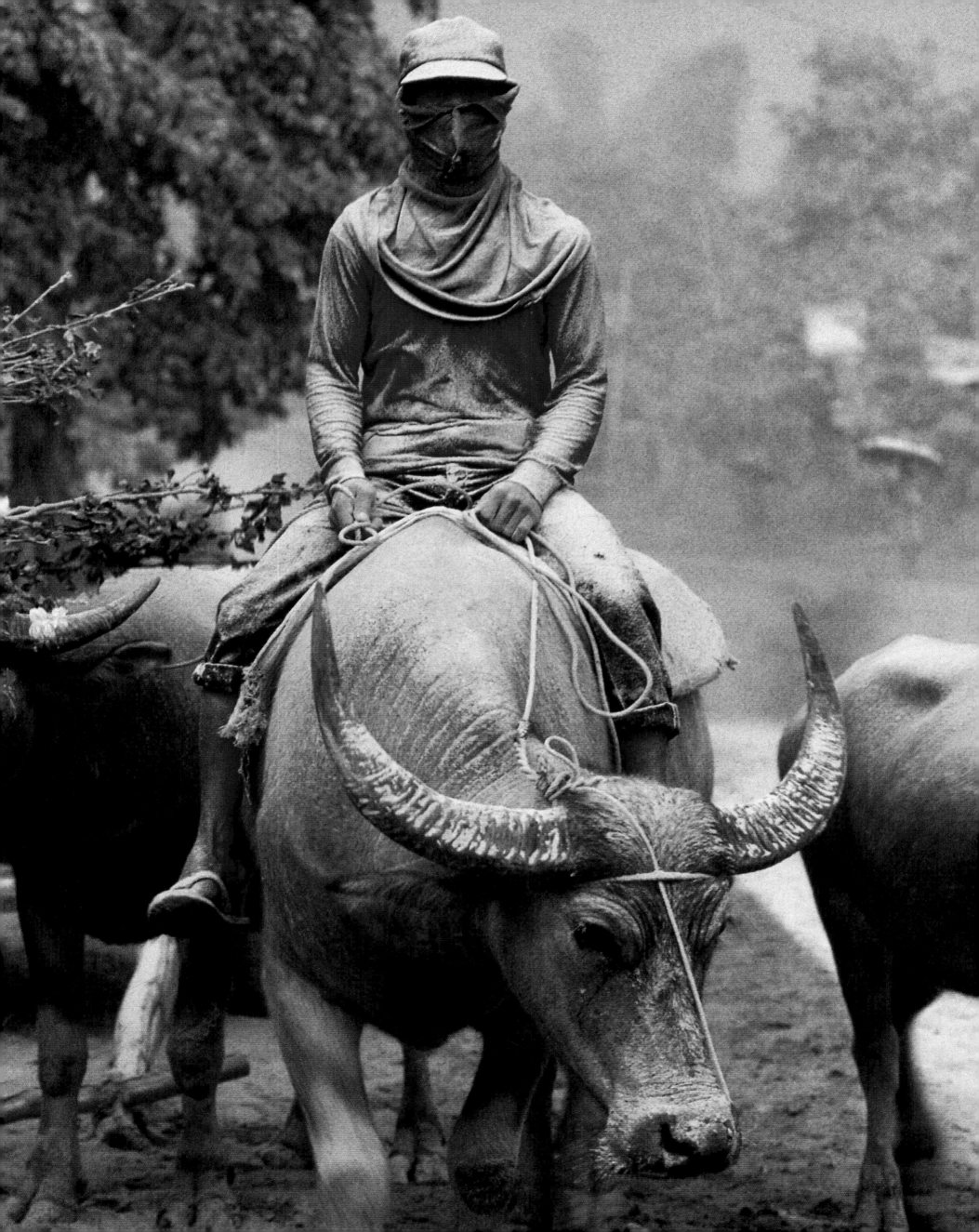

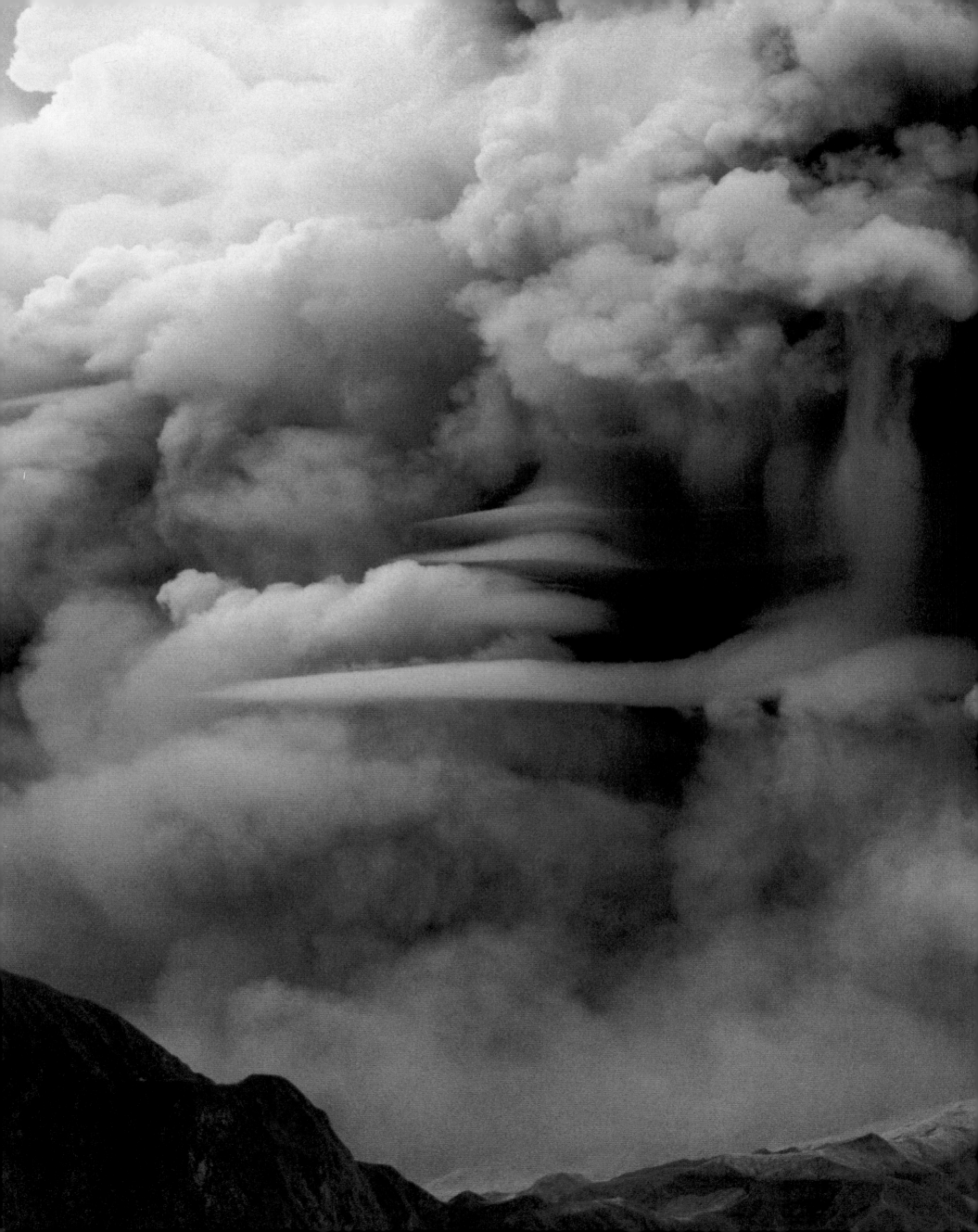

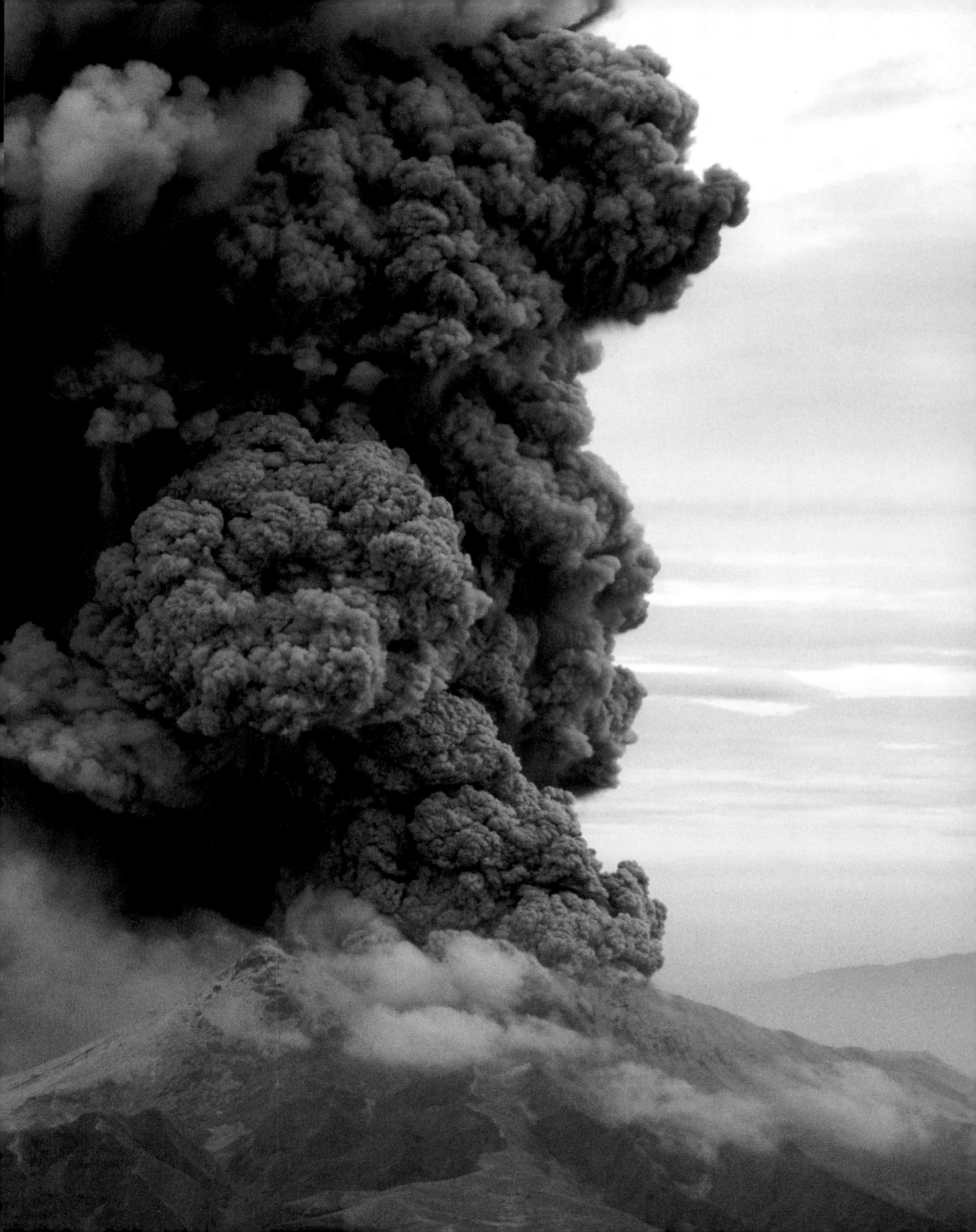

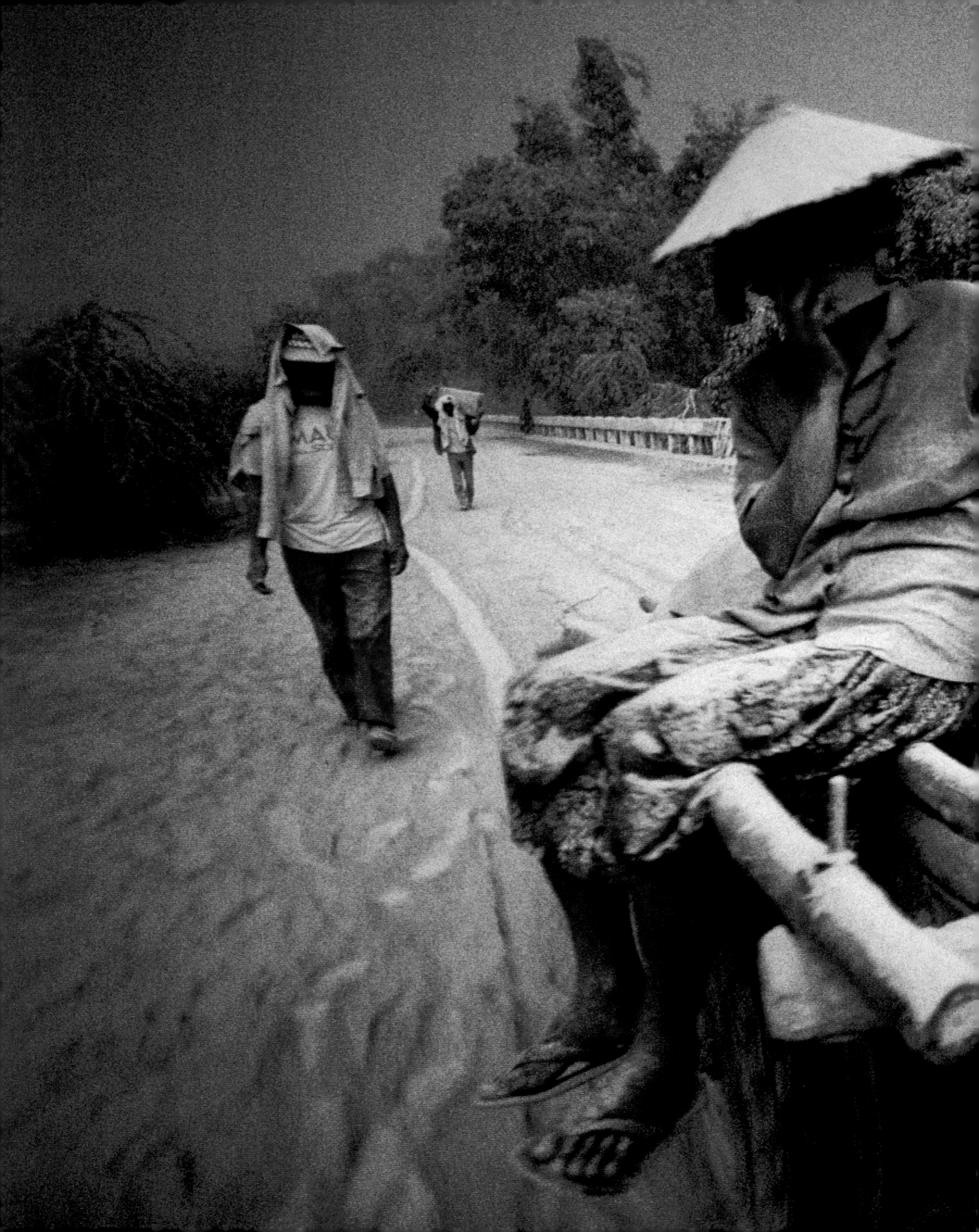

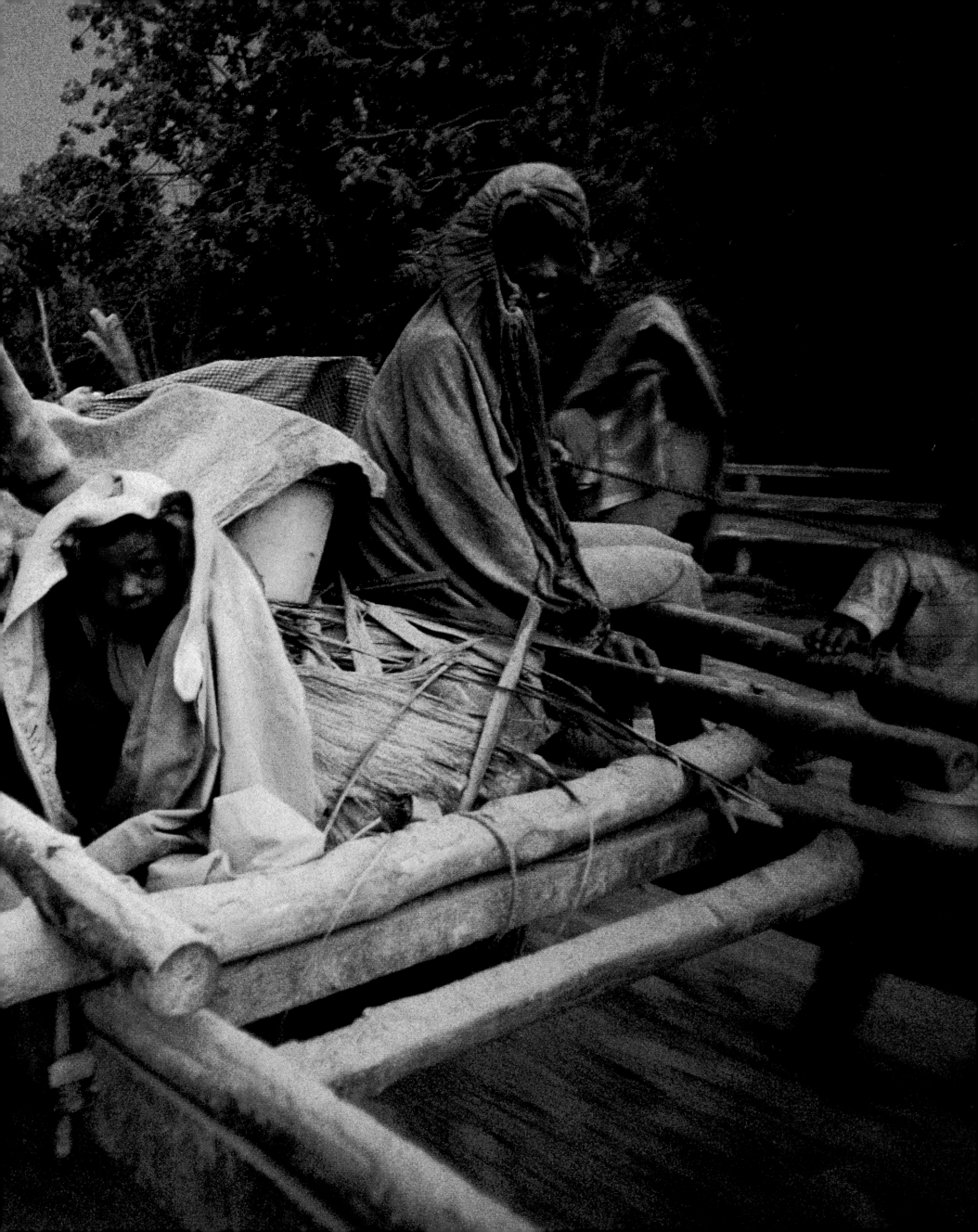

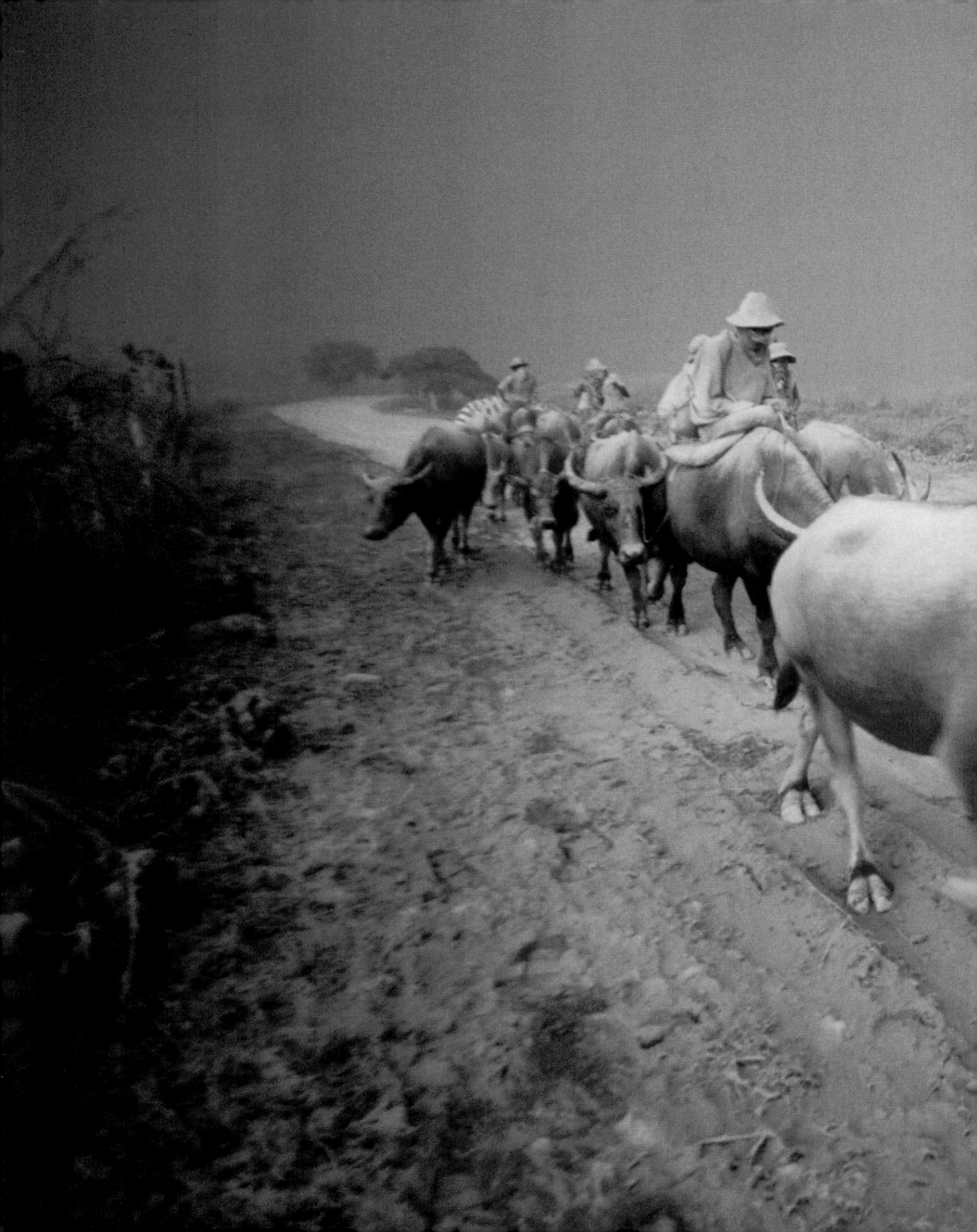

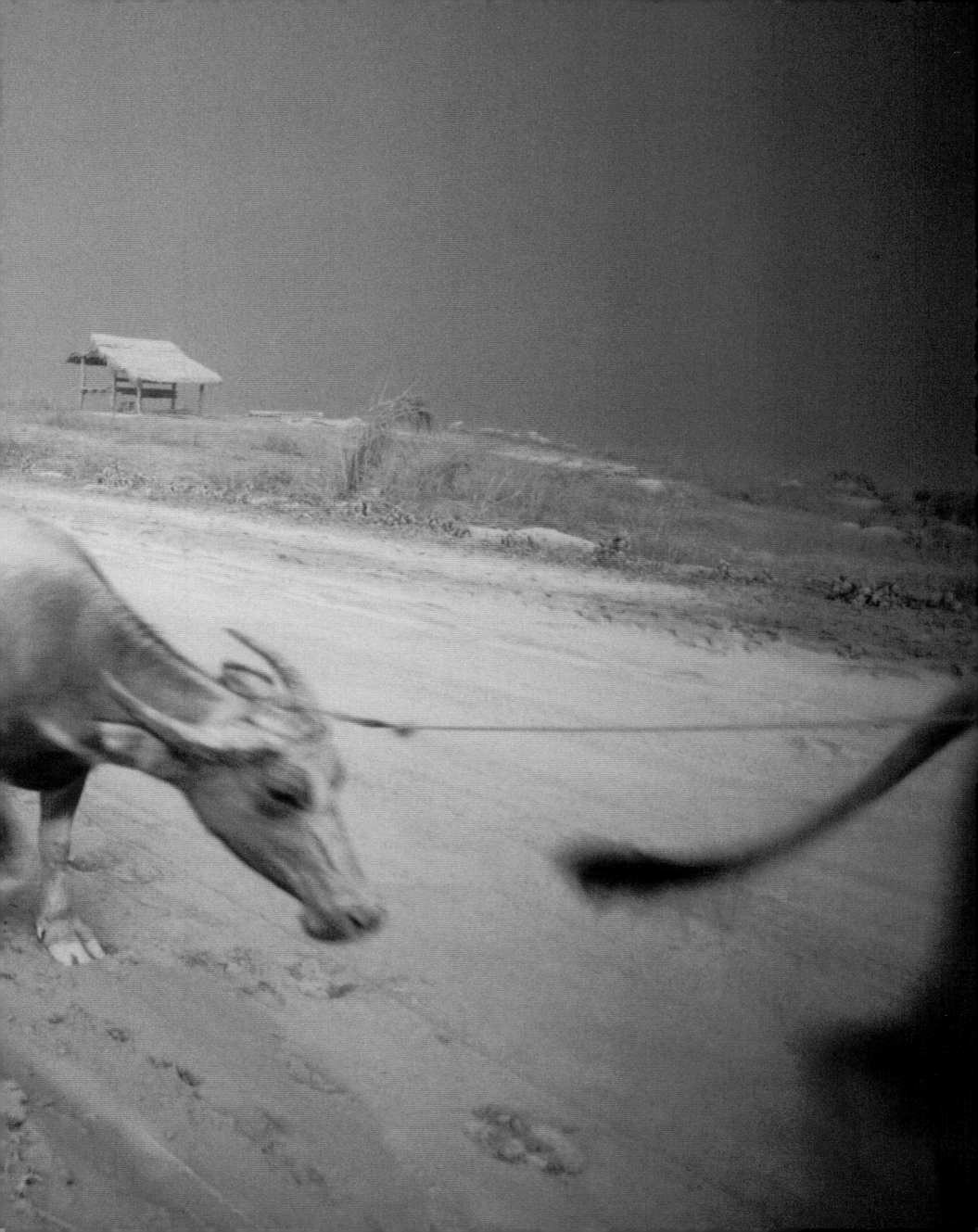

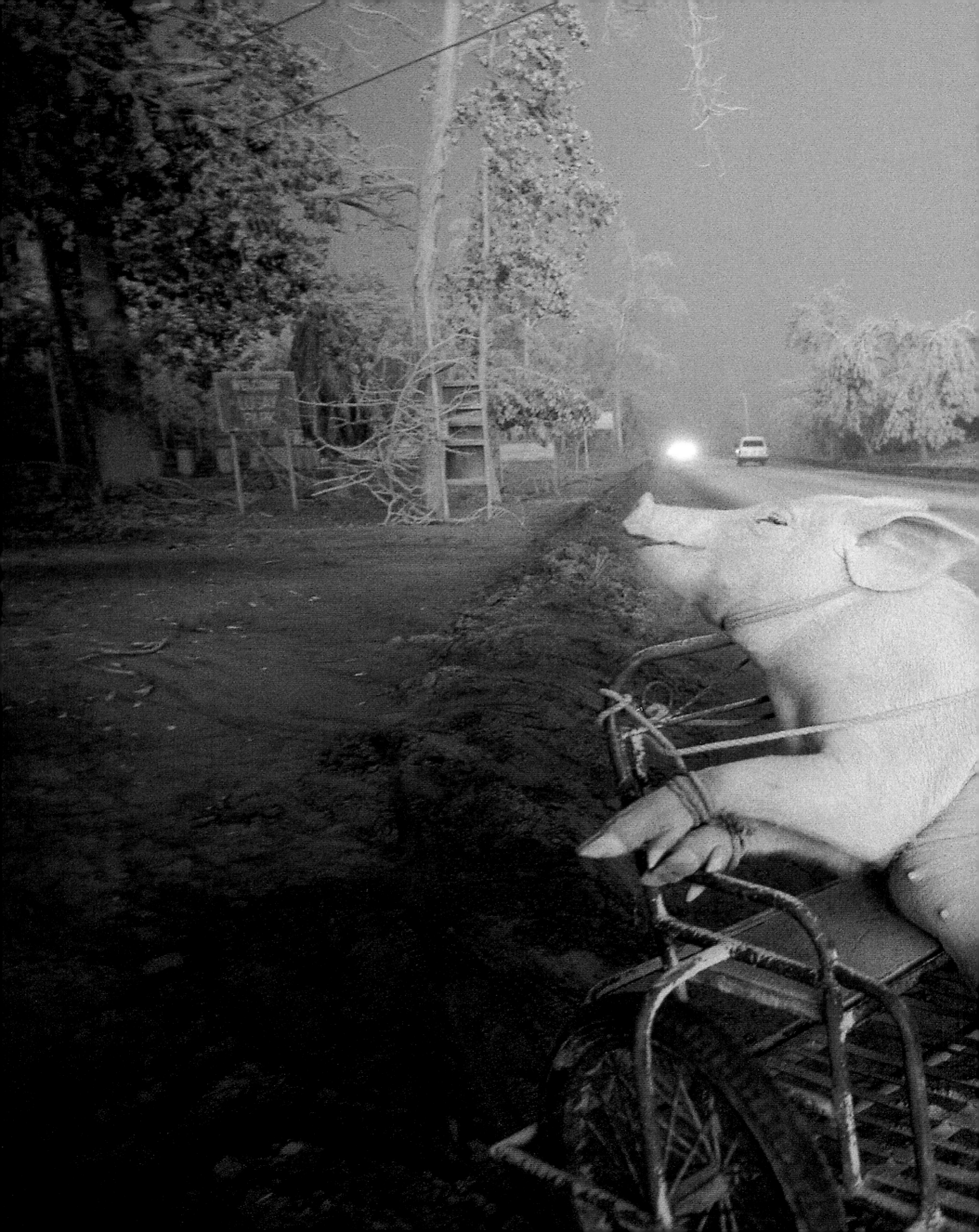

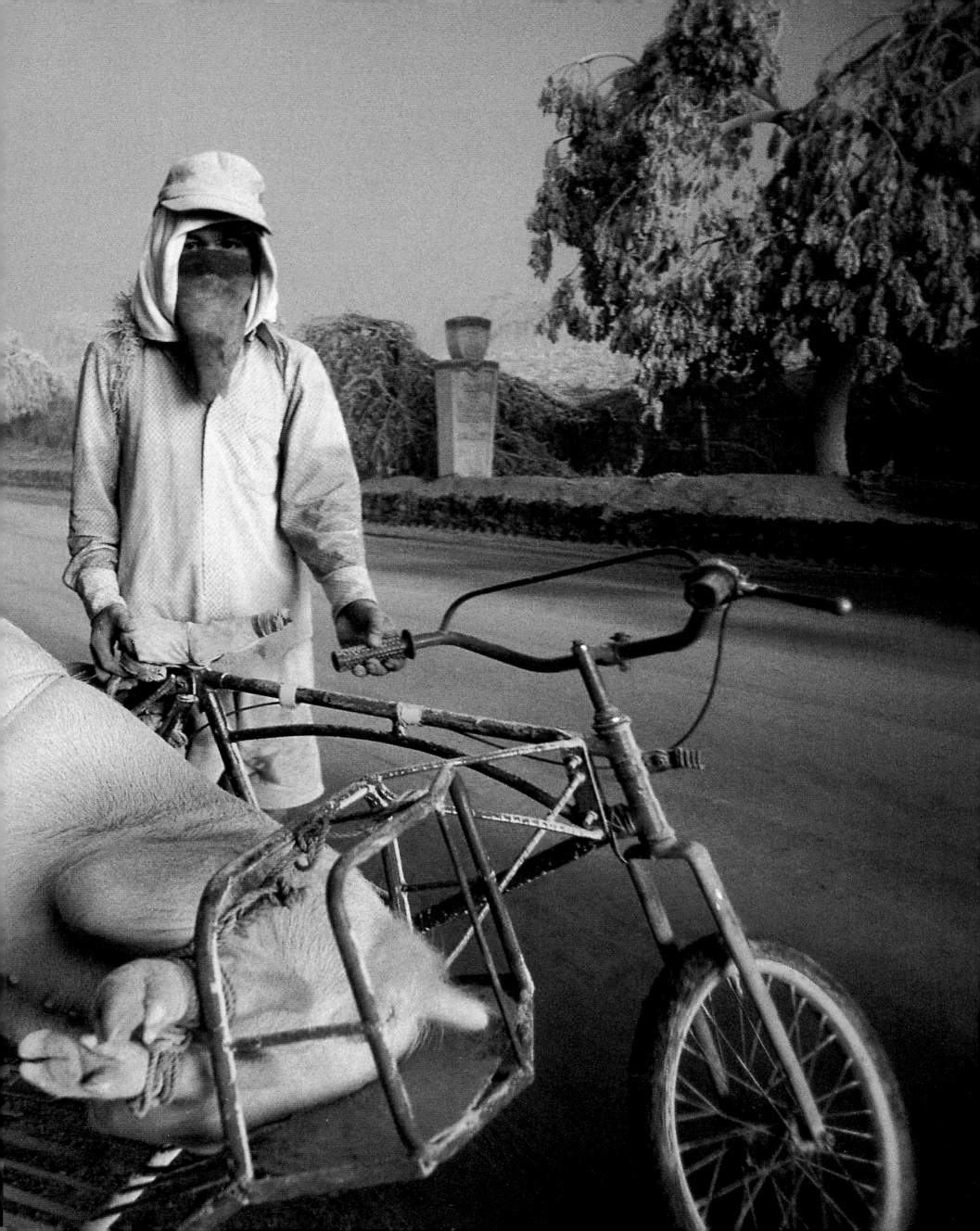

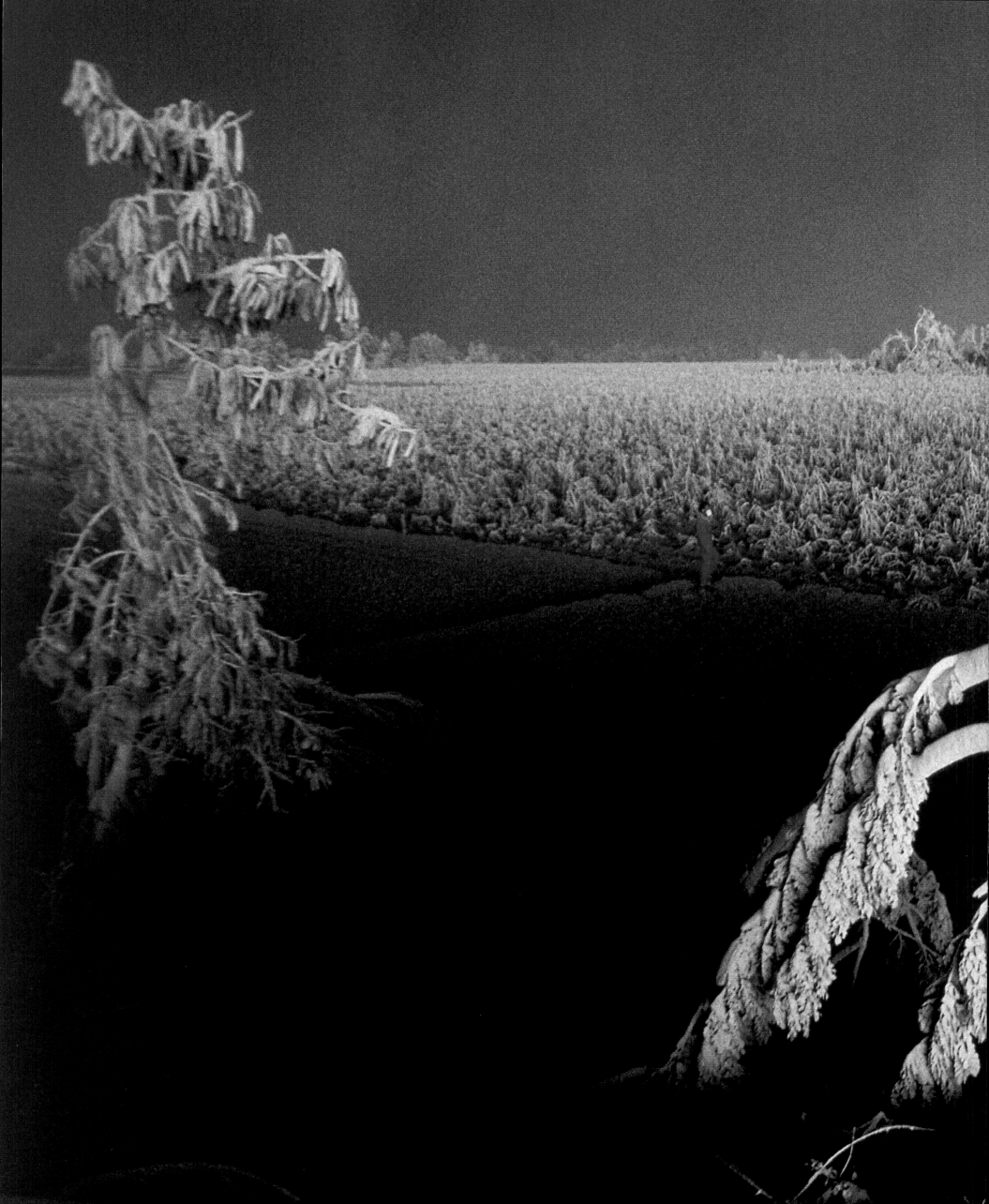

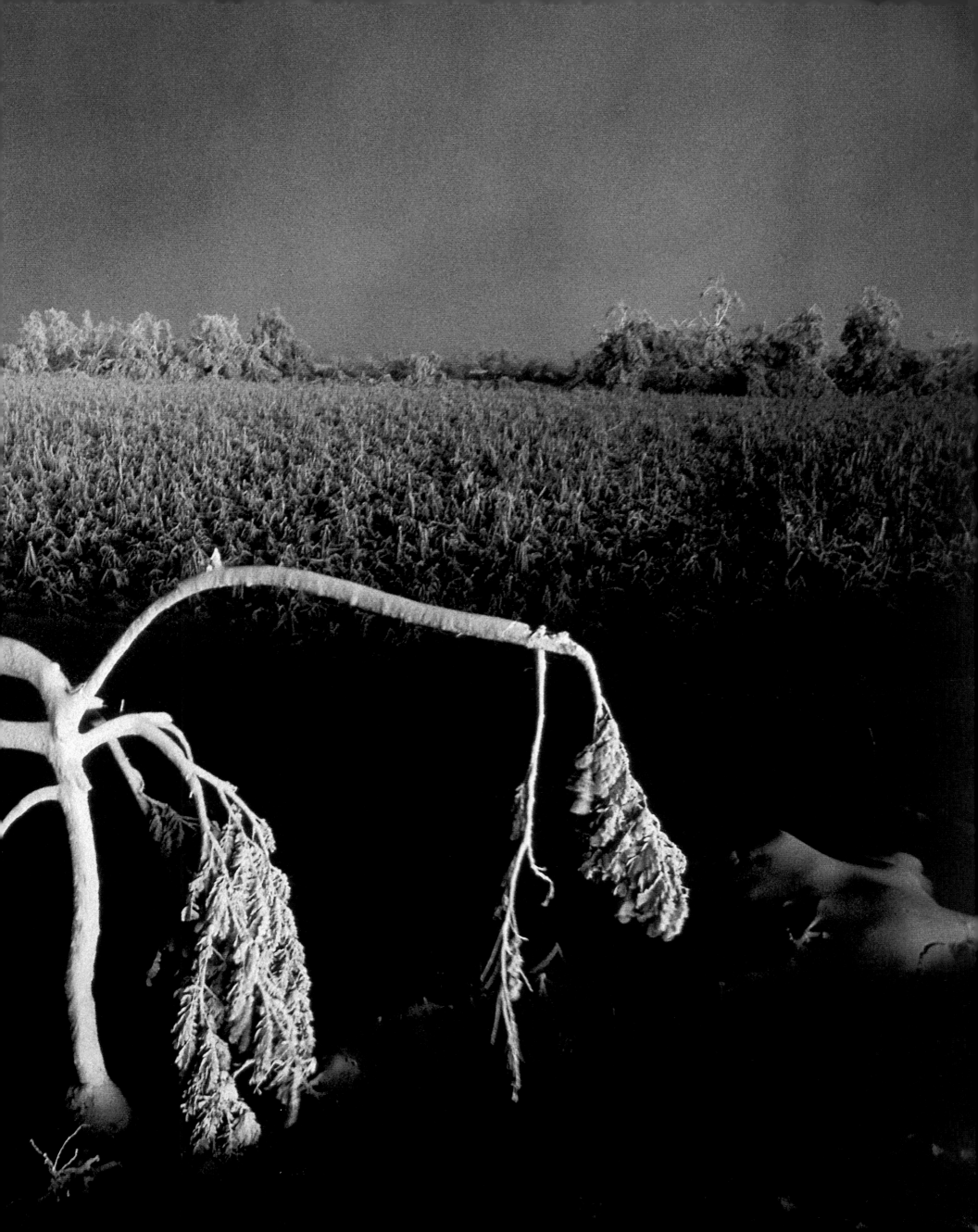

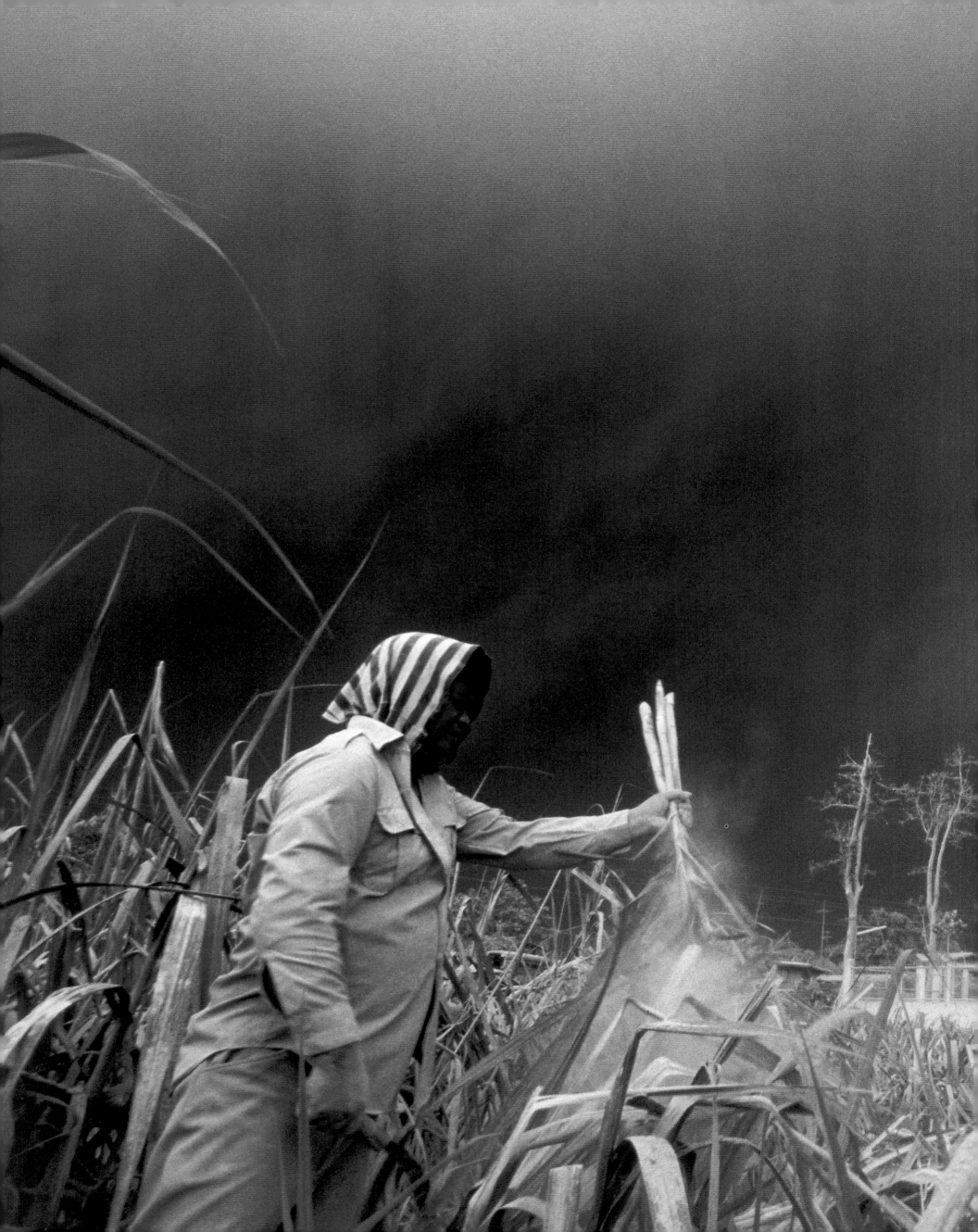

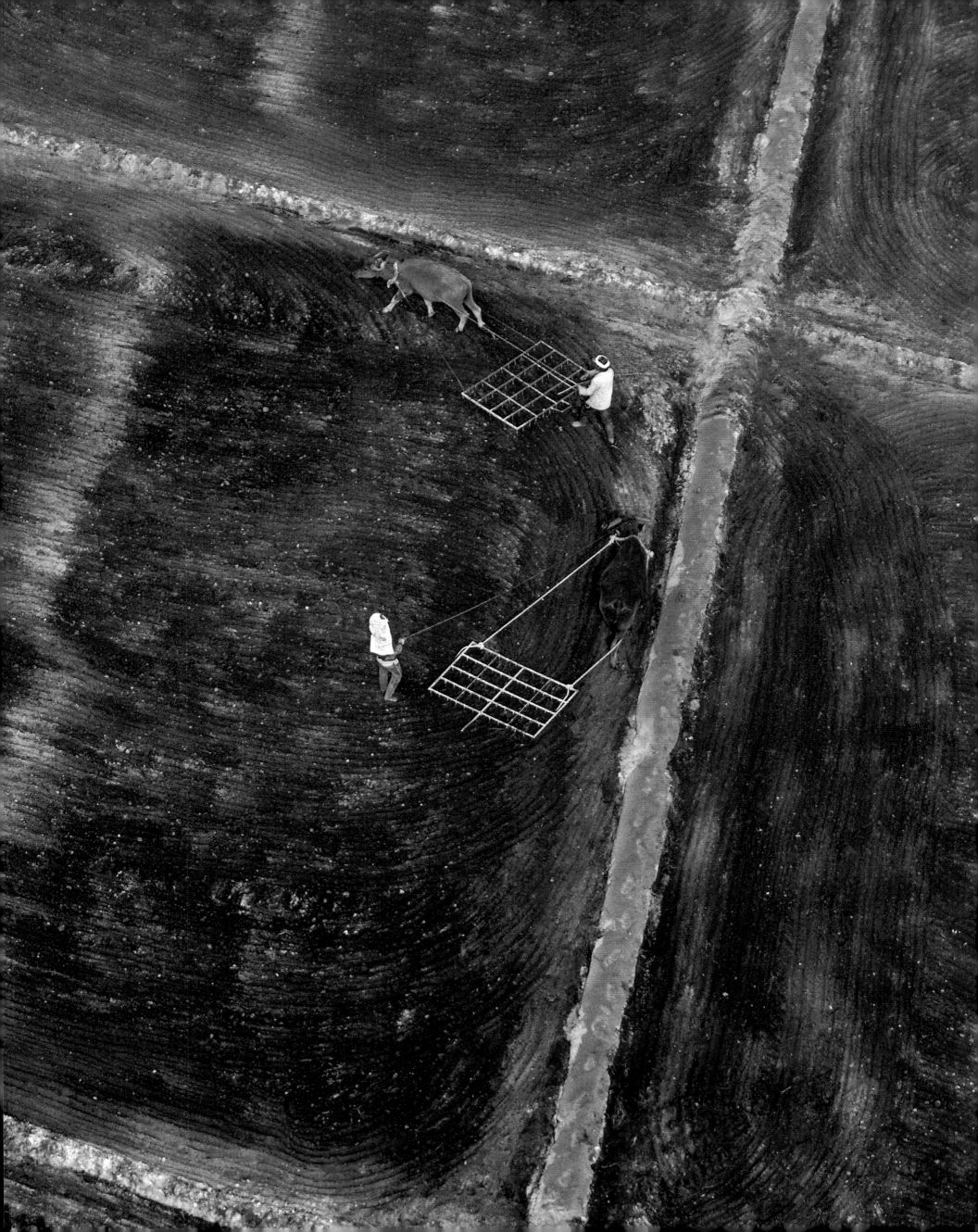

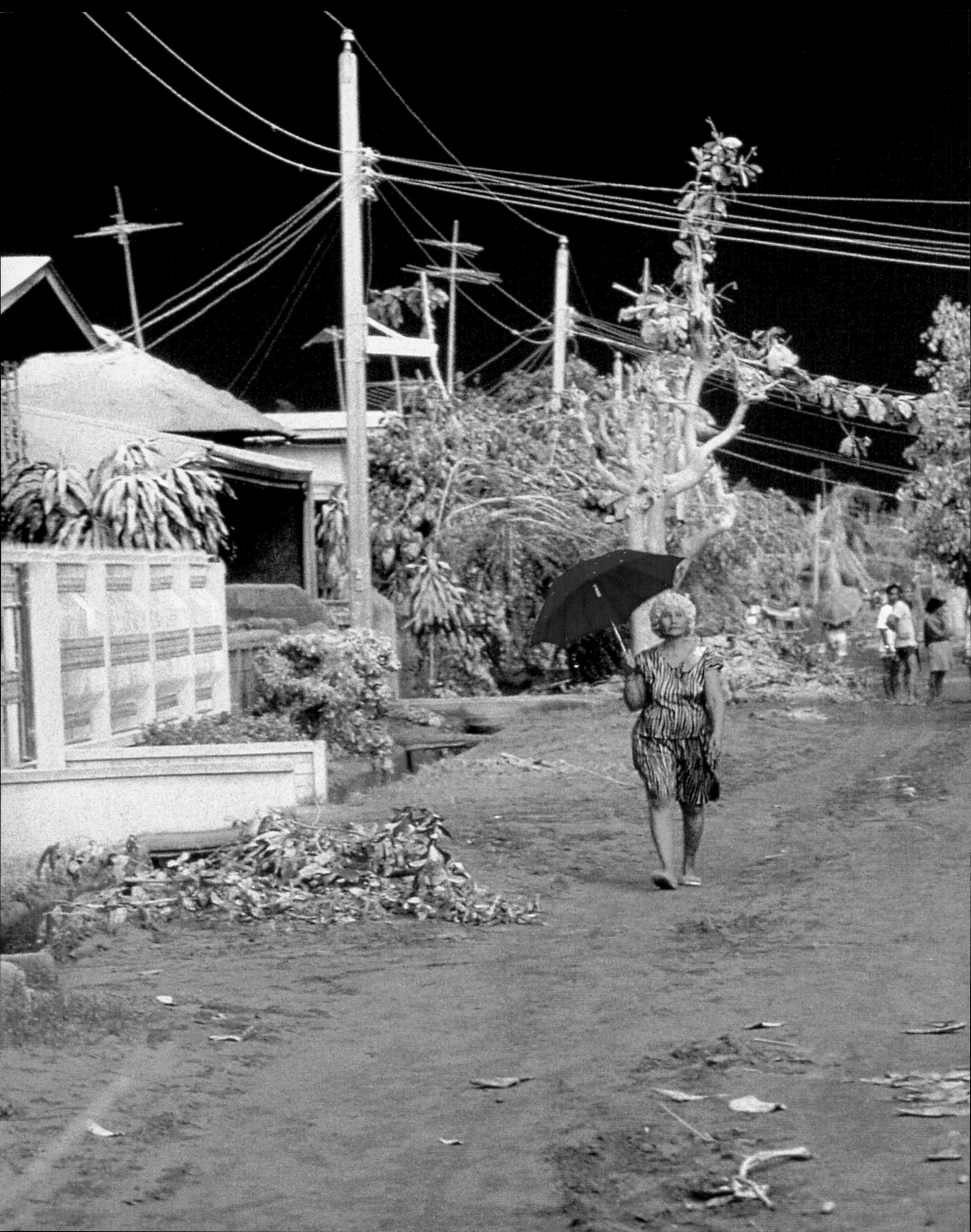

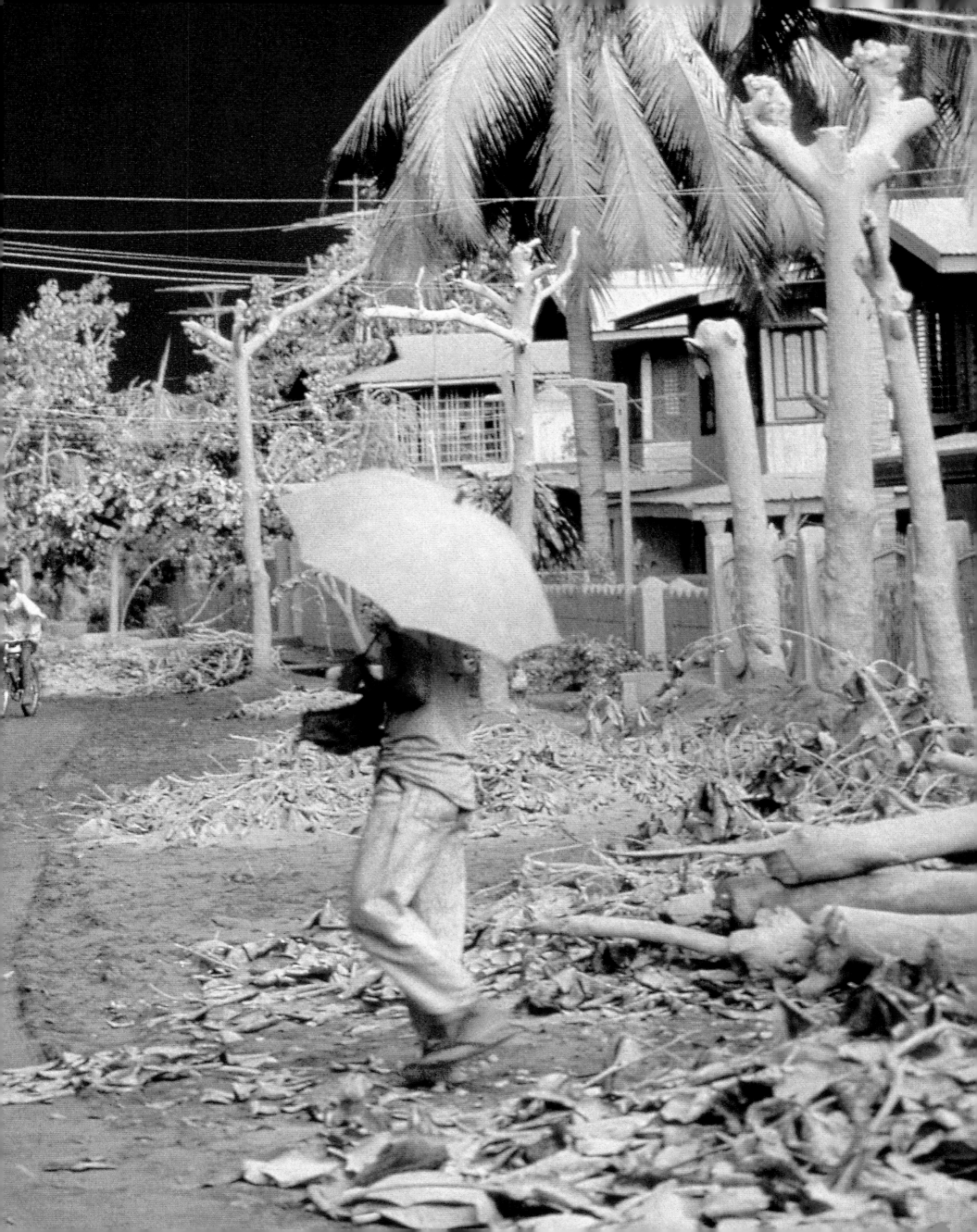

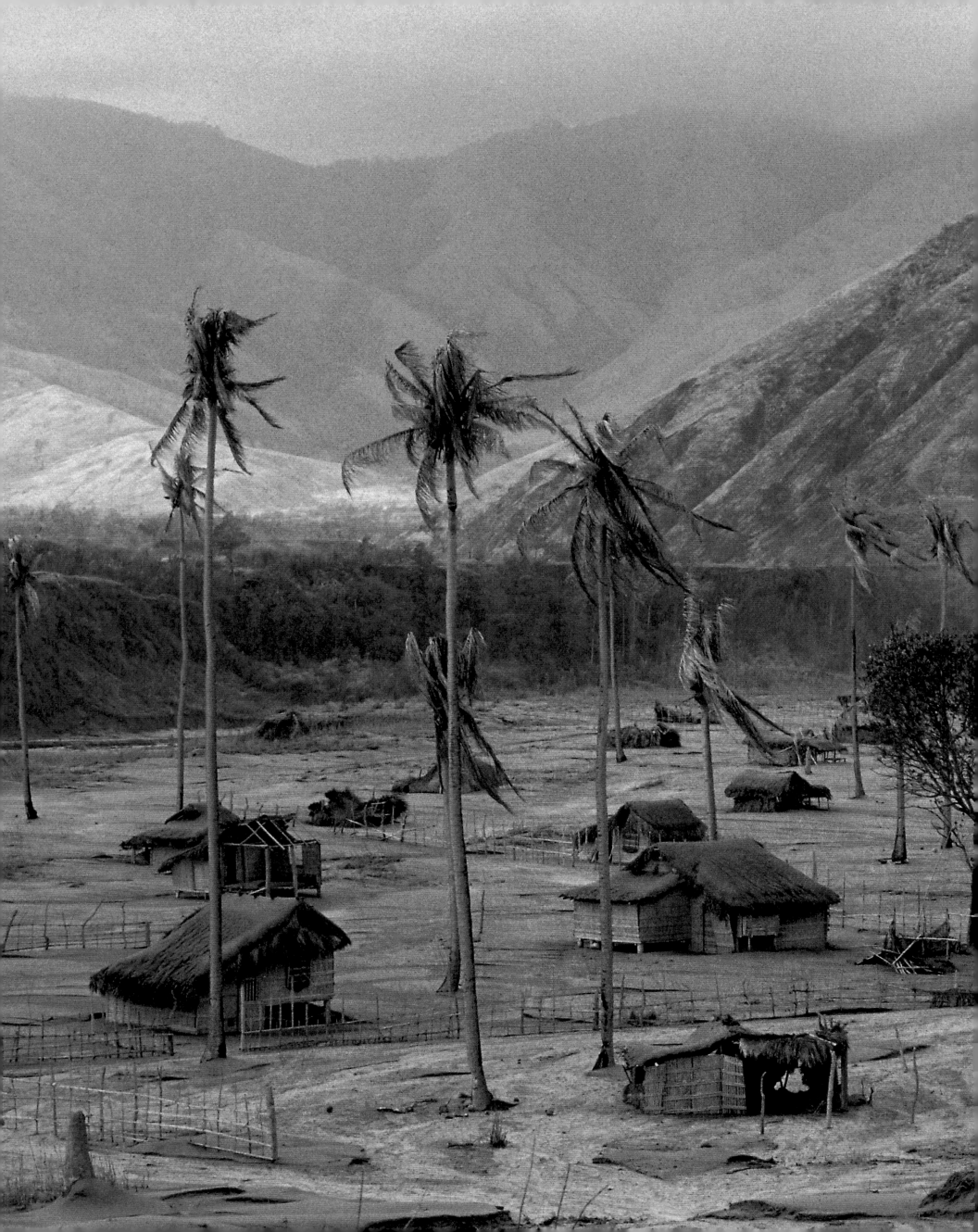

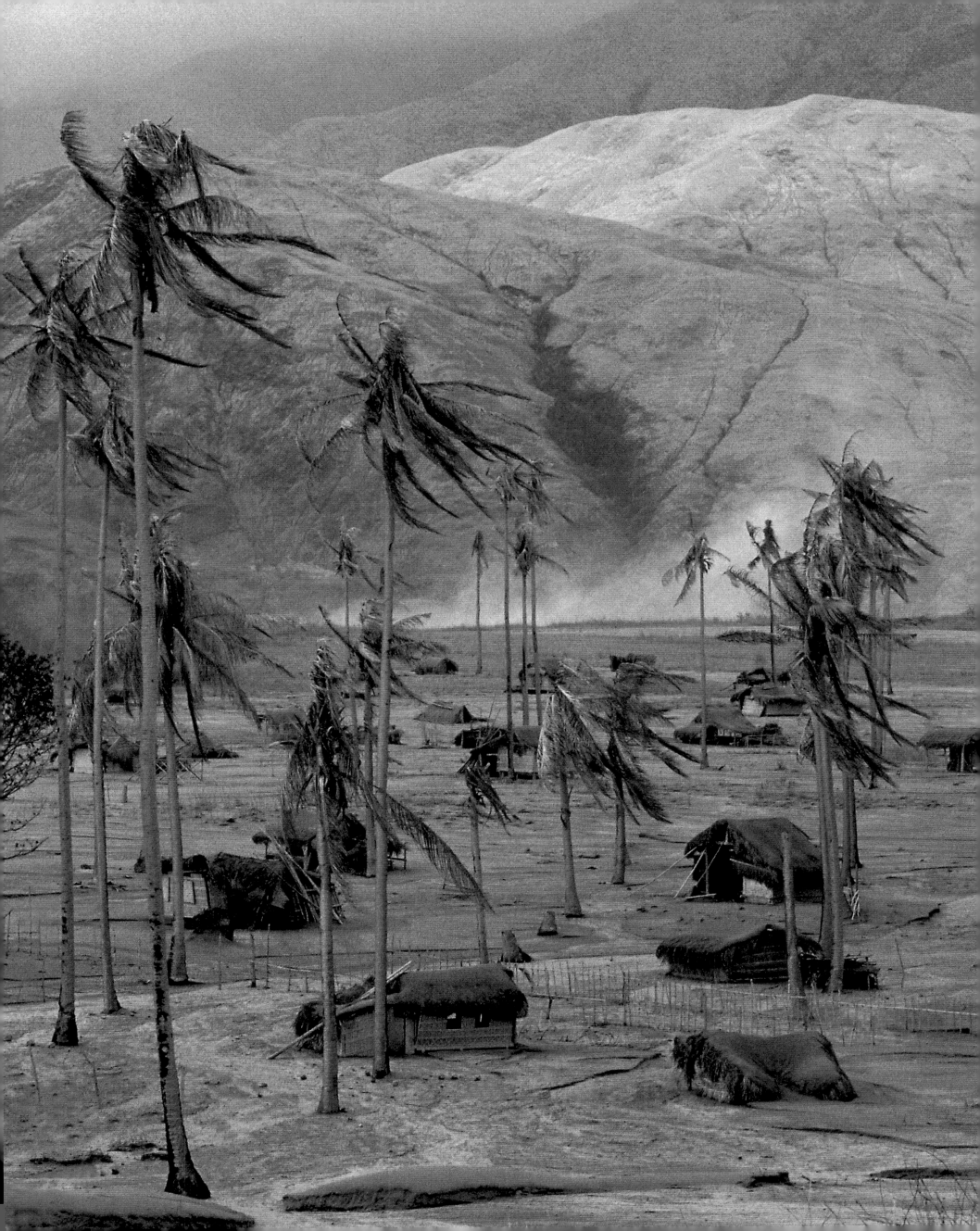

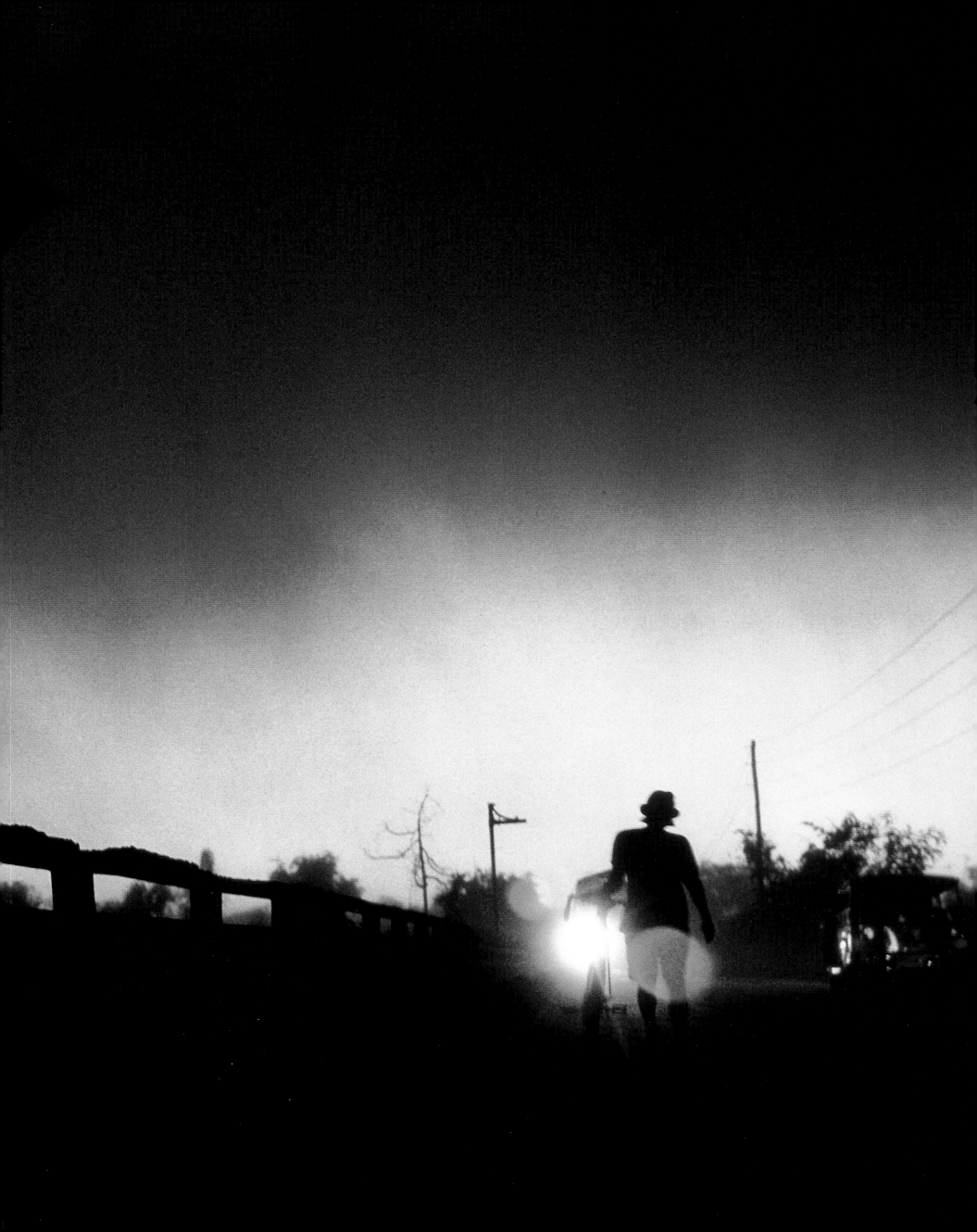

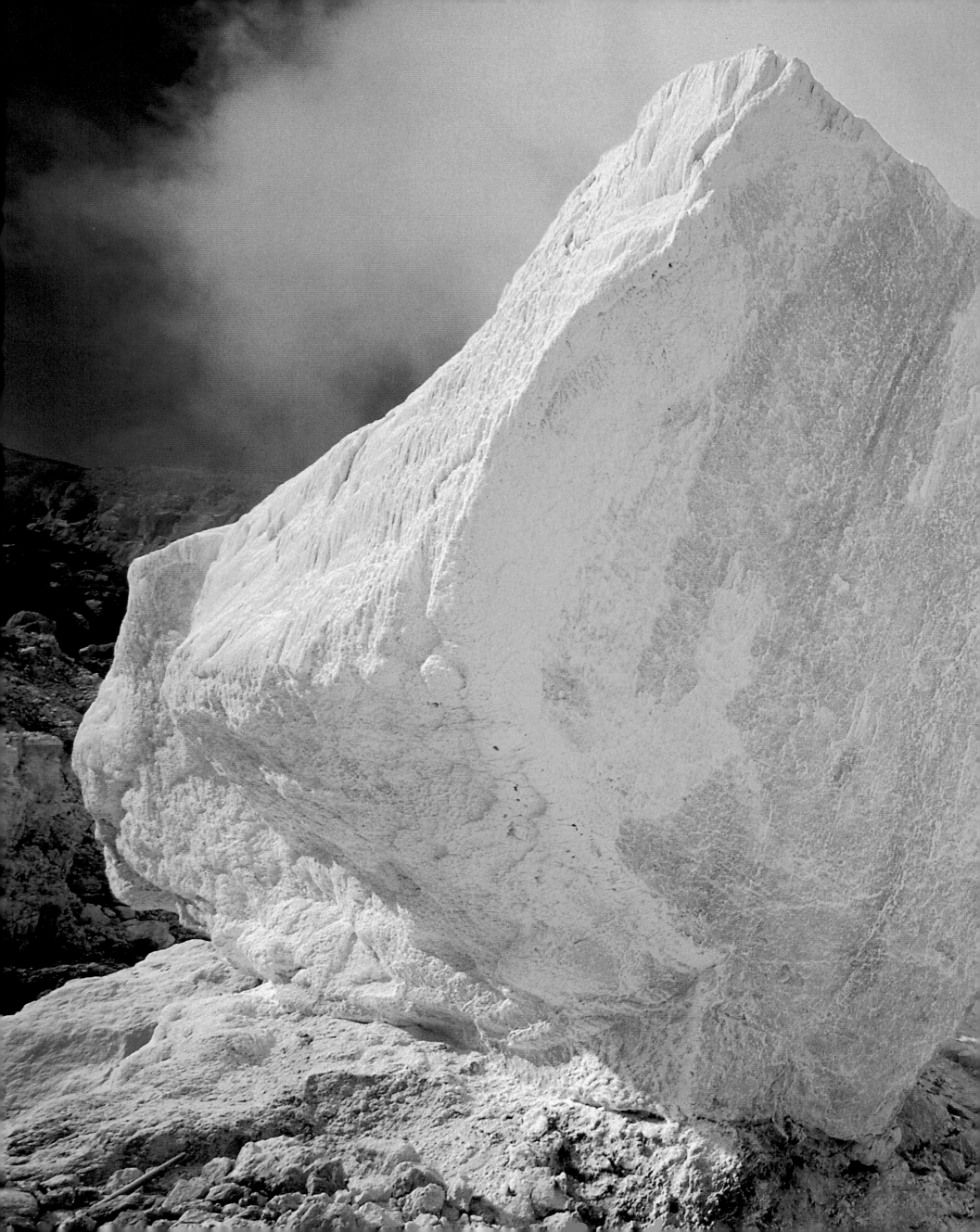

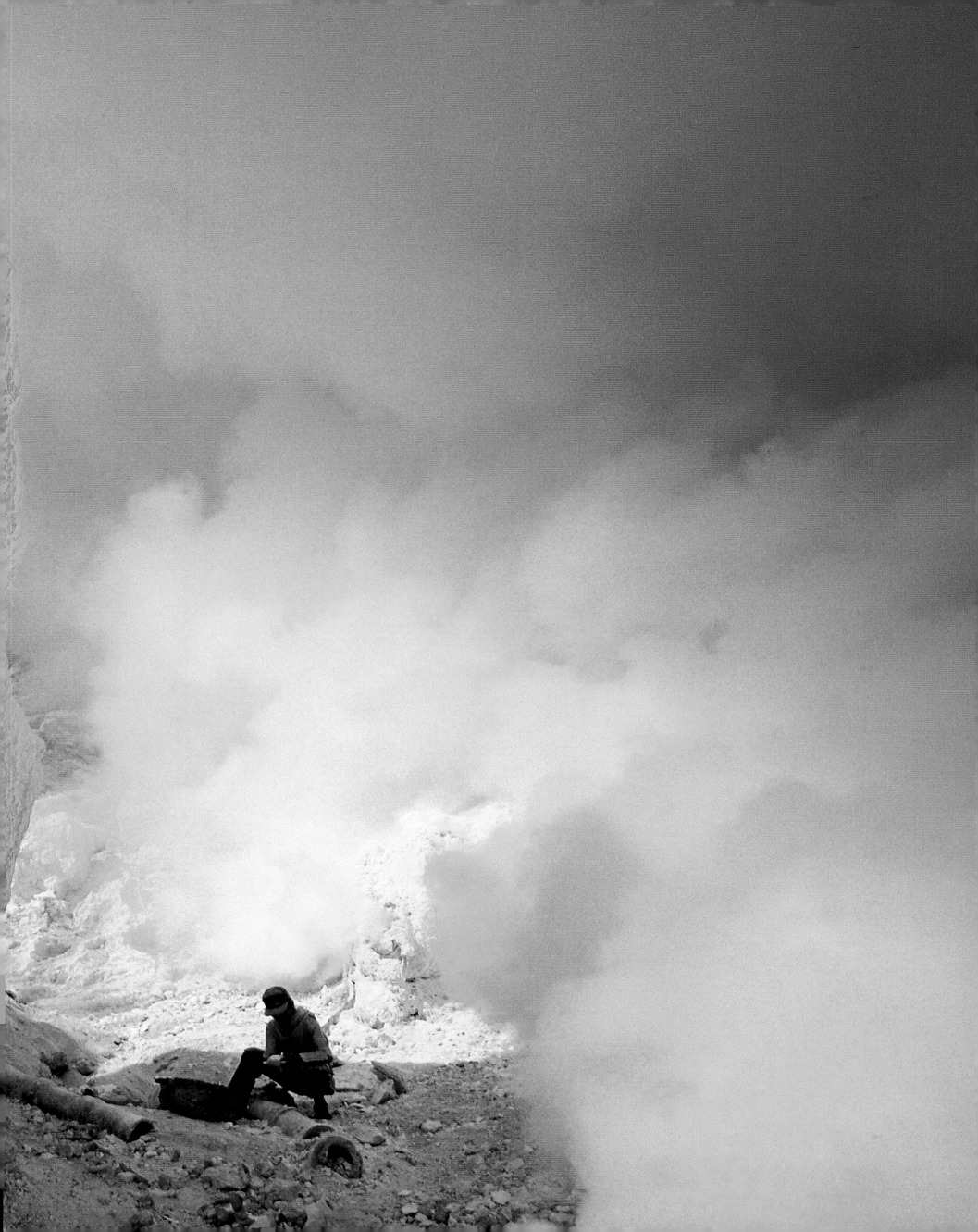

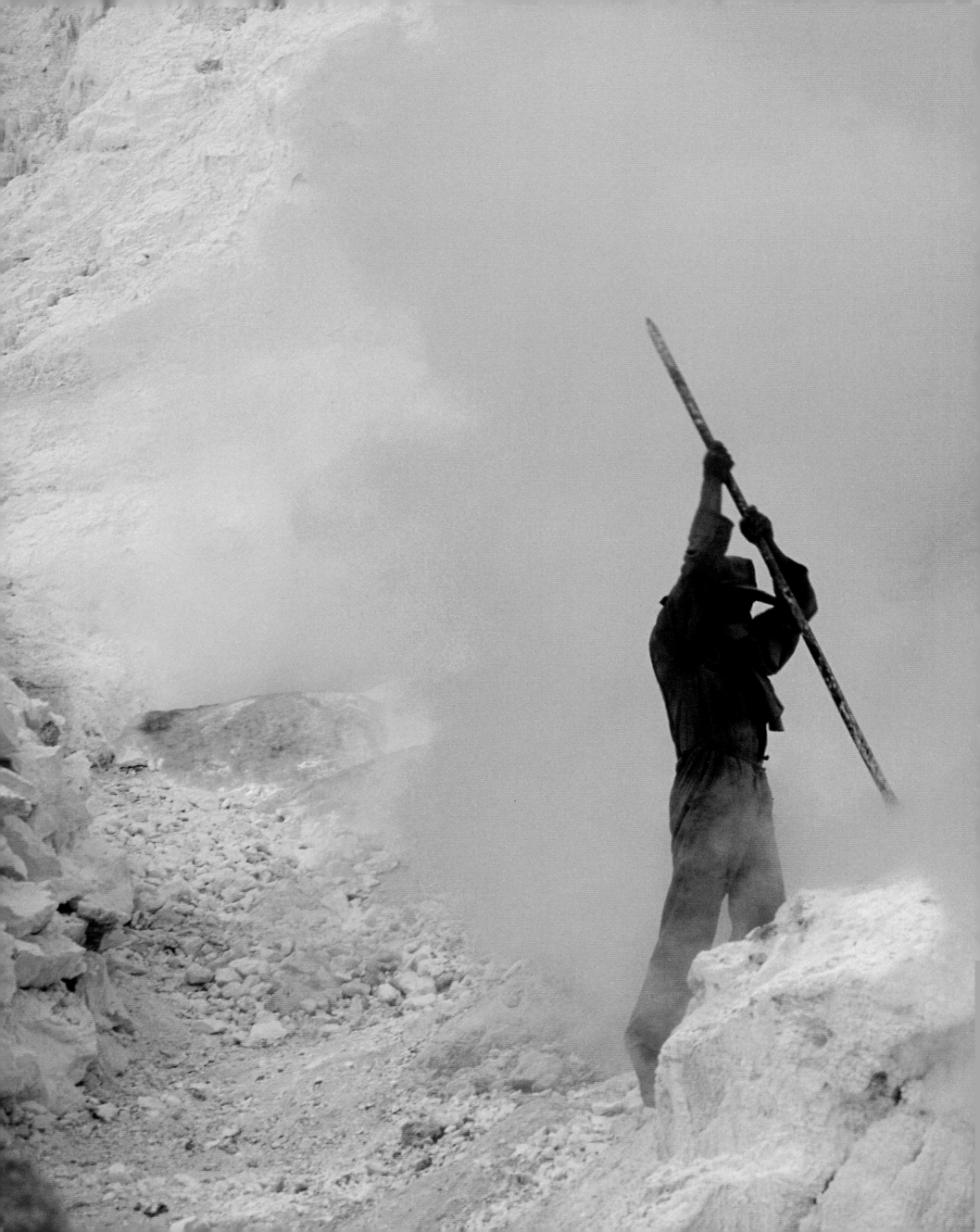

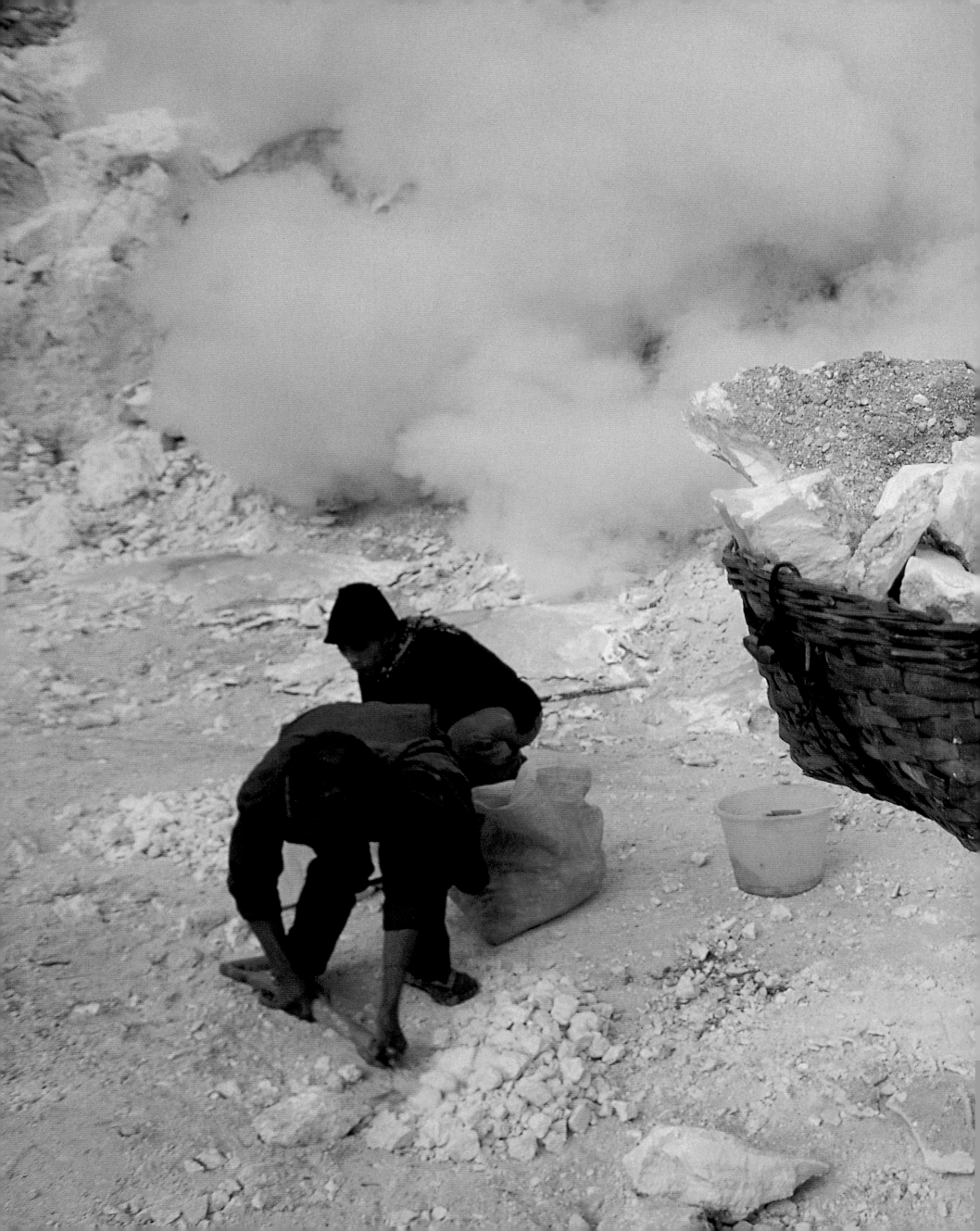

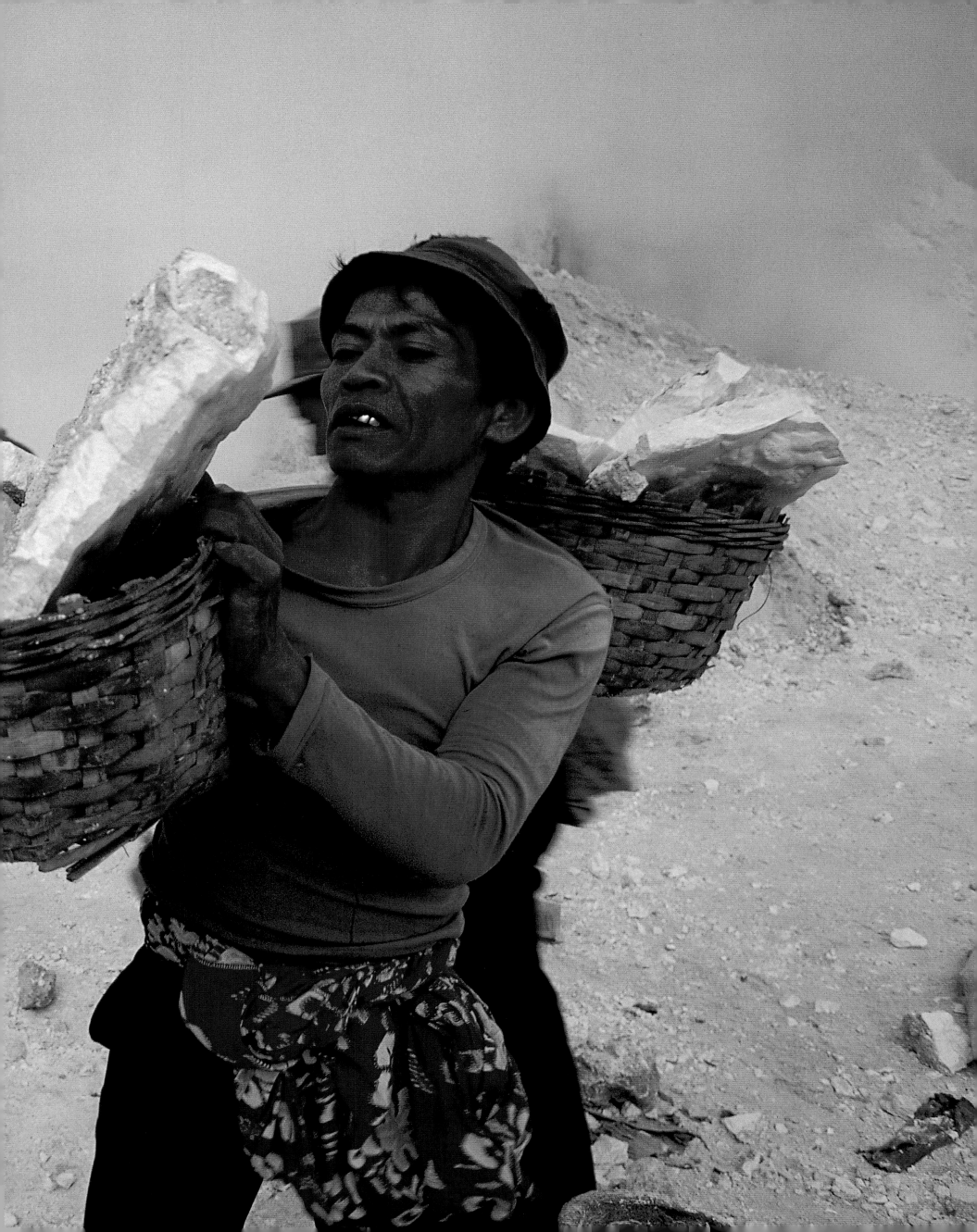

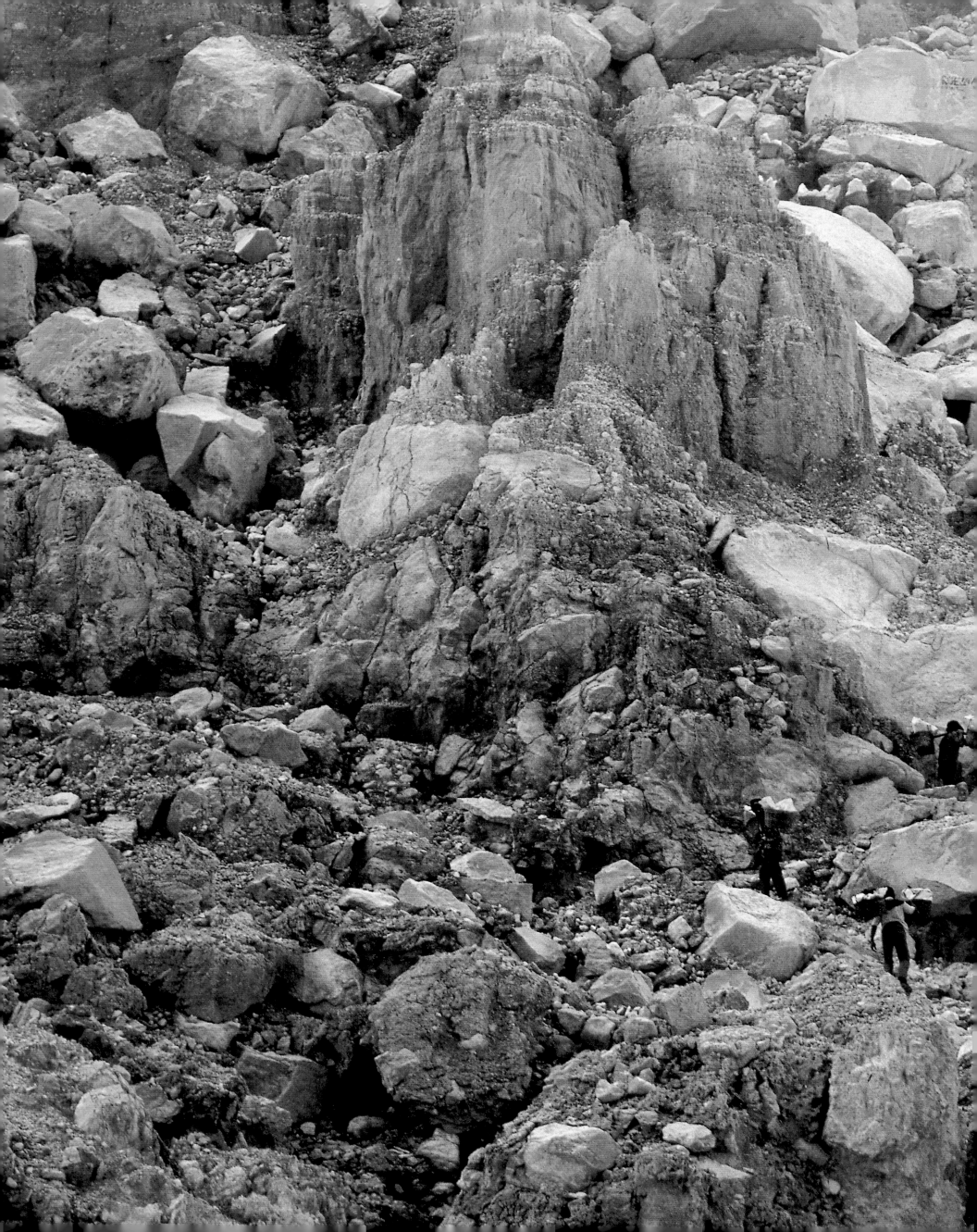

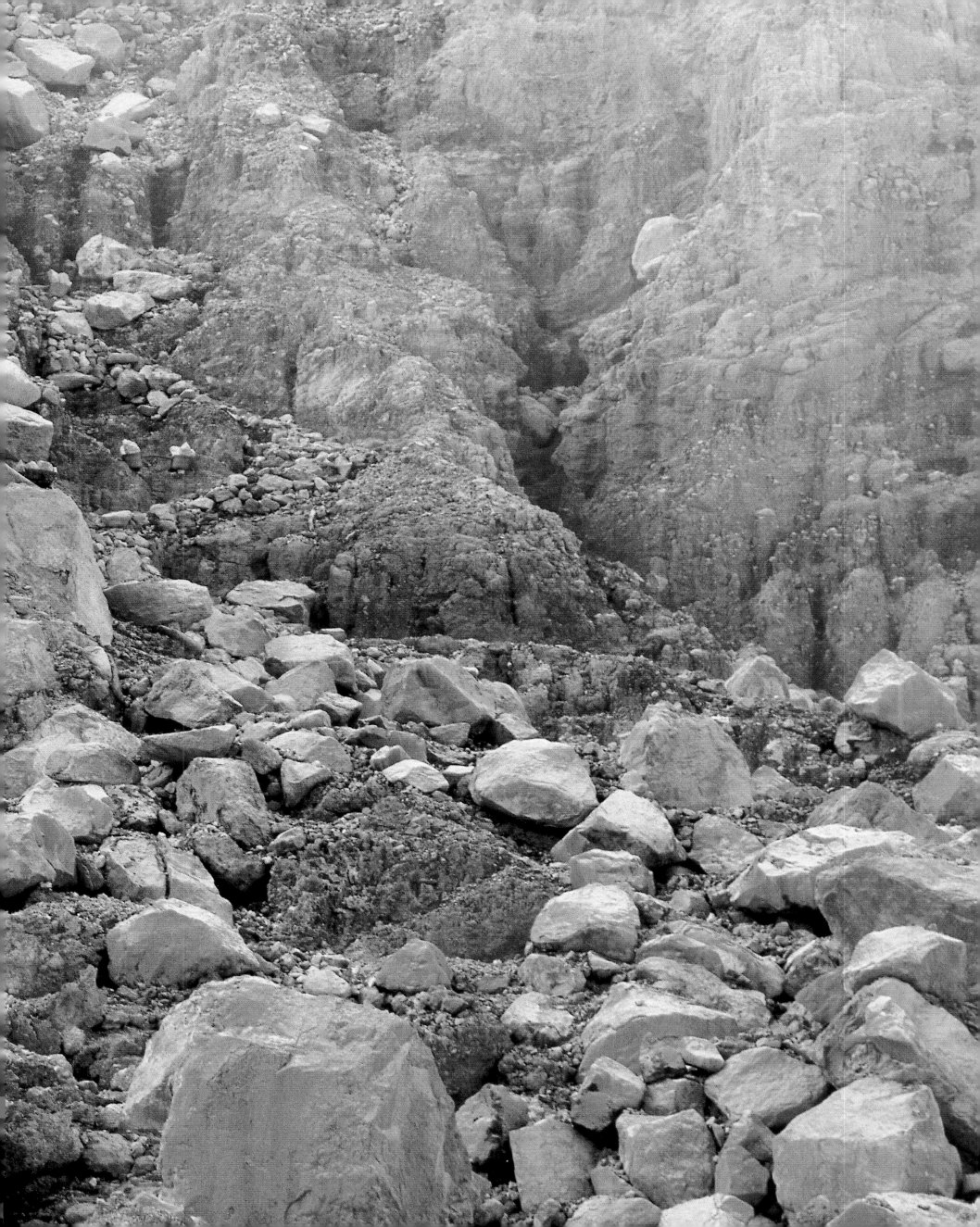

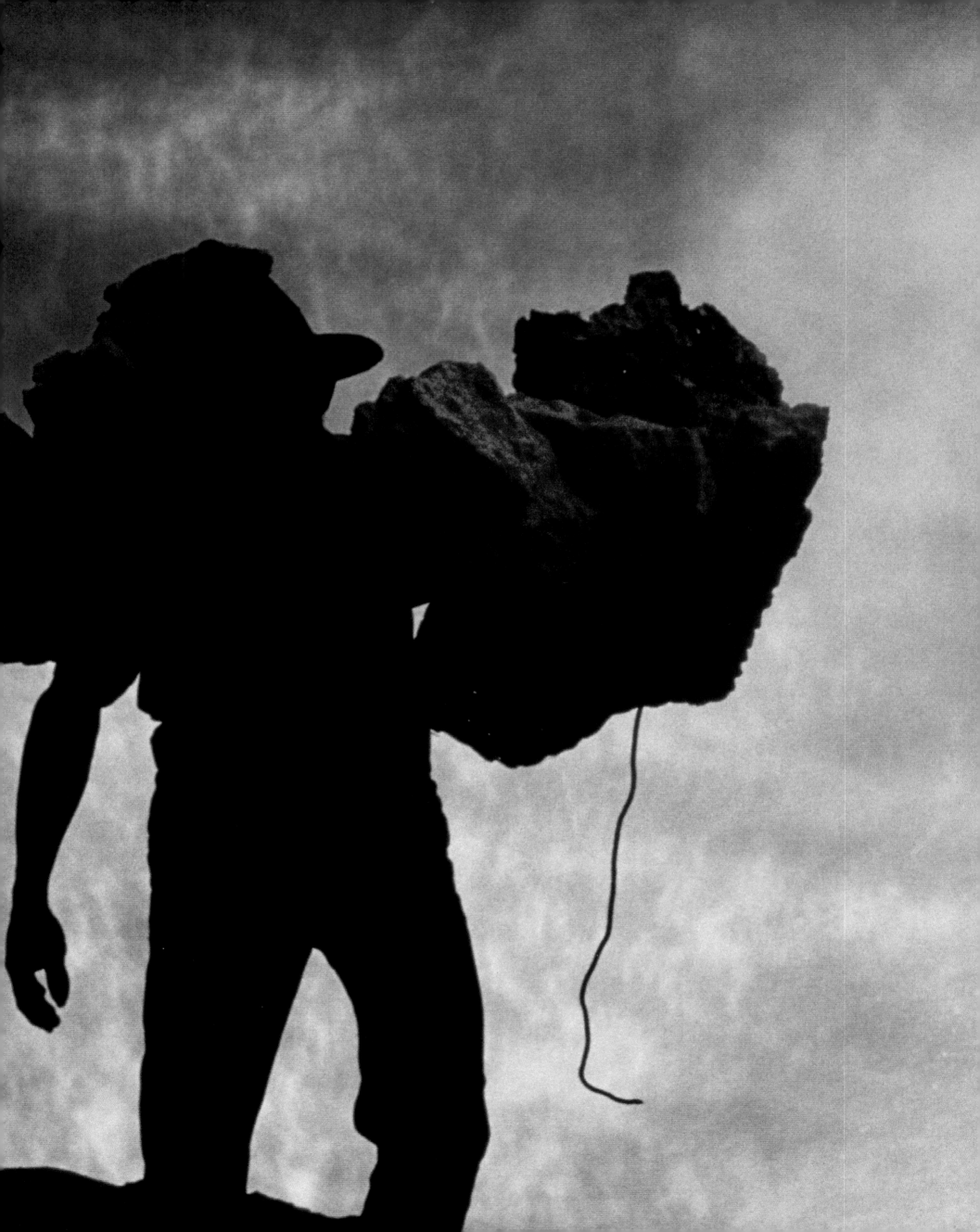

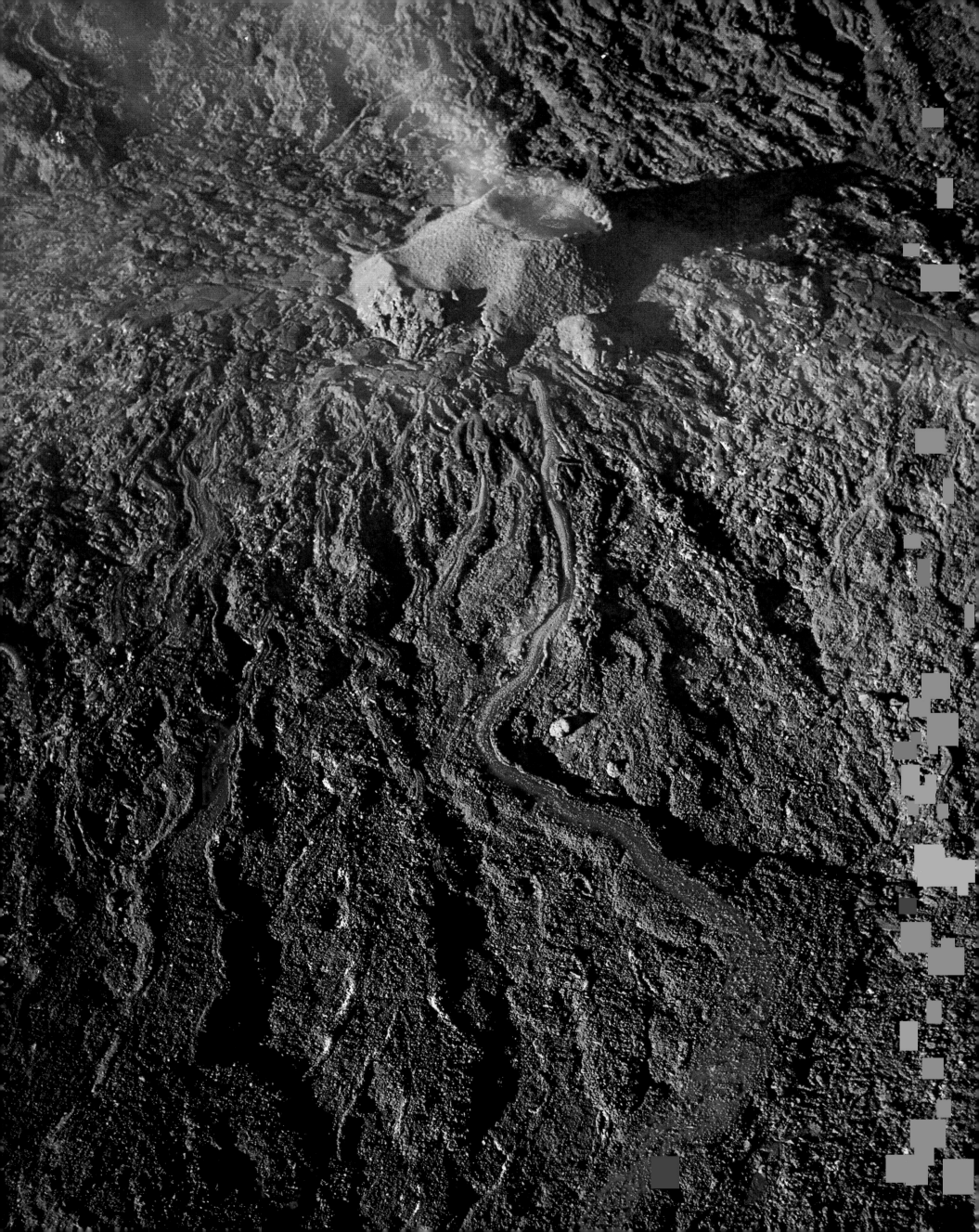

THE SCIENCE OF VOLCANOES

THE EARTH'S STRUCTURE

We have little or no access to the internal structures of our planet. Those structures can best be studied, therefore, by analyzing earthquakes. Each year the earth is shaken by thousands of these events, most of them unnoticed by humans but clearly registered by networks of seismographs covering the globe. Each earthquake, or seism, generates seismic waves that radiate from their point of emission, the spot where the shock originated. The waves travel out in all directions, somewhat as a set of concentric waves spreads when a stone is dropped into a pool of water.

There are two types of seismic waves: P waves (for "primary"), compressed waves that move longitudinally; and S (secondary) waves, cutting waves that move laterally. In a homogeneous setting, P waves are propagated at a much higher speed than S waves (approximately 1.7 times more rapidly). Like light rays, seismic waves can be reflected or refracted when passing through different elements. This speed of propagation can also be affected by the density of the element traversed. Waves generated by a seism will thus cross the globe according to particular pathways, affected by the heterogeneity of the zones covered. When they reach the surface, these waves are registered by many seismographs distributed in various parts of the globe, and all coordinated. The waves' different arrival times and the modifications in their pathways inform us then about the various zones traversed from the point of emission; their analysis will yield a sort of X ray of the earth's interior.

For more than a century, the accumulation of multiple seismic data, the precision with which they are analyzed, the construction of theoretical models based on the laws of physics—all have permitted us to define rather clearly the earth's internal structure. It is formed, rather uniformly, by a series of concentric layers, locally disturbed by other elements like planes of subduction or hot-spot clouds. These envelopes are almost all made up of solid materials; it is thus incorrect to believe that the interior of the earth is liquid. Liquids can certainly appear in certain layers, but they never make up more than a small percentage of the solid zone in consideration.

The Earth's Crust

The earth's crust is the external, solid part of our planet. The thickness of this crust varies from a few miles underneath oceans (oceanic crust) to several tens of miles under continents (continental crust). The thickness of the crust is quite limited, compared to the radius of the earth (3,500 miles). The surface crust has been studied by direct observation, by natural cross-sections (valleys, mountain slopes, nappes extended on the surface), as well as by various holes, some very deep. The oceanic crust, created under oceans by accretion folds, is composed basically of basalt lava and gabbros, their deeper equivalent. The continental crust is composed mainly of granite, with lesser quantities of gneiss. It also contains sedimentary rocks, such as limestone. The continental crust is very rich in silica (Si) and has the lowest densities of any part of earth (between 2.7 and 3).

The external part of the crust, the surface on which we live, is cold. The temperature rises when you descend within the crust (test situations have shown this in mine pits or in drilling); this is what is known as the geothermal gradient. In the continental crust the average gradient is 68° F per kilometer of depth. Different theoretical computations based on analysis of rock show that the average temperature at the base of the continental crust, between 37 and 43 miles deep, is about 1,832° F.

The Mantle

Situated just below the crust, the mantle reaches a depth of 1,800 miles. It represents the greatest volume of the earth, 80 percent of our planet's total mass. A sharp break, registered by seismology at 415 miles underground, separates the outer and inner mantles, and the break also marks an abrupt change in density.

The outer mantle is basically composed of peridotite, a rock rich in iron and magnesium. Its composition is known thanks to fragments brought to the surface by magma and ejected along with the lava in certain eruptions. The density of the outer mantle varies from 3.4 to 4.

The external part of the outer mantle, up to 120 miles in depth, is entirely solid. It joins with the crust to form a rigid and brittle composite called the lithosphere. The lithosphere can be fragmented into great moveable panels; these are the lithospheric plates. The entire part of the mantle located under the lithosphere is called the asthenosphere; it has peculiar physical characteristics. Down to a depth of 240 miles, its temperature is 2,550° F; it reaches 2,912° F at the level of the boundary, at a depth of 415 miles. Lava surface has melting temperatures well below these values, but in the heart of the mantle, considering the high pressure that prevails at this depth, the melting point is not reached. It is rather close, however, a fact that could explain why we observe a certain loss of rigidity in the mantle despite its solidity. The asthenosphere is thus flexible and capable of creeping motion.

The inner mantle is found at depths between 415 and 992 miles. Denser (at 4.5 to 6) than the outer mantle, it is solid. Its total composition is identical to that of the outer mantle, but the great pressure at these depths makes the crystalline structures of the rocks change markedly. Theoretical models show that its temperature can go as high as about 6,332° F at a depth of about 1,800 miles.

The great temperature differences between the upper and lower parts of the mantle, linked to its relative elasticity, cause thermic convection cells to appear on it. Two different hypotheses could explain this: there is convection at a layer affecting the entire mantle, with large convection cells going from the core-mantle boundary to the base of the lithosphere; or convection exists at two levels with two layers of convection cells inside the mantle, layers

Reaching an altitude of 8,630 feet, Piton de la Fournaise, a red hot-spot volcano, is a shield volcano some 530,000 years old. Its peak caldera has a horseshoe depression 6 miles in diameter in which eruptions occur regularly.

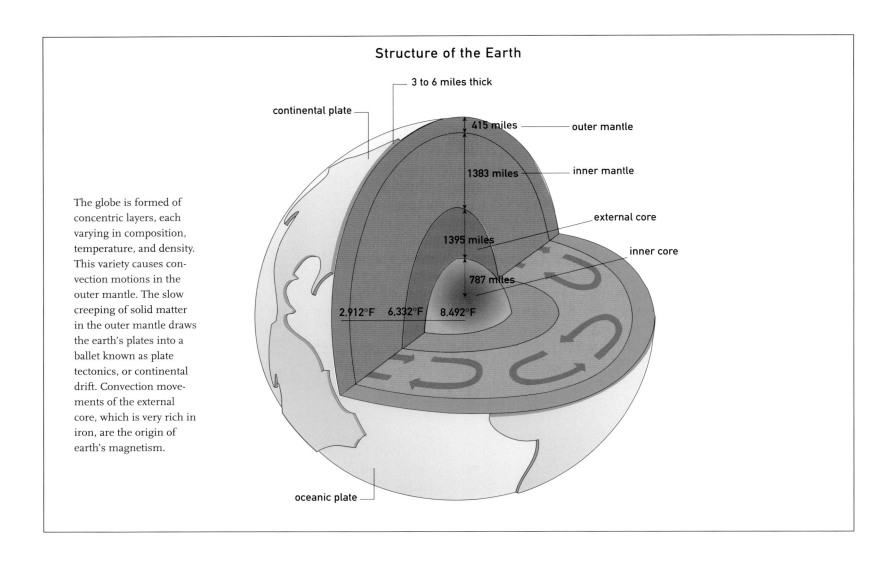

Structure of the Earth

3 to 6 miles thick

continental plate

415 miles — outer mantle

1383 miles — inner mantle

external core

1395 miles

inner core

787 miles

2.912°F 6.332°F 8.492°F

The globe is formed of concentric layers, each varying in composition, temperature, and density. This variety causes convection motions in the outer mantle. The slow creeping of solid matter in the outer mantle draws the earth's plates into a ballet known as plate tectonics, or continental drift. Convection movements of the external core, which is very rich in iron, are the origin of earth's magnetism.

oceanic plate

distributed on both sides of the boundary at 415 miles. Whichever type it is, the convection is responsible for fluid movements of matter that are extremely slow, since it appears that the speed of currents rising from convection cells would not exceed 10 to 20 inches per year. However, this creeping of matter by convection is responsible for movements of large lithosphere panels; this is what is called plate tectonics.

The Core

At 1,800 miles below the earth's surface, a very clear break separates the inner mantle from the earth's core. It corresponds to a great quantitative jump in density, which, in the core, varies from 9.8 to 13. The chemical composition of the core is still not well known, but two major elements can be discerned: iron, which makes up about 80 percent of it, and nickel, about 4 percent. The remaining 16 percent consists of diverse lighter elements, probably in solution, such as sulfur, oxygen, silicium, and carbon.

The core is found at a depth from 1,800 to 3,200 miles. Its temperature is said to reach 8,492° F and, despite the pressure at this level, iron, along with other elements, is liquid here. The internal core, sometimes called the pit, is composed of nearly pure iron and has the highest densities of the entire globe: from 12 to 13. It is solid, since iron here has acquired a crystalline structure still poorly known today. The differences in temperature and the presence of a liquid layer cause a system of convection cells also to develop in the external core, on contact with the lower part of the mantle.

Progression of the motion of matter here can reach a few miles per year, thus a speed almost 100,000 times greater than that appearing in the outer mantle. These very rapid movements (on an earthly scale) of liquid iron cause electromagnetic phenomena, which create the magnetic field that permeates the entire globe.

Plate Tectonics

Plate tectonics, formerly known as continental drift, is a theory created by Alfred Lothar Wegener (1880–1930) following his observation of the outline of continents and the geological and paleontological resemblances between such contours. The theory, expounded early in the twentieth century, was not universally recognized until after 1970, and then only thanks to numerous discoveries both in the dynamics of the mantle and in earthly magnetism. Several major explorations from Iceland to Afar, through the depths of the Atlantic, proved this phenomenon, which is compatible with all current knowledge of the earth sciences.

The earth's lithosphere, the totality of its rigid external envelope, is fragmented into several large panels, the lithospheric plates. They have not always had, and will not always keep, the shapes we see today. The principal plates at present, which emerged 100 million years ago from a supercontinent, are nine in number: the American, Caribbean, African, Eurasian, Arabian, Indo-Australian, Pacific, Philippine, and Antarctic.

There are said to be two types of plate: continental plates, which are made up of light material of the granite type, not submersible in the mantle, and which represent fragments of continents that, in the course of ancient geologic ages, have already undergone other drifting movements preceding the current ones; and oceanic plates, with a density near that of the mantle, composed of basalt lava, low in silica but rich in iron and magnesium.

The motions of the lithospheric plates, dragged by convection currents that agitate the outer mantle, are the surface manifestation of the mantle's movements. They move therefore at an average speed the same order of magnitude as that of the mantle's matter, creeping a few inches per year.

Because earth is a sphere of constant diameter, movable plates present three very different types of boundaries. Straight above the ascending part of the convection cells, divergent boundaries will

appear, where the oceanic plates are formed; these are the zones of accretion. The lower part of the convection cells is dominated by convergent frontiers, where the plates draw closer together. Some sink and will disappear into the mantle; this effect is known as subduction. Other plates, nonsubmersible, collide with full force and will be deformed into collision zones. A third type of boundary occurs where two plates slide into one another; these are transforming faults.

Most volcanoes of the earth are located along active frontiers between lithospheric plates; 82 percent of lava emitted on earth emerges at the boundaries of plates, though they are divided rather unevenly. Zones of accretion, where oceanic plates form, represent 67 percent of the volcanoes on earth but are almost entirely hidden under oceans. Zones of subduction provide 15 percent of emitted lava. The remaining 18 percent is lava emitted not at the edge of plates but instead in the middle; these are volcanoes linked to the activity of mantle hot spots.

VOLCANOES AND ACCRETION

As has already been seen, about two-thirds of the earth's volcanic activity is concentrated along diverging boundaries between lithospheric plates known as oceanic ridges or mid-ocean folds. The combination of all these ridges would form the longest volcanic chain known on earth. Ridges appear in the middle of all oceans, and form series that can be as long as about 42,000 miles. Nearly all large-scale volcanic activity goes unnoticed because it takes place under miles of seawater. However, waves from some ridge segments have been picked up, allowing detailed study of their structure and their action (primarily in Iceland, a short emerging portion of the mid-Atlantic fold, and in Afar, a developing ridge between Arabia and Africa).

Surface study, like submarine observation, shows that these ridges are made up of long reliefs formed by the regular, symmetrical accumulation of large outpourings of lava. These reliefs, a mile or more high, are crowned by a long, narrow collapsed valley lined with normal faults—a rift.

The longest, most characteristic of these ridges is undoubtedly the mid-Atlantic fold. Extending basically from the North to the South Pole, it forms a long volcanic chain over the entire middle of the Atlantic Ocean. Two diverging oceanic plates are formed there: the western American and the eastern Eurasian. This fold is responsible for the formation of the Atlantic Ocean in the middle of a supercontinent that today is divided into North and South America on one side, and Europe and Africa on the other. Active for more than 140 million years, the fold is still widening the Atlantic at an average rate of $1^{1}/_{5}$ to $1^{1}/_{2}$ inches per year. A fold therefore marks exactly the spot where two diverging oceanic plates move apart. This zone is generally located above a small rising portion of a convection cell of the mantle. Warm, light asthenospheric mantle rises there; it contributes to creating the new ocean floor. As lithospheric plates separate, "voids" left between them will be filled by new ejections of mantle material; this is called accretion.

The rise and separation of plates cause a decompression of the asthenosphere, which undergoes partial melting. It yields then about 20 percent of the liquid magma that, emitted in the form of lava ejections and flows, forms the crust part of the new lithospheric plate, while the remaining 80 percent, solid and basically composed of peridotites, will form its mantle portion. The separation of plates, the rise of the asthenosphere, and ejections of magma do not occur continuously along entire ridges; all the world's folds are not erupting at the same time. While the action is discontinuous, its accumulation gradually leads to constant creation of the ocean floor and a regular separation of the plates. It has

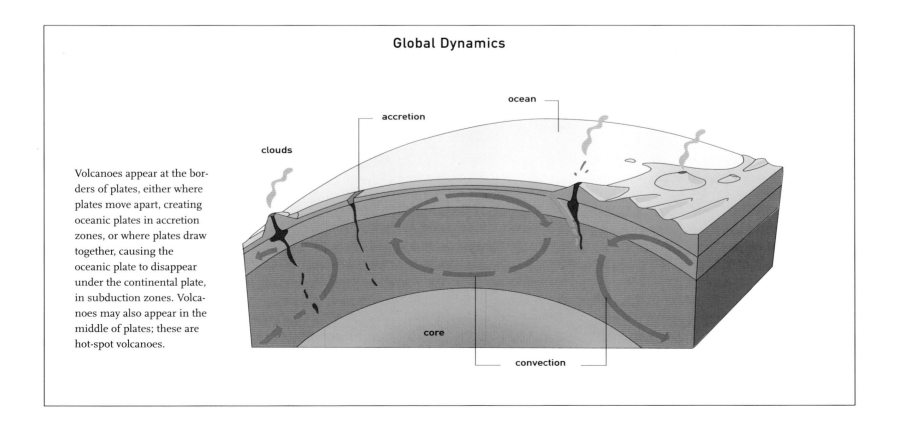

Global Dynamics

Volcanoes appear at the borders of plates, either where plates move apart, creating oceanic plates in accretion zones, or where plates draw together, causing the oceanic plate to disappear under the continental plate, in subduction zones. Volcanoes may also appear in the middle of plates; these are hot-spot volcanoes.

clouds

accretion

ocean

core

convection

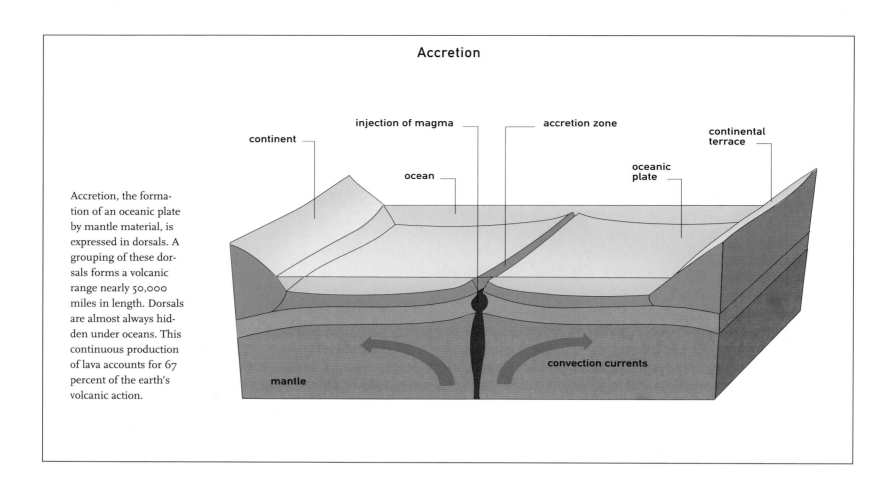

Accretion

continent

injection of magma

accretion zone

continental terrace

ocean

oceanic plate

Accretion, the formation of an oceanic plate by mantle material, is expressed in dorsals. A grouping of these dorsals forms a volcanic range nearly 50,000 miles in length. Dorsals are almost always hidden under oceans. This continuous production of lava accounts for 67 percent of the earth's volcanic action.

mantle

convection currents

been calculated that this creation of oceanic plate in the middle of ridges occurs at an average rate of 5 cubic miles per year.

Eruptive processes at the level of folds are unusual. When the magma reaches the surface, it is subject to pressure from the water above it, often deeper than 6,560 feet. Gases then remain in solution and no explosive phenomena occur. In the same way, no water vapor forms from the contact of lava with ocean water. Eruptions therefore are exclusively effusive. Their outpourings make what is called pillow lava, or cylinders of lava that form under an elastic skin caused by the rapid cooling of the lava on contact with water. Outpourings of lava therefore pile up in a great number of these pillows. Pillow lava was discovered at the bottom of the Atlantic by the first exploratory missions in submersible modules. Because oceanic ridges are very long and a diving mission can only reach a certain depth, no one has ever witnessed, to date, an eruption forming such pillow lava. The mechanism is known nevertheless thanks to aerial observation of lava flows entering the ocean. In sub-oceanic rifts, structures have also been discovered that correspond to great outpourings of liquid lava as well as to lava lakes.

VOLCANOES AND SUBDUCTION

Volcanic activity occurring in the converging boundaries between lithospheric plates is, in terms of volume, much less significant that volcanic action in accretion zones. In subduction zones, volcanoes account for just 15 percent of the total lava emitted on earth. However, compared with volcanic activity in accretion zones, which almost always goes unnoticed because it is effusive and basically submarine, volcanic action linked to subduction is much more spectacular. Here, volcanoes are aerial and their eruptions are usually explosive. This kind of volcanic activity is also almost solely responsible for the damages and victims associated with the world's volcanoes.

In the converging boundaries between tectonic plates, three types of encounter can occur between oceanic and continental

plates. Collision zones occur where two continental plates run up against one another in opposite directions; both are non-submersible in the mantle and thus their collision will deform them. This deformation consists both of matter creeping laterally and of plates folding intensely. These folds throw up mountain ranges. A particularly striking example is the Himalayan range, a result of the Eurasian continental plate being pierced by the Indian continental plate. No volcanic activity is linked to such collision zones.

Another converging boundary can be formed by the encounter of two oceanic plates. Because this confrontation generally occurs under the ocean, far away from continents, it is not directly observed. The older and thus the denser of the two plates will slide under the other and gradually submerge, penetrating the mantle from the effect of gravity. The descending portion will exert traction on the entire plate that, combined with convection currents of the mantle, is one of the causes driving the movement of lithospheric plates.

All along the confrontation zone between the two plates, bending of the submerging plate forms a marine ditch, sometimes very deep. Friction caused by the plate's penetration into the mantle, combined with loss of water as this plate submerges to higher and higher pressures, causes heating and partial melting of the mantle. Hot, light magma is emitted and rises to the surface. Because the subducted plate descends at an oblique angle, this magma will reach the surface behind the zone of contact, under the higher of the two plates. This plate is also deformed by its opponent's subduction and forms a zone of distension. Through the resulting fractures, magma rises to the surface of the plate and causes volcanoes. Formed under the sea, they quickly emerge in the form of volcanic islands that line the subduction axis, forming what is called an insular arc. These long strings of islands are thus the surface manifestation of the subduction occurring between two oceanic plates; they are seen around the Pacific Ocean (the Pacific fire belt): Indonesia, Philippines, Japan, the Aleutians, and so on.

Another type of subduction occurs from the meeting of an oceanic plate with a continental plate. Here, too, the oceanic plate

is subducted, this time under the continental plate that is lighter as well as thicker and thus submerges into the mantle. This is what is known as an active continental margin.

The confrontation of two plates deforms them greatly; the submerging oceanic plate curves inward to form a deep oceanic indentation parallel to the boundary of the continental plate. The continent itself folds and thickens by the rising of a mountain range. The motion of the oceanic plate into the mantle causes a great release of energy as a result of friction and leads to partial melting. But the plate also releases water; through different magma reactions, part of the continental plate also experiences melting effects. The combined effect sends magma to the surface that differs markedly from the magma produced in accretion zones. This magma will produce surface volcanic action with large, extremely voluminous, and highly explosive volcanoes. The finest example of an active continental margin is the Cordillera of the Andes mountains; here, the oceanic plate submerges under the American continental block. The block is bordered on the west by a deep recess caused by the bending of the plate. It raises a major mountain range with alignments of great volcanoes along its length, volcanoes whose destructive eruptions come to the world's attention with some frequency.

VOLCANOES AND HOT SPOTS

As already seen, about 18 percent of the earth's volcanic action occurs inside plates, therefore far from the active boundaries of lithospheric, oceanic, or continental plates. This volcanic action, thus, seems to be independent of plate tectonics, which is the origin of magma action in zones of accretion or subduction.

A hot spot is a thermal cloud from a deep source, arising either from the boundary between the outer and inner mantle, or from the boundary between earth's mantle and core. The origin of hot spots remains a subject of some speculation; it is possible that hot spots of various origins coexist. Theoretical and experimental models have shed light on the progression and evolution of hot-spot clouds. Once emitted at the source, a hot spot makes its way to the surface; it is composed of a broad spherical head that rises within the mantle, like a hot-air balloon, owing to temperature differences. The spherical head, followed by a cylindrical portion, expands as it climbs. On reaching its destination under the lithospheric plate, its diameter can reach 600 miles. This head then bursts and spreads out under the rigid lithosphere; its temperature, hotter than that of the mantle, causes thinning of the plate by partially melting its lower portion, while the pressure it exerts deforms it into a wide swelling. When the plate gives way, forming multiple fissures, the cloud head expels enormous quantities of magma in huge eruptions. These eruptions can last several hundred thousand years and leave such quantities of magma in the form of accumulated lava flows that they form volcanic provinces covering up to 390,000 square miles, with a thickness of several miles. Fortunately, these enormous eruptions are infrequent; there have only been about ten in the past 250 million years. During lava outpourings, the quantities of gases and ash emitted reach such volume that they can profoundly modify the earth's climate, sometimes causing the disappearance of 80 percent of species, both animal and vegetal, living on its surface. One of these eruptions, 65 million years ago, probably led to the extinction of the dinosaurs.

With the cloud head exhausted during the first eruptions, the cylindrical conduit takes over and keeps magma rising to the surface, where it continues to cause volcanic eruptions, in some cases for tens of millions of years. However, considering the conduit's far more modest size, the emissions are lower in volume. This conduit, rising from the source of the hot spot, belongs entirely to the mantle, so it is stable in relation to the lithospheric plates that move above it. These plates, during their passage, are gradually pierced by the rising magma, which will form volcanoes on their surface. The drifting motion of the plates traces a row of volcanoes that will very exactly reflect the passage of the said plate above the stable hot spot.

By measuring the distance between two volcanic ranges, dated by their rocks, it is possible to compute the plate's traveling speed and thus the rate of its drift. It has been observed with interest that these speeds are comparable to those measured at the edge of plates in the accretion zones.

The most famous of the volcanic groups created by the action of a hot spot is the volcanic island chain of Hawaii and the

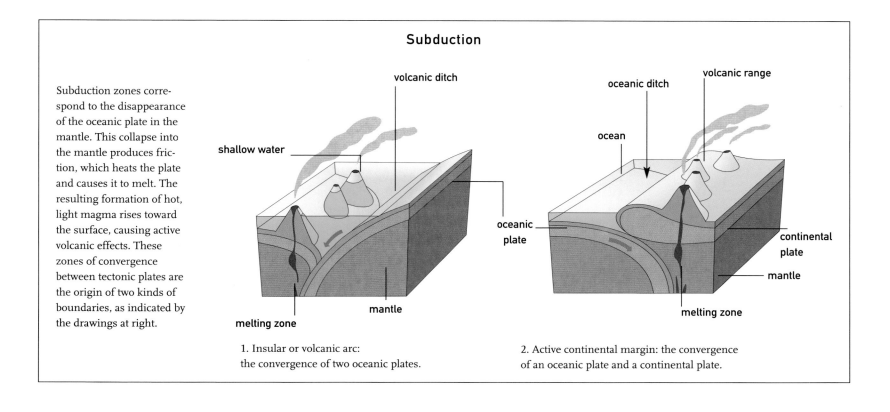

Subduction

Subduction zones correspond to the disappearance of the oceanic plate in the mantle. This collapse into the mantle produces friction, which heats the plate and causes it to melt. The resulting formation of hot, light magma rises toward the surface, causing active volcanic effects. These zones of convergence between tectonic plates are the origin of two kinds of boundaries, as indicated by the drawings at right.

shallow water

volcanic ditch

melting zone

mantle

1. Insular or volcanic arc: the convergence of two oceanic plates.

oceanic ditch

ocean

volcanic range

oceanic plate

continental plate

mantle

melting zone

2. Active continental margin: the convergence of an oceanic plate and a continental plate.

Emperor Islands. This group of volcanoes goes from the Big Island to Hawaii, where the currently active volcanoes (Mauna Loa and Kilauea) include rocks of recent age, and then up to southern Kamchatka, where the last volcano still visible—before disappearing into the subduction of the oceanic plate that carries it—dates to 75 million years ago.

Another celebrated hot spot caused the enormous outpourings of basalt known as Dekkan traprock during one of the greatest eruptive crises ever known. Its activity persists at a much weaker rate and it is found today in the eruptions of Piton de la Fournaise on the island of Réunion, situated where India was located 65 million years ago.

DIVERSE MAGMAS

Magma is derived from partial melting of the mantle. Because the mantle has a homogeneous composition, we would expect to find magma of the same composition on the surface. This is not the case, and in the different geotectonic contexts, accretion and subduction zones, and hot spots, there are a multitude of volcanoes, all different in terms of lava composition or their dynamics.

Magma has been defined as a liquid originating from the partial melting of rocks belonging to the mantle or to part of the lithosphere. Magma's genesis depends essentially on the geotectonic context that causes it. In accretion zones, magma comes directly from the partial melting of the mantle material rising vertically from ridges, melting due to depressurization. The magma produced will have a composition resembling that of the mantle. If it is stored in stockpiles at some depth, the "magma chambers," its composition can develop over time and be differentiated.

In subduction zones, the descending oceanic plate brings up hot, light magma. During its climb, it melts part of the lithospheric plate—oceanic or continental—over it. The magma reaching the surface will thus be enriched by various elements, depending on the composition of the plate that it has traveled through; magmas will thus be found on the surface that differ markedly from those produced at the source. In hot spots, the mantle material that originates very deep below rises to the surface, undergoing only slight changes in composition. Families of rocks found here are very similar to those common in accretion zones.

Magma is a liquid with a very particular composition that includes three different phases: a liquid phase composed of a mixture of different melted silicates; a gaseous phase that, at the high pressures prevailing at great depths, is dissolved in the liquid phase; and a solid phase composed of crystals suspended in the liquid bath. This mixture in three phases will undergo various modifications as it rises toward the surface. In its ascent, the pressure from the weight of the rocks (lithostatic pressure) markedly diminishes. The depressurized magma will first cause the melting of certain solid elements it carries; but, above all, it will allow the dissolved gases to separate from the liquid phase in the form of bubbles. These bubbles rise with the liquid; the closer they come to the surface, the more the pressure diminishes and the greater are the quantities of dissolved gases moving in the form of increasingly large bubbles. Exactly the same thing occurs in a bottle of champagne when reduced pressure is applied to the liquid by the removal of the cork. In the volcano chimney (as in the neck of the bottle), foam rises that is a mixture of gas and liquid. In the volcano's crater, there is a definitive separation of two phases: the gaseous phase is lost in the atmosphere while the liquid phase flows out of the volcano as lava. Magma is lava plus gases, or all lava that we find on the earth's surface corresponds to deep magmas that have degassed during eruption.

VOLCANOES AND ERUPTIONS

Volcanic phenomena on the earth's surface can take many forms, and thus we find eruptions that often differ greatly from one another. Their dynamics are controlled mainly by the viscosity—and thus the composition—of magma and by its gas content. The tectonic context in which magma is reduced and then brought to the surface plays a major role in its composition.

In accretion zones, magma arises directly from partial melting of the outer mantle; it is relatively poor in silica and rich in iron and magnesium. In subduction zones, magma develops from the melting of the descending plate and, in part, of the plate that it travels through to reach the surface; it is much richer in silica, gas, and water vapor. Eruptive action corresponding to these two tectonic contexts will thus differ and, to simplify, we could say that zones of accretion are represented by red, effusive volcanoes while subduction zones produce gray, explosive volcanoes. Of course there are many variants and gradations between these two extremes.

Silica is the predominant element in the composition of all magmas, and the variation in its concentration very directly determines the magma's viscosity and thus the type of dynamic that the magma will produce when expelled at the surface. We do not always witness volcanic eruptions, many of which have taken place long ago. To attempt to define the dynamics, we rely on two terrain criteria observable long after a volcano's eruption: fragmentation and dispersal of the emitted matter. These two physical characteristics of eruptions vary as a function of the magma's viscosity and its silica content.

Accretion Zones: Red Volcanoes

Magma that appears in accretion zones is relatively low in silica (approximately 50 percent); it is fluid and very hot (between 1,832° and 2,012° F). Its low viscosity allows gas bubbles to be released easily, sometimes spectacularly, in lava fountains, but the explosions are weak to nonexistent. The fragmentation of the material is very low or even absent; lava is emitted in the form of flows (with negligible fragmentation because the entire mass of emitted material remains cohesive). These lava flows cover surfaces that, while sometimes extensive (up to tens of miles in length), are quite weak in comparison with other activity; thus we would conclude that their dispersal is weak.

The most characteristic dynamism in this type of magma activity is the Hawaiian variety; it is of course typified by the Hawaiian volcanoes with mild inclines because of the low viscosity of lava, and which emit large lava flows. Eruptions of this type are not par-

ticularly dangerous, since the flows move relatively slowly and their course is foreseeable in relation to the topography of the area.

In some special cases this same magma can be emitted along with water, for instance, submarine eruptions at reduced depths. The temper of the hot lava in contact with cold water will appreciably increase the fragmentation; explosions, however, are cushioned by water and dispersal remains weak, in other words these are Surtseyan effects.

The magmas low in silica produce lava on the surface that usually belong to the largest family of volcanic rocks—basalts. Composition of basalt magma can evolve and become slightly richer in silica. Viscosity increases as a result and explosive phenomena become larger and fragment the lava into great spurts (volcanic bombs) that are sometimes projected to great distances. Such explosive activities coexist with emissions of lava flows, which are also less fluid; for an equivalent volume, they therefore cover smaller surfaces than the Hawaiian flows, but they have greater thickness. The world's most frequent type of dynamism, Strombolian, is as common in accretion zones as in subduction zones.

Subduction Zones: Gray Volcanoes

Magma appearing in subduction zones is relatively high in silica (about 70 percent), viscous, and colder (1,382° F). It is also rich in water vapor and gas. Its great viscosity does not allow gas bubbles to form easily and the explosions can be large, sometimes violent. Fragmentation of the matter is very great and sometimes lava only occurs in the form of fine ash. The violent explosions and intense fragmentation of the lava sometimes make dispersal wide.

Two particular dynamisms can be distinguished here. With Pelean dynamism, named for the eruption of Montagne Pelée in 1902, a very viscous magma reaches the surface, rich in gas and in water vapor. Lava is extruded in the form of great build-ups towering directly over the mouth of the crater—which are called domes. Weak variations in viscosity can produce domes with very different morphologies—flow-domes for the most flexible, with almost solid extrusion needles. In this viscous type of lava, microbubbles of high-pressure gas are often trapped. Abrupt and massive degasing of the dome produces one of the most violent, destructive phenomenon of volcanic behavior: *nuée ardente*, a highly mobile avalanche of high-temperature gases and solid materials in suspension (from fine ash up to large blocks) that flows at great speed down the slopes of the volcano. It is by far the most dangerous known volcanic effect.

The Plinian dynamism, named for the report by Pliny the Younger on the eruption of Vesuvius in A.D. 79 is rare. Generally cataclysmic, it represents the extreme form of eruptive action. It is caused by magmas very rich in silica and in gases, which reach the surface rapidly. The explosive phenomenon is particularly intense and continuous; it deeply fragments the lava, which is then emitted in a permanent jet, transforming itself into a gigantic aerial cloud capable of reaching several tens of miles of altitude.

It should be pointed out that, if various types of dynamism can be considered, there exists an entire range of different activities between these characteristic poles, varying widely from one volcano to the next, or from one activity to the next. However, while scientists have long argued for a classification of volcanoes into clearly distinct types, we have also become aware that a single volcanic edifice, in the course of its geological lifetime, can evolve as, among other things, the composition of magma varies. Today we tend to distinguish among types of eruptive activity rather than types of volcanoes, realizing that each volcano can show a succession of different dynamisms in the course of its history.

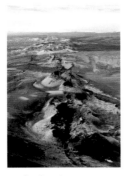

PAGE 377. A range of volcanic cones created by the eruption of Laki volcano in 1783. On 8 June it became active and in 50 days produced nearly 3 cubic miles of lava, with flows extending more than 35 miles. It was the greatest lava emission in modern times. Lakagigar, Iceland.

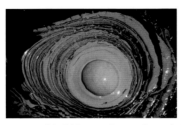

PAGES 378–79. Mud bubble in a fumarole, or hole emitting sulfurous gases. Average temperature here reaches the boiling point. The mud splashes continually, whipped up by the hot gases and the water vapor. Namaskard zone, Iceland.

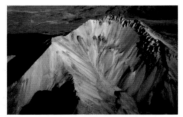

PAGES 380–81. Ancient volcanic cone colored red by ferrous oxides, rocks of which have been eroded by fumaroles. Bolivia.

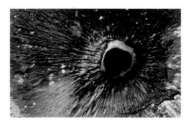

PAGES 382–83. Precipitate of ferrous oxide gives a red color to this mouth of a hot spring. Iceland.

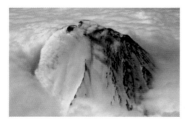

PAGES 384–85. Summit of Sangay volcano in the clouds at an altitude of 17,000 feet. One of the most active volcanoes, its last eruption began in 1934 and continues to this day. Around the volcano are several ash plateaux, carved by canyons more than 1,960 feet deep. Ecuador.

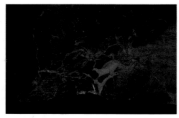

PAGES 386–87. Bursting of a lava bubble swollen by gases and water vapor. Kilauea volcano, Hawaii.

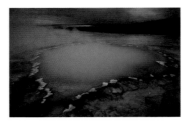

PAGES 388–89. Hot spring of Hveravellir. The color of this basin, called Blahver (blue spring), is caused by light diffraction in the silica in colloidal suspension. The waters underneath are heated by enclosing rocks that are close to the magma. These waters climb to form hot springs, and are also enriched in various mineral salts. Iceland.

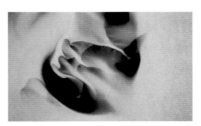

PAGES 390–91. A river colored by mineral salts. Iceland.

PAGES 392–93. Ash deposits on the snowy slopes of Etna. Sicily, Italy.

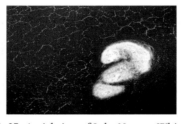

PAGES 394–95. Aerial view of Lake Natron. White efforescences that appear in the red or pink brine are resurgences of caustic soda. The white borders of the polygons are formed of dried soda and harden by contact with air. Tanzania.

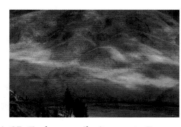

PAGES 396–97. Each year pilgrims go to Bromo volcano, which is several days' walk for some. They have to cross the immense caldera before reaching the crater where they present their offerings. Indonesia.

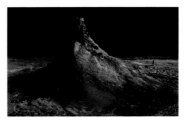

PAGES 398–99. One of the chimneys covering two small lava lakes in the middle of the crater of Oldoinyo Lengai volcano. Tanzania.

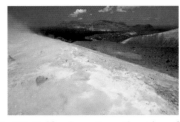

PAGES 400–401. Sulfur deposits on the ridge of the crater of Vulcano volcano. Aeolian islands, Italy.

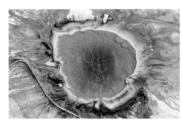

PAGES 402–3. Grand Prismatic Spring, 367 feet in diameter, is one of the largest thermal basins in the world. Its colors are due to the presence of bacteria and microscopic algae that develop in the warm water. Yellowstone National Park, Wyoming.

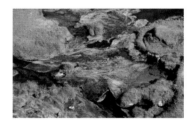

PAGES 404–5. Mineralized hot-water river at Landmannalaugar, in which algae develop. By photosynthesis and thanks to the mineral salts in the water, these algae produce organic matter. Iceland.

PAGES 406–7. A detail of string, or rope, lava. Kilauea volcano. Hawaii.

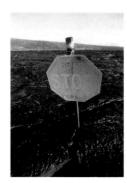

PAGE 408. On several occasions during its great eruptions in 1989, flows emitted by Kilauea volcano cut off Route 130 below the volcano, causing destruction of equipment and of several homes. Kilauea volcano. Hawaii.

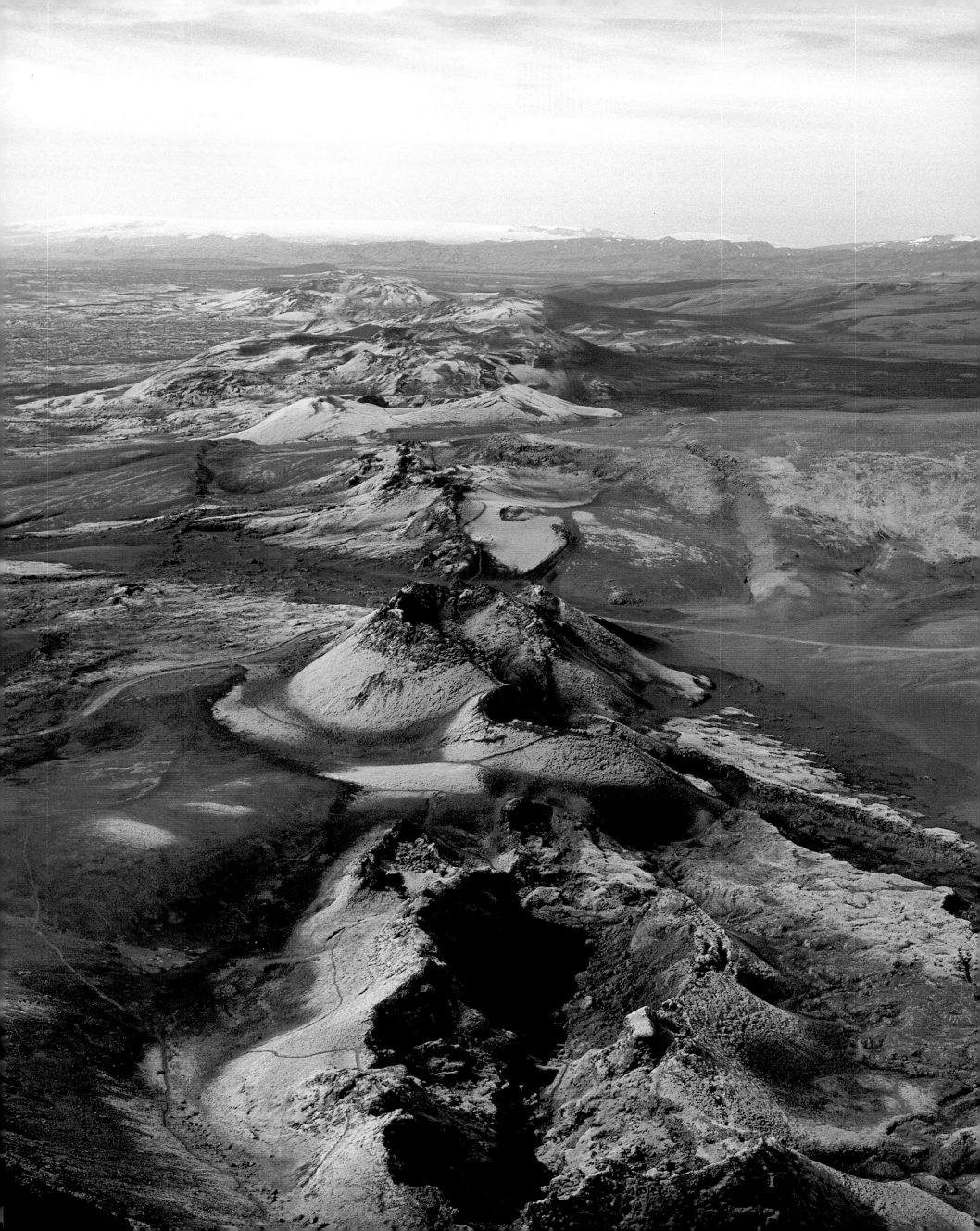

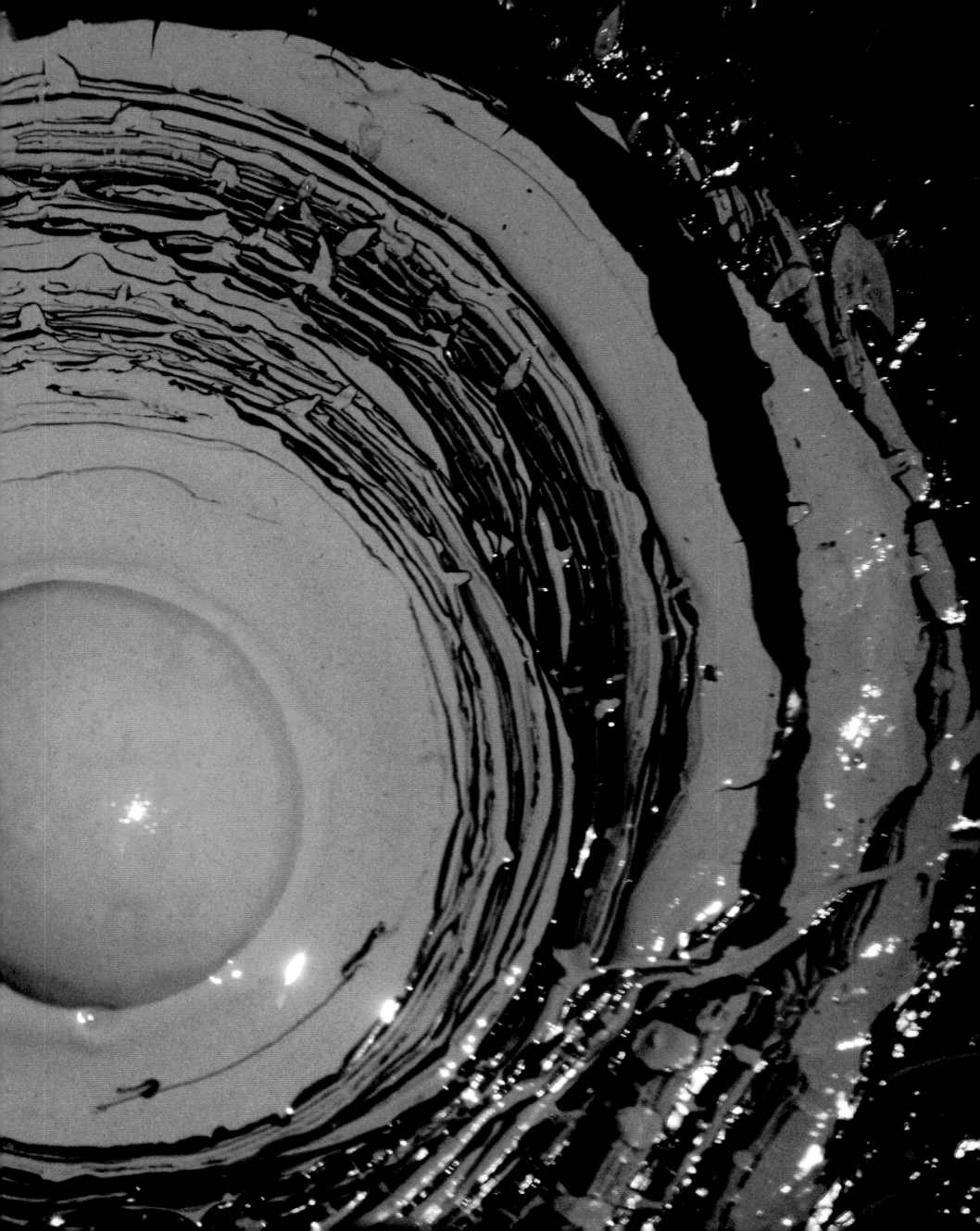

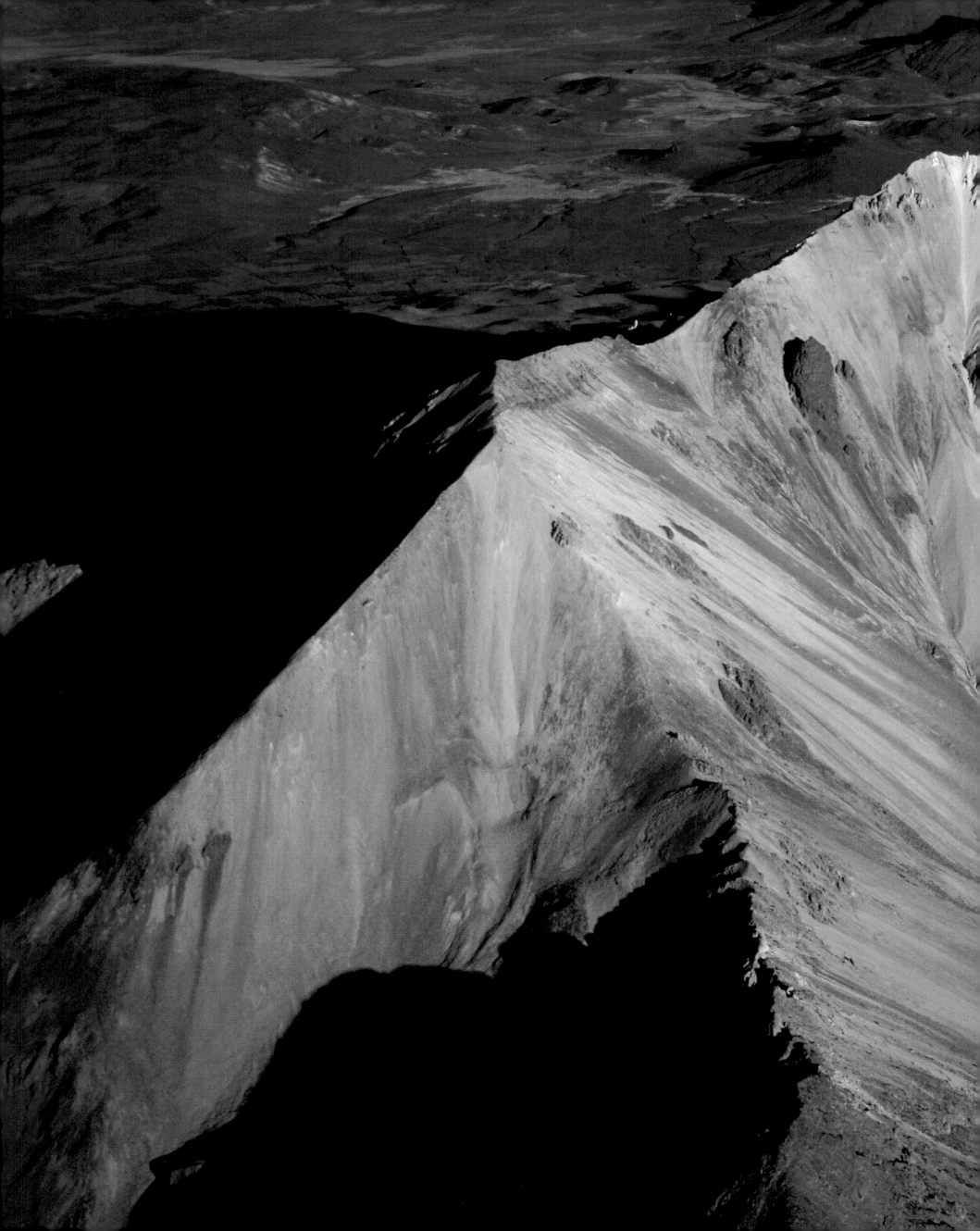

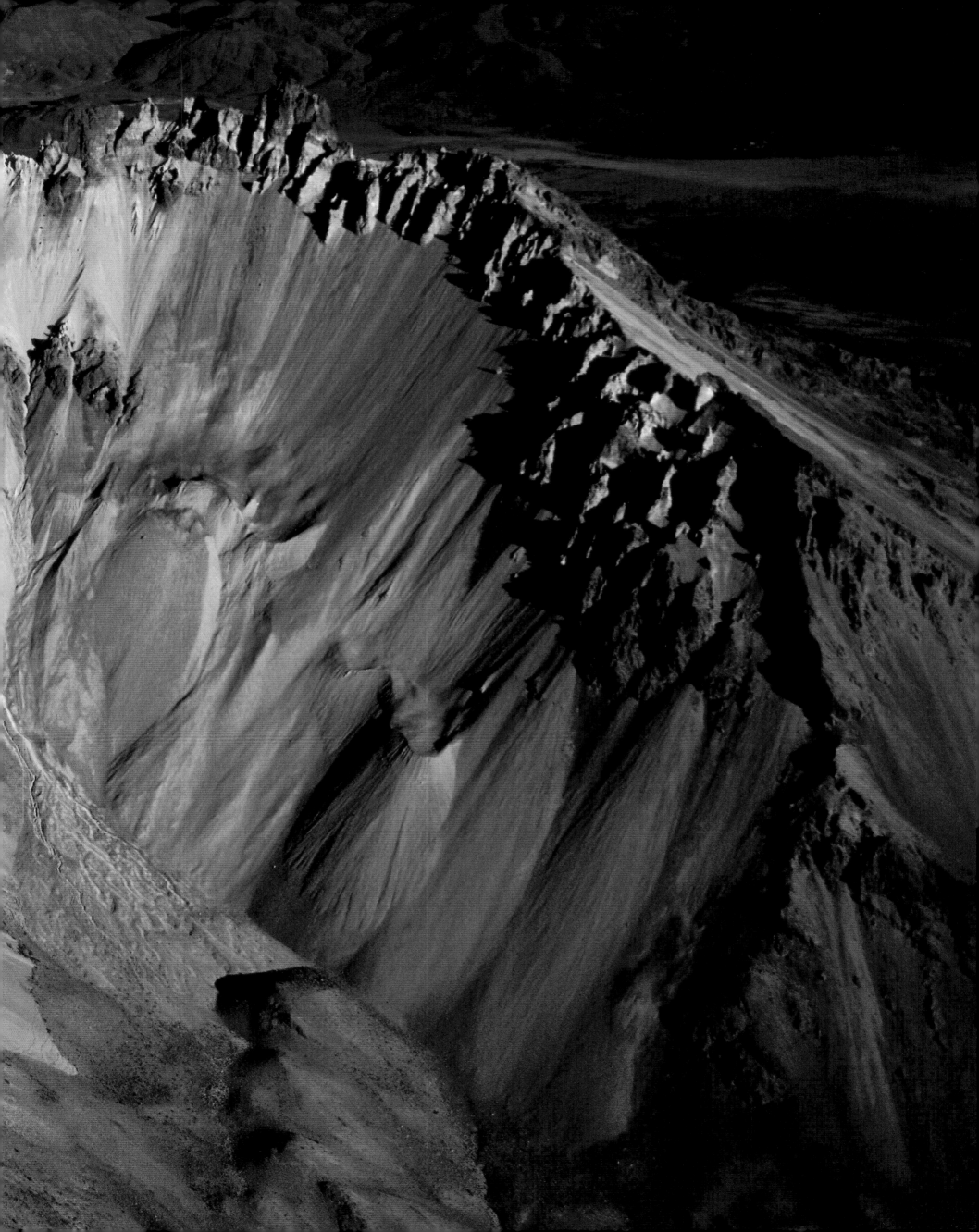

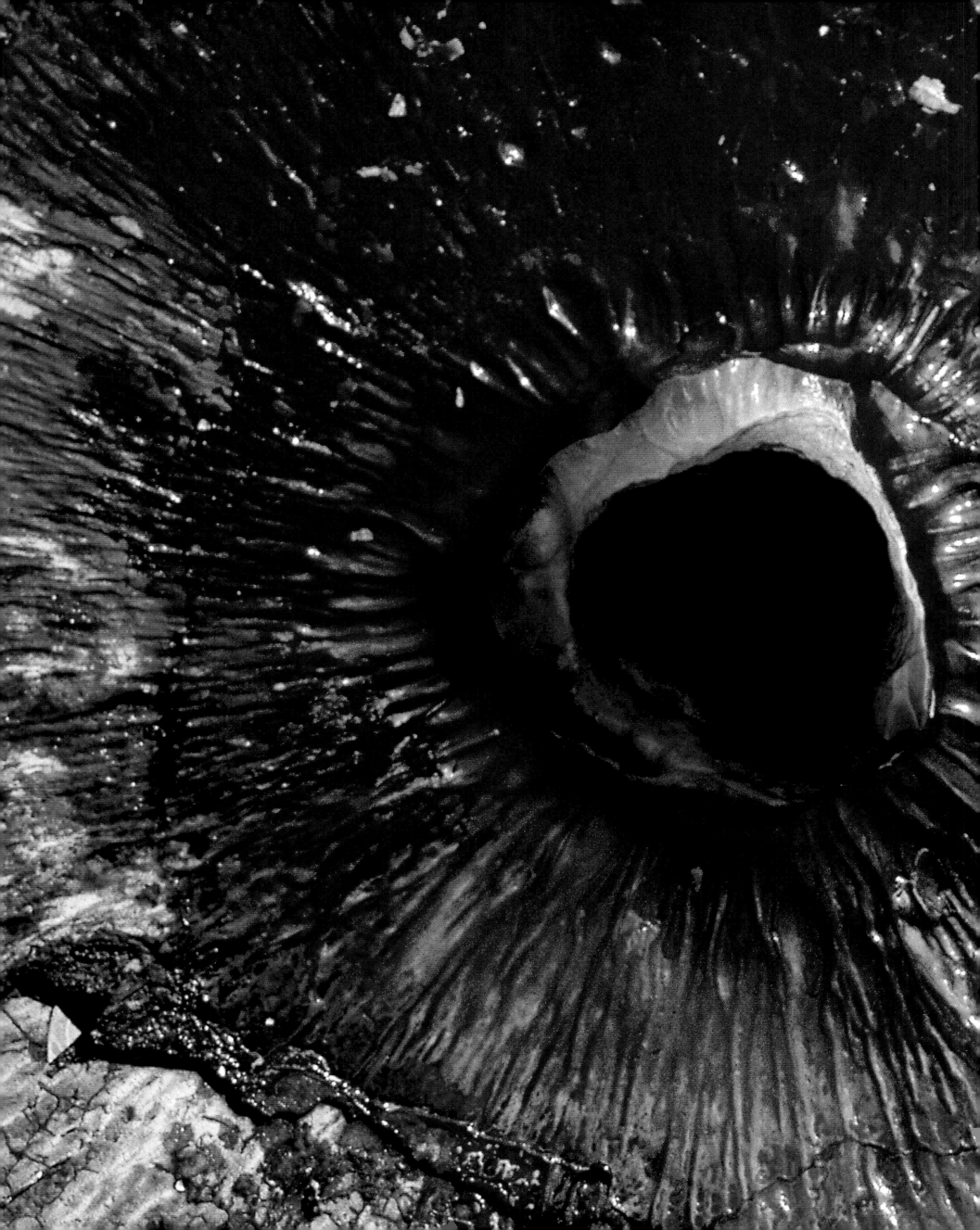

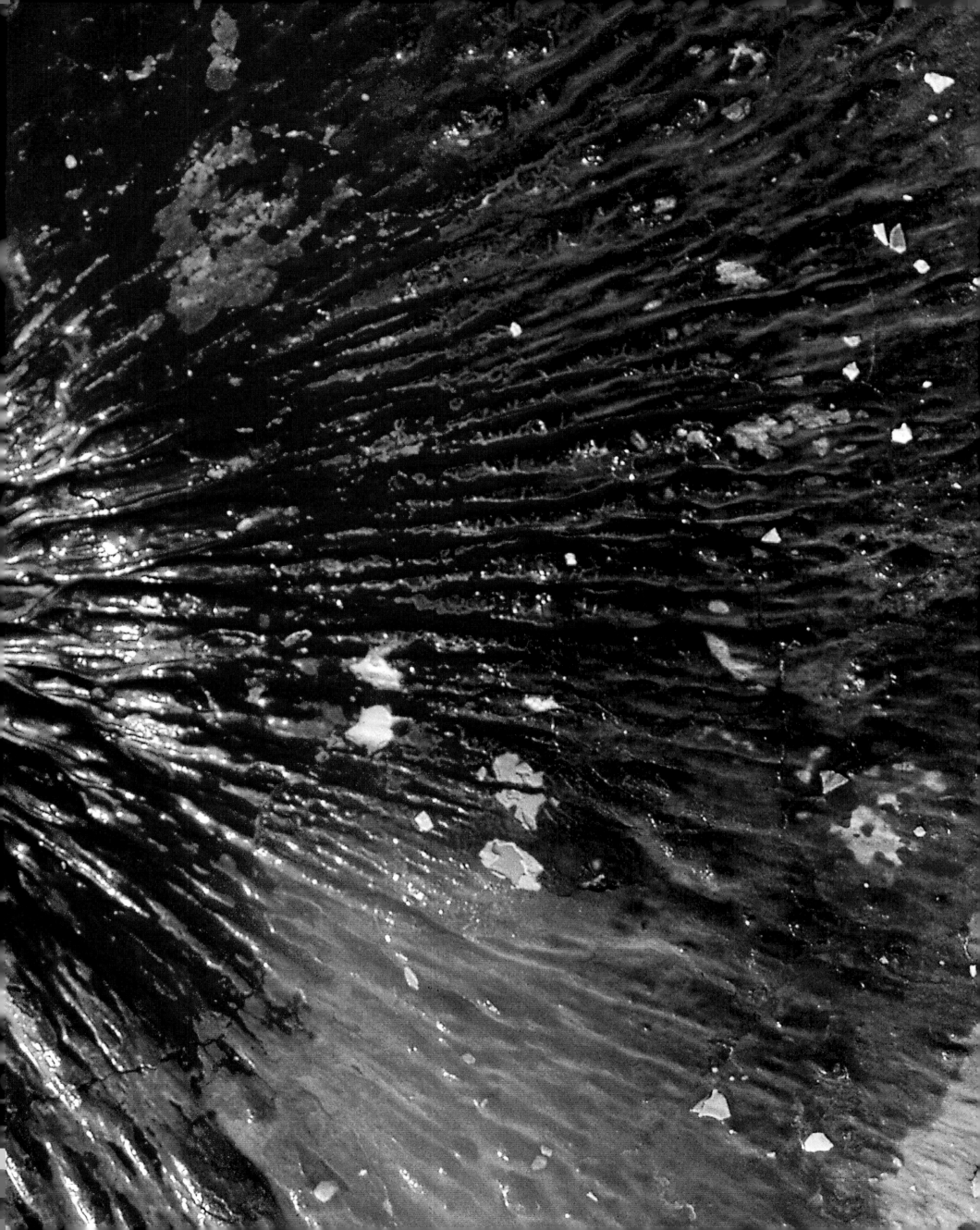

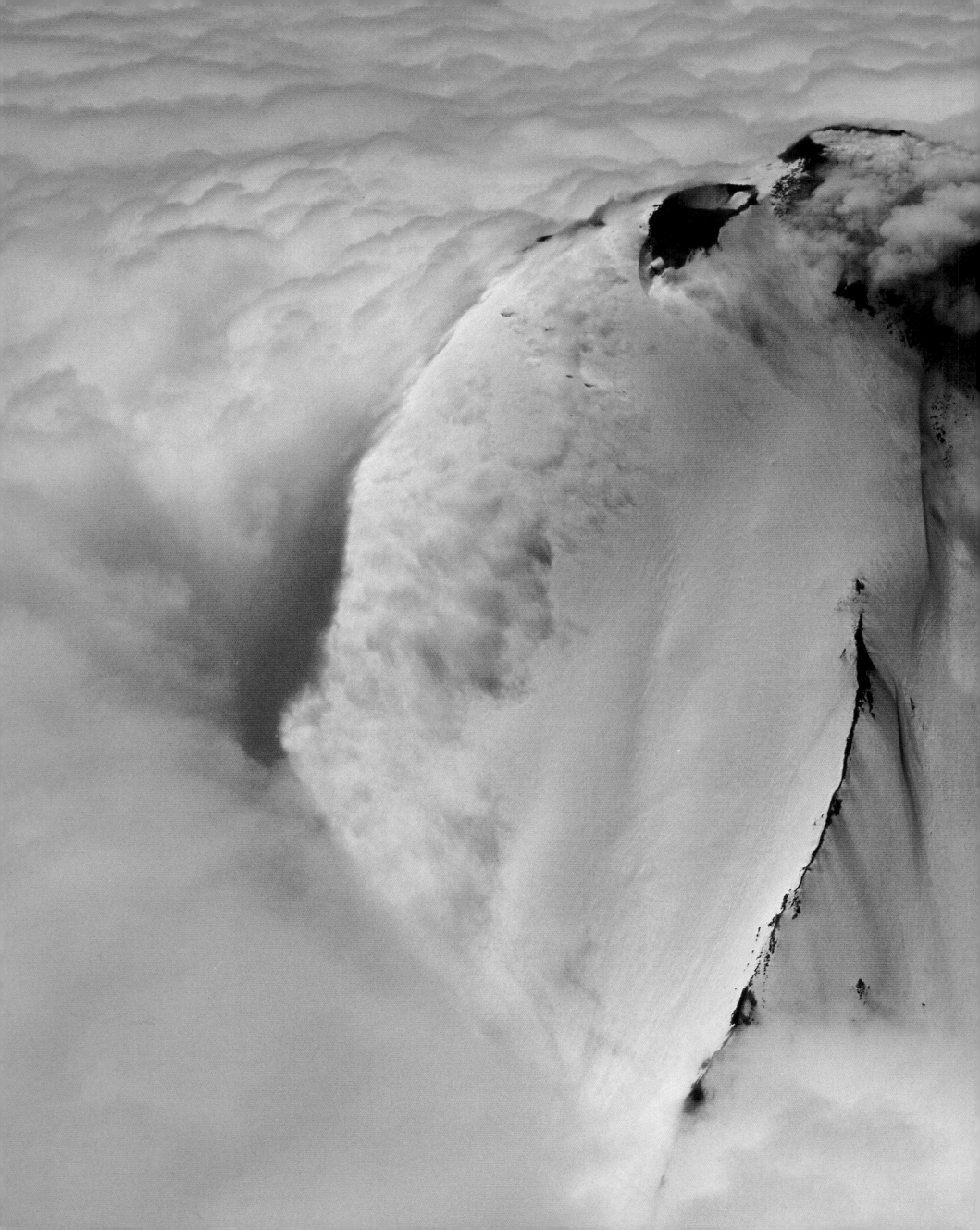

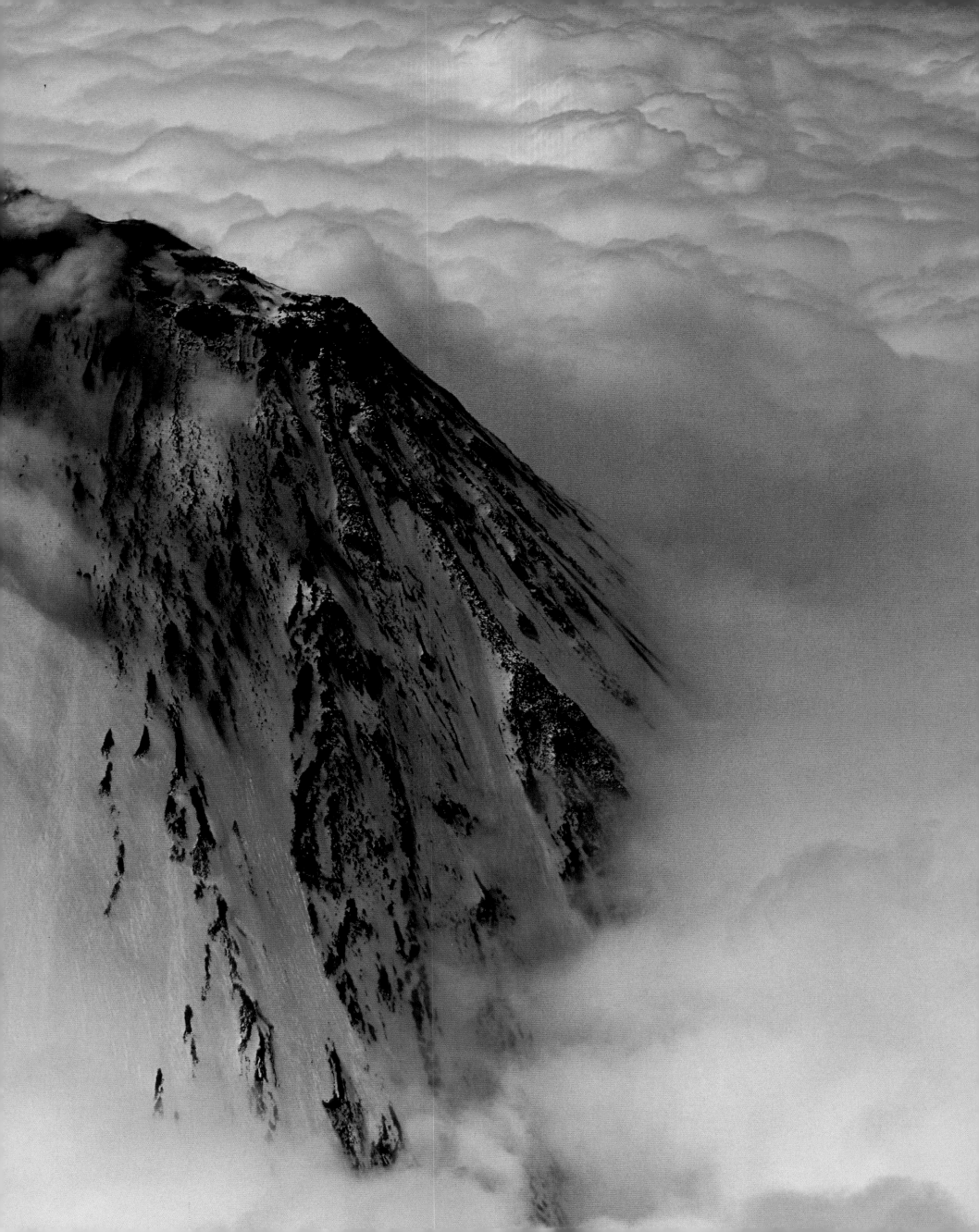

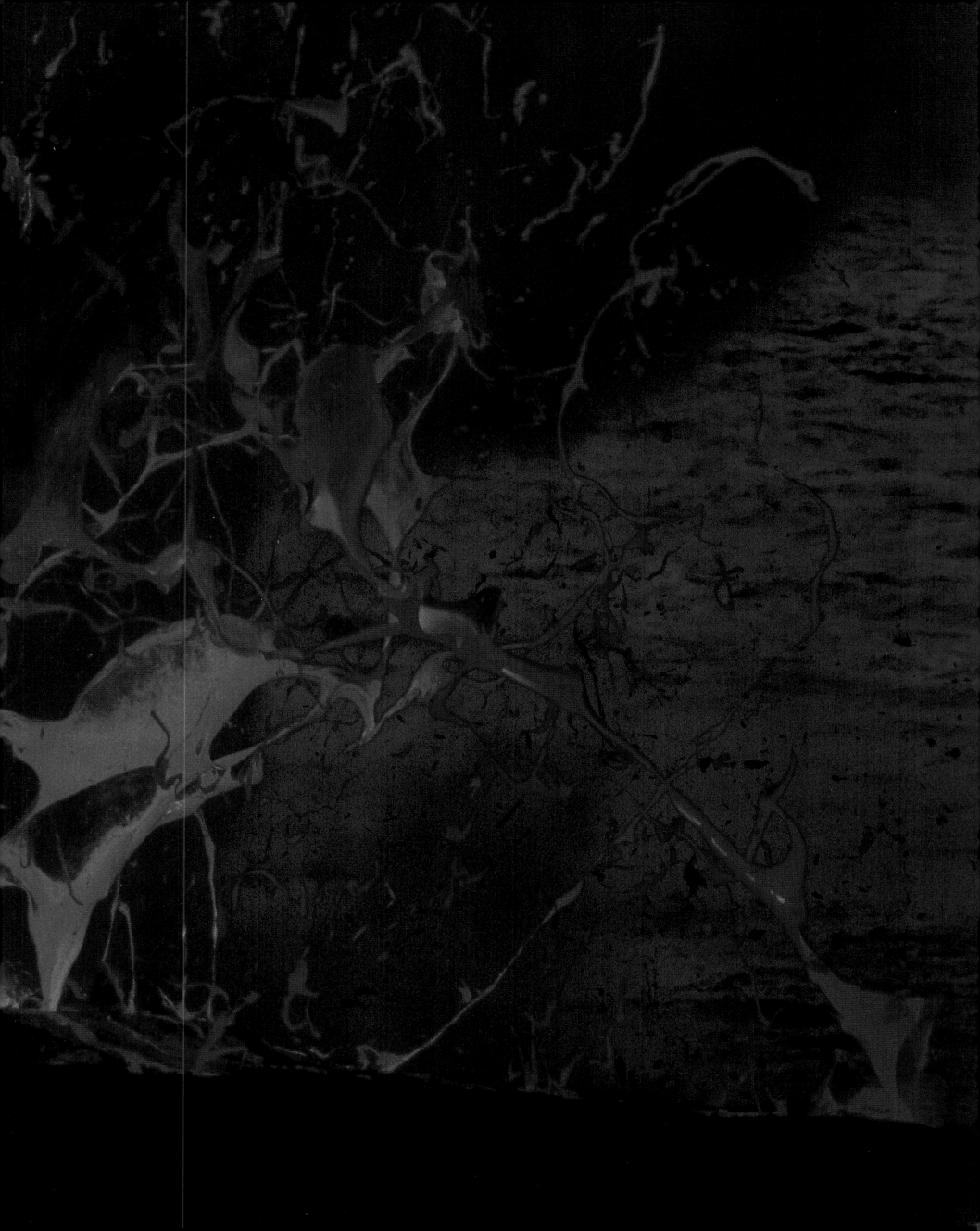

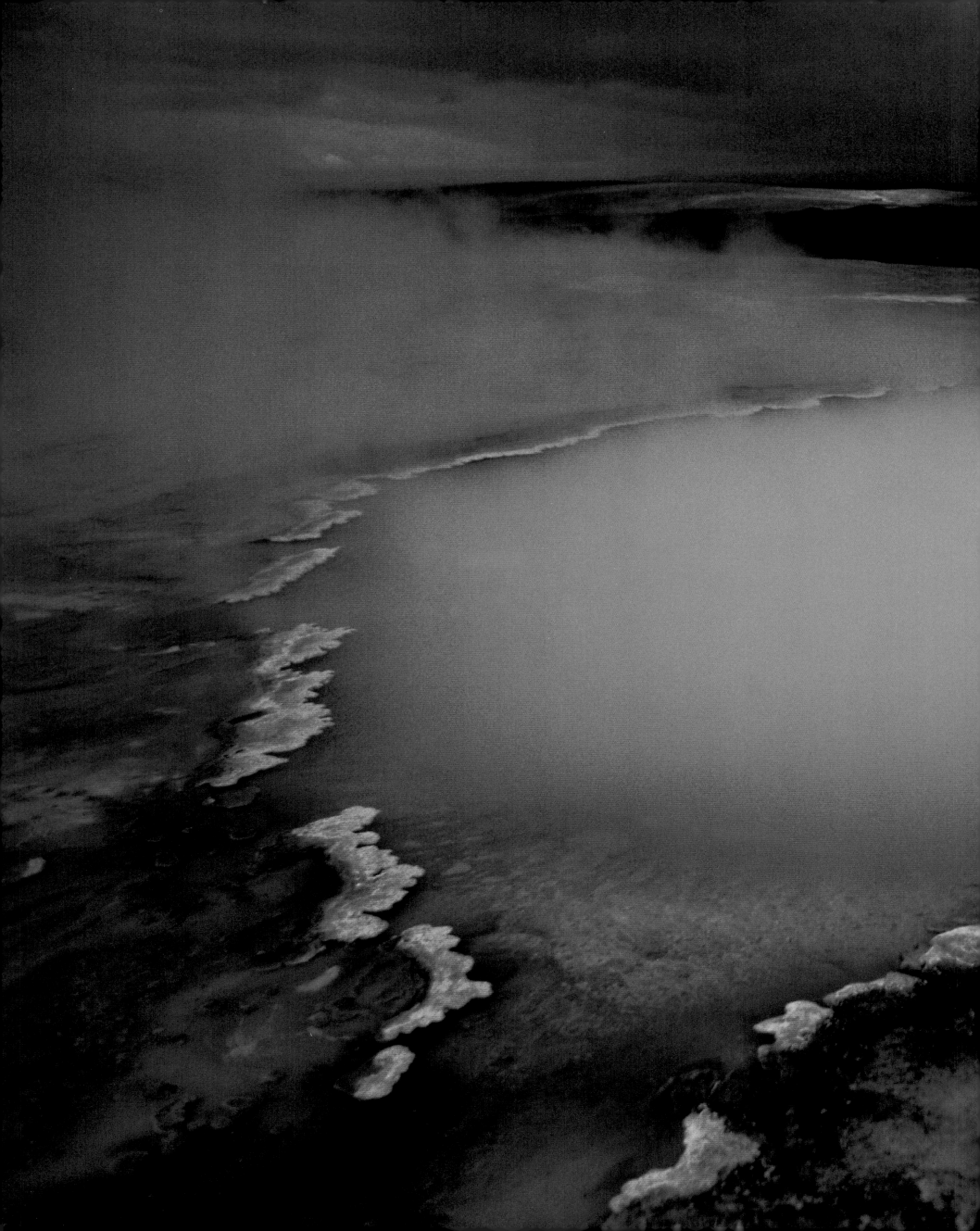

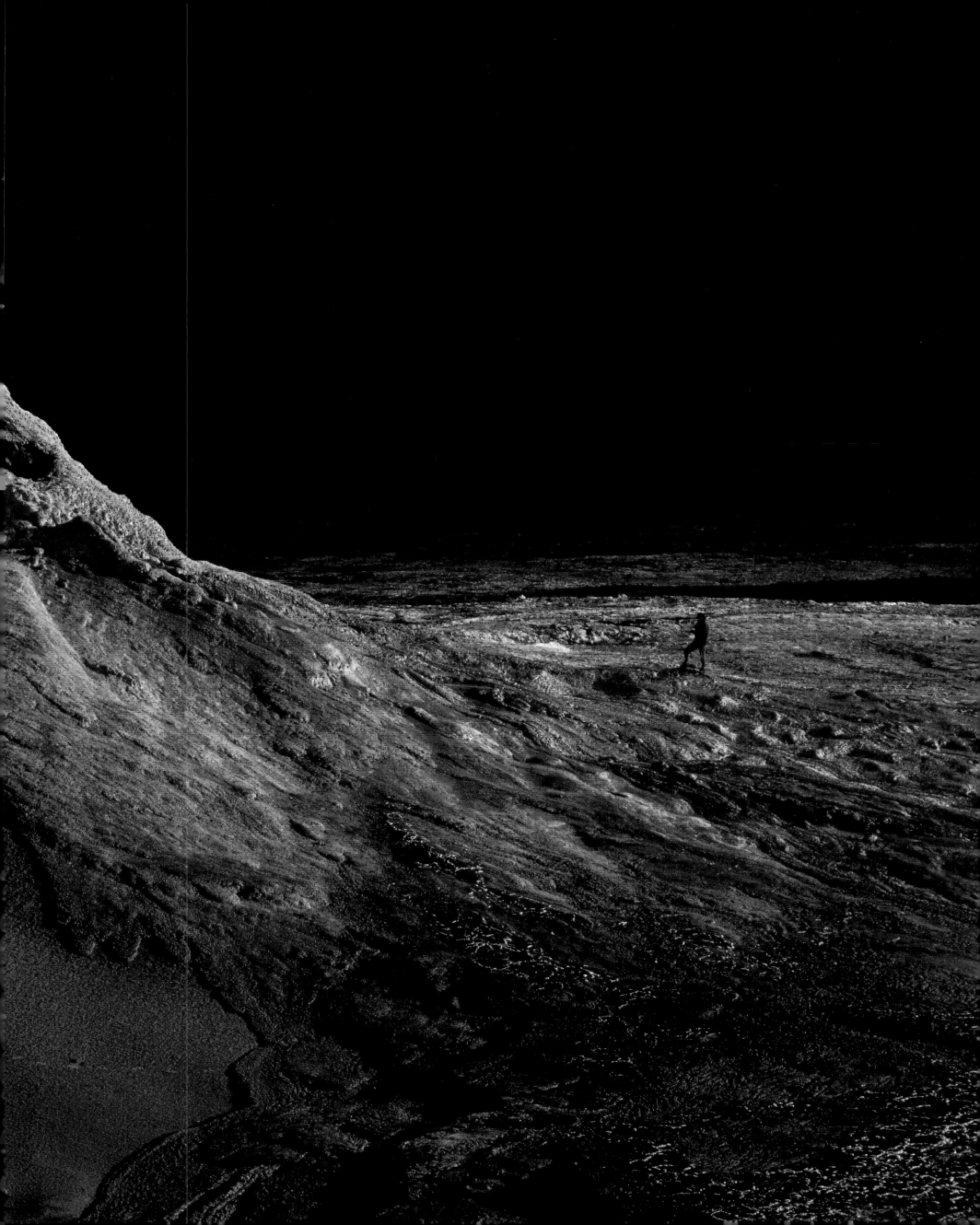

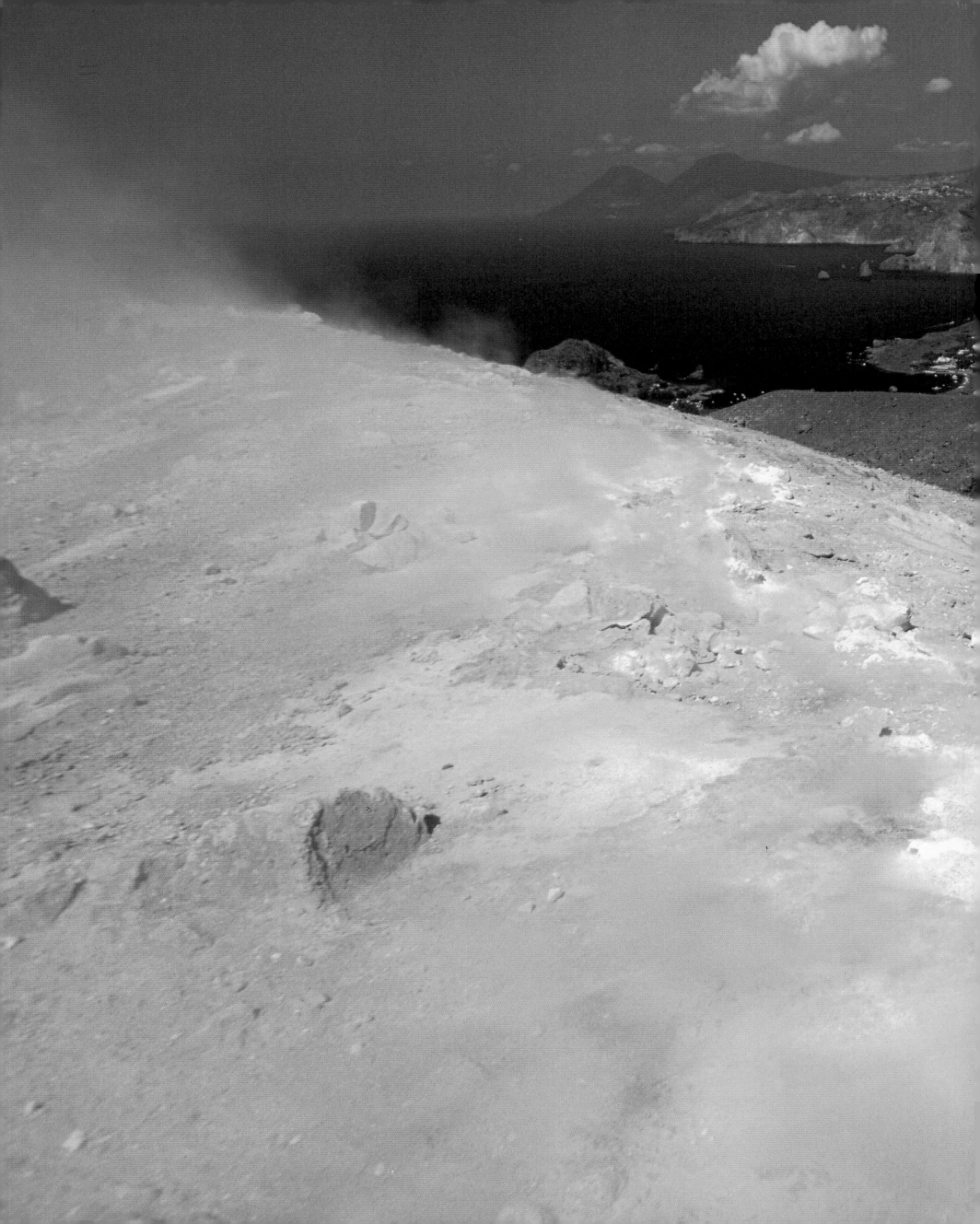

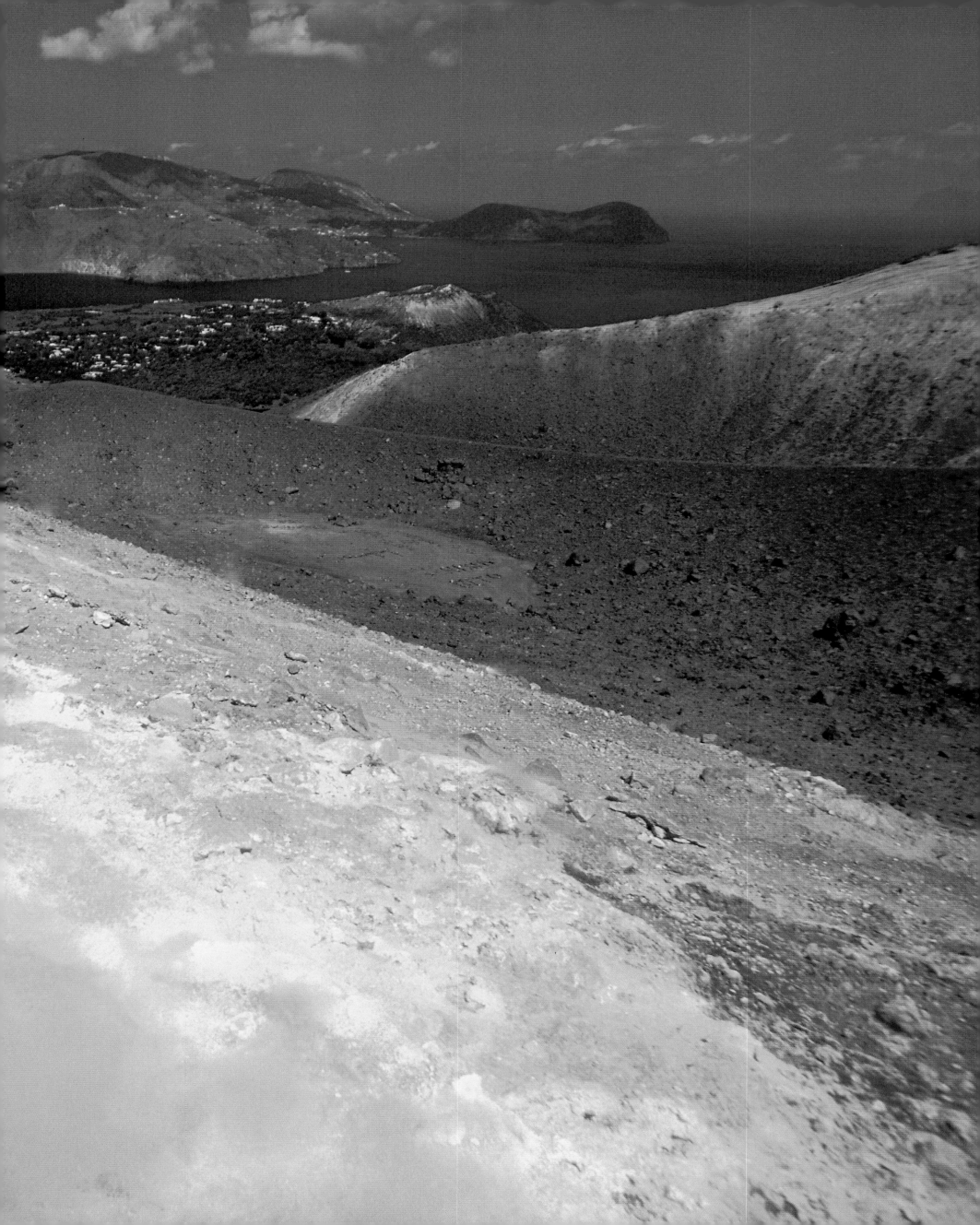

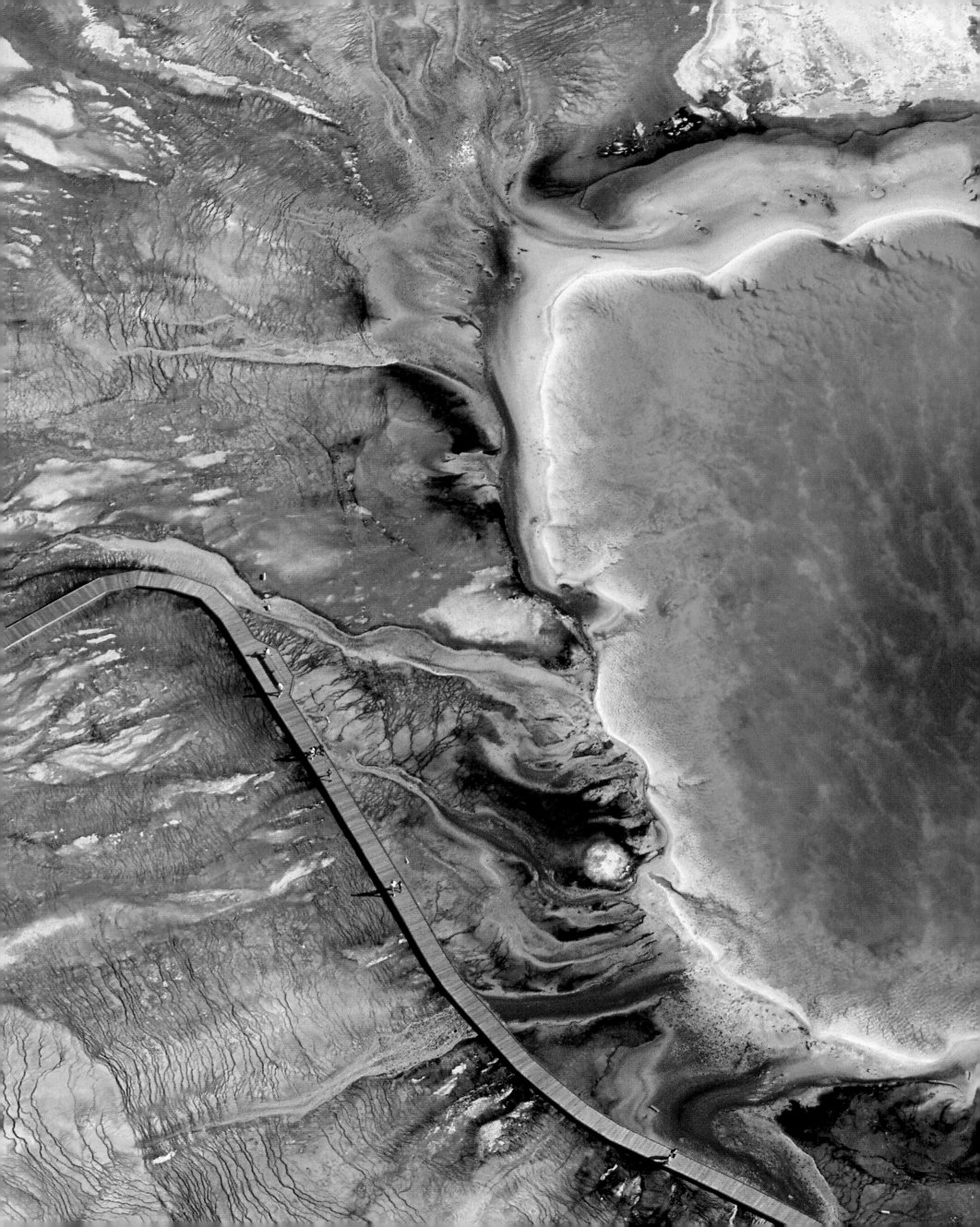

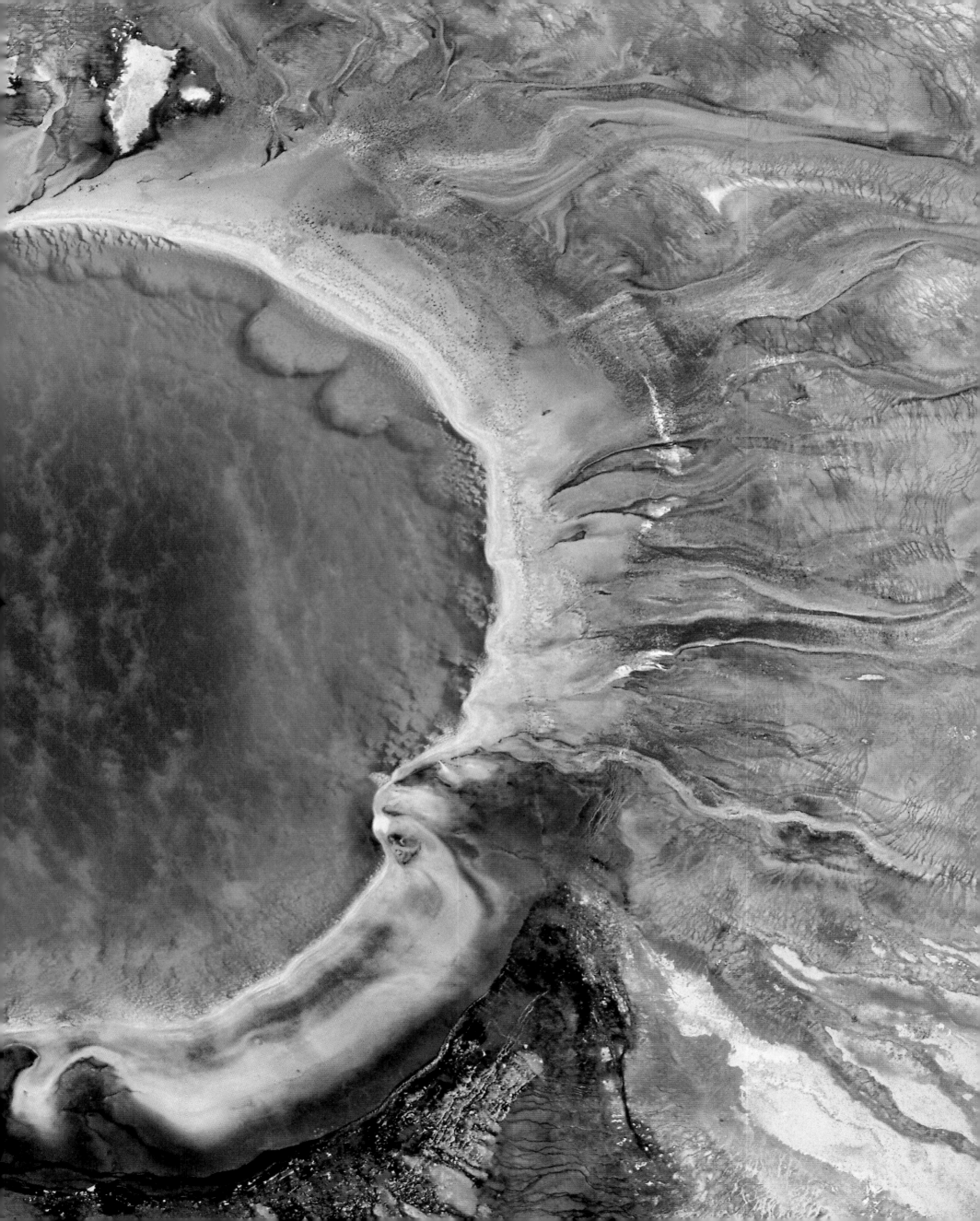

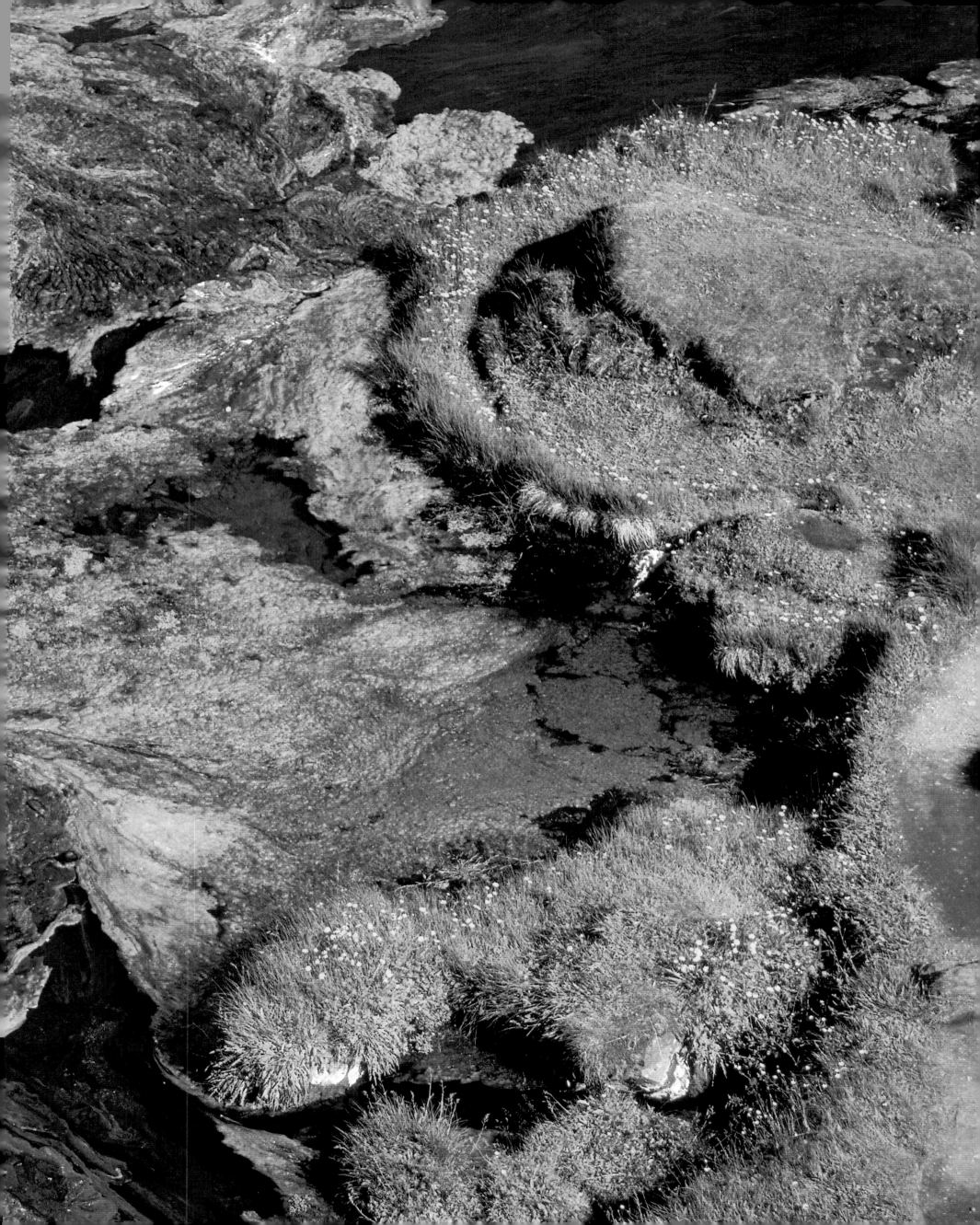

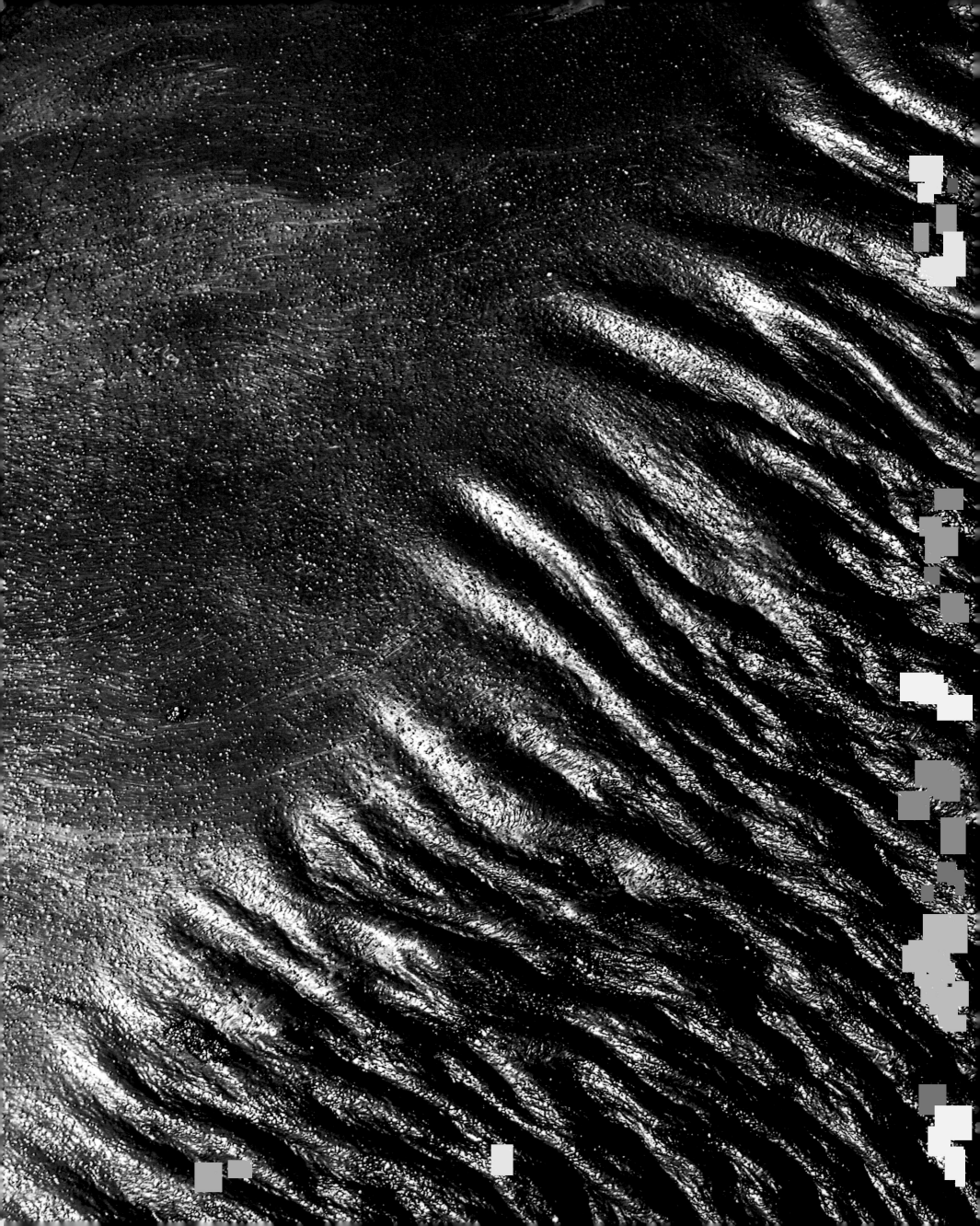

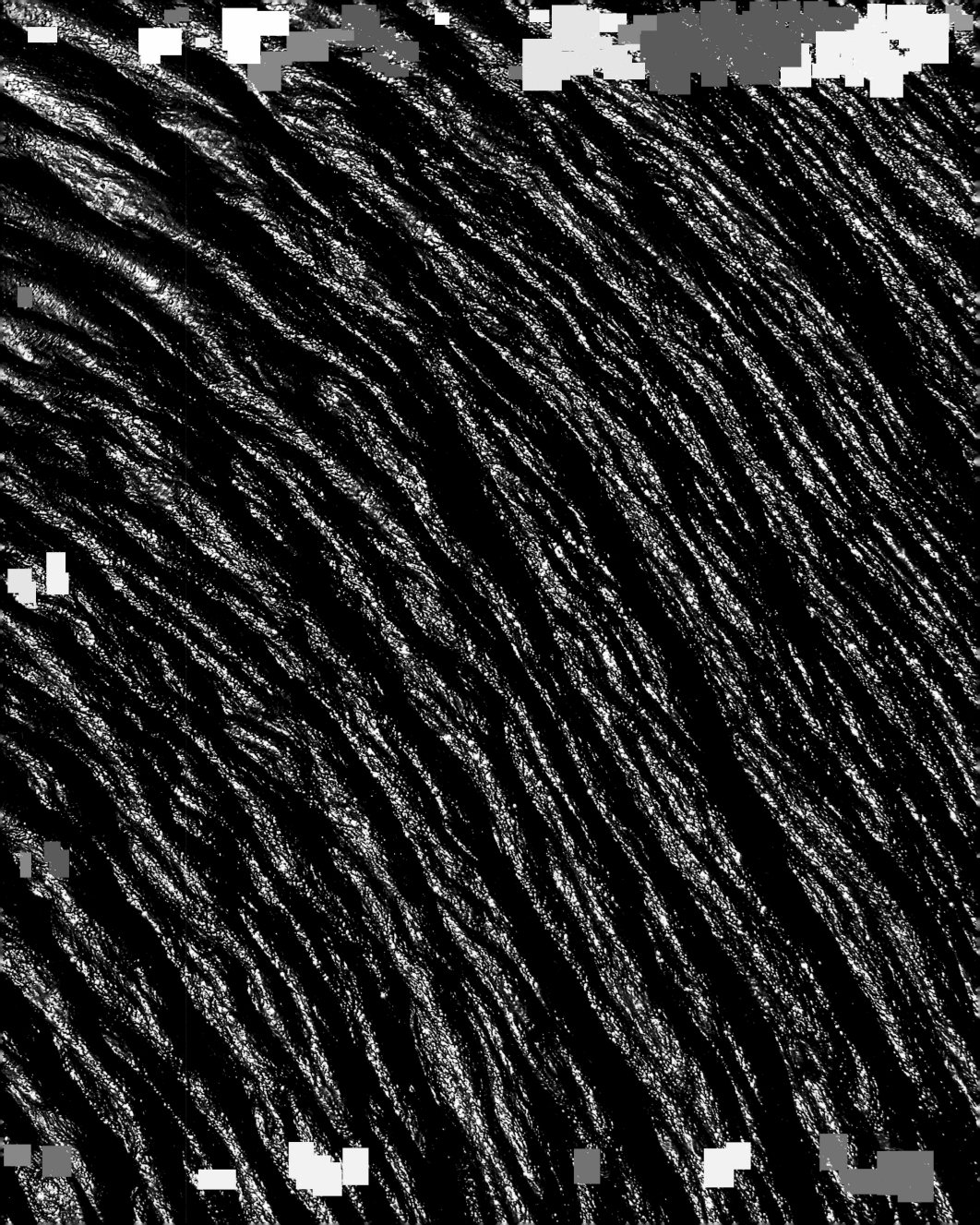

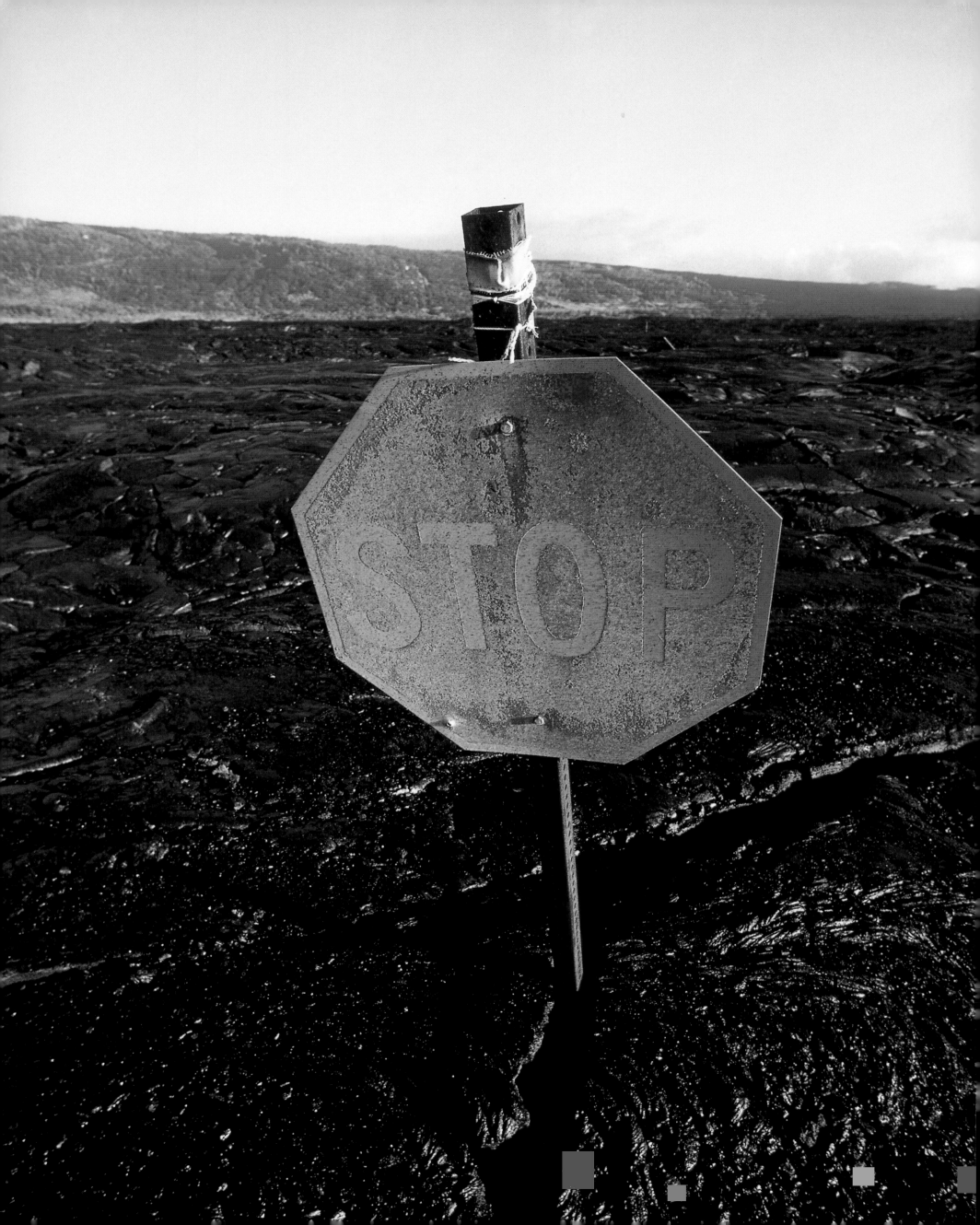

GLOSSARY

Accretion

Enlargement of the oceanic plates at their ridges due to additions of matter from the mantle. Accretion produces the ocean floor.

Basalt

The most common volcanic rock, it constitutes the largest family of lavas. It is relatively poor in silica (45 to 54 percent), but rich in iron and magnesium. Basalt magmas produce lava flows that are rather fluid, extending over great distances and considerable areas. An essential component of oceanic plates, it appears at the level of ridges and is also present in hot-spot volcanoes.

Blast

An air gust from a violent explosion often proceeding in a lateral direction. It expels gases, blocks, and ash. Violent blasts are very destructive even at remote distances from a volcano.

Caldera

Circular or elliptical depression, with a radius of more than $^2/_3$ mile, formed by the collapse of the peak area of a volcano. Its formation is very often the consequence of a massive extraction of lava during a major eruption. Formation of calderas can be accompanied by violent explosions of phreatic origin.

Carbonatite

Very rare lava in which carbonate minerals replace silica. Bright in color, often white, it can resemble limestone or chalk. It results from the differentiation of magma by different fluids, mainly carbon dioxide.

Cypressoid Clouds

Clouds of very black ash drenched with water, projected in bunches shaped like cypress trees. They occur in subaquatic eruptions.

Dike

An often vertical fracture that cuts into the base, lower portion, or flank of the volcano. Magma is injected into these fissures. Sheltered by the surrounding walls, the magma then cools very slowly. The rock crystallized inside often becomes harder than its container. Later it can be exposed by erosion. The dike appears then like a vertical layer or a blade of variable length.

Fissural Eruption

An eruption that develops all along a fissure. A series of aligned volcanic cones can be formed by it. Fissural eruptions appear at the bottom of rifts or on the flanks of wide shield volcanoes.

GPS (Global Positioning Satellite)

A precise technique for locating a point on the earth's surface by successive triangulations taken by satellite.

Hlaup

Icelandic term for a mudflow formed of fragments of lava suspended in water. In Iceland it is a secondary phenomenon typical of subglacial volcanic eruptions (*jokulhlaup*).

Hornito

A small cone appearing at the exit point of a lava flow or on the vault of a sublava tunnel. It is formed by the accumulation of spurts projected by gases when lava degases. In general, it does not exceed a few yards in height.

Hummock

The typical relief of small hills that are formed at the foot of a volcano. These hills are the result of accumulated debris from matter displaced by a collapse of the flank of a volcanic edifice.

Lapillus

A small, hard fragment of lava (tephra), with a diameter between 2 and 50 millimeters, ejected during a volcanic explosion.

Mantle

The earth's mantle, the part just below the crust and extending to a depth of 1,800 miles, or relating to the same.

Moraine

An accumulation of earth and rocks on the frontal or lateral portions of glaciers, which carry and ultimately deposit them.

Obsidian

Vitreous (with crystalline structure) volcanic rock, often black but sometimes translucent when thin. It arises from the particular cooling of an acidic lava (rich in silica). Often very sharp, it has been used for making tools.

Outcropping

A site where, following erosion or any natural or artificial rupture in the terrain, rock breaks through the surface.

Palagonite

Rock formed during a subaquatic eruption by the accretion of fine grains of hot magma fragmented in cold water. The vitreous, hydrated paste during the drenching gives palagonite a characteristically yellow to dark orange tint.